MASTER PHOTO GRAPHERS

Editor: Roberto Koch
Texts by Laura Leonelli, Alessandra Mauro, and Alessia Tagliaventi
Text on p. 231 reproduced by the kind permission of Wim Wenders
Text on p. 407 compiled by Alessandra Mauro

Translated from the Italian by Brian Eskenazi (pp. 30–117, 140–227, 250–293, 338–359,
382–403, and 426–447) and Alta Price (pp. 7–29, 118–139, 228–249, 294–337, 360–381,
404–425, and the German quotations on pp. 430 and 436)
Design: A+G Studio, Milan
Copyediting: Sarah Kane
Typesetting: Anne Lou Bissières
Proofreading: Marc Feustel
Editorial Assistance: Bethany Wright
Production Quality Control: Barbara Barattolo
Printing and Color Separation: EBS, Verona, Italy

Originally published in Italian as *Grandi Fotografi*
© Contrasto srl, Rome, 2012

English-language edition
© Flammarion, S.A., Paris, 2012

MASTER PHOTO GRAPHERS

Flammarion

CONTENTS

INTRODUCTION

Enumerating, selecting, counting, classifying. According to Umberto Eco—who dedicated an entire book to lists and their infinite, vertiginous variations—compiling a list is a key way to study and understand things, create order, establish an image, arrive at a methodology, and achieve real knowledge.

This list of twenty major photographers is no exception: these names have been brought together out of a desire—and a perhaps *chaotic* need, as Eco would likely say—to offer the reader a broad overview of what photography was in the twentieth century and beyond. These artists, whose backgrounds and experiences run the gamut, have all set fundamental milestones not only in the history of photography but also in the broader field of visual arts. They therefore represent twenty waypoints, marking essential junctures.

Is this only a partial catalog? Perhaps. But what artist could ever pick up a camera and try to comprehend its meaning—its intrinsic adaptability, its formal and technical value—without first studying Man Ray's striking work? Who could ever think of attempting a socially investigative photo essay without a knowledge of those done by Walker Evans and Margaret Bourke-White? What kind of portrait photographer could ever ignore August Sander's work? Who would try to sound the depths and true dimensions of the human body and of Eros without thinking of Robert Mapplethorpe? What kind of photojournalist could take on a theater of war, get close to the action, and try to render it as a comprehensible and effective narrative without comparing the result to the images captured by Robert Capa or, more recently, James Nachtwey's photo-reportages?

These photographers' visions have now become part of our way of seeing. Through the eyes of Henri Cartier-Bresson we learned to see and view the world in striking images, meaningful pictures that foresaw the future. We closely followed Robert Doisneau and Elliott Erwitt on their explorations of irony, at times light and at times heavy, hoping that reality might come to resemble their photographs. We got lost in the big-city streets of William Klein's photographs, then reoriented ourselves with the clear vision distilled in Gabriele Basilico's images. And if we still have any understanding whatsoever of community and collective meaning, it is thanks to Sebastião Salgado's epic visual narratives.

Each photographer on this list, and each of their personal contributions to their medium, represents a pioneering moment, a new way of seeing. Peter Lindbergh and Herb Ritts offer a novel means of conceiving fashion photography; Helmut Newton and Nobuyoshi Araki give new form to dreams and perversions; and Mario Giacomelli brings poetic ancestral memories into being. Just as the mere mention of travel photography invariably calls to mind Steve McCurry's extraordinary visual notebooks of his voyages in Asia, anyone who participates in the collective rituals of Western society now finds themselves in a contemporary fresco much like the ones created by Martin Parr.

The list of twenty photographers featured here therefore aims to provide a tool—bringing diverse visions together in a single book—for understanding the value of the photographic experience. Photography has become the shared language, at times refined and lyrical, of contemporary life. But this list has another function as well: it suggests other possible lists, other artists yet to be discovered, studied, and considered. Eco reminds us that, when composing the *Iliad*, Homer could not say how many Greek warriors there were, nor their names, so he was limited to creating a "*catalog of ships.*" Nevertheless, this long, detailed list still didn't cover the real number of boats, nor did it exhaustively define the Greeks' naval power: "At first he attempts a comparison: that mass of men, whose arms reflect the sunlight, is like a fire raging through a forest. It is like a flock of geese or cranes that seem to cross the sky like a thunderclap. But no metaphor comes to his aid, and he calls on the Muses for help: 'Tell me, O Muses who dwell on Olympus, you who know all ... you who were the leaders and the guides of the Danae; I shall not call the host by name, not even had I ten tongues and ten mouths,' and so he prepares to name only the captains and the ships.... It looks like a shortcut but this shortcut takes him three hundred and fifty verses of the poem. Apparently the list is finite (there should not be other captains and other ships), but since he cannot say how many men there are for every leader, the number he alludes to is still indefinite."

Such a list, then, can be a description open to change, just as when an inventory ends with a simple yet indicative "et cetera" that hints at infinite possibilities and variants. And so we find it fitting that this list, too, concludes with a possible, ideal *et cetera* that might open onto other names yet to be noted, other photographic experiences yet to be studied—other lists yet to be compiled.

Alessandra Mauro

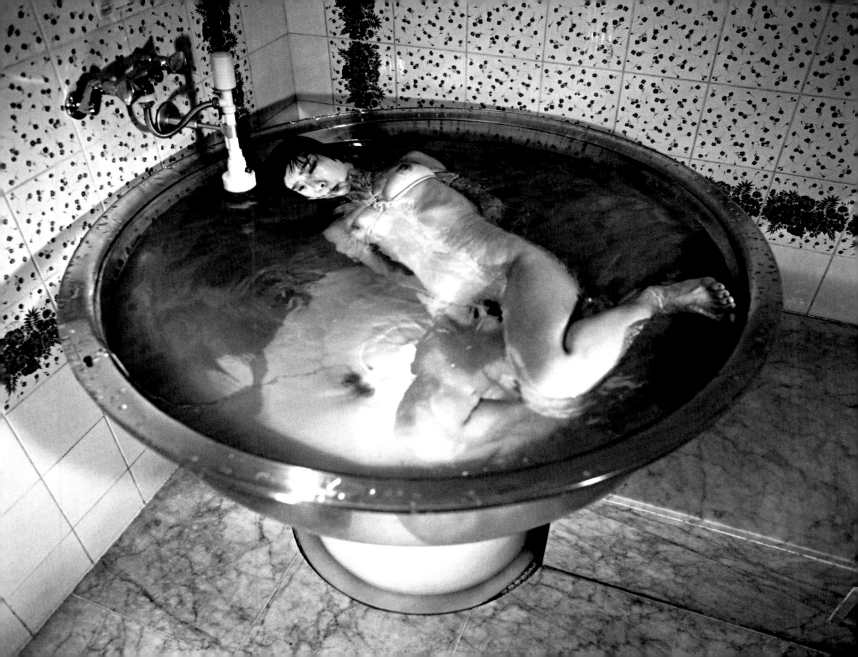

ARAKI

Page 8
From the series "Love in Winter"
"Women interest me a lot because they are mysterious and sometimes wicked. At times they're a Madonna, at times they're a whore. They have countless complex aspects, and never bore me. So, if I continue photographing anything at all, it will always be women."

Above
From the series "Angel's Festival"
"Flowers are alive, but they wilt, and that's why they intrigue me: I get an erotic feeling when I see them wither away."

NOBUYOSHI ARAKI

There is a highly original core at the heart of Araki's photography. It is a pulsating core that, as is often the case, is rooted in his childhood. As he has said, "Everything is determined by the place where you grew up." For Araki that place is Tokyo, the emotional center of his work and life. Venturing even deeper into his own roots and personal past, Araki points to the precise neighborhood of Minowa, the working-class area north of the city center, where he was born. There was a temple there called Jokanji, where prostitutes without families were buried. Araki went there to play, and it left an indelible mark: "That's how I learned that eroticism, life, and death are all connected. This concept has left a permanent imprint inside me. That's the center of my Tokyo, a place where life and death coexist, side by side."

Araki is one of the most provocative, desecrating, and sought-after Japanese photographers, and collectors worldwide covet his work. Eros, in all its forms and facets— love, passion, desire, sexuality, loss—is one of the crucial impulses behind his artistic practice. The models' ethereal and provocative bodies, women's faces, the sculptural intensity of the female sex organs, Japanese skies, Tokyo nightlife, the corporeal density of various foods, and the rich hues of fleshy flowers are some of the subjects at the heart of his poetic universe, in which photography is a fleeting act of love merging the sexual and the sacred. Motivated by that pulsating core, in all his infinite images Araki has done nothing but write the manuscript of his very own visual novel: "As I snap the shutter I'm collecting a bunch of dots that, brought together and connected, make up the lines that compose an entire life."

Nobuyoshi Araki is a histrionic, anarchic, nonconformist animal—a provocateur who hungers after reality, for whom the unusual and the banal coincide with one another. The cameras he always carries are jaws ready to pounce on and bite into as much reality as possible, not so much in order to tell its story, but rather to express his personal emotions about life itself. He shot his first images as an elementary-school student, but it was a bit later, in the 1960s, that he began to think of himself as a photographer. At first, no one wanted to publish his work. Tired of interminable, unproductive meetings with publishers, he decided to go it alone and try to earn his own artistic freedom. With the help of a photocopier he self-published his first books, the *Xeroxed Photo Albums*, and sent them to friends, colleagues, and strangers chosen at random from the telephone directory. In 1971 one of his most intense books, *Sentimental Journey*, came out: its intimate, poetic images were taken while on honeymoon with his beloved wife, Yoko. The book is a veritable act of love. Araki did the layout and editing himself, and considers it the beginning of his career as a photographer.

A year later he left his job at the Dentsu advertising agency and began working full-time on his photography. His first few books were soon followed by hundreds of publications, catalogs, and monographs—book after book, the work marked and retold his experiences.

Women are central in his world. More than mere muses, they are guiding spirits of sorts, powerful and mysterious beings that lead him on his explorations of a feminine essence that is at once carnal and abstract. Araki strips his models, ties them up, transforms them into objects of desire that nevertheless maintain their own mysterious and fleeting independence. He practises *kinbaku* on their bodies, a form of bondage based on *shibari*, the ancient Japanese art of binding objects with cords, and then he photographs them. To use the artist's own words, "I tie women's bodies up because I know their souls can't be tied. Only the physical self can be tied. Putting a rope round a woman is like putting an arm round her."

Japanese tradition and visual culture have deeply shaped his artistic imagination. Through the portraits of his models Araki riffs on and renews the traditions of *shunga*, an erotic genre of printmaking that dates back to the period between 1603 and 1867. His images, split between a very contemporary rawness and ancient poetic sensibilities, are a rediscovery of Japanese sensuality, which was a perennial part of traditional arts that then became censored by modern society. But, above and beyond all artistic traditions, for Araki photography is an essential part of his being in the world. Whether it is the iconic power of a woman's body or a flower, whether it is a portrait snatched from the streets of Tokyo or the almost mystical intensity of a black-and-white sky, with every shot Araki creates a copy of himself.

Araki sees photography as a sentimental journey, as a marriage. His own matrimony ended in an intimate and moving hymn, *Winter Journey*, a book in praise of the love lost following his wife's death. As the artist said in Travis Klose's documentary film *Arakimentari*, "After Yoko's death, for almost a year I photographed nothing but the sky from my balcony. Can you see how they're different from the usual cloud photos? They all have that feeling of sadness in life. That's why photography is a sentimental journey."

Kaori, 2008

"When I perform *kinbaku* on a woman, I establish a very intimate relationship with her, especially if I don't yet know her very well. I am fascinated by the transformation—the physical transformation of the body, but also the transformation of our interpersonal relationship, the intimacy it creates. Furthermore, I don't like to shoot too close up. When you're too close you can't see well. Keeping a physical distance helps you get closer in other ways. I do the same with flowers. Through photography I become an interpreter of life and of women."

In the Japanese tradition of *kinbaku*, the artist wields a rope and, through binding, creates drawings and geometric forms on the female body. The model's body is thereby transformed into a canvas, and the rope becomes a tool for sculpting it and drawing on it. But that is not the only instrument in Araki's arsenal. His other tools include the lighting, composition, pose, and tonal contrast of black-and-white work. The rope tightens around nude flesh or, in this case, it simply lies upon the model's white skin, which appears even more ethereal in the carefully arranged lighting of this refined black-and-white composition.

But the rope around the model's neck also breaks the composition's elegant balance and introduces a mysterious, ambiguous, potentially violent element. The model also raises her arms, making herself available to the viewer's gaze and launching into an age-old game of role play.

The rope's physicality creates a seductive contrast with the smoothness of her slender body, and the constriction symbolized in the knot around her neck contrasts with her straight-on stare, pointed right at the lens, seductive yet far from even the slightest hint of passive submission.

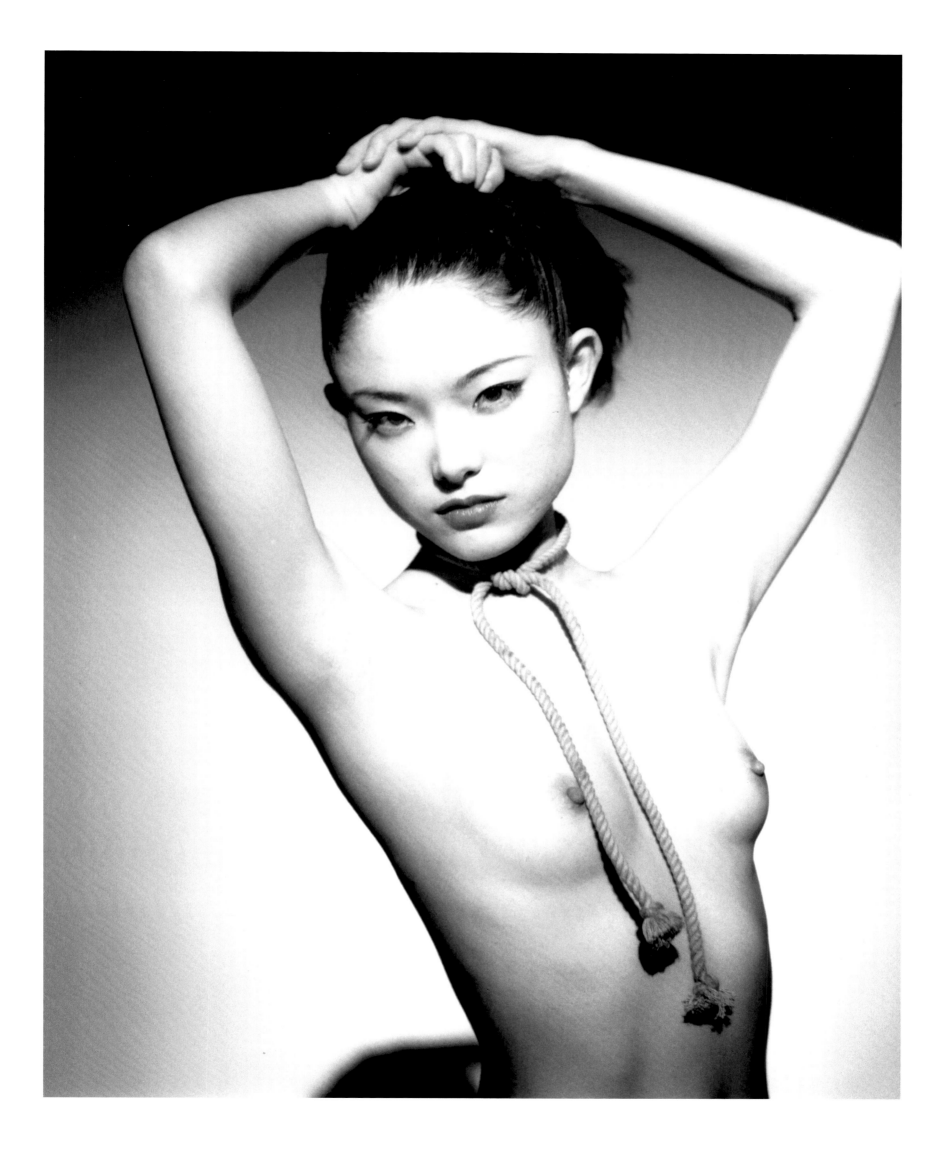

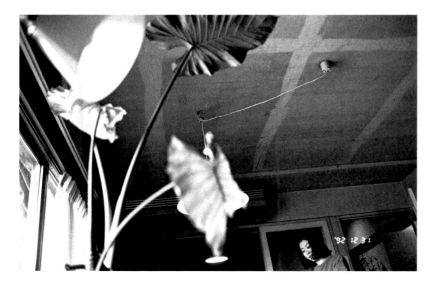

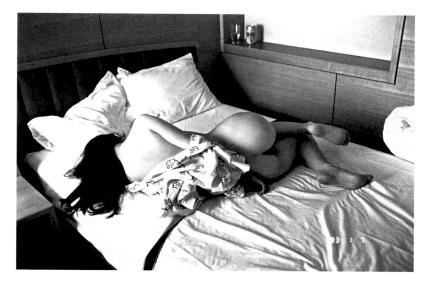

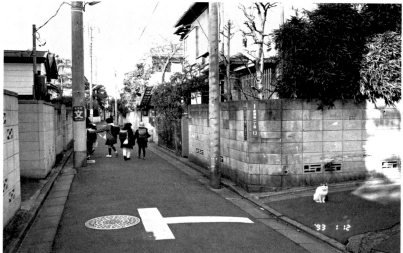

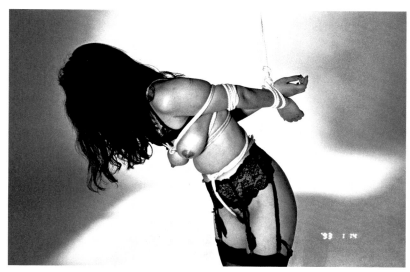

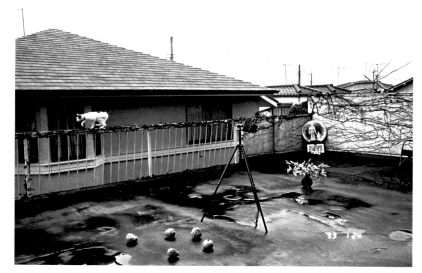

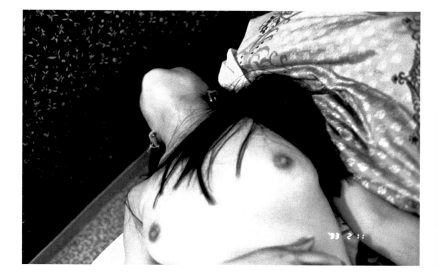

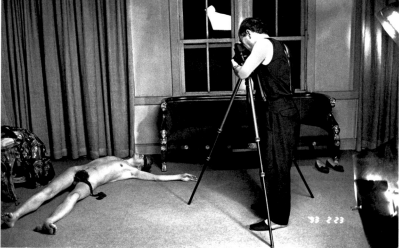

From the series "Photo-Maniac, Big Diary"
Araki explores Eros, in all its possible forms. He pushes it to the brink of pornography, and then investigates those limits. But his images belong to a different realm of speculation. His women, exalted for their femininity or degraded to mere object, seem to explore the boundaries between good and evil, between the sacred and the profane, between reality and fiction. As his fellow photographer Daido Moriyama has said, through his nudes Araki brilliantly combines art and pornography. For him, the two are never separated.

From the series "Private Photography"
"You walk down a crowded street, full of noise and life, but then you turn the corner and find a quiet alley, calm as death. That mixture of life and death can be found all over Tokyo. I'm drawn to it, and that's why I never want to leave. Because of how I live my life, I delve into a monochrome world and get a feel for what death is. But then I return to the world of color and get a feel for what life is. I go back and forth, continuously entering and leaving these two worlds."

"I'D LIKE IT IF MY PHOTOS WERE LIKE SHUNGA, BUT I HAVEN'T GOT THERE YET. THERE IS A DEGREE OF RESERVE IN SHUNGA. THE GENITALS ARE VISIBLE, BUT THE REST IS HIDDEN BY THE KIMONO.... THEY EXPRESS THE MYSTERY OF LOVE. SHUNGA DON'T JUST REVEAL SEX, THEY REVEAL THE SECRET OF LOVE BETWEEN TWO PEOPLE."

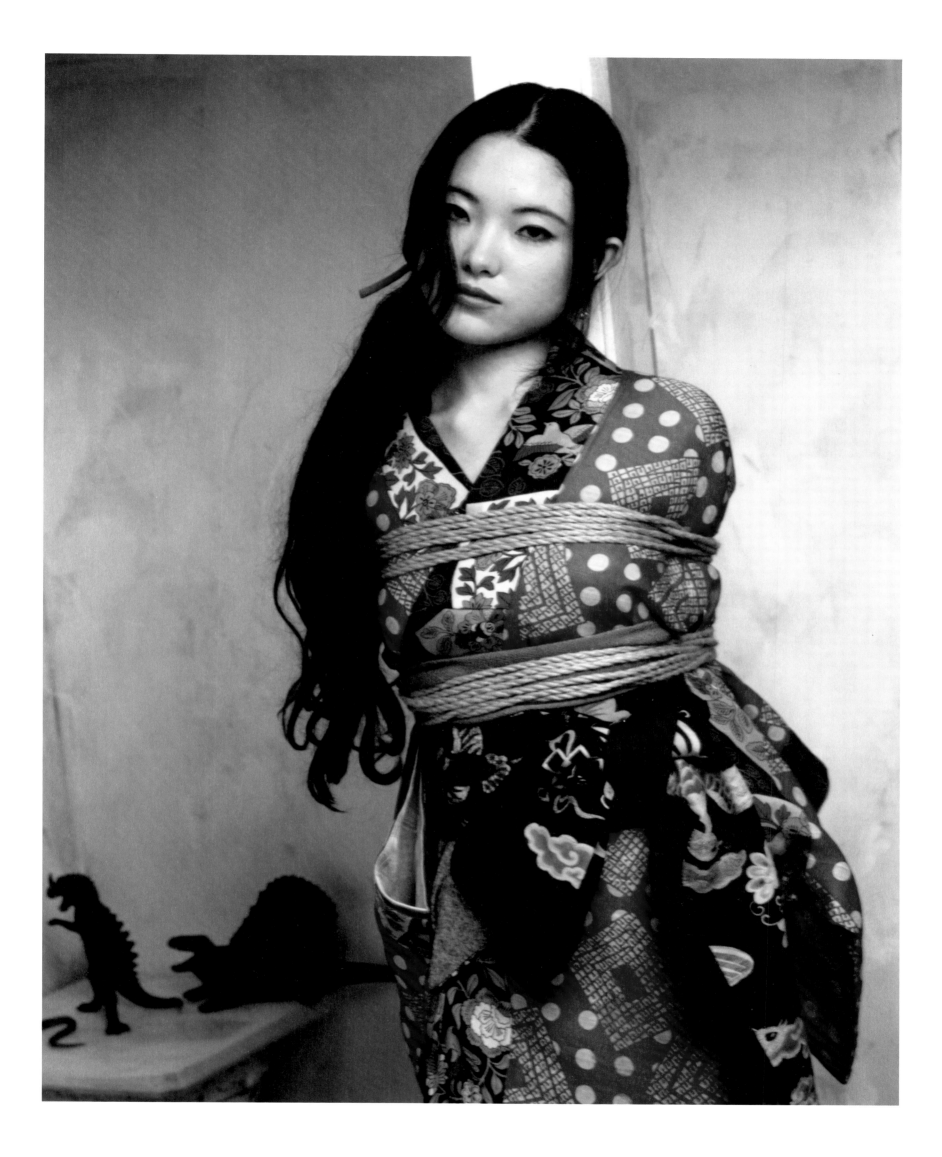

Kaori, 2008
The rope binds and imprisons women in positions where they can be dominated, yet Araki is aware that coercion and domination are purely fictitious, nothing but symbolic gestures. His female faces, hovering between eroticism and apathy, appear enigmatic and elusive before a background of equally indecipherable places populated by strange and mysterious creatures.

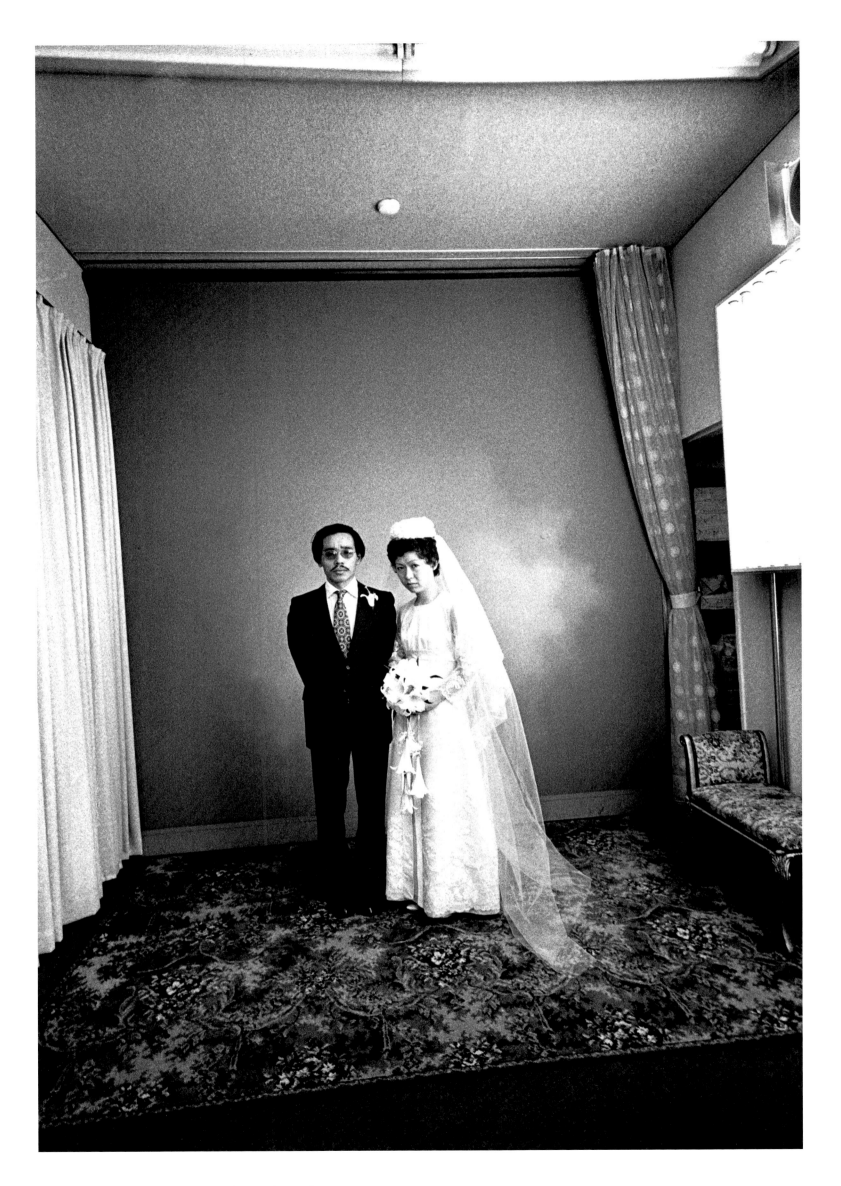

From the series "Sentimental Journey/Winter Journey"
Araki, in his groom's suit, poses next to Yoko, the woman of his dreams and
his best model. This is the beginning of *Sentimental Journey*, the first act of
an epic. "It is my statement. It is my true love, and it launched my career. I
say it's my love because it's the series of photos from my honeymoon. It's
my love because it was my professional debut, and also the beginning of my
personal novel."

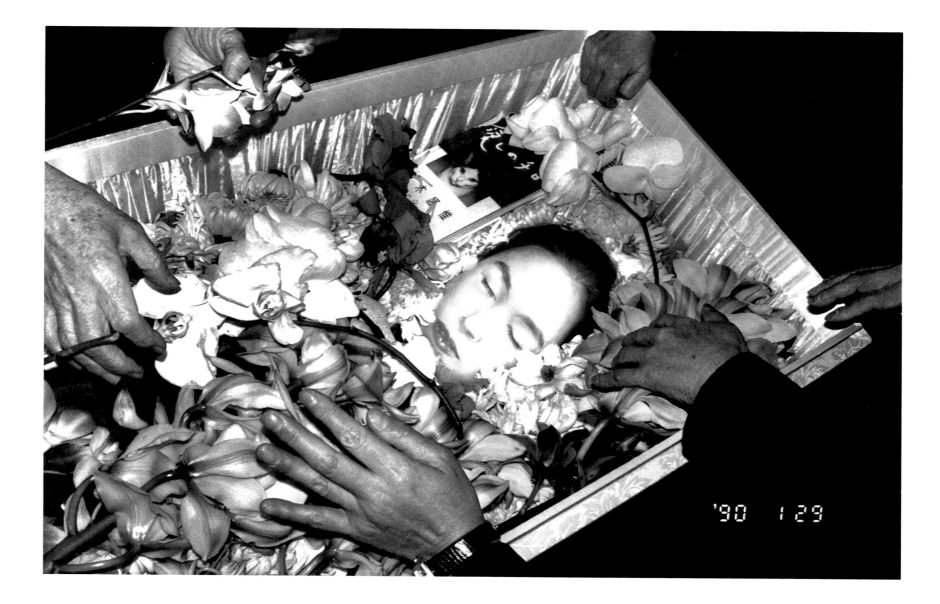

From the series "Sentimental Journey/Winter Journey"
This is the last act of another journey, a darker one this time. It captures Yoko's death, the last image of the woman who, according to Alain Jouffroy, was the crux of Araki's novel-as-life, the center of gravity that both his destiny and his photography depended upon.

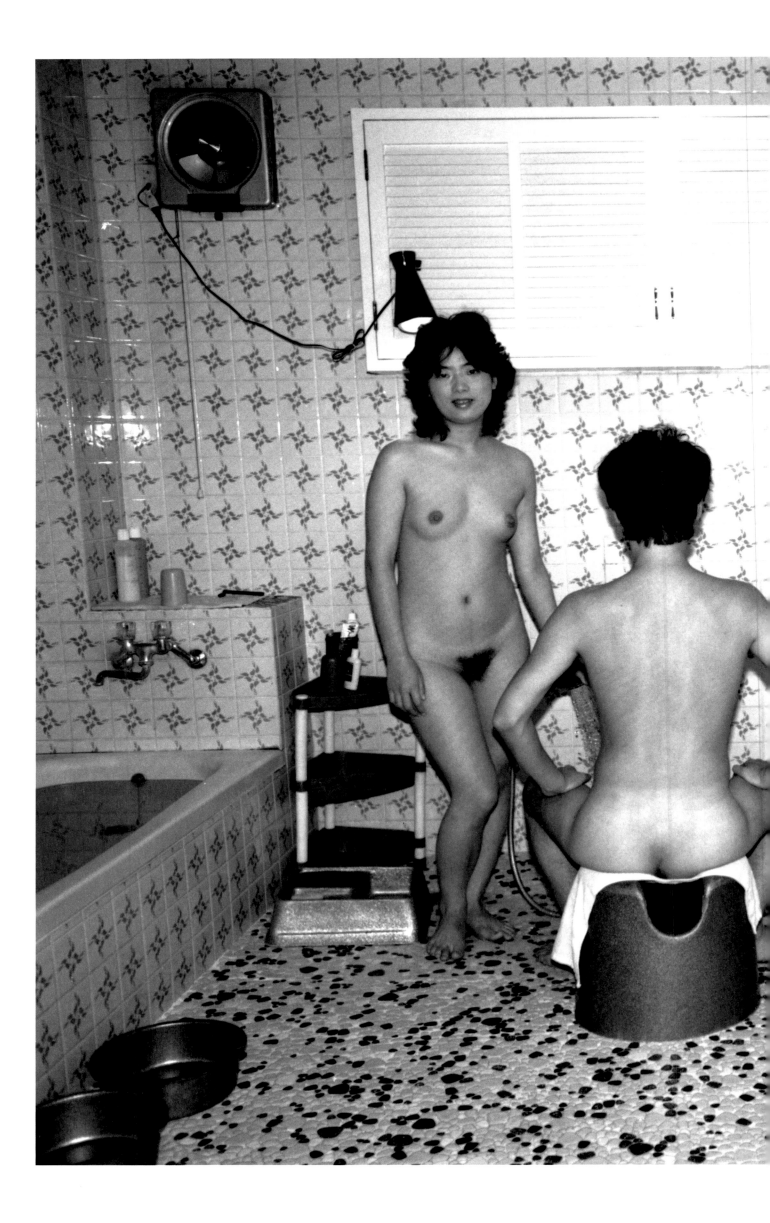

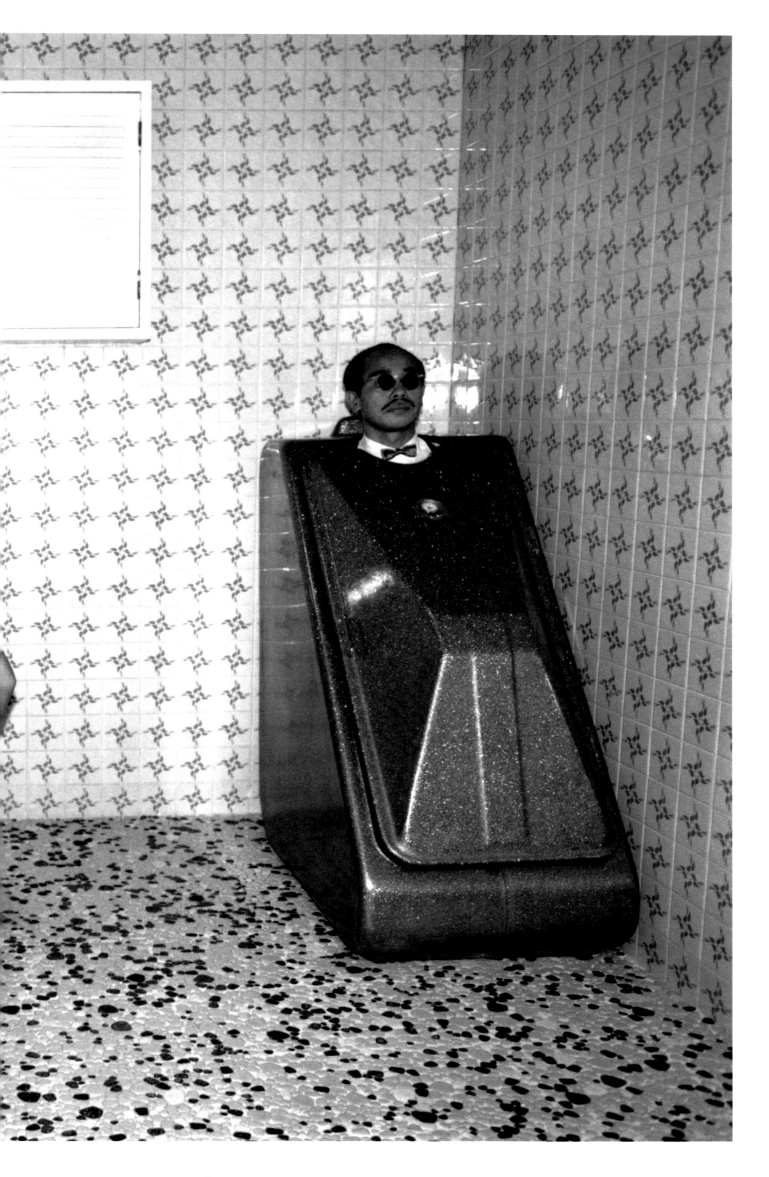

From the series "In Ruins"
Occasionally Araki sneaks into his own images, usually in the guise of a fictional character who interferes with the rules. These "incursions" are often ironic, sometimes surreal, and are invariably acts of freedom with no preconceived meaning.

"I'LL GIVE YOU A CONCRETE EXAMPLE: THE FOREGROUND IS AN EMPTY SPACE AMID RUINS; THE BACKGROUND IS A BUNCH OF SKYSCRAPERS, AND EVERYTHING IS COMBINED. INDIVIDUALS AND CROWDS CLASH AND MINGLE ON STREET CORNERS. EVERYONE IS HEADED IN A DIFFERENT DIRECTION. AND YET, LOOKING MORE CLOSELY, YOU NOTICE THAT EVERY ONCE IN A WHILE THERE IS AN EMPTY PAUSE, NO ONE IN SIGHT. THAT MOMENT, RIGHT THERE, IS WHEN I FEEL TOKYO."

From the series "Tokyo Nude"
Araki has strolled the streets of Tokyo since the 1960s shooting portraits of
strangers, and their faces have become yet another part of his personal novel.
"You have to go on photographing the moments of life; you have to go on living.
For me, taking photos is life itself."

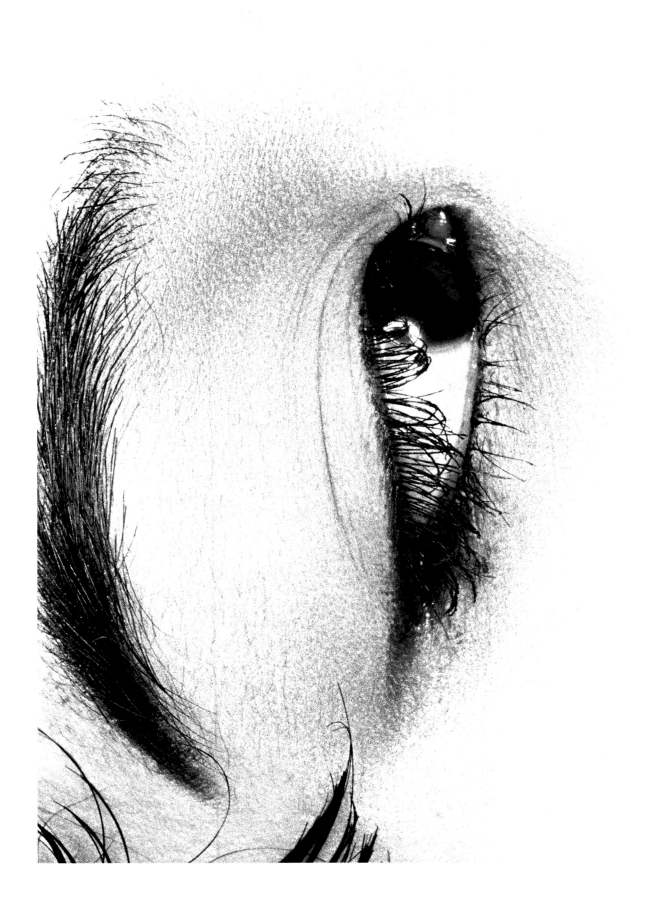

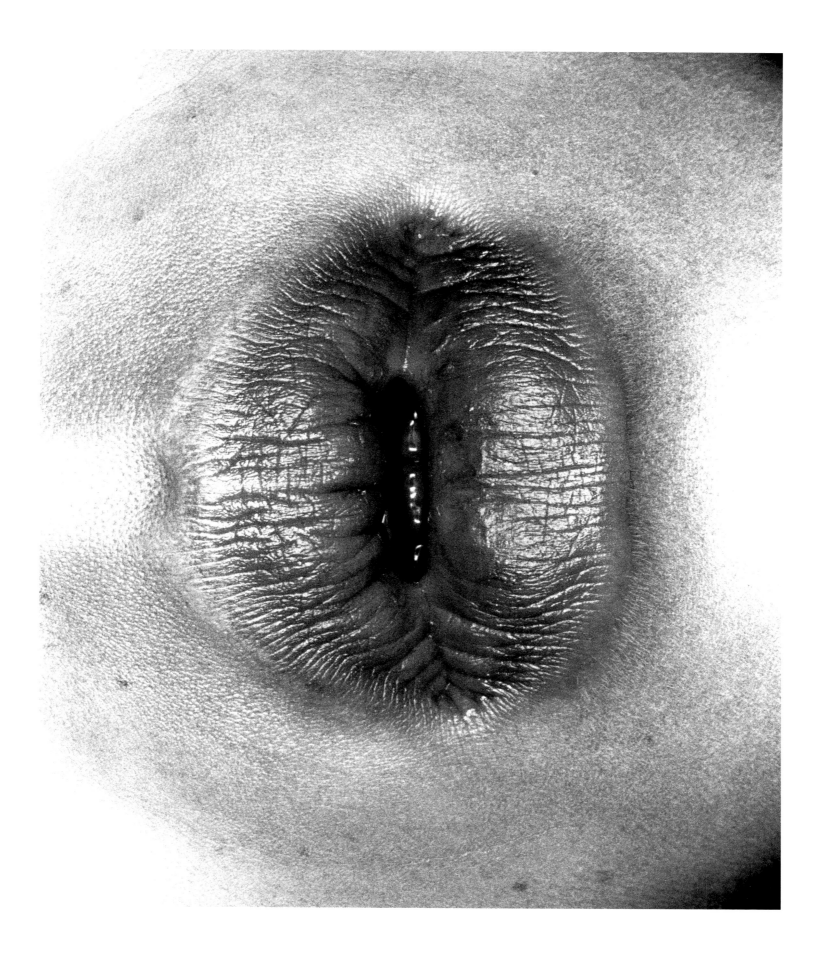

From the series "Erotos"

This series offers a glimpse into a white-hot universe of various erotic elements. Animals, plants, food, details of the human body, genitals, eyebrows, mouths—everything bends to the metamorphic powers of an eye that aims to possess everything. And yet, as often happens in Araki's images, this exuberant eroticism has a dark side, a mysterious and sometimes mournful soul highlighted in an elegant, black-and-white, formal perfection that pins its subject down with the sensibility of a still life.

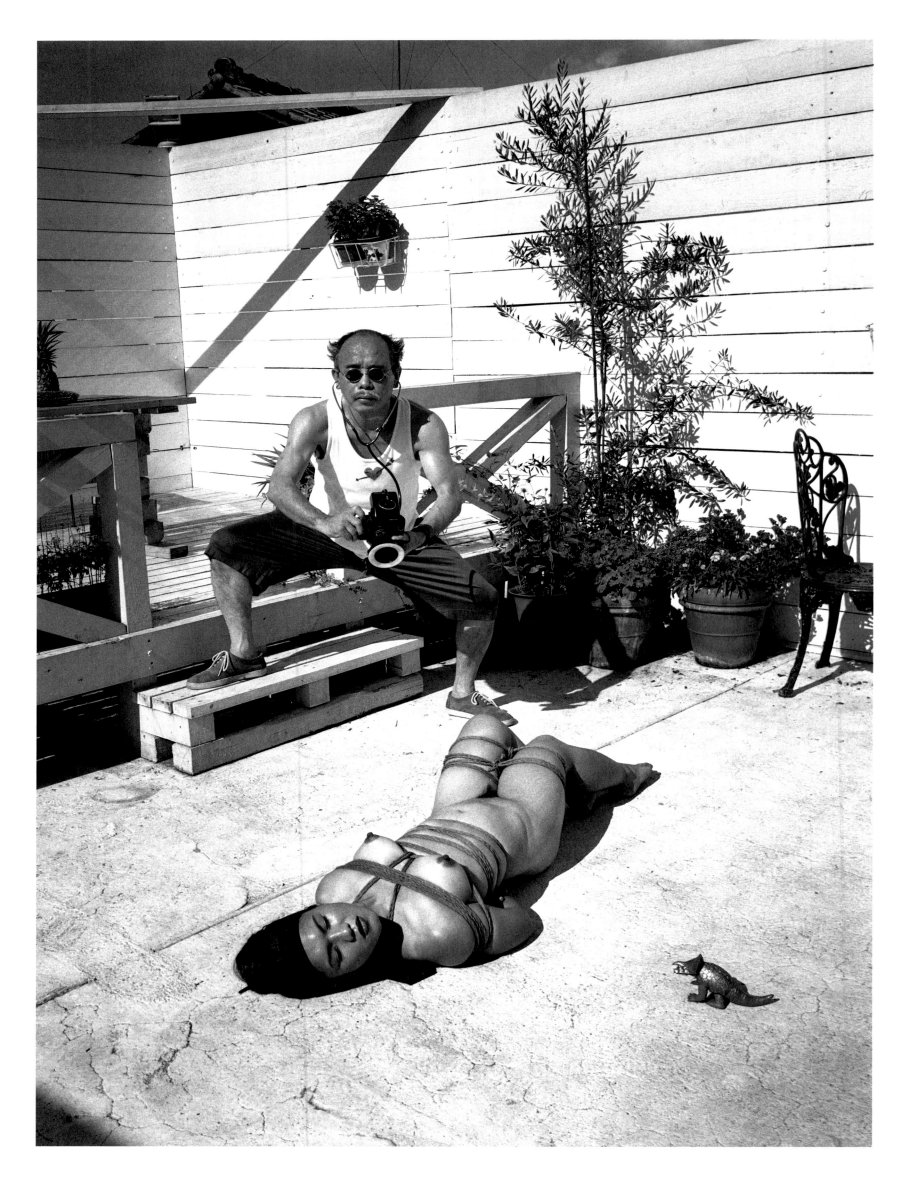

Self-Portrait with Model, 1990s
Here is the main character of the epic, encyclopedic, auto-bio-photo-graphic novel. Part pop artist, part jester, Araki makes fun of everyone—especially himself. The architect Arata Isozaki, his close friend, has called him "a shaman telling his own novel to himself."

Self-Portrait

Araki was born in Tokyo in 1940 to a family of craftsmen who manufactured the traditional Japanese wooden sandals known as *geta*.

In 1952 his father, a photography aficionado, gave him the camera with which he shot his first pictures during school vacations. After graduating from the technology department at the University of Chiba, in 1963 he began working for Dentsu, a famous advertising agency.

At Dentsu he met the woman of his dreams, Yoko Aoki, whom he married in 1971. Araki chronicled their honeymoon in photographs later published in the book *Sentimental Journey*. Later that same year he reissued his previous books by photocopying them and sending them to friends, colleagues, and people chosen at random from the phone book.

In 1972 he left Dentsu to become a freelance photographer. His work became increasingly focused on the nude and the female body, and this artistic practice brought him both national and international attention. In 1981 he produced his first film, *Jokosei nise nikki* (Diary of a Middle-School Girl).

In 1990 his wife Yoko died, and Araki dedicated the book *Winter Journey* to her illness. Later that same year he was elected Photographer of the Year by the Japanese Photographers' Association.

In 1992 he was accused of pornography and heavily fined for the exhibition *Diary of a Photo-Maniac*; the following year the director of the Parco Gallery in Tokyo was arrested for having sold the *Art Tokyo* catalog during an exhibition of Araki's work. In 1994 Araki declined an invitation to participate in the Venice Biennale and created his first theatrical production, *Higan Kara* (Equinox).

In the 1990s he began to exhibit worldwide, and major museums granted him extensive solo exhibitions. Shows were mounted at the Museum of Contemporary Art in Tokyo, the Kyoto Museum of Contemporary Art, the Centre National de la Photographie in Paris, the Wiener Secession in Vienna, and the Barbican Centre in London.

His substantial bibliography includes over four hundred publications, and his life and work are profiled in Travis Klose's documentary *Arakimentari*.

"IN JAPAN THERE'S A BUDDHIST STATUE CALLED SENJU KANNON. IT IS AMAZING, IT HAS A THOUSAND ARMS. I WOULD LOVE TO HAVE IT POSE HOLDING A THOUSAND CAMERAS AND TAKE ITS PORTRAIT."

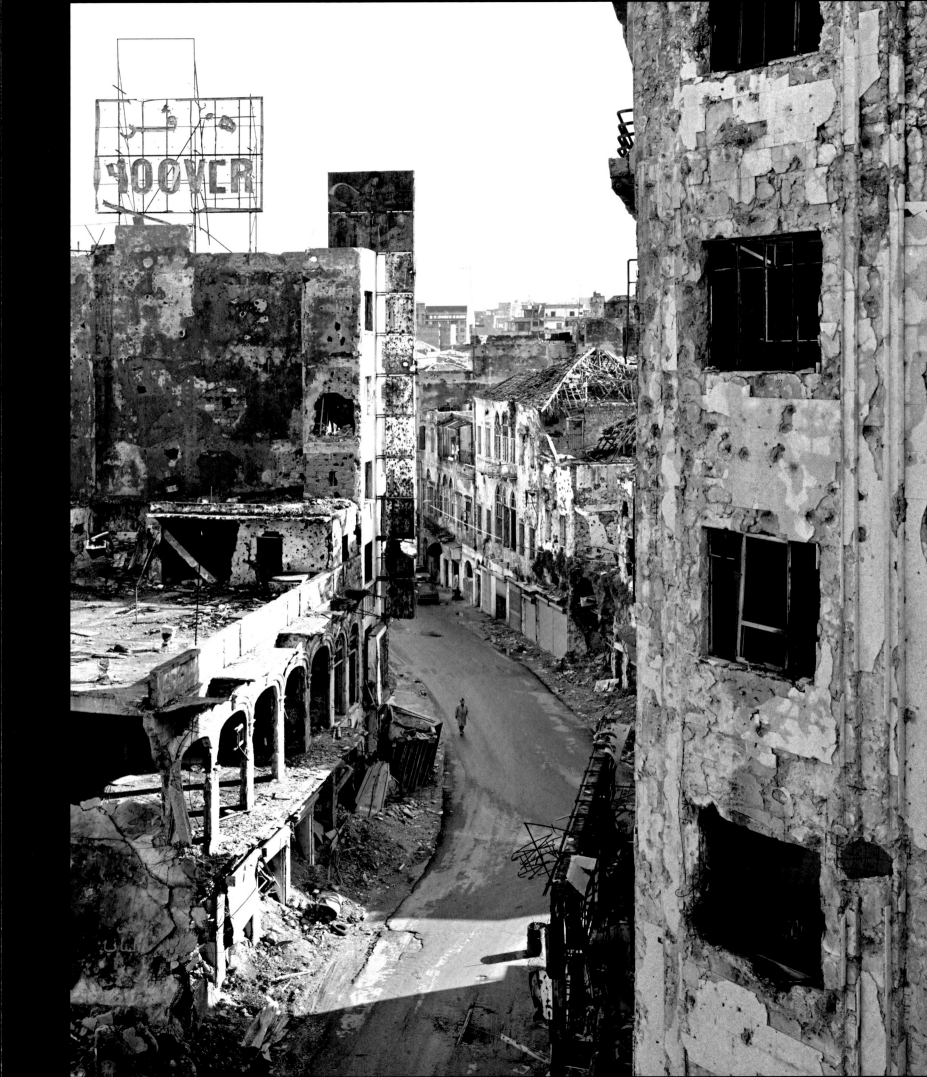

Page 30
Beirut, 1991
In 1991 Basilico was invited to Beirut, together with five other photographers, to document the condition of the city at the end of the bloody fifteen-year civil war. It was not meant to be a reportage, but to fix the image of a tragedy whose visible traces would disappear over time. "Photography was given the civil task of contributing, with the evidence of human folly, to the construction of historical memory." In his images, the ghostly city would show itself, and its afflictions, denouncing the crime committed against it by men who waged an exhausting and absurd war.

Above
Milan, 1980
Basilico's images always show a kind of dual attention: on the one hand to the shapes of the buildings, the depth of the volumes, the façades, and the angles of perspective; on the other hand, the photographer lets his gaze extend to that which is beyond, to all those elements that help form and signify the urban design of the space.

GABRIELE BASILICO

First there was the faculty of architecture. It was the late 1960s and early 1970s, years of particular turmoil. The year 1968 brought with it an awakening of consciousness and a profound desire for change: at the university, social issues and political confrontation became more important than any design exam.

Gabriele Basilico was a student at the Politecnico in Milan, the city of his birth, when he discovered photography. He had the feeling that this language might not only be an essential tool for describing reality but also, thanks to its documentary character, a complex and contemporary way of bearing witness, as well as a tool for political action.

That is where his journey began. Milan was his place of belonging, both physical and mental, and also the playground in which he trained his eye. "This city belongs to me and I belong to it, as if I were a particle moving around inside its body. I am obsessed by the constant need to know its corporeal nature." Basilico began his journey at the extremities of this body, which he explored while keeping in mind the admiration that he felt for the work of photographers such as Walker Evans, or his friend and teacher Berengo Gardin, guides to ethics even more than aesthetics. He left the center of the city for the outskirts. He examined the urban fringes, the borders, the industrial areas, the gray walls, the corners that were voiceless but not silent to anyone who was willing to listen. He would choose the place, rest his tripod on the ground, adjust the camera (medium format), evaluate the view, put his head underneath the black cloth, and then wait: for an automobile to pass by and clear the space, for a ray of sunlight to illuminate and clarify the scene. It was a way of making up for the time and slowness of looking. A way of defeating the "affective gaze" referred to by Luigi Ghirri, to practice the political act of respect and comprehension. The flash of inspiration came on a bright Easter Sunday in 1978. Basilico was walking the deserted streets of the Vigentino, a former industrial area of Milan. He found himself in front of abandoned premises and empty sheds, devoid of human presence, and an extraordinary light that revealed their texture. Silence enveloped the space; the conditions were perfect for taking in the view and trying to absorb it. It was the discovery of a new world. That solitary day spent photographing disused industrial buildings would lead him to his first project, book, and exhibition: *Milano: Ritratti di Fabbriche* (Milan: Factory Portraits). "I put two and a half years of passion into it. With no client in prospect. Saturdays and Sundays, photographing Pirelli and Breda,

Falck and the artisan workshops of Bovisa. I wanted them empty, without people. I was looking for the urban identity of a city. Why did I do it? That is what I asked myself. Because I had to, was my answer." His motivation was a need to find an equilibrium between the social mandate that was in his heart and the desire to experiment with a new language. Thematic consistency and an obstinacy in the "way of looking" were what would make Basilico one of the best-known Italian photographers abroad. He would participate in large international projects. In 1984 the Mission Photographique de la DATAR chose him as one of the photographers given the task of interpreting the transformation of the French countryside. In 1991 he would face the challenge of telling the story of a Beirut wounded by war. Then followed years of constant work and travel during which his sights widened to include the creation of a kind of inventory of great metropolitan areas such as Berlin, Shanghai, Buenos Aires, Beirut, Barcelona, Moscow, and Istanbul. What he discovered was that despite the impression of having maintained their diversity, the expanding urban areas were actually becoming ever more uniform. His camera lens continued to be attracted by the ordinary fabric of the city, that space considered by the architecturally-minded to be of no historic interest.

"His" city contained many visible likenesses as well as strong contrasts that were intensified by the dignified black-and-white of his photos and by the verticality of the existing architecture. It was often ruled by a sensation of suspended time, a kind of ghost-like metaphysics that was in conflict with the continuous transformation and construction of the space. "For me it is important to show the reality that we understand and that we recognize. I do not try to transform reality. I work with the visible, but at times there are things that we do not see at first glance, the role of the photographer being to reveal them. In other words… what interests me is working on the visible so as to photograph the invisible."

The buildings, the urban structure, the logistical chaos of the skeleton of a city speak of his, and our, history. To investigate that space means therefore to try and understand something further of the world in which we live. Basilico's work is characterized by its capacity to convey through an image the richness and complexity of reality. As has been said by Marc Augé, Basilico's images are not only photographs of space but also photographs of time. "I document the present. It has its ruins and its beauties and often there is no difference."

Lausanne, 1987

The city is a phenomenon in continuous transformation. Basilico is interested in everything that contributes to its construction and in everything that an urban space can connote: its intersections, street signs, and traffic dividers, the geometry of its lines, the shadows on the asphalt; everything is carefully composed so as to direct our gaze to the interior of a landscape that even if deserted reflects the presence of man, his actions, and his history.

That sky illuminated by varied shades of gray becomes a backdrop against which the shapes molded by the relationship between light and shadow can be made to stand out. Basilico does not make us pay attention to everything; his gaze is not analytical. What interests him is the investigation of details, grasping the signs that express in both real and symbolic ways a content that is social as well as architectural.

The photographer's lens composes the image in a way that transforms the street signs into totems, as well as creating the space for them to become meaningful objects. "I see the city as a large body that breathes, a body that experiences growth and transformation, and it interests me to grasp the signs and observe the forms, like a doctor who investigates the transformations of the human body. I continually look for every point of view, as if the city were a labyrinth and my gaze were seeking a point of entry." Inside the labyrinth one must wander about calmly and slowly in order to avoid becoming overwhelmed. Basilico finds his way by following the thread of careful observation, with a contemplative attitude free from sentimentalism. His slow gaze allows him to see every detail and to give us new and unexpected visions of familiar places.

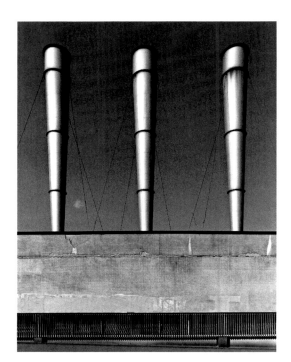
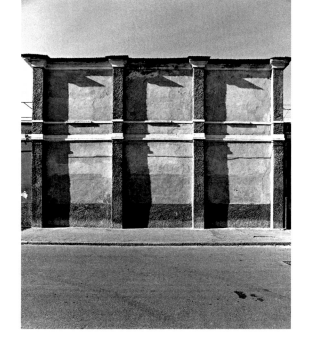

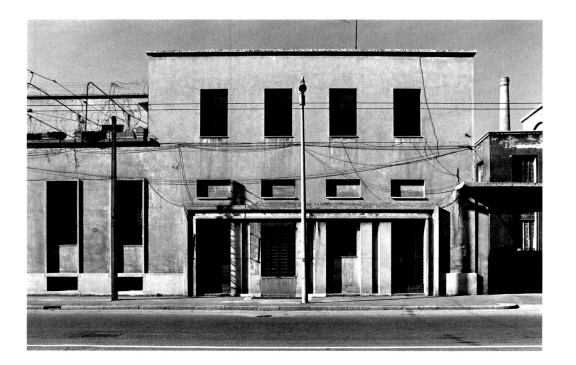

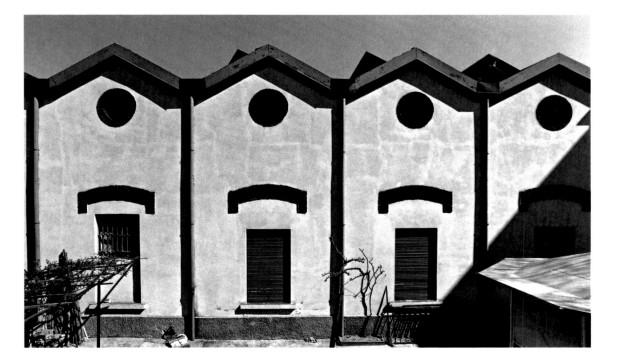

From the series "Milan. Portraits of Factories, 1978–80"
"For the first time I saw the streets, and the façades of the factories, silhouetted, solitary against a clear sky, thanks to which the vision of the space and of the forms suddenly became unusual." That is how Basilico remembers the Easter Sunday in 1978 spent walking with his camera in a former industrial neighborhood in Milan, discovering a new world and in search of a new way of photographing it. The streets were deserted, the sheds abandoned.

From a distance, the geometric forms of the factories became mysterious objects, almost melancholic, sumptuously lit by a light that was ruthless in its brilliance. In the images of *Ritratti di fabbriche*, the silence fills the space, and infuses with a certain mystery the sharp blacks and whites that trace its geometry. In the air one can breathe the metaphysical void of De Chirico's cities. This way of looking uncovers a beauty in these spaces that they had never before revealed.

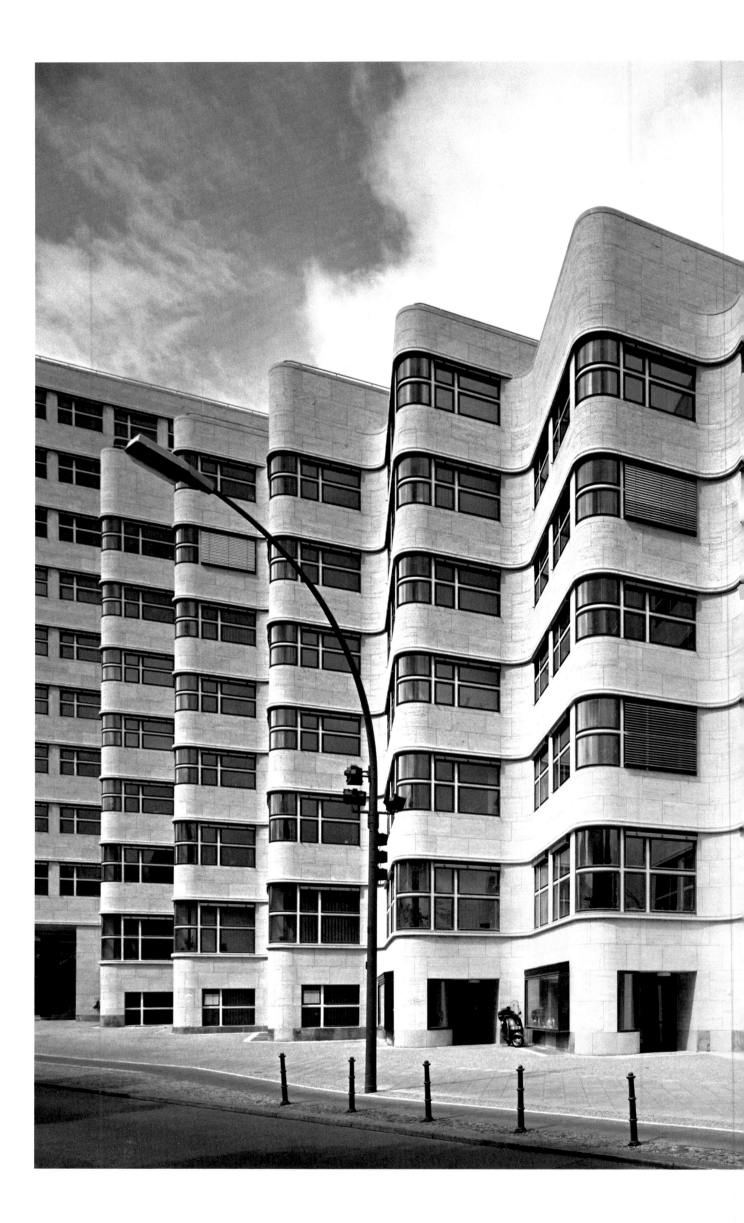

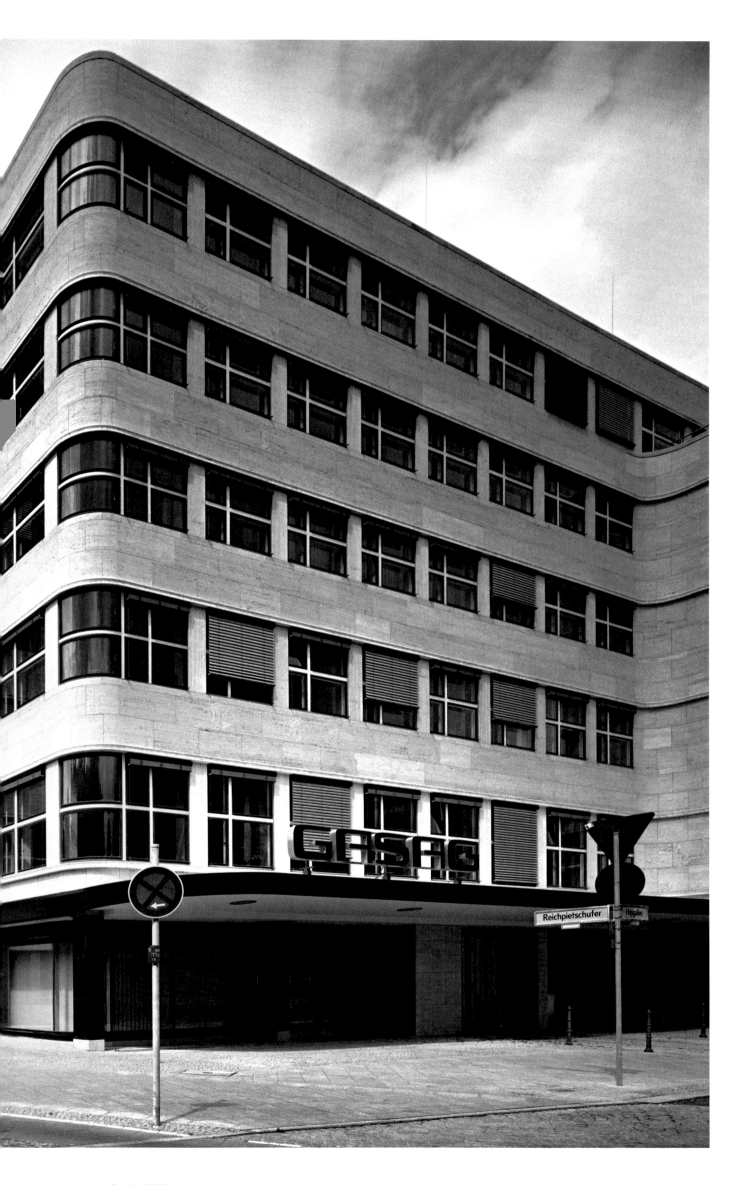

Berlin, 2000
The complex articulated façade of the building fills the frame with its imposing shapes. Despite the mass of the architecture, a strange movement takes hold of the image and of the lines, accentuated by a skillful use of perspective which moves the eye to the left side of the frame, and away from a sky that seems to flee or advance in the opposite direction.

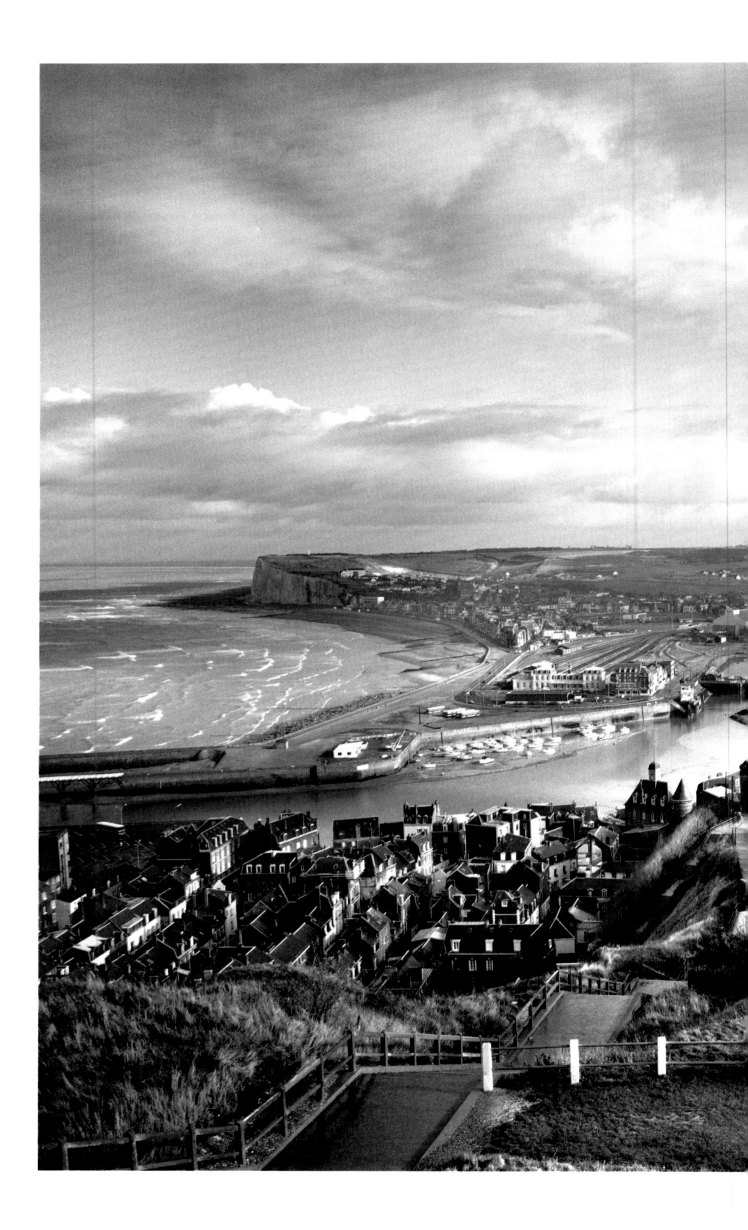

Le Tréport, France, 1985
The project known as DATAR (Digital Automated Tracking and Resolving) brought Basilico to the French town of Le Tréport on the Normandy coast, where "one day, with the connivance of the stormy weather conditions, I saw an image of such power that I might have been inside a painting by Bellotto or Canaletto, and I had a transcendent sensation of the infinite, where you can listen, look, and contemplate for hours what is in front of you, without any impression that time is passing, and then all of a sudden you realize. From that day on my relationship to landscape was changed."

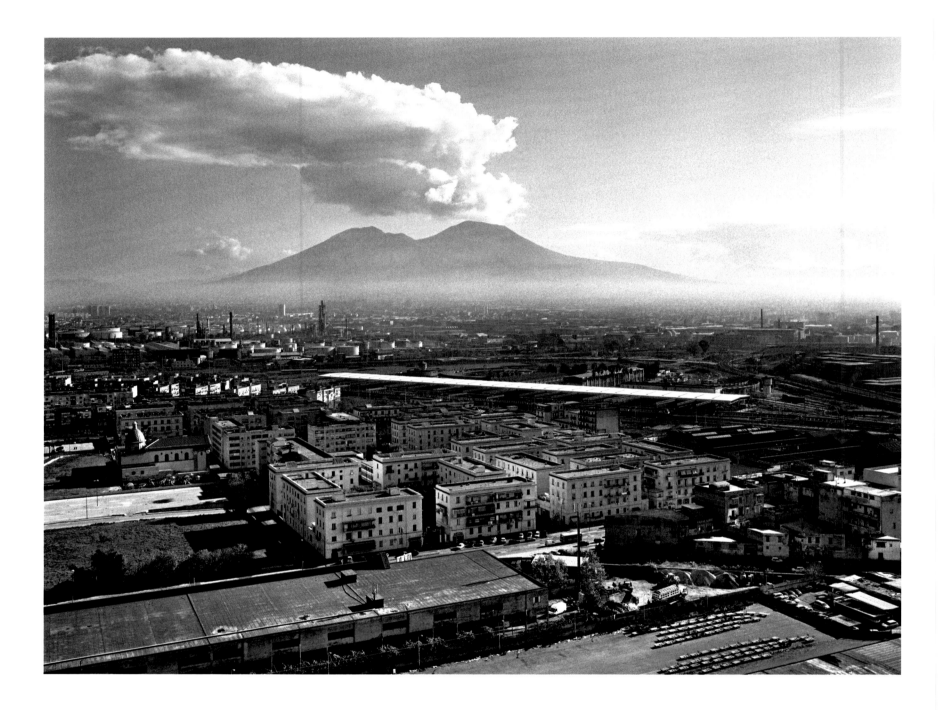

Naples, 2004
Basilico often sought elevated perspectives which widen the gaze. From there,
the natural landscape, the urban agglomerations, the edges of the city, all reveal
the articulated design of an area. In the background the mass of Vesuvius rises
out of a fog that gives the volcano a somewhat dreamlike presence.

Rome, 2000

"I believe that photography, with its power to give a final form to whatever is real, allows one to conjure up history, to use memory as an active and sensitive tool in order to put back in circulation energies that have been kept or hidden behind the shapes of things as they appear."

"LOOKING BACK ON ALL MY JOURNEYS, ON THESE URBAN CROSSINGS, THIS TRAVELING AROUND, IT SEEMS TO ME THAT A CONSTANT ELEMENT WAS THE EXPECTATION OF FINDING CONNECTIONS AND ANALOGIES. THE EMOTIONAL DISPOSITION THAT GUIDED MY MOVEMENTS, AND MY CURIOSITY, I NOW SEE CLEARLY, LED ME AND LEAD ME TO ELIMINATE GEOGRAPHIC BARRIERS. THIS DOES NOT MEAN THAT ALL CITIES SHOULD BE FORCED TO BECOME SIMILAR; IT DOES MEAN THAT IN ALL CITIES THERE ARE PRESENCES, MORE OR LESS VISIBLE, THAT SHOW THEMSELVES TO ANYONE WHO WISHES TO SEE THEM, FAMILIAR PRESENCES THAT ALLOW US TO DEAL WITH OUR BEWILDERMENT IN THE FACE OF THAT WHICH IS NEW."

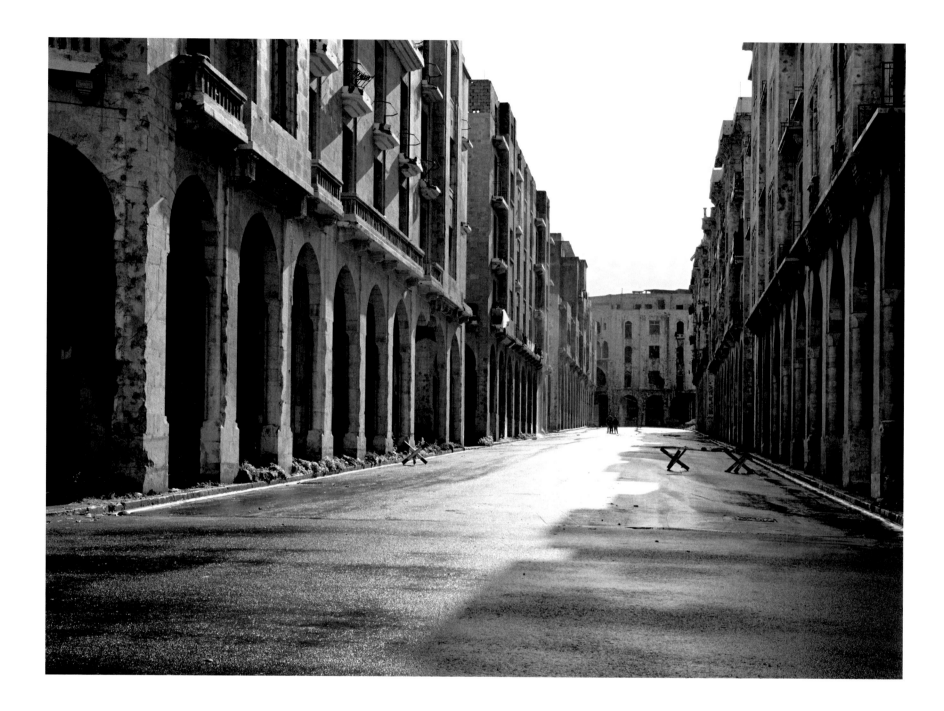

Beirut, 1991
"Beirut's sense of emptiness is seemingly often found in my work on the city.... My impression was that everything was unfolding as if the people had abandoned the buildings and streets in order to return some time in the near future. It was possible to believe that some had gone and that others were about to arrive. In other words, the situation could appear almost normal: the city had only fallen into a long period of waiting."

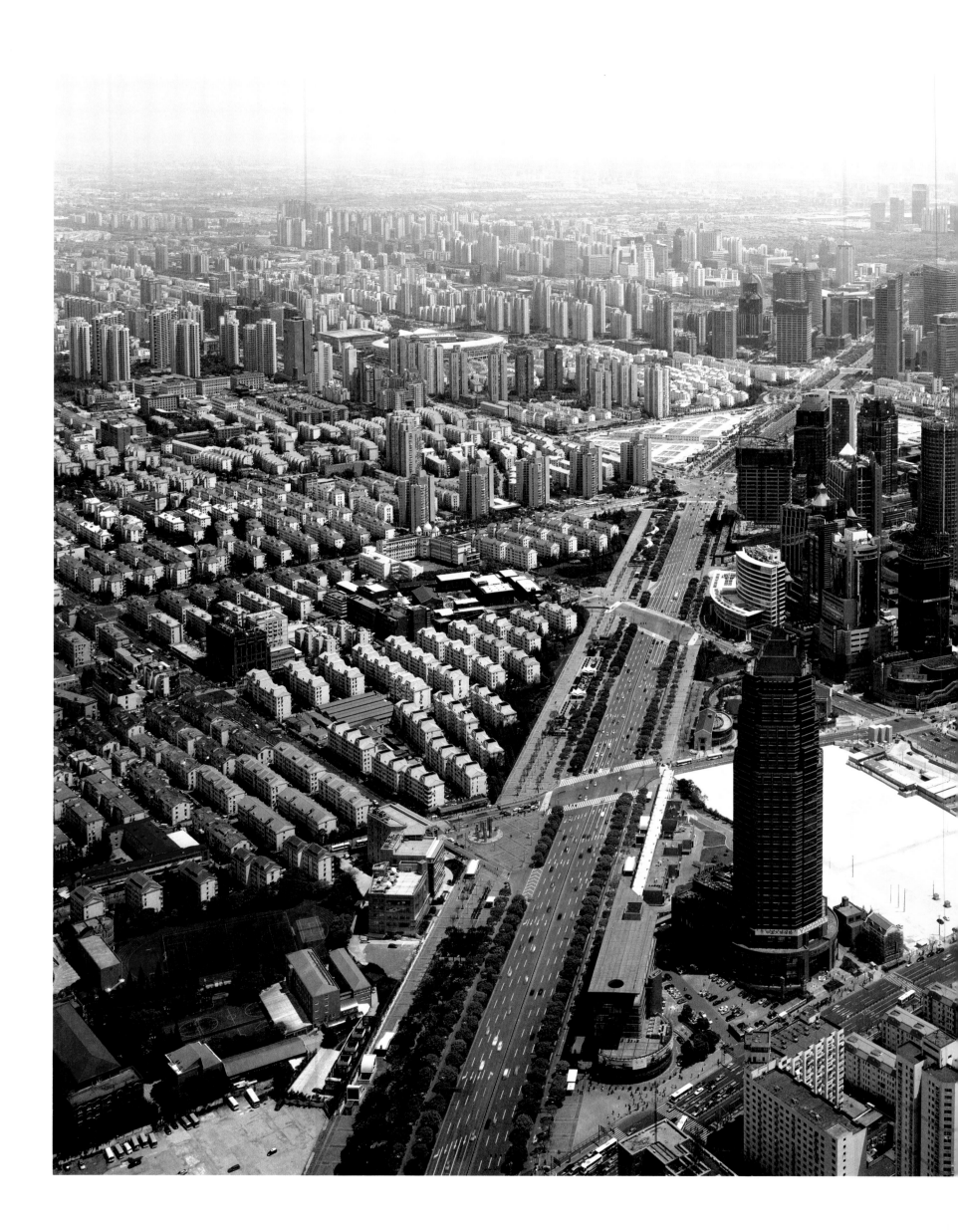

Shanghai, 2010
An urban landscape in rapid and continuous transformation, a metropolis between East and West, launched at great speed toward the future. A many-layered city of great density whose skyline changes from day to day, dominated by the verticality of hundreds of lofty skyscrapers which buttress a space that previously had been horizontal. Basilico uses color and turns it into a more expressive element in the stratification of the image, and in the comprehension and interpretation of reality.

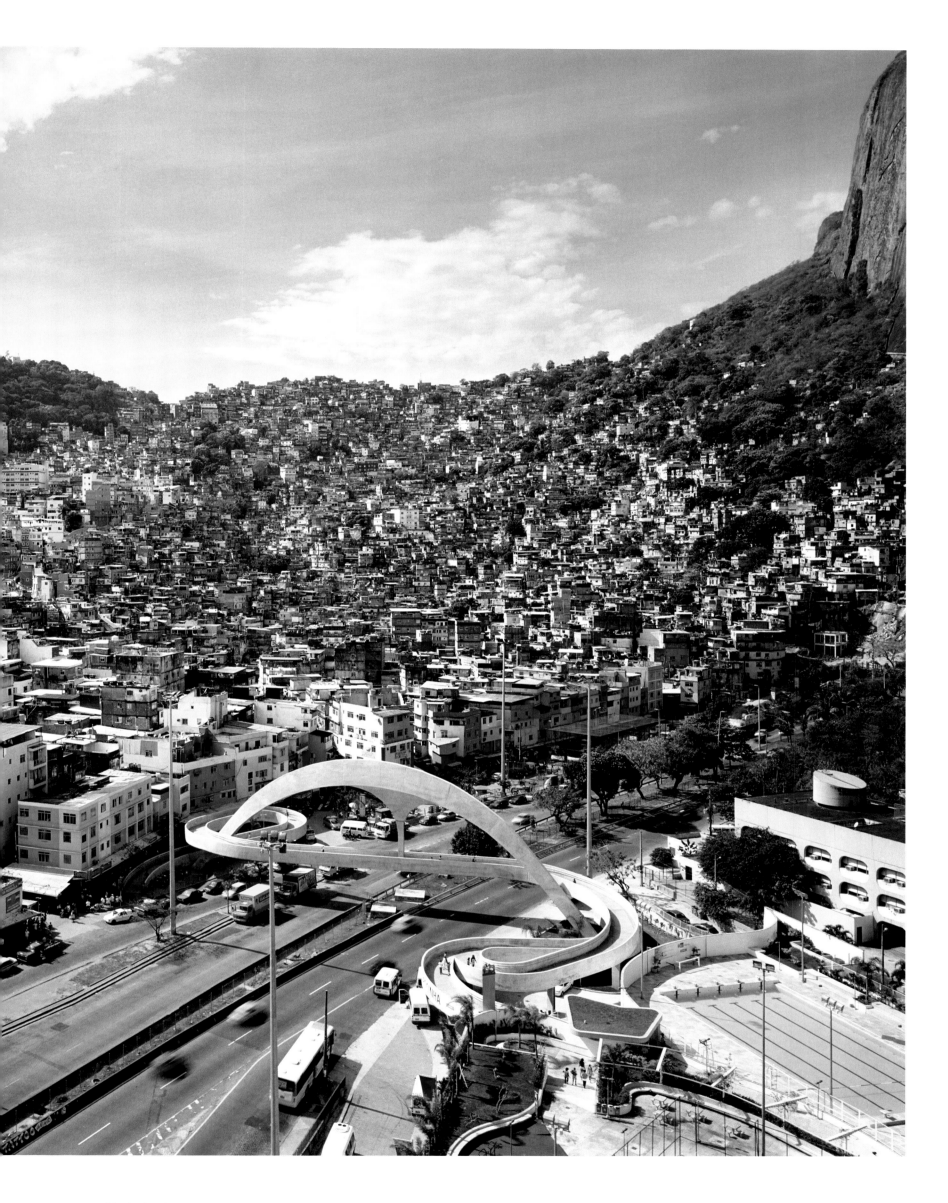

Rio de Janeiro, 2011
"I believe that photography permits, within certain limits, a reordering of the chaos that is in front of our eyes, that it is a common and repeated aspect of the contemporary urban landscape. It is from this point of view that one can speak, but only in metaphorical terms, of planning and design. The goal that I set for myself a long while ago was that of achieving a gaze that is free of moralisms, ideology, and the hidden nightmare of prejudice. Perhaps, in this way, there can be the birth and development of the possibility of reading a 'new beauty,' one that does not exclude, but lives together with, mediocrity."

49

San Francisco, 2007
At the invitation of the San Francisco Museum of Modern Art's Department of
Photography, Basilico produced his first photo campaign in the United States,
in 2007. He covered almost three thousand miles, exploring Silicon Valley from
every angle, in order to show how industrial and economic development can
shape and transform a region.

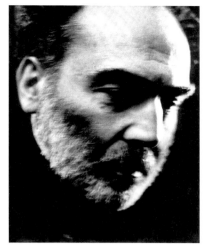

Basilico was born in Milan in 1944 and graduated in architecture from the city's Politecnico in 1973. During that same period he began to take photographs, concentrating his interest on the city and its urban landscape.

In 1983 Basilico produced his first important show, *Milano: Ritratti di fabbriche,* at Milan's Padiglione d'Arte Contemporanea (Pavilion for Contemporary Art). In 1984 he received his first international assignment from the photographic mission of DATAR, a French government project aimed at documenting the transformation of the country's landscape.

Basilico was later invited to undertake photographic research projects in various European countries. In 1990 he received the Prix du Mois de la Photo in Paris for his show *Porti di mare* (Seaports).

Basilico planned and produced an exhibit and book *Bord de mer* (Seaside). In 1994 he took part in the "Mission Photographique" that was sent to Beirut, which had been devastated by Lebanon's civil war. At the 13th International Architecture Exhibition at the 1996 Venice Biennale, Basilico received the Osella d'Oro award for the photography of contemporary architecture.

In 1999 Basilico published the book *Cityscapes,* which, in 330 images, was a survey of his work since 1984. In June 2002, he received a prize for the best photography book of the year from PhotoEspaña for his book *Berlin.* The following year was marked by a return to two places that had been important in his professional life. One was the north of France, where he returned to landscape he had traveled through in 1984–85. The other was Beirut, where he took photos, for the magazine *Domus,* of the central part of the city, now rebuilt, from the same vantage points he had used in 1991. These two return trips resulted in the books *Bord de mer* and *Beirut 1991* (2003).

In 2005 Basilico published *Scattered City,* a collection of 160 unpublished images of the cities of Europe. In 2006, at the Maison européenne de la photographie in Paris, he staged the largest retrospective of his work ever mounted, that same year also seeing the publication of *Carnet de travail.* In 2007 Basilico undertook his first photo campaign in the United States and explored Silicon Valley. Then he began his work documenting the Moscow skyscrapers known as the Stalin Towers. In 2008 the San Francisco Museum of Modern Art gave him a one-man show entitled *Gabriele Basilico – Silicon Valley,* which was accompanied by a book.

"IF, IN THE END, PHOTOGRAPHY IS CERTAINLY NOT ABLE TO CHANGE THE DESTINY OF THE CITY, LET ALONE INFLUENCE IN A DECISIVE WAY THE CHOICES OF POLICY AND DESIGN, WHAT IS ALWAYS NECESSARY IS THE POSSIBILITY OF BEING ABLE TO CREATE A NEW SENSIBILITY. A NEW SENSIBILITY TO BE ABLE TO INTERPRET THE CHAOTIC AND INDECIPHERABLE BUILT WORLD THAT IS IN FRONT OF US."

"A PLACE, AN OBJECT, A SPACE, A LANDSCAPE: EACH HAS ITS OWN HISTORY, OFTEN SO STRATIFIED AS TO SEEM DECIPHERABLE ONLY IN SMALL FRAGMENTS."

GABRIELE BASILICO

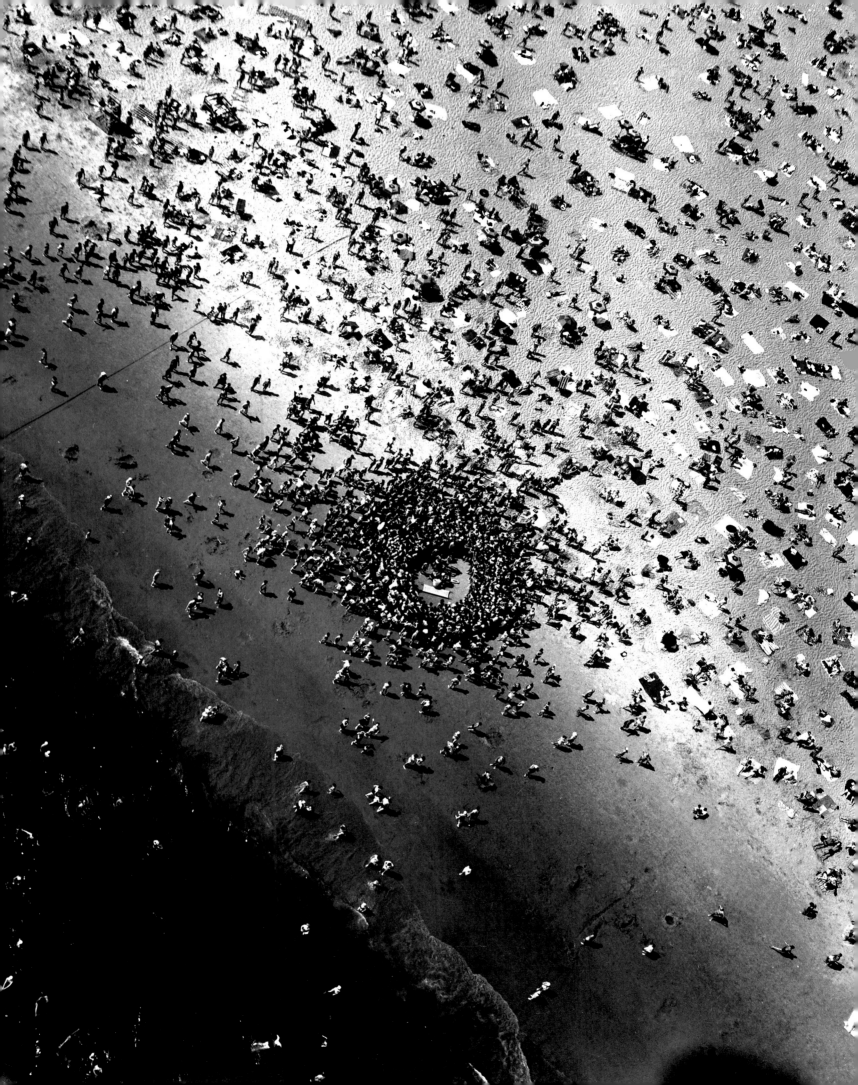

BOU RKE-WHI TE

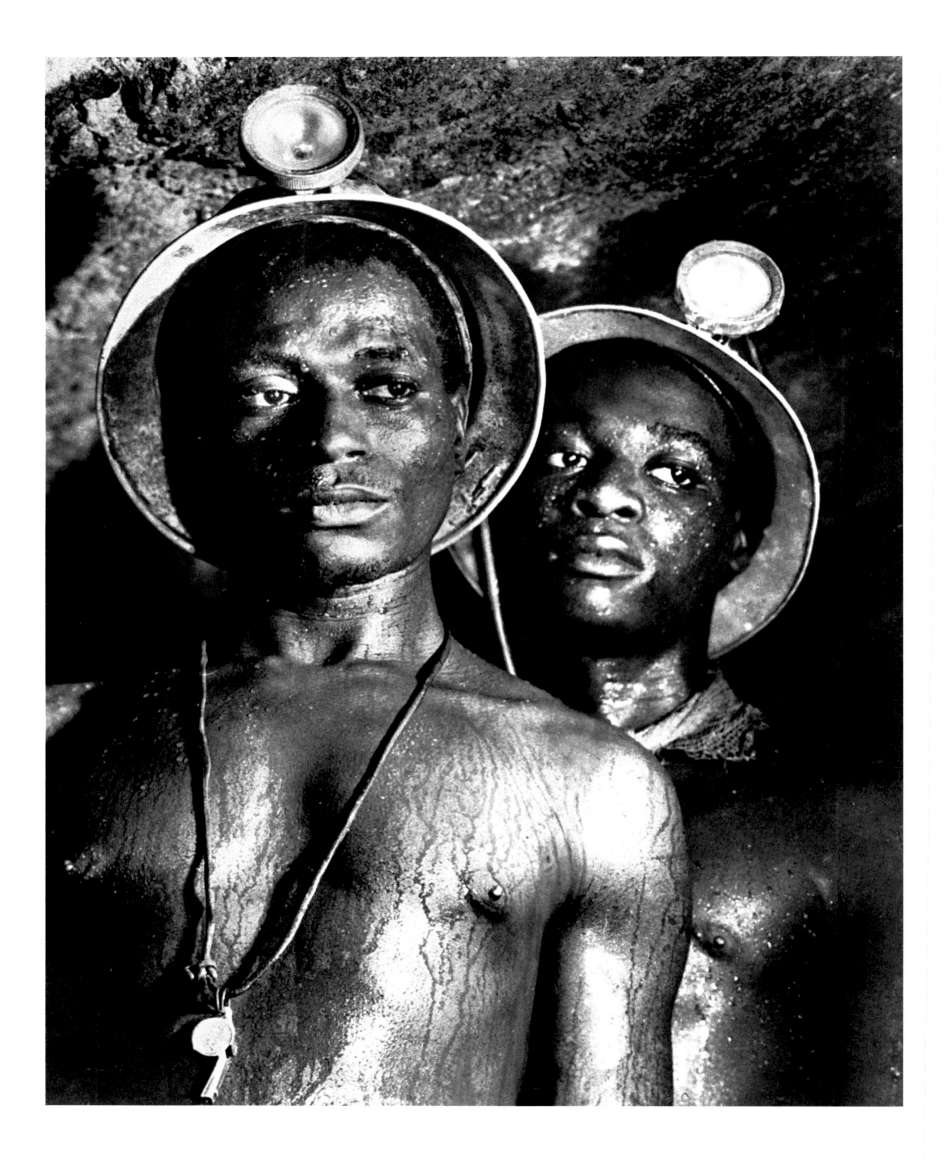

Page 52
Coney Island, Brooklyn, New York, 1952
After one trip or another, a new book, or an assignment for *Life*, Margaret always returned home: either to New York and the editorial offices of *Life*, which was her second home, or to Connecticut and the large cottage in the woods that was her refuge, where she died of Parkinson's disease in 1971.

Above
Gold Miners in Johannesburg, South Africa, 1950
Margaret was not afraid to feel the desperation of the miners. She made herself descend miles below the surface. There, in humid and suffocating galleries, she took photos of the exhausted faces, bathed in heroic sweat, of two miners, numbers 1139 and 5122. She believed that apartheid was an absurdity, and to the extent that she could, with camera and pen, she denounced its madness and the illegitimacy of the South African regime.

MARGARET BOURKE-WHITE

She arrived and it was impossible not to recognize her. The very fashionable overcoat, in the flashiest red. The assured manner, the smile on her face, the air of someone who knows exactly what to do and how to do it. And then, in a supreme touch of elegance and nonchalance, the cloth in which she wrapped the camera was—more often than necessary—a perfect match with her clothes. This was Margaret Bourke-White, a great photographer and one of the most influential women of the twentieth century in America.

She was born in 1904 in New York. Her father was an inventor who instilled in his daughter a love of industry, a need to measure herself against technology, and to surpass it. In her early twenties, after a stormy marriage, she discovered her vocation. She realized that to take and duplicate picturesque views of the university campus could be not only entertaining but profitable, and she began to turn it into a profession. It was the beginning of a long career. She moved to Cleveland, a city that was "roaring" with industry and steel mills, where she confronted, quite literally, fire and flames, in order to become the first pioneering industrial photographer. Furnaces, bridges, railways, big ovens that threatened to melt her camera. Every new opportunity for work became a challenge. Margaret was ready, iron-willed, and unusually talented. Her photos were futuristic interpretations of life: visions that were twisted, or incredibly detailed, the skimming light that caresses the forms making them both magical and tangible.

In 1929, Henry Luce invited her to New York in order to work on a new project, *Fortune* magazine. For many years, Bourke-White would alternate her publicity work (with a studio on the top floor of the Chrysler Building that had a pair of alligators roaming around it) with reportage on the world of work and industry in the United States. She was successful, energetic, and inventive. But she was more than an elegant and ambitious woman. She was courageous and did not shrink in the face of difficulty. She went to Russia during the 1930s and quite soon after began to publish books of her photographs with her own texts. She was independent and in charge of her work. Margaret knew that in order to achieve her goals she would have to be free, in the way she perceived that only men were free. She would have to live without romantic attachments, children, or other ties that might distract her from following her passion.

The Depression years were a turning point. She met Erskine Caldwell, who wrote about tobacco workers and the destitute countryside in the American South, and with him she undertook a long trip through the poorest states in the country. The fruit of their work would be the book *You Have Seen Their Faces*. After steel and industry, Margaret discovered the human and social element. Then she was once again invited by Luce to participate in a new editorial venture, an illustrated magazine in which the photographs would be used to view life, to view the world. The magazine itself would be called *Life*, and a photograph by Bourke-White would be on the cover of the first issue. A stalwart of the magazine, she took on stories all over the world in order to delineate, with her vigorous style of framing, the frontal portraits that stand up to the artist's second thoughts or the magazine readers' repeated viewings. In the pages of *Life* the main figures and events of the world appeared exotic but were always understandable. Margaret seemed to be tireless. She flew from the United States to Europe, stopping in Berlin and then going to Moscow. She photographed World War II, first in Africa and then on the Italian front, returned to Germany with the American troops, and was the first photographer to enter Buchenwald. After the war she went to India in order to document the partition of the country. Then on to South Africa, Korea....

Her photographer colleagues often complained about her excessive harshness, her showy elegance, and the stubborn obstinacy which she displayed in every possible situation. But how else could a woman alone have behaved, in dealing with the war, taking a photo of Gandhi just before his death, or taking one of Stalin, at a time when no other Western photographer was allowed into the Soviet Union? How else could she have convinced her editors that she needed to suspend herself in the sky over Manhattan, descend into a mine in South Africa, or crawl through the rice paddies of Korea, in order to get an important and unique photo? The most difficult trial, the one that she was unable to win, but which instead weighed on her inexorably, was Parkinson's disease. It arrived unexpectedly, and quietly. There was a pain in the leg, a sudden rigidity in the limbs. And then it broke out. Margaret was unyielding and resisted with all her energy. She underwent various therapies and exercises, and an operation that was almost experimental. At times it seemed that she would win; at others that the illness had the upper hand. The struggle lasted twenty years, and ended one day in 1971, when a sudden attack broke her once and for all. Her autobiography ended with an expression of thanks for the destiny that had allowed her always to arrive in the right place at the right time. As befalls all gifted photographers.

DC-4 in Flight over Manhattan, 1939

In a city like New York, at the height of the 1930s, the very sky was the limit to be reached. Bourke-White loved dizzying heights as well as the physical and technological bet which Manhattan seemed to make against tradition and the force of gravity. Margaret was the photographer asked by Walter Chrysler to document the construction of what would be the tallest skyscraper in the city, at more than one thousand feet. "Heights held no terrors for me. Here on the heights of the Chrysler tower, I had additional instruction from the welders and riveters who gave me a valuable rule which I have often remembered and acted upon; when you are working at 800 feet above the ground, make believe that you are 8 feet up and relax, take it easy. The problems are really exactly the same."

Clinging to the highest gargoyle on the building, suspended in space, she quickly learned that it is precisely the view from above which, more than any other, allows one to comprehend a city continuously moving forward, glorious and restless with projects and change.

Besides, Margaret loved to fly and sought to do so, not only, as in this case, to photograph an airliner in the sky over her city, but also during military operations, and air raids, during World War II, at a time when air-craft cabins were not pressurized and cameras felt as heavy as rocks.

But here the flight had the flavor of a happy and exciting adventure, as could be experienced only in Manhattan in the late 1930s, before there were any thoughts of war: "It was a lovely kind of photography. I flew, strapped into a small plane, in close formation with one of the big passenger planes. My pilot flew me over it, under and around it, to get the effect of the big plane looming large in the foreground with the skyscrapers below."

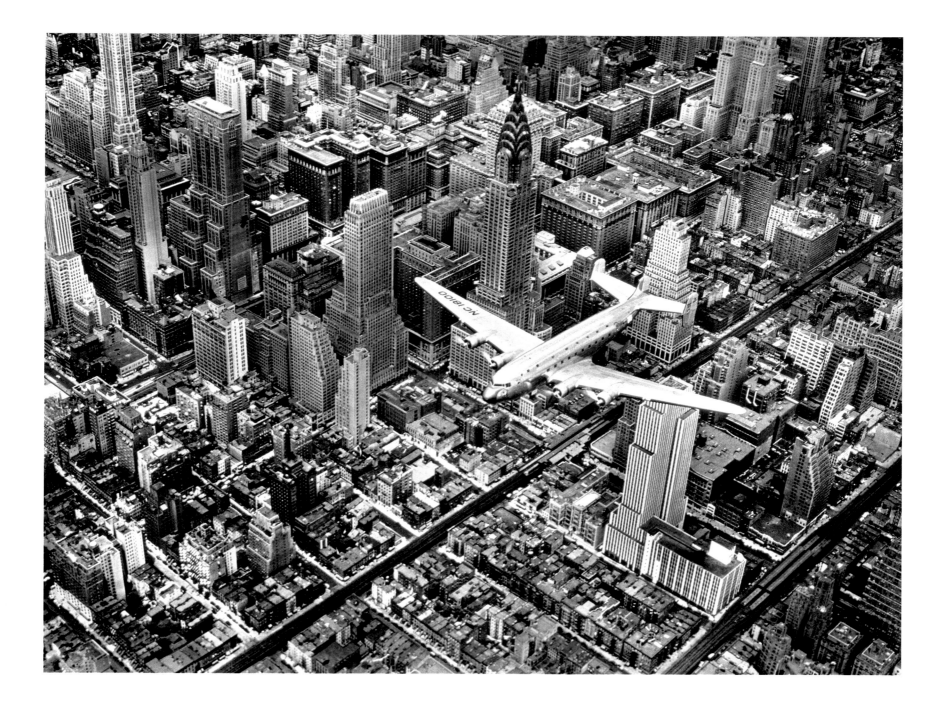

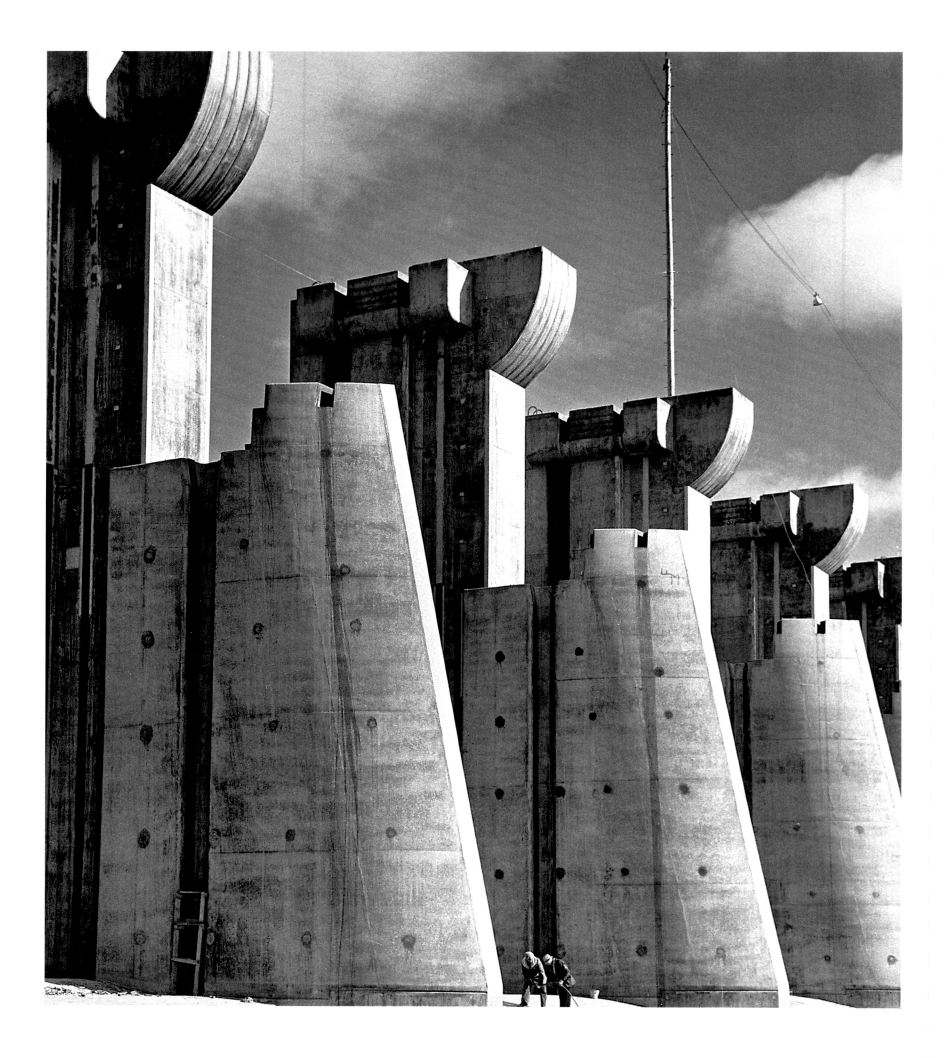

Fort Peck Dam, Montana, 1936
This photo was on the cover of the first issue of *Life*, the magazine that would become a touchstone of photography publishing. Henry Luce, the editor in chief, wanted something large, substantial, and impressive that would suit the new pride in America and in humanity. In response Margaret produced a photo reportage on the largest dam in the world, built on the prairies of Montana at Fort Peck.

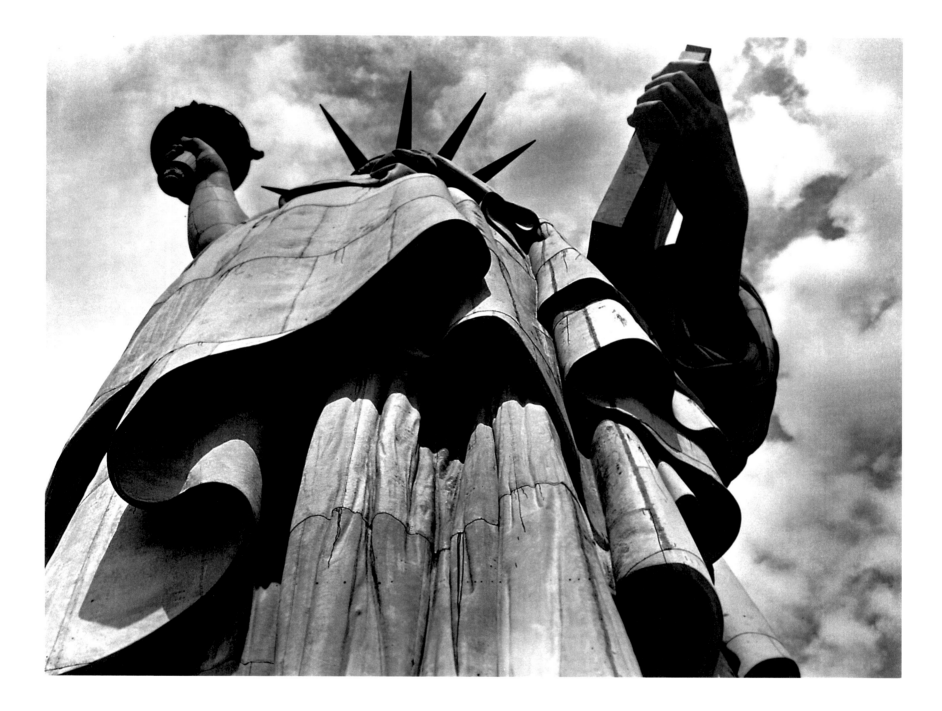

The Statue of Liberty, New York, 1930
A new vision of America, able to enchant and uplift those who saw it and those who lived there. The photo stories produced by Margaret Bourke-White, first for *Fortune* and later for *Life*, tell the story of a young nation resplendent with its rapid and nearly breathtaking rhythm.

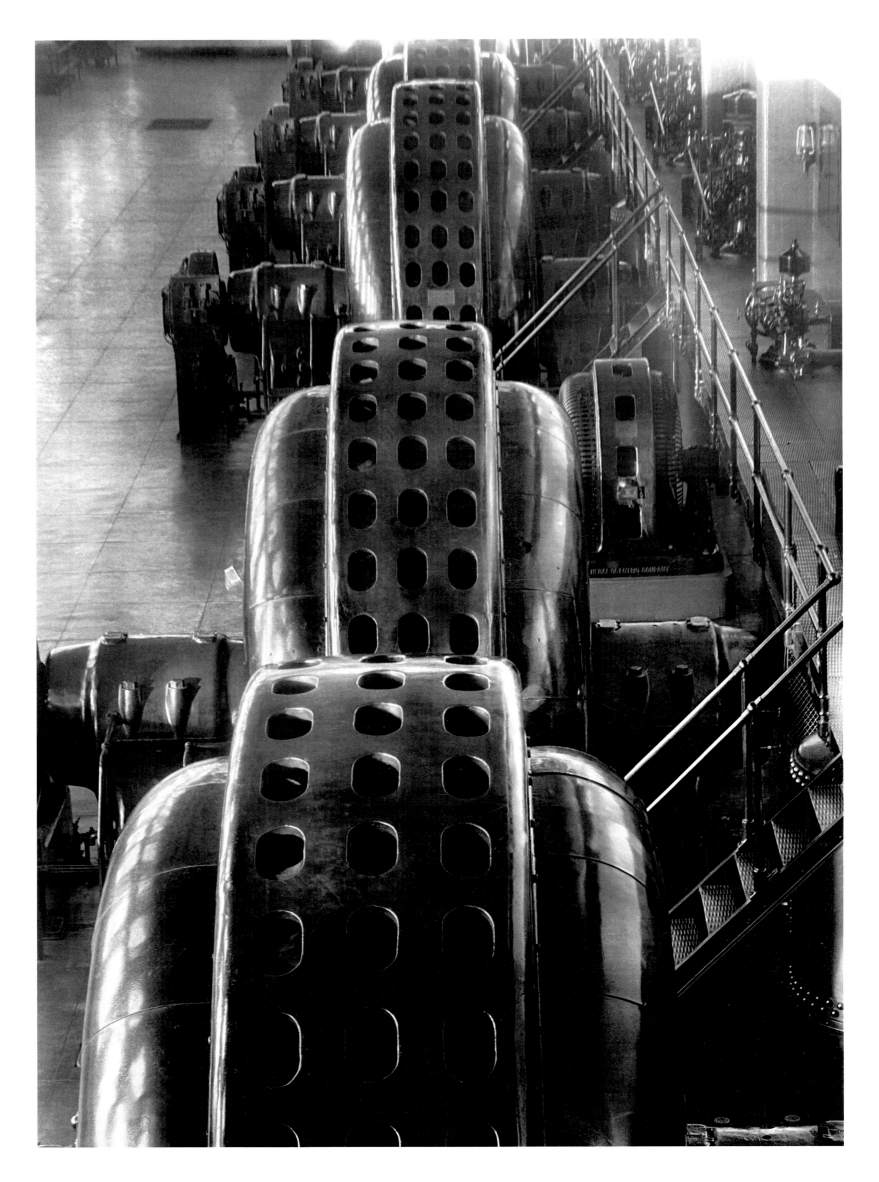

**Hydroelectric Generators, Niagara Falls Power Co., Niagara Falls,
New York, 1928**
The great success enjoyed by Bourke-White began with her courageous and original
manner of reporting on industry. Without being haughty or detached, she knew how
to become fascinated by technology, and in order to realize her visions she did not
hesitate to get close to pouring hot metal, or to climb up wobbly scaffolds.

Plow Blades, Oliver Chilled Plow Co., South Bend, Indiana, 1930
For *Fortune* magazine, Bourke-White documented hidden, or at least little-noticed, aspects of production and work in America. South Bend, Indiana, seemed to be the ideal place in which to depict the industrial cross-section of a city. "We visited all of it, from the auto factories to the foundries, from toys to fishing gear."

"I KNOW OF NOTHING TO EQUAL THE HAPPY EXPECTANCY OF FINDING SOMETHING NEW, SOMETHING UNGUESSED IN ADVANCE, SOMETHING ONLY YOU WOULD FIND, BECAUSE AS WELL AS BEING A PHOTOGRAPHER, YOU WERE A CERTAIN KIND OF HUMAN BEING, AND YOU WOULD REACT TO SOMETHING ALL OTHERS MIGHT WALK BY. ANOTHER PHOTOGRAPHER MIGHT MAKE PICTURES JUST AS FINE, BUT THEY WOULD BE DIFFERENT. ONLY YOU WOULD COME WITH JUST THAT PARTICULAR MENTAL AND EMOTIONAL EXPERIENCE TO PERCEIVE JUST THE TELLING THING FOR THAT PARTICULAR STORY, AND CAPTURE IT ON A SLICE OF FILM GELATIN."

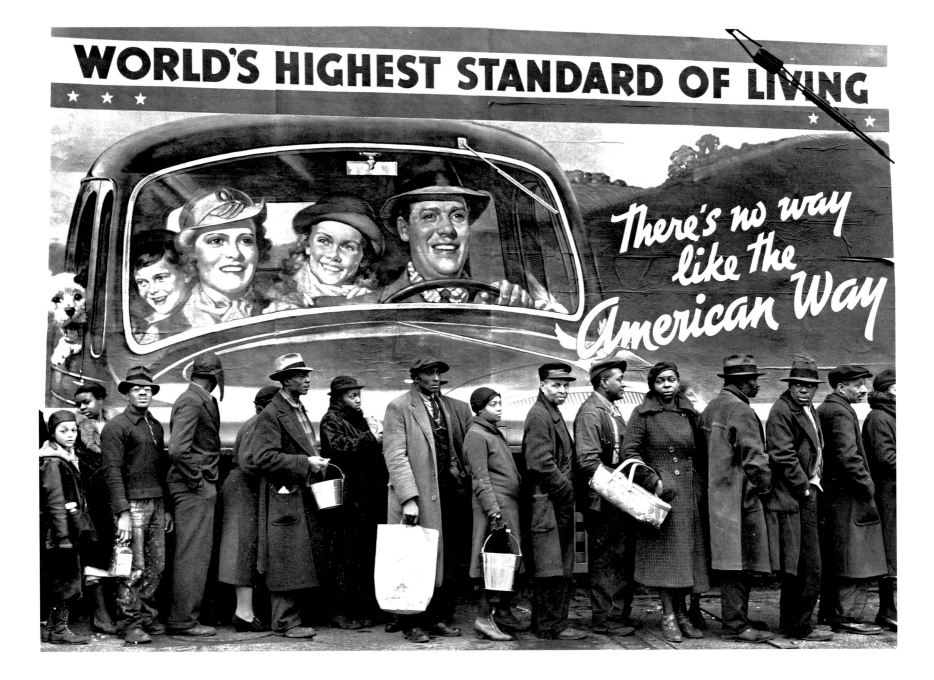

A Bread Line During the Louisville Flood, Kentucky, 1937
The Louisville flood was one of the worst in US history. Bourke-White rushed there and produced a searching photo reportage, once again for *Life*.
A crowd of African Americans line up patiently in order to receive relief assistance. Behind them, a poster shows a (white) happy family, complete with smiling children and a dog, in their car.

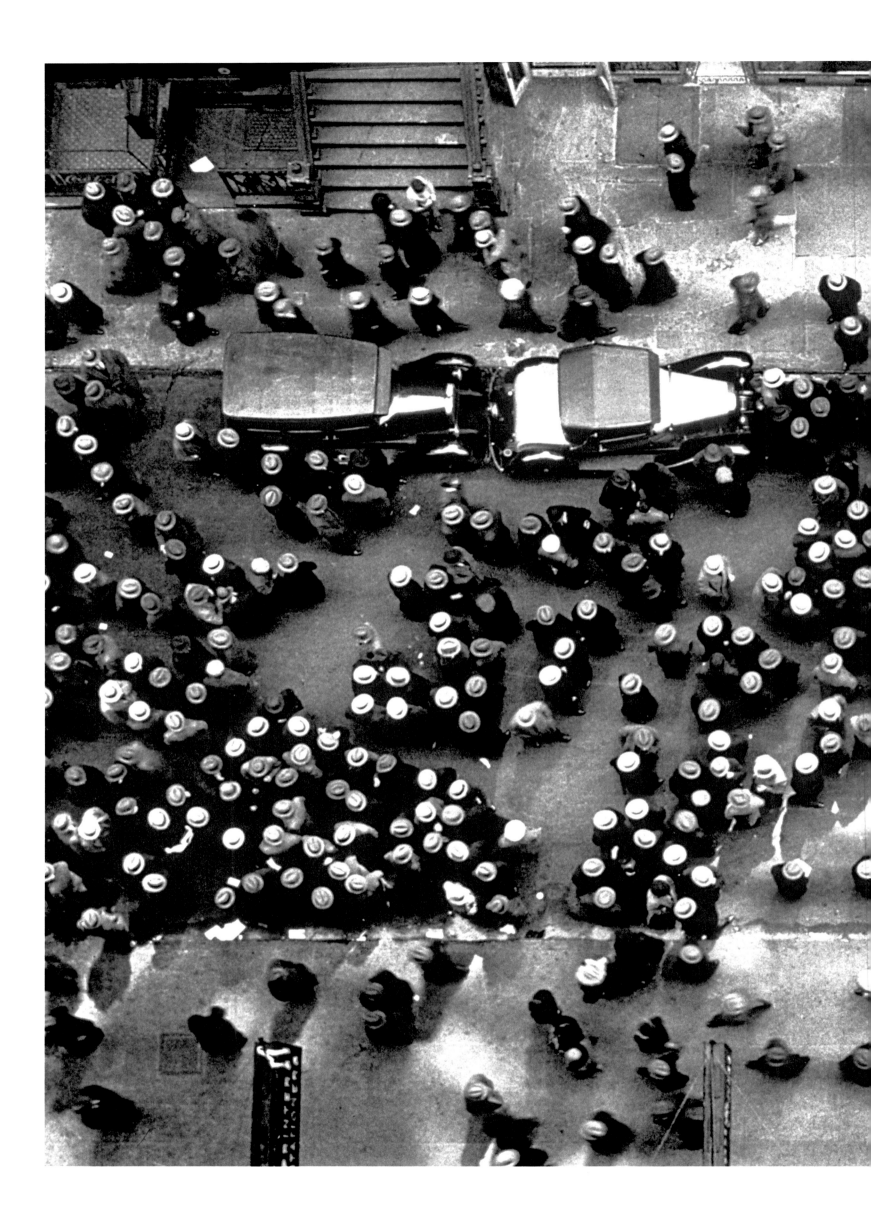

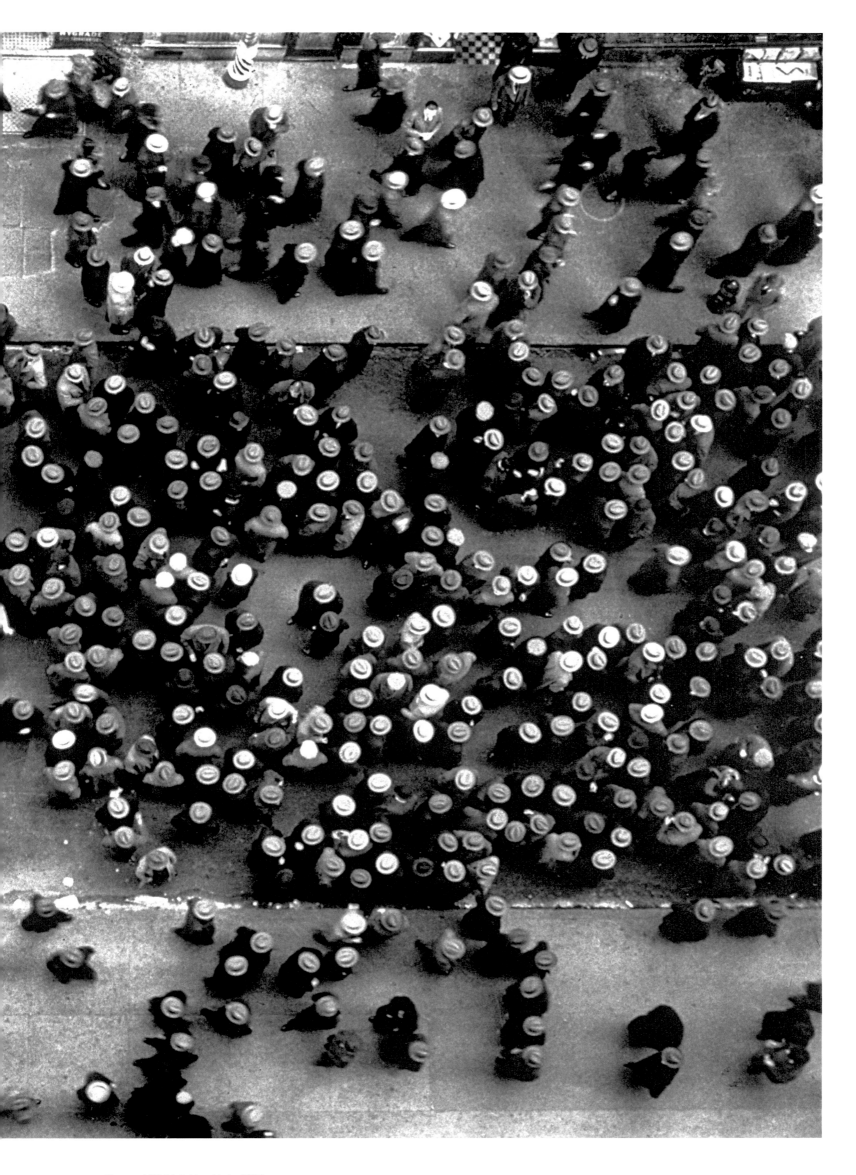

Garment District, New York, 1930
The overhead shot is a recurring feature of Bourke-White's photography. She had her studio "up high" on the top floor of the Chrysler Building. "It turned out that I had not one but a pair of gargoyles resplendent in stainless steel and pointing to the southeast. This was certainly the world's highest studio, and I think it was the world's most beautiful studio, too."

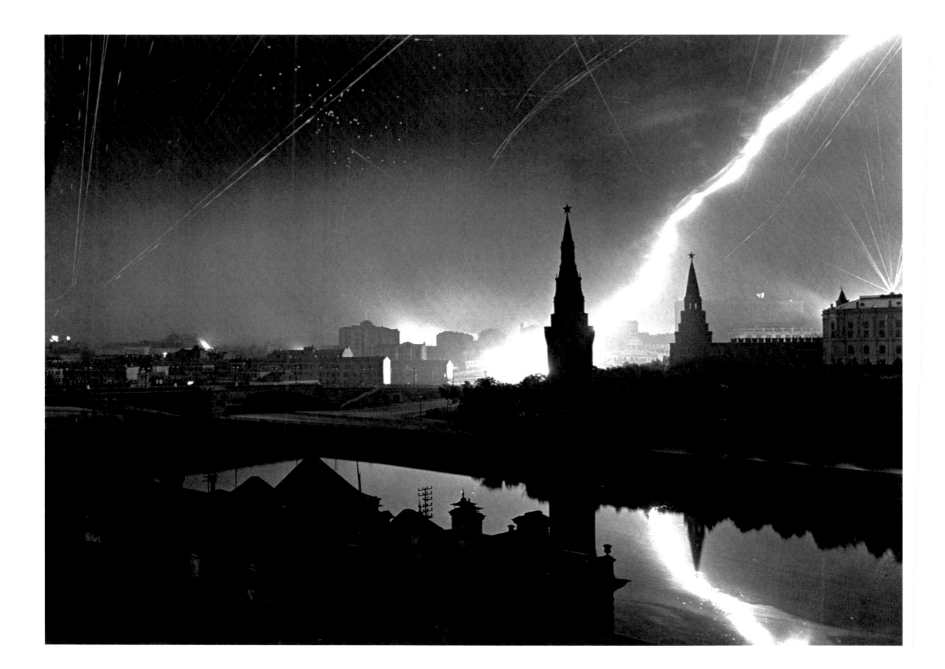

Bombardment of Moscow, 1941
Bourke-White returned to Moscow in 1941 upon the outbreak of hostilities with Germany. She went with her husband, Erskine Caldwell, and was the only Western photographer there.

"Here was I, facing the biggest scoop of my life: the biggest country enters the biggest war in the world and I was the only photographer on the spot representing any publication and coming from any foreign country."

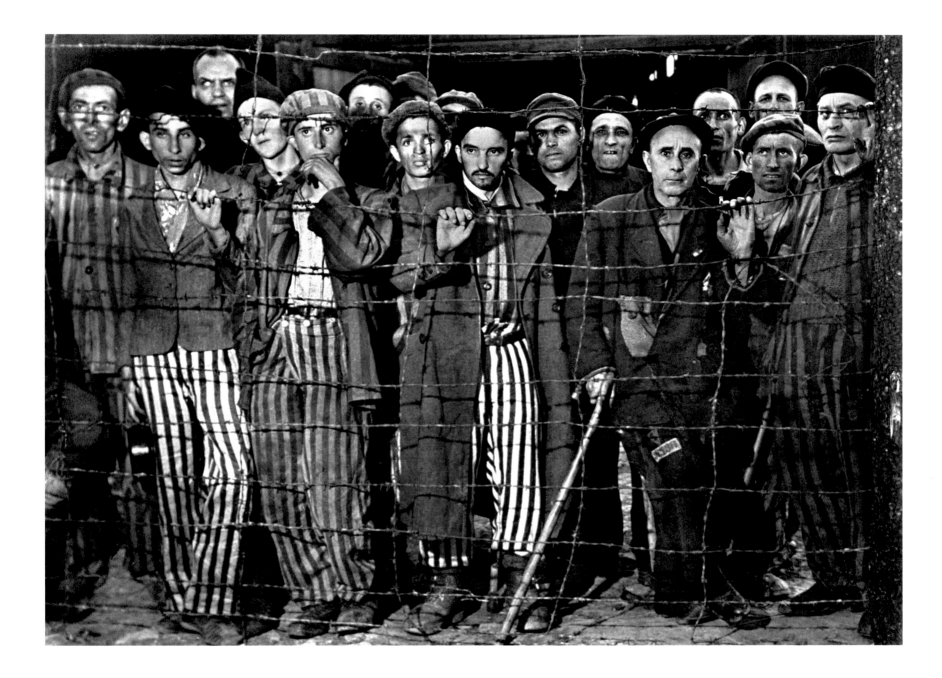

Prisoners at Buchenwald, 1945
Bourke-White succeeded in documenting different phases of World War II, from the air raids in Africa to the campaign in Italy up until the advance into Germany and the opening, by the Allied army, of the concentration camps. The arrival at Buchenwald was very disturbing: "People often ask me how it is possible to photograph such atrocities. I have to work with a veil over my mind. In photographing the murder camps, the protective veil was so tightly drawn that I hardly knew what I had taken until I saw prints of my own photographs. It was as though I was seeing these horrors for the first time. I believe many correspondents worked in the same self-imposed stupor. One has to, or it is impossible to stand it."

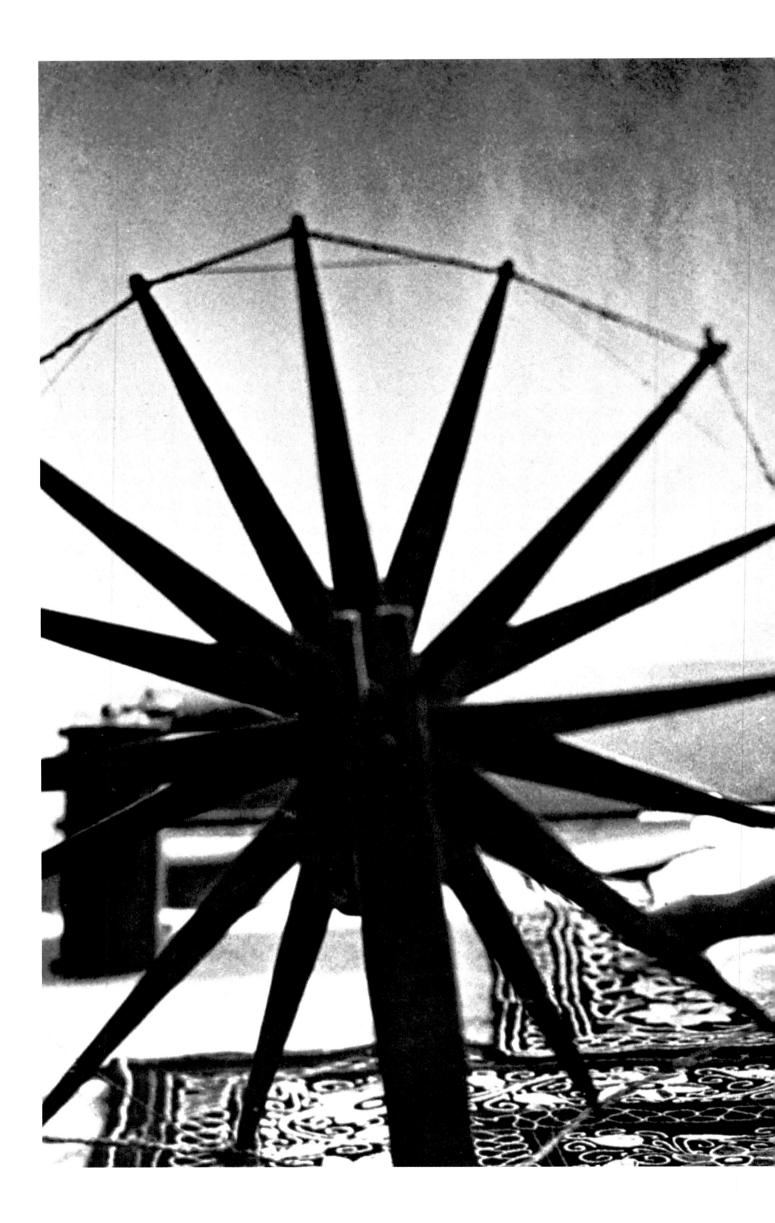

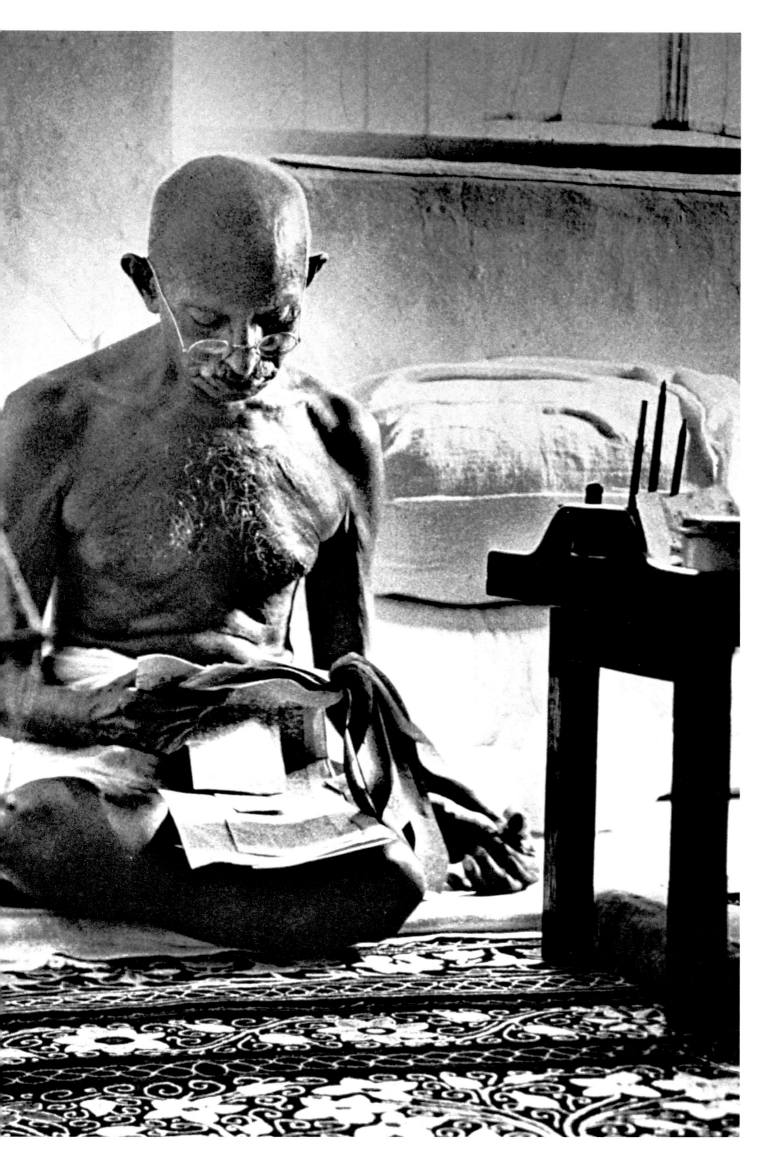

Mohandas Gandhi at his Spinning Wheel, Poona, India, 1946
Bourke-White would say in her autobiography that she was "glad to turn from the decay of Europe to India, where *Life* next assigned me," after Germany. She landed in Bombay in 1946, ready to take photos of a vast and complex country that was on the brink of a fragile and bloody course of events that would culminate in independence and partition. Out of all her travels, her long stay in India, and her encounters with the main actors in the story—Nehru, Jinnah, and others—it was the one with Gandhi that hit her hardest and stayed with her forever: "I had a historical drama to photograph, with a full cast of characters, including villains and one of the saintliest men who ever lived. And when the saint was martyred, I was near."

"THE CURTAIN WAS FALLING ON THE TRAGIC LAST ACT. THE DRAMA I HAD COME TO INDIA TO RECORD HAD RUN ITS COURSE. I HAD SHARED SOME OF INDIA'S GREATEST MOMENTS. NOTHING IN ALL MY LIFE HAS AFFECTED ME MORE DEEPLY, AND THE MEMORY WILL NEVER LEAVE ME. I HAD SEEN MEN DIE ON THE BATTLEFIELD FOR WHAT THEY BELIEVED IN, BUT I HAD NEVER SEEN ANYTHING LIKE THIS: ONE CHRISTLIKE MAN GIVING HIS LIFE TO BRING UNITY TO HIS PEOPLE."

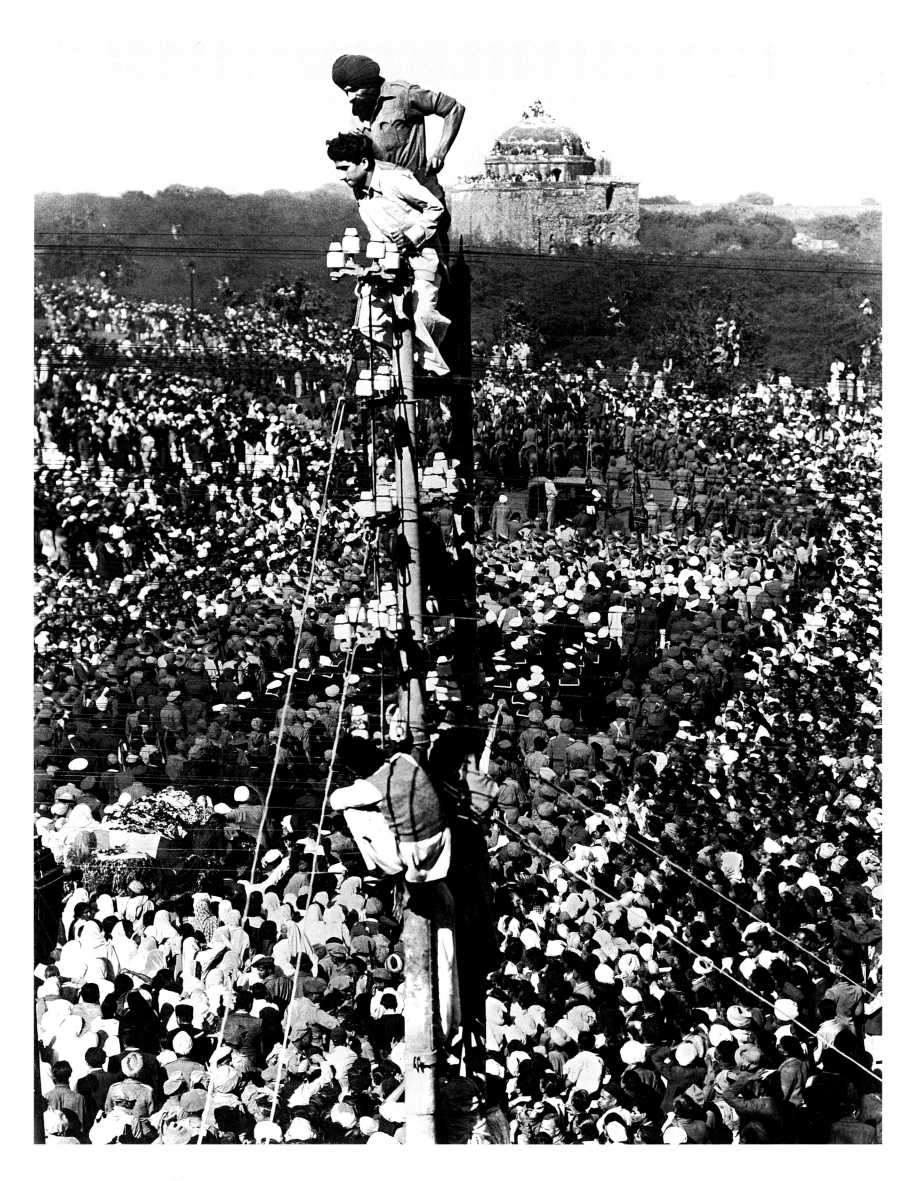

Gandhi's Funeral, Delhi, India, 1948
Shortly before the attack on Gandhi, Bourke-White had interviewed him in the gardens at Birla House, in New Delhi—the final act of a relationship with him, his entourage, and the entire country. "Only a few hours later, on his way to evening prayers, this man who believed that even the atom bomb should be met with nonviolence was struck down by revolver bullets."

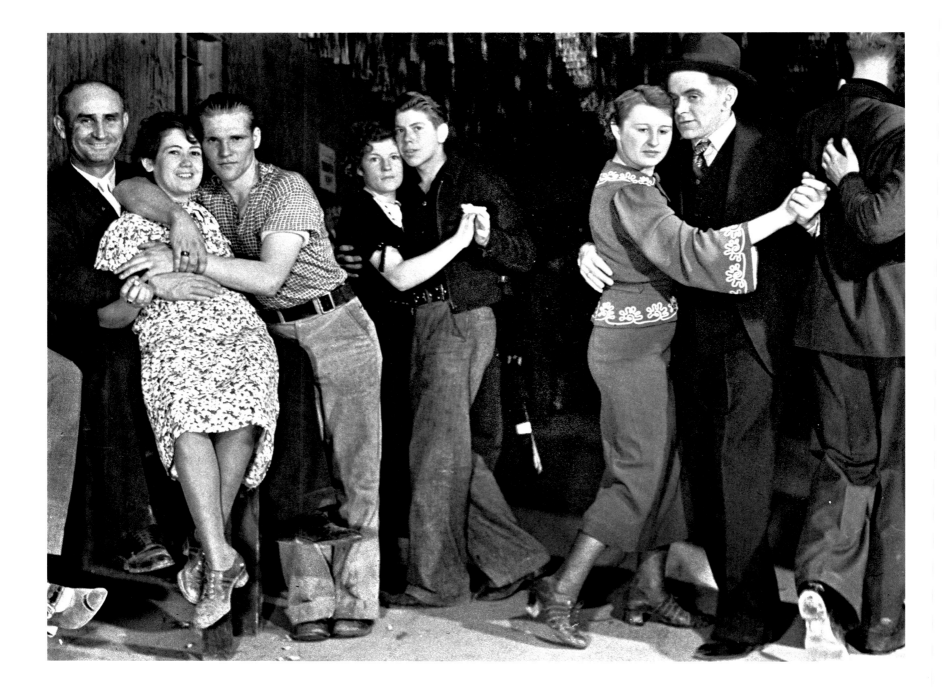

Dancers, Billings, Montana, 1936
If it was with her Depression-era photographs that Bourke-White discovered the importance and value of the human element in a photographic narrative, the portrait would always attract her because of its capacity to communicate joy and respect, dignity and despair. In all her reportage, whether from the

Deep South of the United States, war-time Europe, South Africa, or Korea, she would search the faces of her subjects, try to find something in their gaze, in order to tell their stories: "Not just the unusual or striking face, but the face that would speak out the message from the printed page."

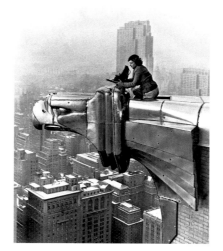

Born June 14, 1904, in New York, Margaret Bourke-White was the daughter of an engineer who was expert in designing printing presses. When she was only eight, her father took her to visit the steelworks where his machines were produced. In her 1963 autobiography, *Portrait of Myself*, she would say, "To me at that age a foundry represented the beginning and end of all beauty." Not long after she entered Columbia University, in 1921, she had already learned enough about photography to support herself by taking souvenir photos of the campus. She attended a photography course taught by Clarence White and by 1927, having arrived in Cleveland, she had become a photographer.

Along with success came a desire to explore new techniques and to produce images that were unusual, dramatic, and richly poetic. In 1929 she met Henry Luce, who invited her to move to New York in order to collaborate on the start of a new magazine: *Fortune*. Thanks to *Fortune*, Bourke-White would photograph the state of German industry following World War I, and the trip would help open a path for her to travel to Russia. Up until 1936 she would maintain a studio for her publicity and corporate work, without neglecting the possibilities for books, exhibitions, and independent projects.

In the mid-1930s, with the country overwhelmed by the Depression, she collaborated with the writer Erskine Caldwell on a long trip through the southern United States in order to investigate conditions there. Together they produced the book *You Have Seen Their Faces*.

In 1936 Bourke-White was summoned by Luce and once again managed to secure the cover and most important story in the first issue of *Life*. When the non-aggression pact between Germany and the Soviet Union was broken in 1941, she was already on the spot for *Life*. She photographed the bombardment of Moscow and took a portrait of Stalin. She then returned to the front: twice in Italy and then, in the spring of 1945, accompanying General Patton's troops, she was among the first to enter the Buchenwald concentration camp.

At war's end, she got ready to document the birth of the new India and its separation from Pakistan, and she met the spiritual guide of India's liberation, Mahatma Gandhi. In 1950 Bourke-White went to South Africa, drawn by the new conservative government and its policy of apartheid. Her reportage was very intense and Margaret went down a gold mine two miles underground in order to photograph a pair of miners who were broken by the terrible heat. There was no assignment on which she did not try to convince some pilot to take her up with him in order to get at least one aerial shot. Her love of flying went back a long way; now, however, the assignments were tailored specifically for her, such as those in the United States that were shot from a helicopter.

When war broke out in Korea, Margaret set off again. By the time she arrived, the armistice had already been signed, but her instincts led her to the story, previously untold, of the guerilla fighting that was breaking apart and dividing Korean families.

It was around this time that Bourke-White began to suffer from a "mysterious malady" that would progressively paralyze her limbs. It was Parkinson's disease, and her brave struggle to defeat the illness would truly be the greatest challenge of her life. She spent her last years trying to fight the progressive paralysis, with two operations, incessant physical therapy, and an inexhaustible optimism. After a fall in her house in Darien, Connecticut, she died on August 27, 1971, at sixty-seven years of age. Throughout her career, Margaret Bourke-White always placed great value on her own professional independence, choosing her reportage assignments herself, launching great social campaigns, looking for work on her own, and committing herself to books and exhibits: a pioneering way to lead a life and to follow a profession.

"MINE IS A LIFE INTO WHICH MARRIAGE DOESN'T FIT VERY WELL. ONE LIFE IS NOT BETTER THAN THE OTHER; IT IS JUST A DIFFERENT LIFE. I HAVE ALWAYS BEEN GLAD I CAST THE DIE ON THE SIDE I DID. BUT A WOMAN WHO LIVES A ROVING LIFE MUST BE ABLE TO STAND ALONE. SHE MUST HAVE EMOTIONAL SECURITY, WHICH IS MORE IMPORTANT EVEN THAN FINANCIAL SECURITY. THERE IS A RICHNESS IN A LIFE WHERE YOU STAND ON YOUR FEET, ALTHOUGH IT IMPOSES A CERTAIN CREED. THERE MUST BE NO DEMANDS. OTHERS HAVE THE RIGHT TO BE AS FREE AS YOU ARE. YOU MUST ABLE TO TAKE DISAPPOINTMENTS GALLANTLY. YOU SET YOUR OWN GROUND RULES, AND IF YOU FOLLOW THEM, THERE ARE GREAT REWARDS."

MARGARET BOURKE-WHITE

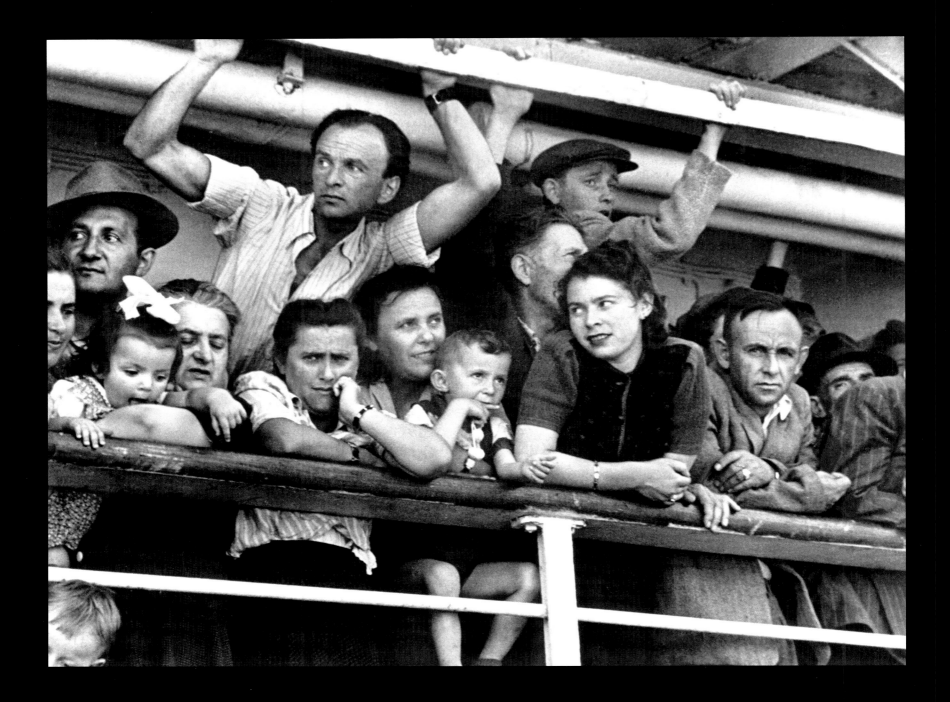

CAPA

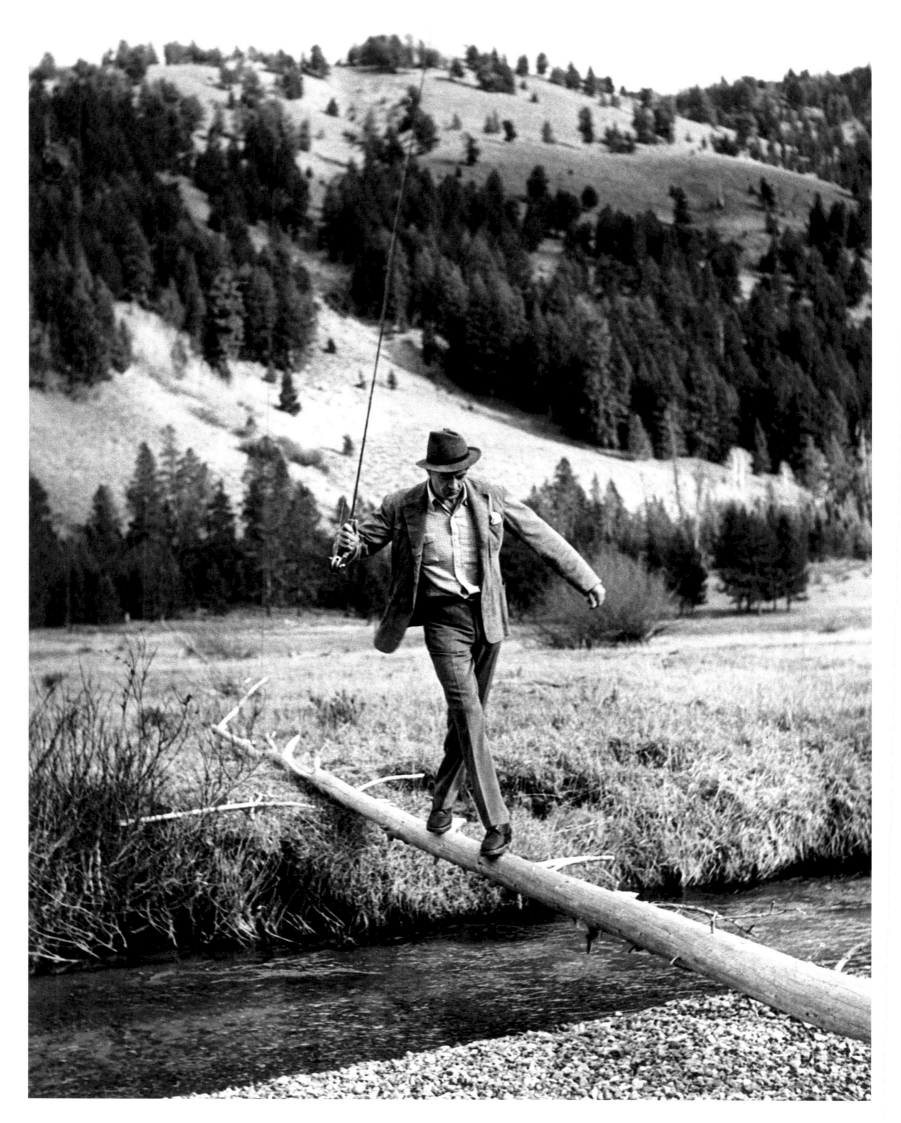

Page 74

The Arrival of Thousands of Immigrants from Eastern Europe, Turkey, and Tunisia. Haifa, Israel, 1949

Robert Capa always considered himself to be a photojournalist, not an artist. But he had the soul of a true artist, because he went about his work with intelligence, passion, spirit, and grace. Leo Tolstoy wrote, "Art is a human activity consisting in this, that one man consciously, by means of certain external signs, hands on to others feelings he has lived through, and that other people are infected by these feelings and also experience them." If we accept this definition, it cannot be denied that Robert Capa was a great artist.

Above

Sun Valley, Idaho, 1940
Gary Cooper during a pause in the shooting of a film.

ROBERT CAPA

When Robert Capa died in 1954 after accidentally stepping on a mine while in Indochina, on his umpteenth photo campaign in a war that was not his own, he was mourned by many. Not only was it the death of a great photographer, probably the most famous of all time, but it was also the death of a great man, one of those rare individuals who succeeds in turning his life, even more than his work, into a work of art and a legend. When one thinks of the existential stages in the life of this man of incurable enthusiasm, lively intelligence, and ready wit, it can seem like reading the chapters of a picaresque novel: his birth in Hungary as Endre Friedmann; his support of socialist ideology; his hurried departure from Budapest for Berlin in order to escape political reprisals; the first attempts at photography under the aegis of Simon Guttman, who taught him his craft; and then, once again, another hasty departure in order to leave a city that had become too restrictive for a Hungarian Jew.

By the mid-1930s Capa was in Paris, with his profession still to be figured out and a city to be discovered. He began a relationship with a Polish-Jewish refugee from Germany, Gerta Pohorylle (later known as Gerda Taro), and the two fell in love. For sure, he was talented, but that was not enough in a city where competition was ruthless. And to complicate things further, there was another photographer with the same name, Friedmann. But Gerda had an idea. Why not invent an identity for a mysterious American photographer whose photographs only they would have the possibility of "sending around" and selling to newspaper editors?

The imaginary photographer could be named Robert, like the film idol Robert Taylor, and Capa, more or less like Frank Capra, the director who had just come out with *It Happened One Night.* The trick worked. Capa aroused people's curiosity and his photos began to circulate. Success came and Endre Friedmann soon revealed his innocent bluff. For all intents and purposes, and to the entire world, he became Robert Capa, always using only that name. Together with Gerda, he left for the front in the Spanish Civil War. It was 1936 and the war in Spain was not just an event to be "covered" photographically but also a place where Europe could lay bare its soul. The two took photos and experienced the difficulties of a country at war as well as the enthusiasm of the troops, with whom they shared their days, who were fighting Franco. When they were published in mass-circulation magazines such as *Vu* and *Life,* Capa's photos caused great excitement. They had a power and immediacy never seen before. It was in Spain that Capa took the photo of the Republican militiaman about to fall just as he was struck by a bullet, the most famous war photo ever taken.

Perhaps it doesn't matter whether the man's name was Federico Borrel García, or if the place was Cerro Muriano instead of some other outpost of the Civil War. Surely, after so many years, the important thing is that we continue to marvel at the force of this image that has become a symbol of the destructive fury of war as it annihilates a helpless man. Gerda Taro was killed during a retreat following the Battle of Brunete. Capa would never completely recover from her death.

Forced to be on the move once again, Capa went to the United States. But before too long, a sincere desire to understand the tragedy of people up close, and to put it in narrative form, brought him back to Europe. Capa, who hated war and dreamed of a day when he could become a "photographer of peace," found himself in the middle of World War II, on the Italian front and, later, unforgettably, at the landings in Normandy. It was the photos of D-Day, when he crossed the English Channel towards Omaha Beach on the first amphibious transports, that made him famous as the father of photojournalism. Those photos, of which only eleven flickering examples have come down to us, due to the haste of the lab technician who rushed the drying time and ruined the emulsion, testify to what it means to be close to the scene being shot, to be at the heart of the story being told.

But Capa's life did not consist only of war and death. His true talent was, perhaps, an ability to charm people (especially women) with his dark eyes and ironic smile, and to make many friends. Hemingway, Steinbeck, Picasso, and John Huston, with whom he played many unforgettable games of cards, as well as Ingrid Bergman, with whom he had an affair, are some of the people who got on well with him and who appreciated his *joie de vivre*. In 1947, with his colleague-friends Henri Cartier-Bresson, David "Chim" Seymour, and George Rodger, Capa founded the legendary agency Magnum Photos, a long-standing dream of his. Capa ran the agency for a long time, recruited new members, thought up a role and a path for each of them, and found the necessary money, even if it meant risking everything on a gamble. And when he was nearly ready to try his hand at becoming a writer, of screenplays perhaps, there was that absurd accident, on an assignment taken only at the last minute, which put an end to a life that was full of vitality, enthusiasm, projects, and ideas.

His brother Cornell remembered him thus: "Robert Capa's life is a testament to difficulty overcome, a challenge met, a gamble won except at the end, when he stepped on a land mine."

A Sicilian Peasant Points Out to an American Soldier the Road Taken by a German Convoy, Troina, Italy, August 1943

The Americans were heading towards Troina, an important town because of its strategic position overlooking the road to Messina. From there, in fact, one could control the main port on Sicily's east coast. The Germans put up heavy resistance in order to defend the city, as well as to give their own troops time to retreat. The campaign in Italy was one of the first times during World War II in which Capa could fully express his character. His courage and initiative enabled him to join up with advance elements of the American army and to take his photos exactly as events unfolded.

In his memoir *Slightly Out of Focus*, Capa tells how he managed to become a parachutist without ever having made a practice jump, even reaching the front.

"All I knew about jumping was that I was supposed to step out of the door with my left foot, count 1,000 . . . 2,000 . . . 3,000, and if my chute didn't open, I was to pull the lever for my emergency chute. I was too exhausted to think. I didn't want to think anyway, and I fell asleep.

They woke me up just before the green signal flashed on. When my turn came, I stepped out into the darkness with my left foot forward. I was still groggy, and instead of counting my thousands, I recited: 'Fired photographer jumps.' I felt a jerk on my shoulder, and my chute was open. 'Fired photographer floats,' I said happily to myself. Less than a minute later, I landed in a tree in the middle of a forest."

During the days that followed, in order to be at the head of the advancing column, Robert Capa passed himself off as an interpreter, even though he didn't know any Italian.

"The exasperated Keyes asked for an interpreter and I offered my services. I got the point over to the gendarmes somehow. I explained that the general wanted to avoid any unnecessary bloodshed and wanted the Italian general to announce the terms of surrender to the populace.

In fifteen minutes a jeep reappeared. Seated in the back, between two beaming gendarmes, was a very unhappy Italian major general. General Keyes motioned the sweating Italian general into his command car and repeated his order to the MPs to not let any-one through. He had a white flag hoisted on his car and it looked as if he was going to take Palermo without the army.

Here goes my surrender ceremony, I thought. But just as the car was about to leave, General Keyes turned toward me. 'Interpreter, come along,' he ordered.

We drove up to the governor's place and dismounted in the courtyard. General Keyes demanded the immediate and unconditional surrender of the town and military district of Palermo. I translated it into French, the language I knew best, and hoped the Italian would understand me. He replied in perfect French and said that he would be only too glad to do so, but it was really impossible. He had already surrendered four hours earlier to an American infantry division that had entered the city from the opposite direction.

General Keyes became impatient at the delay. I explained to the Italian that surrendering the second time ought to be much easier than the first. Besides, General Keyes was the corps commander, and would undoubtedly allow him to keep his orderly and personal belongings in the prisoner's camp. The issue was won. He surrendered in French, Italian, and Sicilian, and asked whether he could keep his wife too."

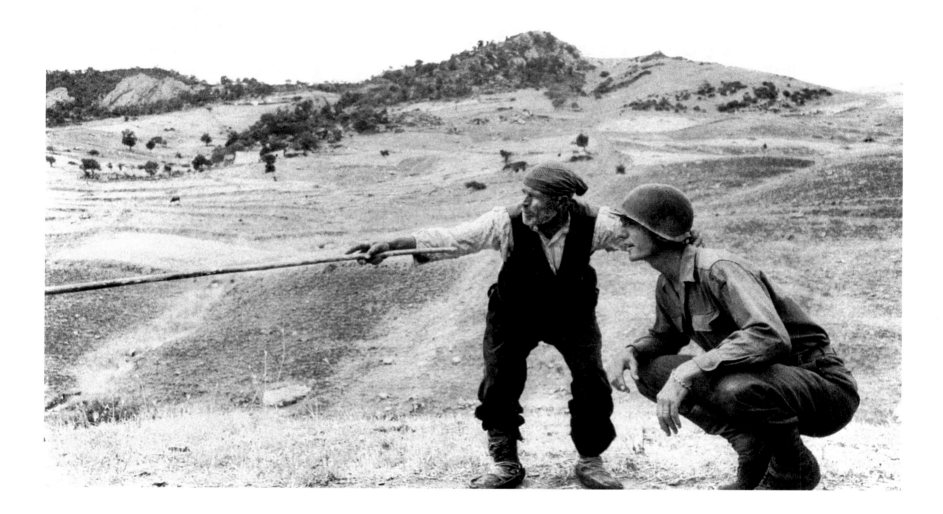

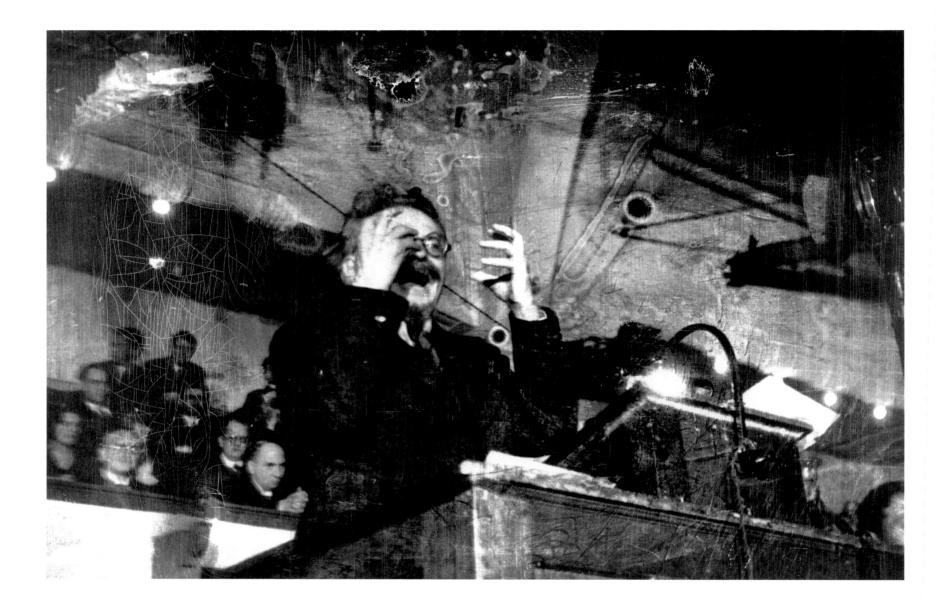

Above
The Political Leader Leon Trotsky Addresses Students, Copenhagen, 1932
After his first local jobs, the first important assignment given to Capa by Simon Guttmann was in Denmark. Trotsky, then living in exile in Turkey, had organized a conference for Danish students in Copenhagen with the title "The Meaning of the Russian Revolution." This was the first photo reportage published by Capa, a full page, in the magazine *Weltspiegel*.

Facing page
A Republican Militiaman at the Moment of Death, Espejo (?), Cordoba, Spain, 1936
This is one of the most controversial pictures in the history of photography, and one of the most important images of the last century. Capa was twenty-two years old when he rushed to Spain in order to document the Spanish Civil War. He took his place alongside the Republican soldiers, became a

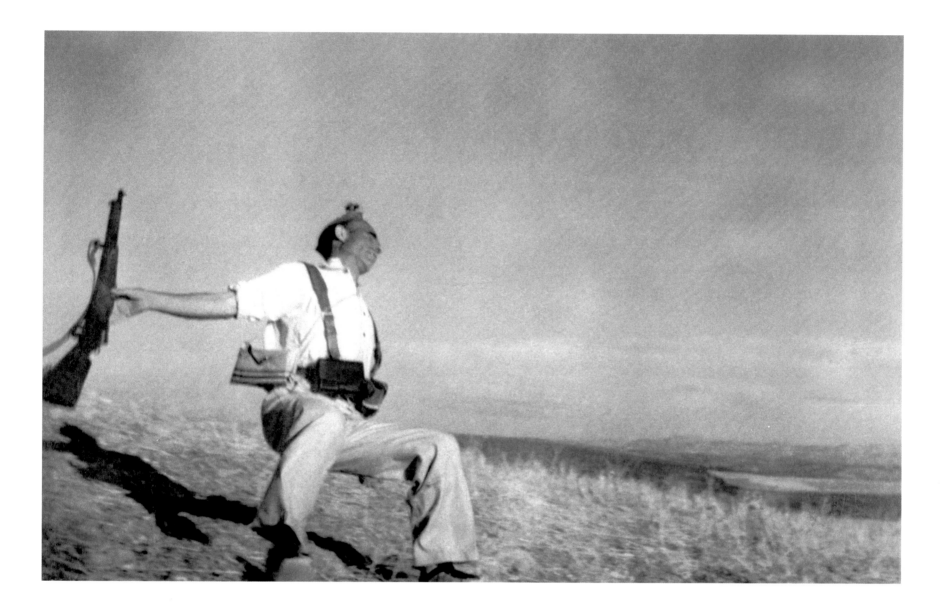

militant, and succeeded better than anyone else in reporting the courage of men in battle and the difficulties of an innocent population. It was in Spain that he took his most famous photo, the one that made him a legend. On the outskirts of Cordoba, perhaps, during a Loyalist offensive, Capa caught the exact moment in which a militiaman was shot dead by a bullet. The image, published on September 23, 1936, by the French weekly *Vu*, and later by *Life*, caused great excitement and became one of the first icons of the twentieth century, the symbol of a tireless but unfortunately failed offensive by democratic forces against the repressive and authoritarian enemy. The photo is so perfect that it has given rise to a series of polemics about its authenticity. It soon became part of the common memory of the twentieth century. Its power turns the document itself into a universal metaphor and transforms a historical fragment into the symbol of a tragedy and the struggle for democracy.

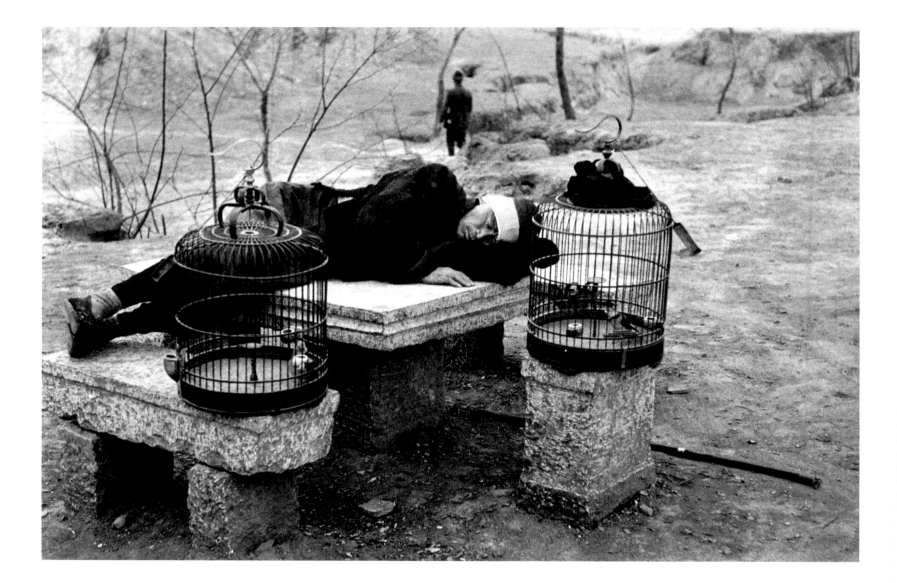

China, 1938
His assignment for *Life* took Capa to China in order to produce with Joris Ivens a documentary about the Chinese resistance to the invasion by Japanese troops that had begun one year earlier. As always, his eye was constantly focused on humanity, as in this photograph in which two bird cages surround a soldier resting on a march.

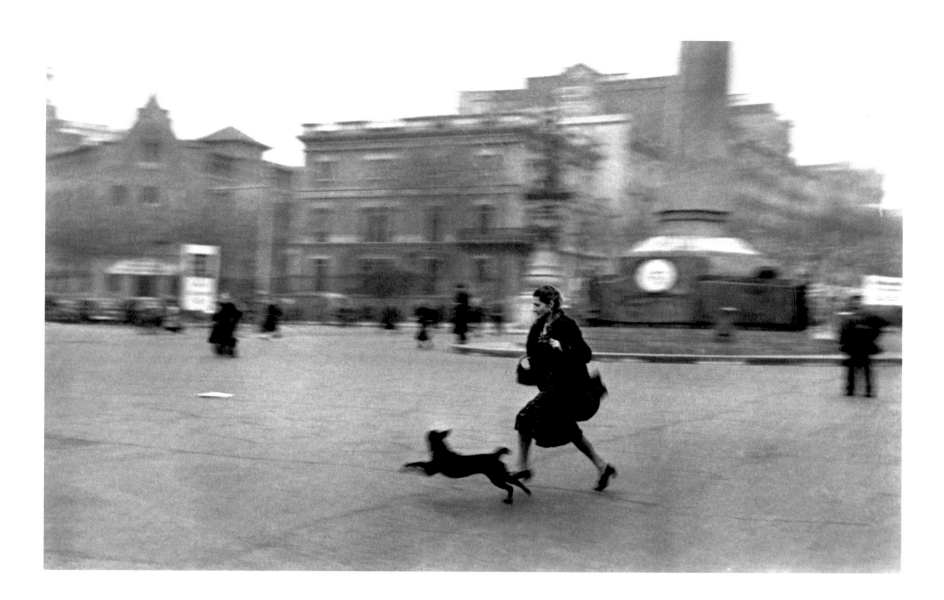

During the Civil War, Barcelona, 1936
A woman runs with her dog toward a shelter during an air-raid warning.
The city was heavily bombarded while Franco's troops rapidly approached.

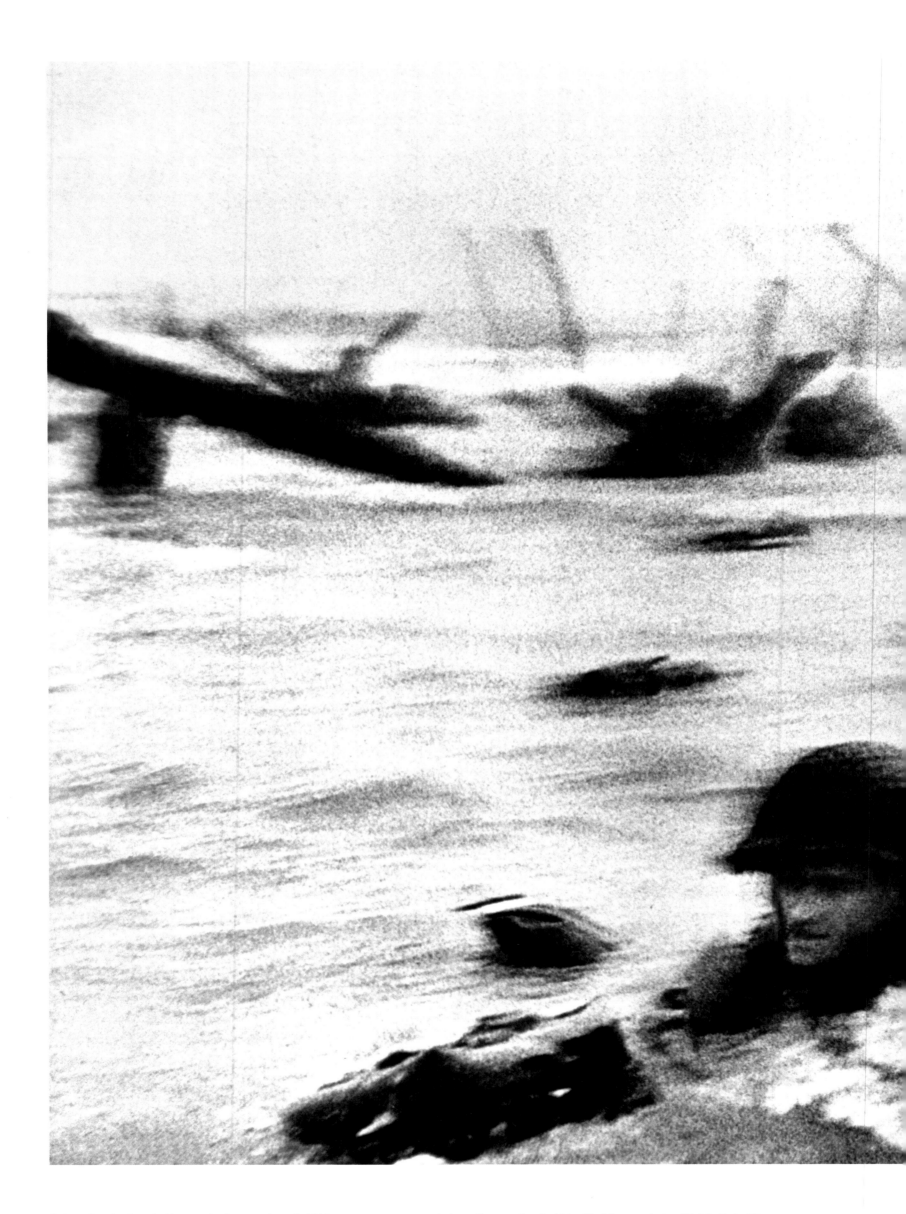

D-Day, Omaha Beach, Normandy, France, June 6, 1944
This photo is an invaluable record of the Allied landings in Normandy. Putting his life at great risk, Capa took seventy-two images, but only eleven were saved, due to an error by a lab technician under pressure to do the job quickly who increased the drying temperature too much. *Life* published the

photos with a caption that identified them as being *Slightly Out of Focus*, a title that Capa used, with great irony, for his autobiography. This is how he described those moments: "I finished my pictures, and the sea was cold in my trousers. Reluctantly, I tried to move away from my steel pole, but the bullets chased me back every time. Fifty yards ahead of me, one of our

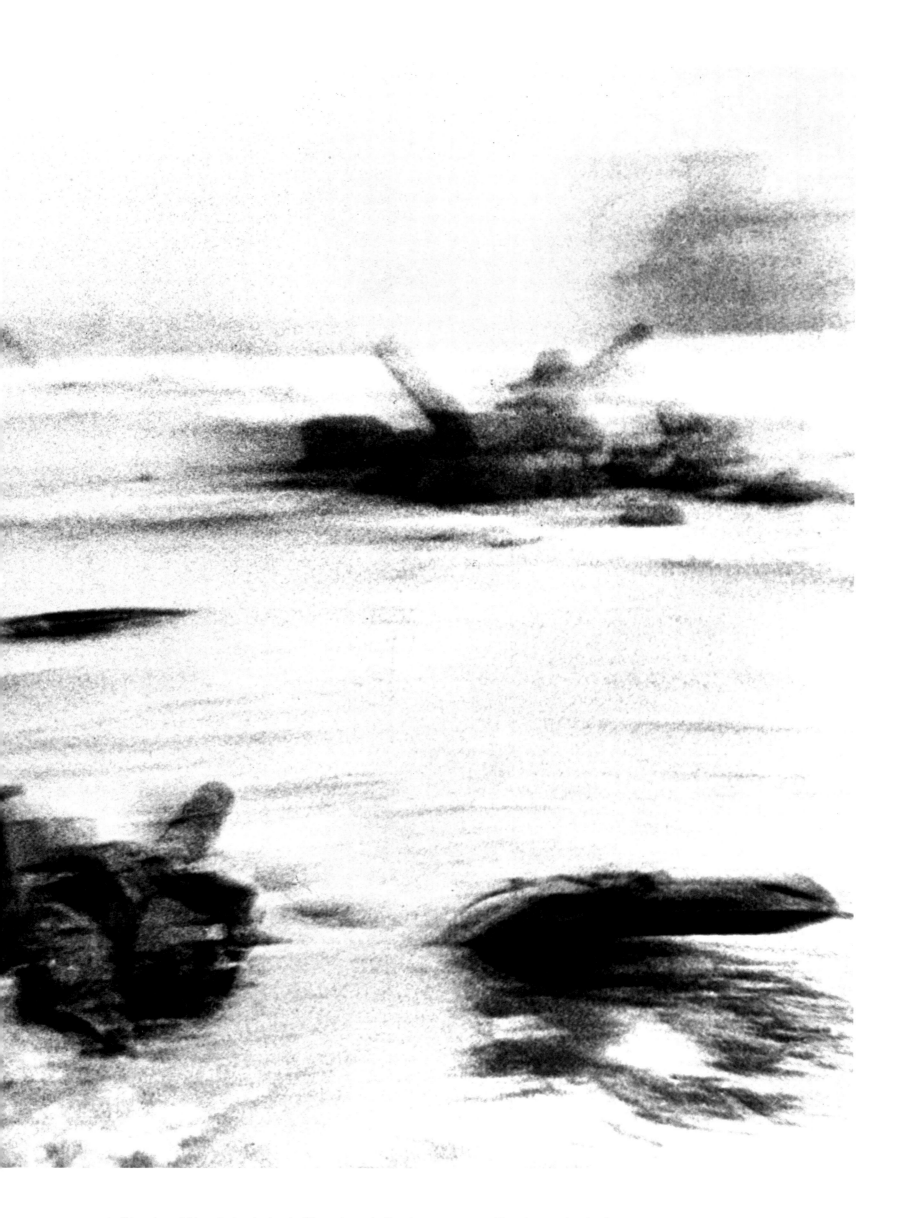

half-burnt amphibious tanks stuck out of the water and offered me my next cover. I sized up the situation. There was little future for the elegant raincoat heavy on my arm. I dropped it and made for the tank. Between floating bodies I reached it, paused for a few more pictures, and gathered my guts for the last jump to the beach."

The photos taken by Capa that day, even though ruined by the lab, are still the most extraordinary examples of his courage and sense of history. They are the main document of the landing and have been used thousands of times in order to reconstruct, after the passage of time, the scene and the context.

"THE WAR CORRESPONDENT HAS HIS STAKE—HIS LIFE—IN HIS OWN HANDS, AND HE CAN PUT IT ON THIS HORSE OR THAT HORSE, OR HE CAN PUT IT BACK IN HIS POCKET AT THE VERY LAST MINUTE. I AM A GAMBLER. I DECIDED TO GO IN WITH COMPANY E IN THE FIRST WAVE."

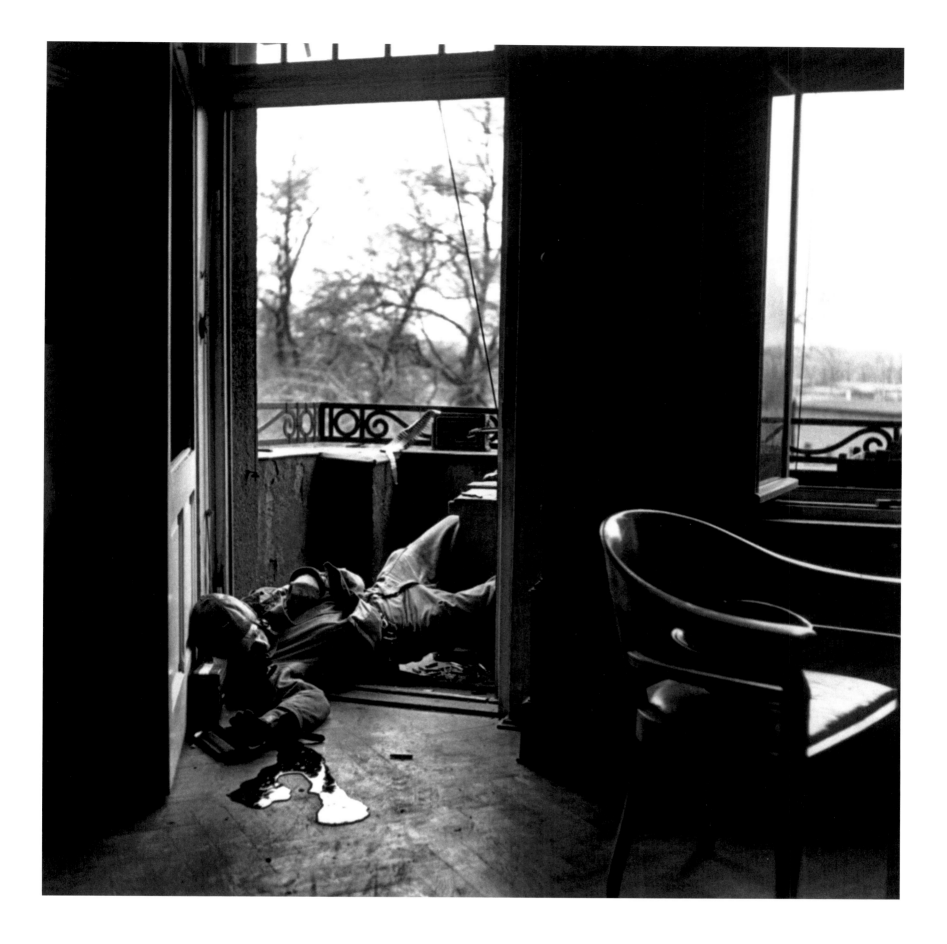

An American Soldier Killed by a German Sniper, Leipzig, April 18, 1945
During the final months of the war, Capa followed the American troops in
Germany in order to report on the conquest of Leipzig. Here, as he himself
affirmed, he took the last photo of the last soldier to die. From inside an
apartment, he took the photo and examined the body of a soldier killed by
a German sniper. He witnessed the last moments of the soldier's life: "The
boy had a clean, open, very young face, and his gun was still killing fascists.
I stepped out onto the balcony and, standing about two yards away, focused
my camera on his face. I clicked my shutter, my first picture in weeks—and the
last one of the boy alive."

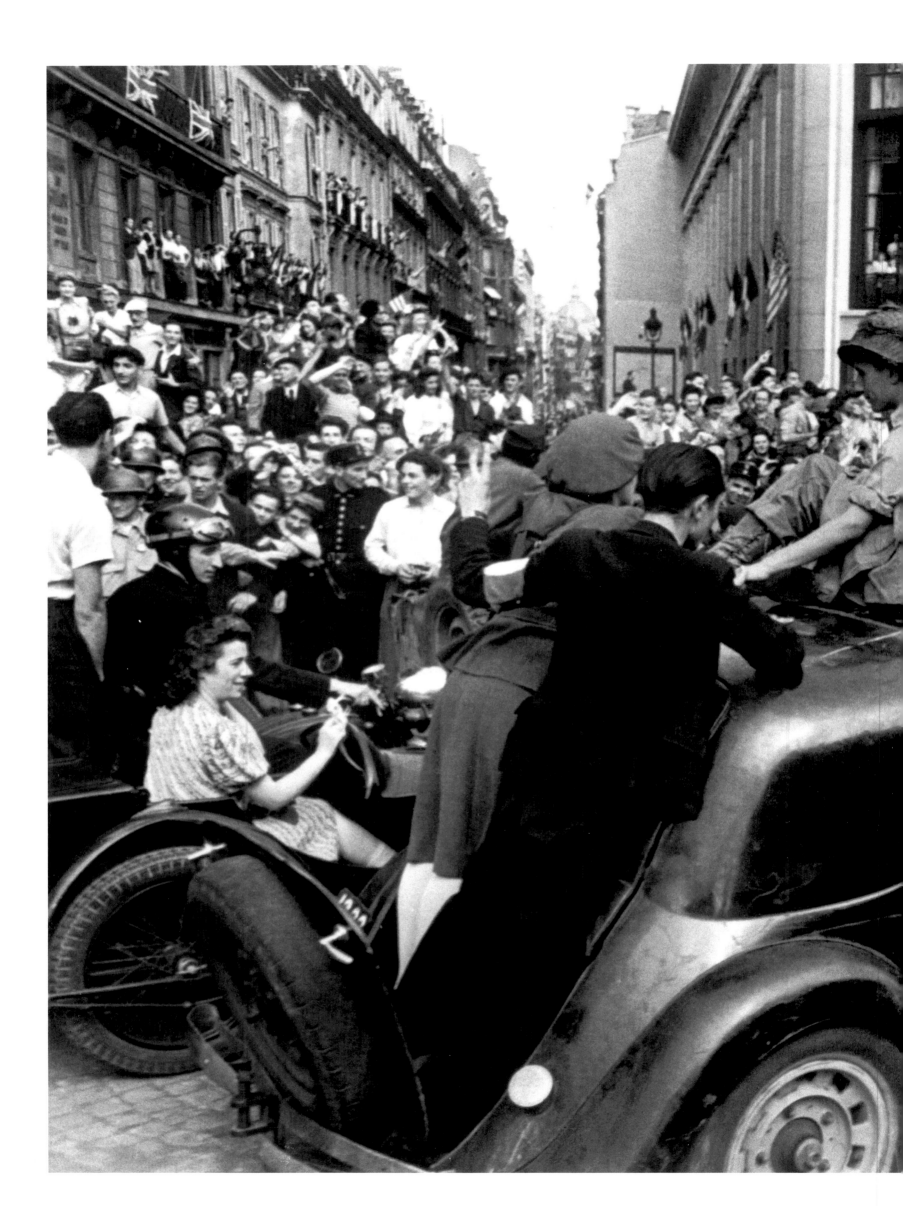

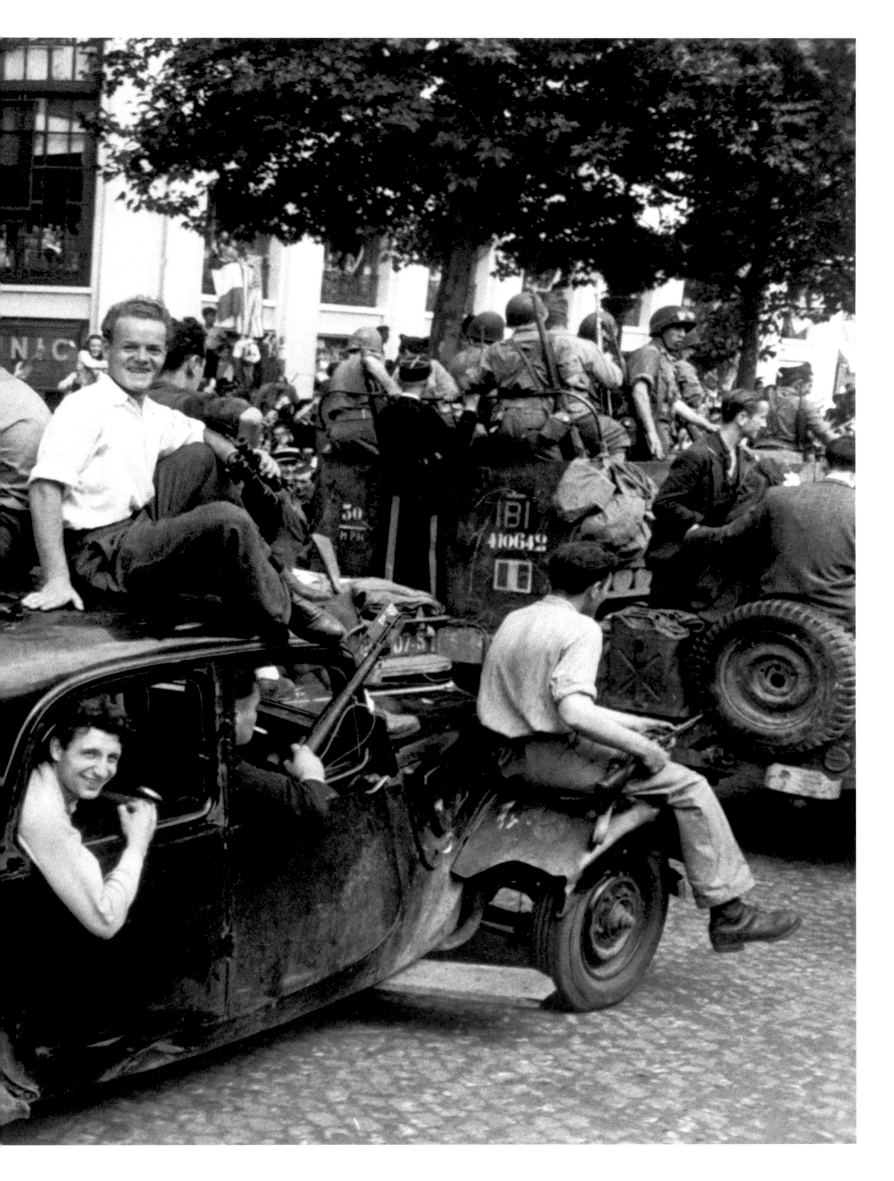

The Liberation of France, Paris, August 26, 1944
Allied troops march down the Champs-Élysées and celebrate with the troops
of the Resistance and the French army.
 Capa wrote in his diary: "The road to Paris was open, and every Parisian was
out in the street to touch the first tank, to kiss the first man, to sing and cry.
Never were there so many who were so happy so early in the morning. I felt that
this entry into Paris had been made especially for me."

"THE WAR IS AN ACTRESS WHO IS GETTING OLD. IT IS LESS AND LESS PHOTOGENIC AND MORE AND MORE DANGEROUS."

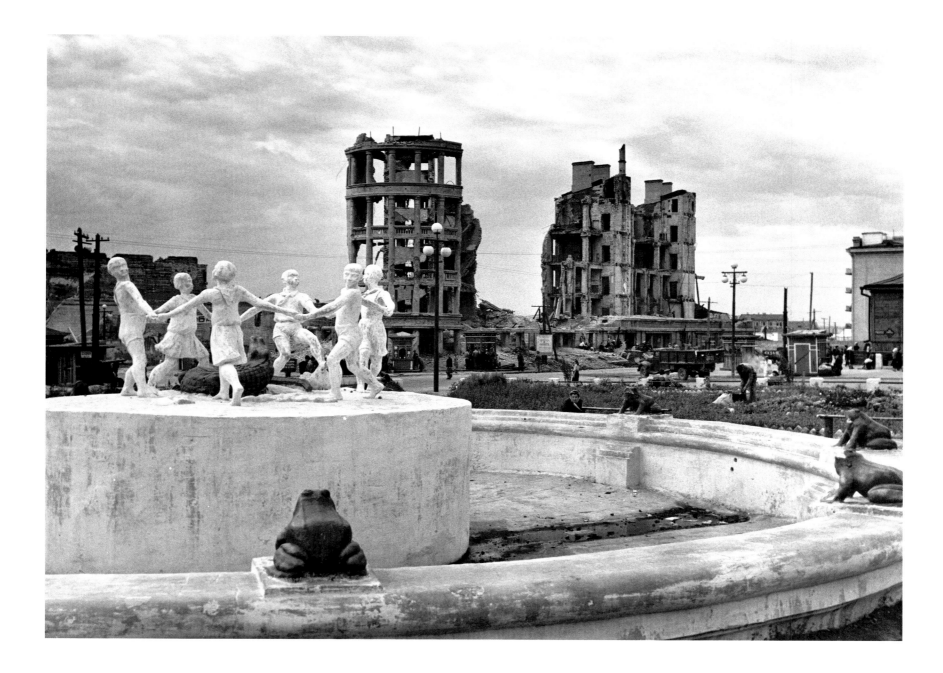

Stalingrad, Russia, 1947
Capa knew John Steinbeck both during and after World War II. In New York, they became great friends. In 1947, they visited the Soviet Union, spending a month together in Moscow. What interested them the most was visiting the city of Stalingrad, reduced almost completely to ruins during one of the longest and bloodiest battles of the war.

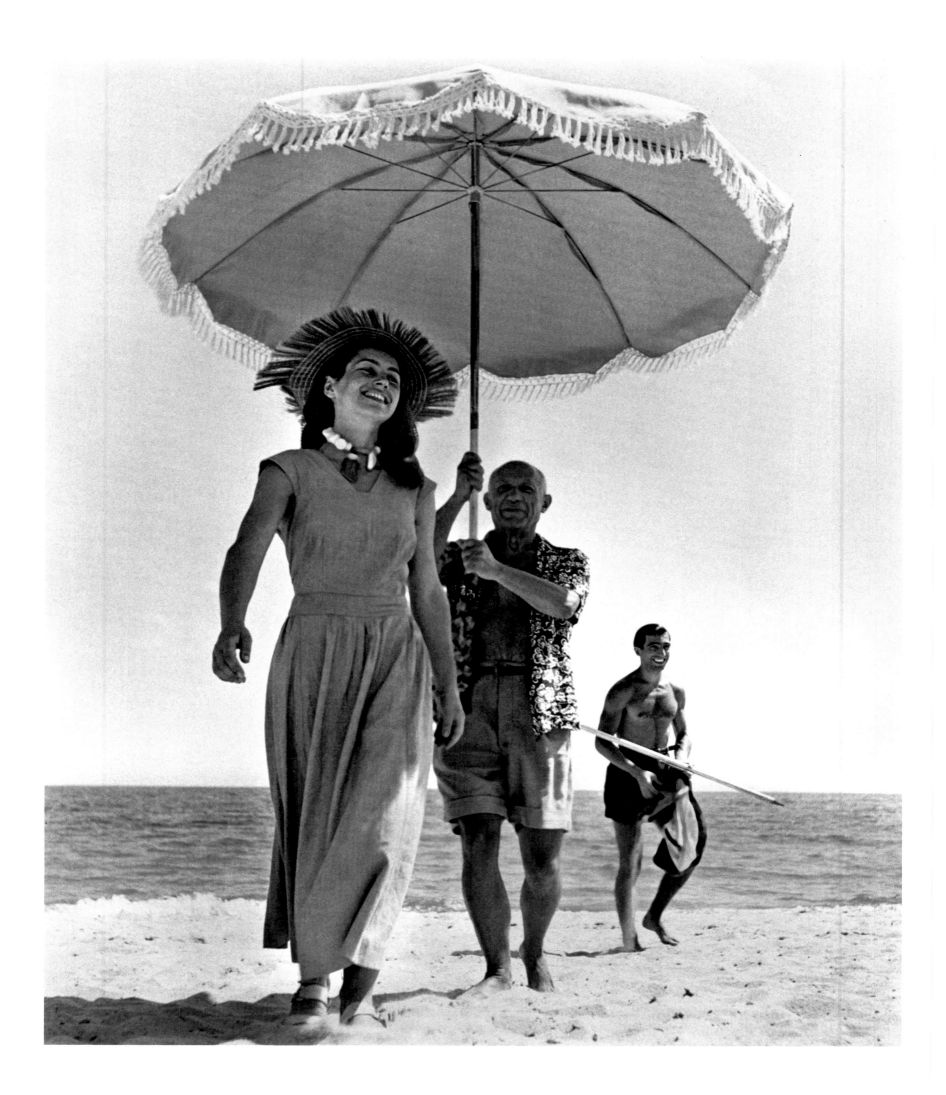

Golfe-Juan, Côte d'Azur, France, 1948
Capa became a friend of Pablo Picasso, whom he visited regularly. In this photo the great painter is with Françoise Gilot. The man in the background is Javier Vilato, Picasso's nephew.

Biarritz, France, 1951
From the end of the 1940s to the beginning of the 1950s, Capa worked on various reportage assignments for the American travel magazine *Holiday*, contributing text as well as photographs. He loved to sign his pieces with a line of which he was particularly proud: "by Robert Capa, with photos by the author."

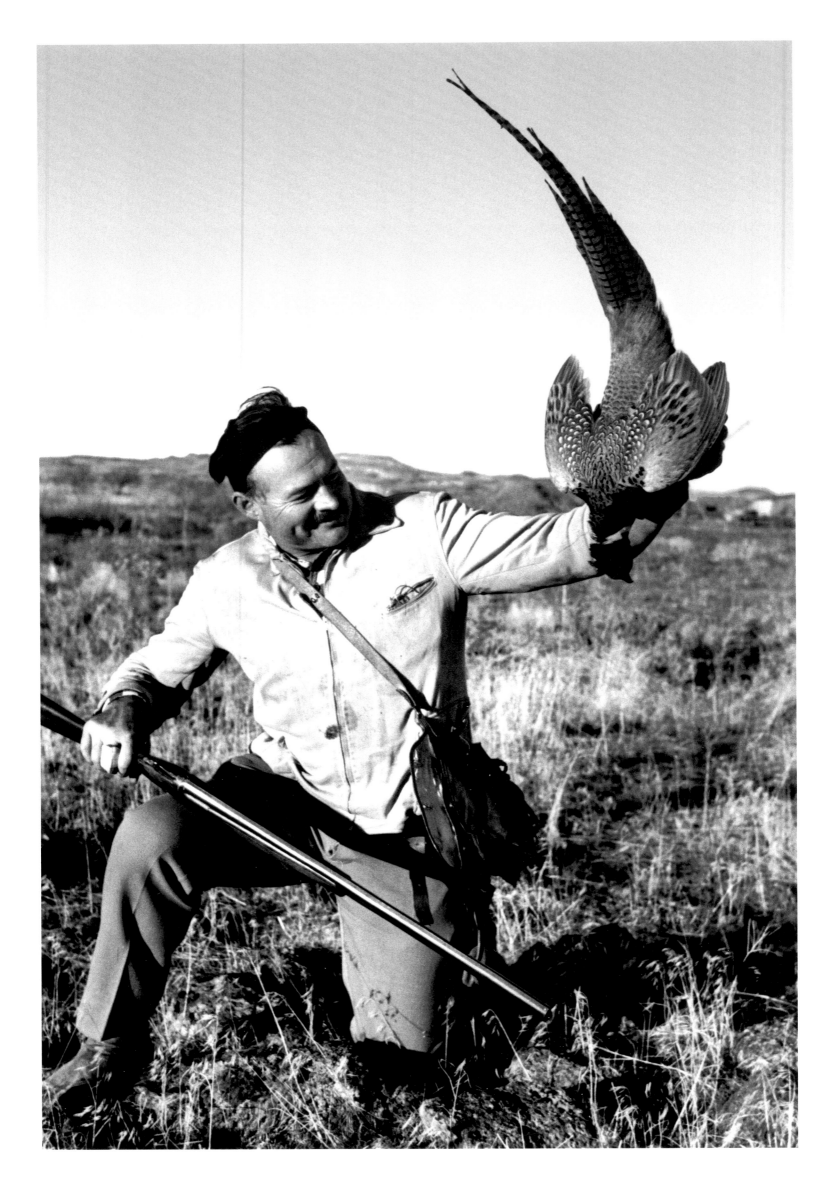

The Writer Ernest Hemingway While Hunting, Sun Valley, Idaho, 1940
Robert Capa and Ernest Hemingway became acquainted in Madrid during the Spanish Civil War. Many parts of the famous novel *For Whom The Bell Tolls* are taken from the stories that Capa told Hemingway about the resistance in Segovia. The book later became a film starring Gary Cooper and Ingrid Bergman.

Endre Friedmann was born in Budapest to Jewish parents on October 22, 1913. An extroverted teenager, independent, and a lover of adventure, he was forced to flee Hungary because of his participation in protests against the extreme right-wing government and his militancy in the local communist party. He studied political science at the Deutsche Hochschule für Politik in Berlin. There he met Simon Guttmann, who founded the Dephot agency and who gave him his first assignments as a photographer. In 1933, due to the menace of the new Nazi regime, he left Germany for France. He sought refuge first in Vienna, and then in Paris, where he met André Kertész, who gave him good advice and took him under his wing. It was in Paris that he met the journalist and photographer Gerda Taro, who would become his companion in life and in work. Together the two invented the fictitious "famous American photographer Robert Capa" and began to sell Endre's prints under that false name. From then on Endre would always be Robert Capa.

Before going to Spain in 1936 to cover the Civil War, he met Pablo Picasso and Ernest Hemingway and forged strong bonds of friendship with David "Chim" Seymour and Henri Cartier-Bresson. After arriving in Spain, together with Taro, he took perhaps his most famous photo: a militiaman at the instant of being shot to death. The image brought him fame on an international level and quickly became a powerful symbol of war. Gerda died in Spain at the early age of twenty-seven, while photographing the retreat from the front after the Battle of Brunete. In 1938 Capa went to China and one year later emigrated to New York. While in the US he had steady work with *Life* magazine, for which he covered World War II. His reportage from various fronts during the war would become part of history, above all the very famous eleven photos that survived the Normandy landing, taken according to his motto, "If your pictures aren't good enough, you're not close enough."

After the war and thanks to Ingrid Bergman, Capa received introductions to people in film and for a while he planned to become a director or a screenwriter. In 1947, in New York, he founded the Magnum Photos agency together with Cartier-Bresson, Seymour, and George Rodger. It was the first photographers' cooperative in history. Capa's insight was that if a photographer did not control his own negatives, he was nothing. He dedicated himself body and soul to Magnum, becoming the driving force in the development of what is still the most important and legendary photographic agency in the world. Capa continued to say that he did not want to be a war photographer, but the risk was part of his nature. During the war in Indochina, where he had gone to take the place of a colleague, he stepped on a mine and died, on May 25, 1954. Regarding his friend, John Steinbeck wrote: "Capa knew what to look for and what to do with it when he found it. He knew, for example, that you cannot photograph war, because it is largely an emotion. But he did photograph that emotion by shooting beside it. He could show the horror of a whole people in the face of a child. His camera caught and held emotion. Capa's work is itself the picture of a great heart and an overwhelming compassion."

"IF YOUR PICTURES AREN'T GOOD ENOUGH, YOU'RE NOT CLOSE ENOUGH."

Robert Capa

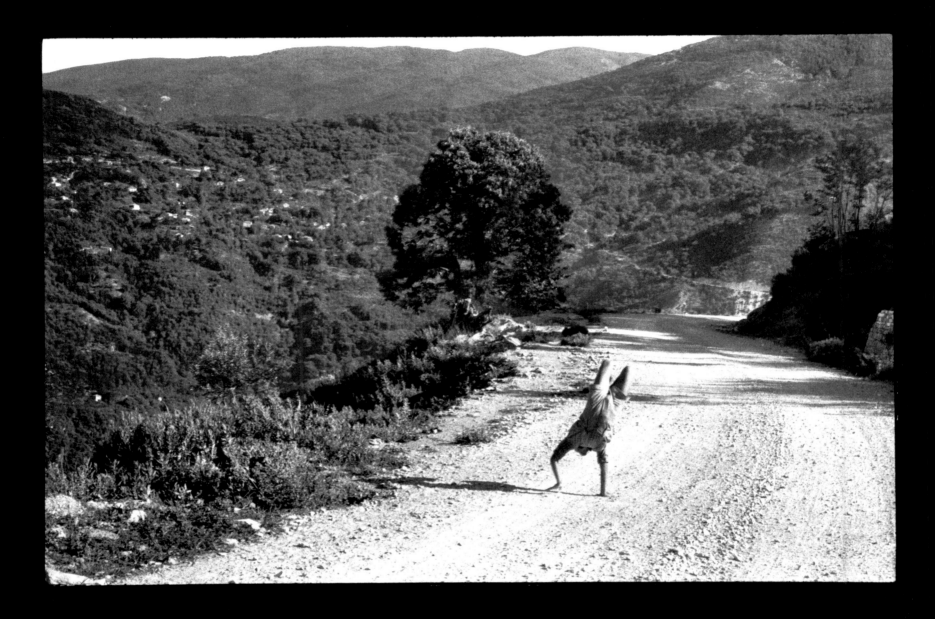

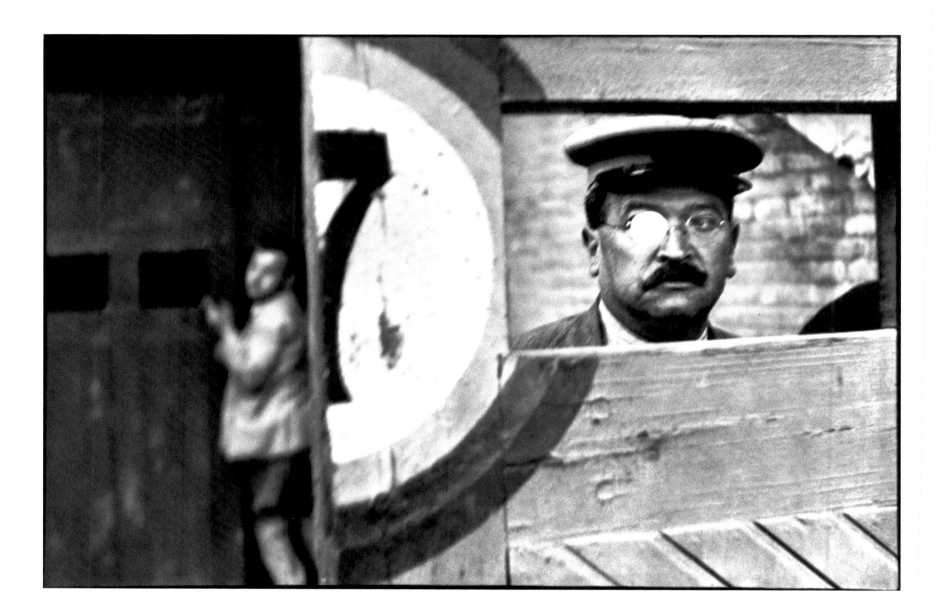

Page 96

Epirus, Greece, 1961

"I walked all day in a heightened state trying to catch photos in the act, like flagrant crimes, in the streets." Cartier-Bresson went in search of the unexpected and the surprising, knowing that by paying constant attention he would find the perfect opportunity. In this image, the unexpected blends harmoniously, and the flash of redeeming joy illuminates the landscape.

Above

Arena of Valencia, Spain, 1933

"To see does not mean to cause to see. Every photograph of Henri Cartier-Bresson proves this axiom. For him photography is geometry, in space and in the moment, placed at the service of the expression of a fact. A difficult school. A steady ascent. Required intuition. Rapidity of execution. The result is obvious." This comment by Robert Delpire, a publisher and commanding figure in the world of French photography, and a close friend of Cartier-Bresson, appeared in the book *Immagini e parole*, an affectionate and sensitive collection of his most famous photographs accompanied by comments from eminent "friends" of the great photographer. Some of those authoritative comments appear in the following pages.

HENRI CARTIER-BRESSON

"The first time that I met Henri Cartier-Bresson, I was struck by the gaze of his blue eyes, transparent and faraway, that would move about, weightless, alighting on everything around him, without favoring one thing over another, but always on the alert. Without doubt, it was thanks to this constant willingness to look and to see that there was a certain complicity, or connection, between him and the world, a conspiracy almost, whose driving force was metaphysical."

These are the words with which Jean Clair, the former director of the Musée Picasso in Paris, recalled his long-time friend Cartier-Bresson and his first encounter with what has many times been called "the eye of the century," the visual testimony of an era just passed.

Cartier-Bresson's biographers describe a man born in France at the beginning of the twentieth century into a wealthy industrial family that manufactured textiles. Even today, some collectors have preserved spools of thread from the Cartier-Bresson factory as precious relics. Cartier-Bresson had a rebellious nature. He was intolerant of authority and any constraint, irritated by the demands of an oppressive schooling, and did not wish to enter the family business. He wanted to be the one to decide his future and his identity as artist or non-artist: thus, as a result, his apprenticeship as a painter, the extended travels for character-building and adventure, and, finally, his discovery of a small camera, the Leica, along with the incredible virtuosity that made it possible to grasp reality in geometrically perfect moments.

The exegetes who seek to explain his photography, the impassioned lovers of his art-without-artifice reconstruct his journey on a road studded with extraordinary encounters—the surrealists of Paris; those whom he met in Mexico, such as the photographer Manuel Álvarez Bravo and the director Luis Buñuel; and an attraction to the cinema, alongside a master such as Jean Renoir. And then his definitive consecration as a photographer, together with his "fellow travelers" Robert Capa, Chim Seymour, and George Rodger, at the head of that miracle of autonomy and collaboration, Magnum Photos, the first photo agency co-operative ever established.

The years spent painting were formative for his artistic eye, training it to recognize life's visual and formal equilibriums within a series of unique and precious moments, but it was his agency work and his contact with photojournalists—especially Capa—that made him what he was: certainly not the last disciple of surrealist photography, but one of the first who strove to interpret reality and create a narrative of the world, a chronicle of an event that would not become a sketch, a portrait of a person that would not become a caricature.

His friends, scattered across five continents, remember his clear gaze, agile body, and the delicate ballet that he would improvise with his Leica whenever he had to take a photo. He was not always of an easygoing disposition, and his thinking was profoundly anarchic, to the point that he was fundamentally allergic to any form of academic bombast or pompous ceremony. And, above all, they remember his frank and straightforward way of speaking and the lessons about life that he could impart with just a glance, a nod, or a smile.

His legacy of images, left to us in 2004, when he died quietly, without any fanfare, at his country house on an August day, seems an inexhaustible mine of faces, forms, and, above all, meanings. The sense of what we are and what we have experienced has never been summed up so well as in his photos, far removed from scenes of war and the urgency of current affairs.

The miraculous moments, those instants in which, as he said, the eye, the mind, and the heart seem to align themselves along the same line of sight, and for the clever photographer there is nothing to do but to shoot and capture, in this way, a decisive moment. They are, at the same time, a metaphor and a record of what has been seen, of what exists. This is the power of Cartier-Bresson and his heritage.

As Jean Clair observed, "There are multiple syntheses at work, not only between the gaze, the spirit, and the hand, but also between these and the parts of the camera. And the darkroom itself, just like daylight, is also lit by the faint light of that clear and lucid room which is the eye."

Hyères, France, 1932

A boy on a bicycle hurries along the streets of the French town of Hyères, seen from the top of a staircase. Nothing could be simpler in this photograph. Yet nothing is more formally and visually complex, balanced, and perfect.

When Cartier-Bresson discovered photography in the early 1930s, he already had a "past," albeit brief, as a painter with a connection to the writers of surrealism and their themes.

Its flexibility, simplicity, and ease of use won him over, together with the joy of running around the world, capturing, with his lens, unique and unrepeatable moments in which the world seems to want to settle in a perfect totality of forms and density of volumes that reveal an internal equilibrium, an orderliness of vision and at the same time a deep and ecstatic comprehension of reality itself.

Leica in hand, Cartier-Bresson went with his friend the poet André Pieyre de Mandiargues on a trip to France, Spain, and Italy, later venturing as far as Mexico. Cartier-Bresson was young and wanted to wander around Europe and train his eye in the rhythm and tempo of the camera, without any constraints. The images taken on this trip remain a dazzling body of photographic work, a subject of study, and a source of important exhibitions, such as the one organized by the Museum of Modern Art in New York in 2010.

As Peter Galassi, the exhibition's curator, wrote, "From 1932 to 1934... in a white streak of invention, [Henri Cartier-Bresson] proved that a photographer can handle the world as freely as a sculptor handles clay, all the while pretending that he (or she) has touched nothing. A child playing ball before a weather-beaten wall becomes a figure of rapture isolated in the cosmos. A woman squinting in puzzlement at the photographer brings her younger self to life in the defaced poster behind her. Who could have imagined that photography was capable of such alchemy? After the early work of Cartier-Bresson, who could deny it?"

And here was that free manipulation of the world: in the vortex-like vision of a glimpse of Hyères. Everything is movement: the stairs, seen from above, impart a rapid and profound movement that, like a flywheel, pushes the bicycle ever more rapidly and farther away in the almost imperceptible rotary motion of the wheels.

The mad spokes seem to be a transformation, in a dynamic metamorphosis, of the balustrade on the first floor of the staircase. The moment, as the smallest unit of time, is distilled to its essence: an astonishing flash of energy caught in an instant while walking through the streets of a city which the photographer perhaps did not know very well, which he passed through with the vigilant and attentive eye of a visitor, ready to be surprised by every possible visual delight. As if the role of the photographer were to travel the world in search of harmonious and meaningful images that reveal the dynamics and relationships of which even we, at times unwittingly, are a part.

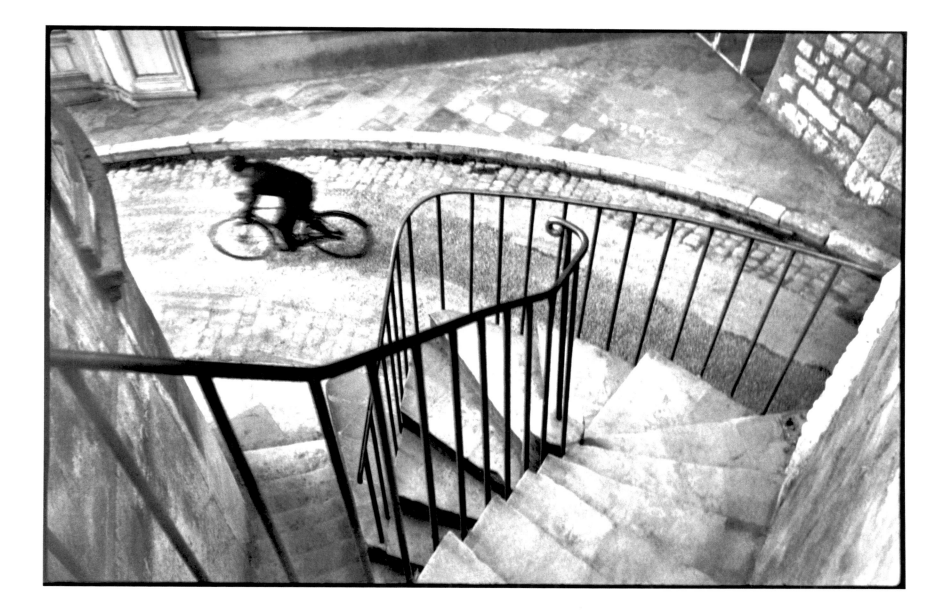

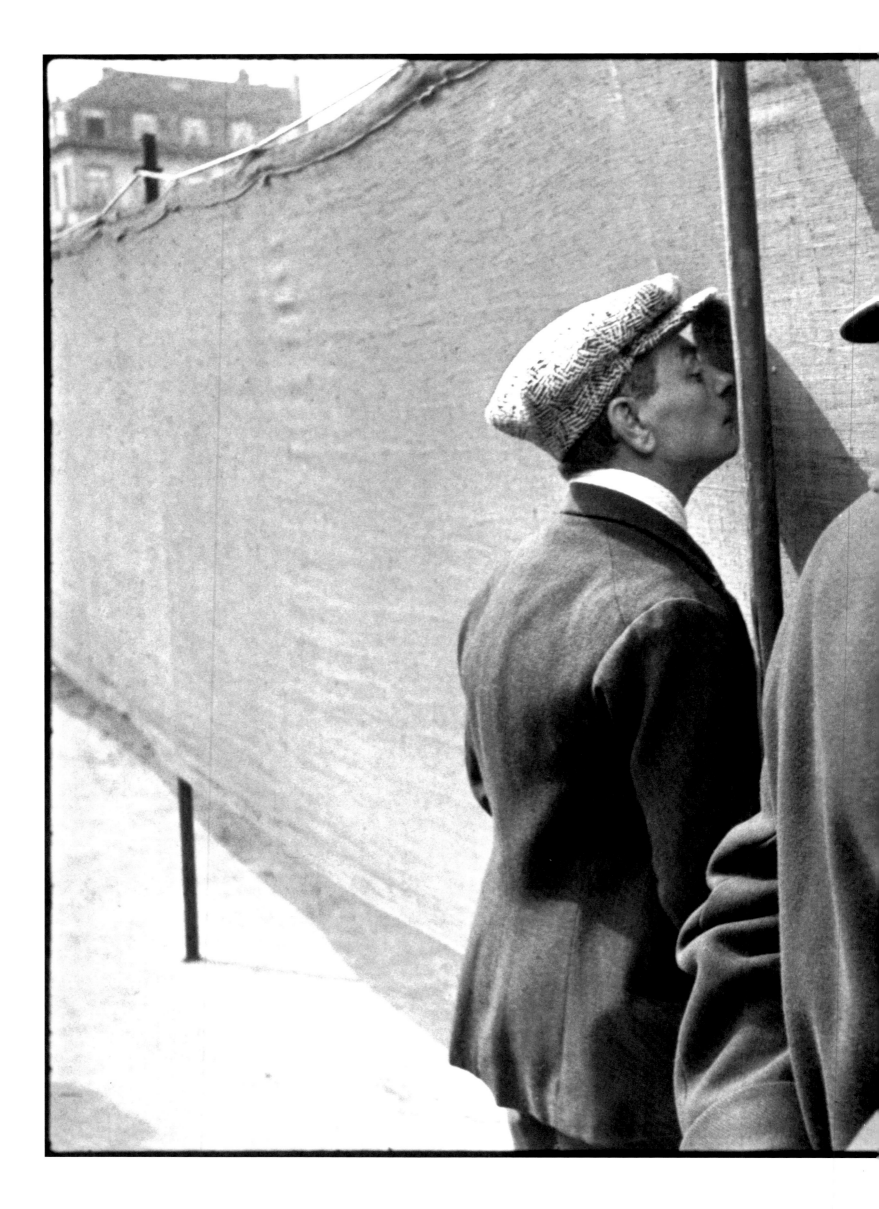

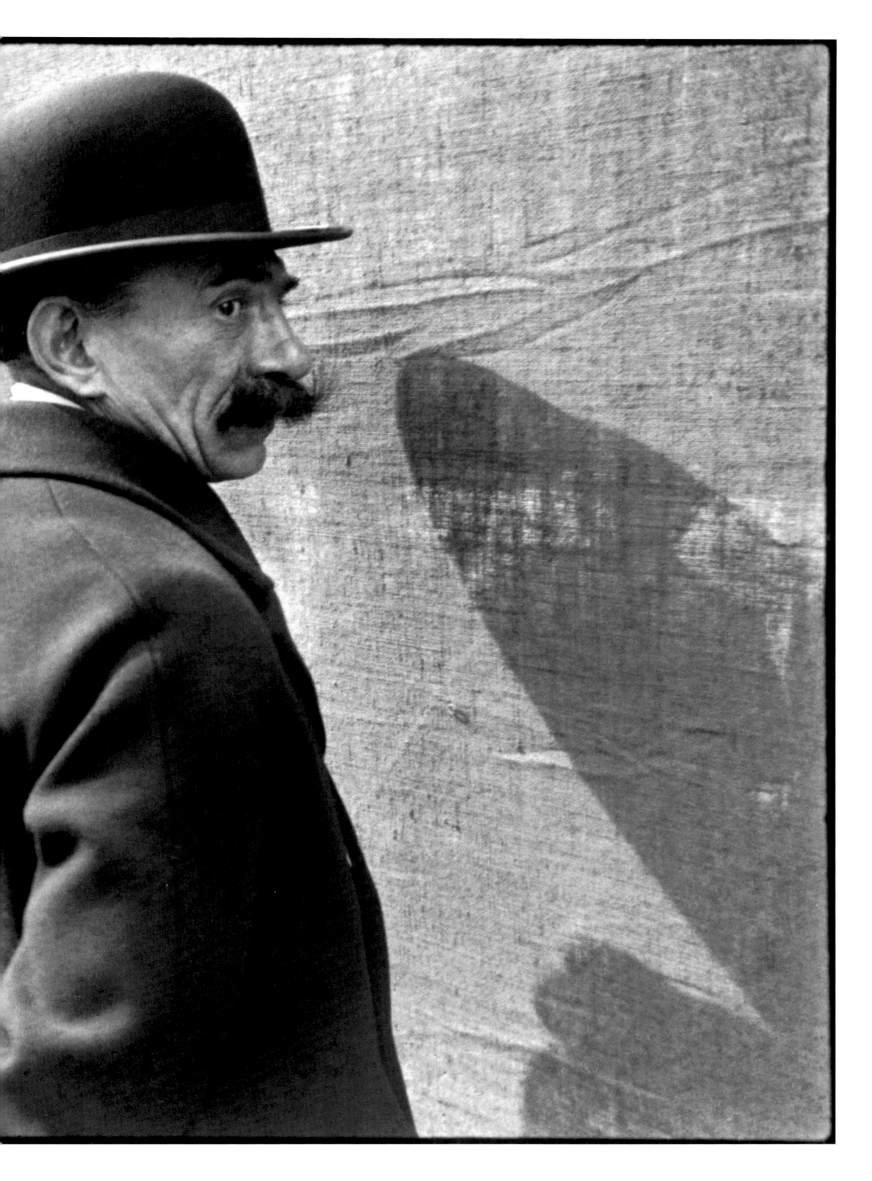

Belgium, 1932

"The photographer has taken two voyeurs by surprise. The one in the background looks through a hole in a cloth strung up on tent poles, at an unknown scene. The other one, who could be, and why not, Hercule Poirot, turns to look at the lens. The man in the cap observes reality through a hole, the other looks at the camera. We, looking at the photo, become voyeurs ourselves. Whether we want to or not, we become part of the photo. We are in the photo. We are all in a picture by Henri Cartier-Bresson."

Eduardo Arroyo

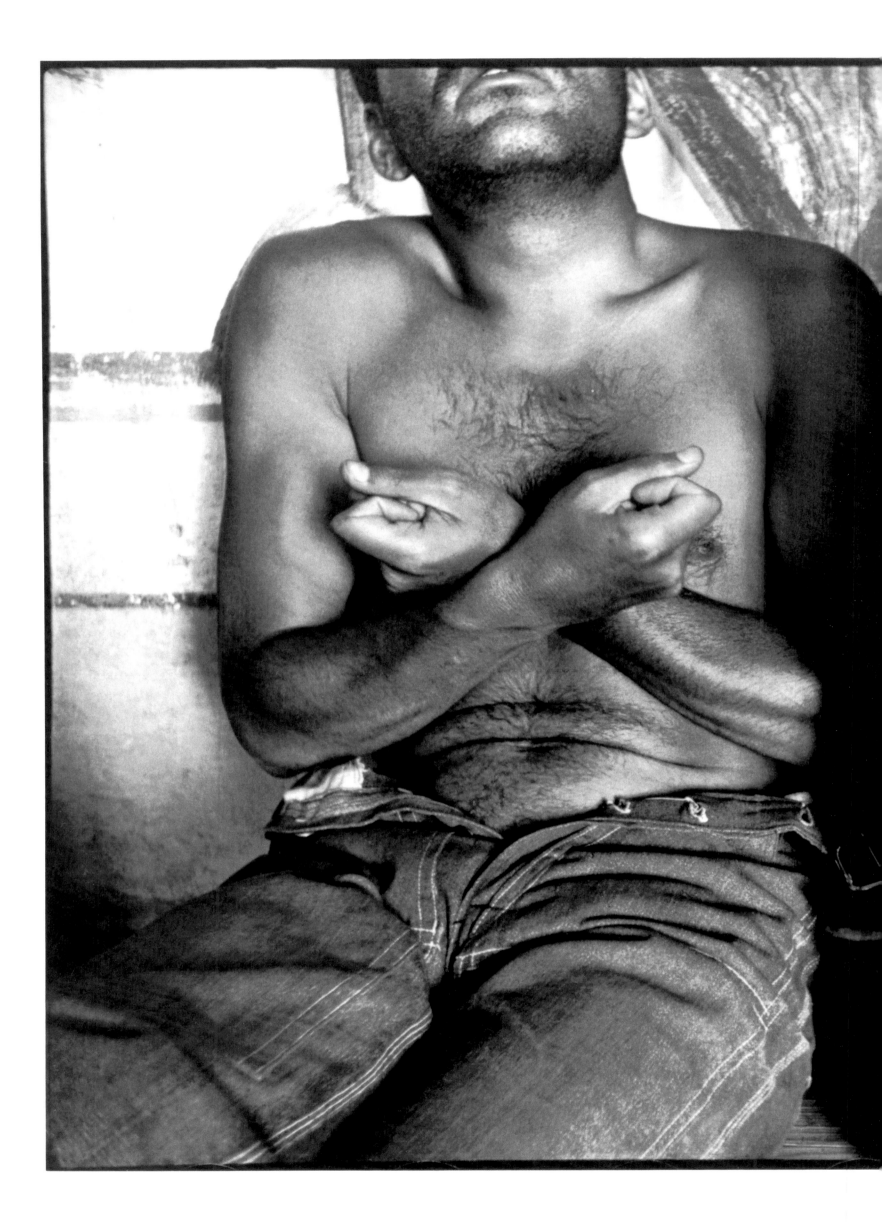

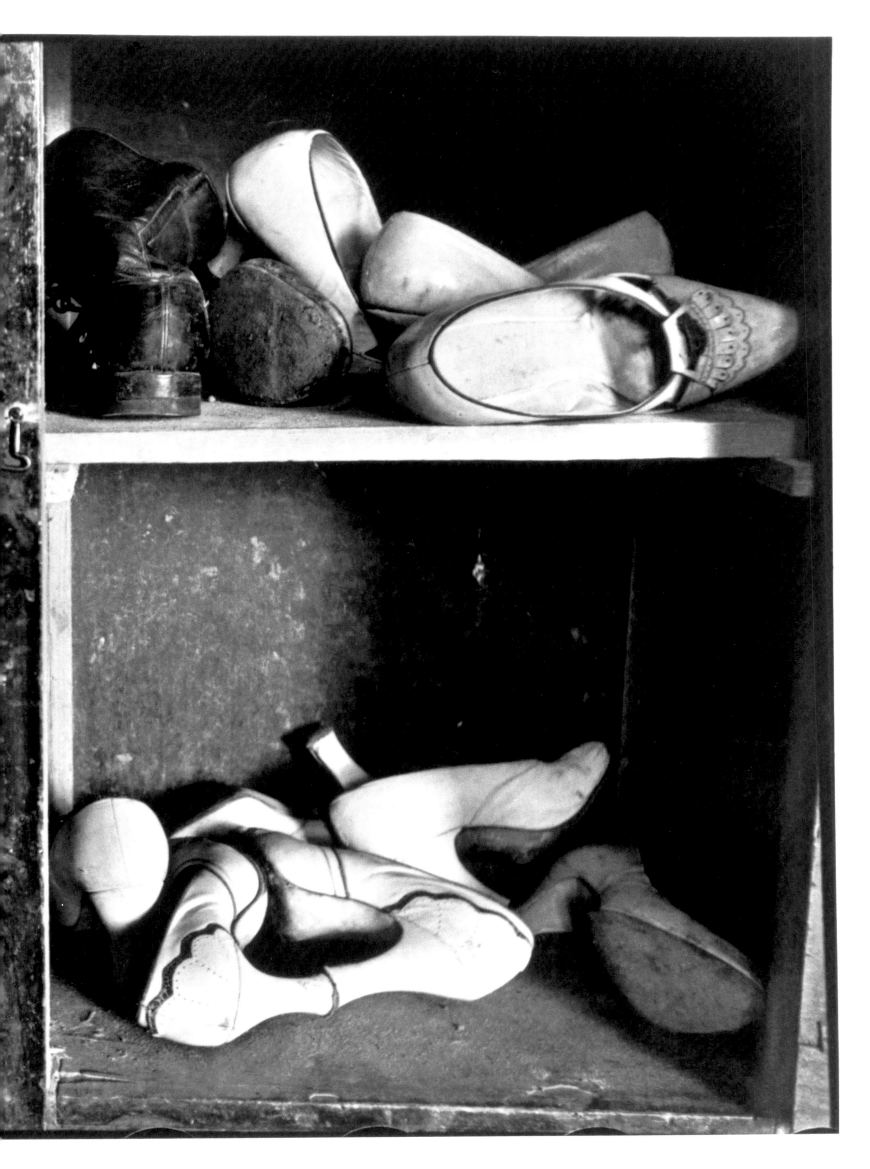

Santa Clara, Mexico, 1934
After his long travels through the countries of southern Europe, including France, Spain, and Italy, Cartier-Bresson arrived in Mexico, home to a surrealism that was earthier and sunnier. Together with the great Mexican photographer Manuel Álvarez Bravo, he would have his first exhibition, in Mexico City. The images from this period would often have the feeling of a transfiguration, ready to be deciphered, with an almost dreamlike reality. The power of this photo lies in the balance between the man's strong and dramatic gesture, of clenching his fists to his chest, and the white shoes, abandoned in what might be a cupboard of memories.

"TIME RUNS AND FLOWS AND ONLY OUR DEATH CAN STOP IT. THE PHOTOGRAPH IS A BLADE THAT CAPTURES ONE DAZZLING INSTANT IN ETERNITY."

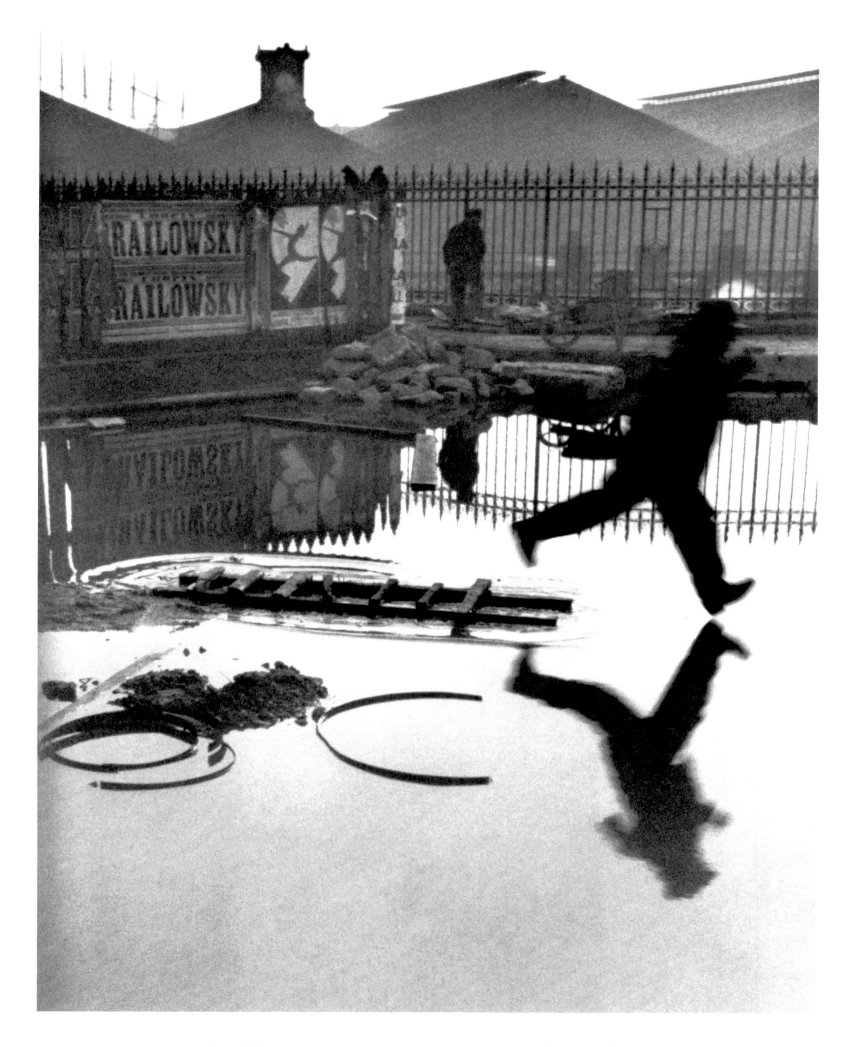

Behind the Gare Saint-Lazare, Paris, 1932
"In the foreground, Raymond Queneau takes a bold leap over the water, his toes never touching the surface. The clock on the warehouse reads twenty past twelve. The battle of the railways will be fought on another day, in another rain shower—although here the ladder already serves as a stretcher and the plank symbolizes rescue. On the deck in the foreground (the base of the photo) ... the rims playfully assume the shape of a monocle or a bracket.... In the poster, the B of "Braïlowsky", like a black button-hole, has been lost. As for the letters "sky" at the end ... what if René Magritte had used them to remind us of the word "heaven"? The onlooker in the background has no Leica in his pocket, no discreet pencil or brush. With a heavy heart, he listens to the throb of the steam engines and observes another scene in which he no longer sees himself."

Pierre Alechinsky

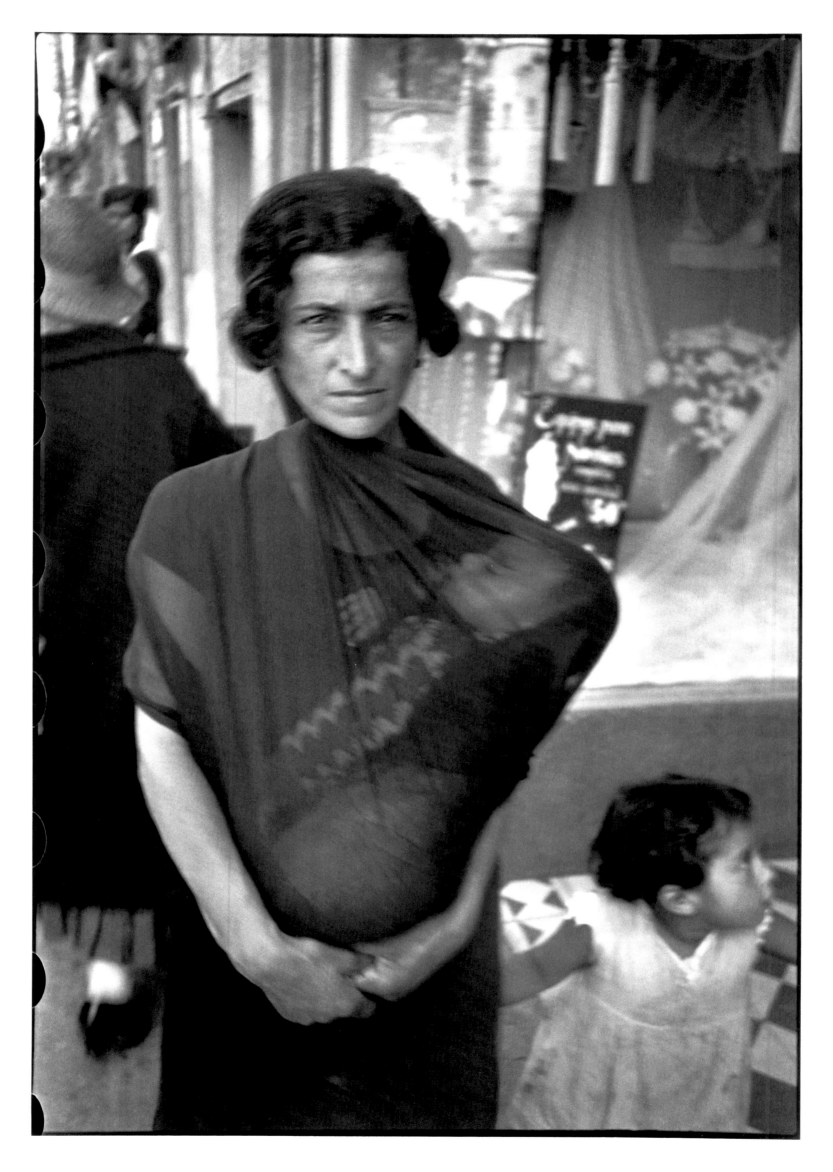

Mexico City, 1934

"If there are many things that I owe to Henri Cartier-Bresson, there is one for which I am especially grateful: the fact that he was totally immune to sentimentalism and the picturesque.

Look at this photo: you see a woman and in her arms a sleeping child wrapped in a veil. It is a risky subject. But how different from the centuries-old iconographic tradition of "mother and child", with its sugary sentimentalism. This mother does not give up her own proud individuality as a woman. To me, the veil, above all, protects the baby, and us, from the blackmail of rhetoric."

Ferdinando Scianna

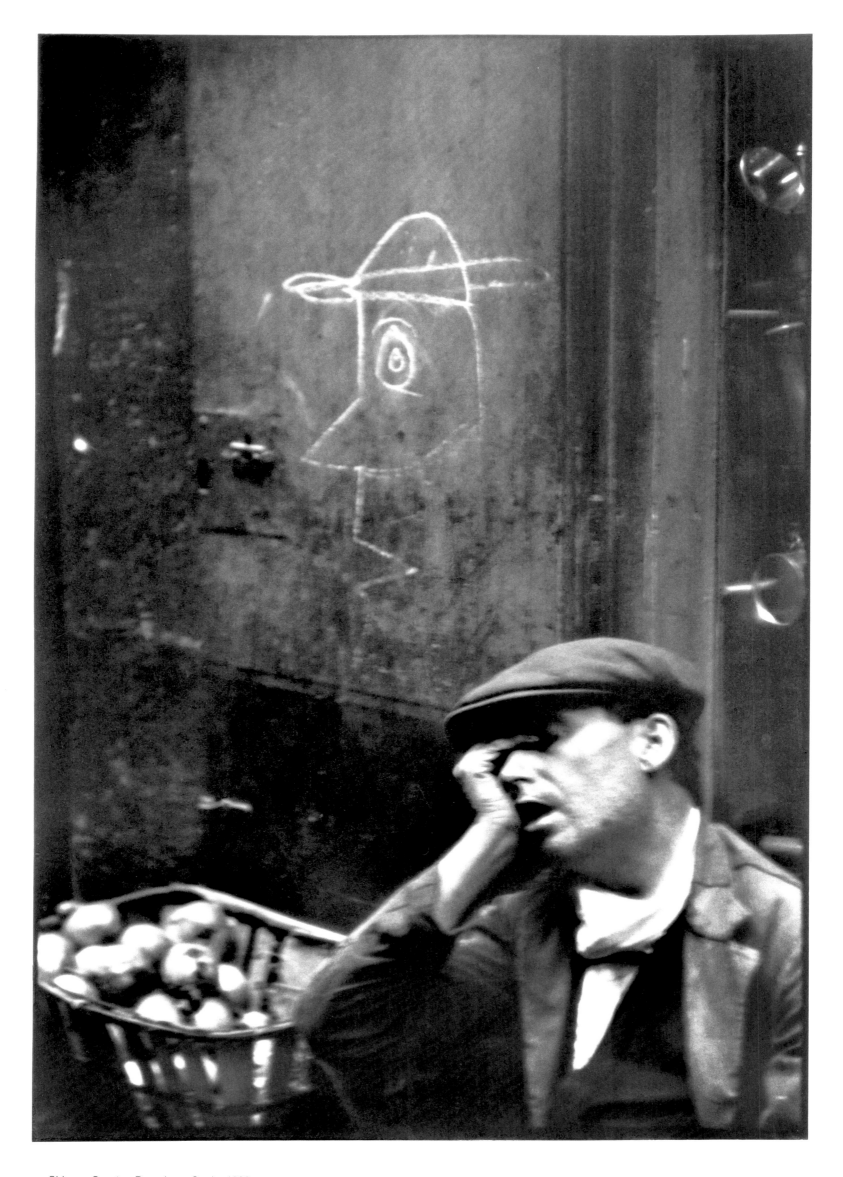

Chinese Quarter, Barcelona, Spain, 1933
In the early 1930s, Spain was dense with images and strong flavors. The preferred "hunting grounds" were the most popular and populated, such as the Chinese Quarter of Barcelona, where Cartier-Bresson succeeded in capturing a reality that could restore its dreamlike aspects and references. A man abandons himself (perhaps due to exhaustion) to the ecstasy of sleep, and while he sleeps, his dream seems to sketch his portrait on the wall.

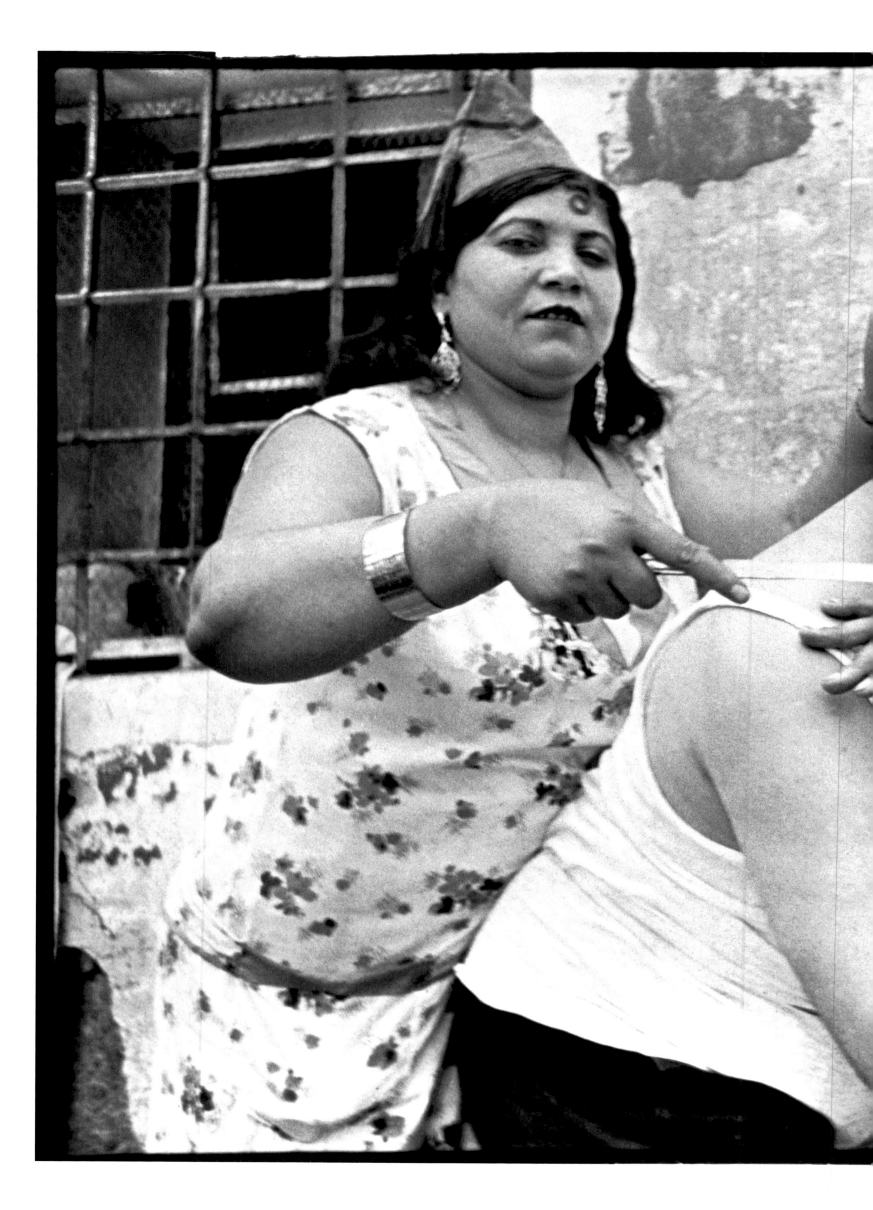

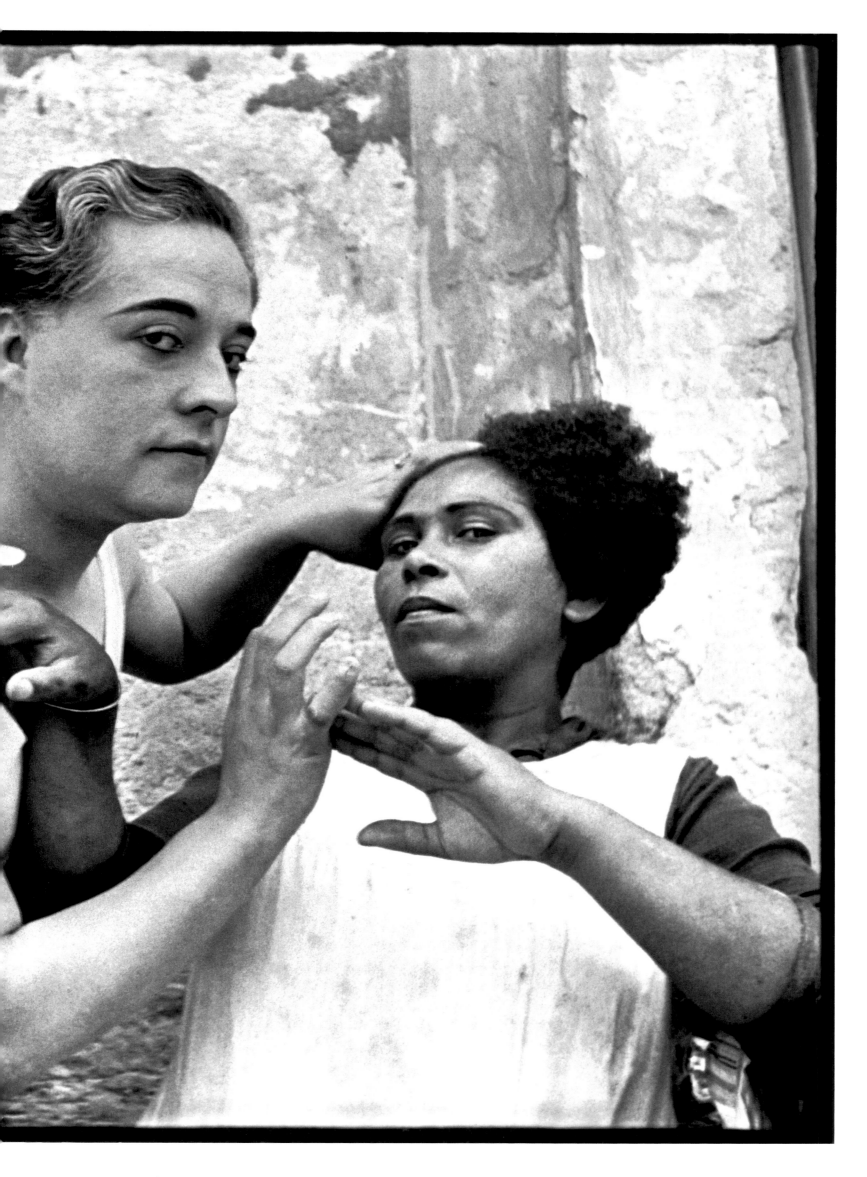

Alicante, Spain, 1932

In the rooms of a bordello in Alicante, Spain, there is a simple, spontaneous, and magic ballet of hands and glances. An encounter that has in it something of a minuet, the ancient commedia dell'arte theater, and the ambiguous. It lives on in the absolute perfection of the crossing of arms and eyes of these three characters.

"TO TAKE A PHOTOGRAPH IS TO HOLD ONE'S BREATH WHEN ALL OUR FACULTIES CONVERGE IN ORDER TO CATCH A TRANSIENT REALITY. THAT IS WHEN THE CAPTURE OF AN IMAGE BECOMES A GREAT JOY, PHYSICALLY AND INTELLECTUALLY."

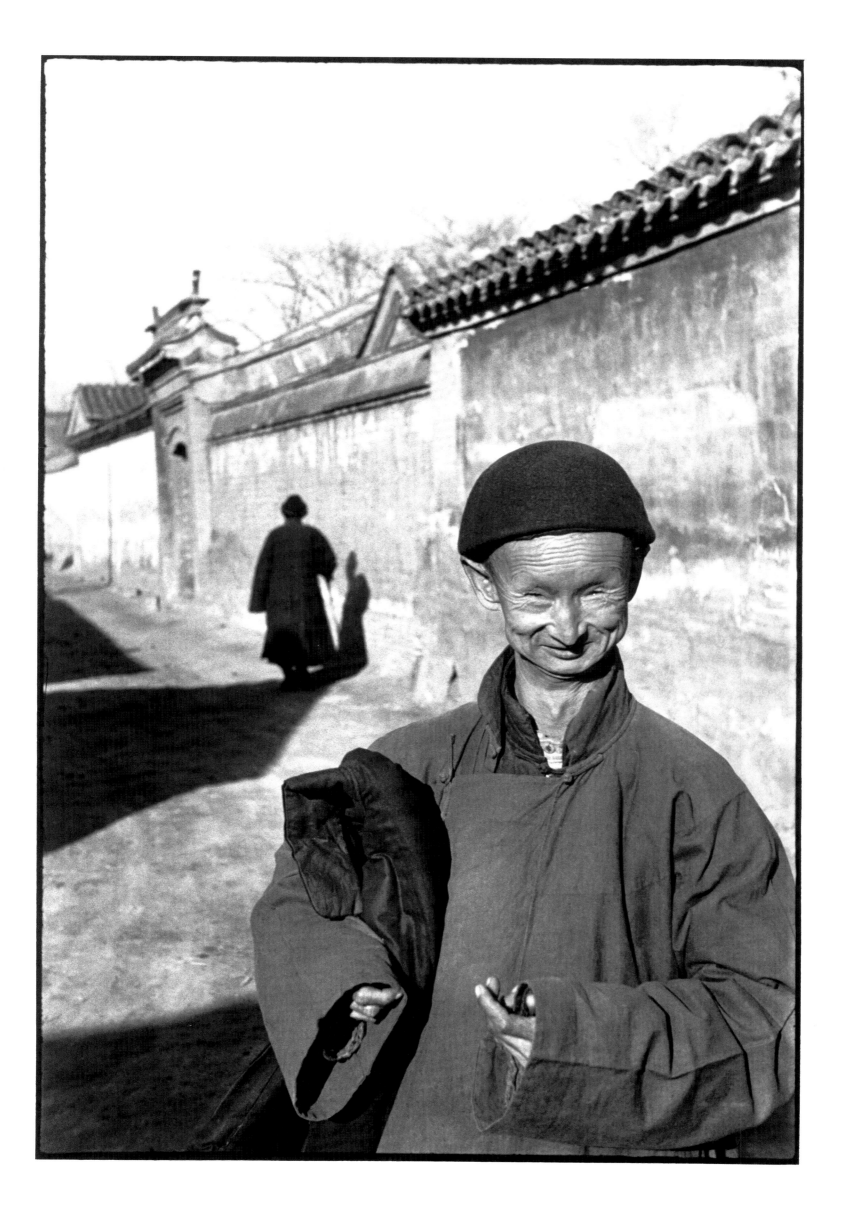

A Eunuch at the Imperial Court of the Last Dynasty, Peking, China, 1949
"This small eunuch was a witness to the last Emperor. His eyes are astonished by the Light which had been extinguished, blown out by men's anger against their Walls.... Cartier-Bresson met him in the street, the anonymous passing the unnameable. This is the history of sight: the constant awakening of sleepers, always surprised by words of struggle and rebellion. Nothing is seen but destruction. Construction is invisible."

Alain Jouffroy

On the Banks of the Marne, France, 1938
In this photograph of a group of workers on vacation, during the first paid holiday in the history of France, Cartier-Bresson's visual recollection plays a game of subtle quotation, recalling Jean Renoir and his 1936 film *A Day in the Country*, on which Cartier-Bresson worked as an assistant. There is the same composition, the same apparently idyllic scene, the same possibility of dressing, in lower middle-class clothing, the descendants of the figures in Manet's great painting *Déjeuner sur l'herbe* (Luncheon on the Grass), which a long line of great French painters had left as a legacy to new interpreters of the vision.

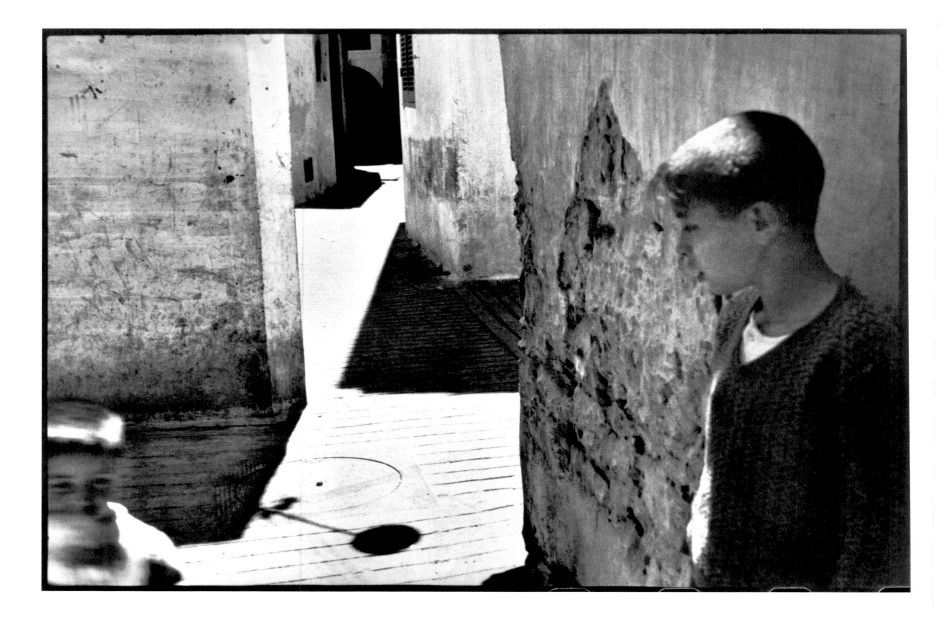

Seville, 1933
"There exists, in this frozen moment, an exact perceptible correspondence
between mass, values, planes, and lines, a kind of musicality, that one
imagines was meticulously worked out. But the opposite is true. In the daily
play of light and chance, it comes from the sudden intuition of the predator.
Cartier-Bresson is the quicksilver of awareness."

Robert Delpire

Henri Cartier-Bresson was born in 1908 in Chanteloup, France, to a bourgeois family originally from Normandy. His mother was a descendant of Charlotte Corday. At the age of fifteen he developed a passion for painting and began to frequent the studios of André Lhote and the surrealists. After a stay in the Ivory Coast that lasted a year and that forced him to return home while still in the grip of a dangerous tropical fever, he purchased his first Leica and began to take pictures. The image that revealed the power of photography to him was a photo by the Hungarian Martin Munkácsi of three black boys running in silhouette toward the banks of Lake Tanganyika. "Can one really produce this with a camera?" Cartier-Bresson asked himself, at little more than twenty years of age. He then left with some friends for Italy, France, and Spain, a trip that would remain one of the most important episodes in his artistic life.

Images irreproachable in their form, full of Mediterranean atmosphere, without sentimentalism: photos in black and white which capture the "decisive moment" that is so central to his photographic production. This is the famous term that would give its name to his legendary book, *The Decisive Moment,* published in New York in 1952 and earlier in French with the title *Images à la sauvette*. That book, produced by the French publisher Tériade, with a cover by Matisse, is now virtually unobtainable. Cartier-Bresson's formulation would in the years that followed become a theoretical touchstone for many, be they photographers or not.

After a period spent in the United States—where he became friends with Paul Strand and often went to see Edward Steichen—and in Mexico, Cartier-Bresson got involved in film and became an assistant to Jean Renoir. After war broke out he was taken prisoner by the Germans. He escaped on his third attempt and joined the French Resistance. For Cartier-Bresson, the end of the war, of which he photographed, among other things, the liberation of Paris, side by side with George Rodger, was a turning point: he no longer wanted to return to drawing or painting. Events were there, they were unfolding in front of his eyes all over the world, and the camera demanded that they be recorded. In 1946, the Museum of Modern Art in New York, believing that Cartier-Bresson had died during the war, gave him a "posthumous" exhibition.

During these years he met Robert Capa and David "Chim" Seymour. With those two, and George Rodger, in 1947, he founded Magnum Photos, the most important photo agency in the world. "We are a group of adventurers driven by ethics," Cartier-Bresson used to say, and especially during the early years the agency developed in an irrepressible way, thanks to the spirit of initiative displayed by Capa and by the great and various personalities that were its members. The agency was based on the principle that the photographer, if he did not own his own negatives, was nothing. On assignment for Magnum, Cartier-Bresson traveled to India, China, Burma, Indonesia, and Japan, followed by Europe, the US, and Mexico. The world was divided up in a very simple way: Rodger had Africa; Cartier-Bresson had Asia, Seymour had Europe, and Capa, besides covering the US, would take himself wherever news was breaking.

During the last twenty years of his life, Cartier-Bresson, who died in 2004, dedicated himself exclusively to drawing. Painting had always been—as he loved to repeat—his great love. His dynamism and the Zen philosophy which he had adopted made him declare, "The great passion is shooting photographs, *which is accelerated drawing,* a matter of intuition and recognition of a formal order, fruit of my visits to museums and art galleries, reading and an appetite for the world." His photos are therefore instantaneous drawings, and drawing, when well done, is a question of aims and speed.

"TO TAKE PHOTOGRAPHS MEANS TO RECOGNIZE—SIMULTANEOUSLY AND WITHIN A FRACTION OF A SECOND—BOTH THE FACT ITSELF AND THE RIGOROUS ORGANIZATION OF VISUALLY PERCEIVED FORMS THAT GIVE IT MEANING. IT IS PUTTING ONE'S HEAD, ONE'S EYE, AND ONE'S HEART ON THE SAME AXIS."

Henri Cartier-Bresson

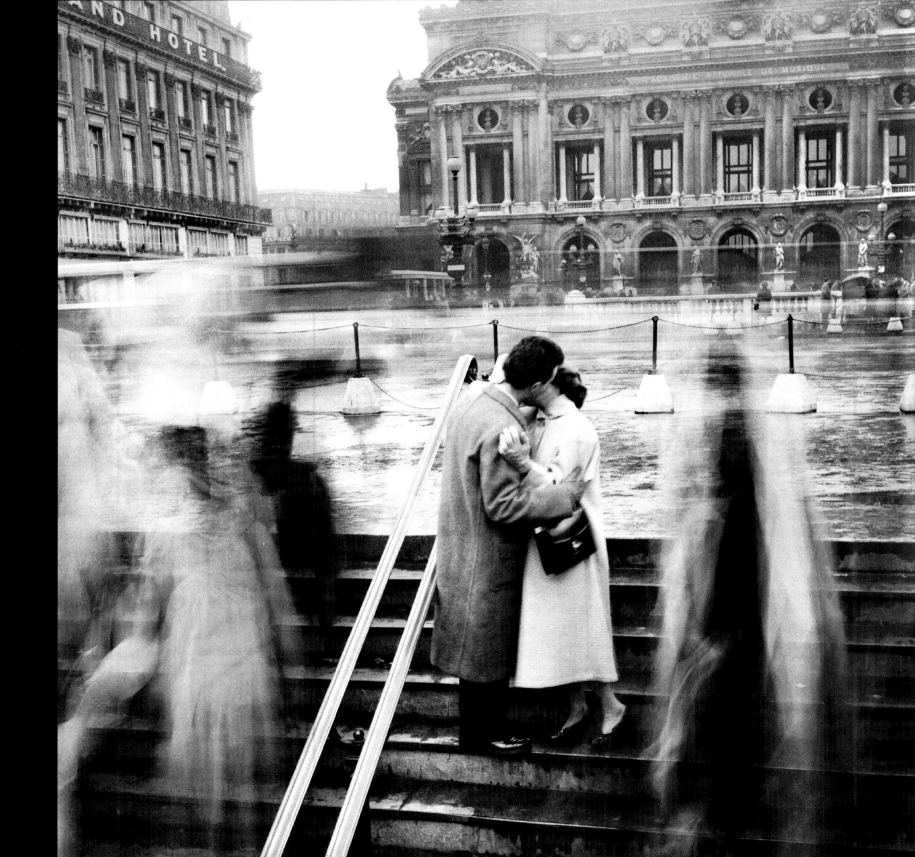

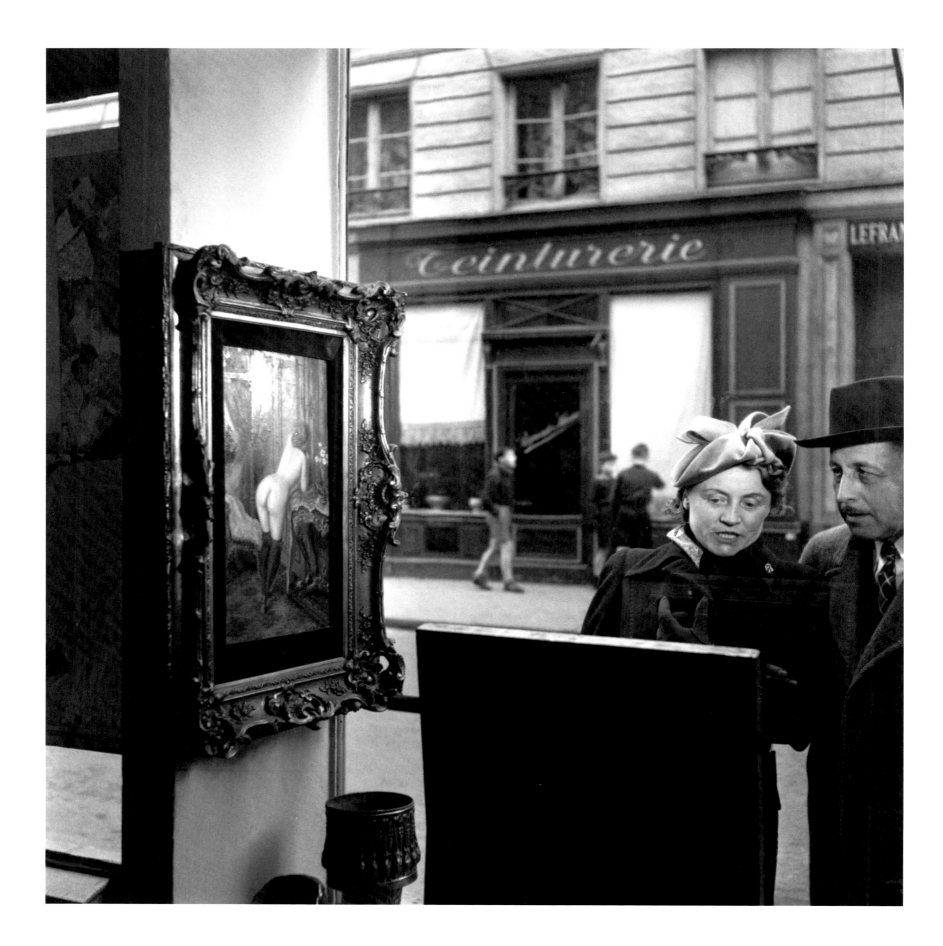

Page 118
Kiss at the Opéra, Paris, 1950
"The marvels of daily life are exciting; no movie director can arrange the unexpected things you find in the street."

Above
Romi Gallery, Paris, 1948
"Everyday gestures, like those seen on the street, bore me. For me, there must be a minimal intent, something really subjective, a hint of deceit." And such "deceit" is also the mise-en-scène Doisneau chose for the window of the Romi antique store. A painting with a mischievous pose was all it took to trigger the amusing reactions of passersby, and Doisneau was there with his camera to capture it all on film.

ROBERT DOISNEAU

Robert Doisneau was a poet of everyday life, and he preferred the subdued, simple, yet sharp qualities of improvised little ditties over the more forceful tone of epic verse.

He was born in 1912 in the suburbs of Paris, and hardly ever left the city. His hunting grounds, the reservoirs from which he drew his images and emotions, and his favorite subjects were all there, among those houses, bistros, and especially the city's many streets. He patrolled every inch, from the center to the periphery, and Paris's boulevards and streets continually told him new stories and gave him new characters to portray— all captured through his gentle gaze and wide-open eyes. The street was the real stage where anything could happen. You just had to wait and watch, or give fate a hand in shaping the scene as a stand-up comedian, an extra, or maybe a singer came out from behind the curtains to center stage, or a dancer slid into the foreground like the entr'acte of a Molière comedy.

The most important thing was that the scene be effervescent, unexpected, capable of hinting at an emotion, a pun, a play on words (albeit never vulgar ones), inspiring a wink or a chuckle. "I strolled the sidewalks and the streets of Paris for years, winding back and forth through the city, going in all directions, for half a century. Ultimately, such exercise is not physically demanding, and luckily Paris is not Los Angeles, so pedestrians are not looked at as if they are crazy or homeless."

Doisneau shied away from the idea of history with a capital H—wars, tragedies, bloodshed, and their major players—to focus on the small realities of everyday life where he felt most comfortable, a Parisian amongst Parisians. He spoke condescendingly of his photojournalist colleagues who followed all the latest news and were drawn to exotic, distant places, going off in search of some dramatization of the tragedies Doisneau so deeply abhorred. He once said that palm trees should hold no particular charm, because sycamores could be just as stunning. To those who accused him of taking facile, trivial photos, he responded by criticizing the "trivialization of violence" that fans the unhealthy flames of facile sentimentality.

He had a deep, visceral love for his work because of the freedom it had given him, the many opportunities, possibilities, and countless chance encounters with which it had filled his life: "Tell me what other profession would have brought me to so many places: into the lions' cage at the Vincennes zoo; into Picasso's studio; down coal mines and up into observatories; into Professor Leibovici's lab as he cut open an abdomen; into Louis de Broglie's office as he contemplated a blackboard covered in hieroglyphics. What other job would have let me wake up one morning in Provence amid shepherds leading their flocks on their seasonal migrations? Be in the kitchen where Blaise Cendrars wrote *The Astonished Man*? Walk on a crane above an infernal steel plant? Watch Bertrand Tavernier nibble his nails behind the camera? Attend an opera rehearsal before heading off with Marceau and Melanie to share a good meal and some fine wine on the Bassin de l'Arsénal? I'd never have had so many opportunities to open my eyes in wonderment had I been a department manager or controller of weights and measures."

For Doisneau, Paris was a world, photography a pretext, curiosity the impetus, and lightness a style: no one has made images as memorable as his, photos that invariably strike an intangible balance, the result of a rare and meticulously pursued wisdom.

His work could not be farther from academic. The light he captures is the result of a constant attention to time and memory. His world is populated by passionate lovers kissing amid city traffic, children doing hand stands, innocent schoolchildren, well-trained dogs, and other affectionate beings, all stopped an instant before disappearing, before being swallowed by the passage of time. A moment after the shot, the lovers will stop kissing and maybe even break up, the children will put their feet back on the ground, the students will definitively enter adult life, losing their innocence forever. Not only does Doisneau's Paris no longer exist, maybe it only ever existed for him alone, the only one capable of catching each memory as it took shape.

"The desire to freeze time, to prolong youth is senseless," he often said, and instead of explaining his photographs he quoted phrases his friend Jacques Prévert had tailored just for him as glosses, both premonitions and epitaphs for his flaneur's approach to photography: "The verb *to photograph* is always conjugated in the imperfect tense of the lens."

Kiss at the Hôtel de Ville, Paris, 1950

"I don't know whether I'm modern or not, I've never tried to be a character, and I'm still taking the same photos I did when I was thirty. Maybe they're better from a technical standpoint, but that's only because of the material, that's all. In any case, I don't believe in accidents, vagueness, graininess—all those tricks used to make things look like they were dangerous or difficult."

The most Parisian of all French photographers was always amazed by the beauty and irony of the world around him, his city and its inhabitants. For Doisneau, leaving the house each morning to photograph meant collecting countless unique images captured with grace, lightness, humor, and tenderness. At the end of the day, his knapsack was always full.

This is doubtless his most famous picture, showing a pair of lovers at the Hôtel de Ville kissing in a moment of care-free joy, heedless of the pedestrians and traffic bustling all around them. It was part of a photo essay he created for *Life* magazine about the romantic, impassioned lovers of Paris.

Looking at the image years later, one wonders how he distilled this miracle of freshness and passion into a shot that, although perhaps not exactly "stolen," nevertheless enchants viewers through the skilled composition of the scene, with the main actors in the foreground and the extras in the background, all set before a truly theatrical backdrop.

Doisneau's humor was contagious, and he commented on this picture with a terse understatement: "This young couple was not interested in the fact that the old Hôtel de Ville behind them had burned down in 1871 and was rebuilt by Ballu and Deperthes in 1874."

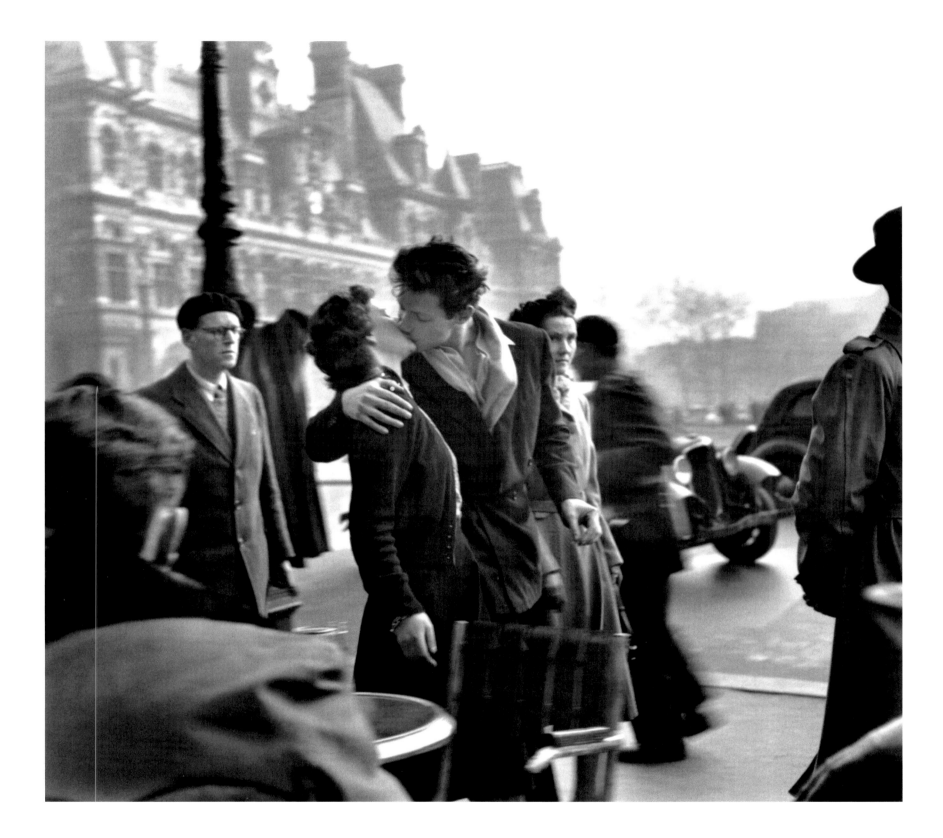

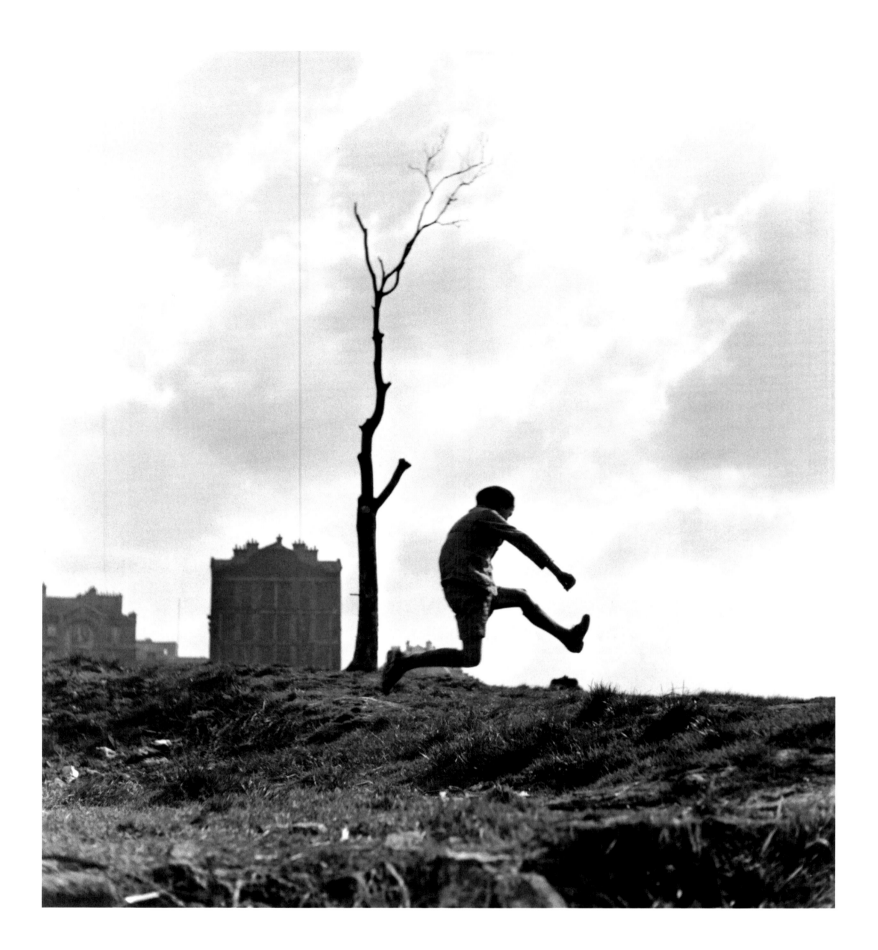

Near the Poterne des Peupliers, Paris, 1934
Paris was Doisneau's chosen place, the subject and stimulus of all his photographs. Anything in this city might give rise to a memorable picture, even a boy's sudden leap over ancient fortifications that have since become a playground. You can almost hear him singing: "A hundredth of a second here, a hundredth of a second there, placed end to end, that only ever makes one, two, three seconds stolen from eternity."

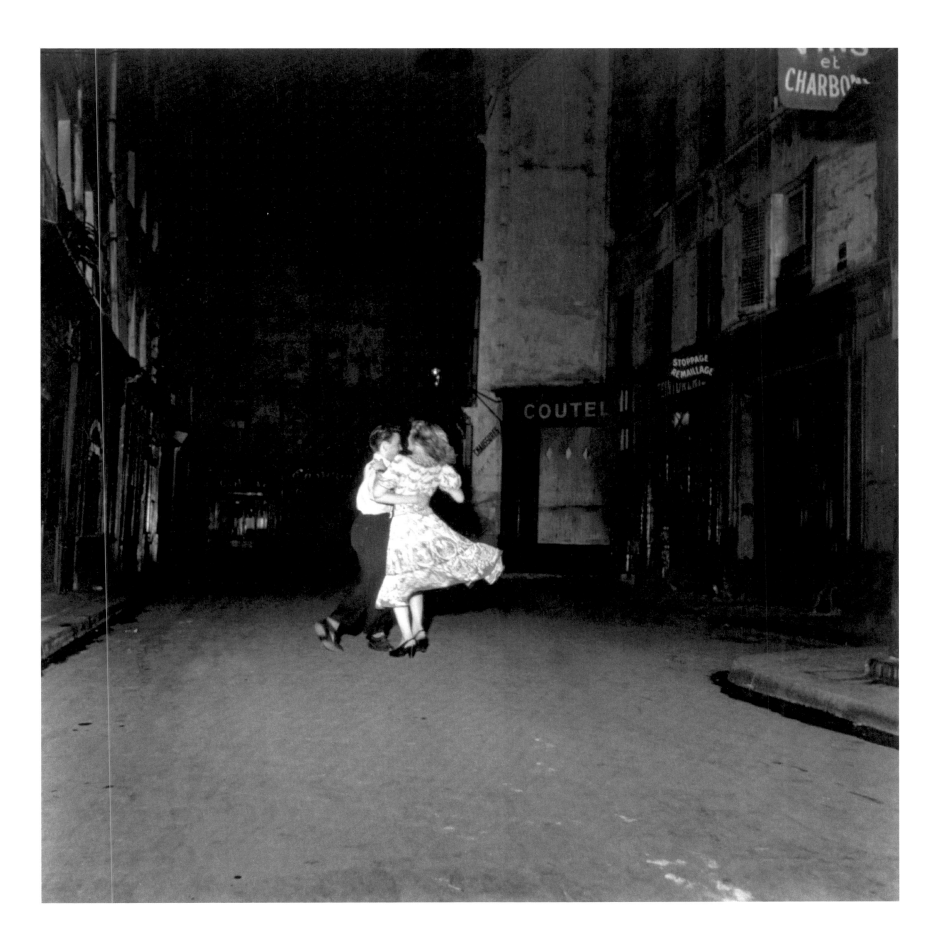

The Last Waltz on Bastille Day, Paris, July 14, 1949
"They danced the waltz as if possessed, unaware that, for true lovers of solitude, such tunes are haunting and melancholy when heard in the deserted streets of the night."

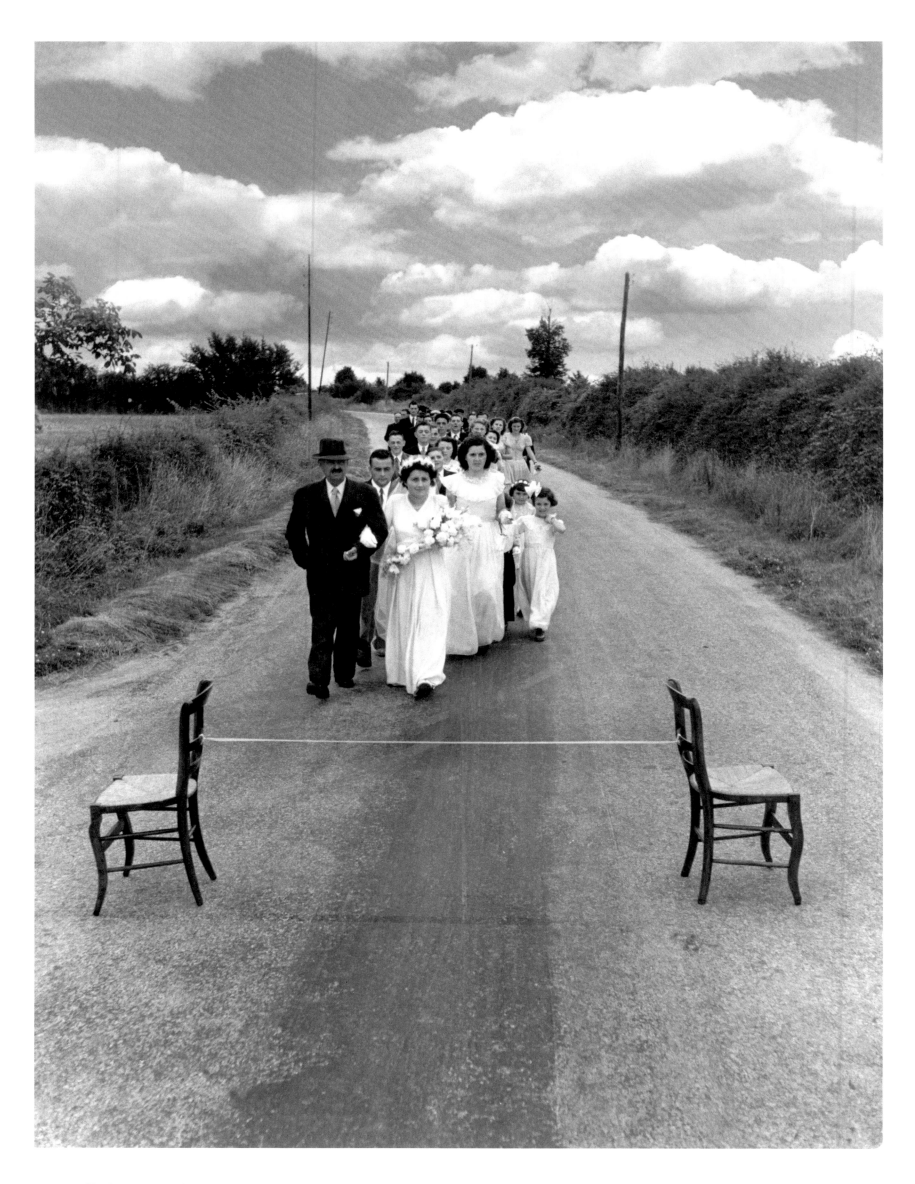

The Bridal Ribbon, Saint-Sauvant, Poitou, France, 1951
This bride from the region of Poitou is completing the traditional wedding-day procession. Accompanied by the groom and the guests, she walks the entire length (in this case, two miles) from her home or farm to the center of town. In front of every house along the way a tape is stretched between two chairs, and the bride cuts each tape as the procession advances.

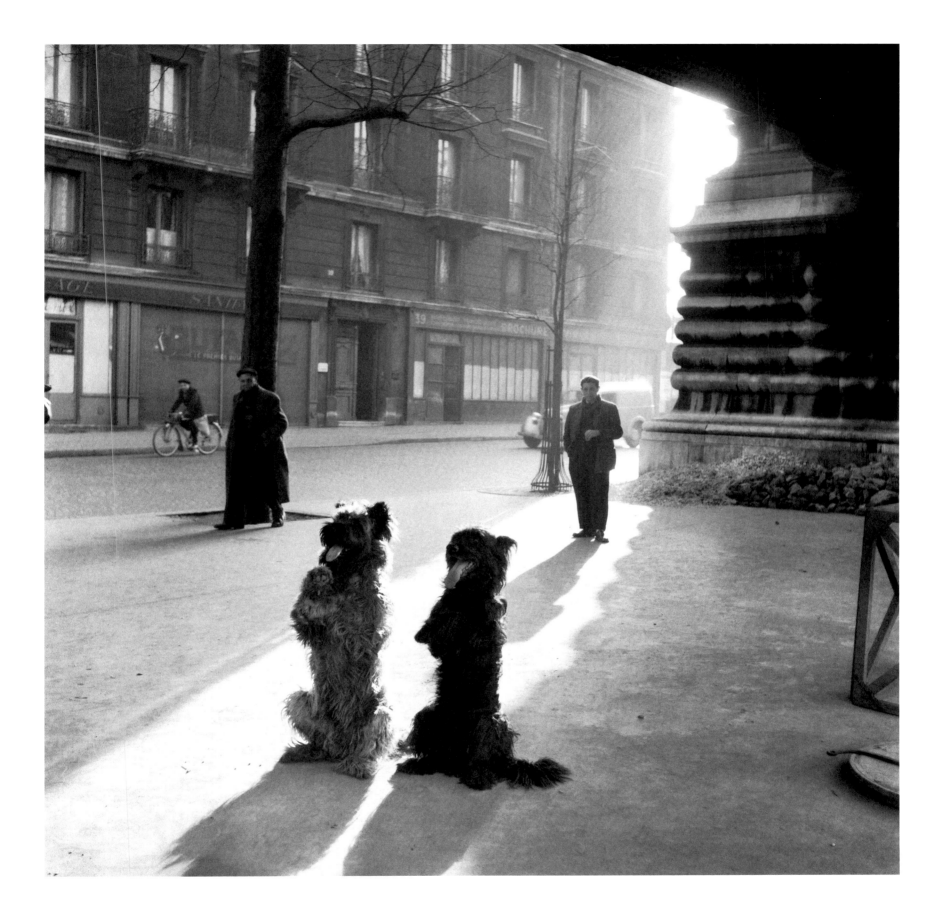

Boulevard de la Chapelle, Paris, 1953
Doisneau was the consummate "participatory passerby" who, camera in hand, captured images of rare purity with his characteristic irony, curiosity, and lightness. Not only did he snap the shots, he glossed them with real zingers: "Dog owners display a pride that only the pets deserve."

"THE MOST BEAUTIFUL AND SIMPLEST REFLEX OF ALL IS THE SPONTANEOUS DESIRE TO PRESERVE A MOMENT OF JOY DESTINED TO DISAPPEAR. THE ACT OF QUICKLY TRYING TO CAPTURE THE FLEETING MOMENT IS MORE CALCULATED—AN IMAGE TO PROVE ONE'S OWN WORLD EXISTS."

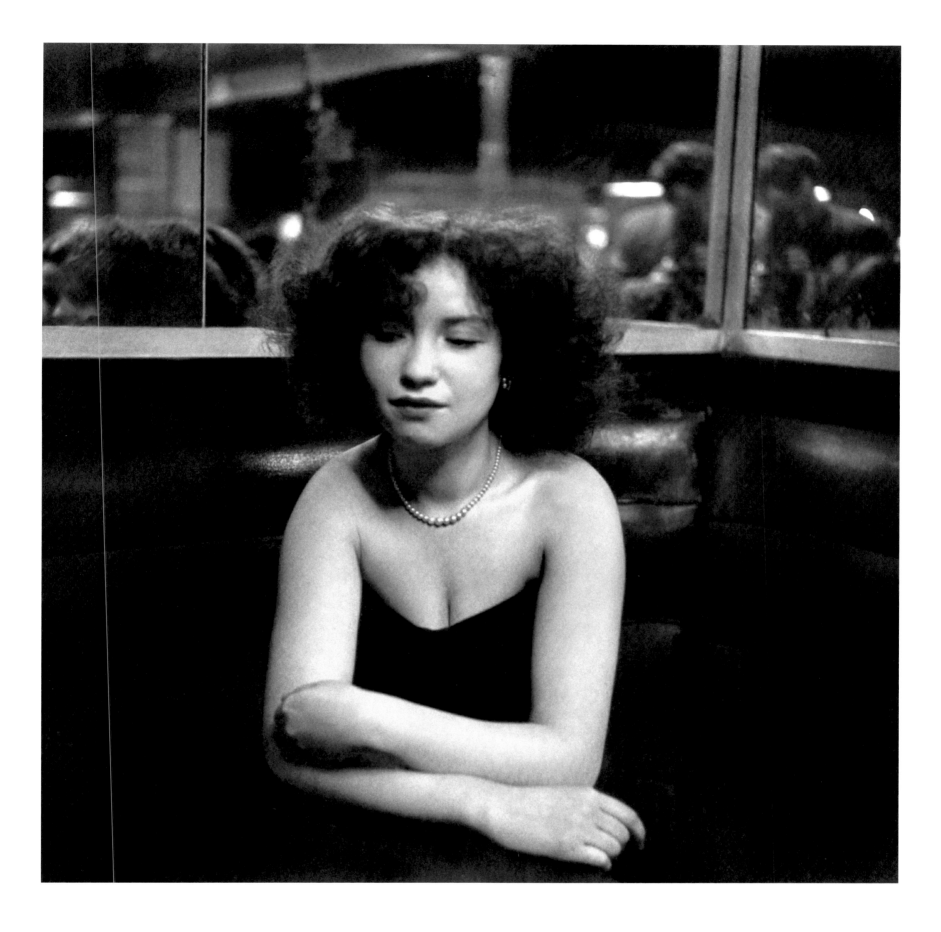

Mademoiselle Anita, 1951

"Aura is the name given to that kind of neon light that glows around certain people, setting them apart for a brief instant. You have to snap it quick because movement can destroy it: 'Don't move, please, don't change anything, I'll explain later.' She must have been aware of the effect she was creating, because she didn't even raise her eyes, she stuck to the pose of stubborn modesty that suited her so well. She wanted to be a dancer. But a photographer approached her in 1951, and ever since that day Anita hasn't budged."

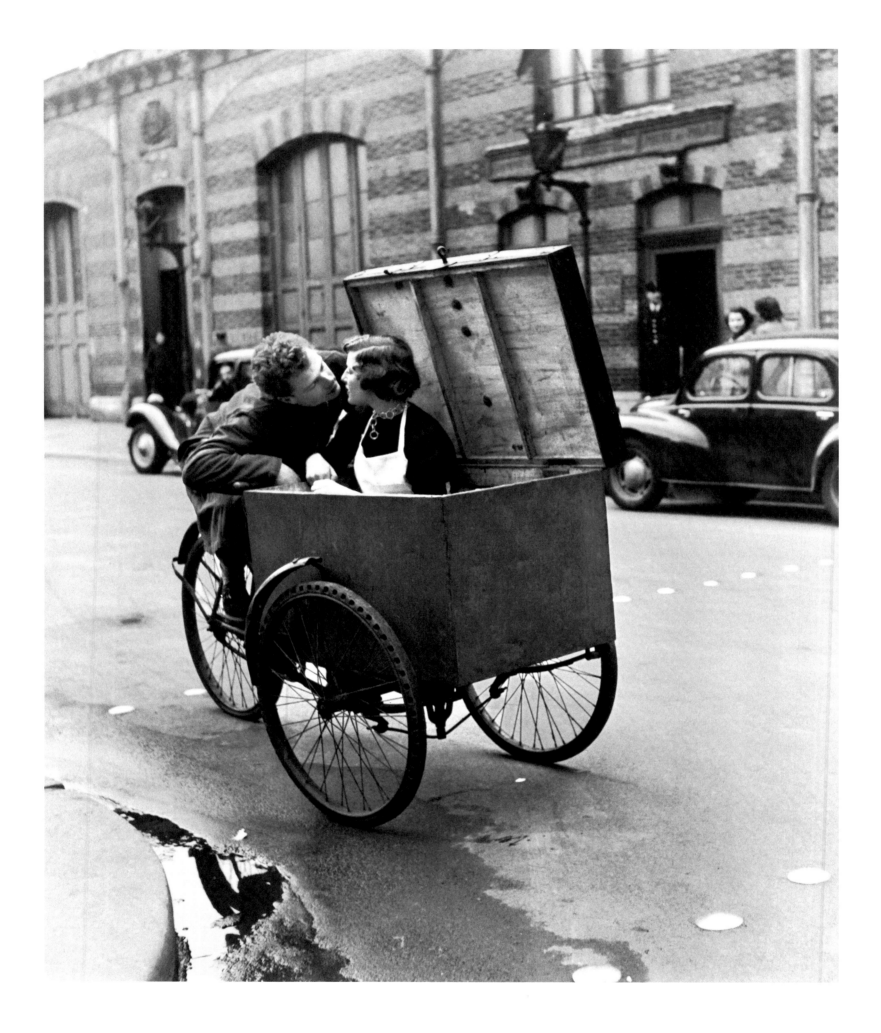

Cosy Kiss, Paris, 1950

"Doisneau always approached his work with a great sense of self-deprecating irony, which was his antidote to the anxiety of *not being*. He became a juggler, a tightrope walker, a magician in order to conjure up even more realism—that is the misleading paradox of this artist. He aimed to have his tricks 'succeed like the illusions of sidewalk artists,' with the modest clarity of a man who was, despite himself, a real artist."

Agnès Sire

Entrance to L'Enfer, Paris, 1952
L'Enfer ("The Inferno") was a cabaret on the boulevard de Clichy; back when ribald jokes and off-color innuendo were all the rage, the bourgeoisie went there to rub elbows with the riffraff.

"OUR TIMES ARE CHARACTERIZED BY AN ANESTHETIC VISION THAT IS FRAMED, DIRECTED, AND CONDITIONED BY THE MEDIA, BY SIGNAGE, BY ADVERTISING. IT SEEMS TO ME THAT, IN A WORLD WHERE THE MEDIA ARE SO POWERFUL AND CONDITION SO MUCH, PHOTOGRAPHY MIGHT BE A WAY OF GETTING BACK TO THE SIMPLER INSTINCTS, A BIT LIKE HORSEBACK RIDING AND SAILING ARE WAYS OF RECONNECTING WITH REPRESSED FEELINGS."

Paris, 1952
"Claude liked to surround himself with fine things: a scantily clad pin-up two feet high. His wife asked me, 'Are they real photos, or drawings?' I replied, 'Drawings, Madame Mireille.' 'Well,' she said, 'I'm not like a lot of other people, when a woman is well built I'm the first to admit it. And these ones here are pretty well built, right, Claude?' Claude chuckled quietly."

Floral Float Competition, Choisy-le-Roi, 1934
"Contestant 43, in the plane, is pushed by his solemnly dressed father, whose motto would appear to be 'participation is more important than victory.'"

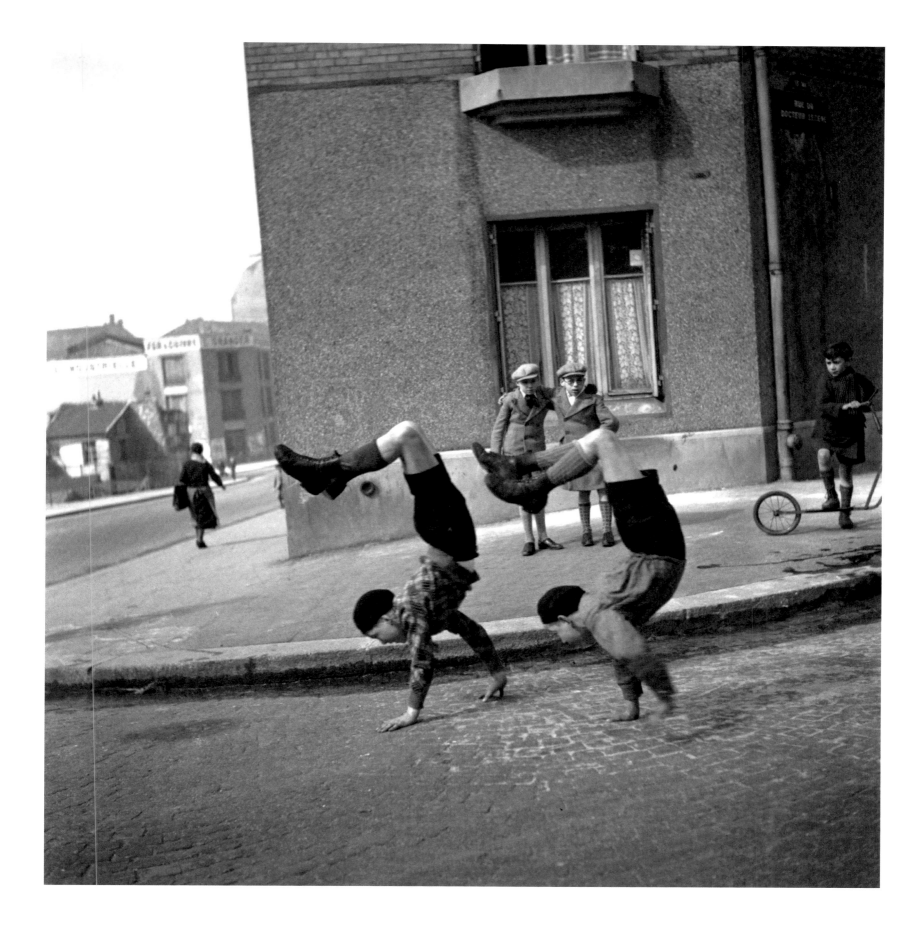

The Brothers, rue du Docteur Lecène, Paris, 1934
"Over time the few images that have survived—the ones that now seem brought together as a group, like so many corks floating on the eddies of a river—were created in the time I 'stole' from my various other jobs. In this image, for example, the two brothers on the sidewalk are watching two brothers in the street."

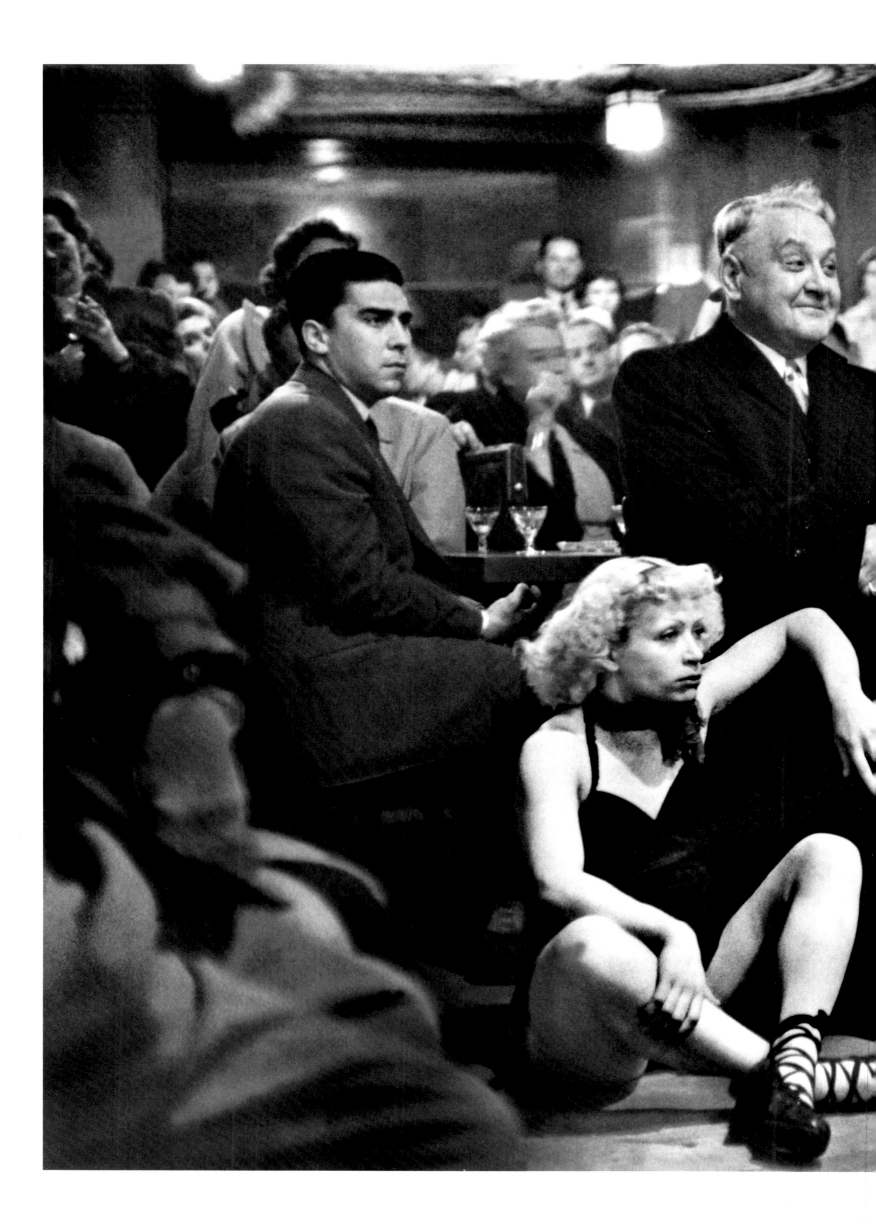

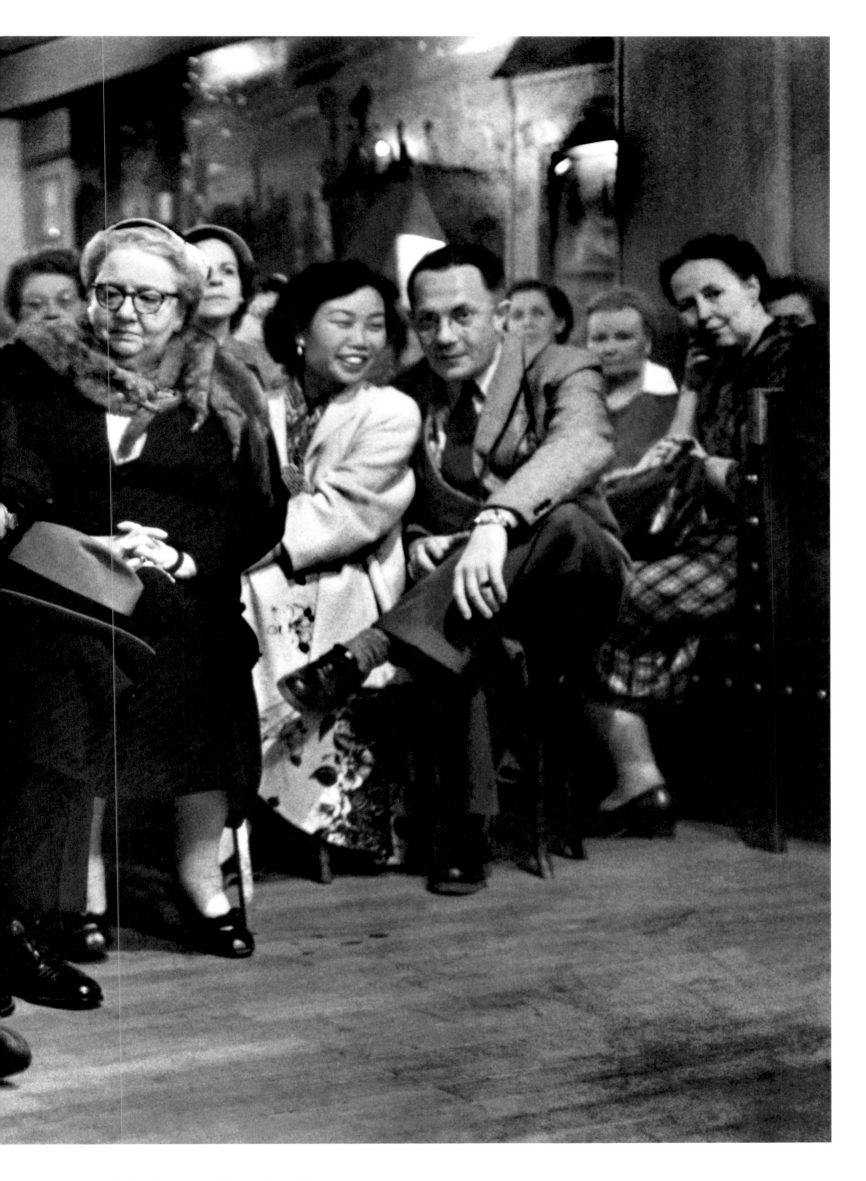

Le Petit Balcon, rue de Lappe, Paris, 1953
"This dancer was apparently booed so badly she took refuge at the front of the audience. The scene takes place at Le Petit Balcon, a dance hall frequented primarily by tourists. The shows staged here were ones of crude revelry, all for the benefit and glory of the triumphant male."

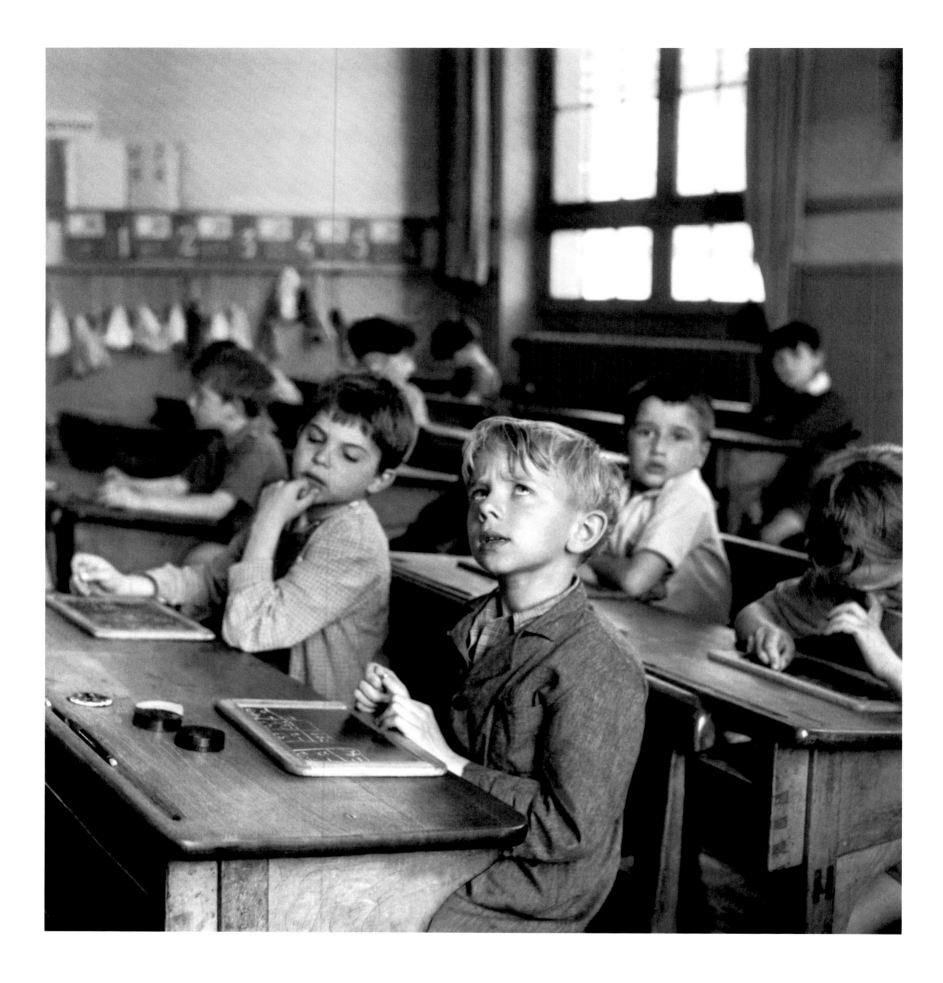

Schoolchildren in Class on the rue Buffon, Paris, 1956
"Photography, for me, is a moment of happiness; you feel elated by what you see, you want to keep it, and it's like saying, 'Hold on, dear executioner, just give me another moment here, please.'"

Robert Doisneau was born on April 14, 1912 in Gentilly, a southern suburb of Paris, where he lived all his life. His mother died in 1920, and two years later his father remarried. At the age of thirteen Doisneau enrolled in the École Estienne, which specialized in printing and binding. Four years later he earned a diploma in engraving and lithography.

He began taking photos in 1929 with a camera borrowed from his half-brother Lucien, and shortly thereafter joined the Uhlmann studio as an advertising designer. His interest in photography quickly grew, and he became an assistant in the studio's recently founded photo lab. In 1931 he met the multifaceted intellectual André Vigneau, who worked as a painter, sculptor, and photographer. Doisneau became Vigneau's assistant, and Vigneau in turn revealed his perception of photography, introducing Doisneau to the avant-garde artistic milieu he subsequently frequented. Later that same year, thanks to his mentor, the magazine *Excelsior* published his first photo essay, on the flea market of Saint-Ouen. In 1933 compulsory military service sent him to the Vosges region, where his anarchist leanings were only strengthened. On his return to Paris he was hired as a photographer for Renault, in Boulogne-Billancourt. He soon lost the job due to "perpetual tardiness" and decided to take the risk of becoming a freelance photographer.

In 1934 he married Pierrette Chaumaison, and together they had two daughters, Annette and Francine. He was called back to military service in 1939, but discharged a year later for health reasons. Work was scarce during the war, but Doisneau continued taking photos for himself and also made the most of his graphic design talents to forge papers for members of the Resistance. After liberation he began to publish regularly in newspapers; he then joined the Alliance photo agency, which he soon left to become a member of Rapho. Little by little, and with increasing regularity, his photos appeared in magazines such as *Life, Point de Vue, Regards*, and *Picture Post*.

His success grew during the postwar years, and he won the Kodak Award in 1949, followed by the Niépce Prize in 1956, amongst others. His photographs tell the story of a Paris that is tender, intense, and sadly lost in a present that is already on the verge of becoming mere memory. The critics and the public responded enthusiastically, and he participated in many solo and group exhibitions. His circle of friends included Blaise Cendrars, Jacques Prévert, Maurice Baquet, and later on the writers François Cavanna and Daniel Pennac, as well as the actress Sabine Azéma.

Doisneau was a tireless worker capable of developing personal photographic projects, often involving many different images, while nevertheless spending most of his time focused on work done for advertising and other commercial commissions. He only achieved full-blown success, however—which brought him worldwide fame and made him a French icon—toward the end of his career and life. It was around 1984 that he gained domestic recognition, at different levels, and a series of monographs and short films were dedicated to his photography and the truly priceless legacy of images created throughout his career.

Doisneau died on April 1, 1994, and was buried next to Pierrette in the cemetery of Raizeux, the small village in the Beauce where they had first met so many years before. He, too, now resides in the pantheon alongside all the artists he portrayed. "I have never asked myself why I take pictures. In reality, I am in a desperate battle against the idea that we are all destined to disappear....I am determined to stop the flow of time. It is pure folly."

"JACQUES PRÉVERT KNEW ME WELL, AND ONCE TOLD ME: 'THE VERB TO PHOTOGRAPH IS ALWAYS CONJUGATED IN THE IMPERFECT TENSE OF THE LENS.' AN IMAGE, A SCENT, A BIT OF MUSIC IN THREE TENSES IS ALL I NEED FOR A PERSONAL MEMORY TO RESURFACE."

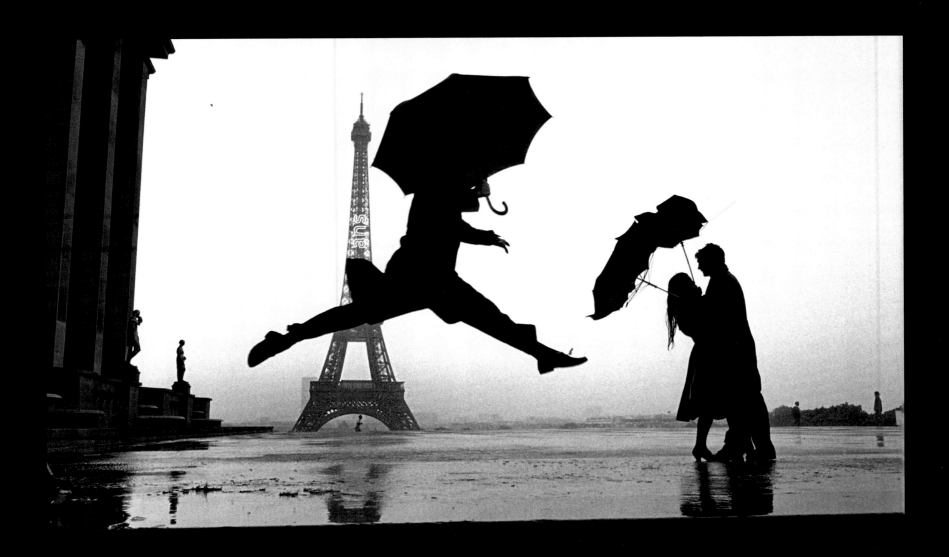

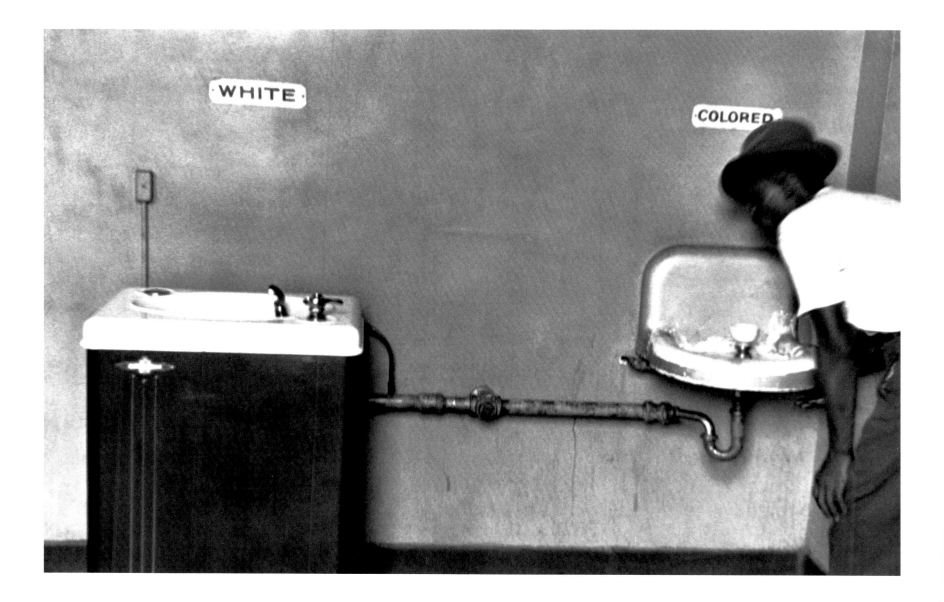

Page 140
Paris, 1989
The epitome of lightness and emotion—defying history and paying tribute to one of the founding fathers of Magnum Photos.

Above
North Carolina, 1950
No other image denounces the horror of racism with such simplicity. A world divided in two, "white" and "colored," rich and poor, one drinking fountain that's clean, another old and filthy. Yet the water that comes out is the same.

ELLIOTT ERWITT

Of all the experiences that have made the talent of Elliott Erwitt unique, this was perhaps the most formative. But formative to the contrary. At sixteen years of age, in the afternoons after school, he worked as a printer in a Hollywood photo studio. He produced hundreds of pictures for movie stars to send to their fans. "Hundreds and hundreds of Ingrid Bergman," remembers Erwitt, "the face beautiful, without a blemish, with nothing unexpected, without expression." But life is not like that. It does not come in a series, or as a copy. It is more than that, and Erwitt throughout his career has chosen to look at what that is, looking for the absurdities, absences, excesses, and coincidences of life; in a word, for the immense richness of signs and sentiments that make the human comedy unique. In the way that he chose to photograph his wife and daughter in the miracle of the first week of life, the widow of the president of the United States with that diamond-shaped tear on her veil, Red Square, the Prado Museum, a nudist camp in England, a beauty contest, a circus, or a parade, Erwitt always favored the tonality of surprise, of humor, and of tenderness, preferring to be entertaining rather than tragic. In 1951, during his military service, he took pictures of soldiers at rest, stretched out on their cots, and gossiping while on the march. There was no rhetoric involved. It was pure antimilitarism. And already a method: "After following the crowd for a while, I'd then go 180 degrees in the exact opposite direction. It always worked for me," he said. It also worked when the photos taken at the army base in Fort Dix, New Jersey, reached the editors at *Life* and won a competition. With the $2,500 second prize, he started traveling again to Europe, where he met Robert Frank and his wife, Maria. Commenting on Frank's style, Erwitt explained, "Quality doesn't mean deep blacks and whatever tonal range. That's not quality, that's a kind of quality. The pictures of Robert Frank might strike someone as being sloppy—the tone range isn't right and things like that—but they're far superior to the pictures of Ansel Adams with regard to quality, because the quality of Ansel Adams, if I may say so, is essentially the quality of a postcard. But the quality of Robert Frank is a quality that has something to do with what he's doing, what his mind is. It's not balancing out the sky to the sand and so forth. It's got to do with intention." And again, "All the technique in the world doesn't compensate for the inability to notice."

In 1953 Erwitt returned to New York and, thanks to Robert Capa, joined the Magnum agency. In his field of vision is a cowboy family from Wyoming, touching in the embrace of a father and son who almost in tears find each other after months of being apart. "Too sad," was the reaction of the editors at *Holiday* magazine who commissioned and then declined the work. But Erwitt had no doubt that what he had to seek were emotions caught in a fraction of a second, their skin-deep appearance, fresh, light, tormenting, never rhetorical. Erwitt also took photos of the great figures in art, politics, and film. These included Marlene Dietrich, Che Guevara, John F. Kennedy, Marlon Brando, Jack Kerouac, Pope Paul VI, Yukio Mishima, Charles de Gaulle, and Marilyn Monroe, of whom he said, "I found her very sympathetic, I must say. She was nice, smart, kind of amusing, and very approachable. Not a bimbo at all." She was flirtatious, intense, in a bathrobe with a book on her knees: the image of the woman that she would have wanted to be. Once again Erwitt turned 180 degrees and changed direction.

His attention was captured by another subject of great humanity, personality, and variety: dogs. Dogs of every size and breed, on every continent. Dogs to be looked in the eye, in the hope of discovering another point of view of the world and of ourselves. The earliest published image goes back to 1946. Next to a pair of black sandals, those of his mistress, a chihuahua wearing a small sweater looks terrified at an eighteen-year-old boy, the photographer, stretched out on a sidewalk in New York. The roles have been switched. The comedy has begun. Over the next half-century of work, in front of Erwitt's camera lens and in a book called *Son of Bitch,* published in 1974, there has been a parade of dogs seemingly more human than their masters, dogs that jump at the sound of a car horn and are ashamed of a horrible clipping, dogs that support us, console us, embrace us, implore us from top to bottom—"A proud dog would choose a dwarf for a master," Erwitt recalled—and naturally they feel sorry for us. Dogs that are better than we are.

"When photography is good, it's pretty interesting, and when it is very good, it is irrational and even magical, … nothing to do with the photographer's conscious will or desire. When the photograph *happens*, it comes easily, as a gift that should not be questioned or analyzed. Sometimes, humor is in the photographs, not in the scene you photograph. I mean, you can take a picture of the most wonderful situation and it's lifeless, nothing comes through. Then you can take a picture of nothing, of someone scratching his nose, and it turns out to be a great picture. What occurs in a scene, in a situation, and what you photograph can be totally different."

Santa Monica, California, 1955

At first sight, they are the protagonists, that marvelous pair of lovers, beautiful, young, he in a jacket and tie, she with earrings and bright red lipstick, even though the photo is in black and white. We are conquered by their love, by that smile which exalts pleasure and which even from land is able to light up the spectacle of the sunset on the sea. But then Erwitt takes a step back and invites us to look beyond that perfect oval, that cameo of absolute romanticism. And then, on the Santa Monica cliffs, in the golden ratio of the frame that holds both the landscape and the automobile, that emblem of the conquest of the landscape, America appears in all the splendor and innocence of the 1950s.

It was 1955 and the country was on the move. Little Richard sang "Tutti Frutti," Elvis Presley signed his first contract, and General Motors was the first American business with sales of a billion dollars a year. Things started to move faster and during those same months James Dean died when his Porsche 550 crashed. Youth was on fire and the endless rivalry between East and West was burning as well. On May 14, 1955 the Soviet Union signed the Warsaw Pact. Two months later, on July 17th, California celebrated the opening of Disneyland, and in 1959 Nikita Khrushchev, on a visit to the United States, asked to see it. Surely, that pair of lovers, kissing with such tenderness, unaware of the presence of the photographer, had no thought for the restless world outside the car window. But Elliott Erwitt did, and with the clairvoyance of a man born in the Old World who fled as a child to the New, he was only too aware that this perfect equilibrium would not last longer than the time taken to snap a photo.

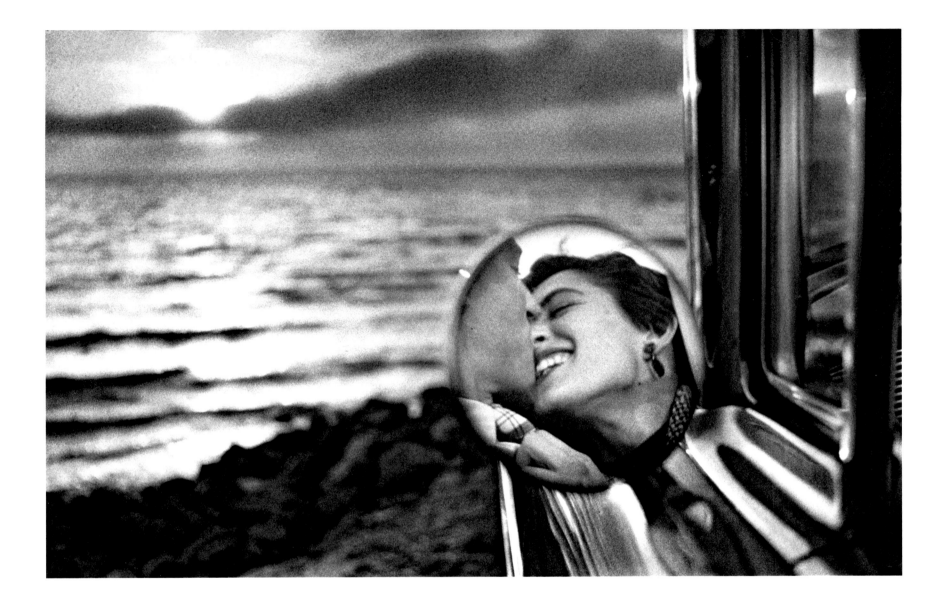

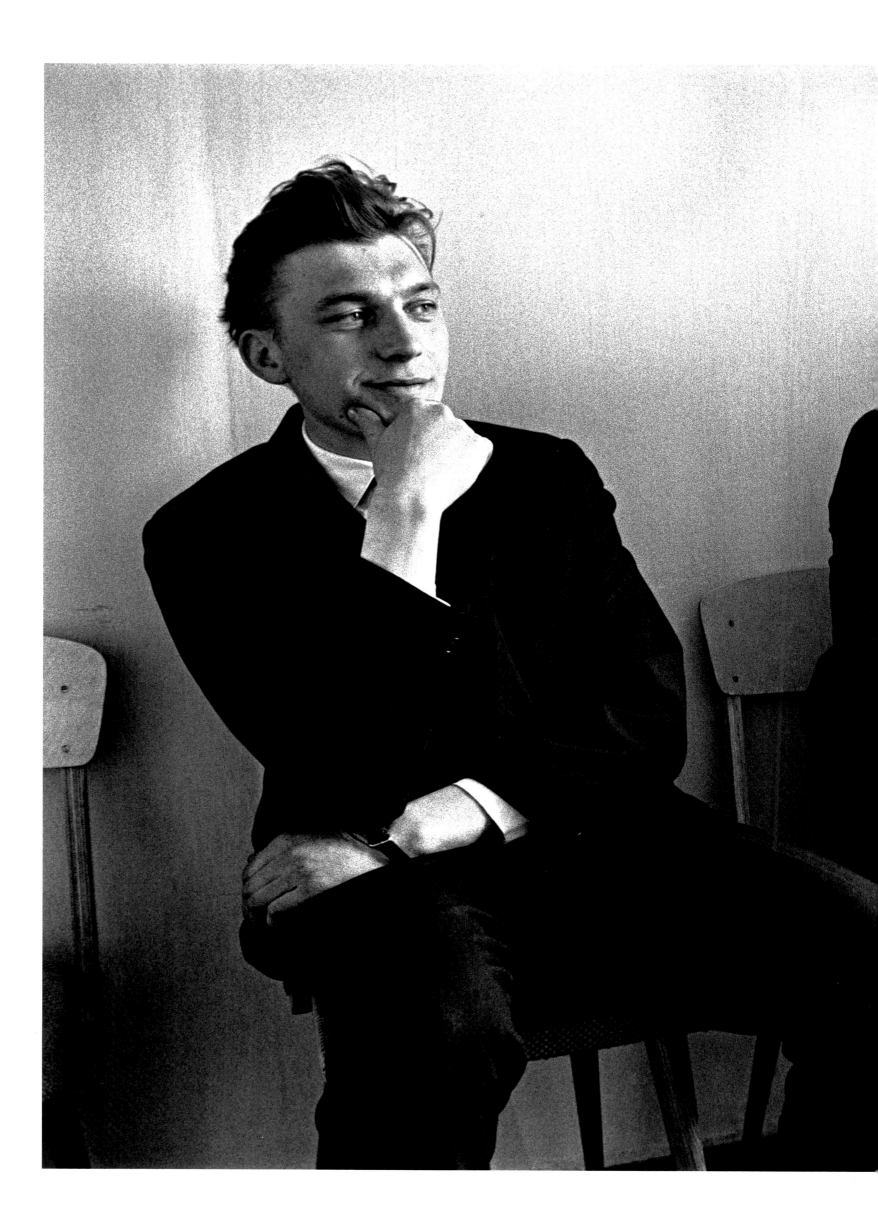

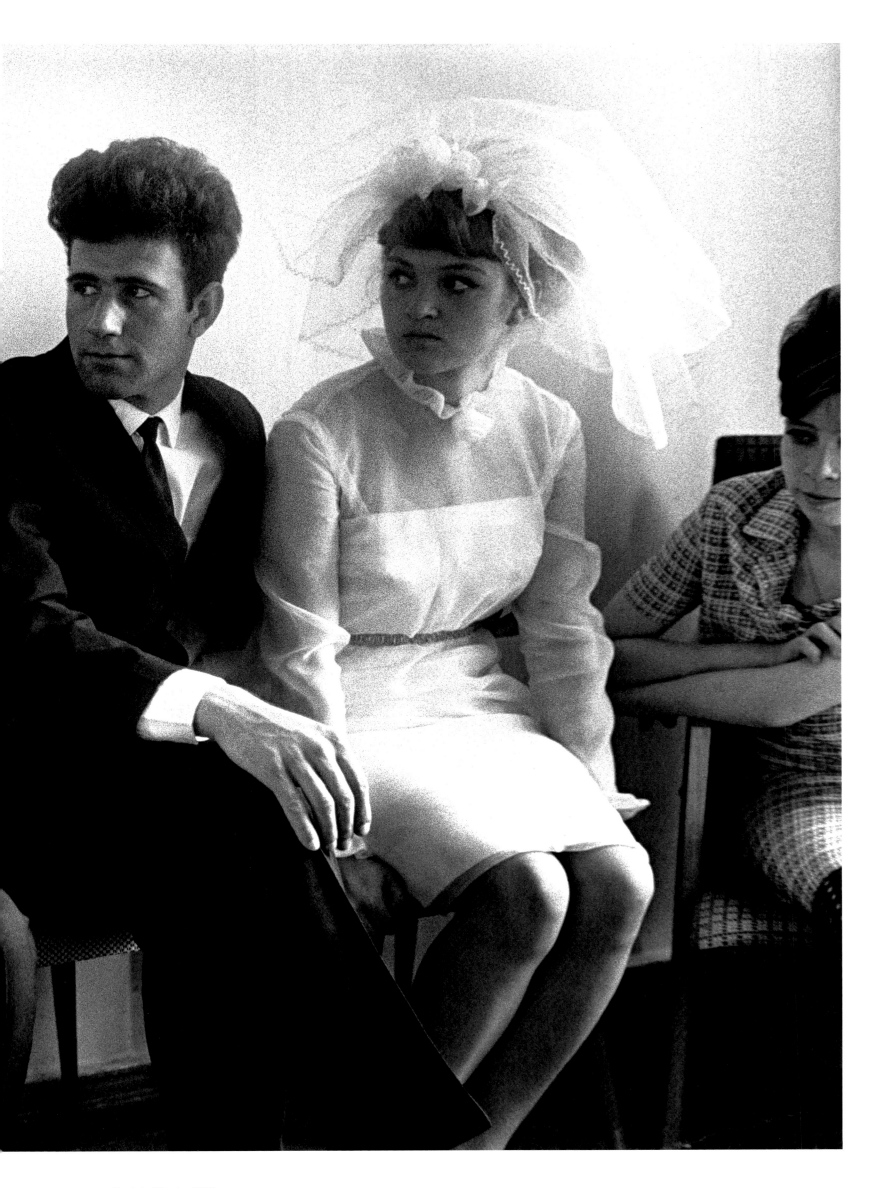

Bratsk, Siberia, 1967
A small slice of the human comedy in the vastness of Siberia. A couple wait their turn. Within a short time an official of the Soviet Union will perform the ceremony. In the meantime, the witness thinks, smiles, perhaps remembers. Is the bride an old flame? Has she told her husband the truth? The question is certain, but so that Erwitt's sense of humor can shine with its own light, no answer is given.

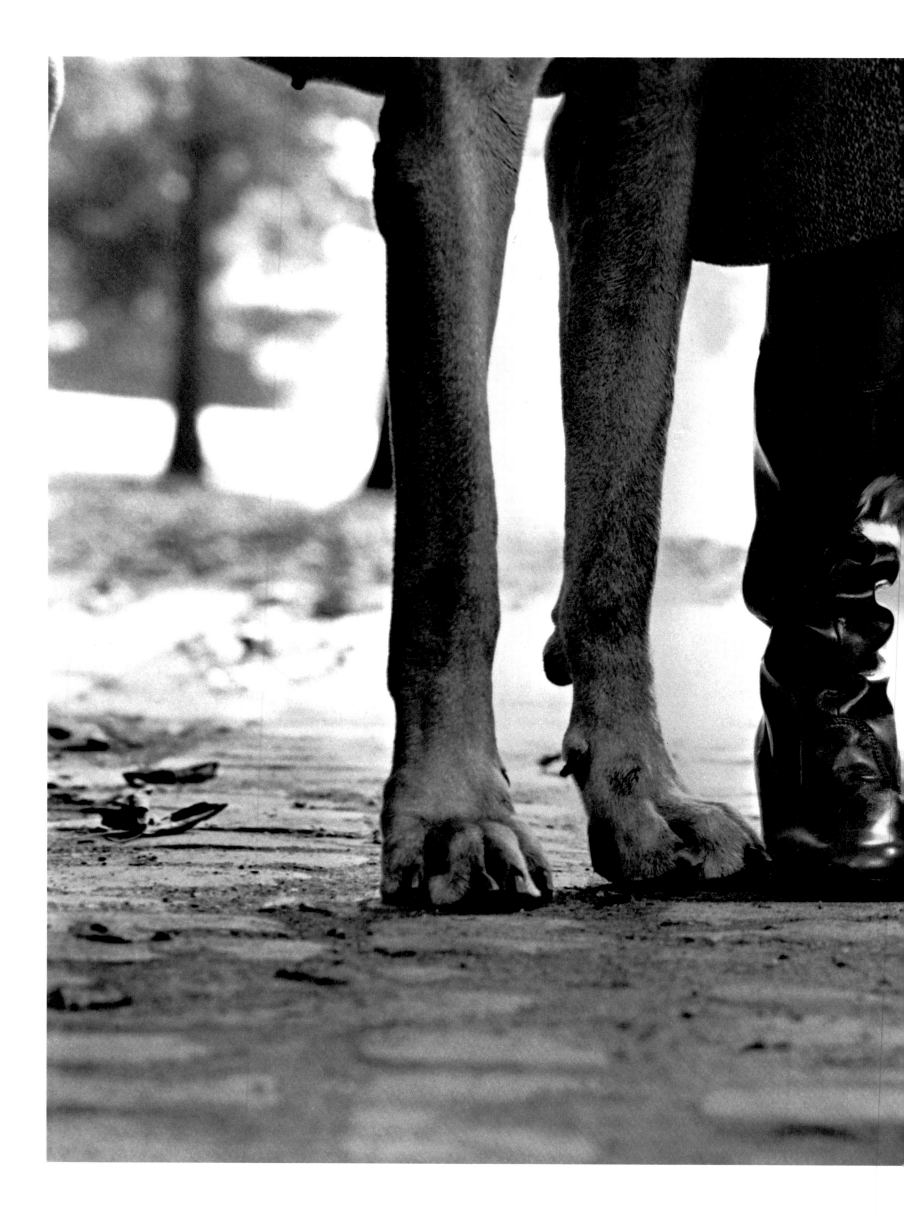

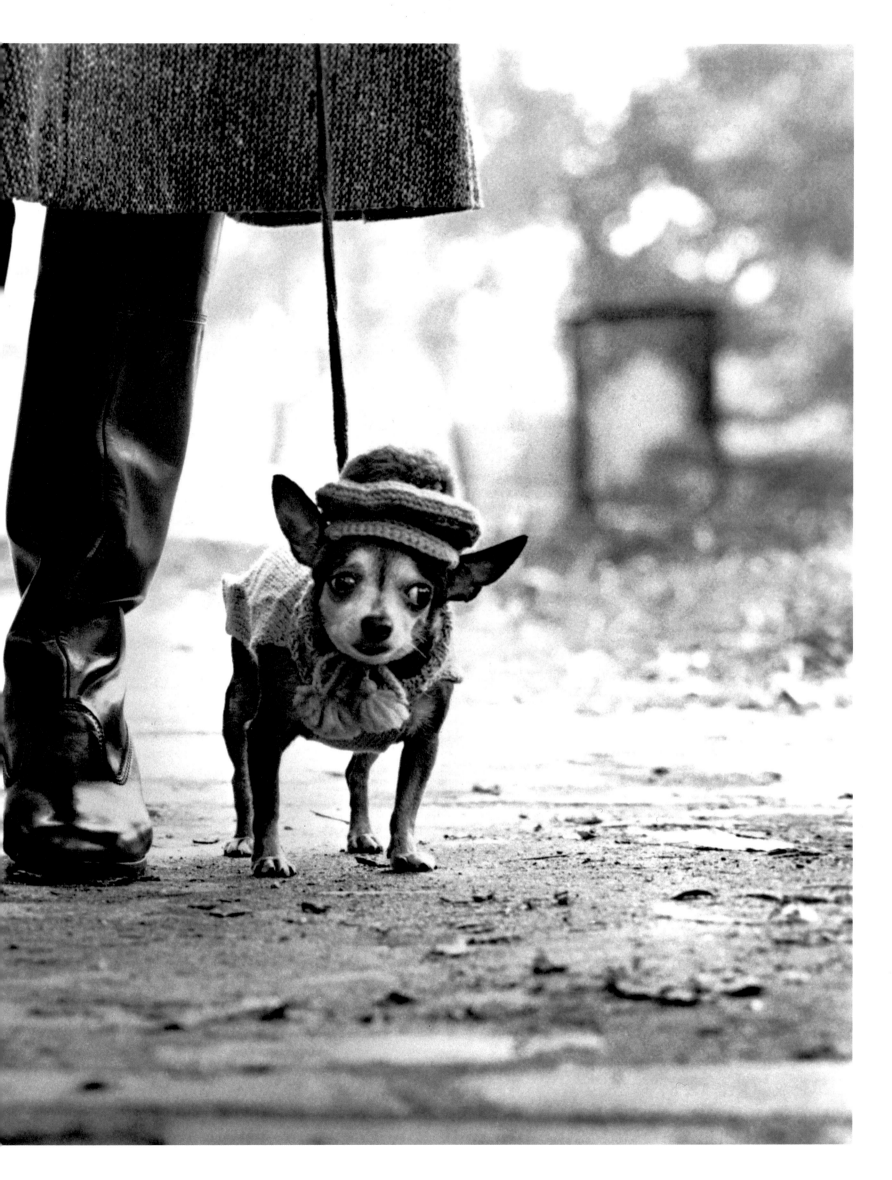

New York, 1974
Who better than they to appreciate the beauty of a pair of boots on a cold day in winter? "They" are dogs, of course, a tiny chihuahua and an enormous Great Dane. In this famous photo from 1946, with dog-loving irony and passion, Erwitt creates not only a publicity campaign for a brand of shoes but also a tribute to the personality of man's most faithful, and critical, companion.

"IT'S ABOUT REACTING TO WHAT YOU SEE, HOPEFULLY WITHOUT PRECONCEPTION. YOU CAN FIND PICTURES ANYWHERE. IT'S SIMPLY A MATTER OF NOTICING THINGS AND ORGANIZING THEM. YOU JUST HAVE TO CARE ABOUT WHAT'S AROUND YOU AND HAVE A CONCERN WITH HUMANITY AND THE HUMAN COMEDY."

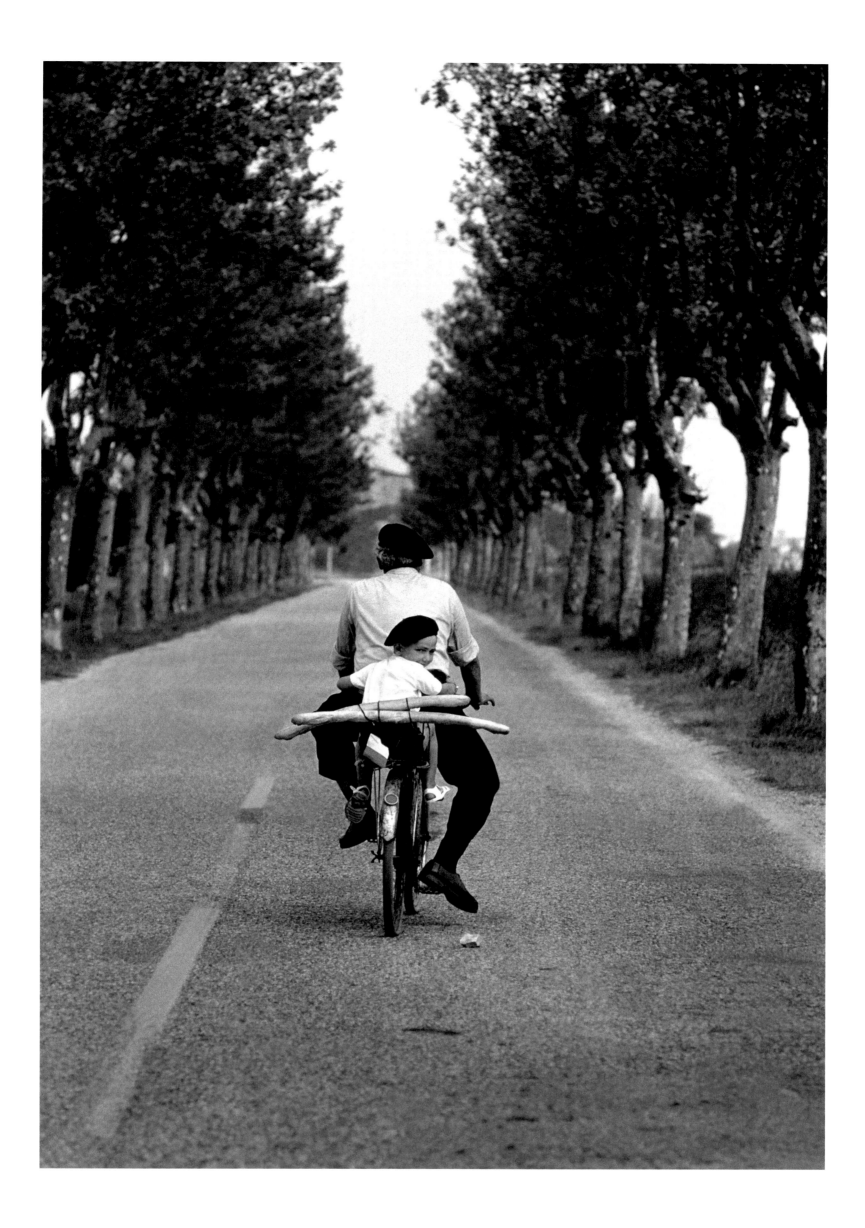

Provence, France, 1955
It is a staged shot, publicity for the French tourism office. But what class and sweet-smelling simplicity! The tree-lined road, the bicycle, the baguette, grandfather and grandson each with a classic black beret slanting downward in the opposite direction. This is the way to describe France, with a lightness of touch that avoids cliché. And that stone in the middle of the road? A marker, the rear wheel passes by, the focus is perfect, and *snap*.

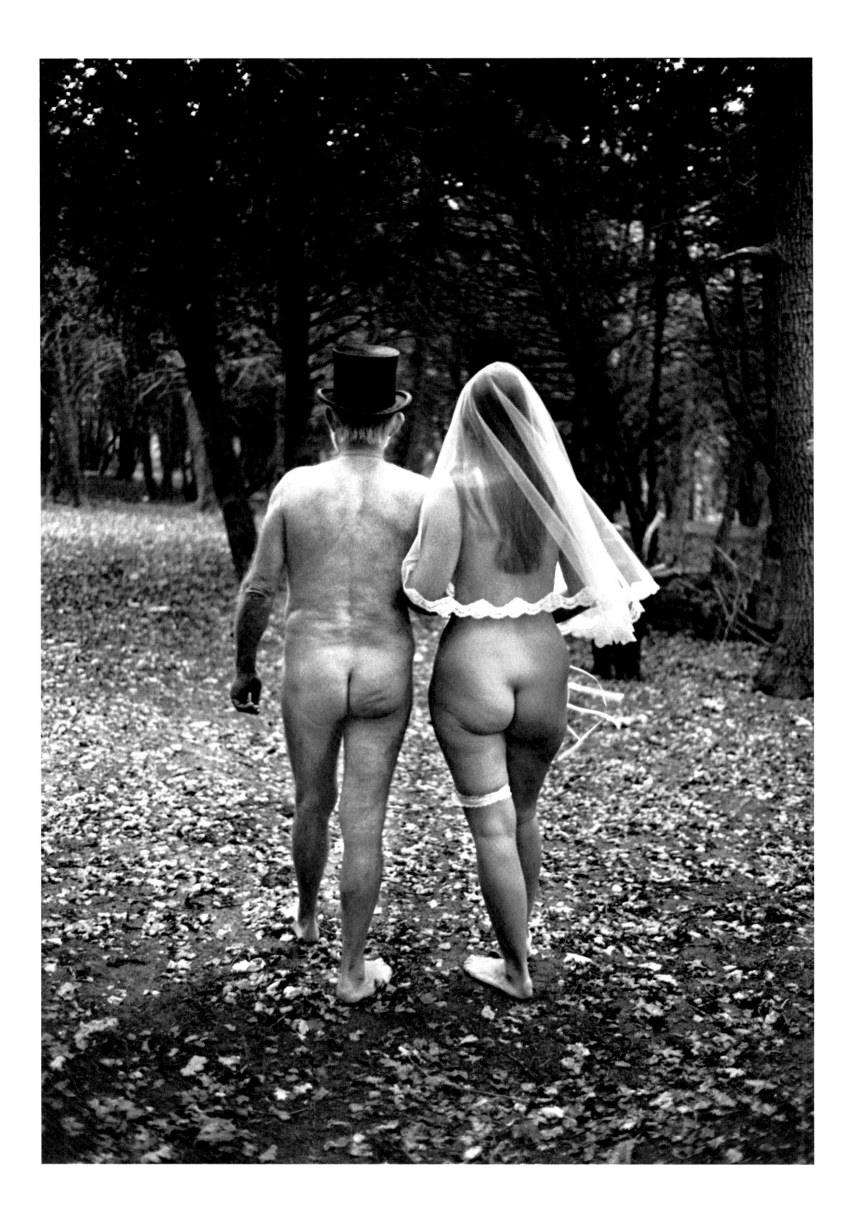

Kent, England, 1984

Erwitt likes weddings. He has had four of them himself, and photographed an infinite number in every part of the world. Even in the English countryside, in a nudist colony, where a couple have just celebrated their wedding. A veil, a garter, and a top hat are all that is necessary. Adam and Eve, on a somewhat warm morning in autumn, triumphantly enter the sham respectability of mankind.

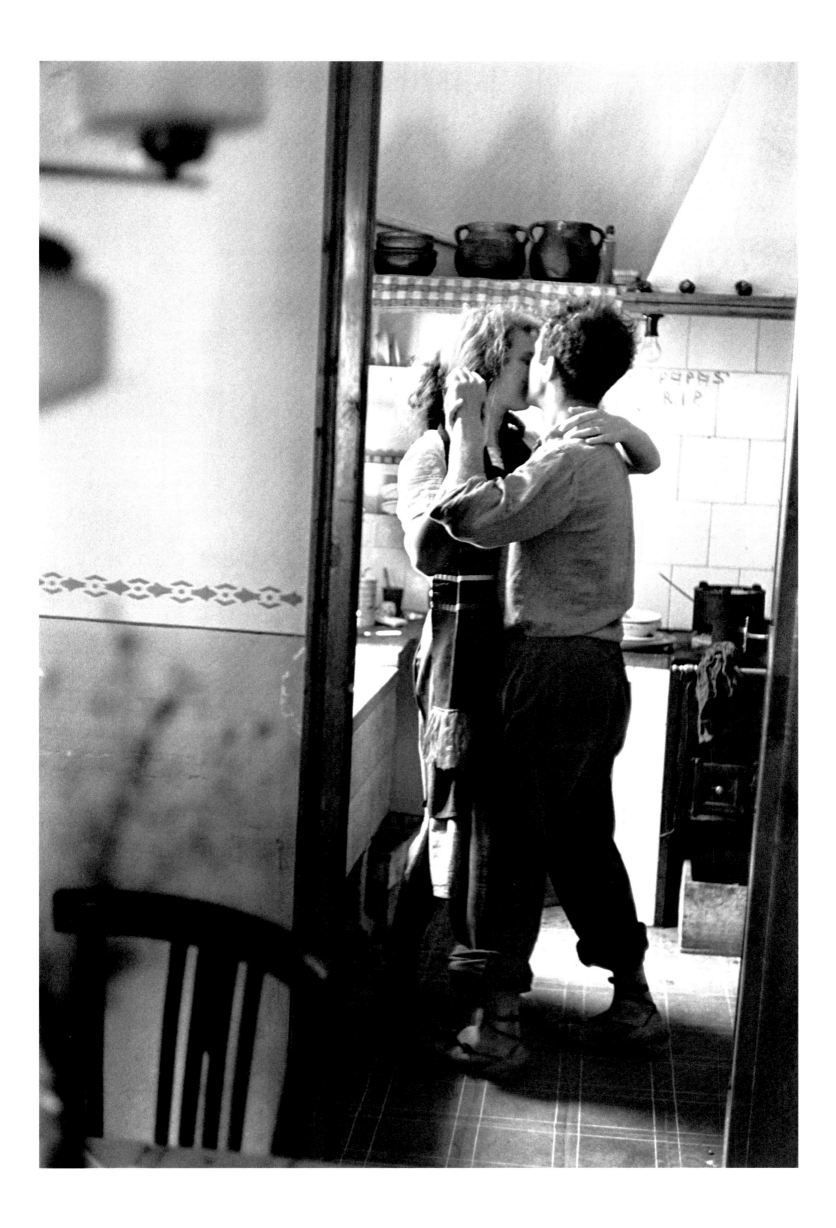

Valencia, Spain, 1952
Another style, another couple. Dancing in the warmth of a kitchen are Robert Frank, the great photographer and author of one of the most revolutionary books in the history of photography, *The Americans*, and his wife, Mary Lockspeiser, a painter and sculptor. Erwitt had met them in Valencia. All three were quite young: Mary was nineteen, Robert twenty-eight, and Elliott twenty-four. The frame is at an angle, and together with a man and a woman the world for a moment turns to the rhythm of a waltz.

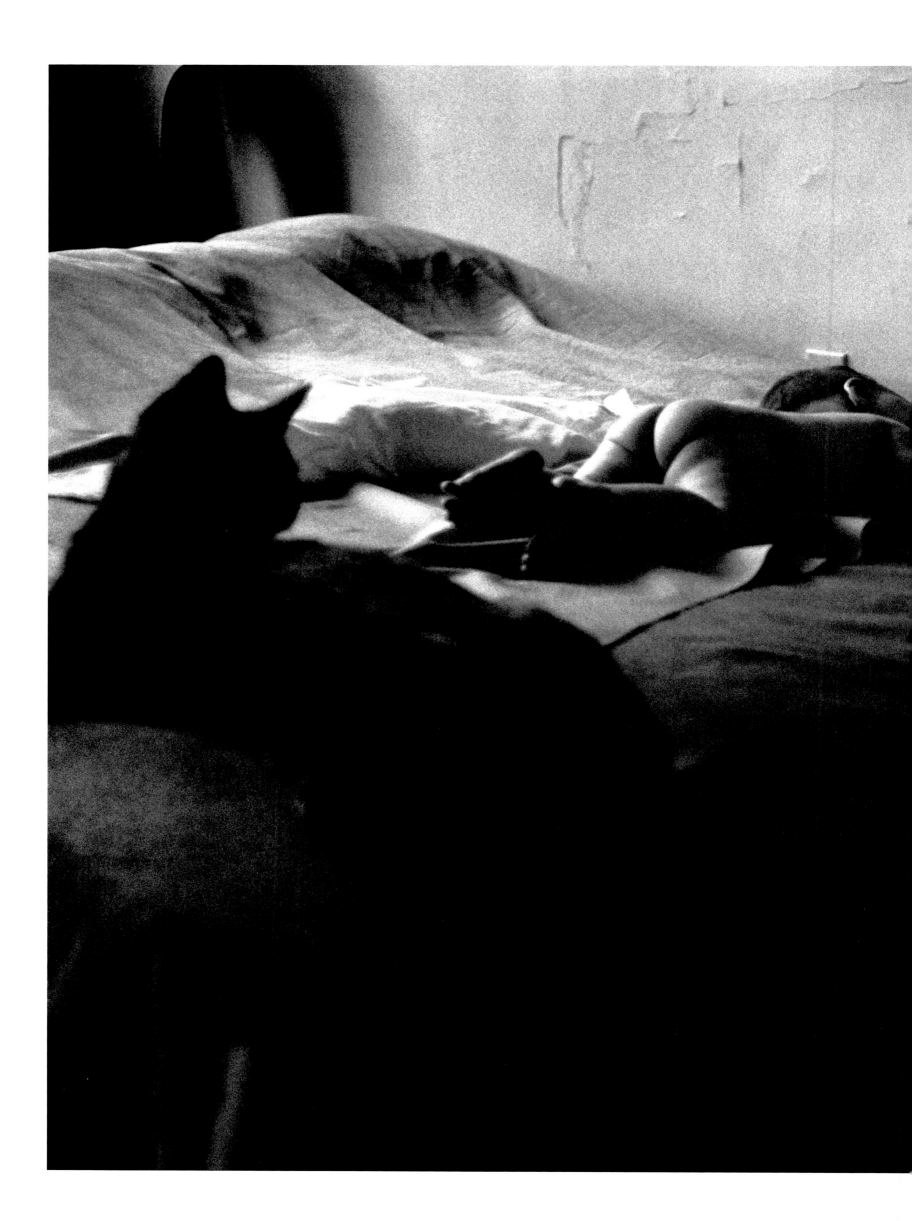

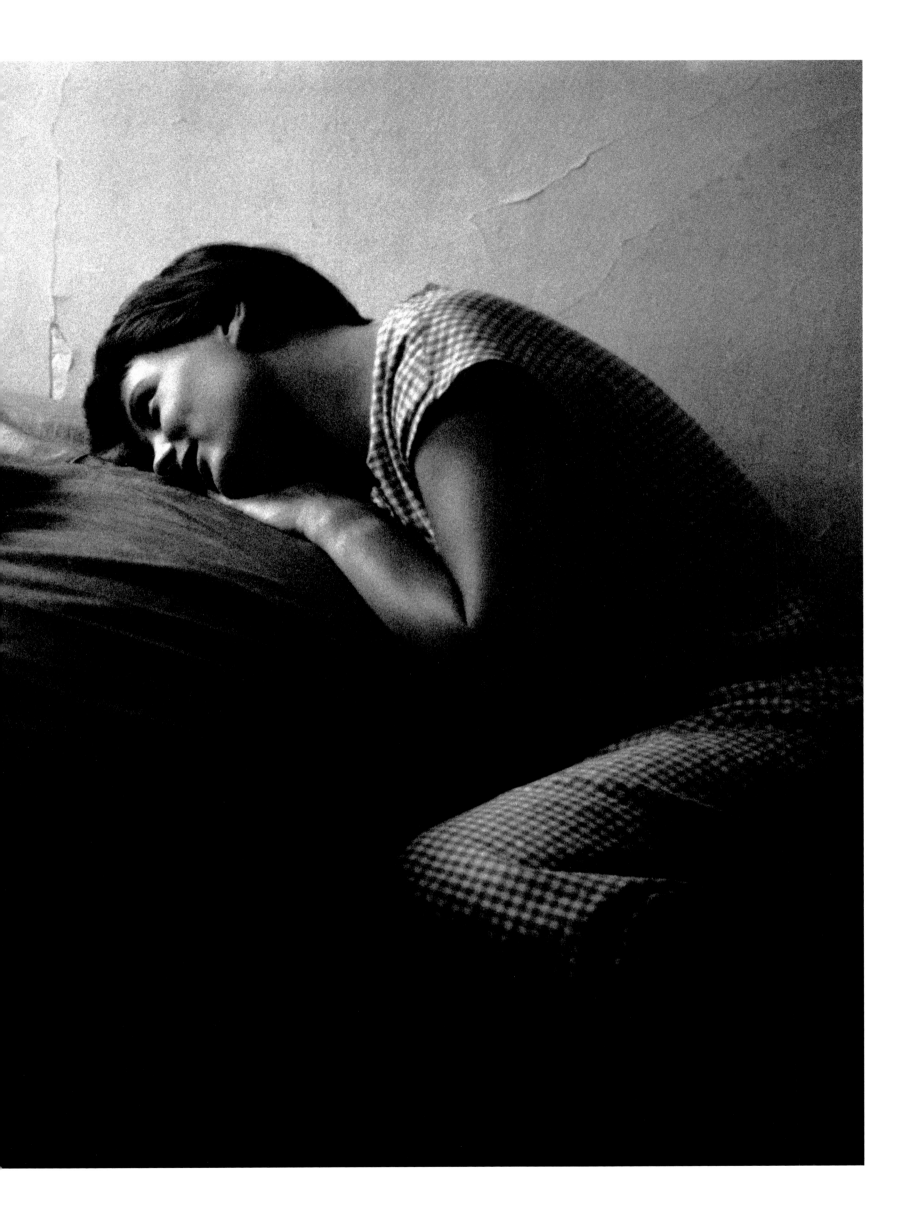

New York, 1953

Characters and cast. Lucienne van Kam, Erwitt's first wife, lies beside Ellen, the couple's first daughter, six days after her birth. Next to them is Brutus, one of the few cats to appear in Erwitt's work. The scene is set in an apartment on the Upper West Side of Manhattan. It is summer. It is a moment of absolute grace. The photo is a classic that two years later would be part of the historic exhibition *The Family of Man*, curated by Edward Steichen.

"THIS KIND OF MANIPULATION OF PHOTOGRAPHS IS NOTHING NEW, IT'S JUST EASIER NOW AND ANYBODY CAN DO IT. IT WAS NOT QUITE AS RADICAL BEFORE BECAUSE IT WAS MORE DIFFICULT AND QUITE EXPENSIVE, BUT IT WAS GOING ON ALL THE TIME, PARTICULARLY IN FASHION, ADVERTISING, AND PRODUCT PHOTOGRAPHY. BUT IT'S THE CHANGING OF PICTURES—WHEN YOU ARE TRYING TO PASS OFF MANIPULATED PICTURES AS REAL PICTURES, THAT'S WHEN IT'S OBJECTIONABLE."

Reno, Nevada, 1961
In 1960 Magnum was given an extraordinary assignment to follow the production of *The Misfits*. This was an epic film, starting with the cast that Erwitt gathered for this group photo. At the center the radiance of Marilyn Monroe and, surrounding her, her husband, Arthur Miller, who wrote the story, Frank Taylor, the producer, the actor Eli Wallach, the director John Huston, and the actors Montgomery Clift and Clark Gable. For many of them, it would be their last film.

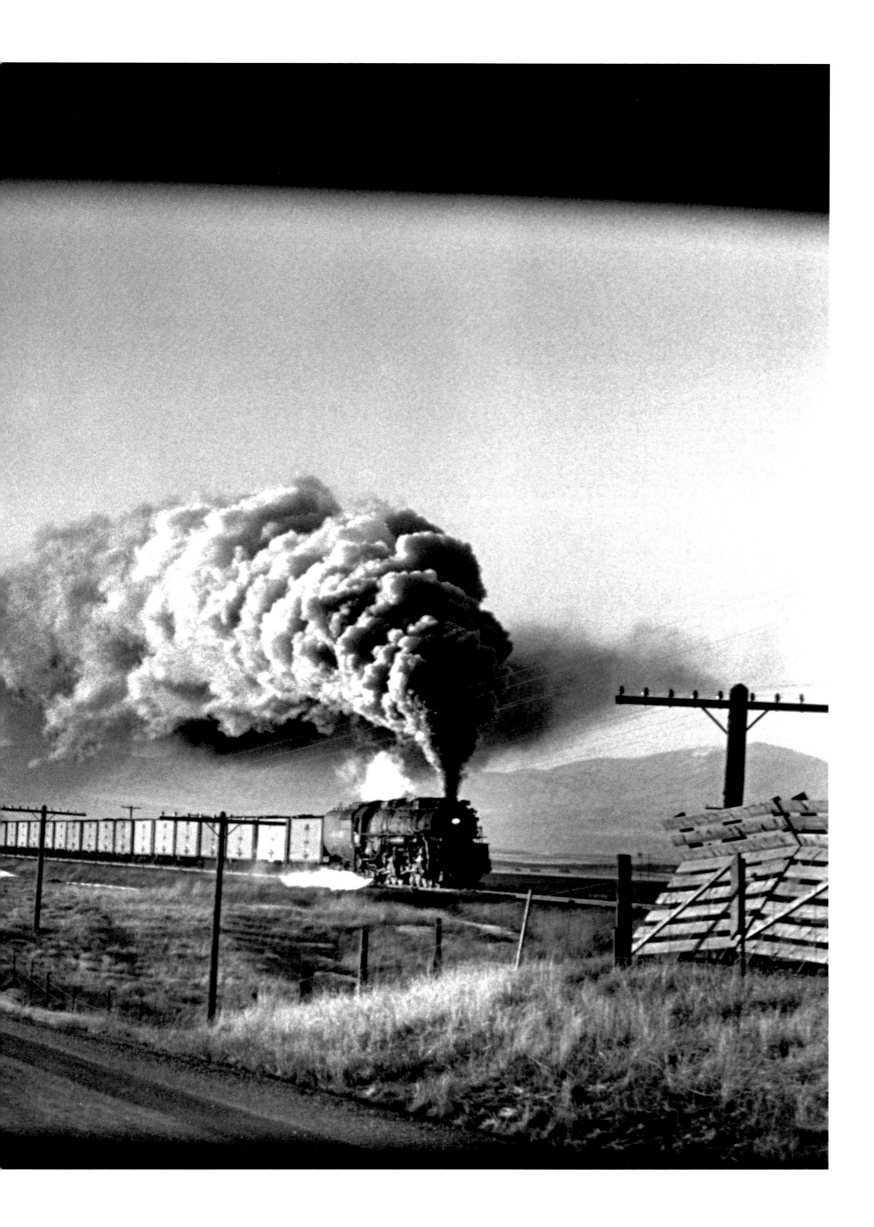

Wyoming, 1954
The open road, a myth of American culture and a symbol of conquest and its thrilling narrative. An automobile and a train move in parallel, framed by the dashboard of another car. Two eras moving together, that of the hoboes of Jack London and that of the Beat Generation of Jack Kerouac, who would publish *On the Road* in 1957. Erwitt had been with Magnum for a year when he took this shot and began his journey among the greats of photography.

Moscow, 1959

In the former USSR as well as in the United States, serious discussions take place in the kitchen. Even at the highest levels. On the occasion of the American National Exhibition in Moscow in July 1959, Soviet Premier Nikita Khrushchev and US Vice-President Richard Nixon debated the relative merits of communism and capitalism while standing in the model kitchen of what was supposed to be a typical American house. It was the famous "Kitchen Debate." As the conversation escalated in tone, and Nixon praised his country's wealth, emphasizing the comparative poverty of the Soviet Union, he jabbed his finger into Khrushchev's chest. Khrushchev, not understanding English, was silent. For the Americans, it was a victory. For Erwitt, the son of Russian parents, in Moscow on assignment from Westinghouse, it was the opportunity for a photo that summed up the arrogance, the fears, and the psychological complexes of the Cold War.

Self-Portrait

Elio Romano Erwitz was born in Paris on July 26, 1928. His father Boris had studied architecture in Odessa. His mother Evgenia came from a rich family in Moscow. The two met in Istanbul and married in Trieste. Boris continued his studies in Rome and the couple then moved to Paris, where their son was born.

The family returned to Italy, specifically Milan, but because of fascism and the racial laws they fled again, to France, and on September 1, 1939, the day Germany invaded Poland, they left for the United States.

Once in New York, Elio Romano Erwitz, who spoke Russian, Italian, and French, but not a word of English, was registered with the name Elliott Erwitt. A few months later the family moved to Los Angeles. In Hollywood, the parents separated.

When he was sixteen, Erwitt worked after school as a printer in a photo studio. It was at this time that he acquired his first camera, an Argus, followed by a Rolleiflex. In 1948 his passion for photography took him to New York, where he worked as a porter in exchange for the chance to attend lectures on film at the New School for Social Research. He met Edward Steichen, Robert Capa, and Roy Stryker, the former director of the Farm Security Administration. Stryker soon offered him a job with Standard Oil Company and a project documenting the city of Pittsburgh, after which Erwitt returned to Europe.

On his return to America and after the military service that would take him to army bases all around Europe, Erwitt was, in 1953, invited to join the Magnum agency by Robert Capa. In that same year Erwitt married Lucienne van Kam, a Dutch girl he had met in France. This was the start of a period of extraordinary activity for Erwitt. He did freelance work for *Life, Look, Holiday, Collier's,* and other periodicals from that golden age of American illustrated magazines. For three years starting in 1968 Erwitt served as president of Magnum.

Erwitt has worked all over the world, from America to Russia, Israel to Cuba, Pakistan to Japan, Afghanistan to Nepal. He has taken portraits of Che Guevara, Marilyn Monroe, Jack Kerouac, Marlene Dietrich, Grace Kelly, and John F. Kennedy. He also took the photo of Jacqueline Kennedy on the day of the president's funeral, with the tear that touched her veil. "It is one of the most beautiful and touching photos that I have ever taken," Erwitt would say. In the 1970s he made a series of documentaries.

Since 1972 Erwitt has published more than fifteen books. During the last few years, after *Snaps* (2001), he published *Personal Best* (2006) and a series of books dedicated to New York (2008), Rome (2008), and Paris (2010). As his alter ego Andrés Solidor he recently came out with a book of strange and unusual color photographs called *The Art of Andrés S. Solidor* (2006).

The photos that Erwitt has devoted to dogs for more than sixty years deserve a chapter all by themselves. Theirs is a complex world that holds a dialogue with our own, and reminds us that the point of view from down below upwards is sometimes the most illuminating.

"THE PHOTOGRAPHERS I ADMIRE ARE THE ONES WHO ARE PART OF MY AGENCY, MAGNUM. THE FOUNDERS, OF COURSE. DOCUMENTARY PHOTOGRAPHERS. THE PEOPLE WHO DEAL WITH THE REAL WORLD AS OPPOSED TO THE CONCEPTUAL ONE. IN FACT I RATHER DISLIKE ... ABHOR ... SOME CONCEPTUAL PHOTOGRAPHY."

Elliott Erwitt

EVANS

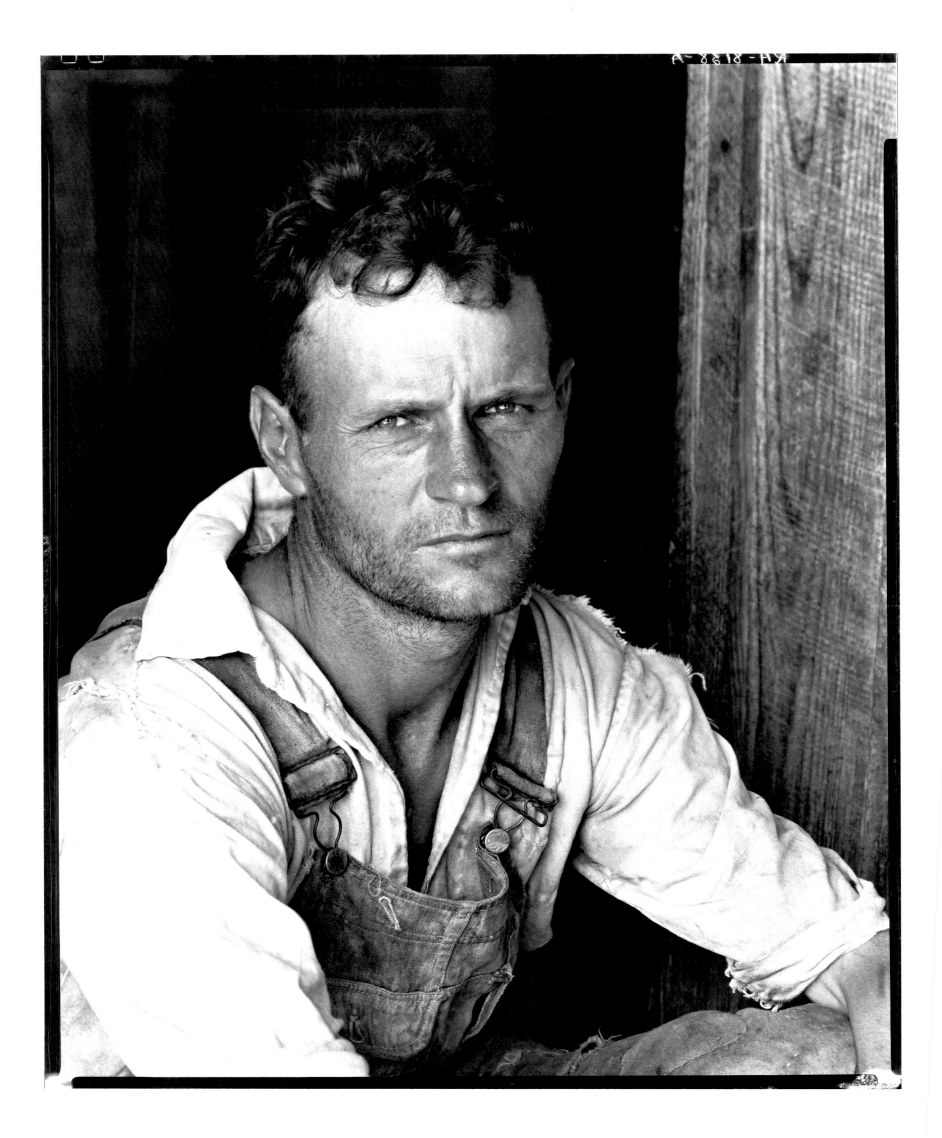

Page 162
Photo Display, Savannah, Georgia, 1936
This collage of sample photos has all the appeal of pop art. It is in fact an advertisement from the shop window of a photographer in Georgia. At the same time it provides an eloquent account of one segment of that society. These were the hard years of the Depression, but the men and women sat down in front of the photographer with smiles on their faces in order to create a visual memory of themselves at that time. If you look at the images up close, you realize how the photographer has made a genuine composition out of it, covering the less successful portraits with photos from other contact sheets that came out better.

Above
Floyd Burroughs, Hale County, Alabama, 1936
In the dusty heart of Alabama, hit hard by the Depression, Walker Evans and James Agee spent several weeks with the Burroughs family, with the idea of telling the story of the desperate social and economic situation in the rural areas of the country. The intense, painful stare of this head of family with his torn clothes provides an eloquent insight into those "bitter years" in the United States.

WALKER EVANS

Walker Evans had studied literature and wanted to become a writer. He loved Flaubert and his particular realism, above all. Evans later discovered photography, and, using the language of photography, succeeded in writing some of the most memorable pages of the twentieth century in America. And he did so with an eye turned always toward his literary model, of whom he said that he admired "the non-appearance of the author. The non-subjectivity. That is literally applicable to the way I want to use a camera and do."

Evans was born in St. Louis, Missouri, to a well-to-do family. After his studies, he worked for a brief period at the New York Public Library and in 1926 he left for Paris, where for a year he attended various courses at the Sorbonne. It was in this period that Evans came to know the photographic work of Nadar, which would always touch him deeply. Once back in the US he bought a camera and decided to become a photographer. His education and the reverential awe that he felt for literature had until then prevented him from becoming a writer. But in his encounters with photography his mind was free and independent. These first years after his time in Europe were marked by great economic difficulty but also by a growing and ever more self-aware creative ferment.

The streets of New York and its working-class architecture were the chosen backdrop for educating his eye. He wanted his work to be "literate, authoritative, transcendent."

In 1935 Evans became part of a group of photographers at the Farm Security Administration (FSA), a government agency established under the policies of the New Deal to support small farmers. The photographers, under the direction of Roy Stryker, produced extensive reportage in order to provide a comprehensive picture of the dramatic social, economic, and moral conditions in the rural areas of the country, those hardest hit by the Depression which followed the financial crash of 1929. For three years, from 1935 to 1937, Evans traveled in the poorest states of the Midwest and South, collecting images of a country that was worn-out. Of all those on the team at the FSA, Evans was certainly the least credentialed. While his colleagues mostly used small-format cameras and produced a great quantity of images, he preferred a large-format plate camera (a folding 8 x 10) which required a tripod and allowed him to take photos that were few in number but perfect in formal terms.

Bare and deserted buildings, advertising signs and posters, faces etched by the marks of hunger, dusty and empty streets: his images are a direct and immediate record of the condition of the country, produced in an austere style, with a clarity and simplicity that rejects any kind of romantic idealism. The same faces and villages, the same landscapes right out of a Steinbeck novel, those of an America that was waking from the glorious dreams of the Roaring Twenties, in search of a genuine truth. Evans would look for the visual detail, not as an end in itself, but as one that might reveal the traces left by a man and his presence. Inanimate objects, a pair of shoes in the center of the frame, a crack on the wall: all these become symbols of the world of which they are a part, and of the people who live in it. His eye manages to give these banal, everyday objects not only beauty but dignity. It is a type of mystery that emanates from the ambiguous simplicity of each image. For example the photos of torn advertising posters which, in the empty streets or even in the poverty-stricken interiors of the houses, continue to promote, almost in a sinister way, a virtual American way of life, with no connection to the times and economic reality.

Evans's images have enlarged and shaped our way of looking at gas stations, junkyards, electricity poles, folk architecture, home interiors, and dusty streets. The public places in which men live and suffer. *Let Us Now Praise Famous Men* is the title of one of the most original books in the history of the relationship between photography, literature, and journalism. It was the result of several weeks in 1936 that Walker Evans and the writer James Agee spent with sharecropper families in an American South hit hard by the Depression. Originally intended to be an article in *Fortune* magazine, it instead became a narrative at once literary, journalistic, and poetic, of the history of a country, an example of collaboration and dialogue between photographer and writer, the symbol of an untiring investigation into the complexity of truth.

Evans's output would in the years that followed continue to challenge the conventional notions of photography of his own time, anticipating future developments in its language and way of seeing. Like the images taken with a hidden camera while riding the New York City subway, or the street portraits, or the instant photos of buildings and landscapes taken from the windows of moving trains.

America saw itself in his images, and what it saw would change its way of looking forever.

Atlanta, Georgia, 1936

In the foreground, in the center of the frame, a car. Behind it, the front of a tire dealer's workshop. The shot is frontal, just like the lighting, and the shed has an almost two-dimensional solidity, as if it were the wing of a theater. The bright light illuminates the rims of the wheels and the particular whites of the image, such as the white skin of the woman whose presence, on the left of the picture frame, gives the image an indecipherable fascination.

It is an ordinary moment in the daily life of an American city: working in a garage in the blinding light of Georgia. And yet Evans's photographs, even taken one by one, in that same moment in which they are able to summon up an incontrovertible sense of the specificity of a place, always keep alive a subtle and meaningful mystery.

Evans would maintain that art is not a document, but that it can adopt a style. He coined the phrase "lyric documentary" in order to define his images. Thanks to their structure and restless beauty they assume the life of a metaphor yet remain intertwined with all the daily and dusty reality of their own time. One must learn how to look because, in the depths of the ordinary, stories that have never been told before are hiding. That truth which is discovered, not constructed.

The poet William Carlos Williams would say this about Evans's photos: "It is ourselves we see, ourselves lifted from a parochial setting. We see what we have not heretofore realized, ourselves made worthy in our anonymity."

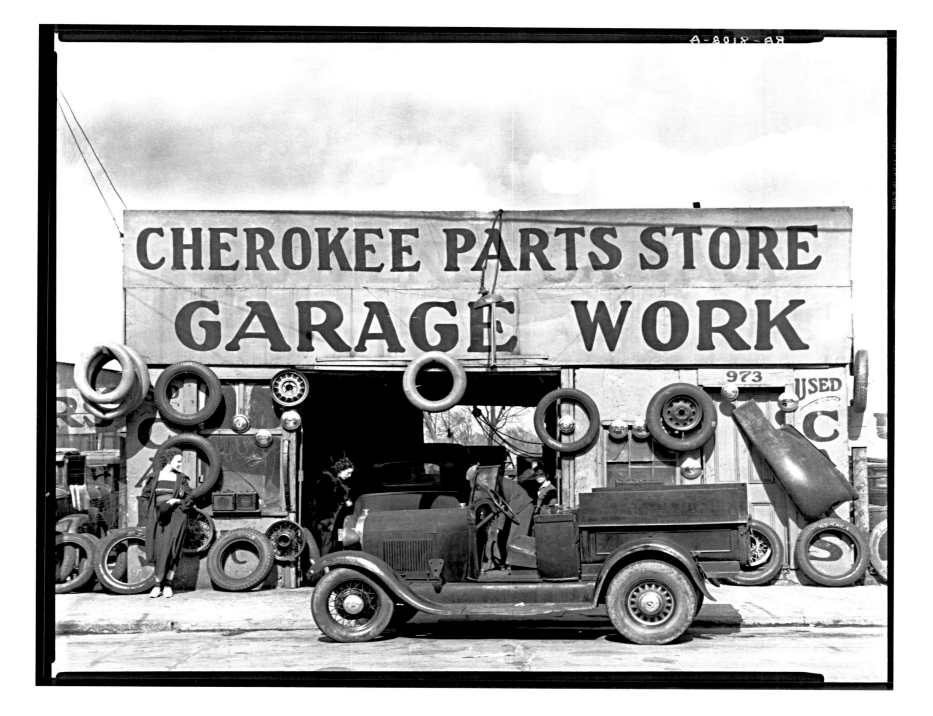

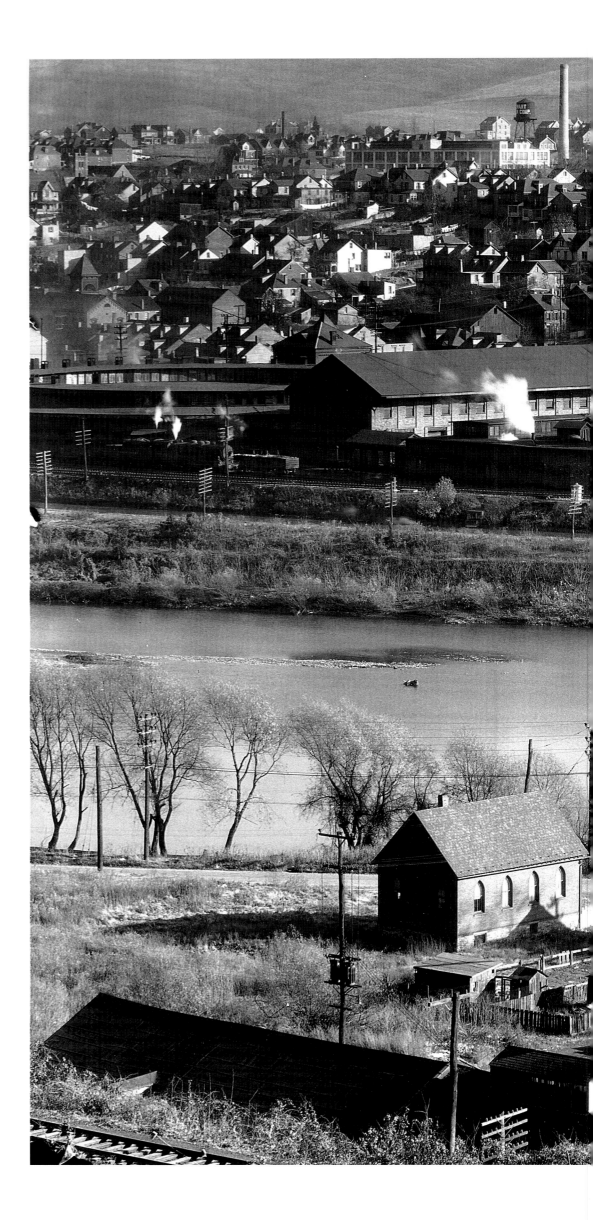

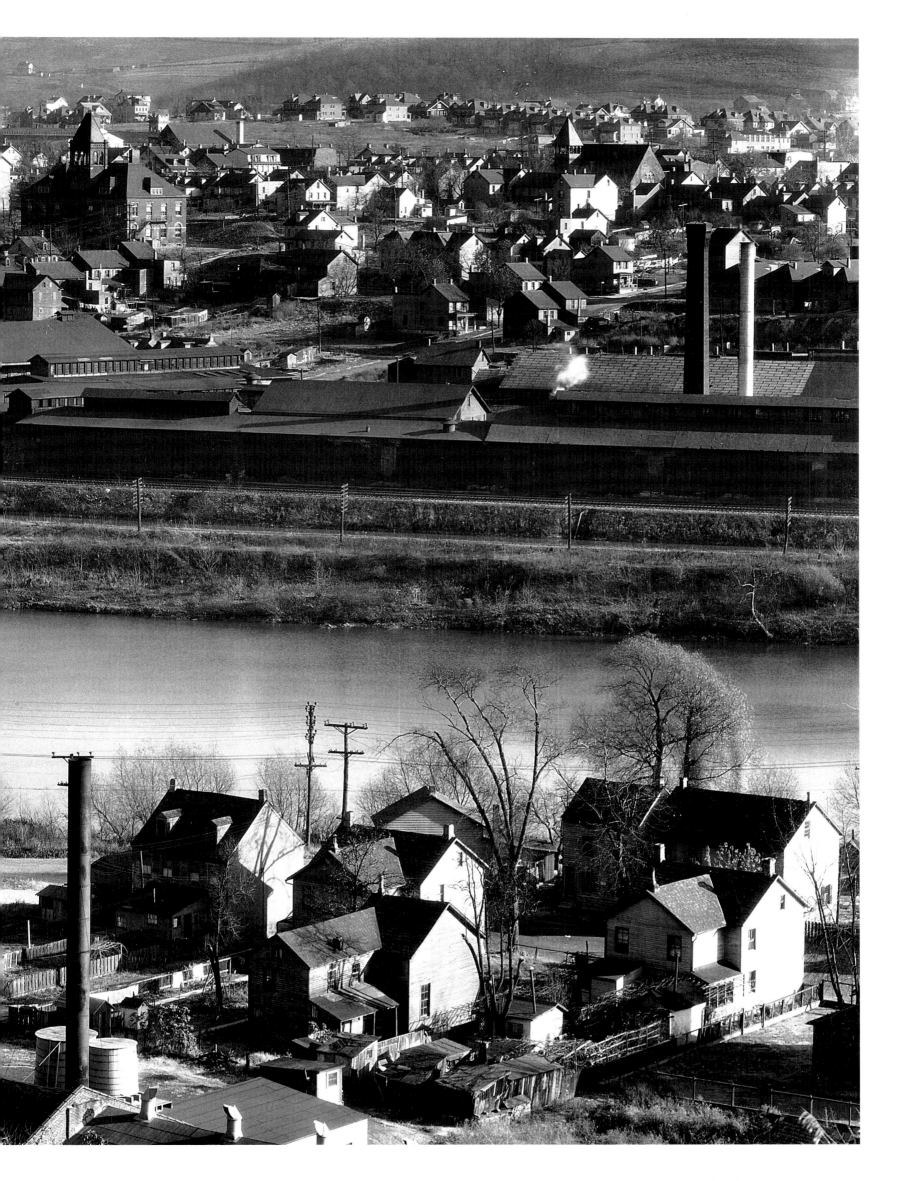

Detail of a view of Easton, Pennsylvania, 1935
Before he understood that he wanted to be a photographer, Evans was already a great collector of postcards. He collected them all his life, becoming something of a historian of the genre. It was precisely with these images, which he called "folk documents," that he completed his early education in how to look at things. This photo was part of a project on which Evans worked in 1935–36 with the idea of producing a series of postcards based on his photographs. The composition zooms in on a handful of low houses and small courtyards. The geometry of the forms, modeled by the light, and the orderliness of the whites and blacks, work to liberate the genre from any nostalgic romanticism, and to elevate it to a form of art.

Ossining, New York, 1932
Photography is the art of observing, according to Evans, and often has more to do with the way of seeing things than with the things themselves. A street photographer abandons the studio and runs along the sidewalk looking for the rhythm of his own era in the automobiles on the road or in the faces of passersby, as in the questioning gaze returned by an unknown person before driving off out of the picture frame.

"THE MEANING OF QUALITY IN PHOTOGRAPHY'S BEST PICTURES LIES WRITTEN IN THE LANGUAGE OF VISION. THAT LANGUAGE IS LEARNED BY CHANCE, NOT SYSTEM; AND, IN THE WESTERN WORLD, IT SEEMS TO HAVE TO BE AN OUTSIDE CHANCE. OUR OVERWHELMING FORMAL EDUCATION DEALS IN WORDS, MATHEMATICAL FIGURES, AND METHODS OF RATIONAL THOUGHT, NOT IN IMAGES. THIS MAY BE A FORM OF CONSPIRACY THAT PROMISES ARTIFICIAL BLINDNESS. IT CERTAINLY IS THAT TO A LEARNING CHILD. IT IS THIS VERY BLINDNESS THAT PHOTOGRAPHY ATTACKS, BLINDNESS THAT IS IGNORANCE OF REAL SEEING AND IS PERVERSION OF SEEING. IT IS REALITY THAT PHOTOGRAPHY REACHES TOWARD. THE BLIND ARE NOT TOTALLY BLIND. REALITY IS NOT TOTALLY REAL."

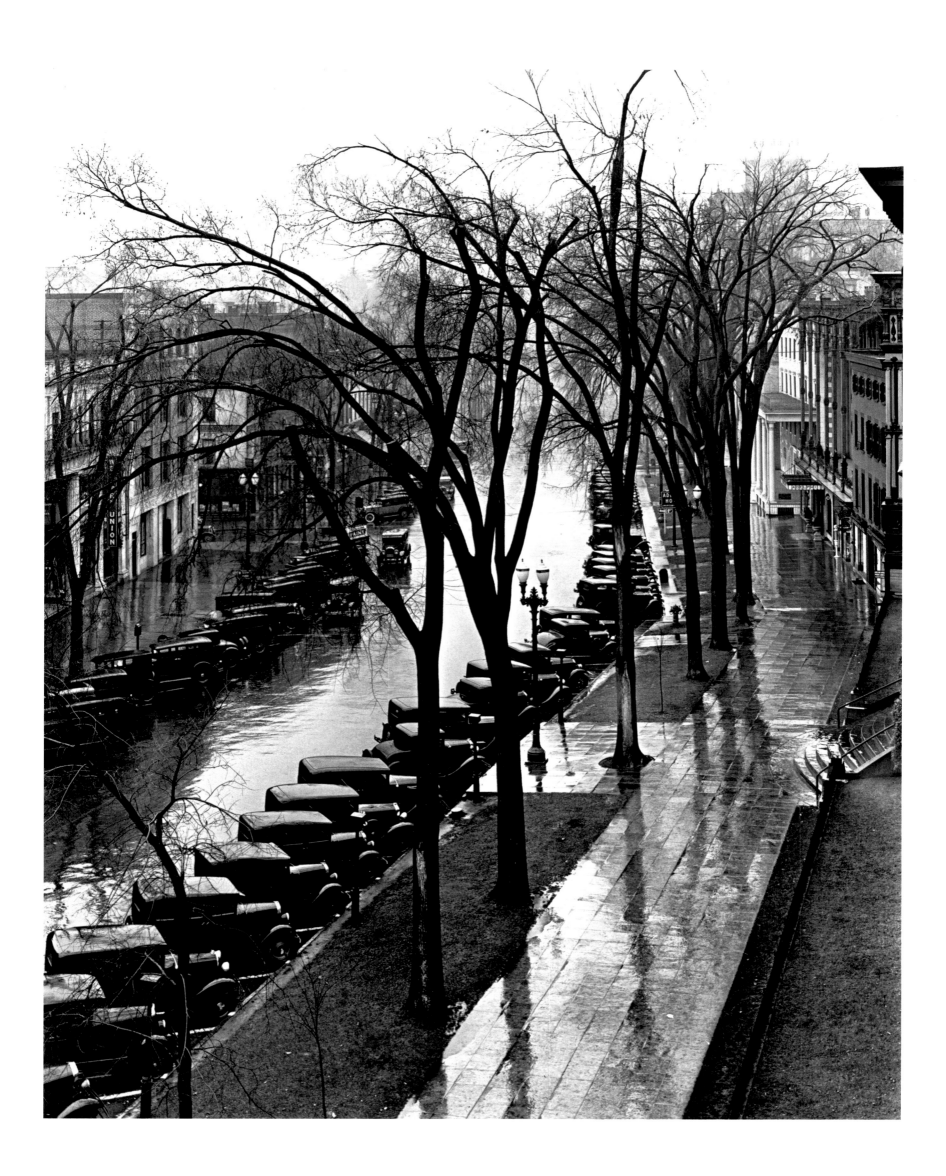

Main Street, Saratoga Springs, New York, 1931
His hotel room in Saratoga Springs looked out onto the town's main street. It had rained a lot that day and, looking out the window, Evans must have quickly grasped the photographic possibilities of that view: the street so soaked with water as to resemble a silvery canal on which rows of black automobiles float in orderly succession. In the foreground, along the vanishing point, the white of the water and sky come together, inundating the view with a delicate lyricism.

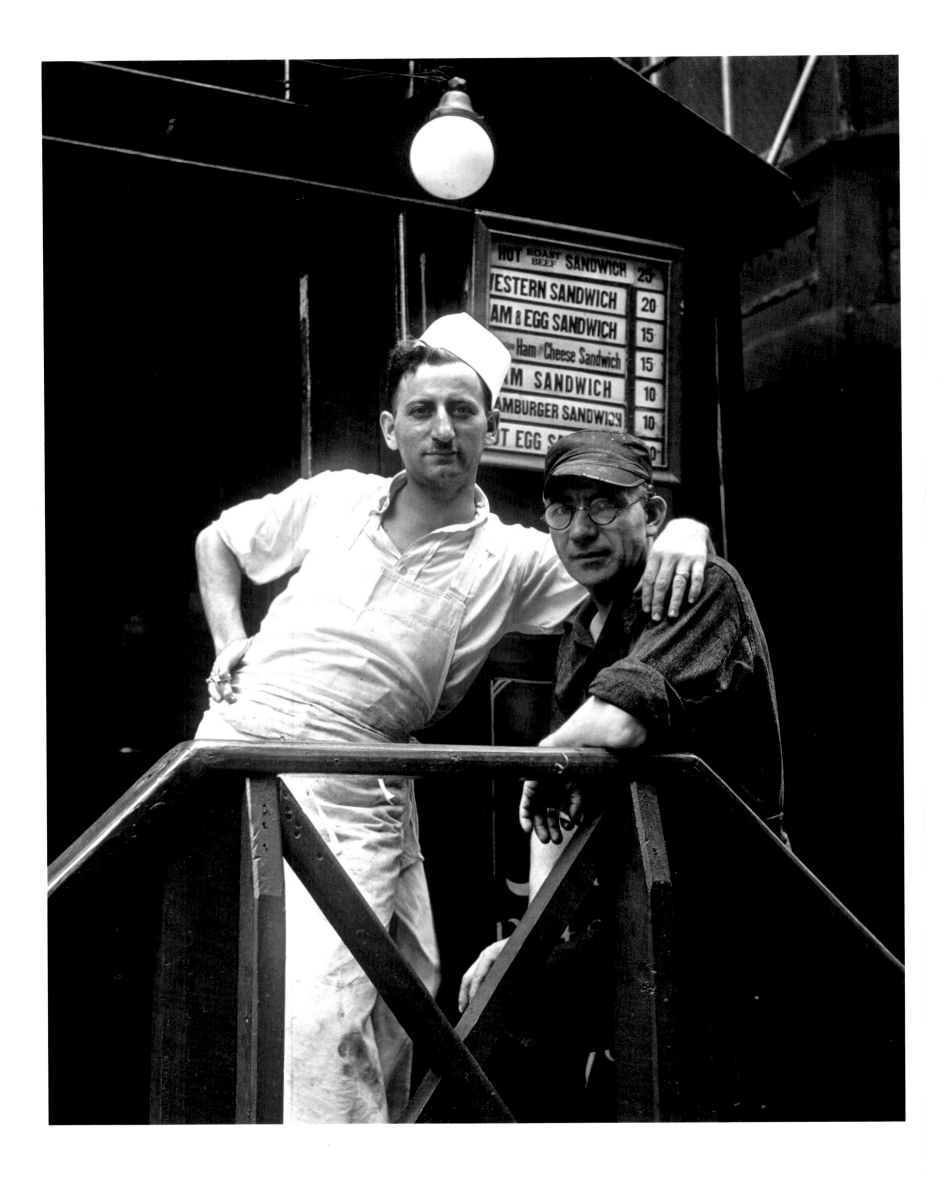

Portraits, New York City, 1931
The interest that Evans had in ordinary things characterized and shaped all his artistic efforts from the first. New York and its working-class neighborhoods were a great source of inspiration and instruction for this great artist, considered the father of American photography.

In 1971, referring to his early photos, Evans said, "I found I wanted to get a type in the street, a 'snapshot' of a fellow on the waterfront, or a stenographer at lunch. That was a good vein. I still mine that vein."

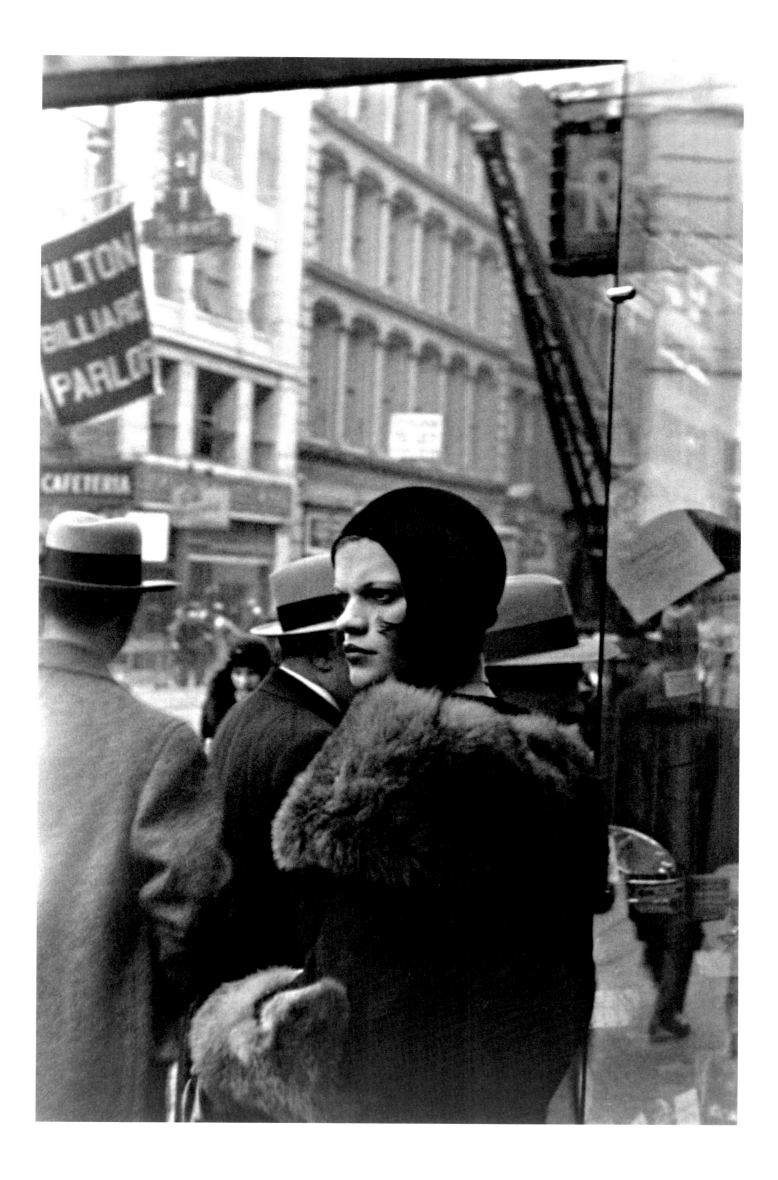

Fulton Street, New York City, 1929

He purchased his first camera in 1928. Those were the years when a chronic shortage of money forced him into a bohemian way of life. But they were also prolific and creative years in terms of the visual apprenticeship that Evans completed on the streets of New York, photographing faces, streets, and working-class buildings. And he taught himself how to look. On this subject, he would say, "It's the way to educate your eyes. Stare. Pry, listen, eavesdrop. Die knowing something. You are not here long."

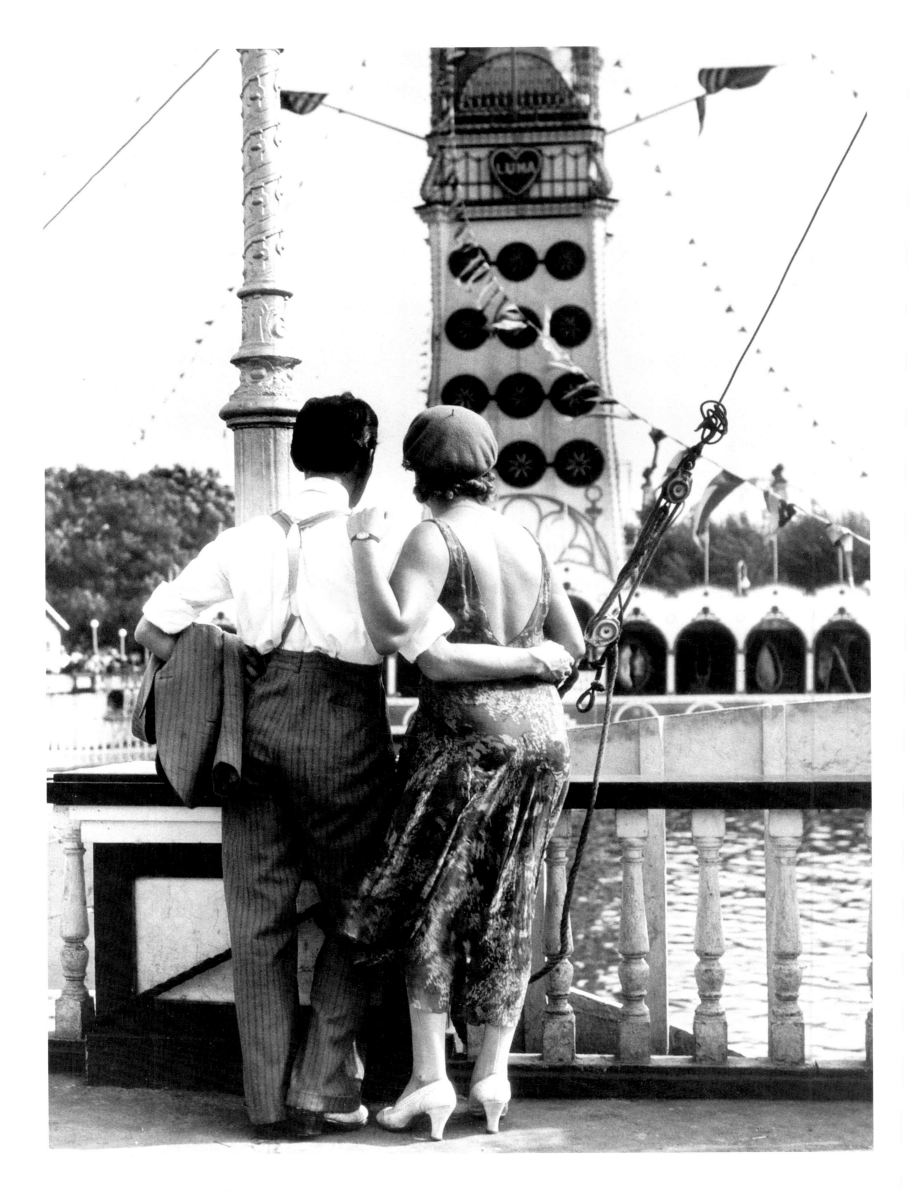

Couple on Coney Island, 1928
The roads of lovers lead to Coney Island. A couple lean on a balustrade in order to look at the ocean, one summer day. Evans is there, unseen, to gather bits of everyday life. He was convinced that the camera could reveal the values of a society, capturing the ordinary gestures of people, their way of walking, their expressions, and their conscious and unconscious ways of appearing.

Torn Film Poster, 1931

As often happened, Evans produced at least two versions of this image. In the first shot, the frame is widened to show the entire poster and the man's protective embrace. In this version, the narrative is broken off and the tear dominates the image, becoming almost a wound on the woman's terrorized face. As Lincoln Kirstein would say, these images of a poster torn by the wind and rain take on the mysterious and disturbing aspect of some horrible accident or crime.

"WHETHER HE IS AN ARTIST OR NOT, THE PHOTOGRAPHER IS A JOYOUS SENSUALIST, FOR THE SIMPLE REASON THAT THE EYE TRAFFICS IN FEELINGS, NOT IN THOUGHTS. THIS MAN IS IN EFFECT A VOYEUR BY NATURE; HE IS ALSO REPORTER, TINKERER, AND SPY. WHAT KEEPS HIM GOING IS PURE ABSORPTION, INCURABLE CHILDISHNESS, AND HEALTHY DEFIANCE OF PURITANISM. THE LIFE OF HIS GUILD IS COMBINED SCRAMBLE AND LOVE'S LABOUR LOST."

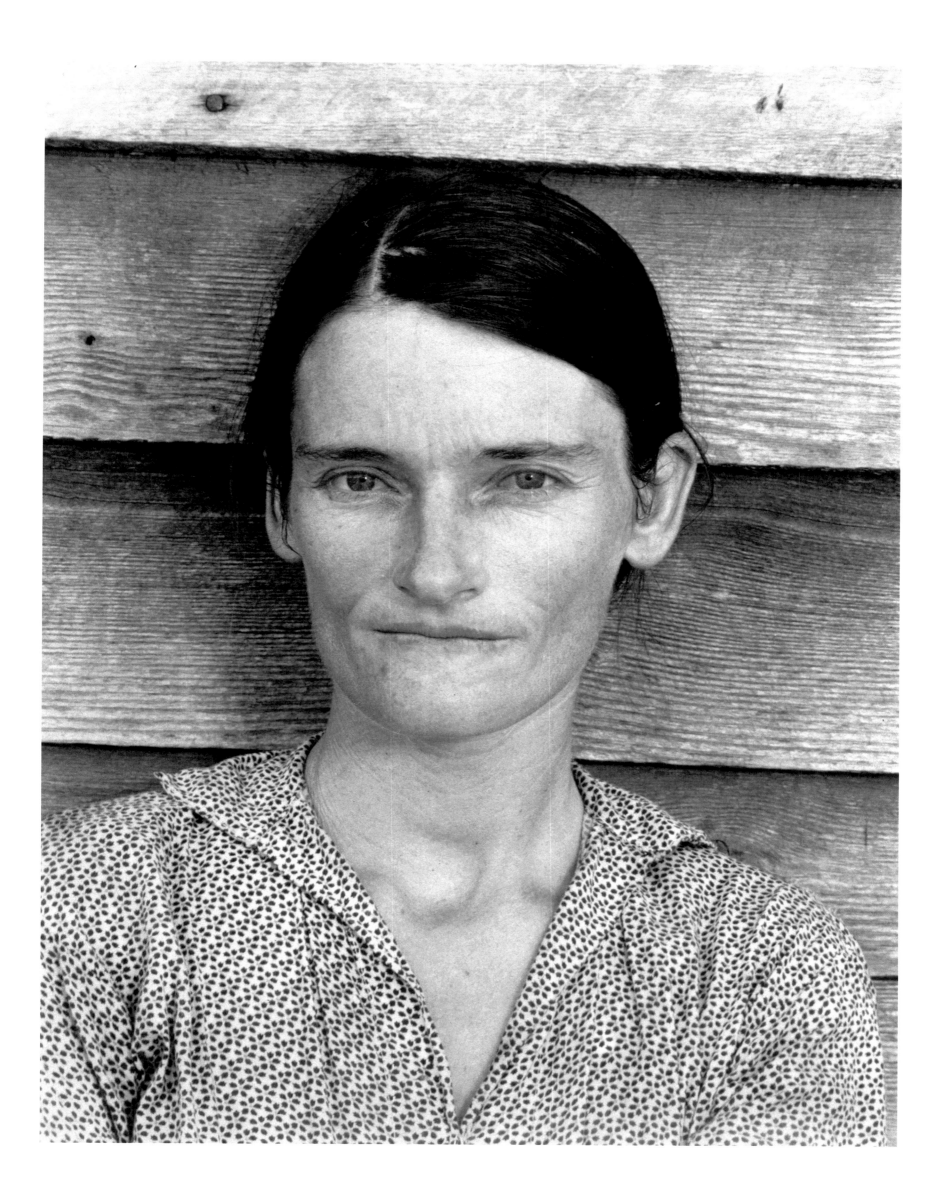

Allie May Burroughs, Hale County, Alabama, 1936
This image has become a symbol of the Depression and an icon of twentieth-century photography. In order to tell us about the contradictions between the reality of America and its ideals, Evans lets the expressions and gazes of farmers and country people speak for themselves. Men and women, their faces lined by poverty, portrayed with an intense simplicity, posed, their frank gaze turned to the camera, looking directly at the observer, who is summoned to a direct confrontation with the subject.

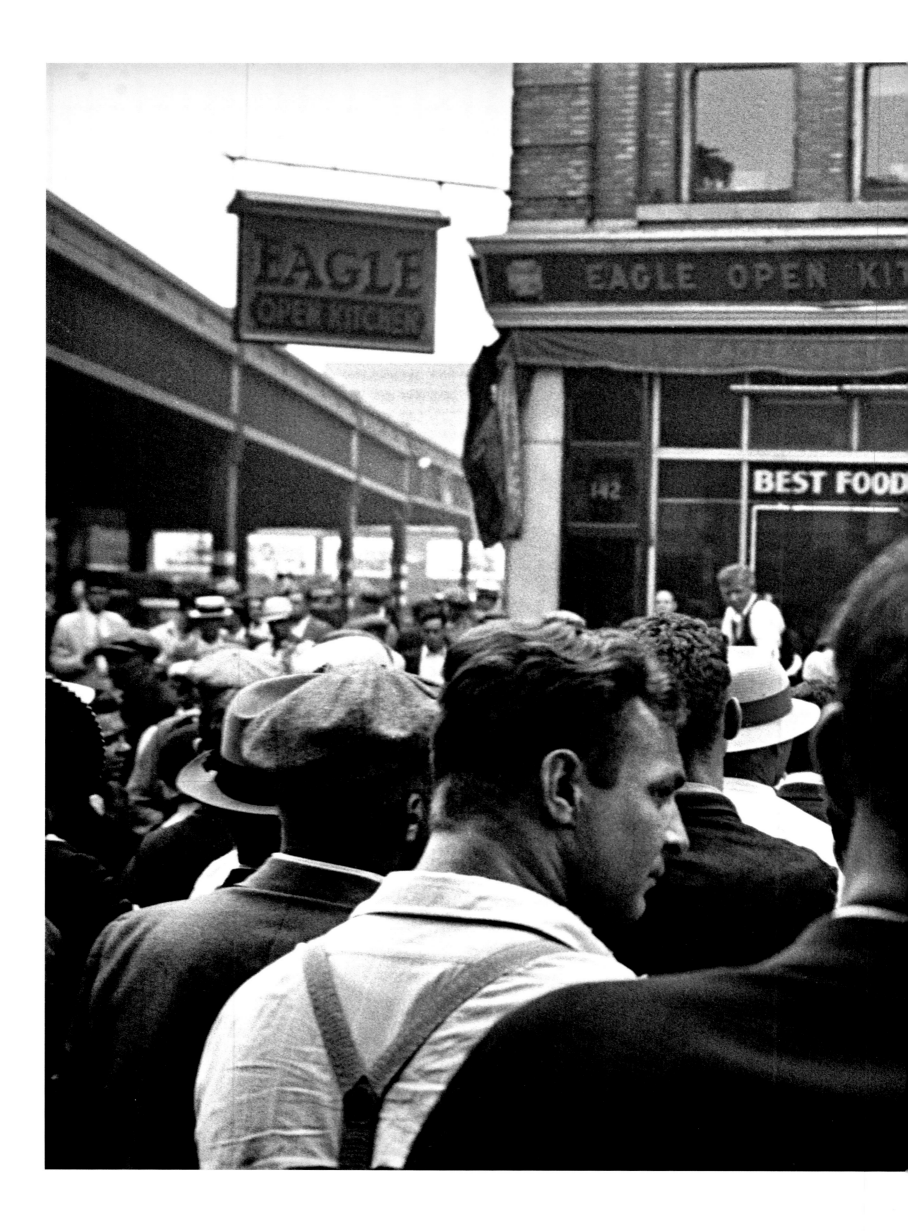

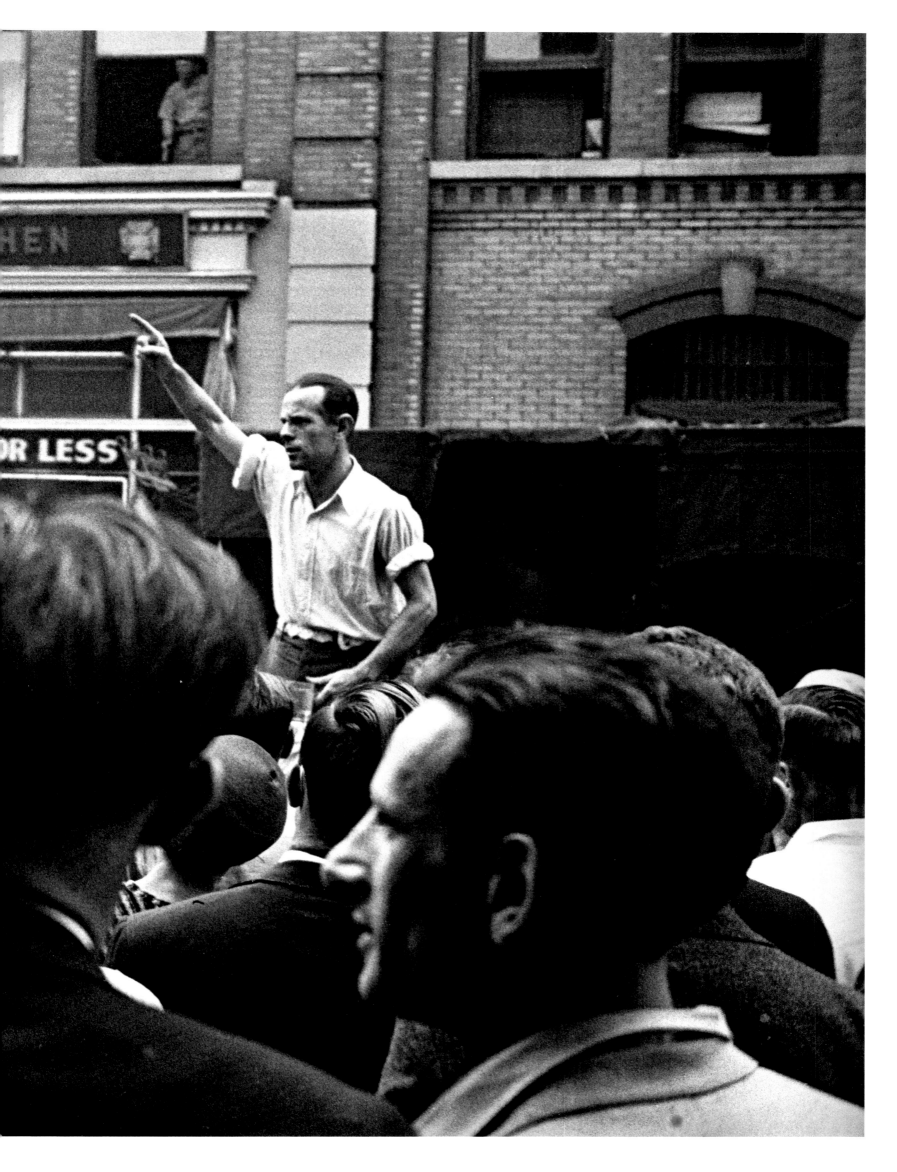

A Gathering at the Port During a Strike, New York City, 1933
"When you say 'documentary,' you have to have a sophisticated ear to receive that word. It should be documentary style, because documentary is police photography of a scene and a murder ... that's a real document. You see, art is really useless, and a document has use. And therefore, art is never a document, but it can adopt that style. I do it."

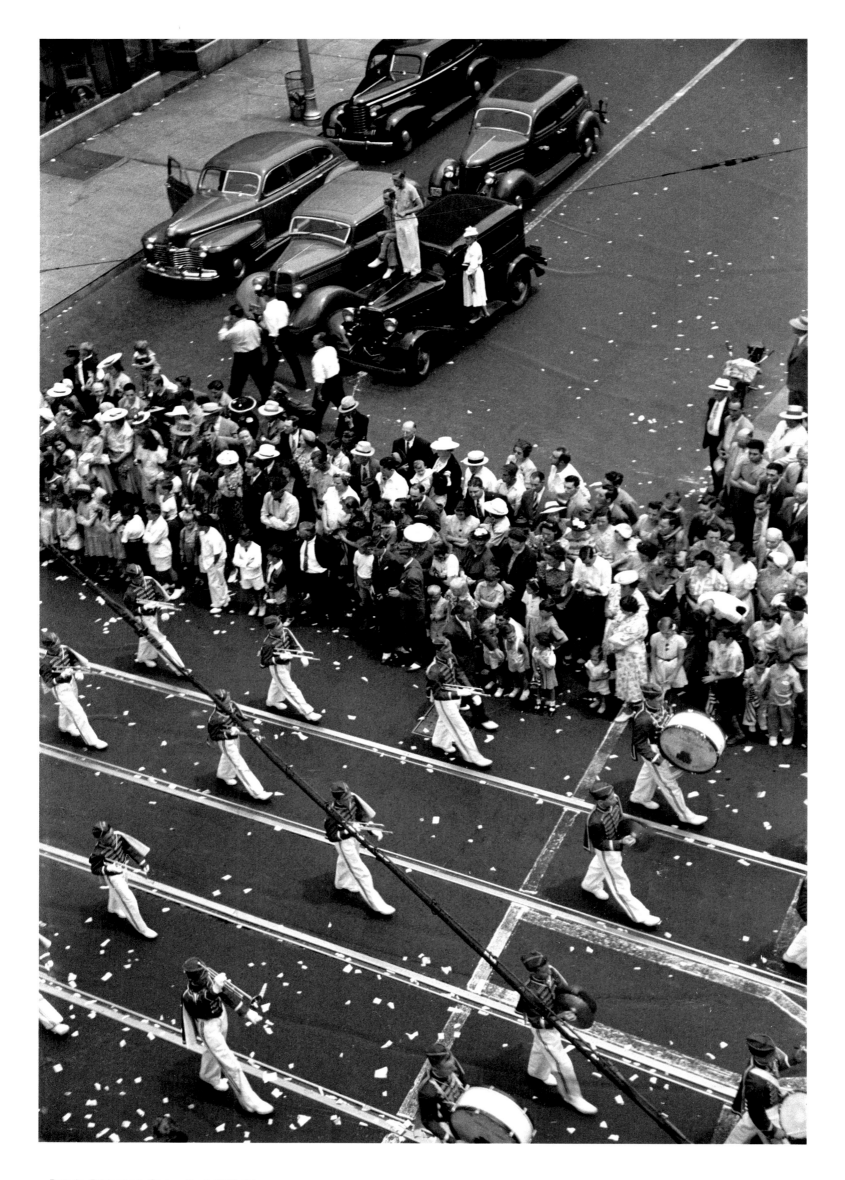

Parade, Bridgeport, Connecticut, 1933–34

This is what Lincoln Kirstein said on the occasion of the Walker Evans exhibition *American Photographs* which opened at MoMA in 1938—the first exhibit dedicated by the museum to the work of a single photographer: "Compare this vision of a continent as it is, not as it might be or as it was, with any other coherent vision that we have had since the war. What poet has said as much? What painter has shown as much? Only newspapers, the writers of popular music, the technicians of advertising and radio have in their blind energy accidentally, fortuitously, evoked for future historians such a powerful monument to our moment. And Evans' work has, in addition, intention, logic, continuity, climax, sense and perfection."

Self-Portrait

Walker Evans was born in 1903 in St. Louis, Missouri. He lived with his family in Toledo and Chicago, where he studied for several years before moving to Paris in 1926, with the hope of becoming a writer and learning French.

He took several courses at the Sorbonne and after one year went back to America, to New York.

Evans purchased a camera in 1928 and, frustrated by his failure to find a job that would allow him to pursue his literary passion, decided to become a photographer. Within a short time he earned the trust and support of artists and writers of the time such as Lincoln Kirstein, Berenice Abbot, and Jay Leyda.

In 1930, Evans published his first three images in *The Bridge,* a book of poetry by Hart Crane. In 1933, he produced a photographic documentation of Havana, Cuba, for *The Crime of Cuba, a* book by Carleton Beals. The photos aroused a good deal of interest.

In 1935, Evans became part of a group of photographers working for the Farm Security Administration, with which he would work until 1937, documenting life in the more depressed rural areas of the US.

In 1936, Evans and the writer James Agee spent several weeks with sharecropper families in the South in order to tell the story of their difficult life. They had been sent on assignment for a magazine, but instead produced the book *Let Us Now Praise Famous Men,* an unforgettable example of collaboration between words and images, published in 1941.

In 1938, Evans's show *American Photographs* opened at the Museum of Modern Art in New York, the first show at MoMA dedicated to the work of a single photographer. The book which accompanied the exhibit, with an introductory essay by Lincoln Kirstein, would exercise a profound influence on the work of young photographers such as Robert Frank and be a milestone in the development of documentary photography.

In 1943 Evans began working as a writer for *Time* magazine, but soon went to *Fortune* in a joint role as writer and photographer. During these years he continued to work on a series of personal projects, among them the series of images *Beauties of the Common Tool.*

In 1965 Evans became a lecturer in photography at the Yale School of Art and Architecture. In 1966 he published *Many Are Called,* the result of a project first started in 1938. It is a series of photos "stolen" while riding the subway, taken with a small-format camera. In 1971 MoMA gave him another solo show, with the title *Walker Evans.* The show's catalog opened with a long introductory essay by John Szarkowski, director of the museum's photography department.

Evans continued his experimentation and artistic efforts and, in 1973, began to use an SX-70 Polaroid. A large collection of those images would be published in *Walker Evans: Polaroids,* in 2001.

Evans died in 1975 in New Haven, Connecticut.

"PHOTOGRAPHY IS NOT CUTE CATS, NOR NUDES, MOTHERHOOD OR ARRANGEMENTS OF MANUFACTURED PRODUCTS. UNDER NO CIRCUMSTANCES IS IT ANYTHING EVER ANYWHERE NEAR A BEACH."

WALKER EVANS

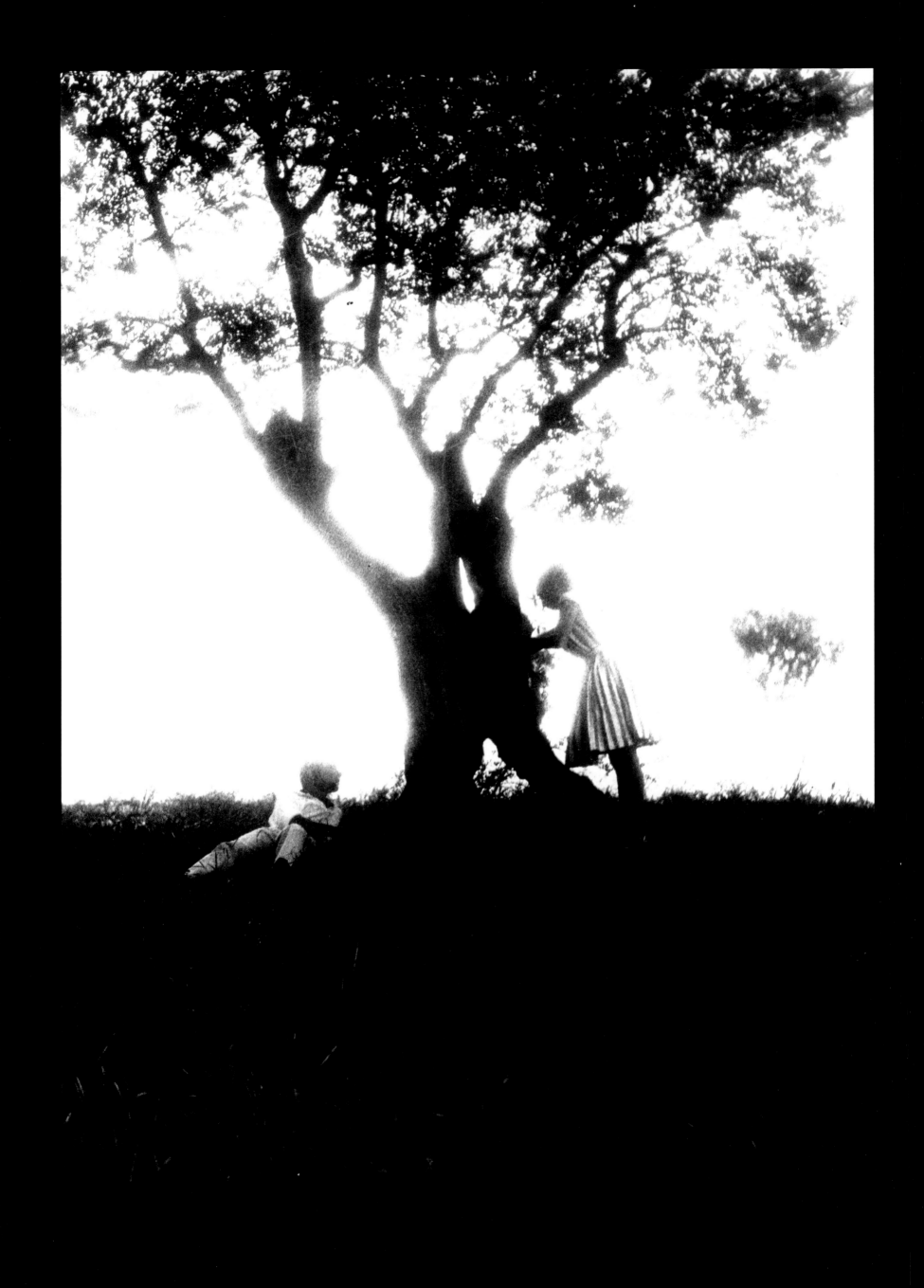

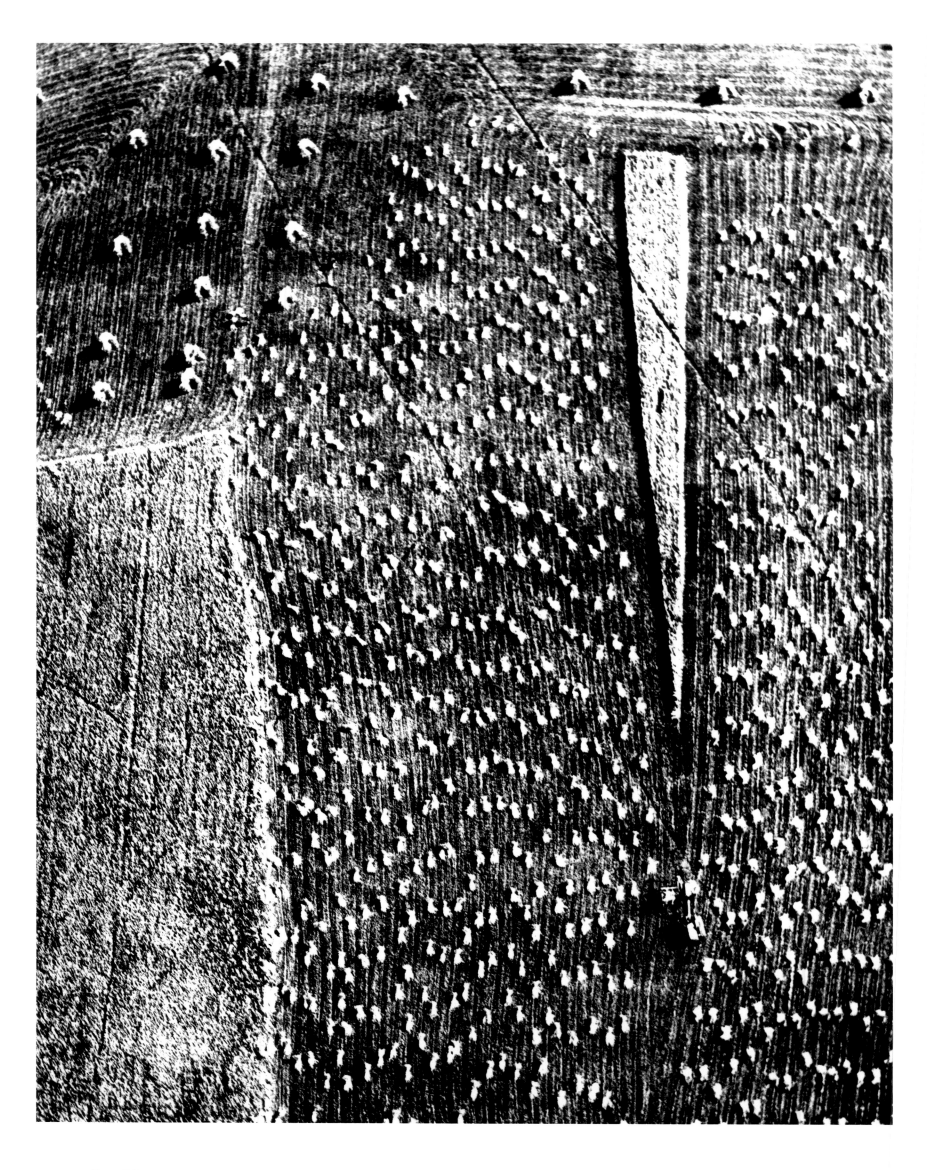

Page 184
From the series "A Man, A Woman, A Love," 1960–61
"If I lived at least one day, if I could live, if I live, I will never know if it were true. I will close my eyes and they will see me die, there will be no before and no after, I will leave my portion in a walled garden of dreams and at every spot, on all the paths, they will stand there in order to describe the ruin of my life where death died. . . . They will never know if it were true."

Above
From the series "On Being Aware of Nature," 1954–2000
"I don't know if it is understood. But around each form there are other forms. Sometimes people are like black voids and surrounding them is the density of reality, other times they are luminous matter and around them flows a rough and hard reality, the traumatic flow of time."

MARIO GIACOMELLI

"It is good fortune to be born poor." The last interview with Mario Giacomelli, by then confined to his bed by the illness that would take his life at age seventy-five, in November 2000, in his native, ever-present, city of Senigallia, began with the observation that to be born in poverty was for him an unavoidable starting point but also, in the final reckoning, an opportunity to know life in all its bitter turns, shuffling through its dramas of existence, so as always later to succeed in drawing out a poem, an enthusiasm for those simple and truthful things that animate human events. At times they make life happy, at others they darken it, but they always mark it with strong colors and contrasting hues. "My father died when I was nine years old; I was the oldest of my brothers and my mother wanted me to study"—this is how Giacomelli remembers his childhood—"there wasn't enough to eat and I never had any toys. When you are poor, everyone looks down on you and my mother had to look for work at the old people's home. At that time there were no washing machines and she did their laundry while I kept her company."

Later, when he was thirteen, young Mario fell in love with typography and decided to make it his career. "I passed in front of the printing shop windows and saw all the typeset material—the back-to-front characters, the upper-case ones....They fascinated me." In the creation of multiple positive images from manipulated negative images, Giacomelli saw that it might be possible to invent new graphic forms. This is how he came to be a photographer, seeking a language that was dense and compact, able to convey his dreams and visions. "I began to see the spots on the wall, the wire threads. They were wonderful. Everything was beautiful.... The whites, the blacks, the blurring: these are techniques that require a lot of precision and if you are not convinced by the result it's better to throw it all out." He worked in series and each one was a working-out, a process, to which he would return again and again, on which he would work like an engraving tool in the making of a print. "For me, it is not the individual photo that is important, but the series, the narrative. What matters is what is born in my mind. It almost always happens that I see the photos before I make them." The blacks are more black than black; the whites blinding and absolute.

He followed his obsessions and gave substance to them. He went back to the old people's home, capturing and creating scenes of life at its limits, drawn out on a thread of existence and desperation. He went to the very heart of suffering, to Lourdes, and on pilgrimages to Loreto. He reported on what he came to know and what never ceased to fascinate him: the rhythm of work in the fields and the calm pace of life in the country, as in the faces and steps of people in Scanno, a town in the Abruzzo region of Italy. And because his visual narrative is essentially poetic, the images in the series often have the names of poems, some famous and some not, that inspired him or struck him with an assonance, a reference, or a possible comparison. The photos in the old people's home would be called "Death Will Come and Will Have Your Eyes." The narrative of a young girl would be called "The Revisitation," or "The Contamination," after Leopardi's poem *A Silvia* (To Silvia). Giacomelli's most famous series, "I Pretini" (Little Priests), would be given the title of a poem by David Maria Turoldo, "Io non ho mani che mi accarezzino il volto" (I Don't Have Hands that Caress My Face). In that series, young seminarians are surprised in the act of enjoying themselves, in a whirl of frocks, chasing after each other, laughing, having a good time, like an unexpected gift from heaven, their hats white with a sudden snowfall.

"Nothing happens by chance, not the white, nor the black. As in that famous photo in Scanno: the black figure waits for the white. When you snap a photo you have to be fast, and for that one I was fast enough."

The series on which Giacomelli worked the longest was the one dedicated to the "vertical" landscape of the Marches region of Italy. He photographed panoramas from above, at times aerial shots, and his land became the map of a territory that was always new, in which the furrows of the plow create unexpected symmetries, and the outlines of the beach umbrellas on the Adriatic become macroscopic reliefs of a biological fabric that is alive and real.

If besides being a document, photography can also be considered a vision, then no one has been a photographer more than Mario Giacomelli. No one has had an equal understanding of the technical and dreamlike limits of film, exposed and worked in the same way a line of poetic verse is fashioned. "For someone like me who uses a camera it is interesting to leave the horizontal plane of reality, to have the possibility of a stimulating dialogue that would give the images an unrepeatable breath. To rewrite things, changing the sign, the customary knowledge of the object, to give photography a completely new emotional pulse. Language becomes a sign, a necessity, a spirit from which the form is released in a creative process not from the outside but from the inside. The out-of-focus, the blurred, the grainy white, and the deep black are all like an explosion of thought that makes the image endure, so that it becomes spiritualized in harmony with the substance, with the reality, in order to document its interiority, the drama of life. "In my photos I would like there to be a tension between light and blacks, repeated until the meaning begins to emerge."

From the series "I Don't Have Hands that Caress My Face," 1961–63

It is 1961. Giacomelli begins to frequent the episcopal seminary in the town of Senigallia and to observe the lives and relationships of the young seminarians there. In the first year he takes few photos, as he needs to get used to the place and understand it. In this way he comes into contact with a separate world, one made of renunciation, a distancing of affections, dedication, and a necessarily different way of being young. The energy and the strength of that youthfulness are truly enclosed within the mechanisms of a separate world that makes a deep impression on the photographer.

The series "I don't have hands that caress my face," a title inspired by a poem by Father David Maria Turoldo, began in this way in January 1962, when a snowfall unleashed a desire for amusement among the young priests and the black of their frocks against the white of the snow lit up the photographer's visual intuition. Once again the contrast between the black figures and the white spaces becomes the key to the entire series, not only in a formal way but also in terms of meaning. One day, while hidden in a garret under the roof of the seminary, Giacomelli took photos of the seminarians during a moment of recreation while they whirled around in circles on the terrace.

In the photos of this series the depth of field is not predominant. Of greater importance are the interwoven threads, the forms, and the dynamics of the signs within the composition. Giacomelli catches the young men, in their dark frocks, while they dance hand in hand in a childish and joyful "Ring Around the Rosie." The feeling of lightness that the photo manages to com-municate comes from the intense whites that isolate the figures. These are obtained during printing by an accentuation of contrast and careful masking that eliminates all spatial details.

The scene is held together by a perfect equilibrium of signs and markers that compose and fill up the frame. At the center, the circle of seminarians immediately attracts the gaze. Their joined hands delimit the space. One of the young priests seems to defy the law of gravity, stretched out on a blanket that cannot but resemble a fabled flying carpet. The graphic effect is extraordinary. Even though it has a surreal spatial relationship to what surrounds it, the blanket is the only object to which Giacomelli accords the solidity of reality. He preserves the grays and allows us to see the patterns and folds of the fabric. The image restores the enchantment of a human moment that is at the same time suspended in a kind of temporal abstraction, a reality that is a construction of the mind of the photographer. "In the series of young priests I found a dimension that had been unknown to me; I stripped the conventional canons from the subject in order to show the naked man."

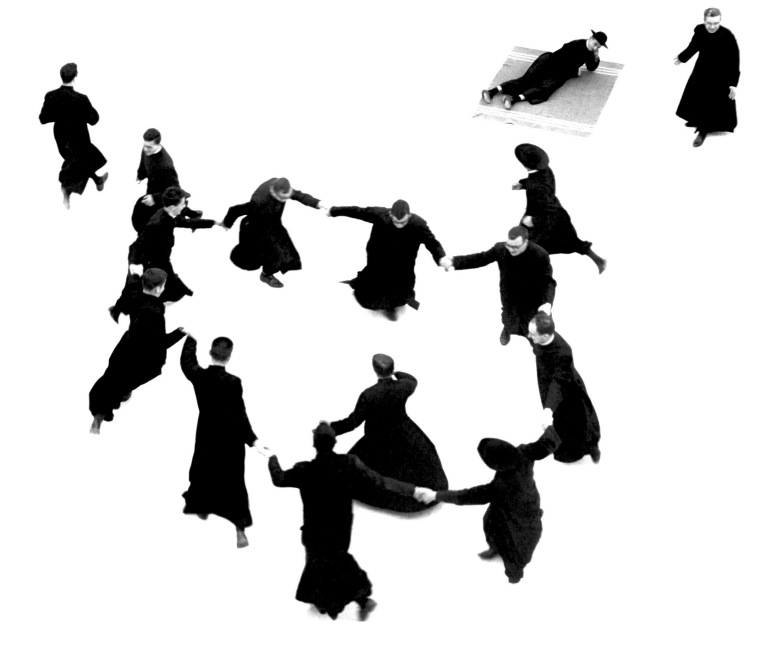

From the series "Death Will Come and Will Have Your Eyes," 1954–56
Mario Giacomelli first began to take photographs in 1953, with a Comet Bencini camera that he would always use from then on, immediately "modifying" it in order to meet his visual needs. The first photos were portraits of his wife, and scenes inside his house, along with photos of Senigallia, the town that he would never leave. The photos of the old people's home were the first important series on which he worked at length.

From the series "Death Will Come and Will Have Your Eyes," 1954–56
A recollection of when, as a small boy, he would accompany his mother to the old people's home where she worked as a washerwoman, these images are studies, cruel and tender, pitiless and humiliating, of the death that lies in wait for us. For this series Giacomelli would choose the title of a poem by Cesare Pavese as a keystone, a sacrament, and an accompaniment to his photos: "Verrà la morte e avrà i tuoi occhi."

"THAT MASK OF PAIN IS ME: I HAVE STOPPED THE PAIN. AN IMAGE INSERTED INTO A NARRATIVE MUST STAND ON ITS OWN, MUST TELL A STORY BY ITSELF. THE WHITE ISOLATES REALITY IN ORDER TO SHOW WHAT I CONSIDER TO BE IMPORTANT."

From the series "Death Will Come and Will Have Your Eyes," 1954–56
"I went there for three years without a camera; they looked to me as one of their own. Only later did I bring a camera. When I photographed I thought of what they say about God: that He is good, that nothing moves without His will . . . but what I saw, in the old people's home . . . I didn't want to send my photos of the home to any exhibitions. It seemed that the photos might be only indifferently good, or bad, and that everything would be a bit left to chance, but it wasn't like that."

From the series "The Good Land," 1964–66
The rural world is a constant in Giacomelli's work. He often turned to the land in search of a link with man in the signs impressed on the landscape and in moments of collective labor such as the harvest. Giacomelli's black-and-white images investigate gestures, shapes, and rhythms, making everything hardened and stylized.

From the series "On Being Aware of Nature," 1954–2000
Giacomelli began to photograph the landscape of his beloved Marches at the start of the 1950s and would pursue this project his entire life. "By means of these photos of the land I tried to kill nature, I tried to take away the life that was given to it, I don't know by whom, and destroyed by the passage of man. I wanted to give it a new life, to restore it according to my own criteria and my own vision of the world. Nature is the mirror in which I see myself, because in saving this land from the sadness of devastation, I wanted in truth to save myself from the sadness that I have inside. I have certainly, at times, used a bad negative, a failed instrument, precisely in order to emphasize this feeling, thereby obtaining an effect with the blacks that was all of a piece with my interior feelings."

From the series "The Good Land," 1964–66
"The image is spirit, matter, time, and space; an occasion for the gaze. Markers that are proofs of ourselves, and the sign of a culture that unceasingly experiences the rhythms that sustain memory, history, and the principles of knowledge."

"TO REWRITE THINGS,
CHANGING THE SIGN,
THE CUSTOMARY
KNOWLEDGE OF THE OBJECT,
TO GIVE PHOTOGRAPHY
A COMPLETELY NEW
EMOTIONAL PULSE.
LANGUAGE BECOMES
A SIGN, A NECESSITY,
A SPIRIT FROM WHICH
THE FORM IS RELEASED IN
A CREATIVE PROCESS
NOT FROM THE OUTSIDE
BUT FROM THE INSIDE."

From the series "Scanno," 1957–59
Giacomelli's most famous photo, the photo that won over John Szarkowski, then head of the photography department at New York's Museum of Modern Art, who chose it for the collection *Looking at Photographs*, is taken from the series dedicated to the town of Scanno, in Abruzzo: "Mario Giacomelli's picture is a pattern of dark shapes on a gray ground, all revolving around the small boy who levitates within the halo of the worn footpath, framed by trembling, wintry crones—two of a presumably endless line that scuttle past like the mechanical targets in a shooting gallery. The pattern seems at first glance almost symmetrical, but its balance is in fact not so simple.

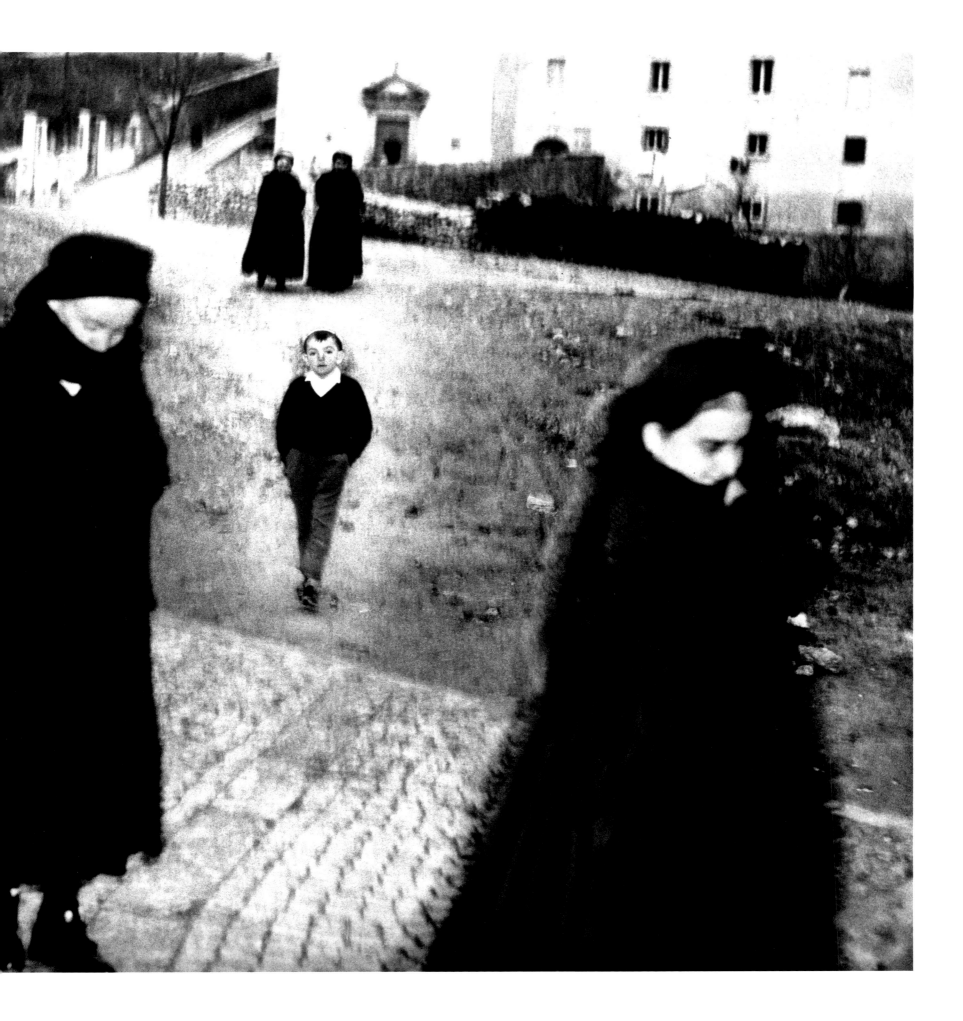

Analysis was surely useless to Giacomelli during the thin slice of a second during which this picture was possible, before the black shapes slide into an irretrievably altered relationship with each other, and with the ground and frame. It seems in fact most improbable that a photographer's visual intelligence might be acute enough to recognize in such a brief and plastic instant the pictorial (two-dimensional) significance of the action unfolding in the deep stage before his lens. Yet many photographers of recent years have educated their instincts."

From the series "Scanno," 1957–59

Giacomelli found a universe of symbols deeply analogous to his own linguistic and graphic experiments in the reality of the small town of Scanno in the Abruzzo region of Italy. "Scanno is a fairy-tale town, of simple folk, in which the contrast between cows, chickens, and people is beautiful, as is the contrast between white streets and black figures, and white walls and black cloaks. I have tried to capture some of those images, in order to let others experience the emotion that I felt in the presence of a world that remained untouched and without affectation."

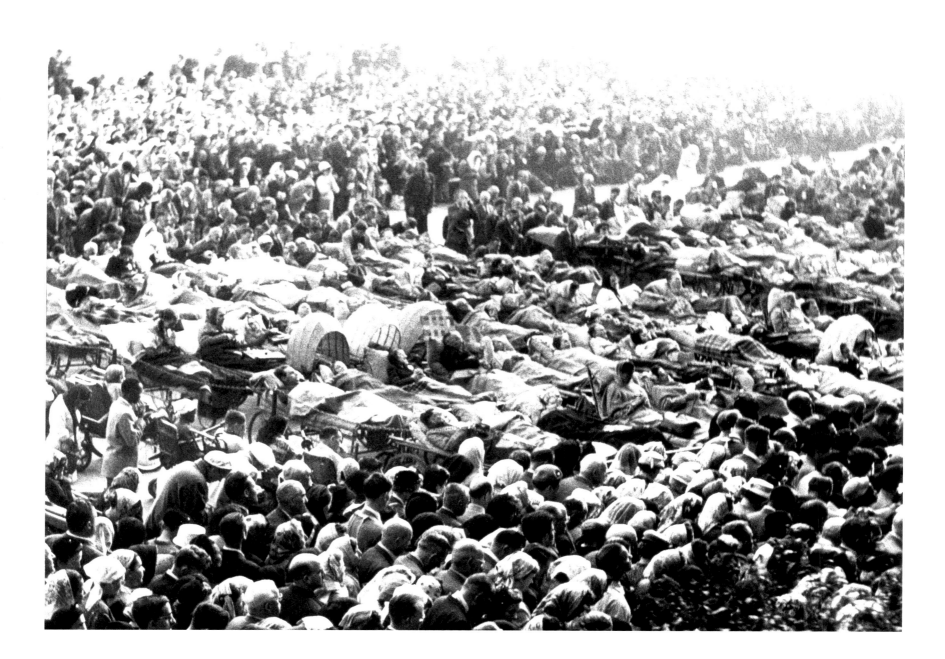

From the series "Lourdes," 1957
On the suggestion of Romeo Martinez, Giacomelli arrived in Lourdes in 1957 with the idea of producing a book. The experience, very intense emotionally, made a deep impression on Giacomelli, who returned to Lourdes in order to complete the project. "I didn't know what was at Lourdes, but then, later, I thought about it and I went back, and I took pictures."

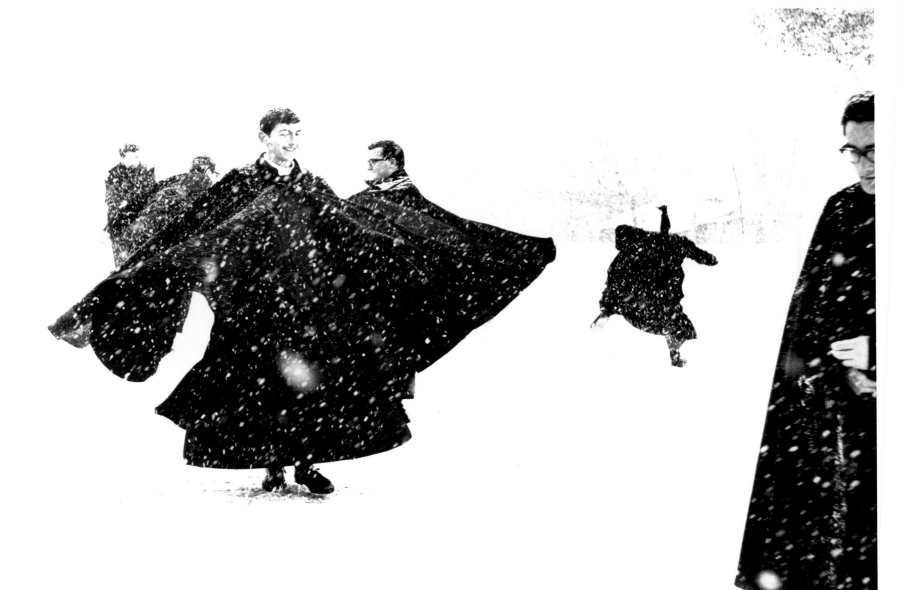

From the series "I Don't Have Hands that Caress My Face," 1961–63
"They are the sons of peasants, humble people," Giacomelli would say
about his "little priests." He was attracted by the rather secret simplicity of an
episcopal seminary that was a world apart from the world, and fascinated by
the graphic motif of the long black cassocks.

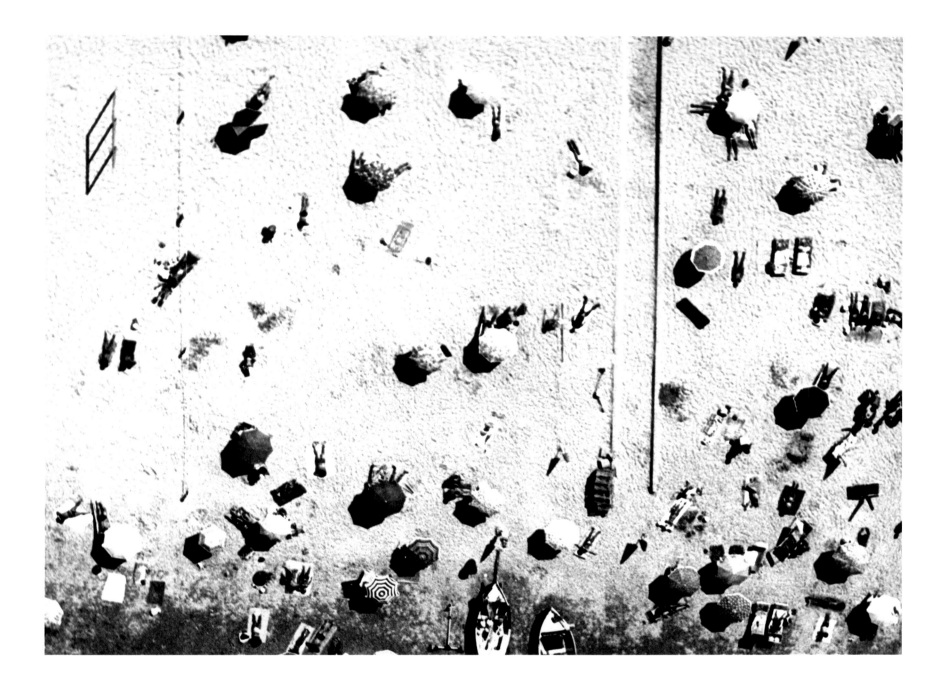

From the series "The Sea of My Stories," 1983–87
"I am interested in the symbols that men create without realizing it, but without destroying the earth. Only then do they have meaning for me, only then do they become emotion. In its essence, photography is like writing: the landscape is full of signs, symbols, wounds, and hidden things. It is an unknown language that begins to be read, to be known, from the moment one begins to love it, to photograph it."

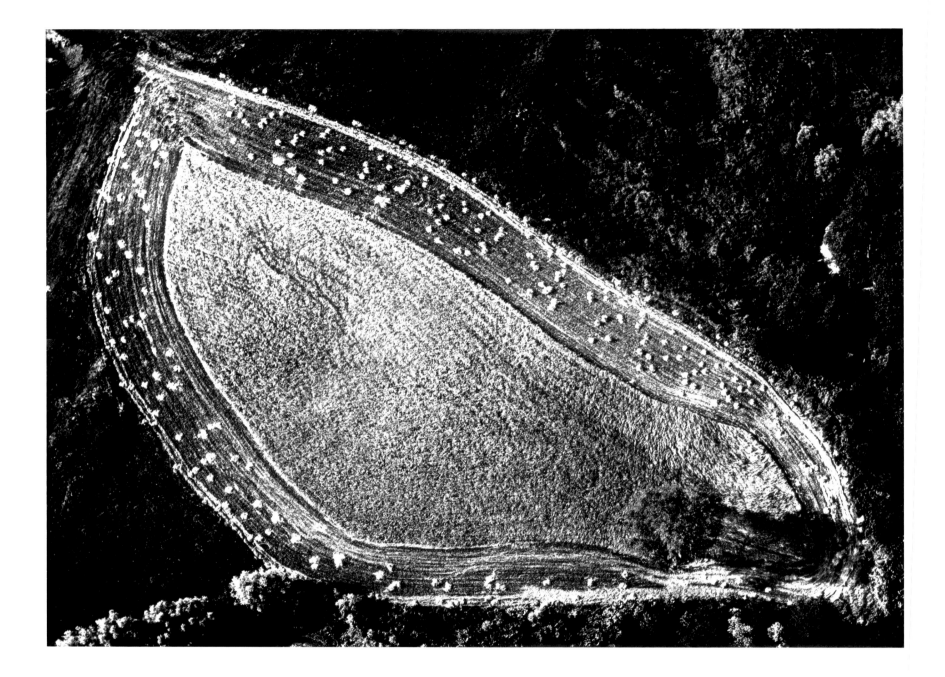

From the series "On Being Aware of Nature," 1954–2000
If his series of photos were always, by definition, "open," ready to welcome the new suggestions and varied reworkings that Giacomelli would bring to his work throughout his life, no series was more open than the landscapes. It was a genre to which he would always return, discerning man's symbols on the land, recognizing the tonal and spatial variations of trees, hills, hedges, and woods, each time finding new recurrences and variations, like a musical score made of living material such as never before, in the ever-diverse backdrops of the landscapes of the Marches.

Mario Giacomelli was born on August 1, 1925, in the town of Senigallia, into a very poor family. His father died when he was nine and his mother, in order to support the family, worked as a washerwoman at a nearby old people's home. At the age of thirteen he began to work for a printers' firm. He liked the work and sensed its creative potential. He discovered the world of art and creativity and, later, of photography. Typographic work would be a constant for him. In 1945 he participated in the rebuilding of the printing works, which had been destroyed during the war, and later became its owner.

On December 24, 1952, Giacomelli acquired a Comet Bencini camera and the next day ran to the seashore in order to try it. This was how he came to take his first photograph, which he titled *L'approdo* (The Landing). He subsequently met the photographer and theorist of photography Giuseppe Cavalli. These years saw the first intense portraits of his wife, whom he married in 1954. The portraits displayed a realism that was already metaphysical. Giacomelli began to participate in photography competitions and to make other portraits, still lifes, and his first landscapes, which would be the leitmotif running through his life. In December 1953, together with Cavalli, Adriano Malfaglia, and Ferruccio Feroni, he founded the photography group Misa, named after the river that flows through Senigallia. In 1954 came his first photo series, called "Vita d'ospizio" (Life in the Old People's Home), with which he returned to the theme of death, an obsession of his since childhood.

In 1955 Giacomelli began his series "Metamorfosi della terra" (Metamorphosis of the Land), focusing on landscapes. He continued with his commitment to make a name for himself as a creative artist, entering and exhibiting at many competitions, winning a number of times. For a short period in 1956 he was part of the photography group known as "La Bussola" (The Compass). Starting in 1957 he worked on the different series dedicated to "Scanno," "Lourdes," and "Zingari" (Gypsies). He exhibited in Arezzo in 1957, in Milan in 1958 (at the Galleria Il Naviglio), and again in Milan in 1960 (at the Triennale). "Puglia" came out in 1958, "Loreto" in 1959, "Un uomo, una donna, un amore" (A Man, A Woman, A Love) in 1960, and "Mattatoio" (Slaughterhouse) in 1961. Around this time Giacomelli began to work on the series "I Pretini" (Little Priests). In the early 1960s his reputation as a solitary and unique genius reached France and Spain, where he exhibited on several occasions. In 1963 he completed the "little priests" series, to which he gave the title of a poem by Father

David Maria Turoldo, "Io non ho mani che mi accarezzino il volto" (I Don't Have Hands that Caress My Face). In 1963, John Szarkowski, the director of the photography department at MoMA, saw the series on Scanno and presented it in New York. The image of the child walking toward the photographer and passing horizontally through a line of women became a key image in the history of photography. It was shown by Szarkowski in the 1966 exhibit *The Photographer's Eye* and later appeared in his book *Looking at Photographs.*

Between 1964 and 1966 Giacomelli worked on his "A Silvia" (To Silvia), inspired by the poem of the same name by Giacomo Leopardi. He had exhibits all over the world. A selection of photos taken from "Vita d'ospizio," supplemented by new shots, would become the series "Verrà la morte e avrà i tuoi occhi" (Death Will Come and Will Have Your Eyes), after a poem by Cesare Pavese. The series "Motivo suggerito dal taglio dell'albero" (Motif Suggested by the Cut of the Tree) came out between 1967 and 1968. Giacomelli's reputation was well established by the 1970s. He participated in the Venice Biennale in 1971 and was included in a show at the Photographers' Gallery in London in 1973 entitled *Five Masters of European Photography*. He later worked on a series inspired by the poem "Caroline Branson" in Edgar Lee Masters' *Spoon River Anthology,* which had been translated into Italian in 1943 by Fernanda Pivano, a former student of Pavese's. In 1976 Giacomelli began to work in color with "Spazio Poetico" (Poetic Space). During the years that followed he would collect his various landscape images together in a new selection called "Chiusa" (Closed) and gave it a title that was more mature and considered: "Presa di coscienza sulla natura" (On Being Aware of Nature). In the 1990s came "Il mare dei miei racconti" (The Sea of My Stories), the series dedicated to seagulls, and "Il teatro della neve" (The Theater of Snow), inspired by the poems of Francesco Permunian. Then came "Ninna Nanna" (Lullaby), "Felicità raggiunta, si cammina" (Happiness Attained, We Walk) after a poem by Eugenio Montale, "L'infinito" (The Infinite) after a poem by Giacomo Leopardi, "Il Pittore Bastari" (The Painter Bastari), and "Io Sono Nessuno" (I am Nobody).

In 1992 Giacomelli received the "Città di Venezia" international photography prize, and in 1993 and 1995 he participated in the Biennale. His last works had a strong dreamlike quality, such as "Bando" (Banishment) in 1997–99 and "Questo ricordo lo vorrei raccontare" (I Would Like to Recount this Memory) in 1998–2000. Giacomelli died on November 25, 2000, in his house in Senigallia.

"THE BLACK AND THE WHITE, AN ALMOST LEGIBLE WRITING, DESTROY IN PART ANY REALISM THAT PHOTOGRAPHY MIGHT HAVE. IN MY IMAGES THERE IS NOTHING ABSTRACT, ONLY THE ESSENTIAL."

Mario Giacomelli

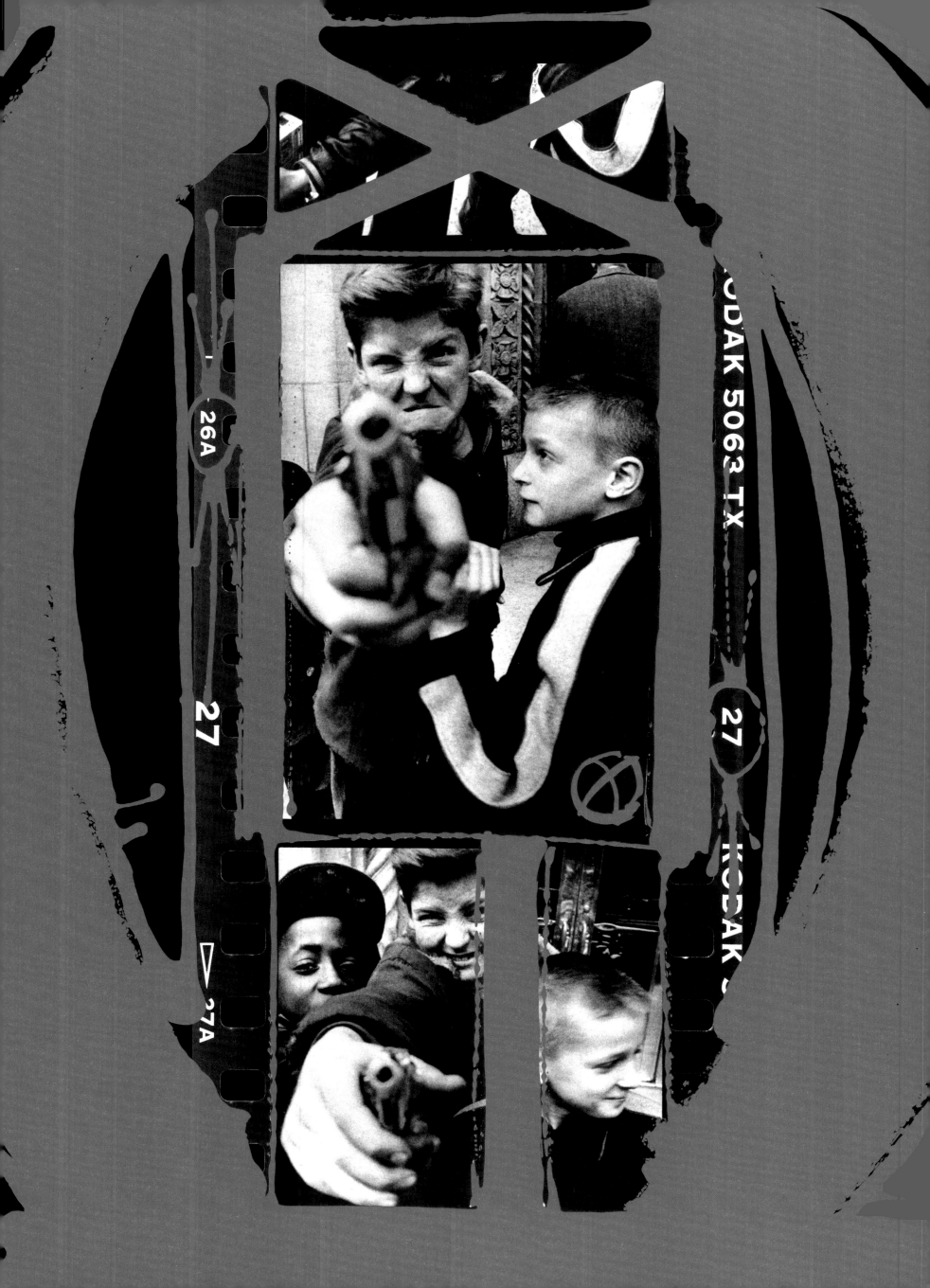

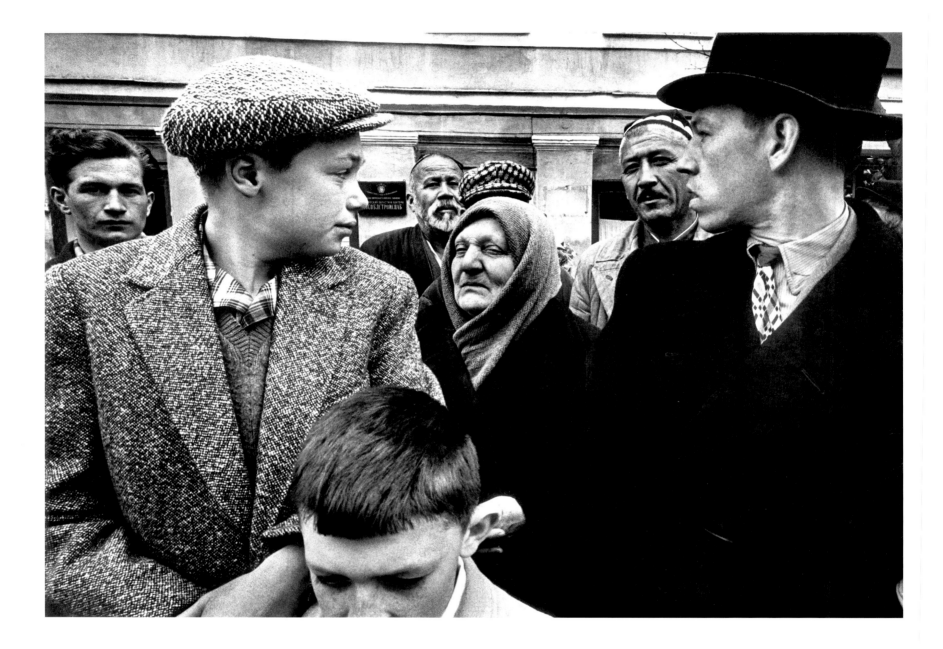

Page 206
Gun 1, New York, 1955

Above
Moscow, May Day, 1961
"In his book *Camera Lucida*, Roland Barthes talks about a few of my photographs, this among them. What did I see here? First of all, Russians in 1961, in ten square feet, representatives of five different national groups, so, a fragment of an empire with, in the bargain, Gorki's grandmother: Then, an illustration of a possible subject-photographer interplay: The grandmother; knowing she is photographed, strikes a pose, her pose. She is in the center with the camera aimed at her; but it's a wide-angle lens

and six other characters have found an author without realizing it. Each demonstrates a possible attitude towards a lens: irony, wariness, distrust or violated dignity. On a formal level, looks cross, heads and bodies converge and form a touching variation on the group portrait. What Barthes sees is the document: Russians in 1961, how they dress, what hats they wear, how they cut their hair. How you read a photo is up to you. And what I like about Barthes is that he sees what he wants and blithely justifies it.

Here, the document. Elsewhere, in one of my New York photos, a boy's carious teeth. His own obsession, which makes him Barthes. What surprises me, though, is his lack of interest in a photographer's intention. For him, photographs are accidents or found objects."

WILLIAM KLEIN

A sly person is smiling, in the self-portrait that he prefers. He smiles with his beautiful face almost in shadow, his hair white. His face seems barely contained by the red outlines of the paint that define the image. He smiles, and seems to say, "try to take me, try to figure me out if you can." William Klein is a photographer, painter, artist, printer, cinematographer, and writer. He has been active, innovative, and iconoclastic in every expressive form. He has moved quickly, impatiently from one discipline to another. When convinced that he has understood something, he seems "closed" in a rectangle, like the cage of his self-portrait, and that is how he continues to surprise us, to invent something new that stirs the conscience and changes our way of seeing.

Klein was born in New York in 1928, the child of immigrants from Hungary. His father had a clothing business and was noted for his strict Jewish religious observance. The young Klein was uncertain of the path he would follow. He was the art director of his school newspaper, wrote articles, did page layouts, and drew entertaining caricatures. In an interview with Groucho Marx, he asked, "but is your moustache fake?" To which Groucho shot back, "and are your big eyebrows real?"

But it was not just an irreverent irony. Klein was avid and curious about culture. He devoured the writers of the nineteenth century, both European and American, went often to MoMA, and was enchanted by the films of Chaplin, von Stroheim, and Eisenstein. After graduating college he enlisted in the army and was posted to Germany. He was later sent to Paris and there, as a soldier, thanks to a cultural exchange program, he attended the Sorbonne for a year and a half. It all happened in Paris: meeting his wife Jeanne, with whom he would stay until her death, and his artistic development. After a period spent in Fernand Léger's studio, the young "American in Paris" would experiment in a style known as "hard-edge painting" and produce large canvases with backgrounds painted in monochrome strokes. He worked in Milan with the architects Angelo Mangiarotti, Marco Zanuso, and Gio Ponti on a series of large panels, movable drop-curtains with domestic scenes. As a way to document his own work, Klein gravitated toward photography. He understood that through photography he would be able to capture what he had always wanted to grasp: movement.

In 1954 Klein returned to New York in order to put together a photographic diary of his native city. On board the ship, as he watched Manhattan emerge from the fog, Klein saw the city in a different way. As if in a trance, he recognized images and sounds that he had long since forgotten, or perhaps never noticed, but was now eager to capture with his camera, a Leica that he had purchased just before his departure. It had been sold to him by Henri Cartier-Bresson in the offices of the Magnum agency in Paris. Once he arrived, he understood that the lens used by Cartier-Bresson, probably a 50 mm, wouldn't work well for his project in New York. Klein wanted to get up close to people. He bought a new lens, a wide-angle, and tried it right away, outside the store. His first images of New York came about in this way, because of a change of lens and perspective.

The book came out in 1956 and it caused an uproar. It was titled *Life is Good & Good for You in New York.* Everything in this book was new: the photos, which seemed made to fit within the confines of the page almost by force, the sequencing, and the pagination, which was appropriate to the subject and cinematographic. The city had the appearance of a theater stage, but without wings. The photographer mingled with his subjects and intruded into their lives, played along with them, and then got away. The rhythm is gripping; a swift mass of emotions that pile up, fade away, and become stirred up again.

There followed other "tributes to cities": Rome in 1956, which was done with the help of Federico Fellini, who had wanted Klein as an assistant on *Nights of Cabiria,* Moscow in 1959, and Tokyo in 1961–62. Klein meanwhile grew closer to the world of fashion, a "baroque universe" and frenetic circus. The images he produced were always something new, mixing irony, movement, and curiosity.

Cinema couldn't fail to be attractive to Klein: in 1958 he directed *Broadway by Light,* considered the first "pop film," and for many years he would concentrate almost exclusively on film. But in the 1980s he returned to photography and to the streets of cities such as the Paris "of old," to which he rendered sincere homage with the book *Paris + Klein* in 2002. And then? Klein continued to be curious, to be provocative, to be fascinated by a smile that was passing by, and to be moved (even if he would never admit it) by a gesture or a story, both as an actor and a spectator in a life that never ceased to involve him in its dizzying flow.

In stark contrast to "hard-edge painting", from which the outside world was excluded, Klein found that photography was like a window onto life itself, enabling him to show his perspective and opinions. He considered himself to be an artist who used photography, not to create art but to remake it. His ethos when photographing New York was 'anything goes'—a motto that has served him well throughout his career.

Piazza di Spagna, Rome, 1961

"Rome is my good luck city. In 1956, my photographic book on New York came out. It surprised and shocked and influenced a whole generation of photographers. I was an abstract painter and was looking for a way to comment on the world around me and couldn't in my hard edged, geometrical painting. So, I experimented with photography. After the New York book I felt I had said all I wanted with a camera, so my next aim was cinema. I was a groupie of Fellini. I arranged to meet him in Paris and wished to give him my book. He said: 'I have it next to my bed. But why don't you come to Rome and be my assistant?' I was in my mid-twenties, so no problem. I came to Rome."

But things didn't work out as planned. Fellini, besides already having many assistants, was not ready to start shooting. As often happens in film production, the money was lacking and the producers were trying to get out of the deal.

"Of course, Federico already had a bunch of assistants. Anyhow, I worked with him on the casting of *Cabiria*, documenting an army of pimps, whores and locations. Then, the film was delayed. So I thought, Ok, I did a book on New York. Why not one on Rome?"

That was the beginning of the book on Rome, which was extraordinary for its images and its freshness.

In a Rome that was ripe for discovery Klein felt that he was on a new "Grand Tour," the ritual that for centuries was part of the emotional and intellectual education of young artists from northern Europe and America who went to the Mediterranean in search of their historical roots, hoping that the sunshine and vital energy of the region would help them in their creative work. Klein's "walks around Rome" were led by guides of exceptional quality: the director and writer Pier Paolo Pasolini, the author and screenwriter Ennio Flaiano, the novelist Alberto Moravia, the publisher Giangiacomo Feltrinelli, and Fellini himself.

In Rome, Klein not only discovered a city but, years after that first dazzling visit, because of what he saw on its streets, he invented—or reinvented—fashion.

For an artist like Klein, the ideal set for any fashion photo campaign had to be the street, and in this famous image, the play of lines and gazes, the white and black of the clothing, all harmonize in a surprising way with the pedestrian crossing of one of the most important piazzas in the city.

"When I was shown the dresses, it was immediately obvious that the models would cross the Piazza di Spagna on the striped pedestrian passage. They would walk back and forth, see each other and do a double take. To flatten the perspective, I went up on the Piazza steps and used a telephoto lens. The girls walked back and forth until they started to attract attention.

I was up on the steps with my camera; nobody saw me. Soon men began to think these girls were crazy hookers and they approached them and tried to feel their asses. The editor from Vogue started to get nervous, afraid there would be, if not a gang rape, at least a traffic jam.The girls continued, the men closed in, the editor panicked completely and signalled wildly to me that we must stop. So we did. She gathered the girls and saved them from a fate worse than death and that was it. A wrap. And maybe one of the best fashion photographs ever."

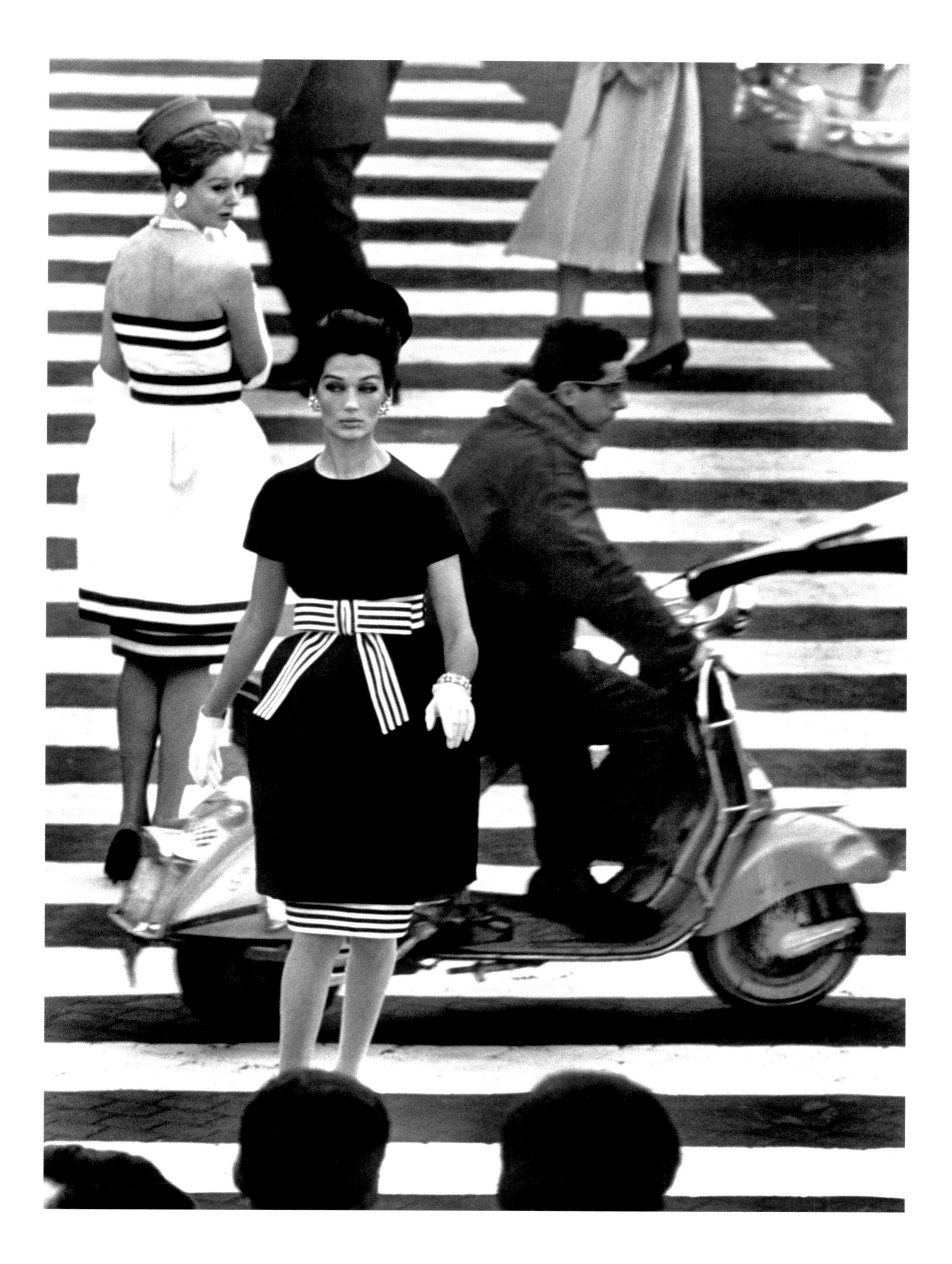

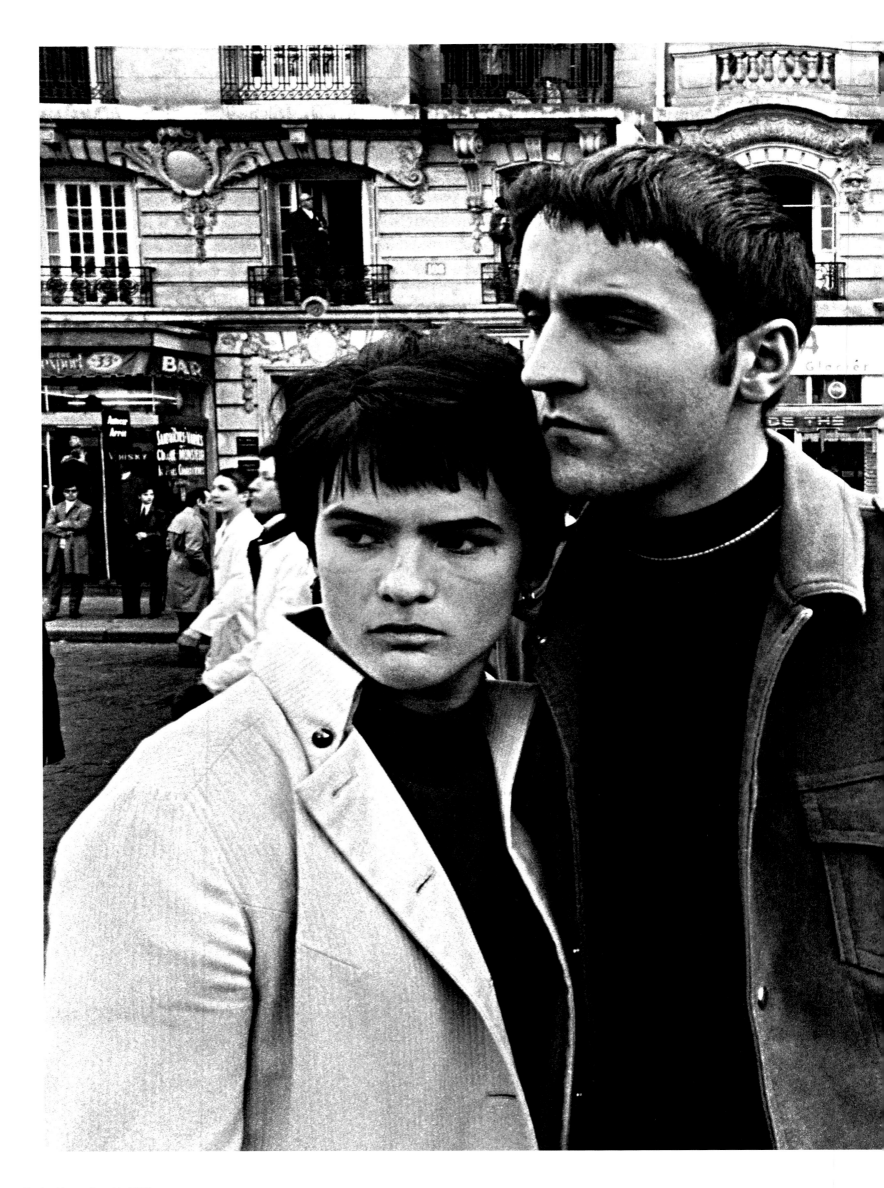

Paris, November 11, 1968
Paris is the city that welcomed Klein when, at the age of eighteen, he left New York, moving about its streets with the curiosity of a "participating observer" who would never be satiated with its images.

"November 11, 1968. In May, I was filming and I hardly took any photos. But today, they're celebrating the fiftieth anniversary of the armistice and most probably the last Armistice Day celebration under De Gaulle. It's cold; they're not even on the Champs Élysées but the Cours la Reine. People are bored, they kiss each other, they watch the procession pass by, and I accumulate shot after shot for posterity."

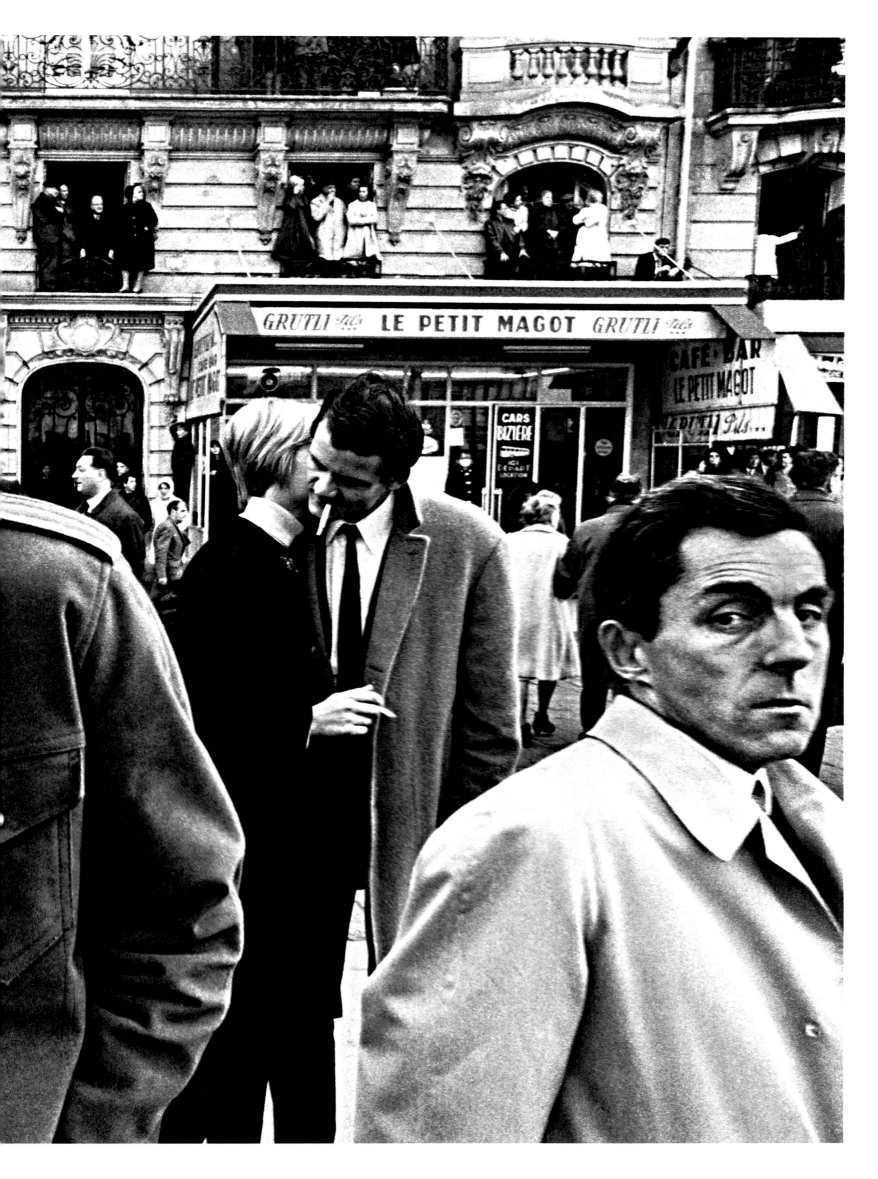

Pages 214–15
New York, 1956
"The sub-title was, in further tabloid-speak, TRANCE WITNESS REVELS. In three words, all I had to say about photography, at least the kind I did then. The "chance witness" is one who comes across a drama by chance. "Revels" is a play on the word "reveals"; "révéler" in English means "to revel,"

to have a good time. All this under the sign of the trance. I rediscovered my town and discovered photography. I had no formal training and didn't know much, and I had to make do with what I could obtain. My training was in other techniques—drawing, litho, painting—which I tried to apply to photography. What other pros would have thrown in the trashcan was for me an exciting material to be reworked."

"PARODY: THE RIGHT PHOTO AND THE *NEWS*. PHOTOGRAPHING A MARRIAGE LIKE A RAID AND, CONVERSELY, A PROTEST LIKE A FAMILY PORTRAIT. AND THEN DADA: BLACK HUMOR AND THE ABSURD. LET'S SAY THAT THIS APPROACH WAS SURPRISING FIFTY YEARS AGO. IT WASN'T FASHIONABLE. IT ISN'T TODAY EITHER."

The Boxer-Painter Shinohara During a Performance, Tokyo, 1961

In 1961, after New York and Rome, Klein left for Tokyo.

"'In the Indies, there is nothing to see, everything to interpret,' said Henri Michaux. In Tokyo, I thought, 'Everything to see, nothing to interpret. I will be the Savage in Tokyo.' Convinced that I would not be able to understand, delighted that I would not have to try, above all I was determined not to judge. Like someone who browses but doesn't buy, who does no harm, I observed."

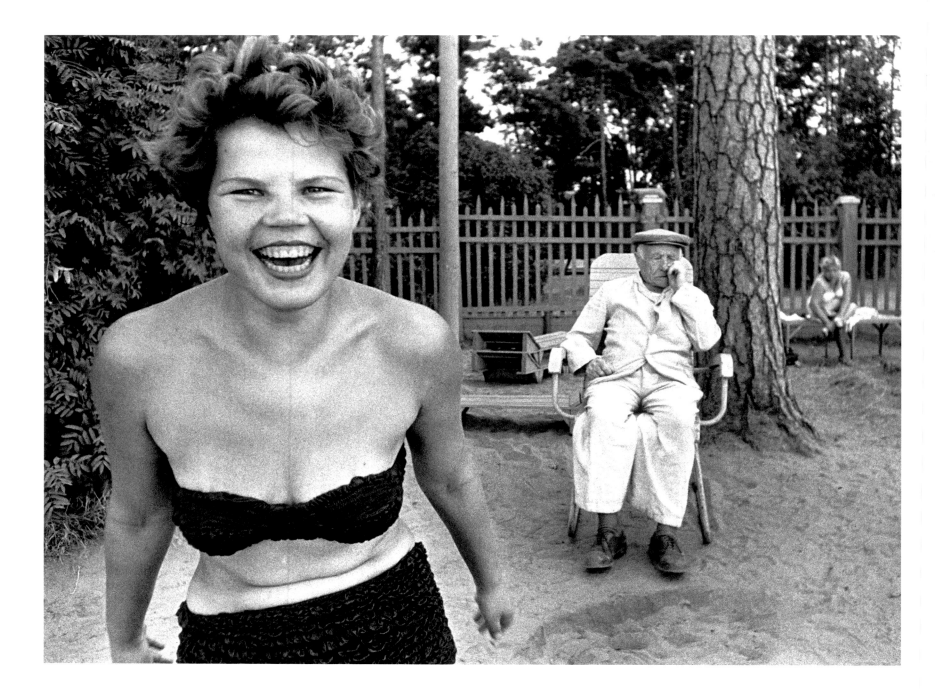

Bikini on Moskva Beach, Moscow, 1959
If New York signaled a return to his origins, Rome a free and intellectual discovery, and Tokyo a comparison with the "other," Moscow was an opening onto a reality ever too distant and ever too close to our own.

Extreme vitality was the characteristic feature that Klein was able to instill into his work, like a pyrotechnic entertainment of which he, at times, seemed to be the first to be amazed.

Movie Poster, Tokyo, 1961
"Now it's our turn to observe the Japanese—me hidden behind my camera, you behind these pages.

 The Zen master, Seng-T'san is believed to have said, 'Walk without tormenting yourself.'

Walk through this book. Look. And forgive me if sometimes I appear to explain something: it was unintentional."

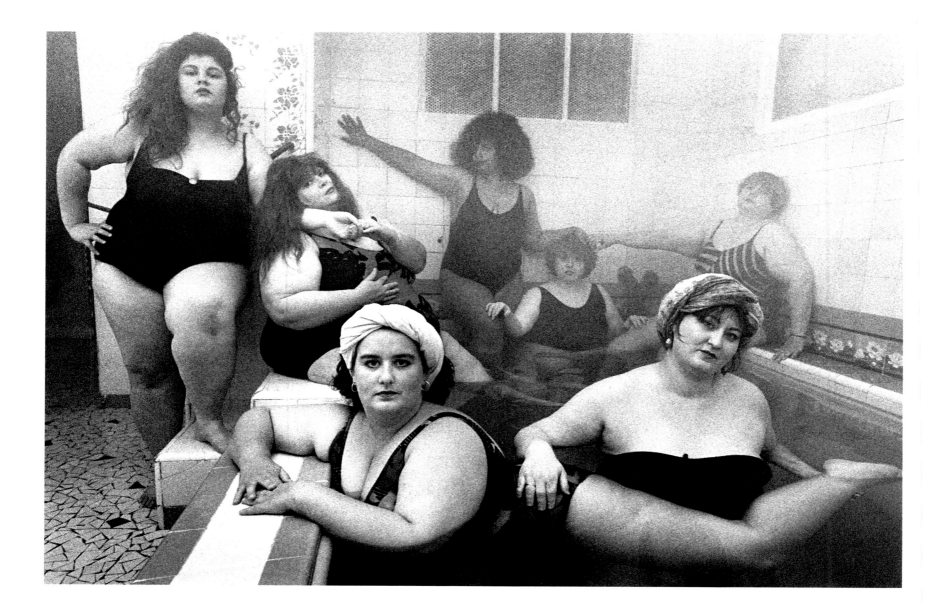

The Allegro Fortissimo Club, Paris, 1970
"Seven members of the Allegro Fortissimo club. A steam room on the rue d'Odessa, closing day. So, freezing water and we have to make 'steam' with smoke machines. There were twenty members of the club at the time. Their motto: fat can be beautiful. In this case, very true. I went to one of their meetings and was surprised to hear the same sort of conversations I heard among top models: 'Are men attracted by what we are on the inside or do they only fantasize about our bodies?'"

"I'VE NOTICED THAT IN GENERAL THE PARIS OF PHOTOGRAPHERS … WAS ROMANTIC, FOGGY, AND ABOVE ALL, ETHNICALLY HOMOGENOUS … BUT FOR ME, PARIS WAS, AS MUCH AND PERHAPS MORE THAN NEW YORK, A MELTING POT. A COSMOPOLITAN CITY, MULTICULTURAL AND TOTALLY MULTI-ETHNIC."

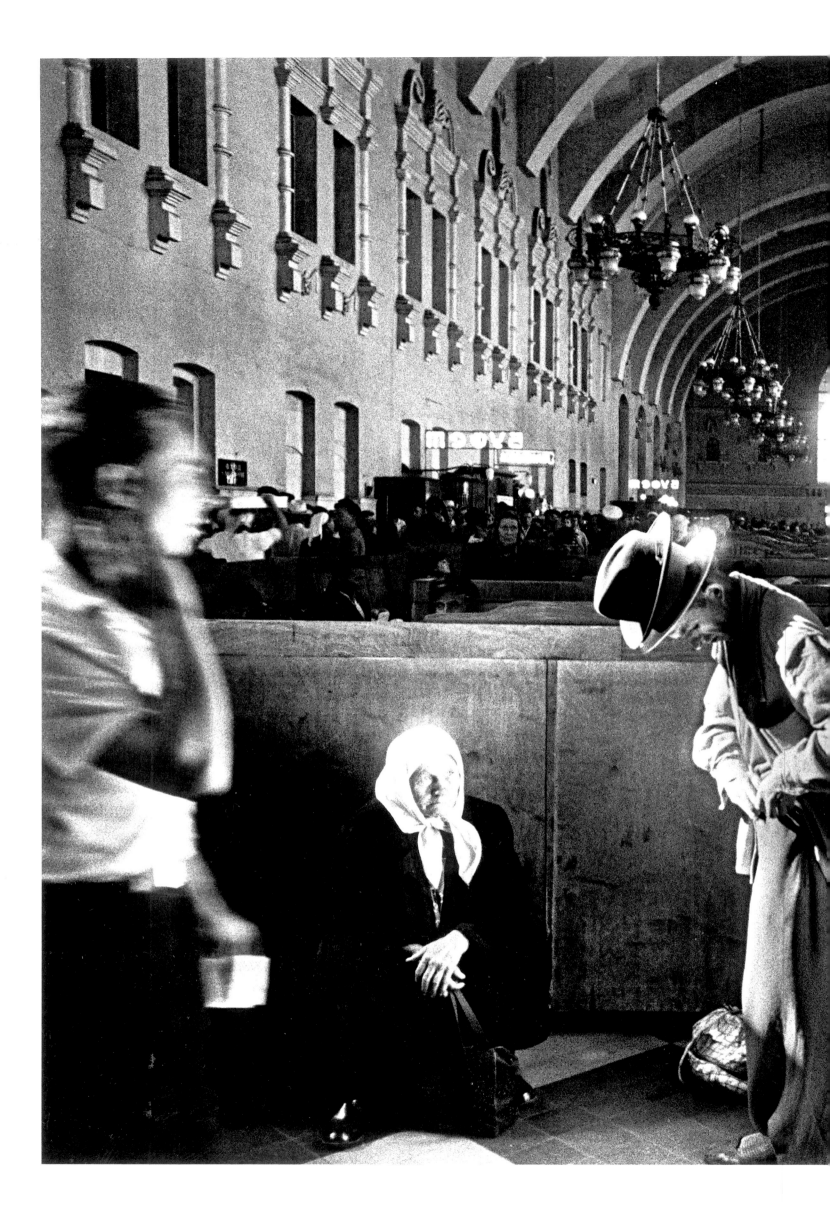

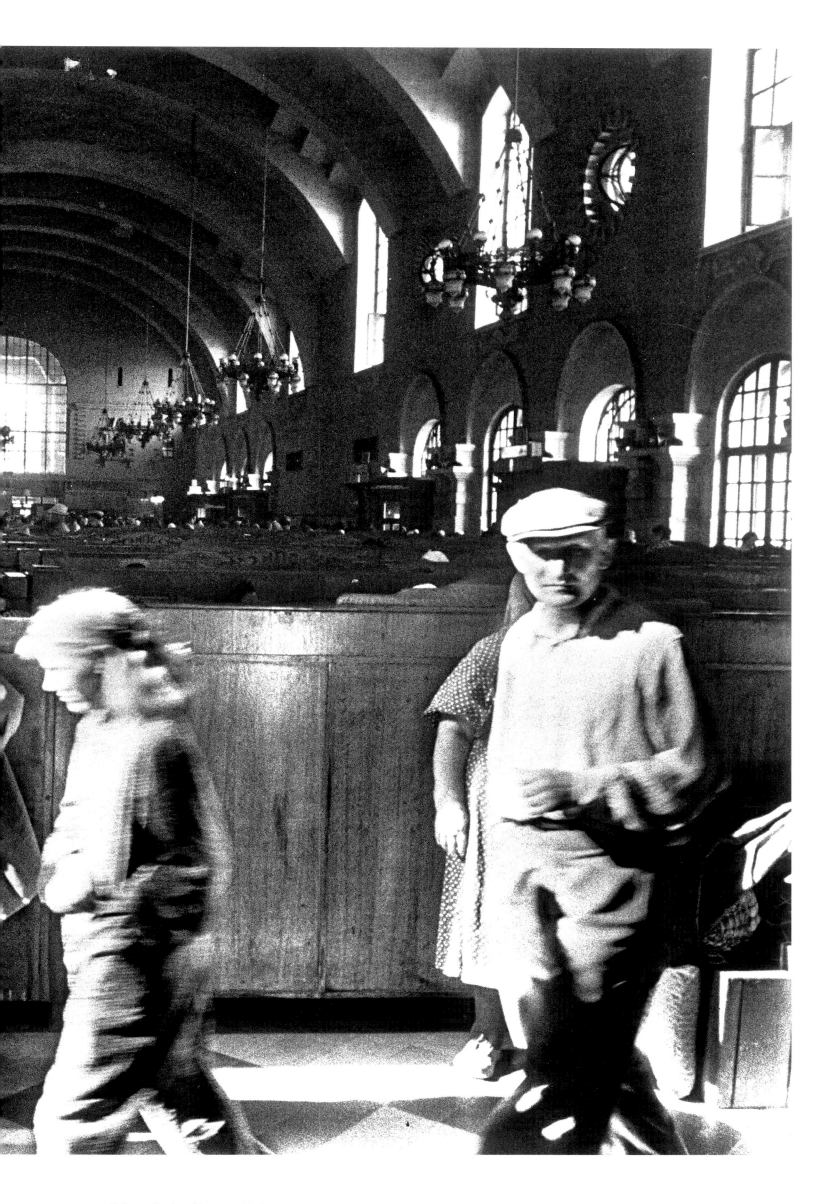

Railway Station, Moscow, 1959
Alain Jouffroy, a French scholar and critic, wrote about Klein and his work: "For Klein, photography is just as much a physical act as a cultural one. A photograph is, for him, a release of energy, sensual, violent. That is why he disrupts traditional composition and introduces the element of chance and the warping effect of movement at all levels. Having made geometry move, Klein was the first of the street photographers to develop this tremor of life that is movement."

New York, 1954–55
"If we accept the idea that the most important characteristic of a photographer is curiosity, because photography shows us the world as we do not see it in reality, Klein's role becomes essential. Not because he is more curious than others, but because he is curious about different things. At a time when photography continues to be taken at face value, when we still think that 'it's true because it's in the photo and the photo is in the newspaper,' Klein doesn't portray himself as the reader of a world that he discovers in order

to show to us. Many people have observed from the beginning that letters, signs, words, and other writings play an important graphic role in many of Klein's photographs. We have often concluded that Klein truly photographed the world of today, with its cars and electric cables, its chaos and pain.

Therefore Klein becomes more a reader than a simple observer. A reader of his environment, of its social, political, esthetic, and material signs, of the environment, a reader of his own photographs."

Christian Caujolle

225

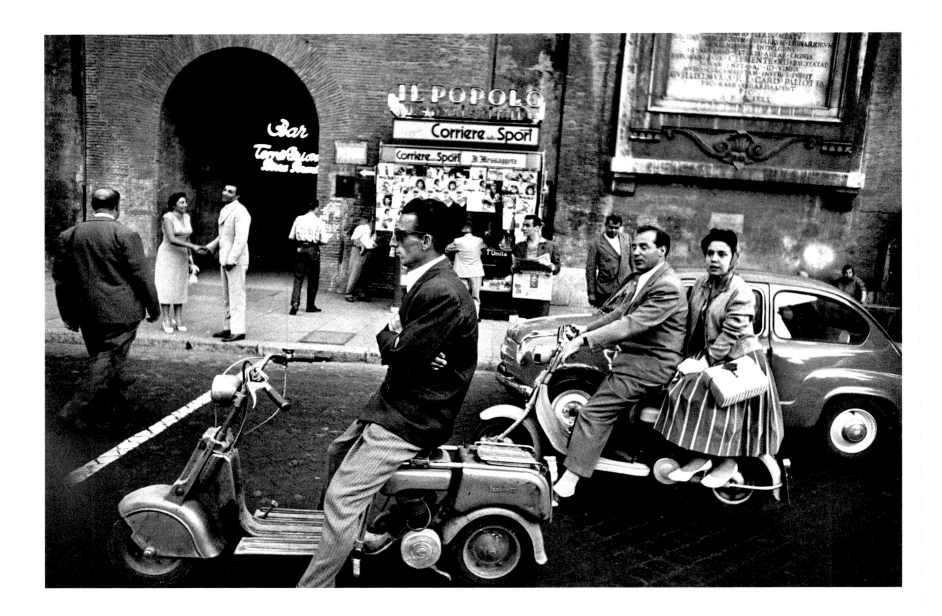

Piazzale Flaminio, Rome, 1956
A meeting with Fellini was the reason for Klein's trip to Rome. He was to become
an assistant to the director—the umpteenth in a series of at least four—for his
Nights of Cabiria. But production did not start and the film was held up for
several months. Just as well. Klein was young, had introductions from Fellini to
Pasolini, Moravia, and Flaiano, went about the streets, was inquisitive, and put
together a new photographic diary.

Self-Portrait

William Klein was born in New York in 1928 to a Jewish family of Hungarian origin. He finished college at eighteen, spent two years in the American army of occupation in Europe, and settled in Paris in order to become a painter. He worked briefly with Fernand Léger. On his second day in Paris, at the corner of the rue des Saints-Pères, he met "the most beautiful girl in the world," Jeanne Florin. She became his wife, principal collaborator, friend, ally, and constant helpmate. Jeanne Klein produced some of his films, conceived the costumes, and guided his multiform career. She was also a painter of great originality and overflowing imagination.

In the early 1950s Klein created a series of kinetic mural paintings for some Italian architects. After his return to New York, he began in 1954 to work on a kind of photographic diary that would come out two years later in a book which he titled *Life is Good & Good for You in New York.*

The book, which was truly revolutionary because of Klein's radically new way of taking pictures, won the Prix Nadar in 1957. Accepted as an assistant by Fellini, he arrived in Rome where he produced the book *Rome* in 1958, followed by *Moscow* in 1961 and *Tokyo* in 1964.

Between 1955 and 1965 Klein took photos for *Vogue*, creating strange images of rare irony. During these years he became involved in film and had a great impact on it, in the same way he had revolutionized photography with his book on New York in 1956. As Claire Clouzot said, "The images that he likes best—in photos, newspapers, television, advertisements, posters, signs, graffiti, collage, publicity, photo journalism, file cards, documents, even the blurred and smeared, the black & white images of a bewildered world—all these have become part of his imagery-cinema. They created that style which is recognizable by everyone, the style of William Klein." In 1958 Klein produced *Broadway by Light,* the first "pop film." For a long time Klein would dedicate himself exclusively to cinema with a series of films that were diverse in style and theme. These films range from the sagas of the "Super Blacks" such as *Muhammad Ali: The Greatest* (1964–74), *Eldridge Cleaver, Black Panther* (1970), and *The Little Richard Story* (1980) to political documentaries such as *Far From Vietnam* (1967) and experimental films such as *Who Are You, Polly Maggoo?* (1966), *The Model Couple* (1976), and *In & Out of Fashion* (1994).

In the 1980s Klein returned to photography and exhibited all over the world. He came out with books such as *William Klein: A Monograph* (1983) and *Close Up* (1989). These were followed by *Torino 90* (1990), *In & Out of Fashion* (1994), *New York, 1954–1955* (1995), *Paris + Klein* (2002), and *MMV Romani* (2005). In 1999 he produced the film *The Messiah* and published a book *William Klein Films.* Among many awards, he has received the Hasselblad Prize, a Guggenheim, France's Grand Prix National de la Photographie, and the Kulturpreis of the German Photographic Society. He has been named Commander of Arts and Letters by the French state and received the Royal Photographic Society's Centenary Medal, and the Millennium Medal.

In 2005 the Centre Pompidou in Paris granted him a major retrospective exhibit accompanied by a catalog. It was a tribute to the career and vision of a man who has always gone against the tide.

As Robert Delpire wrote, "Everything William Klein does serves a voice that states what he thinks is the underlying feeling of a just cause: the right of expression. A voice that the years have not stifled or even diminished."

"I WAS A MAKE-BELIEVE ETHNOGRAPHER, TREATING NEW YORKERS LIKE AN EXPLORER WOULD TREAT ZULUS—SEARCHING FOR THE RAWEST SNAPSHOT, THE ZERO DEGREE OF PHOTOGRAPHY."

William Klein

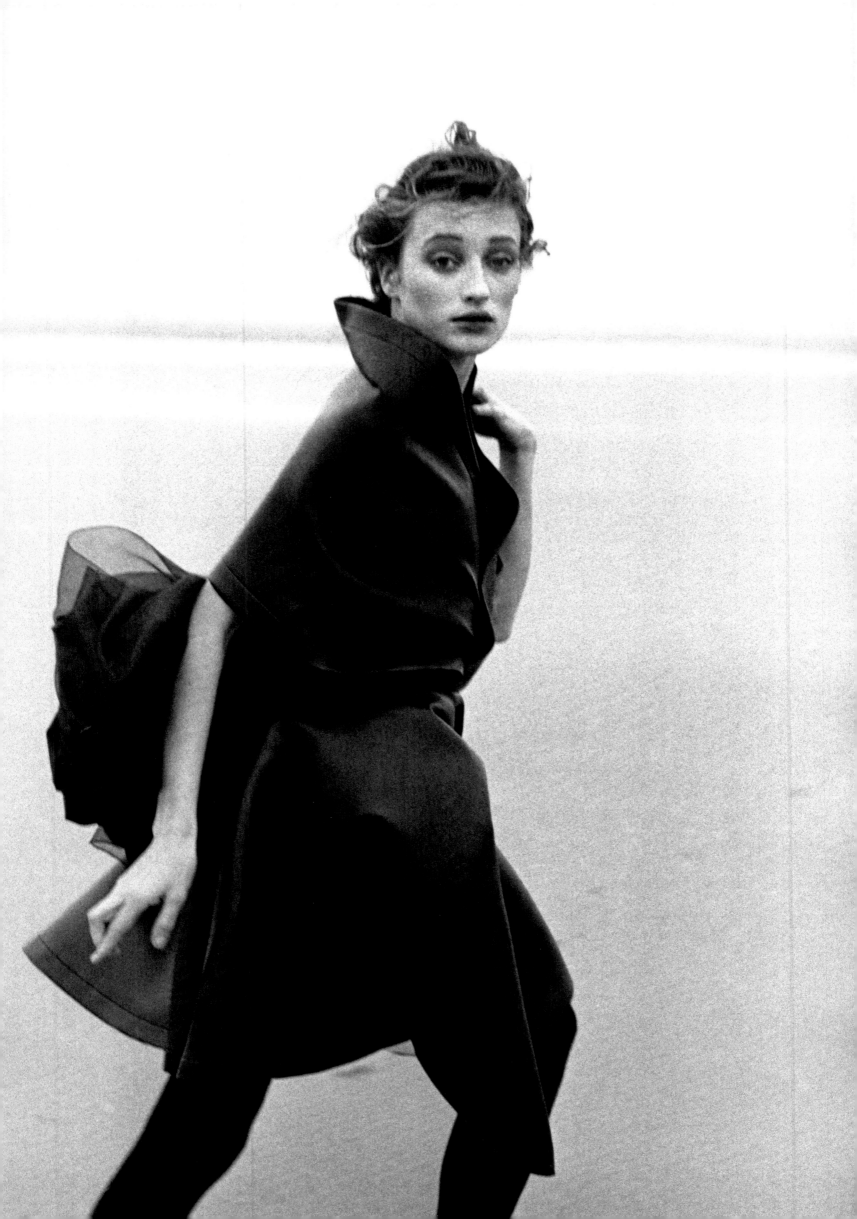

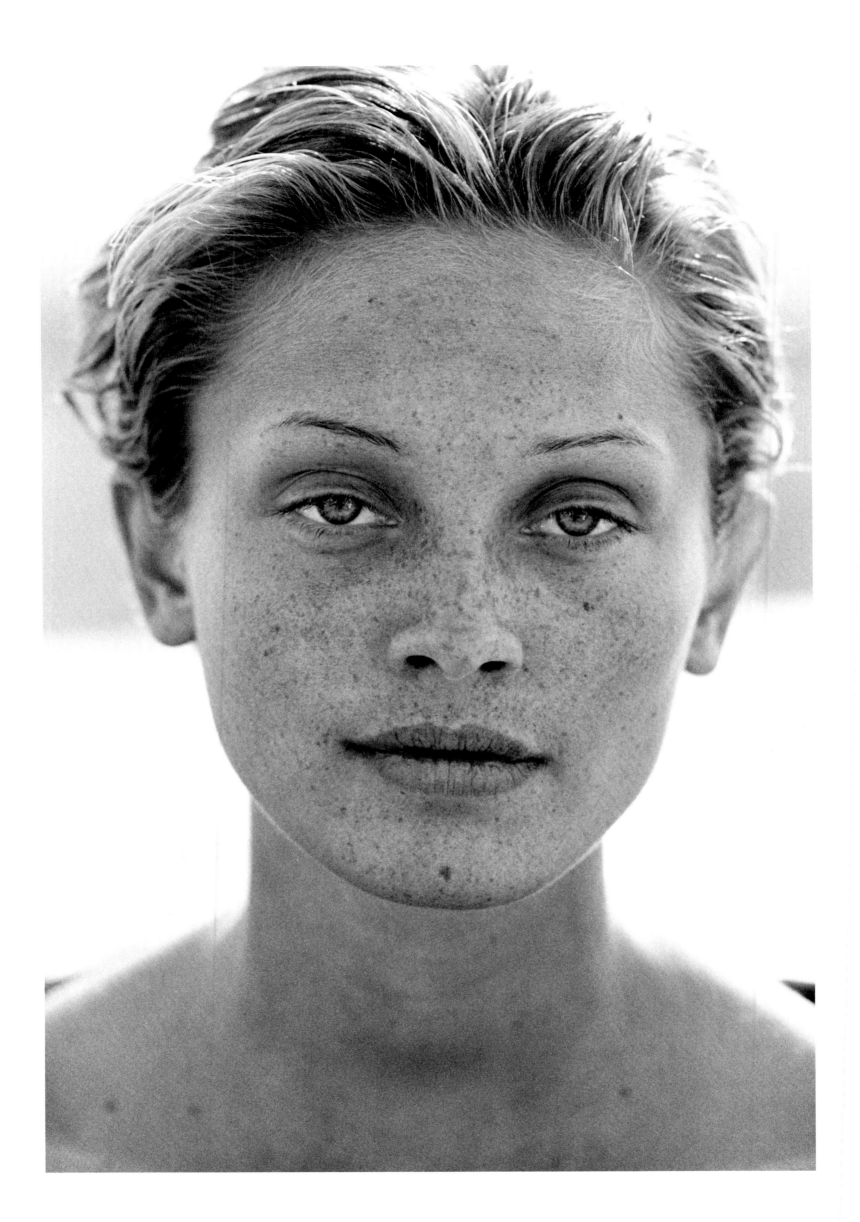

Page 228
Marie-Sophie Wilson for Comme des Garçons, Le Touquet, France, 1987

Above
Berri Smither, *Harper's Bazaar*, El Mirage, California, 1993
Lindbergh loves his models and photographs them fearlessly, without worrying about any small flaws or imperfections; through his lens, such details only accentuate their mysterious beauty.

PETER LINDBERGH

How does he do it?

I'm not talking about his art here,
nor about his craft.
Both are beyond any doubt extraordinary,
beautiful,
mysterious,
unique, but not necessarily beyond my grasp.

I can marvel at his pictures,
gasp,
yearn,
or be stunned,
but as photographs
they are still part of our contemporary universe.
No matter how much we can admire them,
we can still "understand" them:
The beauty of these women in front of Peter's lens,
after all, is known to us.
We've seen them and adored them all
in many other contexts,
with other makeup,
different hairstyles,
in other clothes…
that's not it.

When I seriously ask how "he does it,"
because I seriously don't get it,
I don't want to know how he lifts up his camera,
how he frames what he sees,
or how and when he releases the shutter.
I'm neither mystified by his mise-en-scène,
nor the light,
the scenery,
or the composition.

I'm strictly in the dark about something else.
As you can easily read,
I have a hard time to even put my finger on it.
The world of fashion photography is glamorous,
seductive,
sometimes shocking,
sometimes hitting our deepest dreams and desires.

But we've gotten used to its shiny surface.
After all, it is covering the planet.

You can't open a magazine
without being confronted by it.
You can't move around any city
without seeing it shine down on you from billboards
or out of boutique windows.

Only that Peter Lindbergh's photographs are utterly
different.
They defy all laws of gravity in this realm.
They redefine the very world they depict.

How he does it?
I'm trying to approach the phenomenon naively,
meaning without any prejudice,
and forgive me if it takes some detours.
I find out things by writing about them…

These women he takes pictures of,
Call them "models," "goddesses," or "queens,"
almost by definition never reveal themselves.
They HAVE TO keep their distance from us,
In order to be who they are.
Getting to know them personally, so to speak,
would be a disappointment, not to say a sacrilege.
It would be like looking at family pictures of them.

(And indeed, sometimes, in some awful society or
 gossip pages
you see them robbed of their aura,
and you feel miserable for them,
as if you were an accomplice to the thief
who took their pictures,
"shot them," in the very sense of the word.)

Yet in the photographs of Peter Lindbergh
you do see these extraordinary women
In all their glory
Without their disguises,
Without the "front,"
Stepping right out from behind the shiny surface
They are used to showing us.

They ARE, indeed, radically revealing themselves,
only
that it doesn't demystify them,
it doesn't make them appear naked
or unprotected,
on the contrary!

And this exactly is the total mystery,
the science fiction aspect of Peter's work,
the complete utopia, as far as I'm concerned:
He turns those goddesses into human beings,
Without taking any of their aura away!

Both aspects of that contradiction even enhance
 themselves,
each making the other more believable,
against all odds,
against all laws in the field not only of fashion,
but of public life in general.

Lindbergh quite simply defies the rules of MYTH.

Maybe my initial question doesn't seem so far-
 fetched anymore:
"How does he do that?"

I still don't have an answer,
but it dawns on me all of a sudden
that I might have caught a glimpse of his secret
without recognizing it:
I've seen his smile.
Not much of a secret for a photographer, you say?
You're wrong.

Peter's smile comes from deep within,
From a calm well beyond all the agitation
That might be associated with "photography"
Or more so, with "fashion."

You look into his friendly eyes
and you might start to understand
how this untroubled and unimpressed gaze
will manage to penetrate and transform
whatever's in front of them.

Another soul behind these powerful eyes
would use their force
to strip their subjects naked and "dissect" them,
 so to speak.
(Other photographers do that,
and I am far from denouncing them for that.
I just state
that they achieve the opposite effect to what Peter
 does.)

Let me bring in another idea:

There is a beautiful film by François Truffaut
Called *The Man Who Loved Women*.
You learn in this film
that there is a rare tribe of men
—and I have nothing but the highest esteem for
 them—
who have an altogether different attitude toward
 women
than the rest of us.

They're strong, but defenseless,
 they're tender, but without trying to impress with
 that,
they're honest, as they have no other choice,
they're loving, but in no way possessive.
Somehow, at least that's my memory from Truffaut's
 film,
They're almost a tribe of monks.
But then again,
Women are not their religion.
Here's what sums them up the best:
They are neither intimidated
Nor intimidating.

Mind you: In photography,
That's not an obvious feat at all.
Most of the time, the subjects of photography are
 intimidated
(even if they are supermodels),
and photographers are excitable, or impressed, too,
even if they're supermen.

And second:
the lack of mutual intimidation
is a rare thing among men and women, period.

By chance, one member of the tribe
is a photographer.
Peter Lindbergh.
(If only now somebody could explain his nickname
 to me:
"the Sultan."
That might forever remain a mystery…)

So via these detours
I've found at least some traces of an answer to my
 initial question
Of how he does it:
With an almost unimaginable amount of
 "unimpressedness"
(you might almost call it stoicism)
and that one quality
that I praise more than anything else,
even if it has fallen out of fashion:
GENTLENESS.

Ladies and Gentlemen:
Here's a truly gentle man.

So the answer to my question is quite simply
That after all, the soul of a photographer
DOES show in all his pictures.

That's how he does it.
By letting IT do it.

WIM WENDERS
Introduction to *Stories*

231

Mathilde, *Rolling Stone* magazine, Eiffel Tower, Paris, 1989

Mathilde balances on one of the Eiffel Tower's upper pylons and contemplates the city like an angel fallen to earth; it looks as if her wings have been taken off so she can walk more comfortably, without attracting too much attention amid mere mortals.

A series of cross-references and citations complete the picture, as it brings to mind Marc Riboud's famous series from 1953, of painters giving the tower a fresh coat. This image has the same gravity-defying, carefree grace of those men—shown with brush in hand, hat on head, and cigarette in mouth—agilely moving across the dizzying structures of the world's most famous iron tower.

The heart of this image lies in the contrast between the massive iron structure (a signature presence throughout his work) suggested by the pylon, and the model's slender body, almost androgynous in its lightness. These two opposing forces, rigid power and lightness, help conjure up a feeling of instability, hinting at the flight she is about to begin or has just finished, high above a distant city.

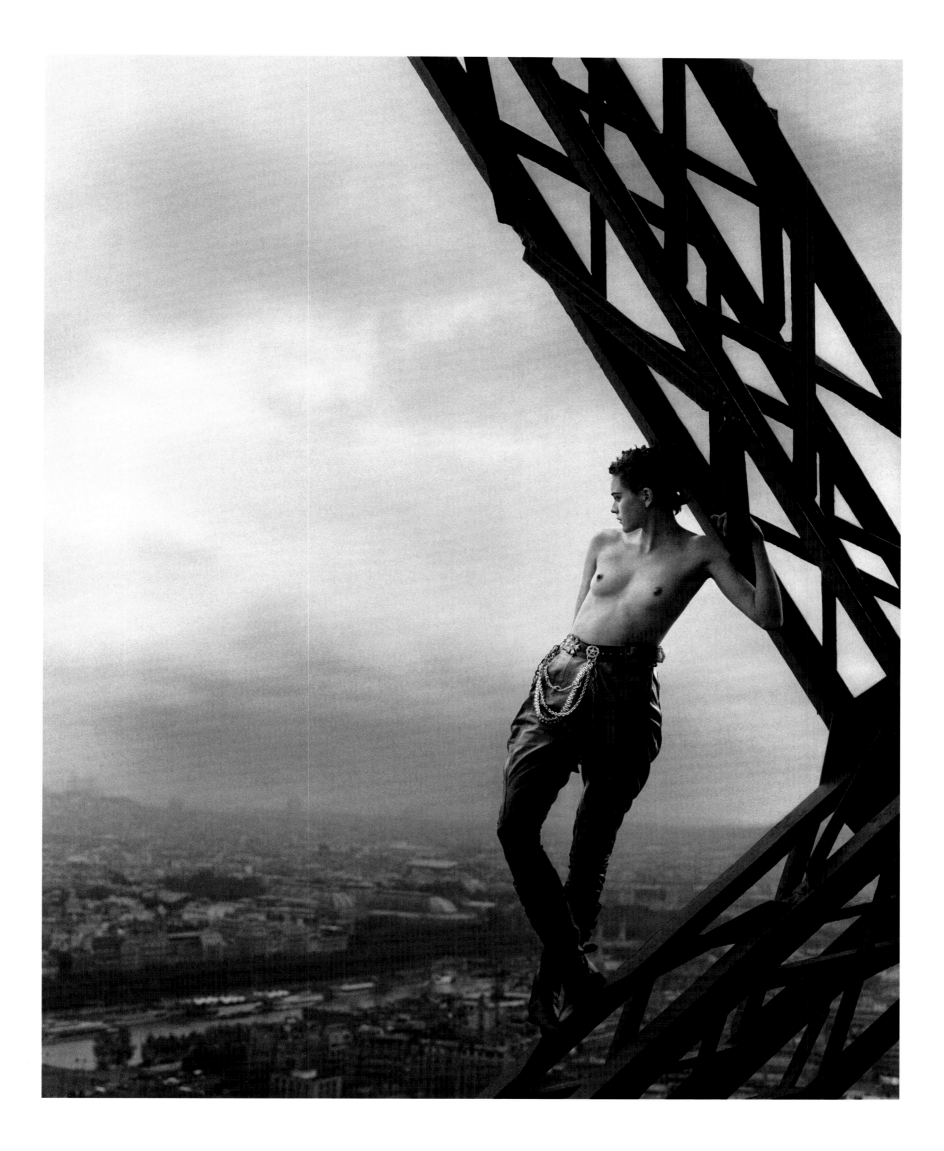

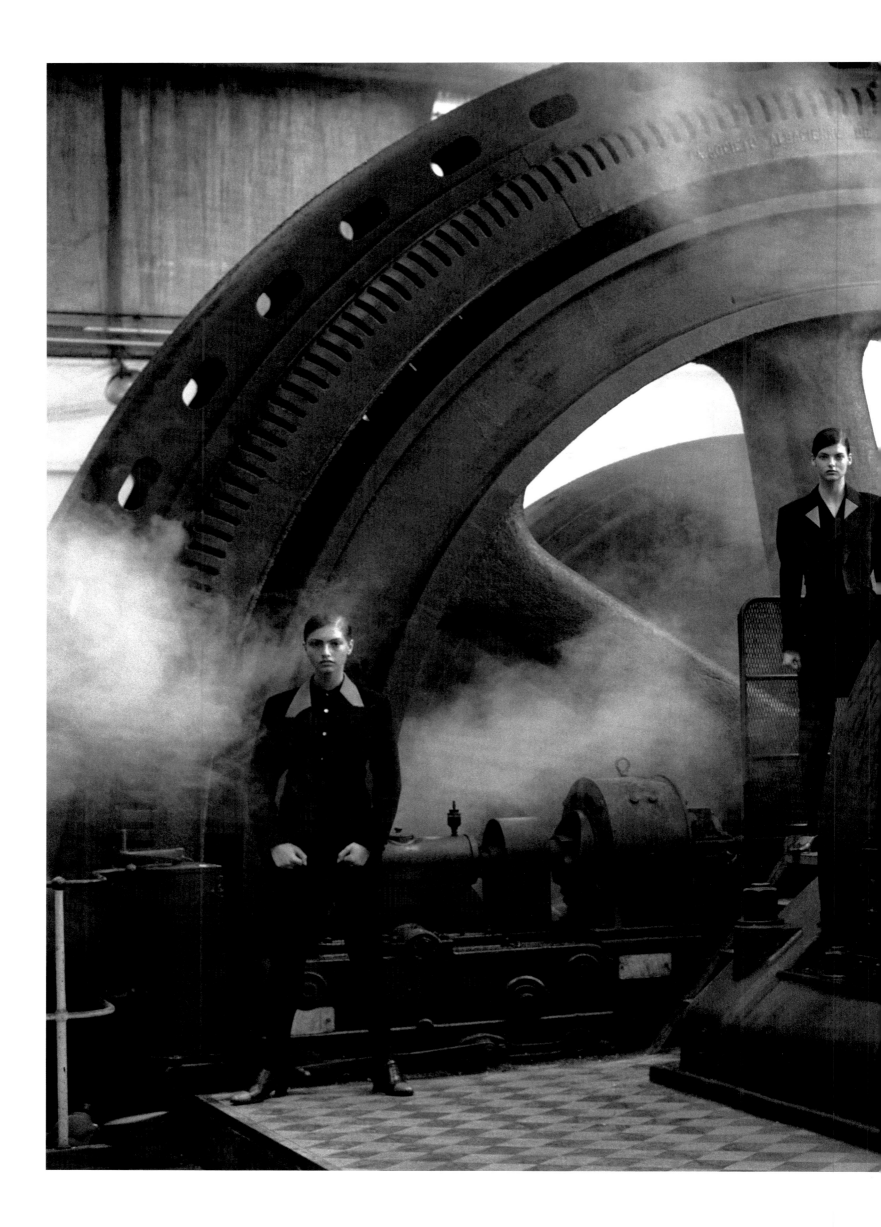

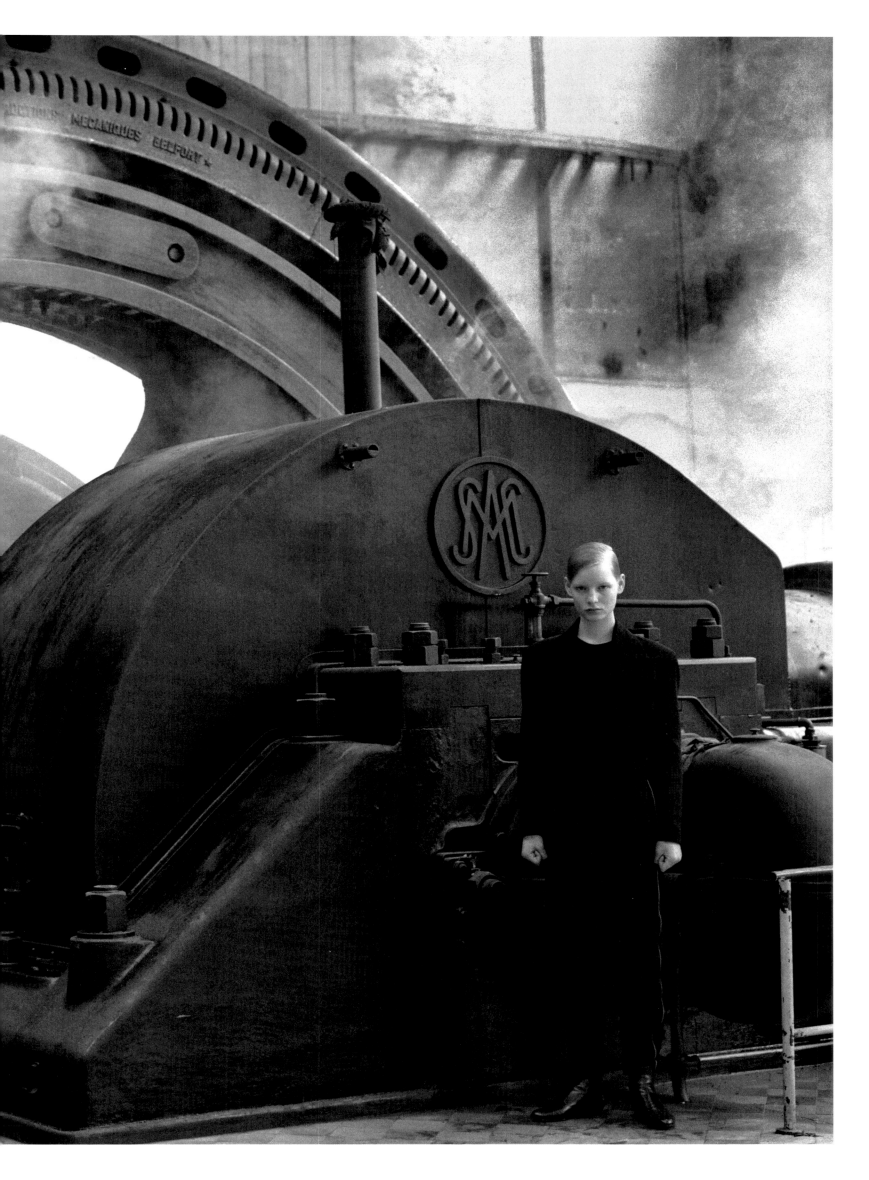

Michaela Berko, Linda Evangelista, and Kirsten Owen for Comme des Garçons, Nancy, France, 1988
A few years ago a writer for the magazine *American Photo* mused that the most important quality in Lindbergh's fashion photographs is their sincerity, their almost shocking honesty. His models seem to open up emotionally for the camera; they seem real as they move amid all the heavy machinery.

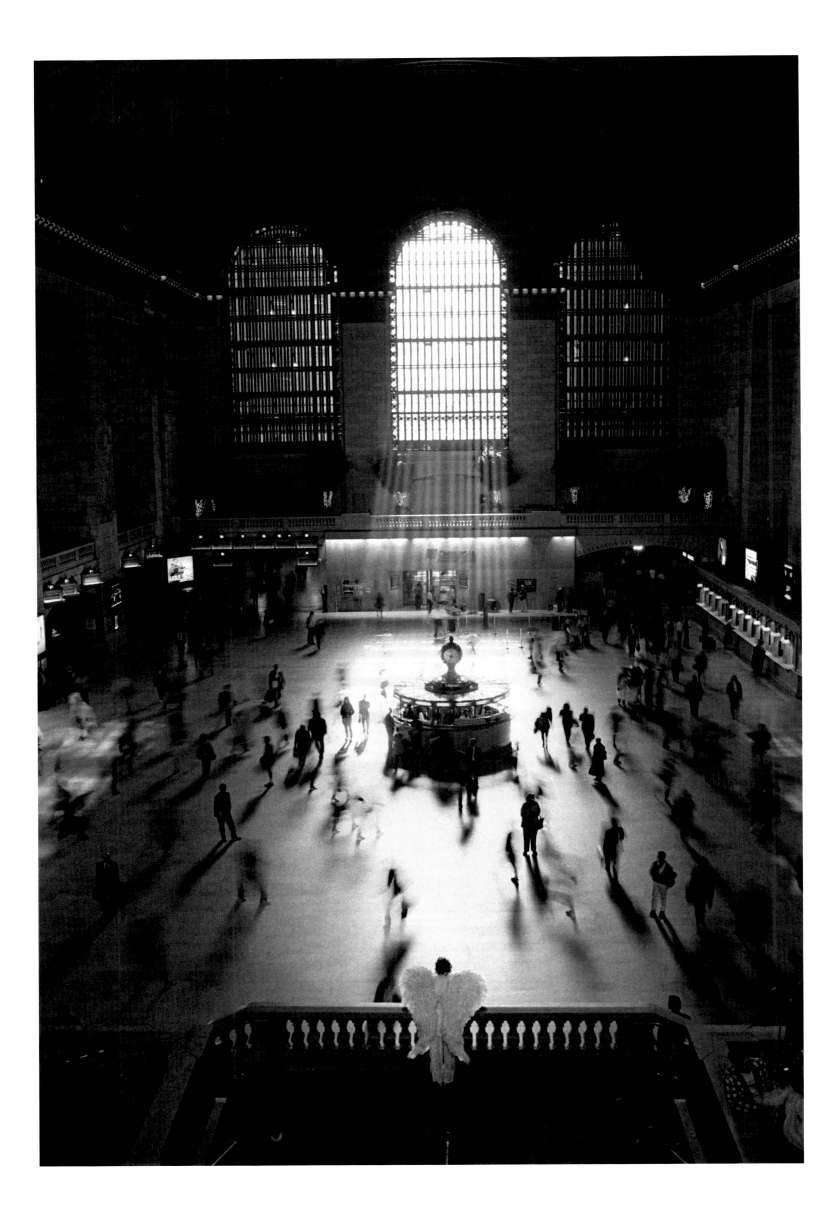

Grand Central Station, *Harper's Bazaar*, New York, 1993
The angel, a recurrent feature of twentieth-century Central European culture, frequently appears in Lindbergh's fantastic, dreamy imagery. Between the multilevel passageways of New York's Grand Central Station, seen from above yet invisible to the hustle and bustle of the workaday commute, a beam of light shines in on an angel with big white wings. Later on (right) we see the angel strolling the streets of New York as a supremely Romantic presence.

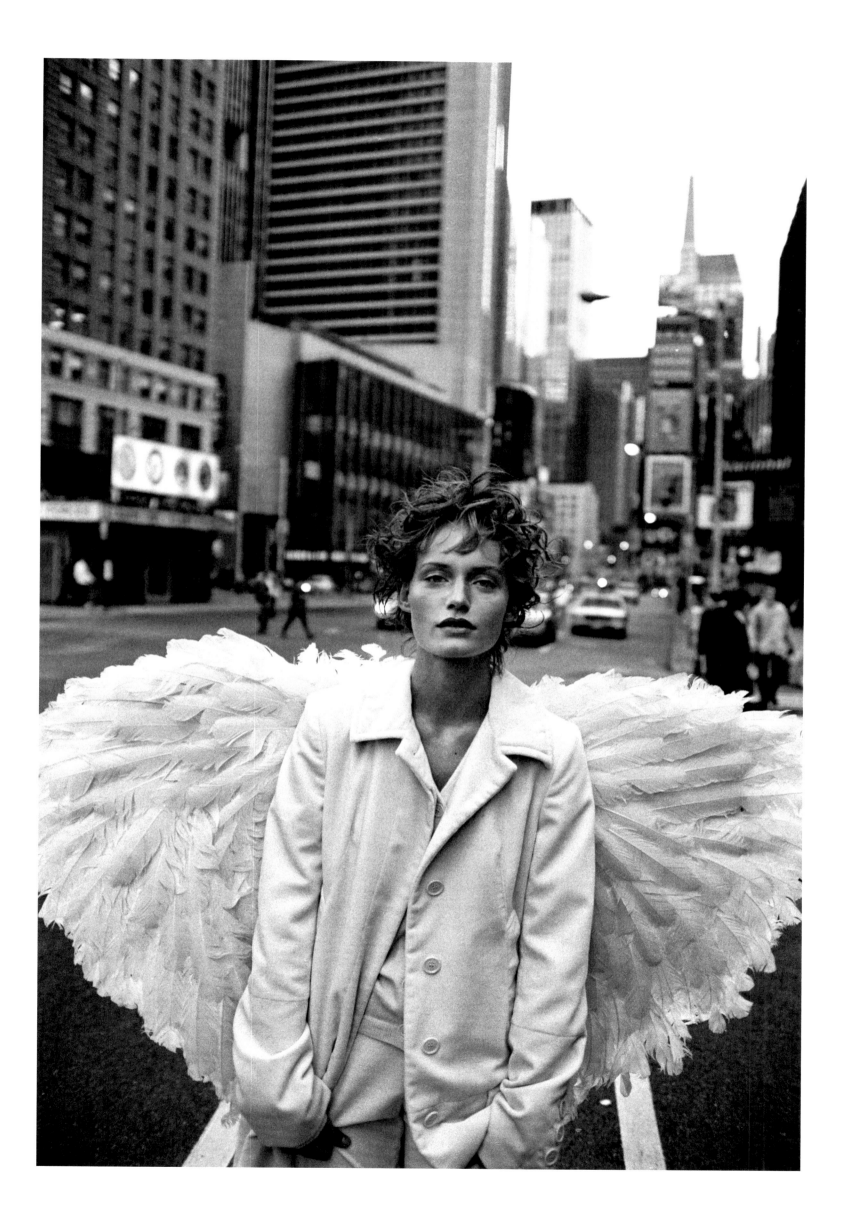

Amber Valletta, *Harper's Bazaar*, New York, 1993

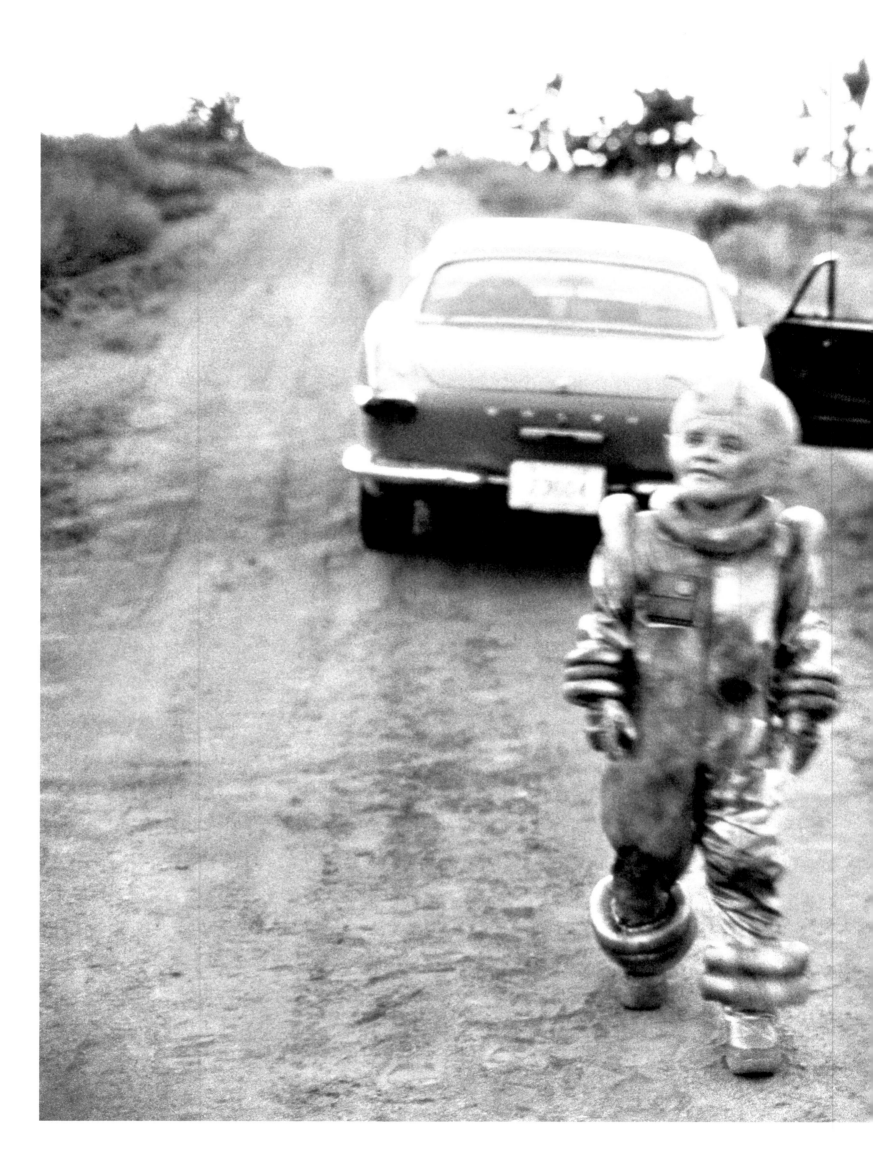

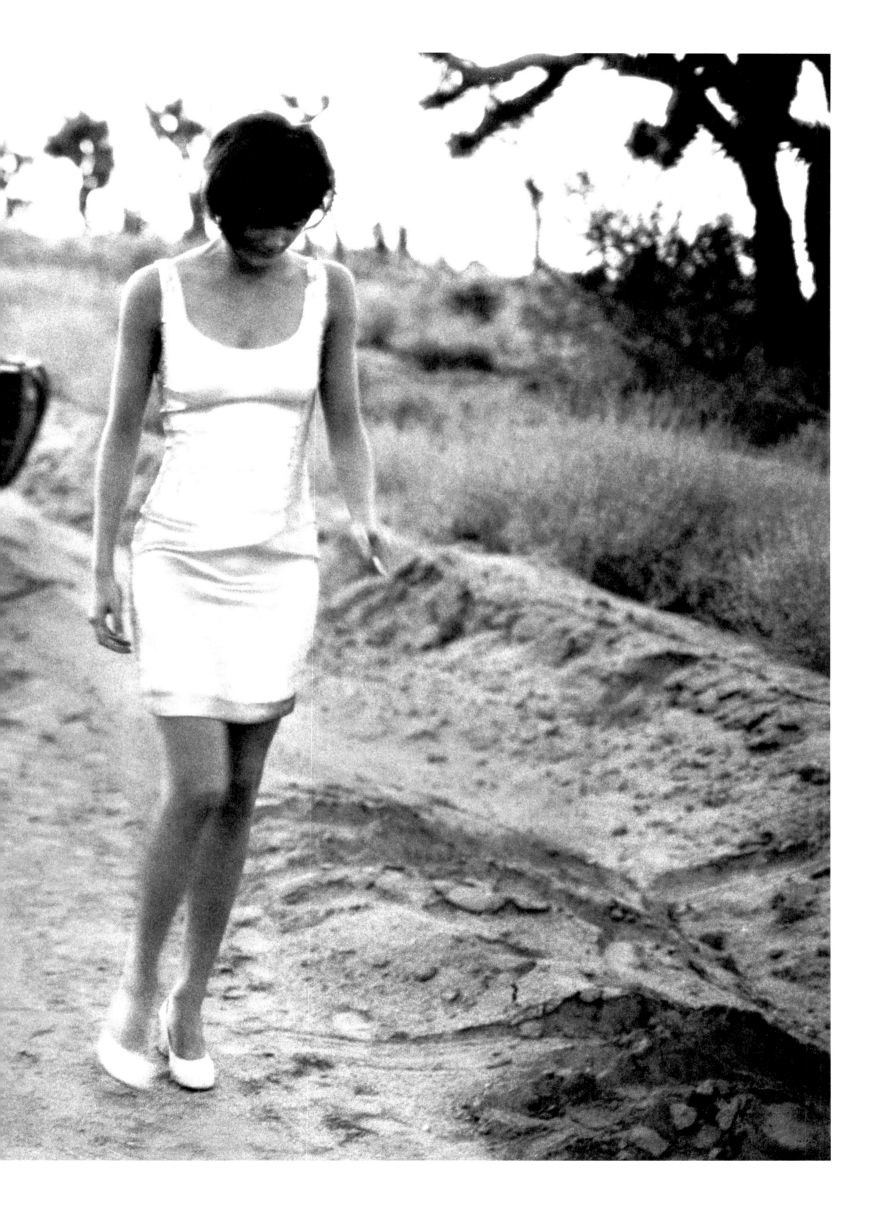

Helena Christensen and Alien, *Vogue Italia*, El Mirage, California, 1990
One of Lindbergh's most successful series was done for *Vogue Italia*, and
shows an alien spacecraft landing in the California desert. In a "behind-the-
scenes" peek at the production, a little alien strolls down a dirt road with
the model.

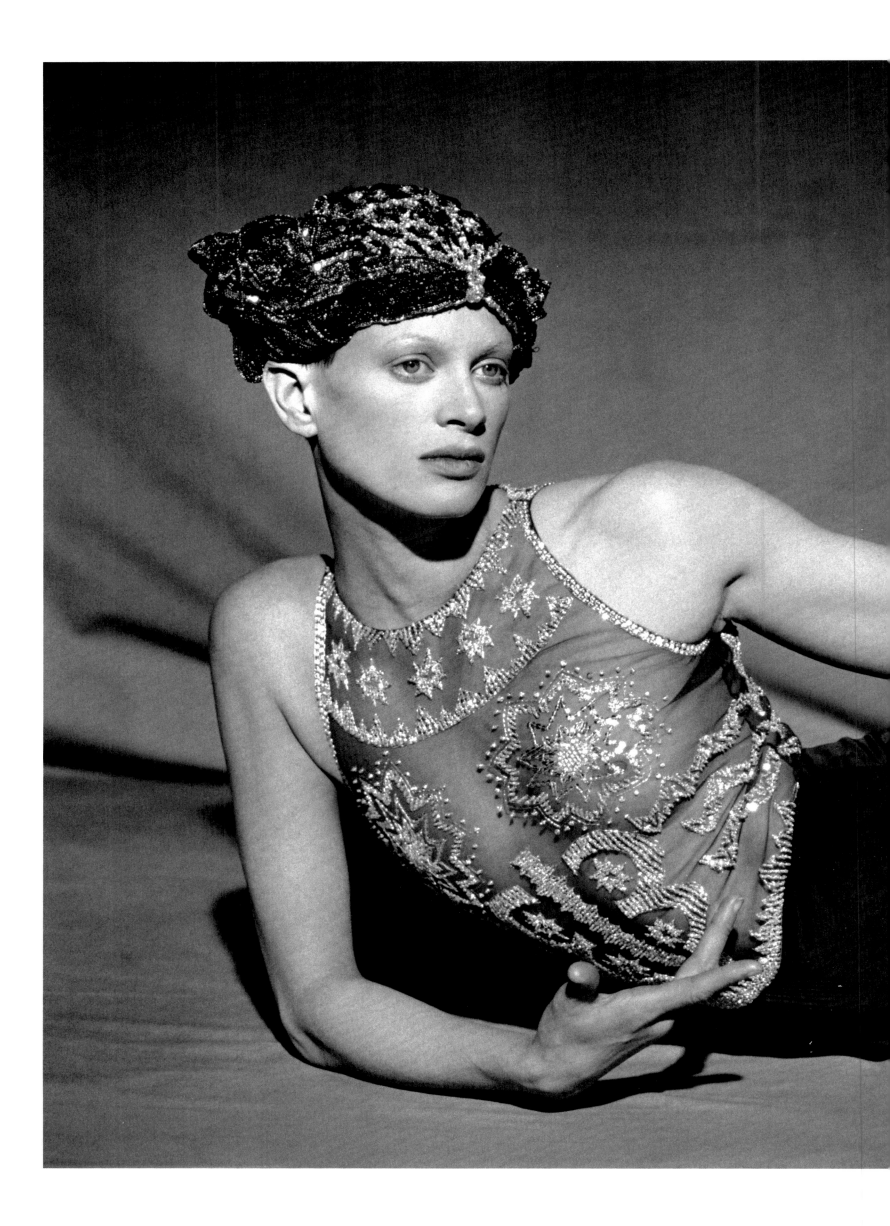

Kristen McMenamy, *Harper's Bazaar*, New York, 1993
Body language is the basis of the complex system underlying the relationship
between photographer and model. This set of complicit signs, coupled with
a deep mutual trust, can create a form of poetry that solidifies at the precise
moment the shot is taken.

Zoe Gaze, Galaxy Craze, and Georgina Cooper, *W Magazine*, Beckley,
West Virginia, 1998
Lindbergh brings his directorial talent to every fashion shoot, and often designs
short, almost cinematic stories that allow him to alternate close-ups, sequence
shots, and highly subjective takes.

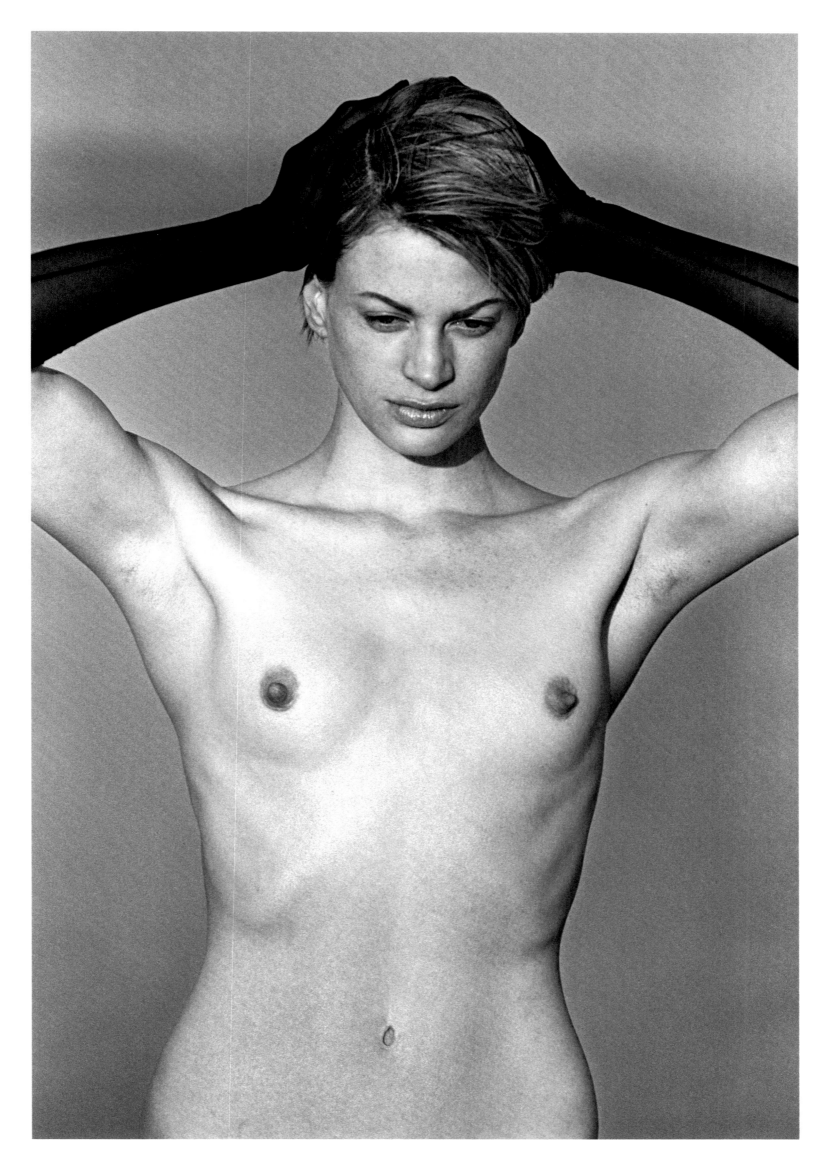

Kristen McMenamy for Pirelli, El Mirage, California, 1996
The female body contains a mystery for Lindbergh. In his work, women are
exalted not as objects of male desire, but rather for their strengths and the
sheer charm their intimate fragility exudes.

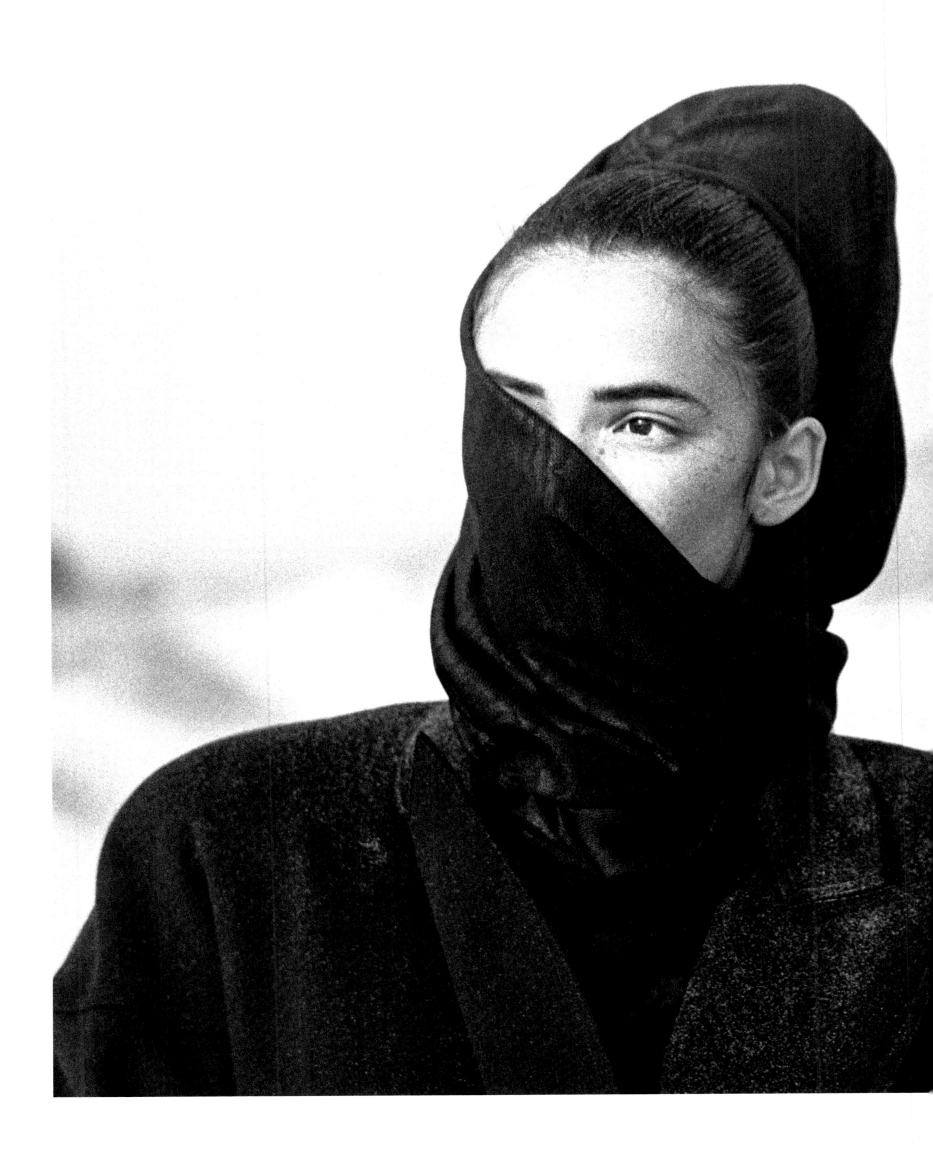

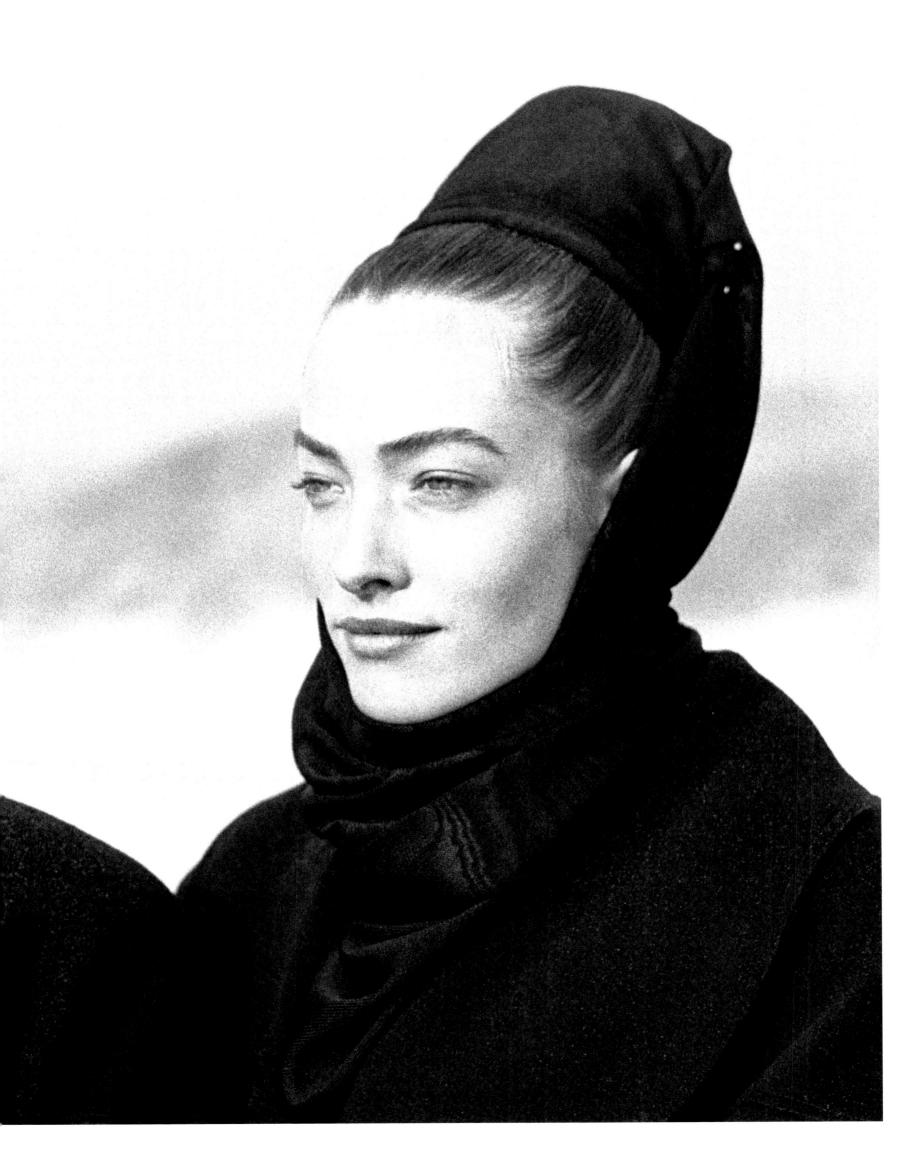

Tatjana Patitz and Linda Spierrings for Azzedine Alaïa, Le Touquet, France,
1986
Photographing fashion is not like documenting reality; rather, it means bringing a
little fantasy to life, turning a piece of history into the fragment of a dream, every
time.

245

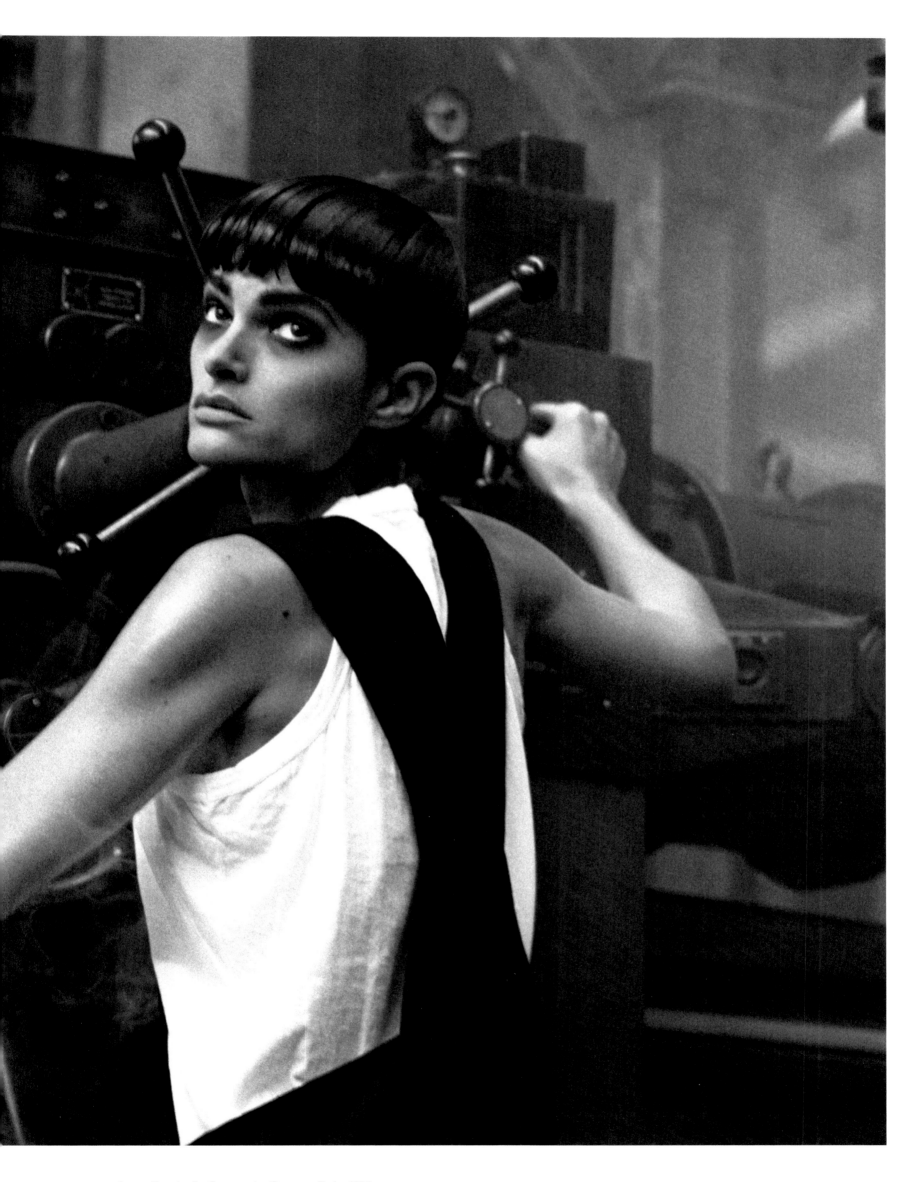

Lynne Koester for Comme des Garçons, Paris, 1984
Peter Lindbergh has always been drawn to mechanical devices. Like relics from
an industrial archeology of the present day, they reappear in his photographs
and establish a dialog with the models, enhancing their strong fragility.

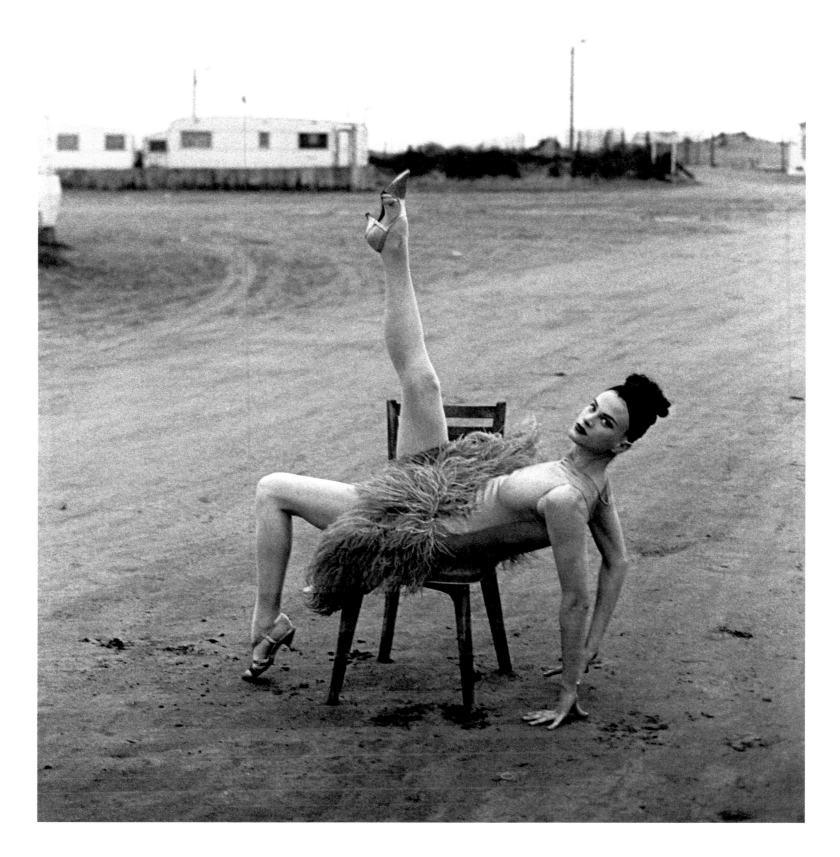

Kristen McMenamy, *Vogue Paris*, Beauduc, France, 1990
Where, exactly, does the invention in photography lie? It lies in the details that
are underlined, enlarged, and emphasized for their perfect evanescence.

Peter Lindbergh was born in 1944 in a Polish town near the East German border and spent his childhood in the city of Duisburg, West Germany. He picked up a camera for the first time at age twenty-seven and soon became an assistant to photographer Hans Lux. In 1973 he began working in advertising. Lindbergh's early photographs have a strong narrative quality. In 1978, after his work was first published in the magazine *Stern* and a series of prestigious projects followed, he moved to Paris. Since then his images have appeared in major fashion magazines like *Vogue* (in the Italian, French, British, and American editions), *The New Yorker*, *Vanity Fair*, *Stern*, and *Rolling Stone*. Between 1992 and 1997 much of his work appeared in *Harper's Bazaar* thanks to the magazine's exclusive contract with the artist, which was unprecedented at the time.

Lindbergh has created advertising campaigns for major fashion designers including Giorgio Armani, Prada, Donna Karan, Calvin Klein, Jil Sander, and Hugo Boss. His first book, *Ten Women*, a series of black-and-white photos dedicated to the ten top models of the day, was published in 1996. The second, *Peter Lindbergh: Images of Women*, a collection of his best images from the mid-1980s to the mid-1990s, came out in 1997. In 1999 he published the monograph *Peter Lindbergh*, followed by *Stories* in 2002.

Thanks to a series of exhibitions in galleries and international museums, his original photographs began to circulate on the market in 1996, and are actively collected. The exhibition *Peter Lindbergh: Photographs* included 200 images from the book *Images of Women* and toured Europe and Japan.

Lindbergh has directed numerous short films and advertisements. In 1991 he released his first documentary, *Models—The Film*, shot in New York with Linda Evangelista, Cindy Crawford, Naomi Campbell, Tatjana Patitz, and Stephanie Seymour. In 1996 Peter Arnell invited Lindbergh to make a series of short films and an advertising campaign for Hanes starring Tina Turner; his collaboration with the singer continued in Paramount's Los Angeles studios, where he directed the music video for her song "Missing You." That same year he produced the annual Pirelli Calendar with Nastassja Kinski, Tatjana Patitz, Carré Otis, Eva Herzigova, Kristen McMenamy, and Navia; he was selected to shoot the calendar again in 2002 with Brittany Murphy, Mena Suvari, Kiera Chaplin, Selma Blair, and many others.

In 1995 he was named best photographer at the International Fashion Awards in Paris, and became an honorary member of the German Art Directors Club. In October 1996 he received the Raymond Loewy Foundation Prize, the highest honor in European design, awarded annually in Berlin. In 1999 he directed *Inner Voices*, a thirty-minute documentary on the theme of self-expression in the world of theater. It premiered in Milan and New York; the following year it was screened at the Locarno and Edinburgh film festivals, and was named best documentary at the Toronto Film Festival. In 2001 British television station Channel 4 commissioned him to produce a documentary about choreographer Pina Bausch.

At the 2007 festival in Cannes he presented his film *Everywhere at Once*, co-directed by Holly Fisher. He currently lives and works in Paris, New York, and Arles.

"SOME PEOPLE ARE DRAWN TO CREATE AND EXPRESS THEMSELVES, OTHERS ARE DRAWN TO REFLECT ... IN THE END, THEY ALL COULD BE CREATIVE IF THEY HAD THE DESIRE TO EXPLORE THE WAY IN WHICH THEY ARE INTEGRATED IN THE WORLD OF THEIR EXPERIENCES. BECAUSE CREATIVITY IS REALLY A REBIRTH, A TRUE TONE WE FEEL FOR OURSELVES AND FOR OUR WORLD. THEN OUR WORK BECOMES A REAL PART OF WHO WE ARE. MAYBE ALL THIS IS A QUESTION OF HOW DEEP WE ARE WILLING TO GO...."

Peter Lindbergh.

MAN
RAY

Page 250

Spooled Film, 1923

A spiral that multiples itself in space, weightless. A disorienting effect.
 "An original is a creation motivated by desire. Any reproduction of an original is motivated by necessity. It is marvelous that we are the only species that creates gratuitous forms. To create is divine, to reproduce is human."

Above

Self-Portrait, 1931

A man, his instrument. A single destiny. A critic at the *New Yorker,* commenting on the first Man Ray anthology, *Photographs 1920–1934*, wrote: "Man Ray is an able technician who has done everything with a camera except take photographs." A harsh criticism and, unconsciously, the perfect description of an artist who, before pressing the shutter and taking a photo, as many do, had created a world different from all others.

MAN RAY

"Man Ray: masculine noun, synonymous with joy, to play, to enjoy." With these words Marcel Duchamp gave one of the most beautiful definitions of the American artist with whom he shared the beginnings of the Dadaist adventure and, later, a long and faithful friendship. The words are somewhat unemotional, somewhere between a dictionary definition and an absurd catalog of human nature, from which followed that fantastic creative explosion, under the banner of erotic enjoyment and creative joy. A joy that makes every artist into a god. And Man Ray was truly the god of small things, of those objects, those bodies that suddenly in the luminous night of dreams gain a new life and in the cosmic darkness of the darkroom reveal another identity, mysterious and extremely light. The feather-weight of a secret.

It is certain that as far as secrets are concerned, Man Ray never revealed much. He was a painter on the road to cubism who first became more abstract, then Dadaist, and then a photographer in anticipation of surrealism. His accomplice was Paris. As he wrote to his brother Sam, "Here everything is joyous and in movement." And then, "Here I have become a child again." In the artistic capital that was Paris, Man Ray had to start over from scratch, bewildered, without work and without speaking a word of French. A man of quiet disposition who spoke little, within a few months he was able, thanks to his Dadaist friends, to enter the most avant-garde circles in every field, including fashion. In 1921 Man Ray produced the first true fashion photos for Paul Poiret, a couturier and collector of modern art (including some wonderful statues by Brancusi). Clothes, elegance, culture, and modernity were all of a piece. But the push toward extreme innovation, something quite risky considering that within a few years the energy of Dadaism would be exhausted, was balanced by a skillful reference to the past. As he would say, "My hands are full with Europe."

Beauty was an emblem of the old continent, Europe, even during the years of the rush to modernism and anti-bourgeois anger at the start of the twentieth century. It was Renaissance-like, in those continuous lines that turn the body itself into a continent. But Man Ray was above all a classicist, preferring Ingres, with his generous and extremely smooth volumes, his rose-pink mother-of-pearl, his erotic risks that left a woman only the modesty of a turban. And it was this compound beauty, never stiff or dusty because it was struck through with the current of "solarization," which guaranteed the artist and us safety in the world of dreams. It was a world to which Man Ray discovered the key a few months after his arrival in Paris, working in a darkroom one winter evening in 1921 or '22. A blank sheet slid by chance—that randomness and automatism so beloved of the surrealists—into the developing tray, the artist leaned it against a glass funnel and a thermometer, and without thinking turned on the light. In a few seconds, like magic, without the help of a camera, an image appeared on the paper. It was the revolutionary "rayograph," which he named after himself. It was not a faithful copy, but a distorted, indistinct outline that could be superimposed on top of others in a game of infinite combinations. It was as if reality had unveiled another level of consciousness. According to Man Ray, "the objects have never been so close to true life as in my new work."

Tristan Tzara also witnessed these first experiments. His enthusiasm was boundless: "These images are undersea visions, cloud crystals, flights of sharks across waves of applause." Perhaps it was too much, because Man Ray was irritated by the passion and poetic fantasy of his friend. Possibly he saw it as a threat to the exclusivity of his invention. It is the instinct of the demiurge. The pleasures of mastery and control mark the emotional life of the artist, who dominates his women and keeps them nearby by means of the fascination of photography, in passion and in moments of crisis. And the women return this absolute and bewitched love, leaving a mark on the master's work through their diverse personalities, their generous (and not so generous) figures, and their defiant (or not so defiant) eyes. It started with Kiki, so carnal and direct, his first love in Paris, whom Man Ray reinvented and redesigned, and whose make-up he would personally put on each evening before they went out. Then came Lee Miller, a model and a photographer who was both ambitious and ethereal, the only one of his companions considered a true equal. And, finally, Juliet Browner, who was exotic, sparkling, open to any kind of amusement, and who stayed with him until his death. They met in Los Angeles, where Man Ray had gone after fleeing Paris because of the war. They married in 1946 and relocated to Paris together in 1951, ending a period that to Man Ray had been a cultural as well as political exile.

Once in Paris, for the second time, Man Ray went back to being a child and began to play and enjoy himself again. He proved that dreams, if they are explored with masterly technique, and fearlessly, can never be exhausted.

Le Violon d'Ingres, 1924

A pastime, a light story that leaves a mark on the skin and then flees. Man Ray, a painter from the beginning of his career and a painter to the depths of his soul, spoke in this joking way about his photographs. As if they had been a second choice, a second opportunity to create those mysterious and suspenseful atmos-pheres that made him first a master of Dada and later a master of surrealism. To take photographs as a hobby is "un violon d'Ingres," according to the French expression, because the famous painter, greatly beloved of Man Ray for his classicism, also had a secret passion: the violin. "Violon d'Ingres," in its linguistic and autobiographical versions, became the title of a marvelous "portrait-manifesto," dedicated by Man Ray to Kiki of Montparnasse, his companion, muse, and model.

They first met in Paris in 1921, in a cafe on avenue du Maine, in Paris. Kiki, which was the stage name of Alice Prin, was twenty years old, beautiful, brazen, sublime in the perfect oval of her face, and happily vulgar in the words that came from her Cupid-bow painted lips. Kiki was alone that day, without a man at her side, and, what was worse, without a hat. Scandalous. The waiter didn't want to serve her. A storm of insults. A few tables away, Man Ray sat with his friend Marie Wassilieff, also a painter. The brawl had almost reached its peak when Man Ray got up and, pretending to know Kiki, invited her to sit with him. Peace. That evening they dined together and then went to see *Foolish Wives*, the latest film by Erich von Stroheim. Like a young boy, in the darkness of the theater, he held her hand. They would live together for six years. This portrait of Kiki was produced by Man Ray in 1924 and published that June in number 13 of the review *Littérature*, edited by André Breton. The title, "Violon d'Ingres," was therefore not a joke, as he would have had people believe, in an umpteenth burst of irony.

In October 1924 Breton himself sent the first *Surrealist Manifesto* to the printer. But in a way, the manifesto had already been written on the pure white skin of Kiki, that foolish woman and innocent child who had posed for Man Ray as the "Valpinçon Bather," a painting by Ingres from 1808. She had the same rose-pink flesh of dawn, the same rotund elegance, and the same turban hinting at the mysteries of the Orient. But on her back were painted the two "f-holes" of a violin.

Two black signs, two unnatural clefts that transform the woman and her defenseless body, which has no arms, into a pure instrument of pleasure and an object of desire.

Five years before, in 1919, Marcel Duchamp, celebrating with a Dadaist spirit the four hundredth anniversary of the death of Leonardo da Vinci, had painted a version of the Mona Lisa with a moustache and beard. With its anti-bourgeois irreverence and sexual ambiguity, it was the first illuminating meditation on the role of the artist and his presumed originality in an industrial age. Man Ray, the iconoclast, accepted the challenge, so difficult and with no way back, but tempered it by his admiration for ancient art, feminine beauty, and Kiki. She, in turn, feeling the originality of that bond, loved to present herself in public as "Kiki Man Ray."

Not a wife, but a ready-made object of love.

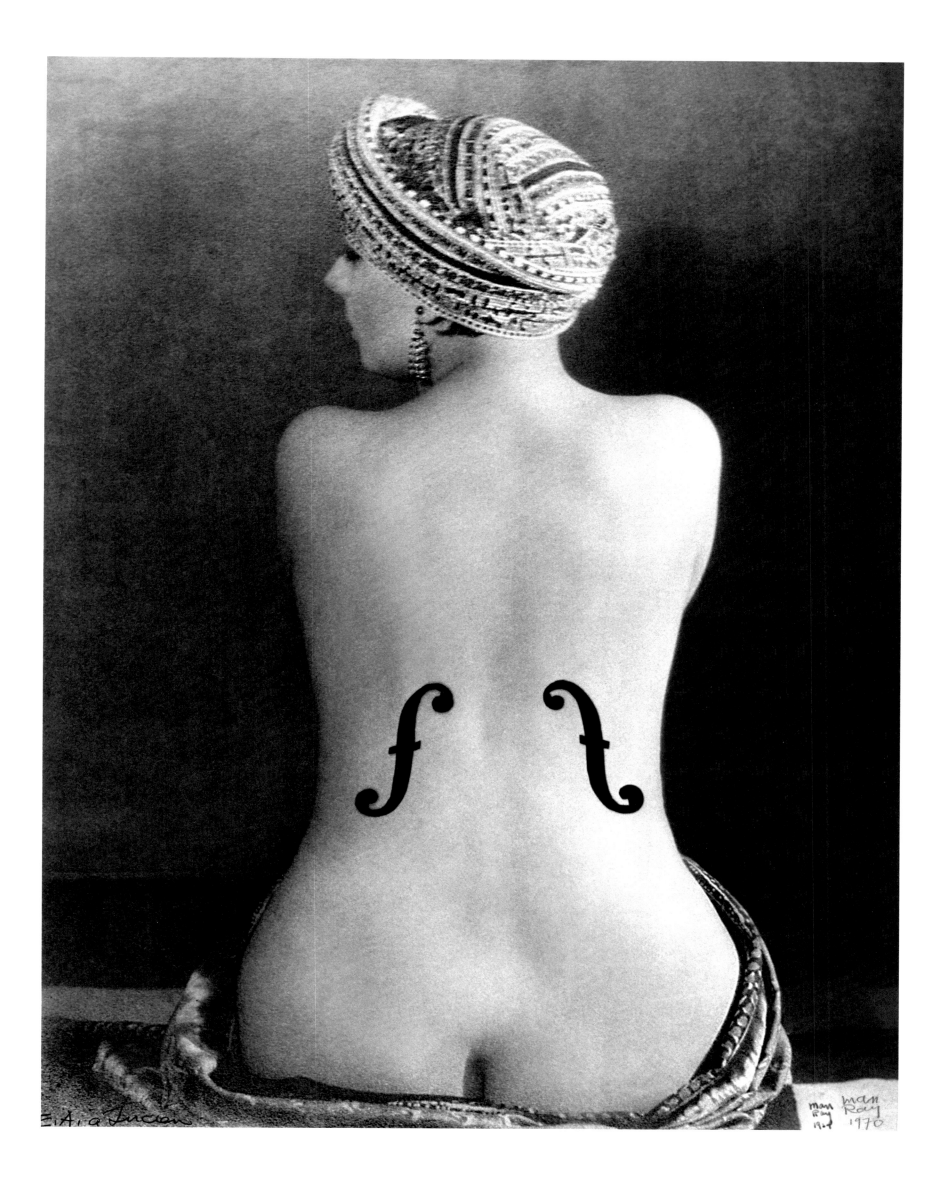

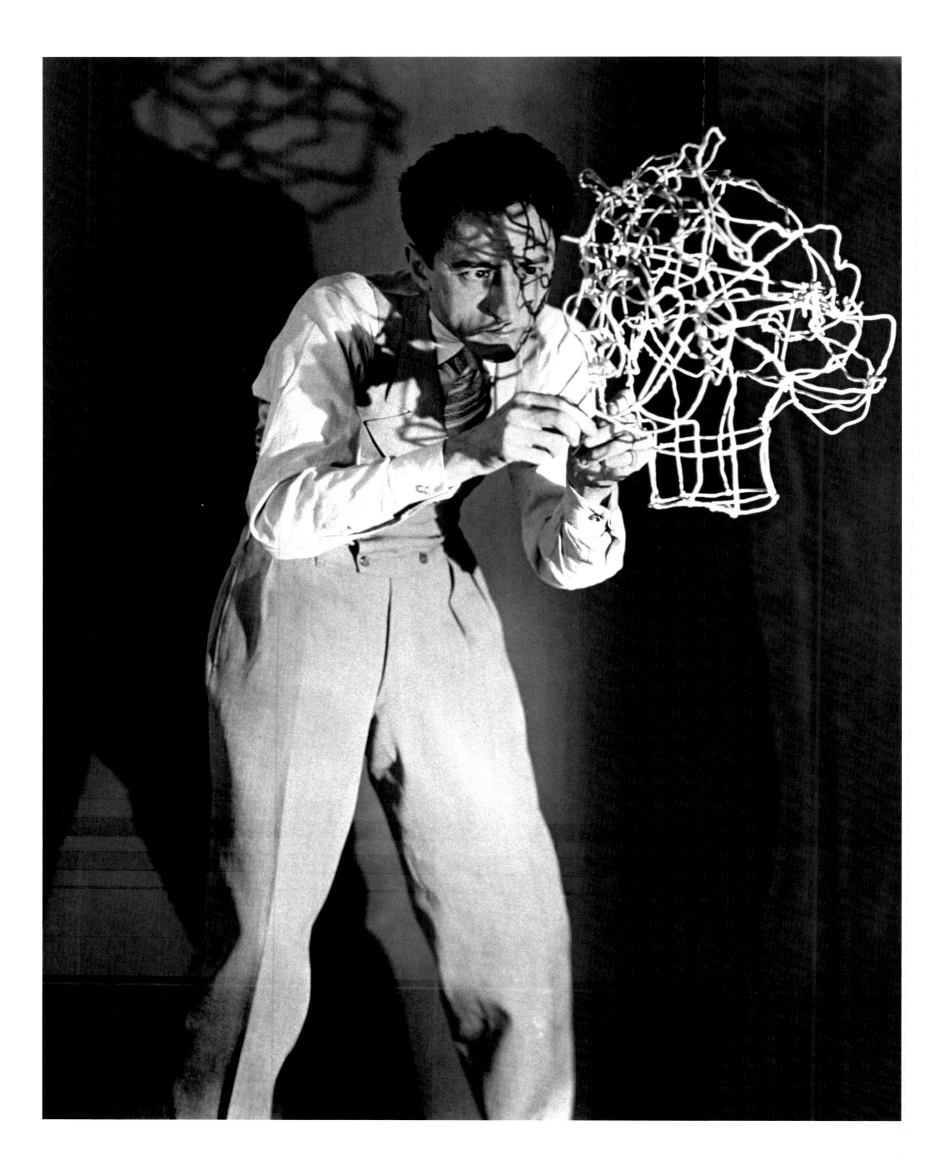

Jean Cocteau, 1926
A framework for dreaming. A lightweight support for the weight of that
dark world that resides in the recesses of our consciousness. This is the
surrealist work and that is the secret of a portrait that captured Jean Cocteau
during the creative process. Behind him, his shadow. In front, the face of a
mysterious creature. In between, an artist who passes through the phantoms
of the mind and brings them to life.

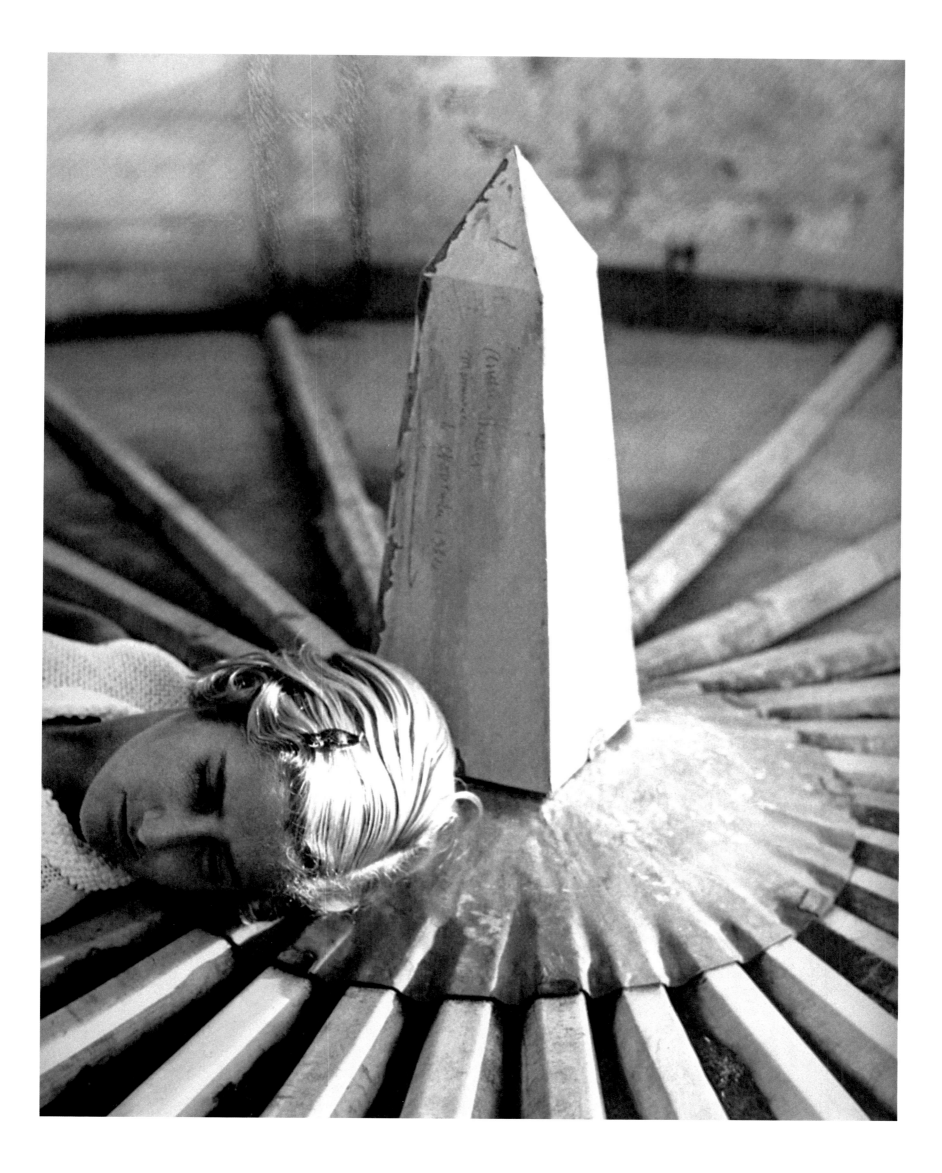

The Dawn of Objects, 1937
They would not have had to do anything other than "give pleasure, disturb, bewilder, and cause reflection." That is how Man Ray presented the collection of his "Objects of affection." Another universe, free to follow the rules of desire and abandon. To leave the paths of logic, this the sole rule in order to see, with closed eyes, the rise of that hidden meaning which alone allows the birth of a work of art.

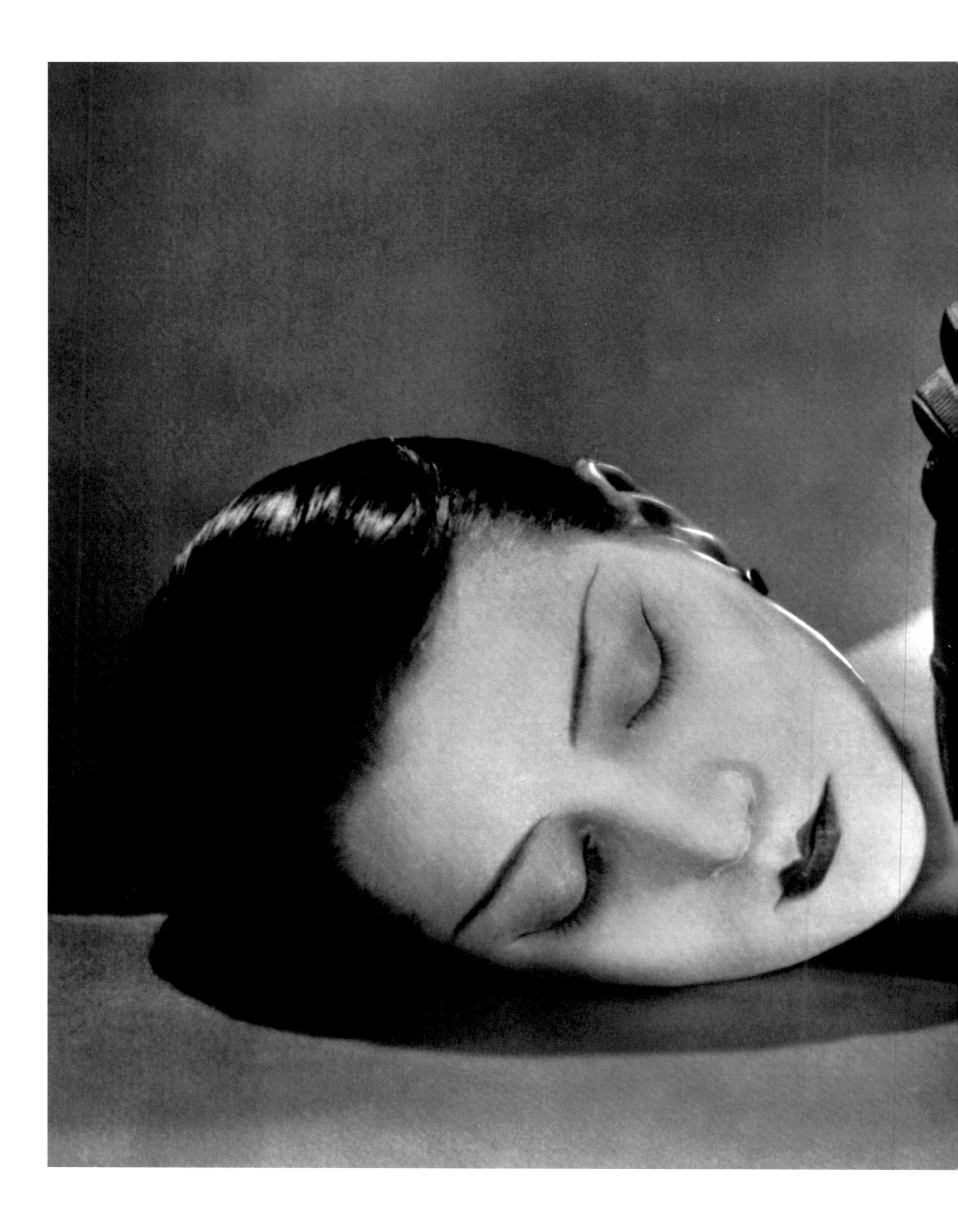

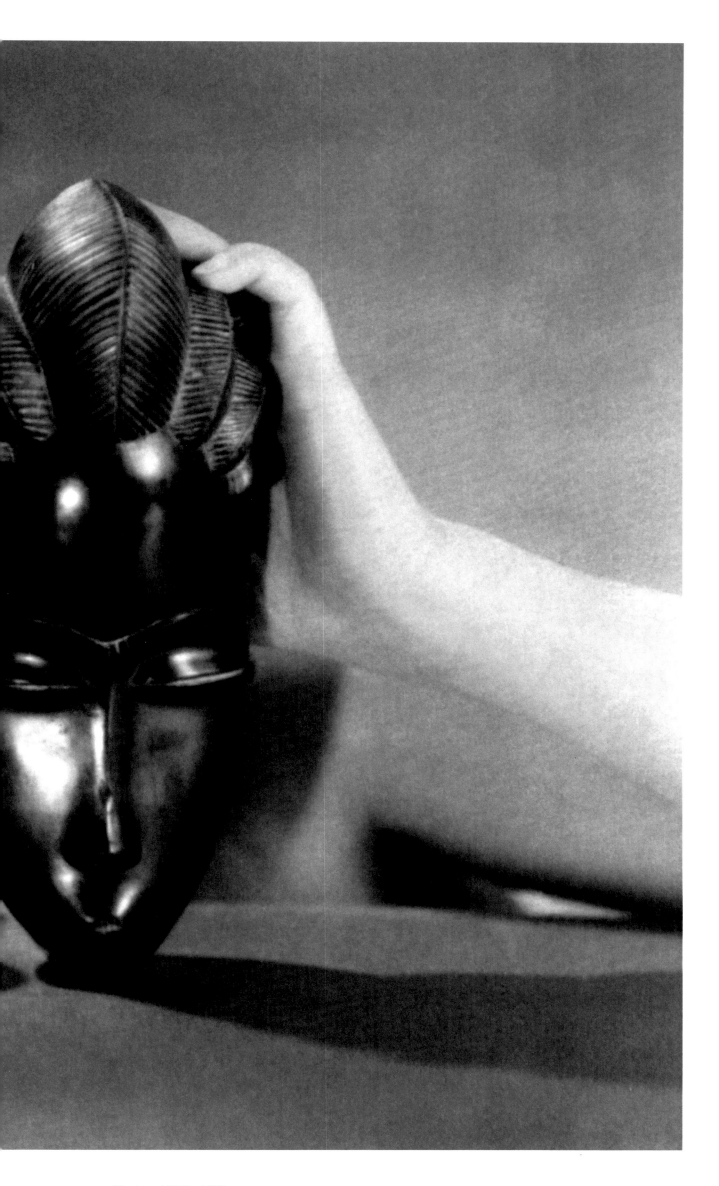

Black and White, 1926
African art. Another hierarchy of signs that, at the start of the 1900s, changed
the course of European culture. Black and white, chromatic opposites that
meet even here in the face of a Yoruba mask and the face of a sleeping Kiki.
Twenty years after Picasso's *Demoiselles d'Avignon*, Man Ray did not distort
the bodies or their features, but elegantly allowed the two ladies of the world
and their beauty to converse.

"I PAINT WHAT CANNOT BE PHOTOGRAPHED, THAT WHICH COMES FROM THE IMAGINATION OR FROM DREAMS, OR FROM AN UNCONSCIOUS DRIVE.
I PHOTOGRAPH THE THINGS THAT I DO NOT WISH TO PAINT, THE THINGS WHICH ALREADY HAVE AN EXISTENCE."

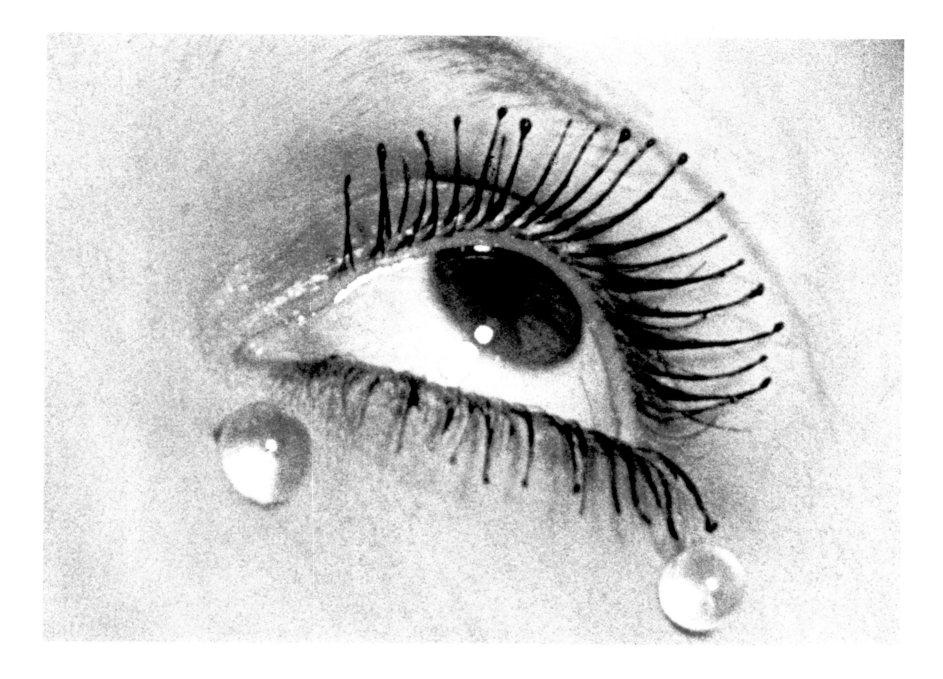

Tears, 1932

Truth and make-believe. Heartbreak and tears of glycerin. For the critic, the image is a play of opposites that can chill the most romantic souls. The umpteenth knife in the tender heart of the bourgeoisie.

But the newspapers indicate that Man Ray took the photograph the day after his separation from Lee Miller—a model, photographer, and love of his life.

Unforgettable. Even in the details, as witnessed by Lee's eye fixed on the famous metronome and her lips that fly to heaven in his painting *À l'heure de l'observatoire, les amoureux*. No abandonment by a lover has ever been exorcised with so much passion.

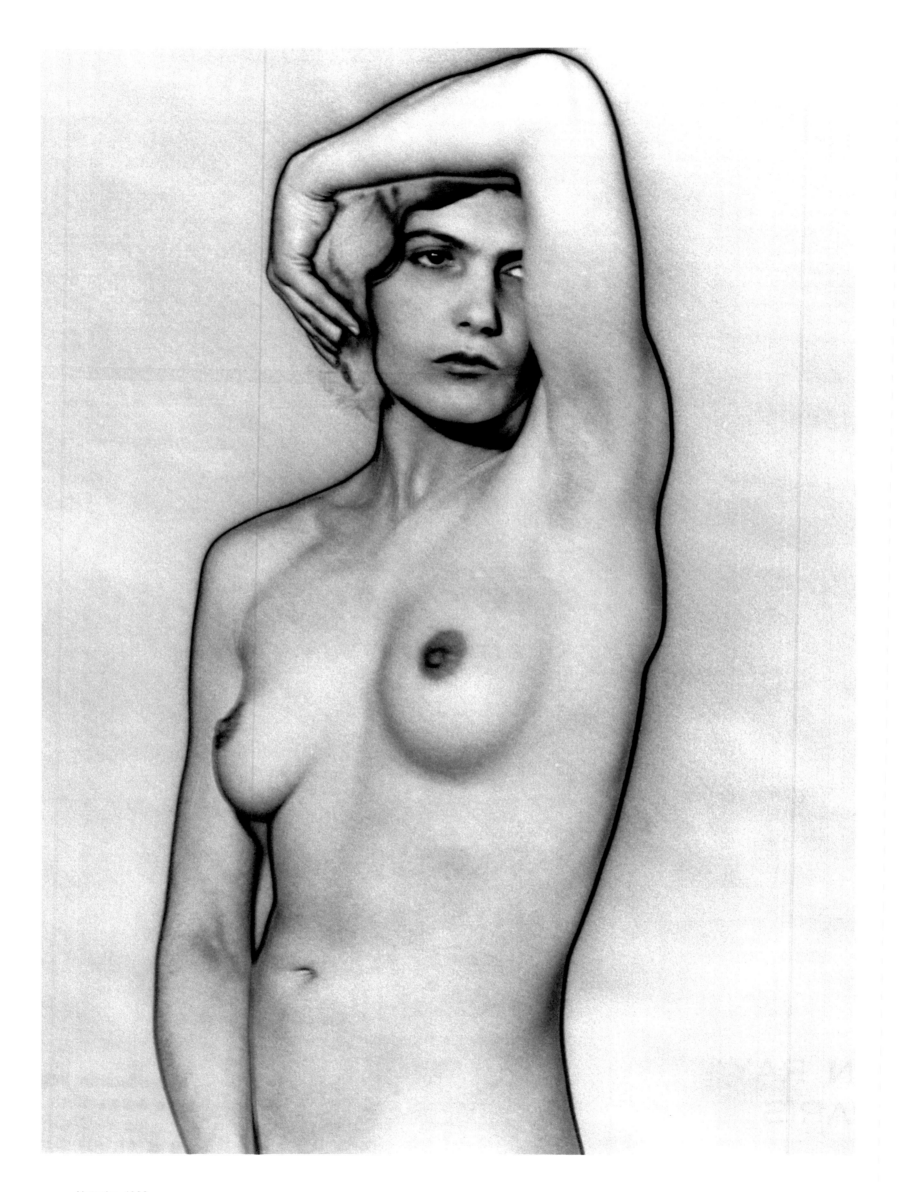

Natasha, 1930

A classic nude, if not for the dark line that isolates the body from the background and electrifies it with a light never seen before. It is the "solarization" effect, a dazzling technique discovered by chance by Man Ray and Lee Miller in 1929. Legend has it that while they worked in the darkroom one night Lee was frightened by a mouse and her sudden movement caused the darkroom light to go on during the printing. The image, a portrait of Suzy Solidor, was developed anyway and right under the eyes of the two photographers there appeared the miracle of a new sun.

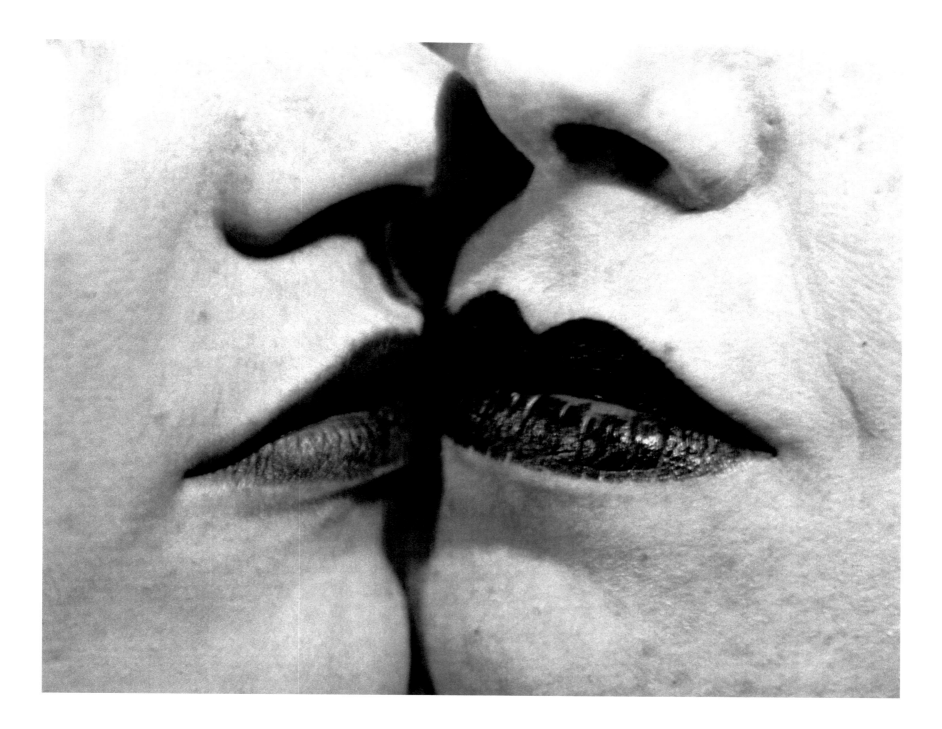

The Kiss, 1930

Two feminine profiles that brush against each other but say the inexpressible. On the left is Lee Miller, on the right her friend Belbourne, joined in the famous kiss. One of the first to pave the way, with the seduction of elegance, for the sexual freedom that was so scandalous in bourgeois society at the beginning of the 1900s.

And again there appears a female body in pieces, first the back, then an eye, and further on the hands. A sign that perhaps Man Ray and the surrealists feared the enchantments of women. But in small drops the poison is never deadly.

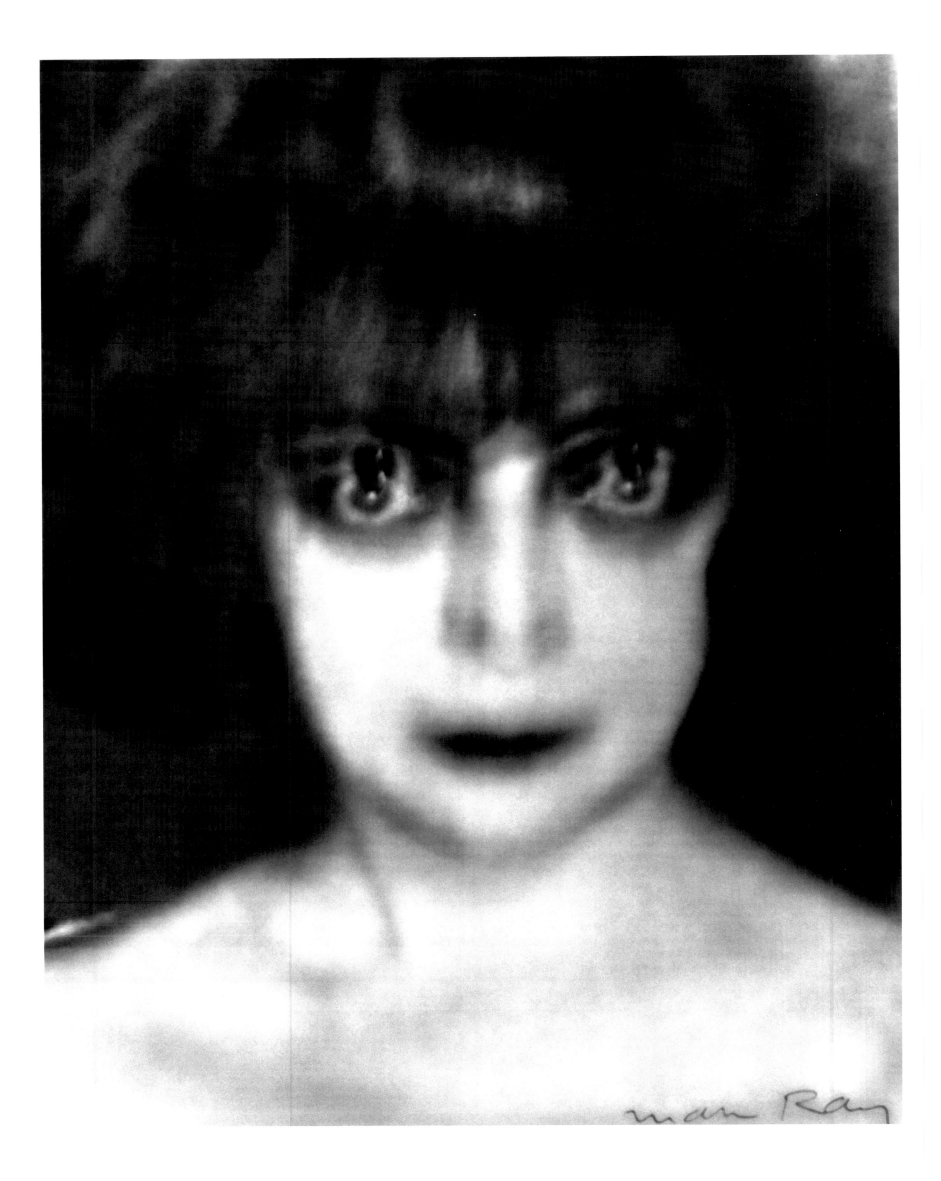

Marchesa Casati, 1922
He considered it a mistake, the fault of that noblewoman—a friend of Gabriele D'Annunzio and someone famous in the salons of Paris—who could not manage to sit still in front of the camera. She, on the other hand, considered it to be "the portrait of my soul."

Evanescent, split, with Medusa eyes that actually duplicate themselves and make us see that there must be more than one vision of reality. Better to look beyond, therefore, and with that pair of eyes further explore ourselves within. And all this two years before the drafting of the *Surrealist Manifesto*.

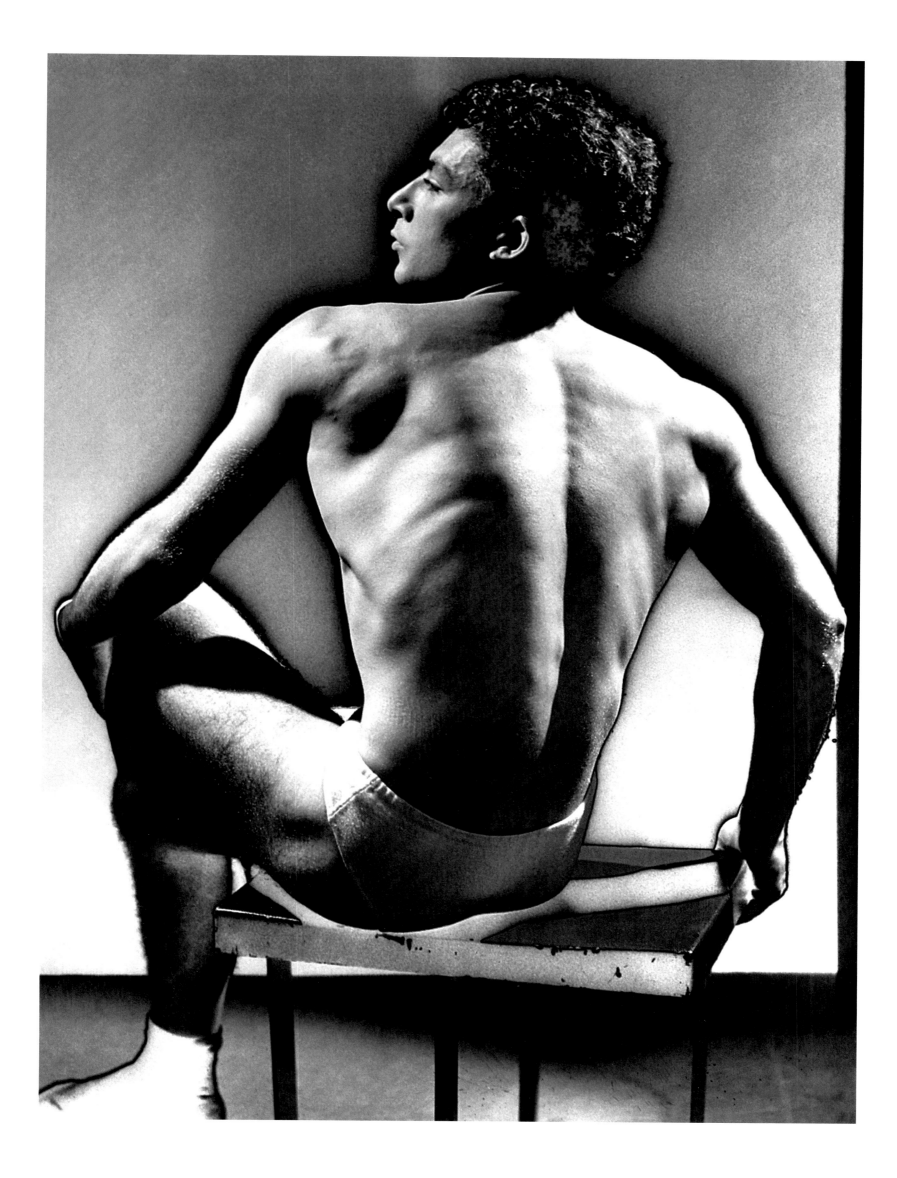

Masculine, 1933

Modernity and historical reference. A masculine body shot through with the quiver of solarization and at the same time a reference to Michelangelo, a master of the Renaissance. Twisting, screw-like, but never to breaking point, because Man Ray, first a Dadaist and then a surrealist, equidistant from the polemics of Tzara and Breton, maintained a firm connection to the past. Without ever renouncing the pleasures of beauty, in a time of war and iconoclastic crusades. It may, perhaps, have given him the armor he needed to survive the violence of those revolutions unscathed.

"I LIKE CONTRADICTIONS. WE HAVE NEVER ATTAINED THE INFINITE VARIETY AND CONTRADICTIONS THAT EXIST IN NATURE. TOMORROW I SHALL CONTRADICT MYSELF. THAT IS THE ONE WAY I HAVE OF ASSERTING MY LIBERTY, THE REAL LIBERTY ONE DOES NOT FIND AS A MEMBER OF SOCIETY."

"IT HAS NEVER BEEN MY OBJECT TO RECORD MY DREAMS, JUST THE DETERMINATION TO REALIZE THEM."

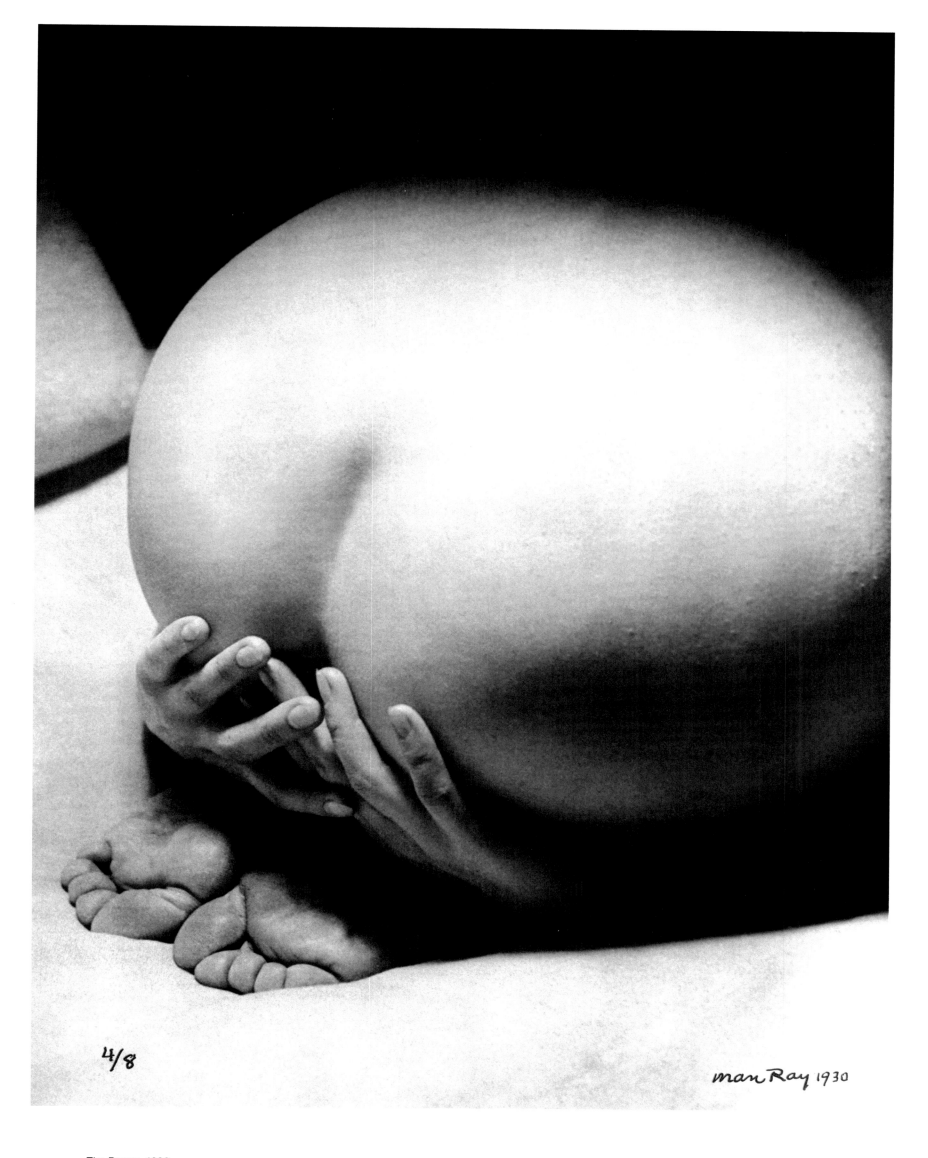

4/8

man Ray 1930

The Prayer, 1930
Thus, kneeling, with head bent to the will of God, on a soft, pure white bed that becomes the pavement of a church. And those hands that instead of being joined on the breast, in prayer, cover and exalt another part of the body. A woman of new faith, that of Man Ray. It is anticlericalism pushed to an extreme, Man Ray's, which follows in the steps of Duchamp and Dada and which offers itself in sacrifice to the religion of Eros.

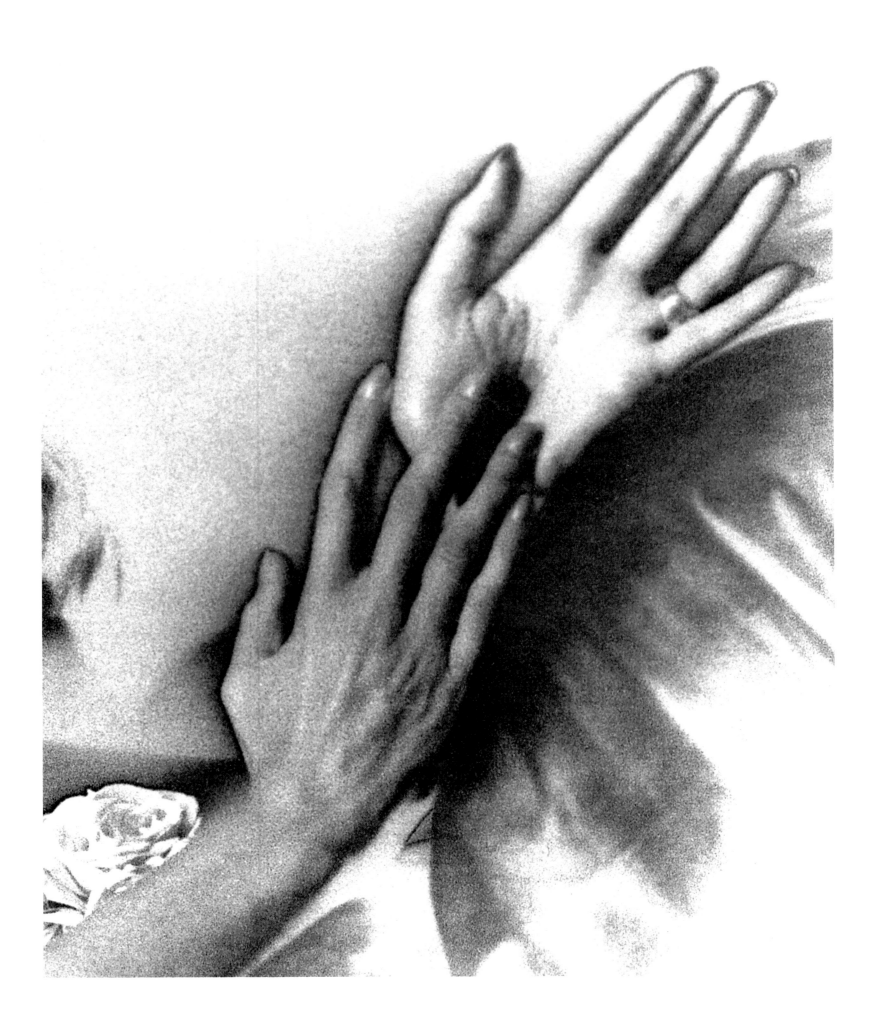

Hands, 1935
Caresses, enchantments to evoke the occult powers of heaven and earth.
With solarized hands one can do anything. One's hands can hold the face
of a lover and the secret destiny of the world. Surrealist art is full of hands
and their more sensual coverings, gloves. A magical response to the horror
of mass production, from which the hand of man and his power to perform
miracles seem forever exiled.

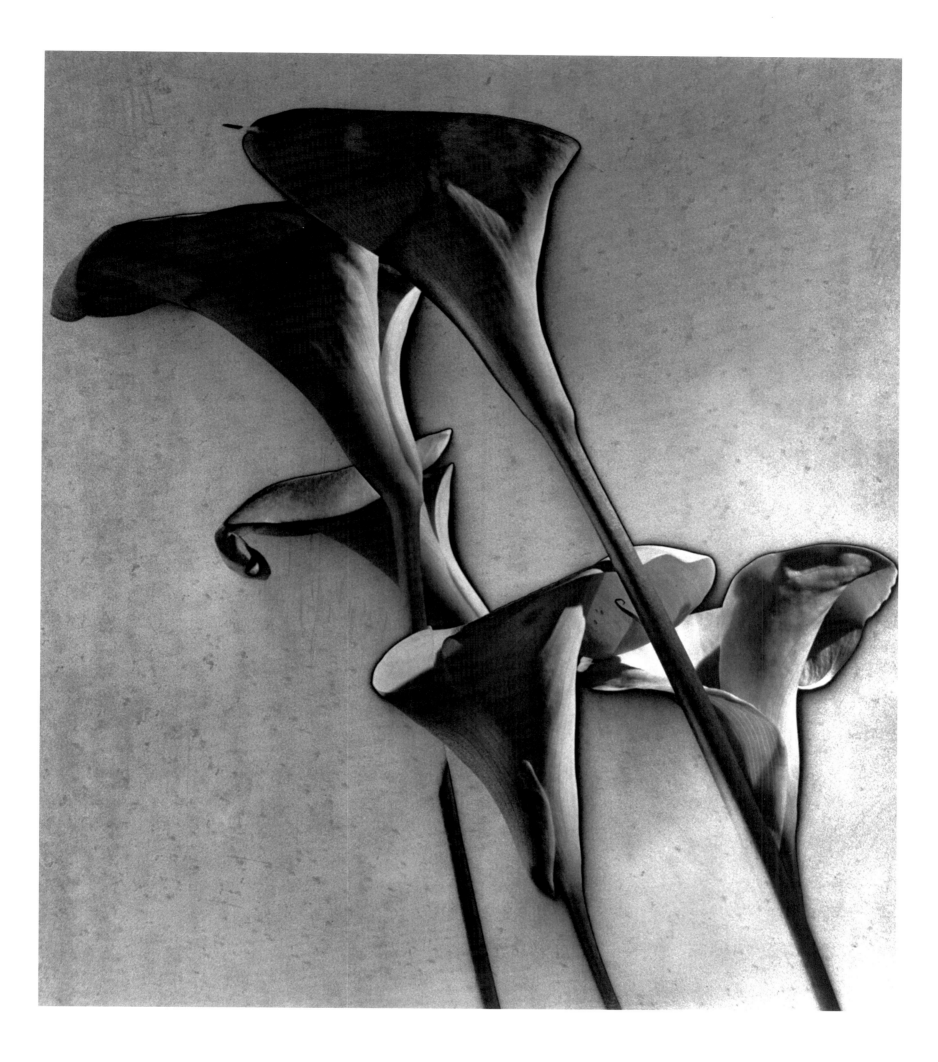

Untitled, 1930
The calla lilies enter Man Ray's garden as the most sensual of flowers. Not
a simple academic exercise, they are an emblem of desire, a perfect hollow
ready to receive, a smooth, immaculate mass that shows the luminous
virtuosity of solarization. A bright image, dynamic in its diagonal cut that
seems to want to grow beyond the limits of the frame.

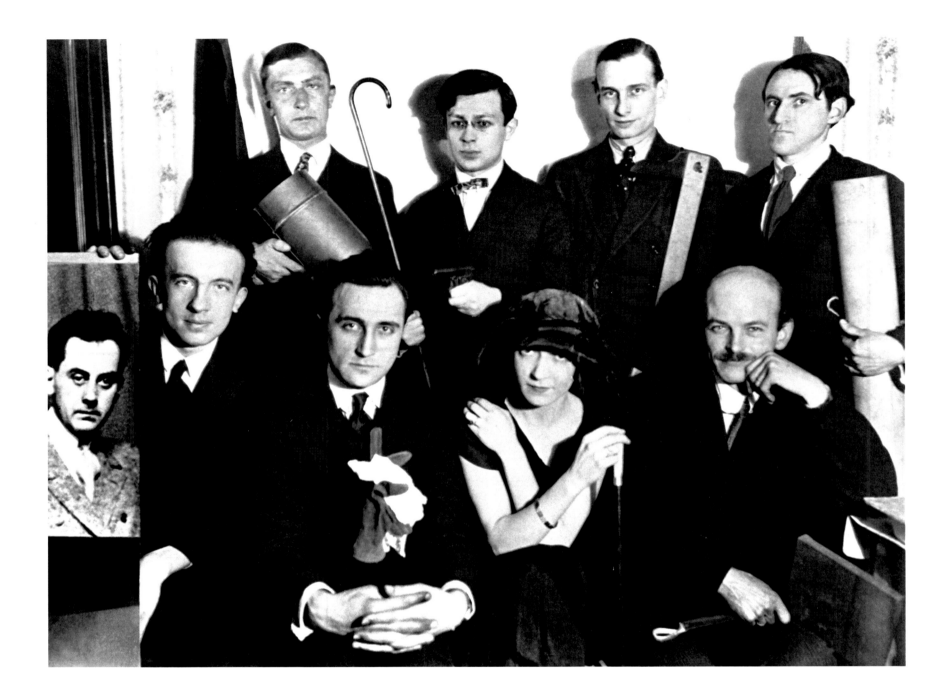

The Dada Group, 1922
A true portrait of a quarrelsome and turbulent family. This was the Dadaist group that Man Ray photographed in Paris in 1922. In the top row, from left to right: Paul Chadourne, Tristan Tzara, Philippe Soupault, and Serge Chadourne. In the front row, next to the photo of Man Ray himself: Paul Éluard, Jacques Rigaut, Madame Soupault, and Georges Ribemont-Dessaignes.

Self-Portrait

Man Ray was born in Philadelphia on August 27, 1890, the son of immigrants from Russia. His given name was Emmanuel Radnitzky and his family called him "Manny." The last name Ray, shortened from the original to make it easier to pronounce, was chosen by Emmanuel and his brother Sam. It was already in use in 1911 as the signature on the painting *Tapestry*, a collage made of lengths of cloth that was a tribute to the occupation of his father, who was a tailor.

In 1897 the family moved to Brooklyn, New York. Manny's academic grades were disappointing, but not his talent for art. He took his first lessons in technical drawing in 1904 and in 1910 he studied at the revolutionary Ferrer Center. During this same period Man Ray went often to the 291 Gallery, which was run by Alfred Stieglitz. There he saw works by Cézanne, Brancusi, and Picasso as well as photos by Stieglitz. In 1914, at the famous Armory Show dedicated to the European avant-garde, Man Ray discovered the work of Francis Picabia and Marcel Duchamp. They would soon become friends and companions in work. In that same year Man Ray married Adon Lacroix, a Belgian poet who introduced him to Baudelaire and Rimbaud. They would separate four years later.

In 1915, on the occasion of his first personal show at the Daniel Gallery in New York, Man Ray took up photography for the purpose of reproducing his work. The success of the show encouraged him to move away from traditional painting. Critical in this was his shift to the air-brush, a technique that was more detached than painting but more involving than photography. This was the start of the parallel development, at times conflicting, of Man Ray as a painter and Man Ray as a photographer. "I paint what cannot be photographed... I photograph the things that I do not wish to paint." he would write in his autobiography. In October of that same year, in New York, Man Ray would meet Marcel Duchamp. A year ahead of the European movement, the two artists created works that already showed the spirit of Dada, and in 1920, along with Katherine Dreier, they founded the Société Anonyme, an organization that sponsored traveling exhibits of modern art and was itself a kind of museum of modern art.

In June 1921, Duchamp returned to Paris. Man Ray followed him in July and a few months later met Kiki de Montparnasse. The art world was in ferment. In the Dada group, led by Tristan Tzara, there was talk of a break-up. Three years later came the pull of André Breton and the birth of surrealism, of which Man Ray would in his turn become a major figure.

In the meantime, Man Ray photographed the paintings of his friends. Gabrielle, the wife of Francis Picabia, introduced him to Paul Poiret, the couturier and collector of modern art. As a result, Man Ray produced the first innovative fashion photos, published in *Vogue* and *Vanity Fair*. The number of his acquaintances and commissions grew. Man Ray took portraits of Jean Cocteau, Erik Satie, Gertrude Stein, Georges Braque, James Joyce, and Breton. There was a widening of horizons, even in the darkroom. On a winter night in 1921–22, Man Ray discovered by chance that he could reproduce objects without a camera by placing them directly on light-sensitive paper. These were his famous rayographs.

In 1923, Berenice Abbott entered his studio as an assistant. She would later become one of the most influential photographers of the twentieth century. The next year Francis Picabia and René Clair filmed a chess game played by Marcel Duchamp and Man Ray. It was called *Entr'acte*. In 1928 Man Ray directed *Étoile de mer*, with a screenplay after a poem by Robert Desnos. By this time Man Ray was an established photographer in high society circles. In 1929 he met Lee Miller, who would be his companion and model until 1932. Together they would discover, again by chance, the technique of solarization. Then war broke out and in 1940 Man Ray left Paris for New York, and then Hollywood, where he met Juliet Browner. They led a life of high society, lectures, and fashion work. In 1946, there was a double-wedding in which Max Ernst and Dorothea Tanning, and Man Ray and Juliet Browner, were married. The ceremony was in Beverly Hills. In 1951 Man Ray went back to Paris, with Juliet. He conducted his first experiments in color photography. For another twenty-five years, until November 18, 1976, the day of his death, he continued his painting, film, and photography. Man Ray was buried in the Montparnasse cemetery. A thought for Kiki, and the circle was closed.

"OF COURSE, THERE WILL ALWAYS BE THOSE WHO LOOK ONLY AT TECHNIQUE, WHO ASK 'HOW,' WHILE OTHERS OF A MORE CURIOUS NATURE WILL ASK 'WHY.' PERSONALLY, I HAVE ALWAYS PREFERRED INSPIRATION TO INFORMATION."

man Ray

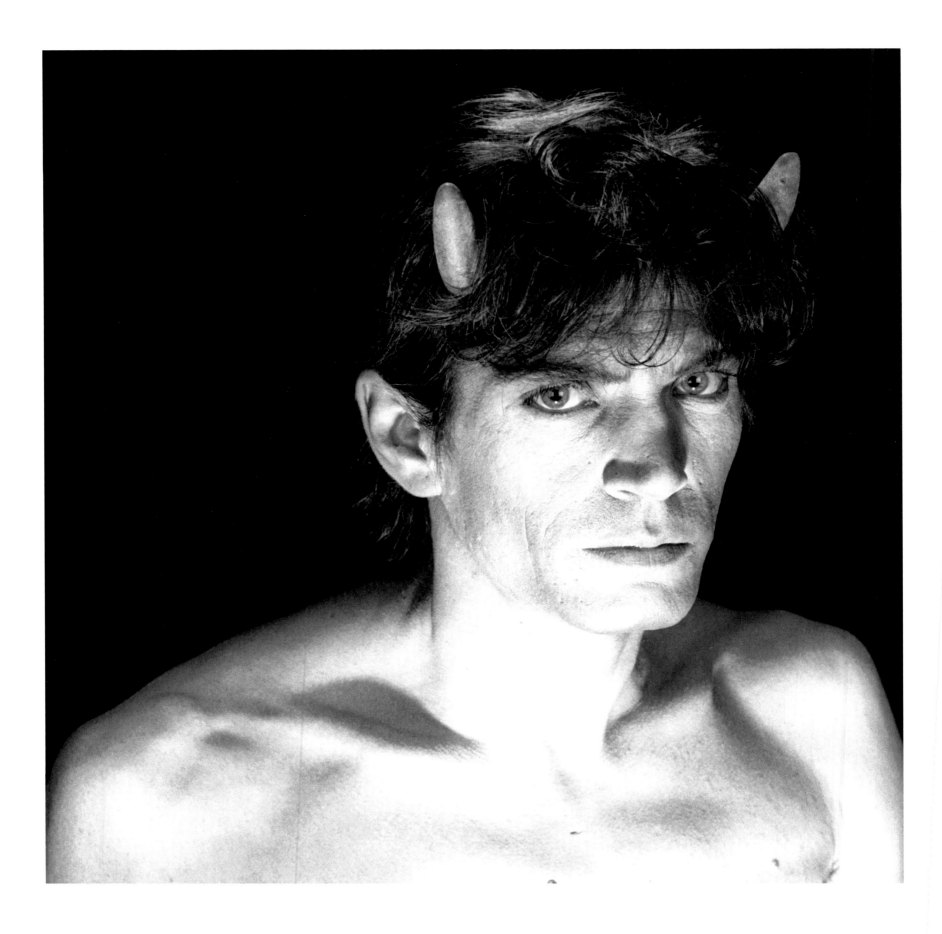

Page 272
American Flag, 1977

Above
Self Portrait, 1985
"Well, unbeknownst to myself, I became a photographer. I never really wanted to be one in art school;...but then I realized that all kinds of things can be done within the context of photography, and it was also the perfect medium, or so it seemed, for the seventies and eighties, when everything was fast." The speed of action that photography allows makes it possible to create self-portraits that are rapid and lightning-like visions of the self. Throughout his life, Mapplethorpe would explore the self-portrait as an intense and psychological way of examining his inner self, his identity, and his body, in all its transformations and in its intimate essence.

ROBERT MAPPLETHORPE

He always spoke in a low voice. This detail, the sign of a shy person, might be surprising in a man who cried foul at the scandal provoked, if not by the physical pain, then indirectly by the sight of his most extreme images: the male sex organs between iron nails, the male nipples pierced with rings, the eyes masked with zippers and leather eyelids. Pistols, whips, and knives also appear in his images, as if the weapon of sex itself had not lacerated the flesh enough. That was the beginning, in the exaltation of violence as the greatest source of pleasure, of Robert Mapplethorpe's voyage through the underground culture of New York, and, from there, in the most rapid of ascents, both artistic and urban, toward the lights of Manhattan and its gleams of glory. It was a "vertical" path that unfolded over less than two decades.

It all began in 1970, when Mapplethorpe received a Polaroid camera as a gift and set out to explore and photograph his own homosexuality. The end came in 1989, the year of his death, when his once young and beautiful body was only a memory: in the foreground the knob of a walking stick in the shape of a skull, in the background the shadow of a face. It was the first and last time that an image of Mapplethorpe would appear out of focus, with that morbid softness that distanced itself forever from the carnal splendor of life and its maximum expression: sex. Lived always in the first person and therefore authentic and believable, but never voyeuristic even when Mapplethorpe was behind the camera. Nevertheless, the subversive tumult of sadomasochistic sex needed different clothes if it were to emerge from the games of the private clubs. It needed a new light that would caress the chains, and the customary leather outfits, and the bodies posed within them, as if they were the most elegant of subjects.

In all his work, Mapplethorpe did, in fact, strive to illuminate with all his virtuosity, and to reproduce within the magic perimeter of an individual frame of his Hasselblad camera, what no other photographer before him had ever dared to show outside the confines of pornography. This was his great intuition, the acrobatic leap that would put him above other photographers and that would make accessible, and give value to, material that was otherwise at the limits of the acceptable. It was a diabolic operation, and in the second half of the 1970s, in part thanks to these images, Mapplethorpe became successful. A self-portrait, one of so many that punctuate the narrative of his romantic life, caught him in waistcoat and black leather pants, with a whip between his buttocks. Over time his wardrobe would become more extensive, gaining with that same brazen self-confidence a drag queen's fur coat, a tuxedo, and, finally, a silk dressing gown and pair of soft embroidered slippers.

At the same time, Mapplethorpe's artistic horizons became wider and he would count among the masters who influenced him Michelangelo, Caravaggio, and Canova among Italian artists; Ingres, David, and Géricault among the French; and among photographers Man Ray and Edward Weston. And because he favored pop art above all, Andy Warhol. It was everywhere a triumph of bodies and their contours depicted in relief, like landscapes. The time of the sadomasochistic puppet theater was over; now the aesthetic was that of the museum shrine and of the single profile, statuesque, bronze-like, reflected also in the decision to portray African-American models. But again, since the heart did not stop beating, the vigor of the male sex organ continued to shine at the center of the composition. And this was the pivot of Mapplethorpe's poetics, like a solitary planet that brings other forms of existence into its orbit. First and foremost are the flowers with their anatomical shapes, corresponding to every phase of sexuality: the arousal, the encounter, and the downward curve of pleasure once enjoyed.

And then, the women. The first, Patti Smith, boisterous in her talent and that erotic combination of fragility and hardness. Mapplethorpe photographed her curled up next to a radiator and would follow her at every stage of her career. He gave her the splendid covers for her album *Horses,* with that black jacket slung over her shoulder, and her album *Wave,* in another style, in white with two doves in her hands and the vengeance of the Furies in her eyes. Some years later another figure, Lisa Lyon, would appear, another combination of feminine and masculine. Thus, it was *Lady: Lisa Lyon,* our lady of body building, as the title of the book produced by the model and the photographer announced. In the introduction to the book, Bruce Chatwin wrote, "His eye for a face is that of a novelist in search of a character." And like every writer steeped in the myth of French romanticism and the cursed work, even Mapplethorpe ended his diary at the moment just before death. And it was not sickness that marked the end of the book, but the will of the artist who knew that he had by that time explored and made visible every secret of his world. To begin again with the wrinkles of his own face would not have been as interesting.

Calla Lily, 1988

After having shown the virility that exists in the tension of pleasure, and having restored it, soft and supple, on the marble of a butcher's countertop, Mapplethorpe descended into the garden of the graces and picked a flower. It was, naturally, white, so that it would be able to receive every virtuosity of light. It was, naturally, wicked, so that it would be able to narrate, in the poetic language of allusion, how much had already been revealed in the account of a sadomasochistic encounter. And then, instead of a male sex organ immersed in a flute glass of champagne, instead of those orifices explored by all kinds of whips, here is a white calla lily, its stem illuminated by a clear reflection, and then that wave of petals like a long dress that pushing toward the corolla and beyond, in vertical ascent, to the pistil.

Mapplethorpe's world, and his moods, are all found here, in the hollow of a flower that art deco had already chosen as its emblem and which painters and photographers of the 1920s and 1930s had taken up and given greater vigor. It is enough to think of Edward Weston's lilies, framed by a length of glass, and those of Tina Modotti, Imogen Cunningham, and May Ray, pure energy of form. Or the absolutely carnal and carnivorous lilies of Georgia O'Keeffe, and the ones painted by Diego Rivera, a blinding flash on the golden skin of a nude woman.

With the wisdom of a cultured man, and the cunning of a small faun, Mapplethorpe welcomed this inheritance, already laden with eroticism, and dragged it through the underground abyss of his work. As if it were an extremely weightless and pure counterweight to a universe dressed in leather and chains. An opportunity for virginity to be restored, sewn up again, between the open mouths of orchids, the sharpened tips of stamen, the buds of tulips, and, always, the lilies, photographed as if they were a triangle of white velvet whose surface revealed the evidence of an embrace.

In turn, Mapplethorpe's work in black and white also gave the flowers a different scent. More intense and forbidden. One smiles at the thought that this *enfant terrible*, egocentric and colossal in his technical virtuosity, could be surprised by the evidence that his sado-masochistic images were printed more often than his tributes to flowers. Bodies and flowers were, in the vision of the artist, integral parts of the same universe. X and Y, masculine and feminine, together. And perhaps he was right to cling to the idea, because without those flowers, aggressive but natural, the violence in his gaze would have lost that candor which has assured his place in the history of photography.

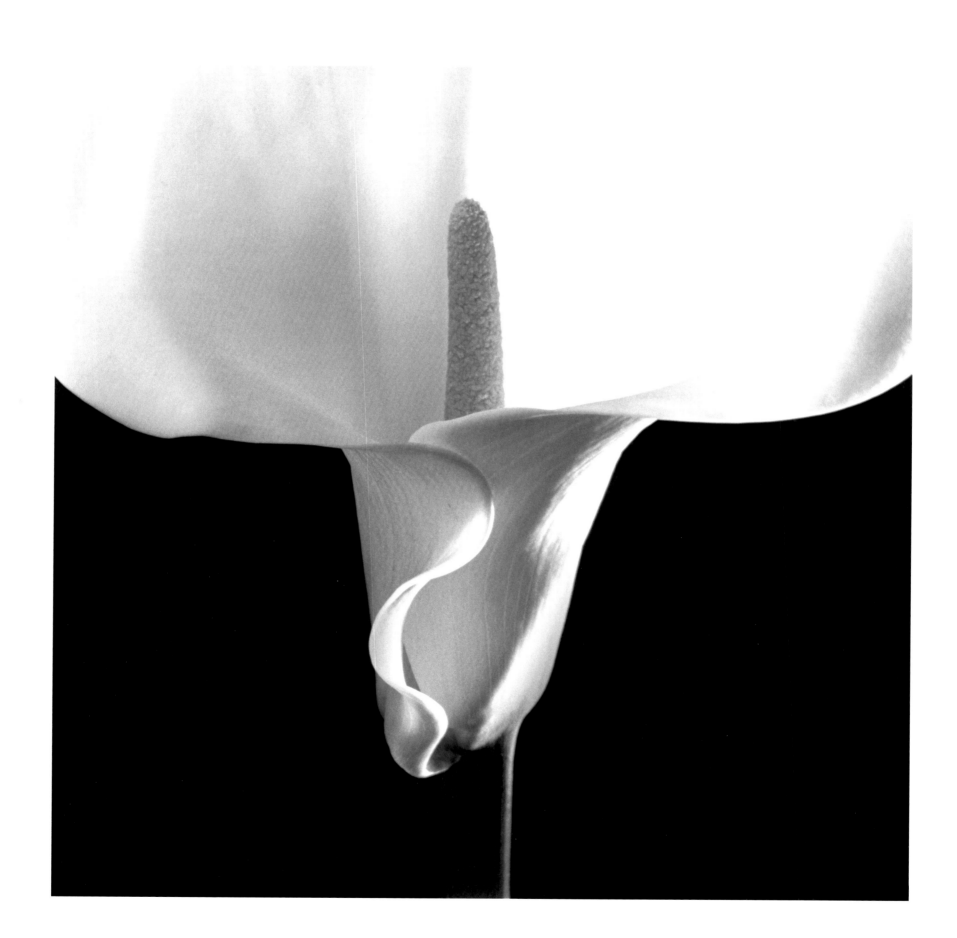

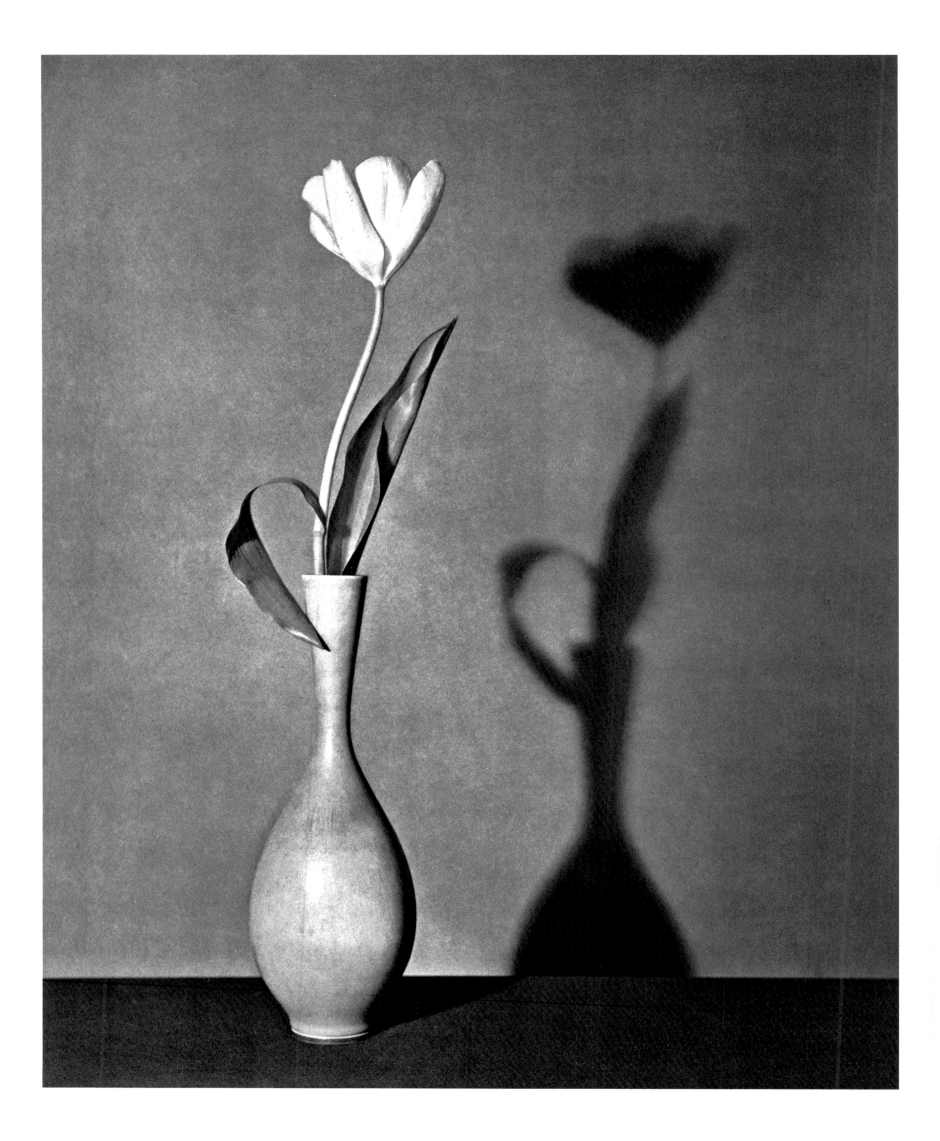

Flower, 1983

"My approach to photographing a flower is not much different than photographing a cock, basically it's the same thing. It's about light and composition. It's the same vision."

From the beginning of the 1980s, Mapplethorpe looked at flowers with the same gaze that he used to pose his nudes, almost transforming them into sexual bodies to be observed and explored. The flowers emerge luminous and menacing from the darkness, from the dense blacks, occupying the surface of the image with a disturbing and carnal beauty that has the features of a revelation. The photos are still lifes, "dead nature," and yet there is nothing motionless in these flowers which throb with a mysterious life, echoing its seductive messages.

Larry and Bobby Kissing, 1979
In front of the photographer's lens, Larry and Bobby kiss, wrapped in black leather. Mapplethorpe is there to direct the scene from behind the lens, as both director and member of the cast, artist and participant, involved in the story of an eroticism that up till then had not yet found its narrator.

Ken Moody, 1983
"I'm looking for perfection in form. I do that with portraits. I do it with cocks. I do it with flowers. It's no different from one subject to the next. I am trying to capture what could be a sculpture."

Thomas, 1987
The bodies of Mapplethorpe's models have the perfect proportions of Leonardo da Vinci's famous drawing of the Vitruvian Man. That seems to be the implied reference in the series of photos taken of Thomas, in which the body of the model is forced, with both grace and tension, against the inside of a rigid circular form.

"THERE'S NOTHING TO QUESTION AS IN A GREAT PAINTING. I OFTEN HAVE TROUBLE WITH CONTEMPORARY ART BECAUSE I FIND IT'S NOT PERFECT. IT DOESN'T HAVE TO BE ANATOMICALLY CORRECT TO BE PERFECT EITHER. A PICASSO PORTRAIT IS PERFECT. IT'S JUST NOT QUESTIONABLE. IN THE BEST OF MY PICTURES, THERE'S NOTHING TO QUESTION—IT'S JUST THERE. AND THAT'S WHAT I TRY TO DO."

Ken Moody and Robert Sherman, 1984
"I'm looking for the unexpected. I'm looking for things I've never seen before."

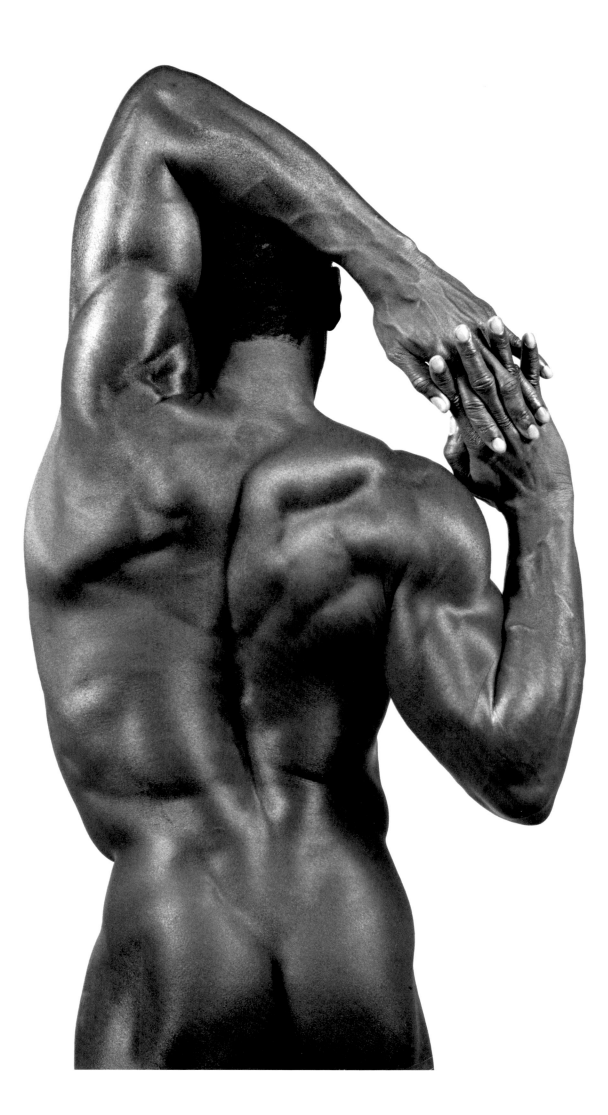

Derrick Cross, 1983
Mapplethorpe worked with the same models again and again. The portraits were produced in a studio, in most cases against a neutral background. Within the rigor of the composition, he used light as a dramatic element. Mapplethorpe's ability to manipulate the lighting allowed him to sculpt the forms and to capture the grain and the particular density of black skin.

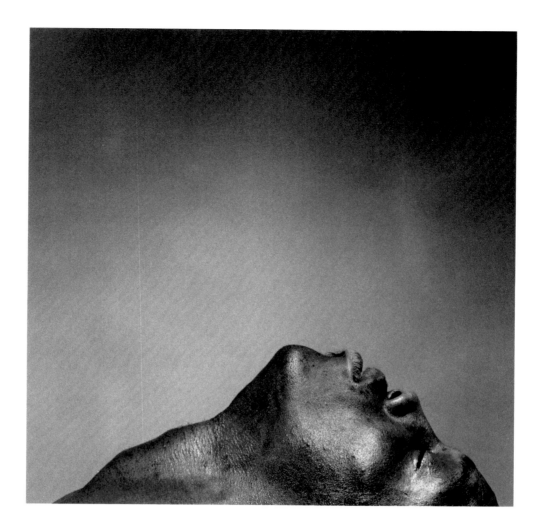

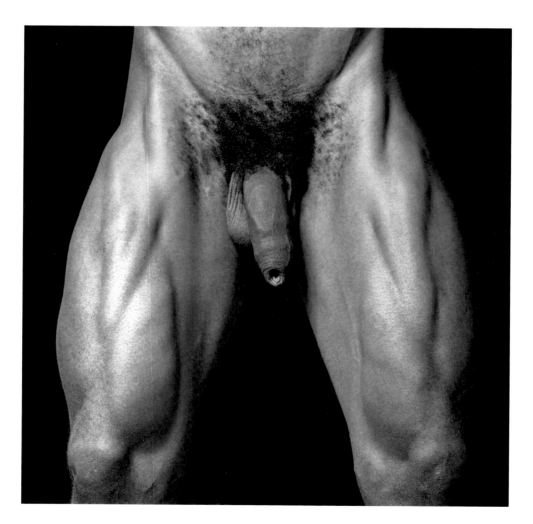

Alistair Butler, 1980

Untitled/Milton Moore, 1981
Starting in the mid-1970s, Mapplethorpe began to work on the ennobling of sexual love. His compositions became more rigorous, and light was used to sculpt the muscles and the texture of the skin so that the athletic bodies of the models would not be transformed into reincarnations of the Greco-Roman ideal of statuesque beauty. The strongly provocative and sexual subjects of his images were thus elevated by the purity of the forms, yet at the same time were able to preserve all of their sensual and carnal charge. Beauty and menace, purity and eroticism: the duality fills the images in a significant way, urging us to reconsider our idea of what is permissible.

"I NEVER LIKED PHOTOGRAPHY.
NOT FOR THE SAKE OF PHOTOGRAPHY.
I LIKE THE OBJECT. I LIKE
THE PHOTOGRAPHS WHEN YOU
HOLD THEM IN YOUR HANDS."

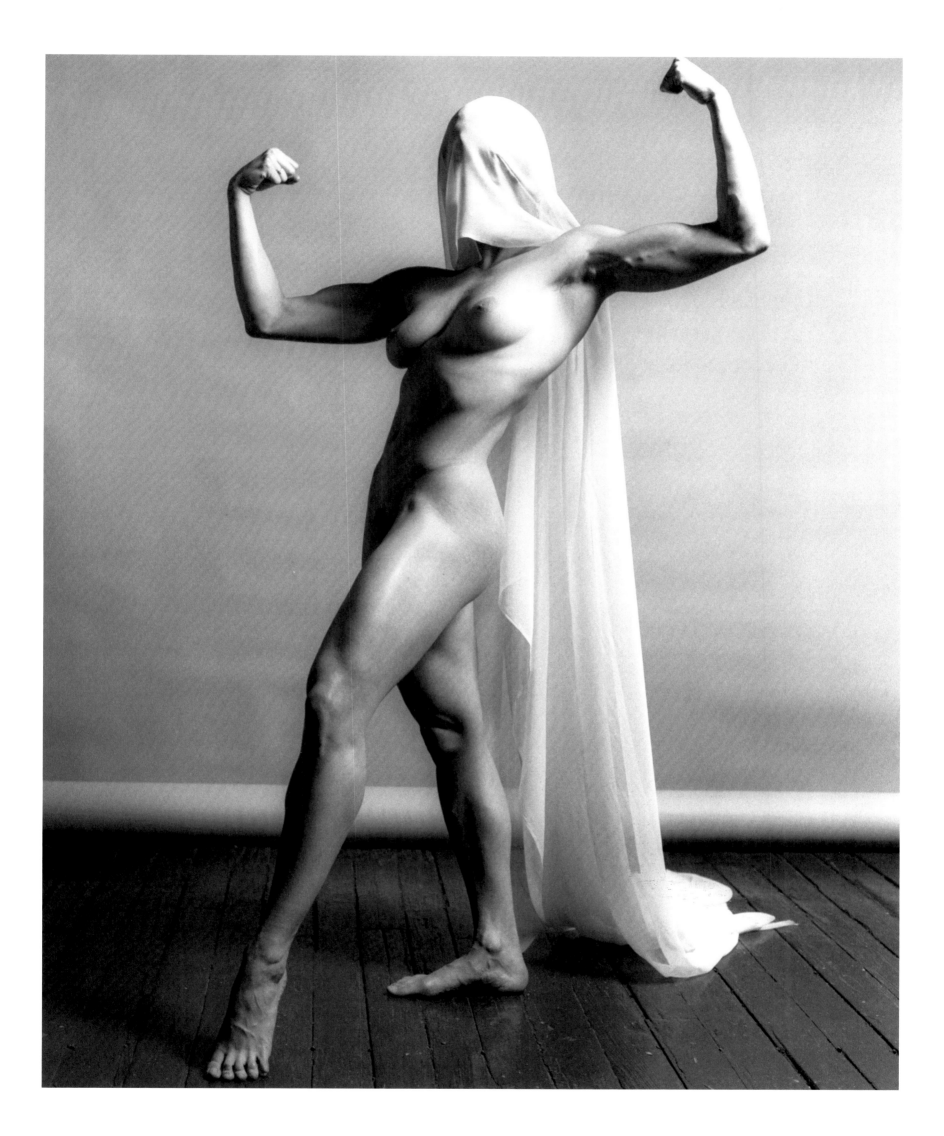

Lisa Lyon, 1982
In 1980 Mapplethorpe met Lisa Lyon, one of the leading women bodybuilders and a women's weightlifting champion. In the years that followed, he worked with her on a series of portraits and body studies that led to the publication of the book *Lady: Lisa Lyon* in 1983. Lisa's physicality was profoundly dualistic in nature, combining in itself both masculine and feminine, strength and fragility, which permitted the photographer to work toward a visual subversion of stereotypes.

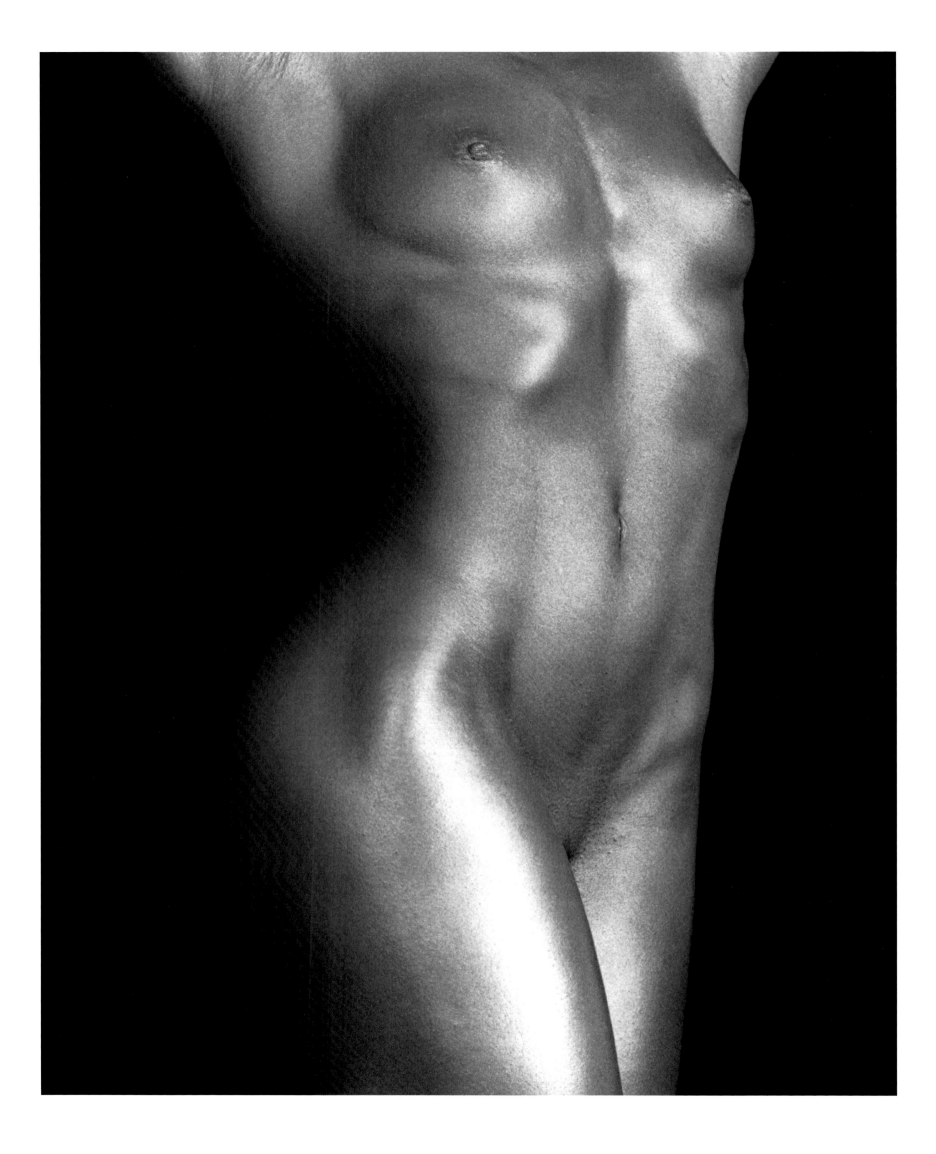

Lydia Cheng, 1985
"If I had been born one hundred or two hundred years ago, I might have been a sculptor, but photography is a very quick way to see, to make a sculpture."

All of Mapplethorpe's work expresses a single, constant vision. Whether he photographs scenes from the world of sadomasochism, the perfect nude bodies of black men, genital organs, flowers, or the faces of friends, for him the images have the same identical nature.

Legs / Melody, 1987
Everything becomes an object of art and a perfection of form. Everything is shaped by a gaze that leads one to walk the boundary line between photography and sculpture, a border with metaphorical powers in which the most extreme manifestation of Eros is ennobled and the symbols of purity are made menacing.

This duality permeates the images in a way that is always meaningful. Mapplethorpe's art is at the same time both physical and abstract. The more the body bursts onto the scene and into the gaze of the viewer, with erotic and sensual force (the human body as well as the bodies of flowers), the more the working out of the forms achieves a degree of perfection that heightens the symbolism.

Louise Bourgeois, 1982

"I'm only half the act of taking pictures, if we're talking about portraiture, so it's a matter of having somebody just feel right about themselves and about how they're relating to you. Then you can get a magic moment out of them. In portraits, taking the actual picture is only half of it; developing your personality to a point where you can deal with all kinds of people—that's the other half."

Mapplethorpe's portraits are an anthology of some of the key personalities in American culture of the 1970s and 1980s. Speaking about his portraits, Susan Sontag said that Mapplethorpe portrays "not the truth about something, but the strongest version of it."

Patti Smith, 1979

Patti Smith and Robert Mapplethorpe met in the sparkling New York of the late 1960s. They were kids, twenty-year-olds. But their story became one of artistic and human symbiosis that would last a lifetime. She would be his first model. In soft black and white, he was able to capture her haunted face and the intensity that she, a thin and bony shaman with a feverish voice, could release with a single gesture of her hand. Mapplethorpe would create the cover of *Horses*, her first album, with a new black-and-white portrait that was intense and magnetic.

Self Portrait, 1985
"Right from the beginning, before I knew much about photography, I had the same eyes. When I first started taking pictures, the vision was there."

Self Portrait, 1980

Robert Mapplethorpe was born in 1946 in Floral Park, Queens (New York City). Of his childhood, he said: "I come from suburban America. It was a very safe environment and it was a good place to come from in that it was a good place to leave." In 1963 he enrolled at the Pratt Institute, in Brooklyn, where he studied design, painting, and sculpture. Influenced by artists such as Joseph Cornell and Marcel Duchamp, he began to experiment with different materials and to produce mixed-media collages, including in his compositions images cut from newspapers and magazines.

In 1970 he acquired a Polaroid camera. He began to take photos and to use them in his collages. That same year, together with Patti Smith, whom he had met three years earlier, he moved into the Chelsea Hotel in Manhattan. In 1973, the Light Gallery of New York City gave him his first solo show, *Polaroids*. Two years later, Mapplethorpe, by now using the medium-format Hasselblad camera which had been given to him, began to take photos of friends and acquaintances—artists, musicians, porn stars, and members of the S&M underground. He also worked on commercial projects, producing an album cover for Patti Smith and Television and a series of portraits and party photos for the magazine *Interview*. In the late 1970s, Mapplethorpe's interest in the New York S&M scene became more intense. The resulting photographs are shocking for their content and noteworthy for their mastery of form and technique.

Mapplethorpe gave an interview for *Artnews* magazine in late 1988 and said, "I don't like that particular word 'shocking.' I'm looking for the unexpected. I'm looking for things I've never seen before... I was in a position to take those pictures. I felt an obligation to do them." Meanwhile, his career continued to meet with success. In 1977 he participated in documenta VI in Kassel, West Germany, and in 1978 the Robert Miller Gallery in New York

became his exclusive representative. In 1980 he met Lisa Lyon, the world women's bodybuilding champion. During the years that followed he worked with her on a series of portraits and nude studies that would result in the book *Lady: Lisa Lyon.*

During the 1980s, Mapplethorpe produced a group of images that simultaneously challenged and adhered to the standards of classical aesthetics: stylized compositions of nude men and women, delicate flower still lifes, and portraits of artists and celebrities, to name but a few of his preferred genres. He used different formats and techniques, including 20" x 24" color Polaroids, photoengraving, platinum prints on paper and linen, Cibachrome, and dye transfer color printing. In 1986, he worked on the set designs for the Lucinda Childs' dance production *Portraits in Reflection,* and produced photoengravings for a printing of *Une Saison en Enfer* (A Season in Hell), the poem by Arthur Rimbaud. In addition, he received a commission from the curator Richard Marshall for the book *50 New York Artists*. That same year, Mapplethorpe was diagnosed with AIDS.

Knowing that he was sick, Mapplethorpe began to explore different spheres of creativity and accepted a good deal of work on commission.

The Whitney Museum of American Art mounted Mapplethorpe's first US retrospective in 1988, one year before his death. His vast, provocative, and powerful body of work has made him one of the most important artists of the twentieth century.

Mapplethorpe is today represented by numerous galleries and his work is in the collections of major museums around the world. His artistic legacy also lives on thanks to the work of the Robert Mapplethorpe Foundation in New York City, founded by the photographer in 1988 in order to promote and support photography at the institutional level, and to finance scientific research in the fight against AIDS and HIV.

"I'M LEFT WITH A DIARY OF PHOTOGRAPHS I'VE TAKEN OVER THE YEARS. I DON'T WRITE, SO THAT'S IT. I WOULD RATHER GO THROUGH THE PAGES OF MY LIFE, SO TO SPEAK, AND SEE PEOPLE THE WAY I WOULD LIKE TO HAVE SEEN THEM."

ROBERT MAPPLETHORPE

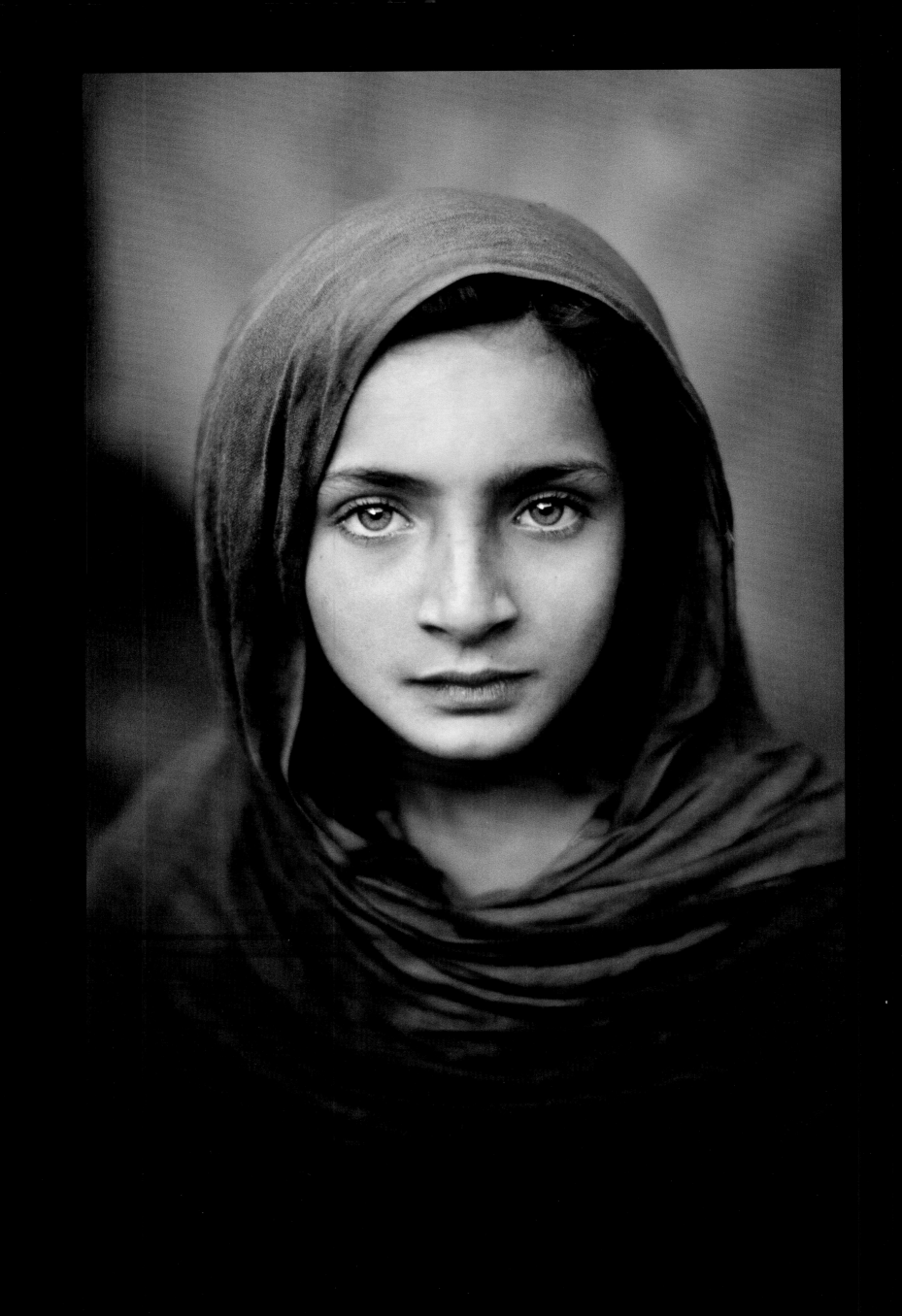

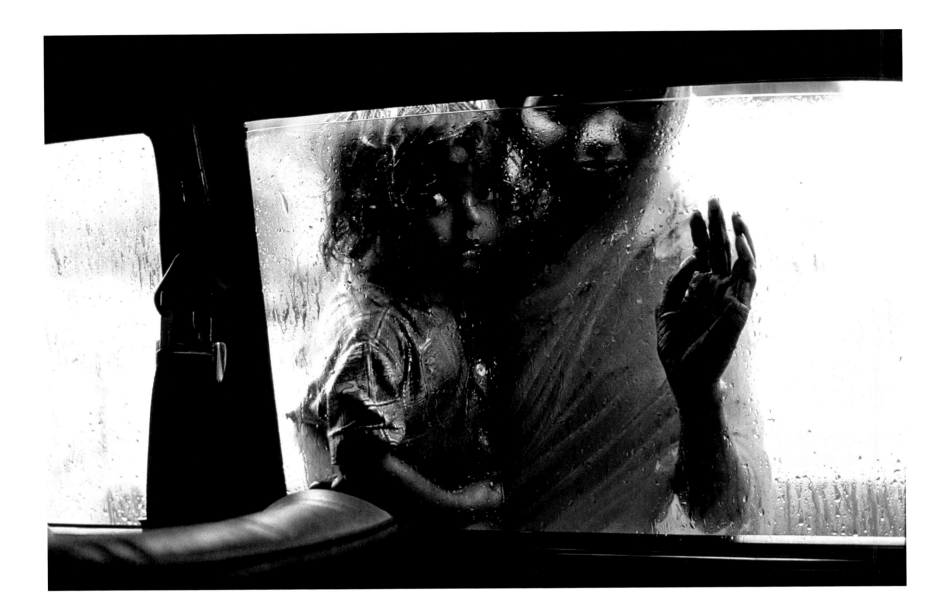

Page 294
Peshawar, Pakistan, 2002
The eyes of this young woman, amplified by the veil covering her head, pierce into the viewer. Her serious expression is both a story and an indictment.

Above
Bombay, India, 1993
"I spend a lot of time looking at faces, and the faces seem to tell a story. When something about the life experience is etched on the face, I know the picture I'm taking is going to represent more than just that moment. I know there's a history here."

STEVE McCURRY

The unguarded moment is the precious instant every student looks for in the life of his teacher, and also a moment every great teacher is not afraid to hide. This unique moment gave McCurry the title for one of his many exquisite books. It signifies the moment one's guard comes down, and reality emerges in all its freshness to become a wonderful portrait—in this case, a self-portrait. In 1979 twenty-nine-year-old McCurry was living in small-town America and felt trapped in the routine of his local newspaper, covering things like Lions Club meetings. The understandably restless, rebellious photographer knew there was more to life and so, following his generation's sacred texts, he set out for India, from there went to Pakistan, and then on to Afghanistan, because he is first and foremost a journalist, and because a group of refugees needed his help breaking the news of the civil war ravaging their country. And that was his unguarded moment, the small confession that marks the humanity, history, and growth of all authentic individuals. As McCurry recalls, "I slipped into Afghanistan across the border with Pakistan in 1979. I went with a couple of guides who did not speak English. I certainly didn't speak Dari or Pashto so our only form of communication was improvised sign language. I was woefully unprepared. Among my belongings were a plastic cup, a Swiss Army knife, two camera bodies, four lenses, a bag of film and a few bags of airline peanuts. My naiveté was breathtaking, yet my Afghan guides protected me and treated me as their guest. That was my first experience with the legendary Afghan hospitality."

Here McCurry followed the advice of travel writer Paul Theroux, with whom he later collaborated, and became a stranger in a strange land, humbled. His reliance on that humility, and an attachment to the land, its people, and the verbs of their everyday life—eating, sleeping, sowing, reaping, loving, giving birth, accepting death, defending, and fighting—led to his first remarkable photo essays, published in *Time*, *Life*, and the *New York Times*. It also solidified his signature style, with faces and landscapes bound together in a joint destiny. He captured it all: men, women, and children from the globe's many vast panoramas; the contrasts and colors of the world, enhanced by the old, very real beauty of Kodachrome—a timeless, refined, pre-Photoshop kind of beauty.

Right from the start McCurry chose the East, or, to use its old designation, the Orient—the perfect land for orienting oneself, for finding one's way. Once there,

McCurry photographed many wars, capturing their faces, including the emblematic one originally known only as "Afghan Girl." But amid the violence, poverty, and hands begging for help—even by just leaning on a car window—moments of peace and grace flourish as well, like the evocative dance of a sandstorm through the desert.

It seems odd that on all these travels, moving from the traffic of an Indian megalopolis on to Bangkok, Hong Kong, Kathmandu, and Lhasa, the voices in McCurry's photos can always be heard. Every human presence, every single thing, every temperature, breeze, storm, and drought carries its own unmistakable stamp, an individuality the photographer respects and gently exults. You can hear a fire crackling amid the ruins of Herat, an oar paddling through the cool waters of a lake in Kashmir, the rustling veils of a group of women in Rajasthan, the rain falling on the road to Angkor Wat, the slow rhythm of prayer wheels in a Tibetan temple, and the lands and skies McCurry so adores. Along with the sounds come the scents: the spice market of Taizz in Yemen, bread baking in an oven in Kabul, the vegetables on a peddler's cart in Jodhpur, and the fresh smell of the trees and streets refreshed by the monsoon.

How is such harmony even possible, and how does McCurry capture it right at the golden hour, in the sublime light (the light of all great photographers) that envelops all of creation at dawn and dusk? The answer lies in the eyes, in the photographer's discreet gaze, and in the composed closeness of those who respond to his invitation, his curiosity. It might be a boy's huge eyes becoming the eyes of the gods in the euphoric Holi festival. It might be hand prints on a wall that seem to hold a child back and freeze his sprint in eternal levitation. It might be an evening or morning shadow projected on the Golden Rock of Kyaiktiyo, Burma.

A sigh, a speck of dust, and everything could fall apart—a moment later the image no longer exists. The crescendo of the monks' prayer falls silent before the shrine. The pink shade caressing the clouds and gilding the rock forever fades. This is just one of many unguarded moments. The gods smile, or maybe they are just distracted. Reality slows down and this adventurer, photojournalist, and documentary filmmaker (as McCurry defines himself) is there to capture the tiny yet immeasurably vast mysteries of the human condition.

Afghan Girl, Peshawar, Pakistan, 1984

We now know her name, but will wait just a few more lines so that her tender age and her country can have their say. Her Afghanistan has been plagued by twenty-three years of war, with over 500,000 dead and 3,500,000 refugees. This girl with large green eyes as deep as lakes, is one of the latter. McCurry meets her for the first time in 1984, in the Nasir Bagh refugee camp in Peshawar, in a school set up under a tent. She is shy, and a mixture of fear, pride, and damaged dignity lights up her eyes like a gust of wind.

But this light, averse to human violence and beloved of great photographers, works its magic and becomes sweet, just gentle enough to caress the colors moving in concentric waves through the composition: green eyes, amber skin, dark hair, a veil that seems made of sun-scorched earth, and the green of the plastic tent that becomes a rich backdrop for this Kodachrome masterpiece.

A few months later this portrait appears on the cover of *National Geographic*.

It travels the world, becomes a timeless icon. And yet time passes, and it takes more than seventeen years for McCurry to find those eyes again. The long search, accompanied by a television crew, begins in Nasir Bagh, Pakistan. The news travels, and a man recognizes the girl in the photo, she was one of his peers years before in the refugee camp: she returned to Afghanistan years ago, he says, and now lives in the mountains near Tora Bora.

McCurry recognizes her as soon as she enters the room—it's her. She was the six-year-old girl who lost her parents in the Soviet bombardment. She ran away with her grandmother and three brothers under the cold cover of night. She took refuge as one of the 100,000 displaced. Married at sixteen, she has three daughters, and hopes they can continue their studies. Her face is marked by every pain imaginable. And now she has a name: Sharbat Gula.

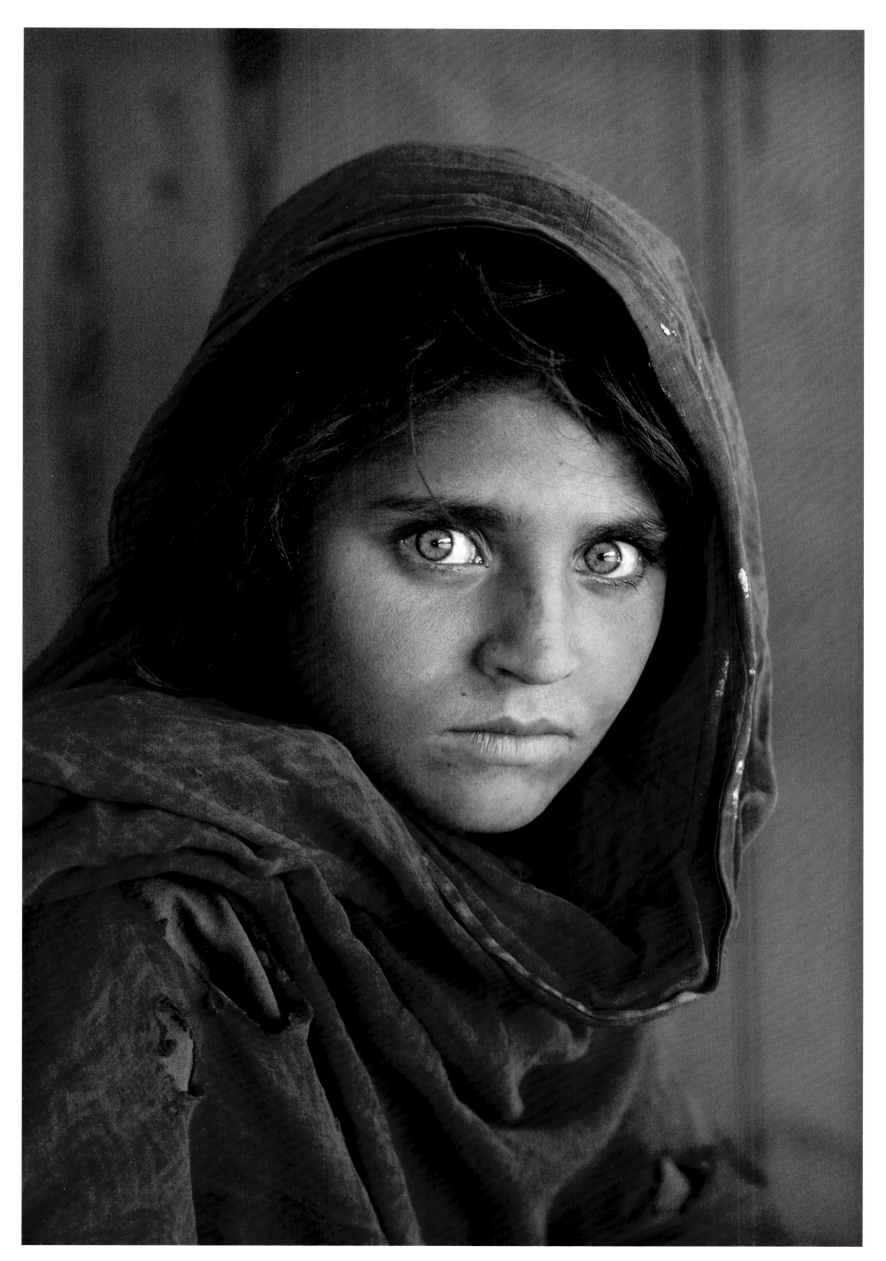

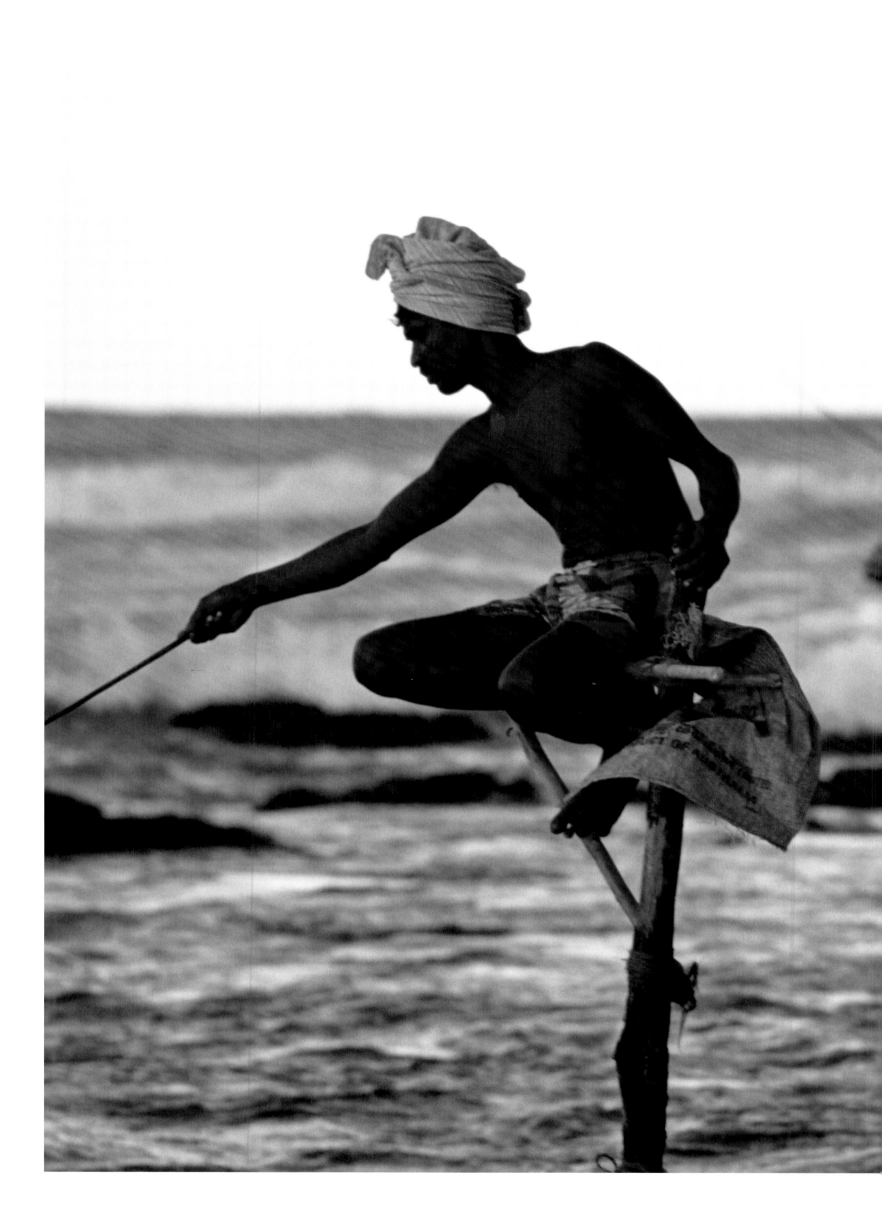

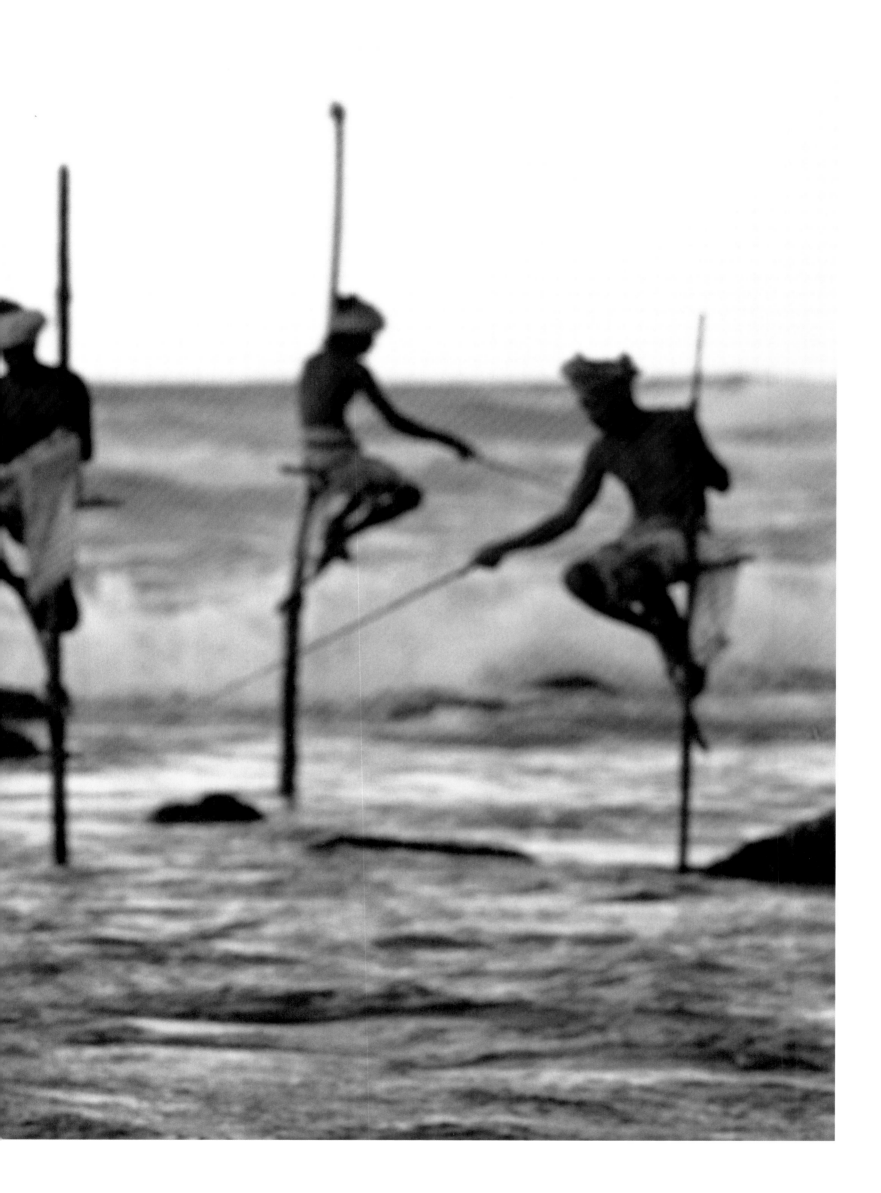

Weligama, Sri Lanka, 1995
For over five hundred years the men of Weligama have climbed atop tall poles to fool fish that otherwise would not swim to shore. They patiently await the arrival of their daily meal, but, as in every scene captured by McCurry, their fatigue disappears, and the world does its marvelous dance in the delicate light of dawn. What McCurry wants people to take from his work is an understanding of the human relationship between all of us, whether they live in India, Africa, Latin America, or wherever—the commonality we all share.

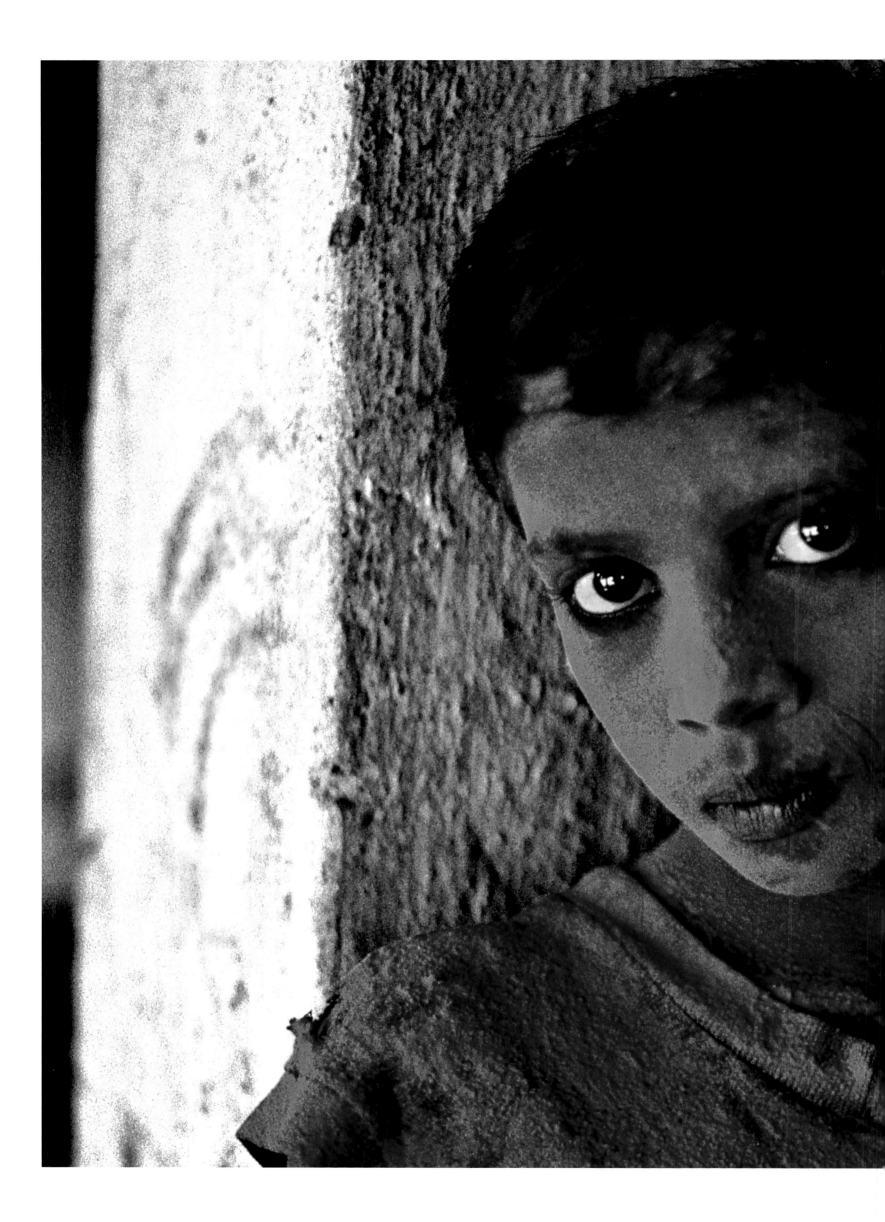

Bombay, India, 1996
India is a country that transforms both its visitors and itself. During the spring festival of Holi, the face of a child euphorically changes color. For centuries Western emissaries have had their very souls changed, traveling to other latitudes to feel closer to the energy of the world. "Above all, I feed on the colors of Asia: deep henna, hammered gold, curry and saffron, rich black lacquer and painted-over rot. As I reflect back on it, I see it was the vibrant color of Asia that taught me to see and write in light."

"AS A PHOTOGRAPHER, I AM SUSTAINED BY THE RHYTHMS OF EVERYDAY LIFE: THE ROUTINES OF HERDING AND FISHING; THE CHANTING OF PRAYERS AND THE HAWKING OF WARES. WHERE DO HUMANS SLEEP? HOW DO WE FEED OURSELVES? HOW DO WE KEEP WARM? FOR ME, DOCUMENTING THE INFINITELY VARIED WAYS WE MEET THESE FUNDAMENTAL HUMAN NEEDS HAS PROVEN TO BE A PROFOUND JOURNEY."

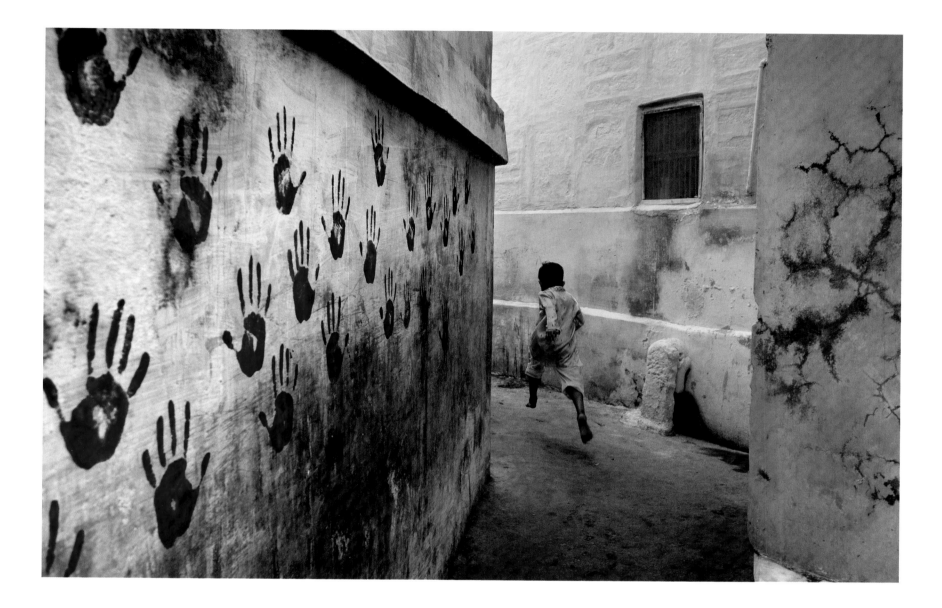

Jodhpur, India, 2007
"I've been going back to this visual ancient quarter of Jodhpur for probably twenty years, and I know that area very well, I must have photographed every street. But there was one corner that I realized had potential for an interesting composition with these hand prints on the wall."

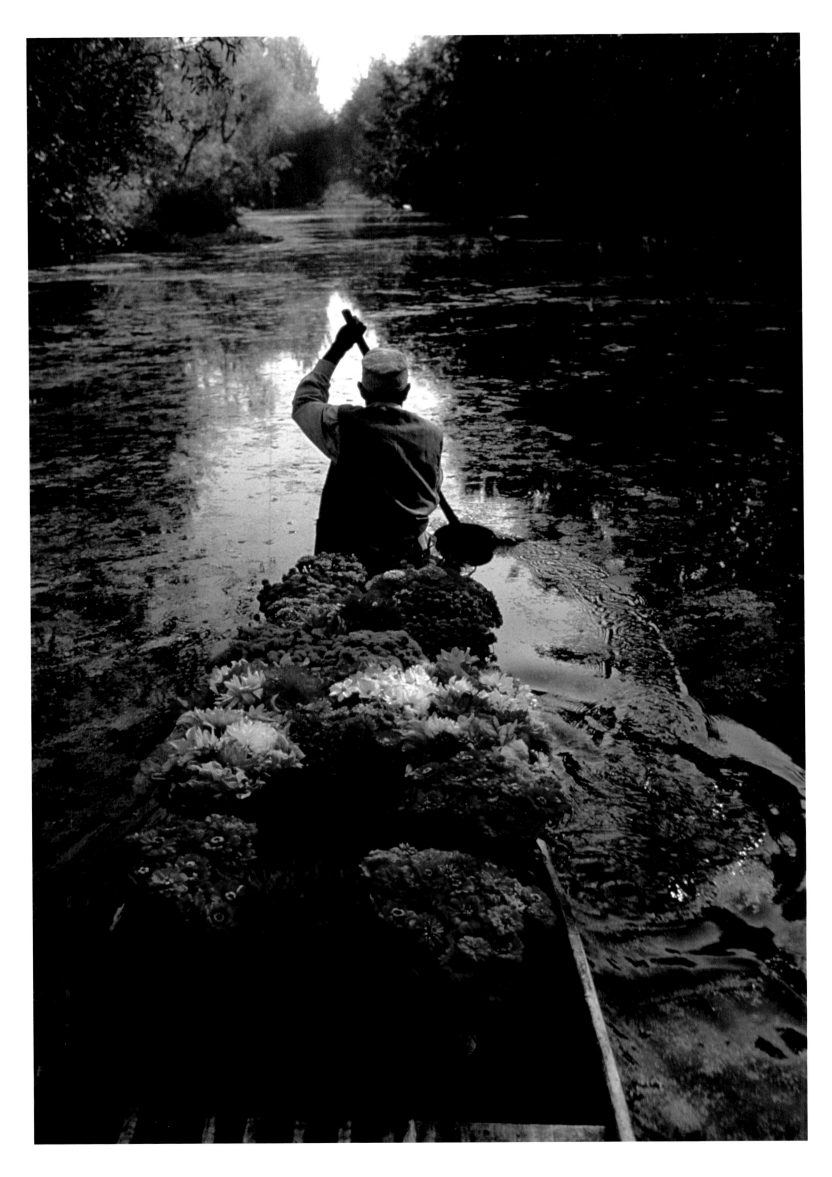

Lake Dal, Srinagar, Jammu, and Kashmir, 1999
This beautiful, vast lake is known as the jewel in the crown of Kashmir. A flower
vendor crosses it, and the rippling waters hint at the fear that the war might
arrive even here.

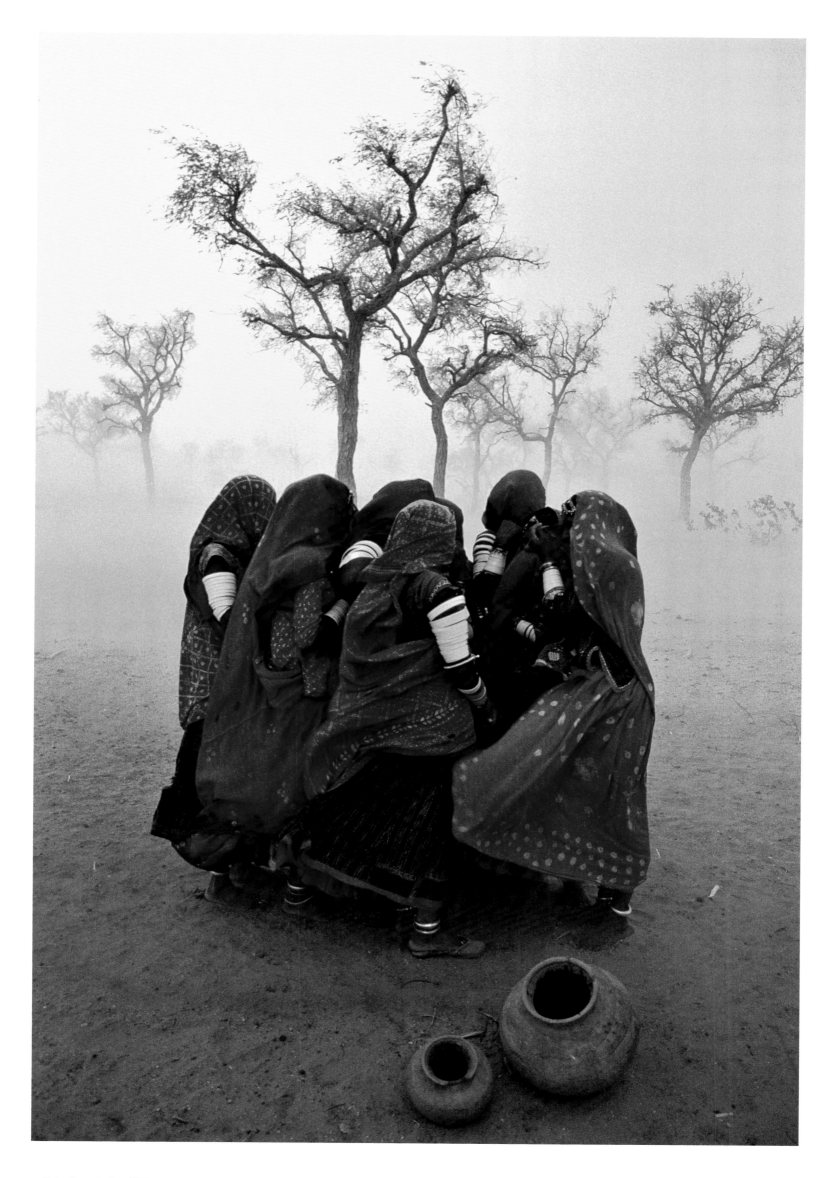

Rajasthan, India, 1983
A sudden sandstorm forces a group of women to huddle into a circle, taking shelter next to each other. It is a veritable dance of colors, veils, bracelets, and branches swaying in the background of a land afire.

"It is amazing how, in the camera's third eye, Asia's dust spins such golden abundance and clarities with such undersea depths."

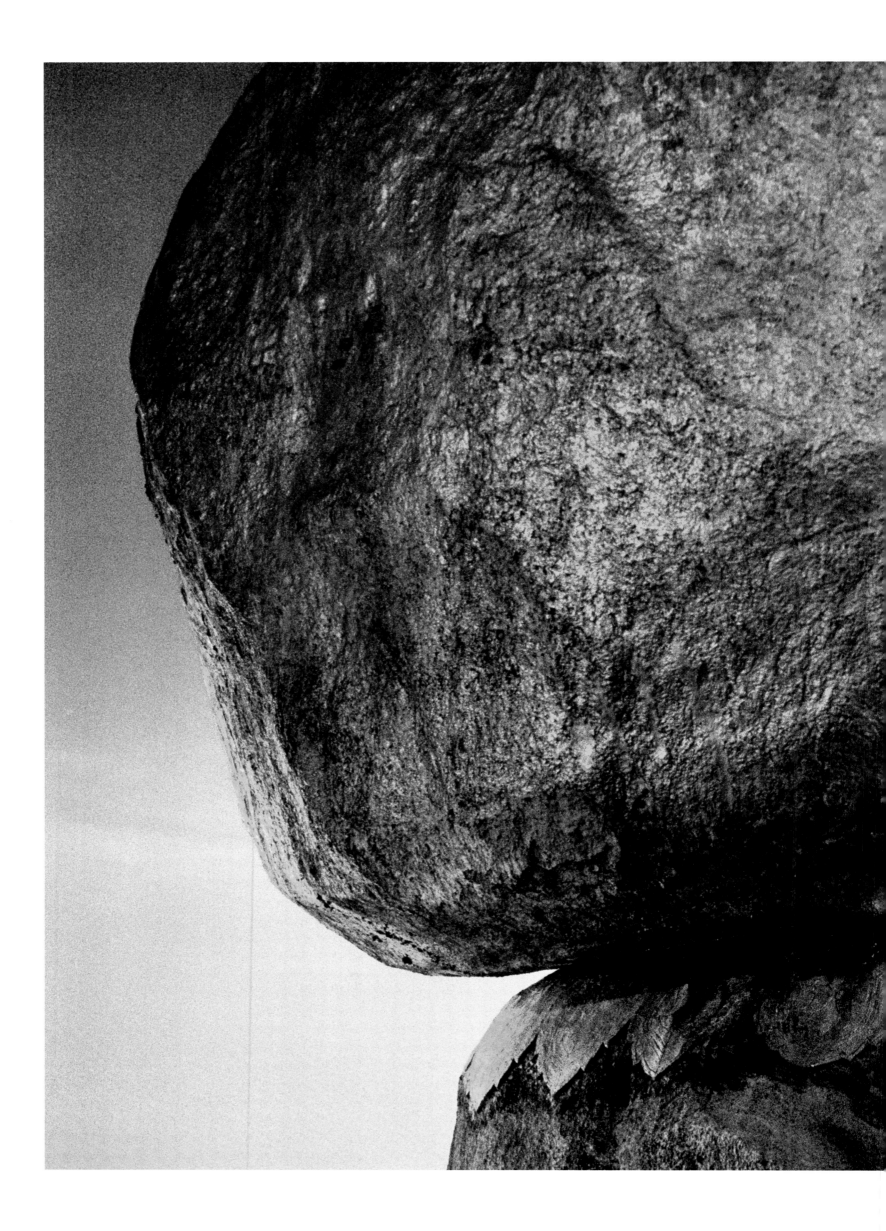

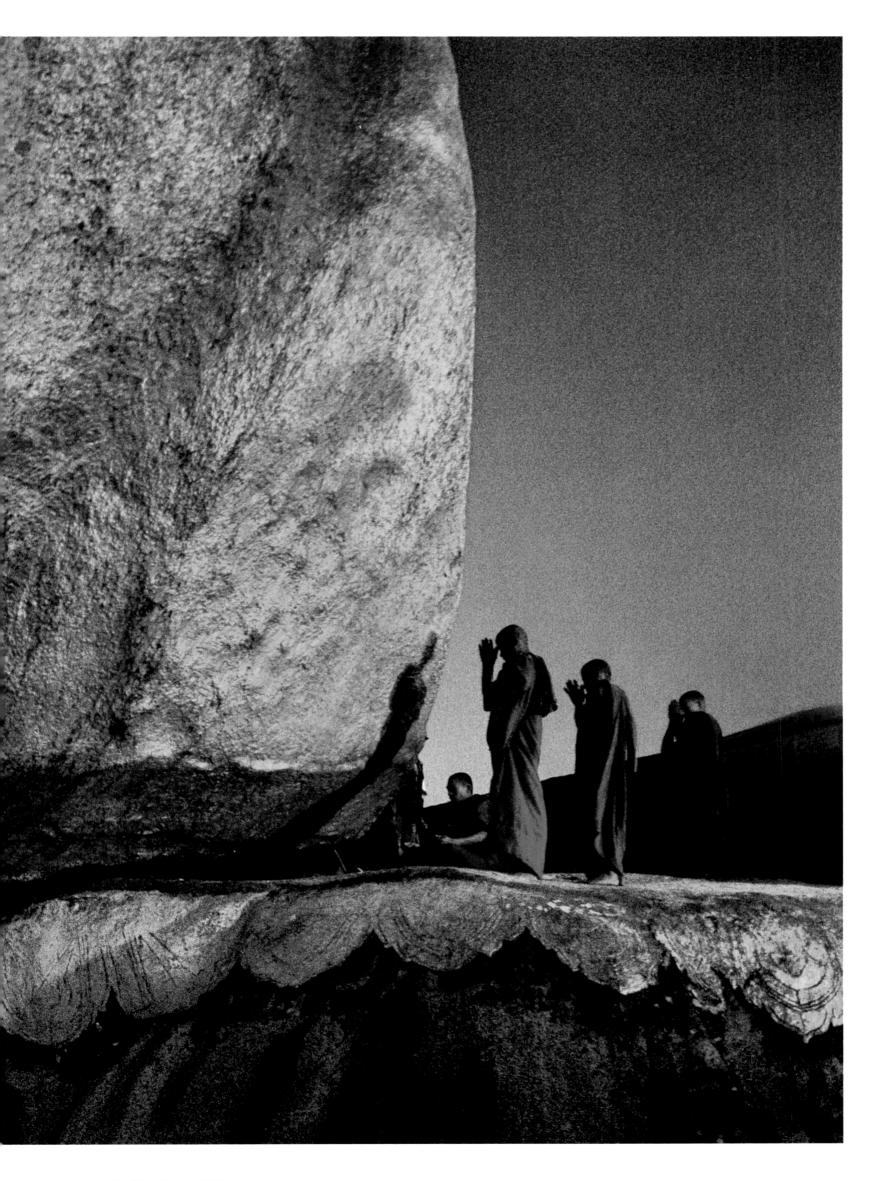

Kyaiktiyo, Burma, 1994
This scene of the Golden Rock, one of the most important pilgrimage sites in
the Buddhist world, challenges both gravity and reason. McCurry has chosen
to omit the small temple atop the boulder from view. Indeed, a shadow is all it
takes to understand the strength and true weight of faith.

"INDIA WAS THE FIRST PLACE THAT I REALLY STARTED WORKING INTENSELY. I JUST THINK IT'S SO DIFFERENT FROM HOW I GREW UP. YOU HAVE THIS EXTREME RANGE OF CLASS AND CASTE AND RICH AND POOR, AND PEOPLE TEND TO LIVE THEIR LIVES OUT ON THE STREET, WHEREAS IN THE U.S. PEOPLE TEND TO DO EVERYTHING INDOORS. THERE'S JUST A FASCINATION. SOMETIMES IT'S SHOCKING, BUT IT'S ALWAYS INTERESTING. YOU NEVER GET BORED. IF I WALK DOWN THE STREET IN CLEVELAND, I FEEL LIKE IT'S ALL VERY FAMILIAR, LIKE I'VE SEEN IT BEFORE, AND IT DOESN'T INTRIGUE ME. INDIA'S A MUCH MORE INTENSE EXPERIENCE."

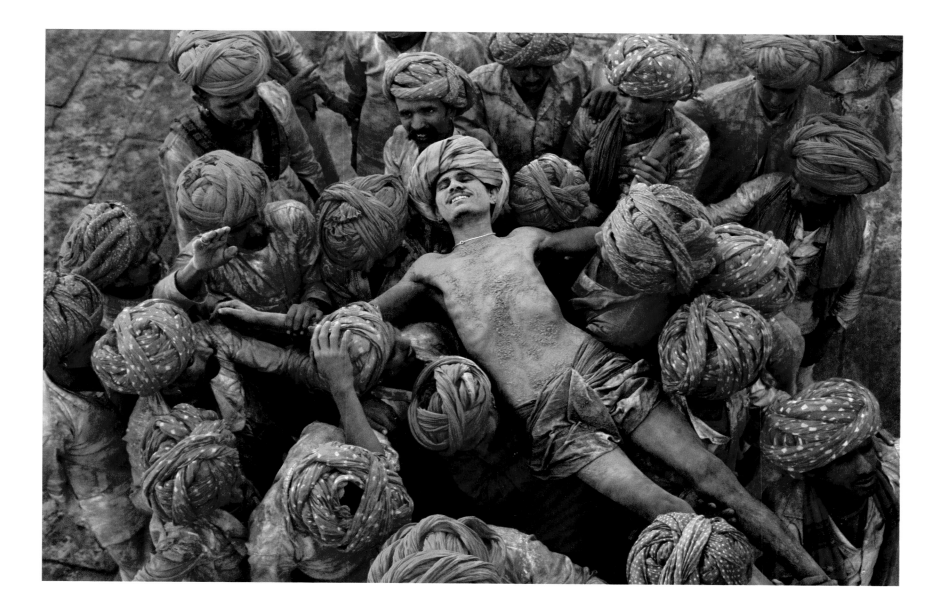

Rajasthan, India, 1996
In March, the month of Phalgun, the full moon marks the celebration of the Holi festival, the return of spring. Brightly colored powders are cast all about, and a body joyously surrendering itself to the crowd looks like earth itself, as green as new life. McCurry has said that even if he had to stop shooting he would continue to travel, because travel and photography are so closely intertwined. He is fascinated by both, so if he could no longer photograph he would opt to be a professional nomad.

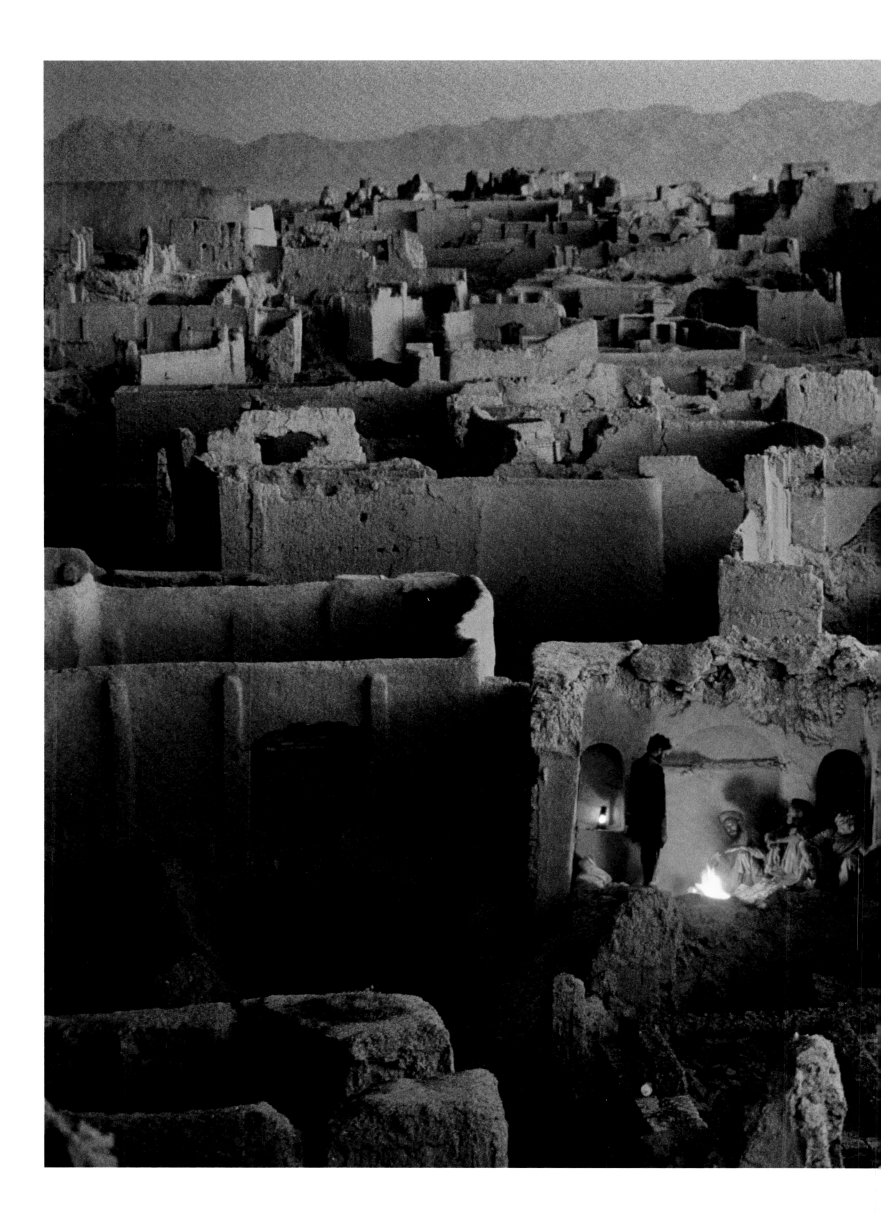

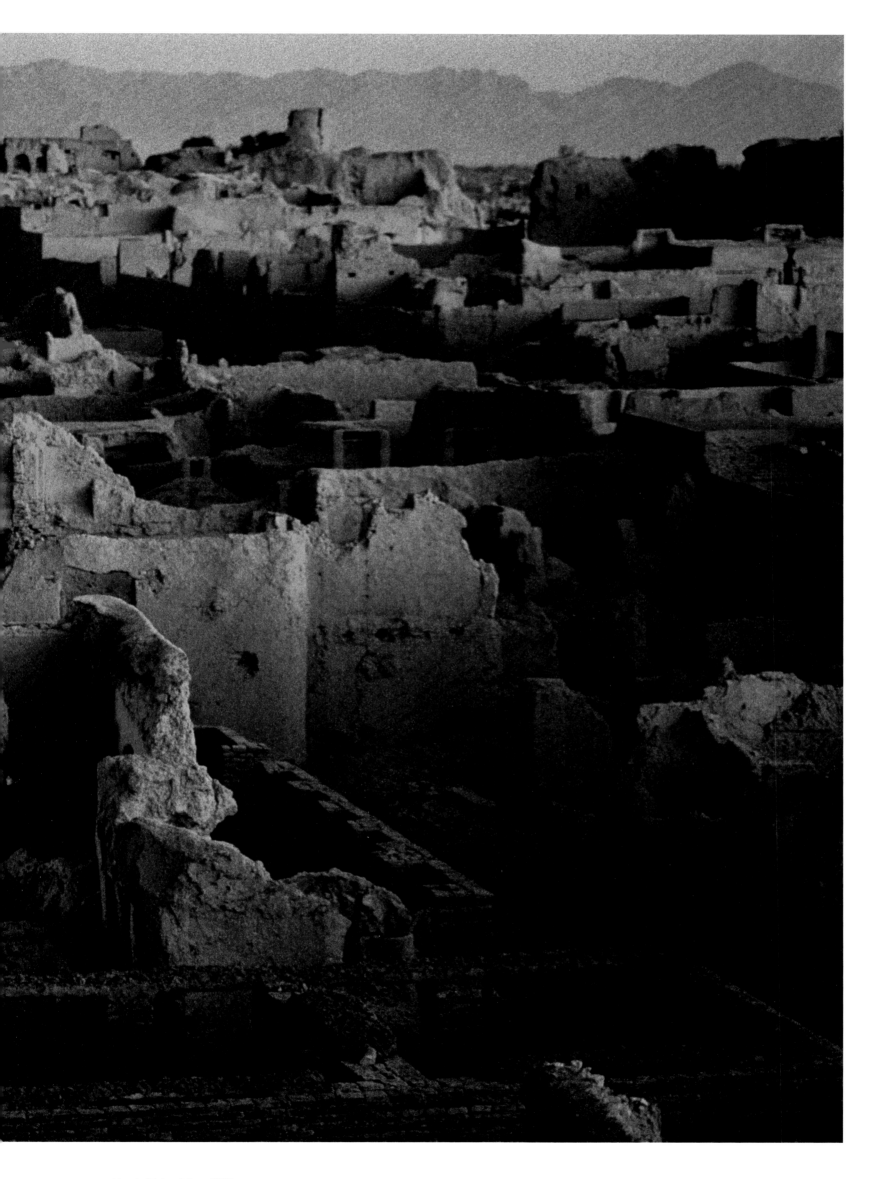

Herat, Afghanistan, 1992
In December 1979 the Soviet army invaded Afghanistan, bringing war, violence, and death with it. Ten years later the defeated troops of the former USSR withdrew, leaving behind the ruins of a destroyed country. Soon thereafter the Taliban came to power. The intervening time was just long enough to light a flicker of hope and breathe in a moment's respite.

After Afghanistan McCurry photographed conflicts in other parts of the world, but he remained deeply attached to Asia—even without a camera, its allure is hard to resist.

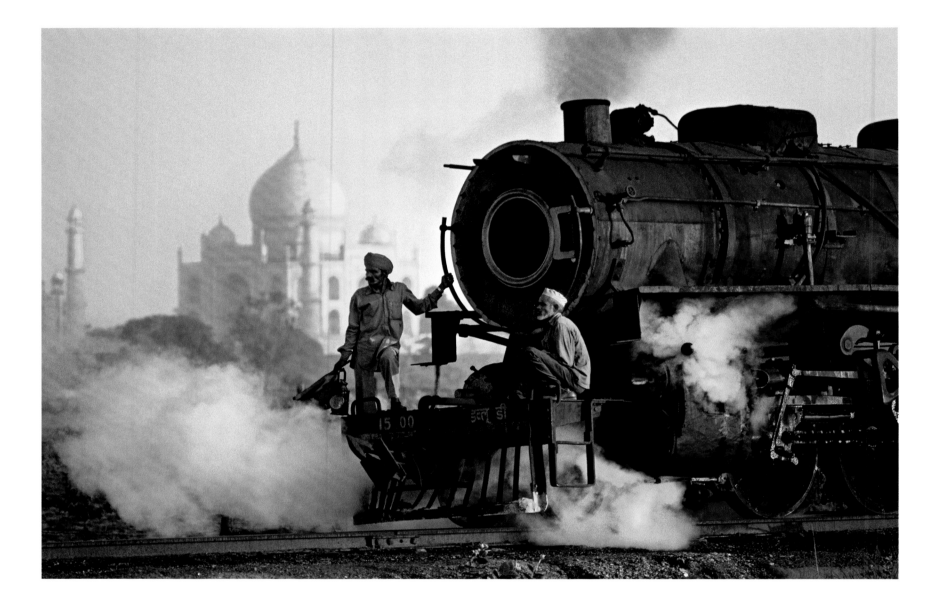

Agra, India, 1983

It took three days of waiting, sunrise to sunset, for this mental image to suddenly become a reality. The Taj Mahal graces the background like a lovely mirage, symbol of the Mughal Empire. In the foreground looms a locomotive, in all its strength and weight, symbol of the British Empire. Two worlds look at one another, and the great journey begins.

Steve McCurry was born in 1950 in the small town of Newton Square, Pennsylvania. After high school he spent a year in Europe, supporting himself by working as a chef. Upon returning to the US he enrolled in film and directing courses at Penn State University. His first contact with photography was through the work of Dorothea Lange and Walker Evans. As a student he began photographing for the *Daily Collegian*, the university newspaper. His interest in photography soon took over, and after graduating in 1974 he began working at *Today's Post*, a small local newspaper. The routine and rather narrow horizons got to him, so he left the paper for India, where he freelanced for two years. The country, its people, its fascinating beauty, and its lack of clichés cast a spell on him. He felt it was one of the few places where the spirit of the original culture had remained in its pure state, yet he also recognized that it takes more than just a turban to make a photo interesting.

In 1979 in Chitral, a village in northern Pakistan, McCurry met a group of Afghan refugees. Civil war had broken out, their country was destroyed, and they needed someone to help spread the word. Dressed as one of them, McCurry went to Afghanistan to join the rebels just a few weeks before the Soviet invasion. The images—captured on rolls of film he saved by sewing them into his clothes—won him the Robert Capa Gold Medal for best foreign photo reportage for courage and resourcefulness. Over the years McCurry has returned to Afghanistan many times, so it has virtually become a second home: "To me, a place like Afghanistan is fascinating to go back to and see the changes and see how that situation has evolved. So I can see going back to a place like Afghanistan over and over again. I have friends there. I'm very familiar with the political situation. It's almost like an old friend that I want to go back and re-meet and get re-acquainted with again." His experiences there were collected in the book *Afghanistan 1982–2002*. He went on to cover conflicts in Lebanon, Yugoslavia, Iraq, and the Philippines. His early work in black and white soon shifted into color, which became one of his trademarks. Soon afterwards he began a long collaboration with *National Geographic* magazine, publishing reports from all over the Middle and Far East, from Tibet to Burma, India, Yemen, Cambodia, and Nepal.

In 1984, two years before joining Magnum, Steve McCurry photographed a twelve-year-old Afghan girl in a refugee camp in Peshawar. Her face and beautiful green eyes graced the cover of *National Geographic* and become an emblem of the war and its atrocities; in 2002 he reunited with the girl, now a woman of thirty.

After establishing an extraordinary career in the rich colors of Kodachrome, in 2005 McCurry went digital. In 2010 he requested one the last few rolls of this game-changing film, first released in 1935, for a special project. He shot the thirty-six images of the roll for a photo essay created over eighteen months, taking thirty portraits of outstanding people worldwide, including Robert De Niro in New York, Amitabh Bachchan in Bombay, fellow American photographer Elliott Erwitt, and Turkish photographer Ara Güler. At the end of the project McCurry personally delivered the roll to Dwayne's Photo in Parsons, Kansas—the sole remaining Kodak-certified lab specialized in Kodachrome development.

McCurry's first book was published in 1985 and featured a text by Paul Theroux; titled *The Imperial Way*, it chronicled the train trip from Peshawar to Chittagong. Numerous books followed, including *Monsoon*, *South Southeast*, *Path to Buddha*, *Sanctuary*, and his most recent, *The Iconic Photographs*.

"MOST OF MY IMAGES ARE GROUNDED IN PEOPLE. I LOOK FOR THE UNGUARDED MOMENT, THE ESSENTIAL SOUL PEEKING OUT, EXPERIENCE ETCHED ON A PERSON'S FACE. I TRY TO CONVEY WHAT IT IS LIKE TO BE THAT PERSON, A PERSON CAUGHT IN A BROADER LANDSCAPE, THAT YOU COULD CALL THE HUMAN CONDITION."

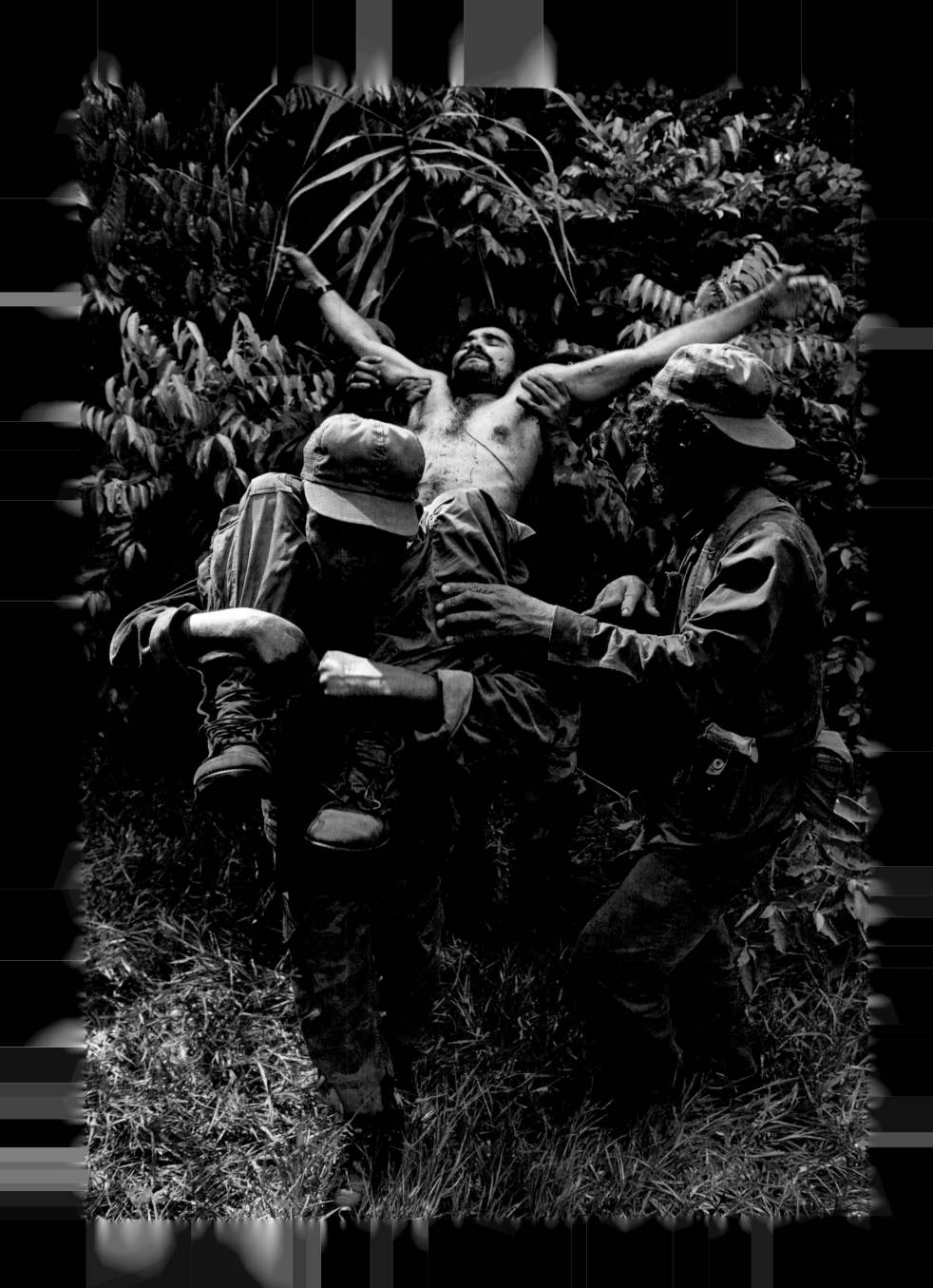

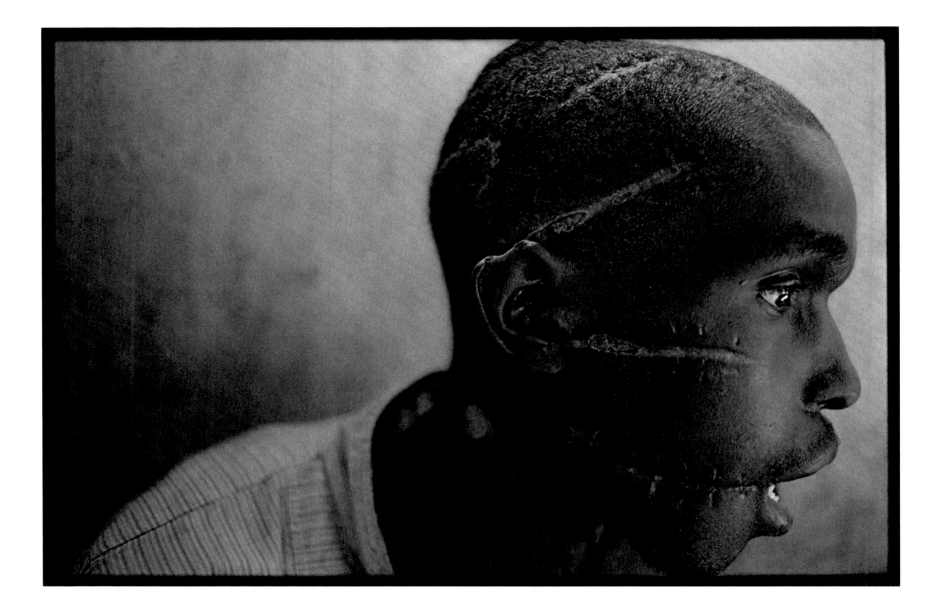

Page 316
Contra Mortally Wounded in Jungle Warfare, San Juan del Norte, Nicaragua, 1984
Every frame of Nachtwey's work shows much more than a war fought or a death suffered. The pain of this deposition scene taken amid the Nicaraguan guerrillas has all the mystery of a dead Christ. This ancient subject matter is renewed as a corpse is carried by comrades through the jungles of Central America—now as before, humanity cannot avoid its tragic fate.

Above
Survivor of Hutu Death Camp, Rwanda, 1994
In 1994 a terrible massacre occurred in Rwanda: in just 100 days, 800,000 Tutsi men, women, and children were slaughtered. Hundreds of Hutu moderates were also victims. The man pictured here is one of them. According to Nachtwey, he had just been liberated from a Hutu death camp, where the (mostly Tutsi) prisoners were systematically starved, beaten, raped, and killed. The photographer has said he wants the viewer to feel responsible for this picture, and rather than turn away, instead understand that his opinion counts—each viewer is part of an electorate.

JAMES NACHTWEY

Writing about James Nachtwey should ideally have his same tone of voice, warm and calm—the voice that accompanies images of extreme suffering with extreme sobriety. His speech, like his images, is punctuated by silences and moments of reflection. The pauses between one image and the next show that the real voice speaking is that of all humanity, wounded by war, ravaged by disease, weakened by hunger and by defiant forces of nature.

For thirty years now Nachtwey has photographed pain, injustice, violence, and death—the kind of death whose features, instead of the fullness of old age, have the eyes of a child, the skeletal hands of hungry women, the emaciated face of a man plagued by poverty. In his descents into the deepest woes of the human condition and the vortex of eternal suffering, he is sustained by his conviction that photojournalism, at its best, can still influence public opinion, document current events, and, ultimately, change history. This was the formative lesson he took from the 1960s. Images of the Vietnam War and civil rights marches reinforced his commitment to combat hypocrisy, keeping our attention—and our conscience—from turning elsewhere. And it was precisely to keep us in contact with the suffering, lonesome parts of the world that Nachtwey chose the equally extreme route of beauty, albeit of an atypical sort. The extraordinary beauty of his images is a political, moral beauty. It is an instrument of struggle, a gesture of compassion. The photographer offers himself up to pain, accepting it, powerfully and gracefully transforming it. We are left speechless, shaken, and immobile in the face of such atrocity captured in a miracle of light. His perfect compositions serve to suture wounds, offer consolation, and take us in among the "forgotten ones." In this particular inferno, we are Dante and Nachtwey is our Virgil.

We look, and now we know. In Zimbabwe a man suffering from AIDS and tuberculosis leans against the walls and speaks to us of an imbalanced world, terminally ill with its indifference. In Mostar, Bosnia, in a bedroom that was once a comforting haven, a Croat sniper shoots at his Muslim neighbors and the dirty, rumpled bed sheets speak of the obscenity of ethnic hatred and its destruction of civil society. In Iraq the pained body of a dying soldier, protected by a body bag as if it were just a blanket, as if life were defying death, speaks of a country that sends its men away to die far from home. A country that is still lying, once again deceiving itself, even after the horrors of Vietnam.

Nachtwey has seen the arrogance of power and the brutality of conflict. In 1981 he was in Belfast, during IRA activist Bobby Sands's hunger strike; Sands refused food in protest, and paid with his own life. Soon thereafter Nachtwey gave up the "extremes" of war and its most dramatic moments, choosing instead to expand the story into a stream of images, a flood that follows the photographer's footsteps, vision, losses, and sense of mercy wherever he goes.

His time in Romania in 1990 following the collapse of the USSR was a point of no return. The gates opened—onto the Eastern Bloc, and onto another inferno. Rationally, Nachtwey was still looking for the best photos, but when he was confronted by the appalling conditions in which the children and elderly people were kept, he was truly shaken. Although he didn't know the details of Ceausescu's experiments, he was certain that they constituted a crime against humanity. He wanted to run, but felt a responsibility to record the events with his camera.

Those unavoidable, wild-eyed, close-up stares were soon joined by many others. He captured the face of hunger in Somalia, where a lack of food was used as a weapon of mass destruction, and by mid-1992 epidemics and famine had struck down more than 200,000 lives. Then came Sudan, also devastated by war and famine. Then Bosnia in 1993, Rwanda in 1994, followed by Zaire, Chechnya, and Kosovo. Moving from war to the devastating effects of natural contagion, the pain reaches even farther, leading Nachtwey and his lens to capture the poverty of India and Indonesia, the tuberculosis epidemic, and the gestures of love from those close to the ill.

And on September 11, 2001, war—which for over sixty years had not plagued the rich part of the world—returned to the West. For Nachtwey and millions of Americans the war has hit home, for the first time in their lives. And it was at home that he—no longer a war photographer, now an antiwar photographer—discovered the chasm that opens up in the consciousness of anyone who crosses a battlefield. In World War II his father had fought as a soldier in Europe; his gear and camouflage were still in the garage, just as the horror had remained in his soul. The photographer's father opted not to respond to his questions—silence, composure, an acceptance of responsibility for one's own fate, and the strength to start anew were the best answers.

Darfur, Sudan, 2004

A land martyred—first by drought, then by a near genocidal civil war that in 1956 split the country in two, pitting the Muslim Arabs against the animist Christians in a country where drought, malnutrition, disease, and poverty were already endemic. Over 150,000 people were victims of the ethnic cleansing endorsed by the government, and nearly two million became refugees.

This mother and son were among the refugees. The boy was being treated for hepatitis by Médecins Sans Frontières (Doctors Without Borders) and, pictured beside his mother, both became emblems of one of the most appalling humanitarian crises. Diseases like hepatitis are another scourge, especially when the only available water comes from infected pools because the camps are surrounded by the pro-government Janjaweed militias, who kill or rape men and women who venture out in search of food or firewood. Such suffering and horror can be depicted in many ways: through the scarred profile of a Hutu concentration camp survivor (p. 318), a portrait of the violence unleashed upon the face of a man whose mouth opens but whose hand grips a silent throat, as there are no words; or through images like this one, showing a moment of intimacy and silent suffering amid the chaos that rages all around. This moment of private contemplation transcends all questions of race, place, and religion, leaving a feeling of respectful human empathy. Nachtwey has worked at length in Darfur to try and tell a story that is all too often forgotten. In keeping with his role as an active photographer and participant, he donates a portion of the proceeds from sold images to Médecins Sans Frontières.

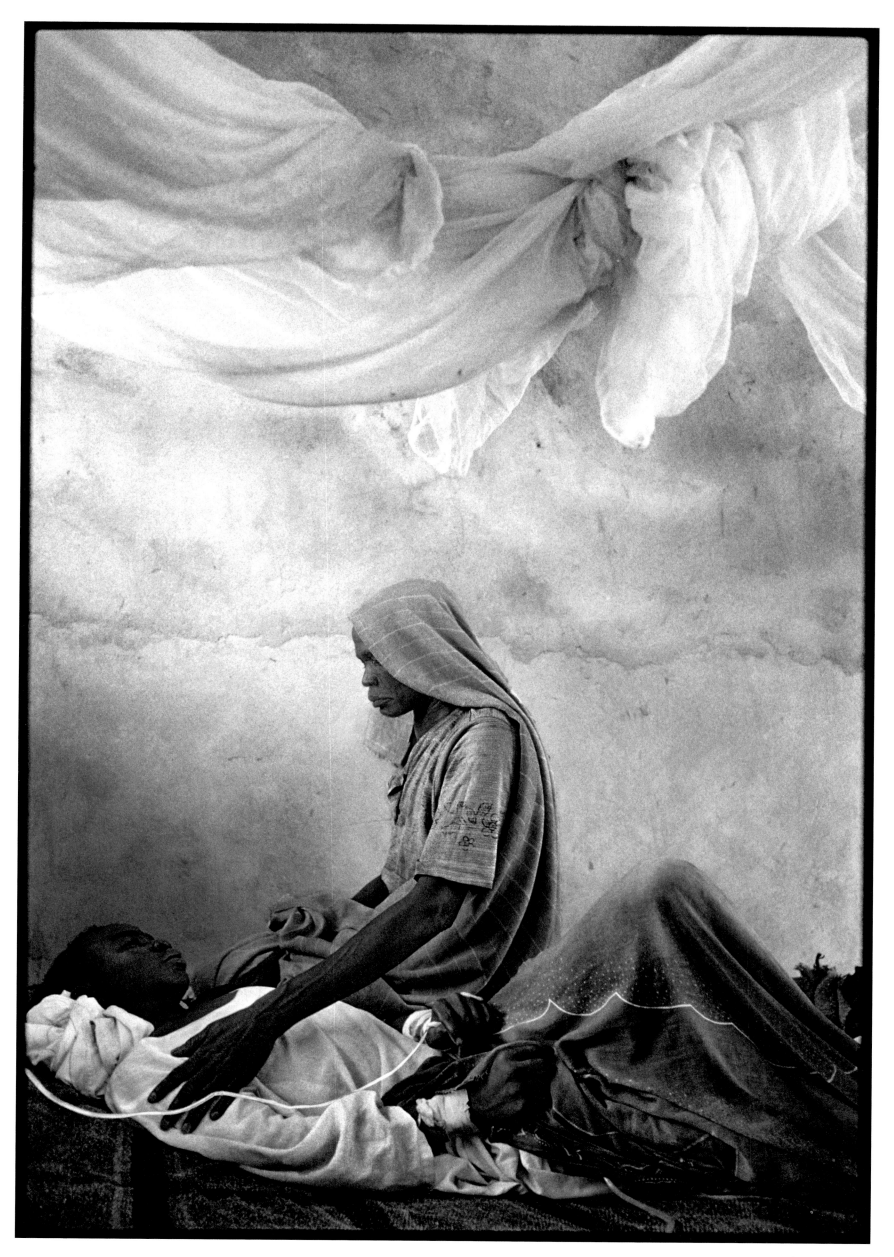

Ethnic Cleansing in Mostar: Croat Militiaman Fires on his Muslim
Neighbors, Mostar, Bosnia, 1993
A man wields a gun and shoots, hidden behind bedroom curtains. He is a
Croatian soldier fighting the Muslims of his own city. Nachtwey does not
center the picture on the man's face or the gun, his lens targeting instead
the entire room. In the former Yugoslavia, as in many other theaters of war,
houses became bunkers, and what had been the most intimate domestic
space became a place to kill or be killed.

Palestinians Fighting the Israeli Army, West Bank, 2000
Nachtwey has followed the situation in Palestine for years, and was in the West Bank in 2000 when the second Intifada broke out. He captured the revolt when it was still only stones and Molotov cocktails against an entire army. This image embodies the power of an impassioned, participatory approach to photojournalism, willing to delve into events and run the same risks as the fighters. It puts the photographer alongside the people, at the heart of the scene. Following in the footsteps of Robert Capa, Nachtwey shows the face of war and what happens to the people who live on the battlefield.

"I WANTED TO BE A PHOTOGRAPHER IN ORDER TO BE A WAR PHOTOGRAPHER. BUT I WAS DRIVEN BY AN INHERENT SENSE THAT A PICTURE THAT REVEALED THE TRUE FACE OF WAR WOULD ALMOST BY DEFINITION BE AN ANTI-WAR PHOTOGRAPH."

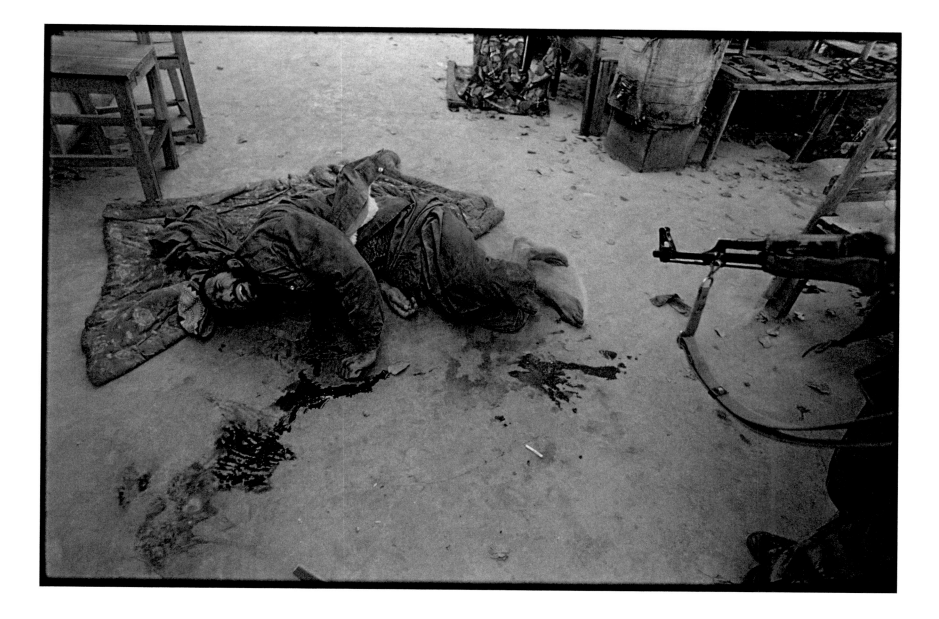

Afghanistan, 2001
A Taliban fighter has just been shot, perhaps fatally, and fallen to the ground.
The threatening barrel of the gun can be seen on the right. Only the weapon is
visible, not the hand that wields it, nor the face of whoever fired the shot. Much
like he did back in 1996, in 2001 Nachtwey continued exposing the desperate
reality of a country immersed in endless ethnic conflicts since the late 1970s,
fueled by foreign interests and occupations.

Collapse of the World Trade Center's South Tower, New York, 2001
The war comes home. The war America has long fought far from its own borders suddenly strikes the heart of the nation's most symbolic city, New York. With this attack on the West and its values, September 11 becomes known as 9/11. The Twin Towers collapse behind a rusty cross, unleashing the apocalypse. Three thousand people die, including over three hundred firefighters, engaged in a desperate attempt to retrieve the victims.

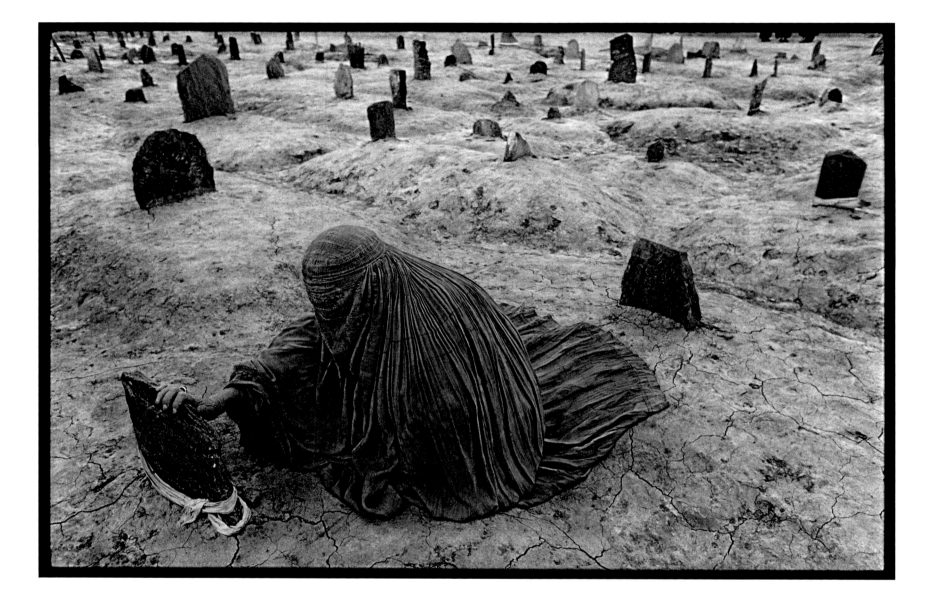

Mourning a Brother Killed by a Taliban Rocket, Kabul, Afghanistan, 1996
One last caress, one last moment of contact. We see nothing of this woman
but her hand on the tombstone. Her burka pours across the ground along
with the tears shed over the death of her brother, killed by the Taliban.
Alongside this individual loss, the tragedy of an entire country devastated by
war and intolerance is mourned.

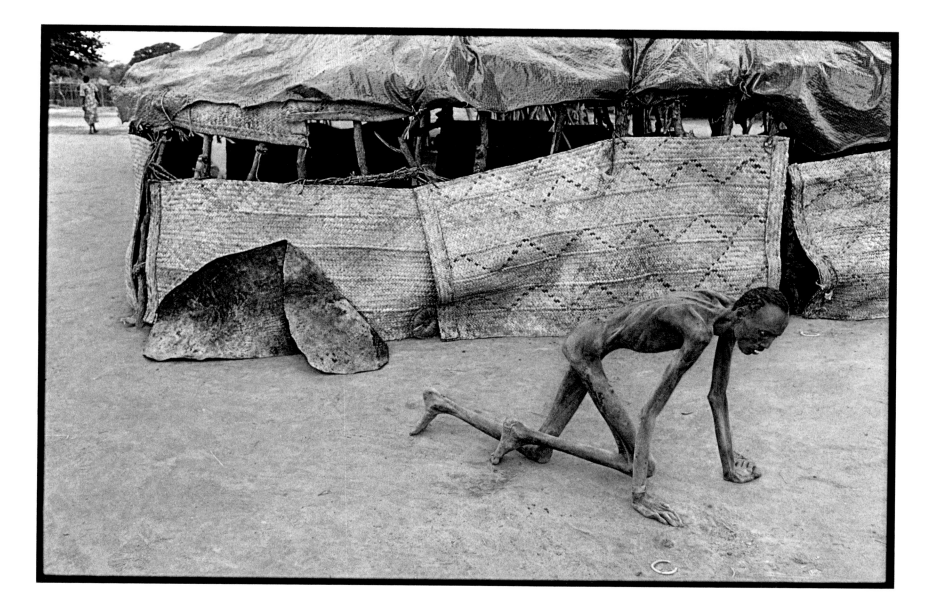

Famine Victim in a Feeding Center, Sudan, 1993
How many more steps can this man, transparent as his own shadow, take? How much longer can his body, ravaged by AIDS and tuberculosis, resist? TB, far from relegated to the past, has become even more resistant, and continues to claim thousands of victims, from Africa to Cambodia, from India to Siberia. Nachtwey has devoted a large body of work to this overlooked epidemic. "I try to stay open. It has become only harder—not easier—to do. But I realize that if I don't do it, then I won't be as effective; my pictures won't have the same depth and humanity."

"I DON'T USE THE FORMAL ELEMENTS OF PHOTOGRAPHY FOR THEIR OWN SAKE. I DON'T USE WHAT'S HAPPENING IN THE WORLD TO MAKE STATEMENTS ABOUT PHOTOGRAPHY, I USE PHOTOGRAPHY TO MAKE STATEMENTS ABOUT WHAT'S HAPPENING IN THE WORLD. I'M A WITNESS AND I WANT MY TESTIMONY TO BE ELOQUENT."

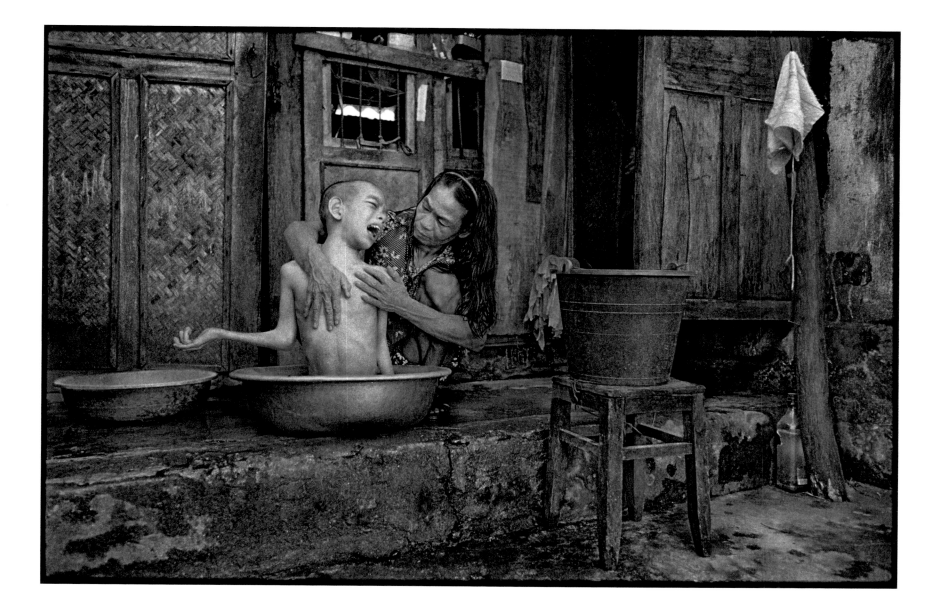

Cam Lo, Quang Tri Province, Vietnam, 2004
During the Vietnam War, the US poisoned the pristine nature of the Mekong Delta by bombarding it with Agent Orange, a chemical defoliant more devastating than napalm. Half a century later, the poison continues to pollute the waters, as well as the blood of a third generation of Vietnamese.

Nachtwey ventures to these places to show that the consequences of war go far beyond any peace treaty, penetrating the genetic code of an entire population. In this picture a woman exposed to Agent Orange during the war washes her severely disabled fourteen-year-old son.

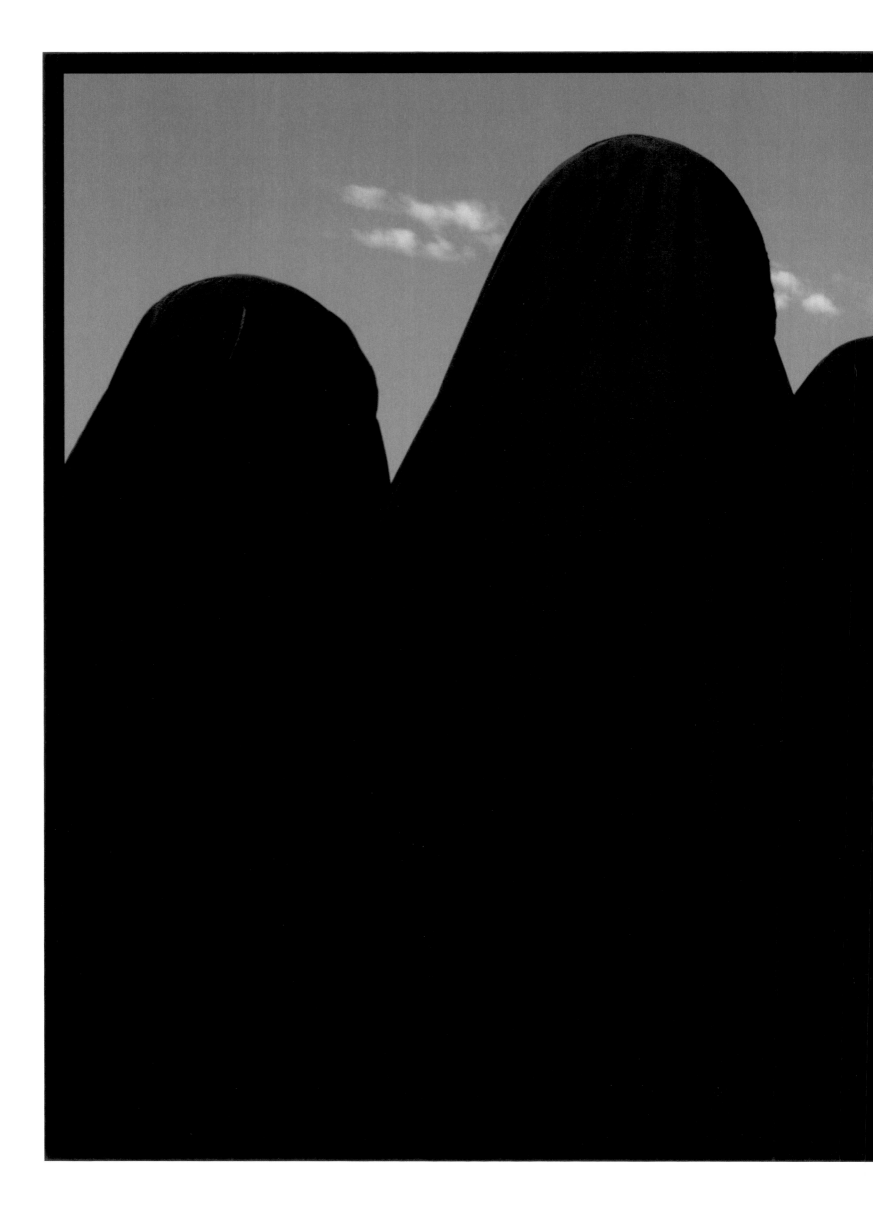

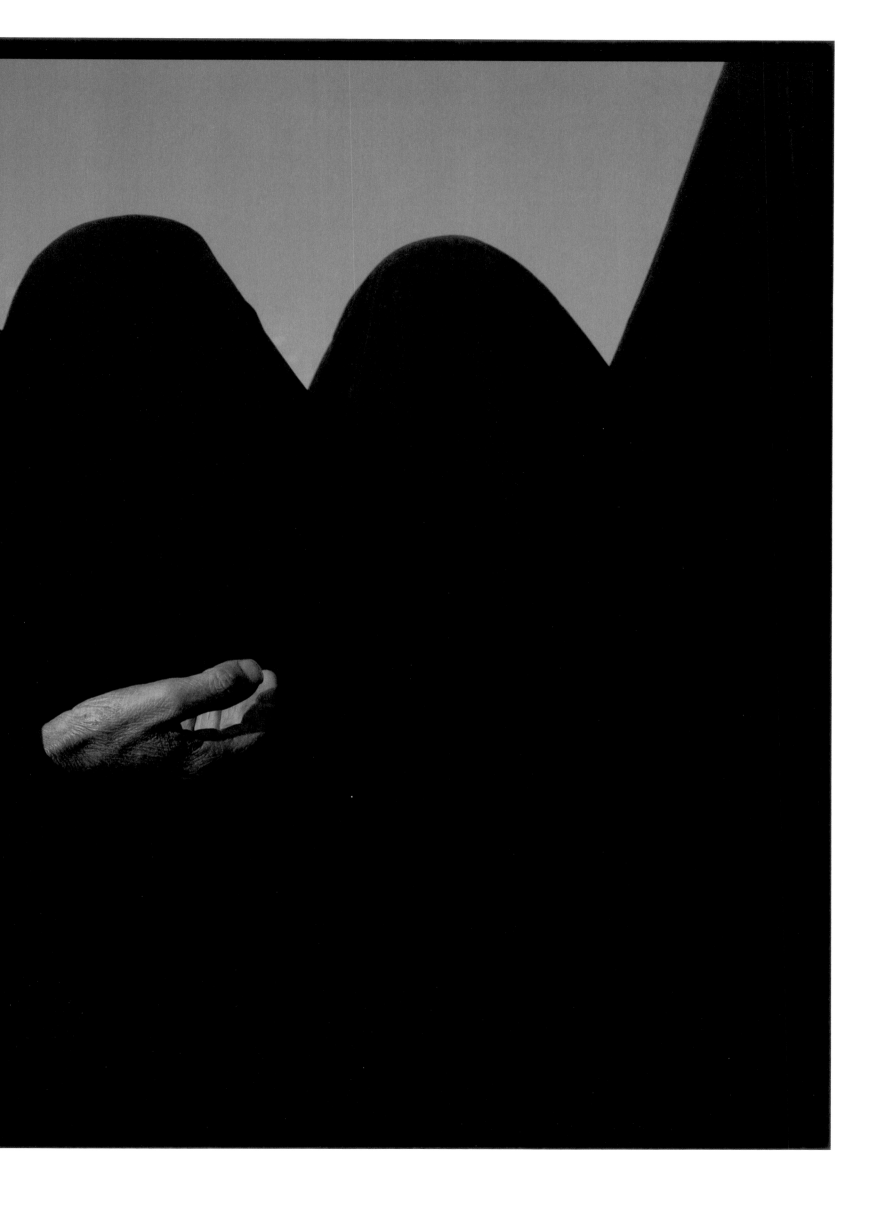

Iraq, 2003

Detail and color are often the best ways of telling the most difficult stories. This group of veiled silhouettes—outlined against the intense blue of a sky dotted by just a few clouds—speak of one aspect of Islam and its female world, one that is mysterious and tough to depict. These women are praying before the sacred Shiite shrine marking the spot where Imam Hussein was killed.

A significant detail at the center of the image breaks the wall of black burkas to show a praying hand, a palm turned skyward to receive God's blessing.

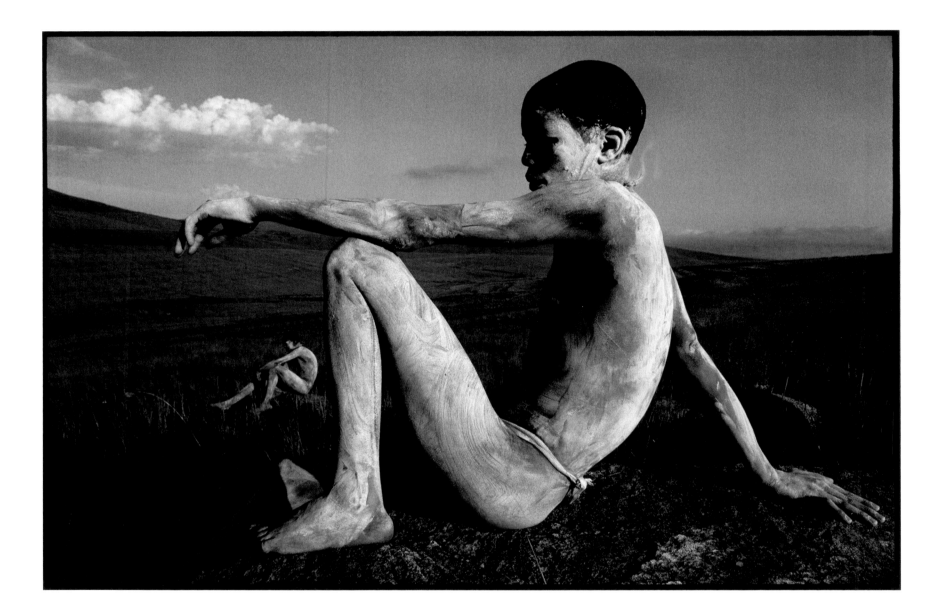

Xhosa Young Men in Rite of Passage, South Africa, 1992

During the ancient rites of initiation into manhood, the youth of the Xhosa tribe are circumcised, covered with plaster, and forced to live outdoors, far from their villages.

The body of this young man covered in white fills the frame, assuming an almost statuesque scale and proportion. In the background, another young man strikes an almost identical stance. The two unusual figures are surrounded by a natural scene so serene and peaceful it almost looks like a set painting, giving the image a surreal, mysterious feel.

© Antonin Kratochvil

James Nachtwey was born in Syracuse, New York, on March 14, 1948. In 1966 he enrolled at Dartmouth College, Massachusetts, and took courses in art history and political science. The images of widespread protests against the war in Vietnam and the struggle for civil rights were deeply engrained in Nachtwey's consciousness. "Our political and military leaders were telling us one thing and photographers were telling us another. I believed the photographers and so did millions of other Americans. Their images fueled resistance to the war and to racism. They not only recorded history, they helped change the course of history." After graduating in 1970 Nachtwey held several different jobs, working as a sailor for the merchant marine, a truck driver, and an assistant news editor. He came to photography as an autodidact, studying the work of Henri Cartier-Bresson, Eugene Smith, and Don McCullin. In 1976 a newspaper in New Mexico hired him as a photojournalist. In 1980 he moved to New York, and in 1981 he was sent to document the civil war in Northern Ireland, his first foreign assignment. In 1983 he won the first of five Robert Capa Gold Medals. A year later he signed on with *Time* magazine, and has done contract work with them ever since. From 1986 to 2001 he was a member of Magnum. Upon leaving Magnum he and a group of colleagues founded the VII photo agency, of which he remained a member until 2011.

From 1981 on, war has been the keystone of Nachtwey's work, and he is considered one of the world's greatest war photographers. His stint in Northern Ireland was followed by work covering several Central American revolutions, from Nicaragua to Guatemala, then the Israeli-Palestinian conflict, which he followed over many years, documenting the dramatic shift from the first to the second Intifada. In the 1990s, following the collapse of the Soviet Union, Yugoslavia dissolved as civil and ethnic wars broke out between Bosnia, Croatia,

and Serbia. Fighting spread from house to house, pitting neighbor against neighbor, and Nachtwey captured it on film. Shifting continents, when Nelson Mandela was freed in 1990 after twenty-seven years in prison, Nachtwey followed the end of apartheid; at the same time he also documented the tragedy of famine in Somalia and Sudan. In 1994 he returned to South Africa for three months to report on the elections; when Nelson Mandela won the presidency, Nachtwey said it was the most uplifting event of his career. But the day after he left for Rwanda and said "it was like taking the express elevator to hell." The tragedies unfolding worldwide were relentless, and he went straight from the Rwandan genocide to cover the war in Kosovo, the conflict in Chechnya, industrial pollution in the republics of the former Eastern Bloc, poverty in Indonesia, the war in Afghanistan, heroin addicts in a detoxification center in Pakistan, the effects of Agent Orange in Vietnam on later generations, the tragedy of Darfur, AIDS in Africa, and an in-depth coverage of tuberculosis in collaboration with Médecins Sans Frontières.

Then came September 11, 2001. Nachtwey was at home in his apartment at the South Street Seaport, just minutes from the Twin Towers, and the images he turned in to *Time* just twelve hours later were the most dramatic documentation of the catastrophe. The invasion of Iraq was just around the corner, and he followed.

In 2002 Nachtwey received the prestigious Dan David Prize for his outstanding photography. In 2007 he was awarded the TED Prize and expressed his "world-changing wish": to bring greater attention to the plight of TB victims. In 2011 he received the Dresden International Peace Price. His many books include *Deeds of War*, published in 1989, and *Inferno*, from 1999, which Richard Avedon called "the most painful and most beautiful book in the history of photography."

"I WANT TO RECORD HISTORY THROUGH THE DESTINY OF INDIVIDUALS WHO OFTEN BELONG TO THE LEAST WEALTHY CLASSES. I DO NOT WANT TO SHOW WAR IN GENERAL, NOR HISTORY WITH A CAPITAL H, BUT RATHER THE TRAGEDY OF A SINGLE MAN, OF A FAMILY."

JAMES NACHTWEY

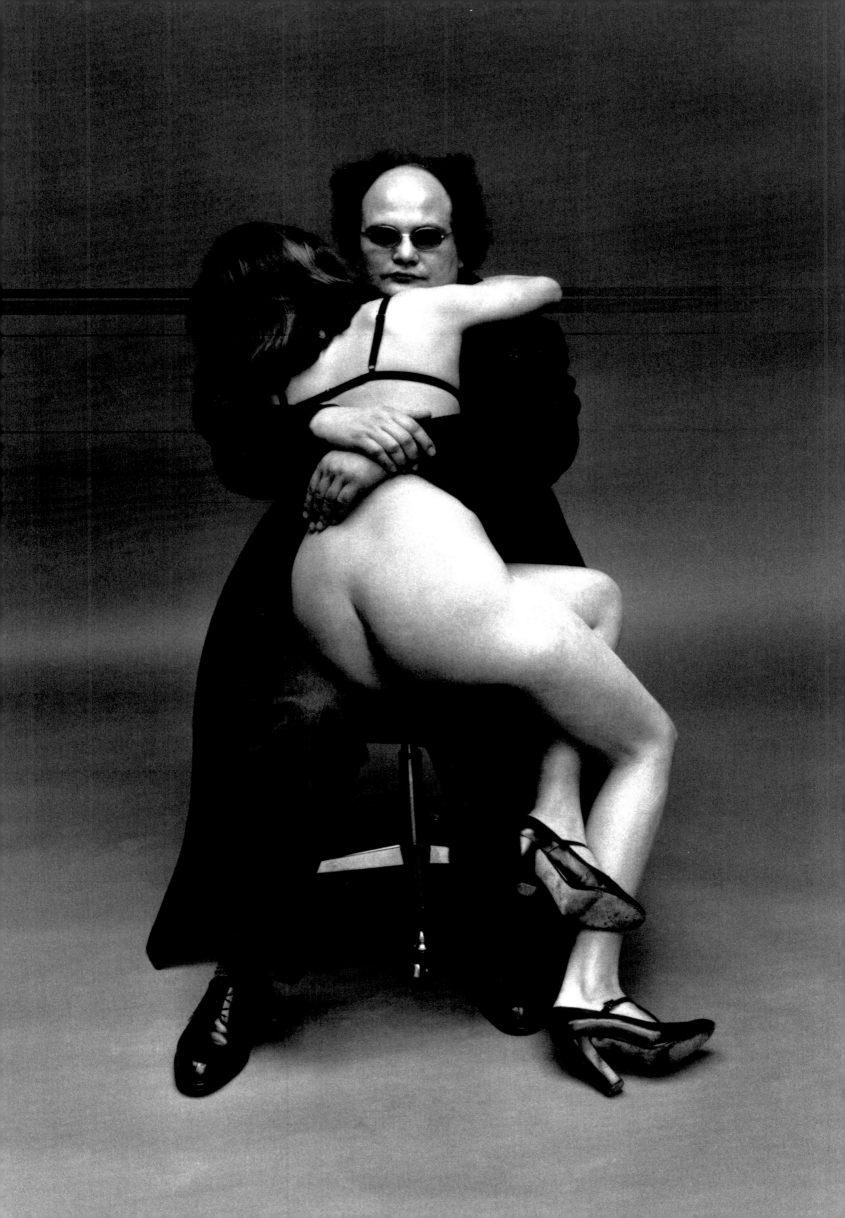

Page 338
Xavier Moreau with a Friend, Paris, 1974
A publisher—he published Newton's *World Without Men*—passionate about books, but also about women. It would be easy to replace the dark shape of Moreau with that of Newton. The terms of the portrait would not change and neither would its ideal of femininity. So 1930s, so Berlin, with that delicious body, those shoes, and that black brassiere, thin as a whip that cracks in the air.

Above
Ava Gardner, London, 1984
"A fashion picture is much more *mise en scène*. I try and do a *mise en scène* for a portrait. For instance, when I photograph an actor or an actress, I always give them the same spiel, which I believe in and which works. I say, I don't want an actual picture of you. To the actresses I say, 'Look, imagine you're playing a part.' When I photograph I'm really not interested in actual pictures, because I'm too contrived. I find it boring. What is a natural picture? A snapshot."

HELMUT NEWTON

It is a story about buckles and buttons. The buttons that Max Neustädter, Helmut Newton's father, manufactured in Berlin in the 1920s, and which his son, one buttonhole after another, preferred to leave undone. And so, dreaming as men do of the provocative and self-absorbed elegance that by chance can lead a woman to loosen the shoulder strap of her dress, or "open the curtain" of her evening gown, and permit, under the light of a bedside lamp, or of a lit match, the glittering display of a magnificent bosom. These are the dreams of men and the longings of women, that no one has ever depicted, with clothing as a symbol, or with no clothing at all, with such force and originality. An absolutely unique vision, always recognizable as Newton's, which, in a career of seventy years, from its beginnings in the photo studio of Yva in Berlin to the editorial offices of *Vogue,* up until the pages of *Helmut Newton's Illustrated,* created a world all its own. A world parallel to our own. Not a world without men as suggested by the title of one his books, but a world in which the one who managed the stage sets and costumes, who would look through the camera lens or in the mirror, was the only man, him, Helmut.

A family photograph caught him at three years of age, in velvet shorts and patent-leather shoes, and it is that boy, spoiled and subject to fainting fits, who would as an adult remember the embrace of his mother, in brassiere and pearl necklace, saying goodbye before leaving for the theater. And it was again that same boy who would peep at the first nudes in the pages of *Das Magazin,* and remain breathless at the sight of Erma La Rossa, a prostitute in riding boots holding a riding crop, which his brother Hans showed him one day on the Tanentzienstrasse.

The years passed and then everything changed. The Nazis came to power in Berlin and Helmut had to leave for Singapore. But his gaze remained the same and his eyes held the image of a young lady cooling herself on the terrace of a hotel suite after a romantic encounter, and on her skin there was nothing except the pleasure that remained after taking a shower. Another journey, another disruption to his life, as if there were no buckles and no buttons capable of keeping his life in order, and Helmut found himself in Australia. It was in Australia that the myth was born. And to transform Newton into one of the photographers most loved by women even more than by men, it had to be a woman, "different from all the others." It would be June Browne, later June Newton, wife, helper, the model in extraordinary portraits, editor, curator of her husband's work, and herself a photographer under the name Alice Springs.

Helmut met June in Melbourne in 1947. June was an actress, and was very intense; a brunette with blue eyes and red lips. Thanks to her, during their fifty-five years of life together, the magic of the theater, the inventiveness of the stage, the performance, the taste for the witty remark—all these became part of Helmut's work and its soul, and together formed that theory of signs and moods which other photographers tried in vain to imitate.

Beginning with the subject of the script: sex. Because sex is the best theater in the world, the most exciting stage, and therefore the most authentic, on which men and women measure their power and force of attraction every day. The rooms of the great hotels, from Paris to Los Angeles, with the ephemeral luxury of their furnishings, are the perfect settings for a sexuality that is so deep and revealing, even in its voyeuristic and sadomasochistic variations. Or the endless corridors to be walked, and flights of steps to be climbed, in long dresses open at the back, with open vents from the buttocks down. Beyond is the street, lit by a lamp, as in the photos of Brassaï, much loved by Newton. Or it might be a landing strip, a garden, even the Luxembourg Gardens in Paris. Among the trees a urinal can be glimpsed, and a woman in a fur coat with smoky gray stockings and wild blond hair, seen from behind, who observes the scene, and perhaps her boyfriend.

Newton's women stand out, their gaze lost in cigarette smoke, with shadows under their eyes that speak of life lived, and sleepless nights, and lips that always look dark in the black-and-white photos, because they are heavy with lipstick. The women rely on Newton, and they would always feel his absence, because only he knew how to bring them, with style, to the limits of provocation, one step from vulgarity, as in the detail of a high-heel on a spotless carpet. With him, actresses and models, and whoever might dream of having their portrait taken, were able to experiment with the forbidden games of make-believe. A *belle de jour,* but only for a day. How much is enough to feel the excitement of a fur coat on the skin, to take off one's clothes and get inside the belly of a crocodile, in that most erotic version of the story of Jonah? A few seconds, a click of the shutter, and life goes back to what it was, and the fingers start to close the buttons of a blouse. The end of the performance, because without Newton the show of seduction, sexy, intelligent, and never violent, is truly ended.

Big Nude III, Henrietta, Paris, 1980

What must we concentrate on in order to avoid being overwhelmed by the monumental impressiveness of this lady? On the cut of her hair, on the halo of curls surrounding her face attempting in vain to soften her gaze? On the neck muscles that are so tense and hard, almost the triangle of an hourglass that sets itself in opposition to the one formed by the ribs and the stomach? And what to say about the breasts, with tips like diamonds but spherical like two fruits made of glass that end their vertices in the dark hollow of the navel? And if up till now we have freely explored the perfection of this body, letting the sands of desire slip through the hourglass, it is the arms in their vice-like grip, with those fingers that grab the wrists and transform the pubic area into an impregnable fortress, which now constrict the gaze and prevent it from going elsewhere. The eyes surrender and proceed further, following the line of her flanks, magnificently sculpted by the shadow. And from there with the speed of a drop of sweat, one arrives at the knees, the calves, barely swollen, and at the ankles, extremely thin, and finally to the feet, which rest, as if they were the base of a statue, on the heels of a pair of pointed shoes. It is here that the adventure of a voyeur might end, on his knees, as may be deduced from the cropping of the frame. But starting from those feet that strike the eyes and pierce the asphalt there is an evanescent shadow that tries to climb back up the white backdrop of the studio.

He is exhausted. And how could he not be, with this series of photographs produced in Paris in 1980 and collected under the epic name "Big Nudes." Printed in large format, and large in the sculptural personalities of the models. Priestesses in a universe of men's dreams, in which the ones to triumph, dominate, and emerge victorious from the arena of seduction are the women. And this, outside of every silly feminist polemic, is the greatness of Helmut Newton and his images, which have no name; in this case, only a number indicating the progression of the series.

And yet, time, events, and the history of the century, which seem so remote in the absence of any staged setting for these photographs, have marked the birth of these portraits. At the origin of such impressive stateliness are the images of Nazi propaganda, those arrogant muscles, those precisely outlined faces. And next to them, the ID photos of the German police. Two styles of power and control. Newton, who was a victim of Nazi power, decided to offer this violent and fierce iconography a second chance. A second incarnation in which to transform an object into a subject and to offer to the female nude the power of a new desire to be the center of attention. With those legs planted on the ground and those defiant eyes that strip us of every false modesty.

Arielle After a Haircut, Paris, 1982

One moment before going on stage. The final preparations, the razor that trims the hair, the jet black make-up that surrounds the eyes, and that soft body ready to offer itself to the embrace of a divan. But the photo already exists, in Newton's intuition. That is his ideal woman. With the Louise Brooks haircut, the high cheekbones, the straight line of the nose in competition with the curve of the eyebrow drawn in pencil. And then the perfect swollen breast and the arm, pressed against the breast, which in its turn reveals the contours of a female body. As if it were a free interpretation of Man Ray's photo *Le Violon d'Ingres*, itself after the famous painting by Ingres, but without the overtones of male irony. Finally, in a stroke of genius, there is the cut hair that has fallen on the breasts and on the arm. And the magic of the image is precisely here. In the desire to draw close and to blow away the shadow of a marvelous trap.

Monte-Carlo, 1983
"There must be a certain look of availability in the women I photograph. I think
the woman who gives the appearance of being available is sexually much more
exciting than a woman who's completely distant. This sense of availability I find
erotic."

Vogue Paris, 1978
"I had found out that I did not function well in the studio, that my imagination needed the reality of the outdoors. I also realized that only as a fashion photographer could I create my kind of universe and take up my camera in the chic place and in what the locals called *la zone,* which were working-class districts, construction sites, and so on. To work for French *Vogue* at that time was wonderful: Who else would have published these nudes or the crazy and sexually charged fashion photographs which I would submit to the editor in chief?"

Naked and Dressed, *Vogue Paris*, 1981
First the body, with its generous dimensions in that alternating of soft flanks and elbows at an acute angle. First the women, with their gaze fixed on the vertices of the studio. Lord and master. This is the beginning. The rest comes later: the fashion, the jackets pinched at the waist, the cloaks that descend from the shoulders and end in a point, like the shoes. These things are indeed a trampoline that one cannot do without, in order to walk confidently down the streets of the world.

Naked and Dressed, *Vogue Paris*, 1981

"The right girl at the right moment has always been my inspiration; it's a matter of timing. Not that I ever consider what will excite the public. If I were to do that, I would never take a picture. No, I just please myself. Long before anybody wanted to see an overweight, plump model, I begged and pleaded with the fashion editors to cut the backs of dresses so that these beauties could fit into them."

"MY CAMERA, MY FAVORITE NUDE MODEL, MY WIFE JUNE WATCHING THE MODEL, THE *VOGUE* STUDIO WHERE SO MANY IMPORTANT EVENTS IN MY LIFE HAVE TAKEN PLACE.... THIS IS A TRULY AUTOBIOGRAPHICAL PHOTO."

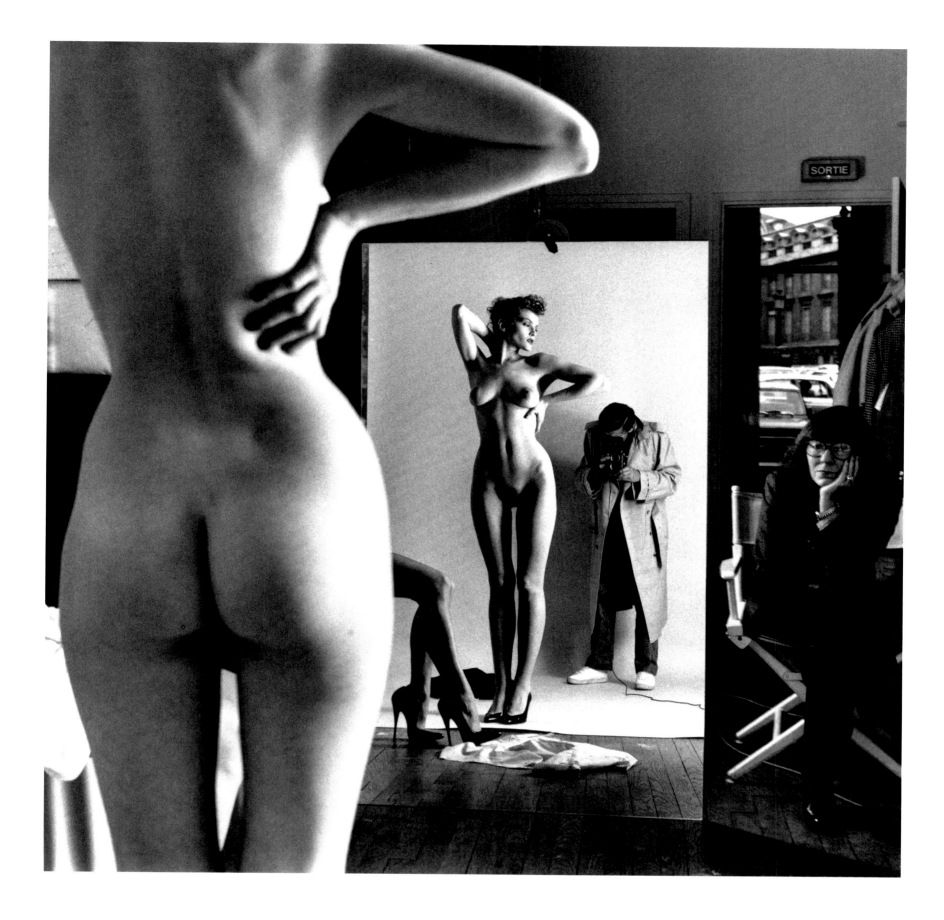

Paris, 1981
One photo to narrate a life as a "manipulator." And, rising up in the background of the frame, as if he were the origin of every story, there is a man bent over the camera lens, protected by a pale raincoat. The photographer wears clothes, the model is naked. In the middle ground, as if she were the link between real life and fiction, between the unique being and the infinite female variations, is June Newton. The director's chair is not there by chance.

Wuppertal, Germany, 1983

It is neither a circus act, nor a reckless swim in the waters of a tropical river. No, a wonderful ballerina from the Pina Bausch dance company has—of her own free will—slipped between the jaws of a crocodile, daring to enter this dark and inviting kingdom. Her spindly body is reminiscent of a quill telling the story of other women, actresses or models (and us along with them), which, thanks to Newton's elegance and restraint, takes us on an exploration through the mysteries and physical power of sexuality. One more inch of skin, in spite of her total nudity, the jaws opening a little wider, a lighter shadow, and all that would be left of this mouthwatering body would be scraps of flesh devoured by the jaws of vulgarity.

Ramatuelle, France, 1976

Nature—perhaps because it is perceived as feminine—has always held a significant place in Newton's work. It gave him that "black light" which filters down through the clouds before a storm and illuminates clothes and naked bodies better than any other source of light. And then came the gardens, innocent even in the most erotic images. Only the wind had remained noticeably absent in Newton's photographs. The photographer's gaze alone was enough to send skirts fluttering, to rustle the curtains of a hotel room. The time had come to change that.

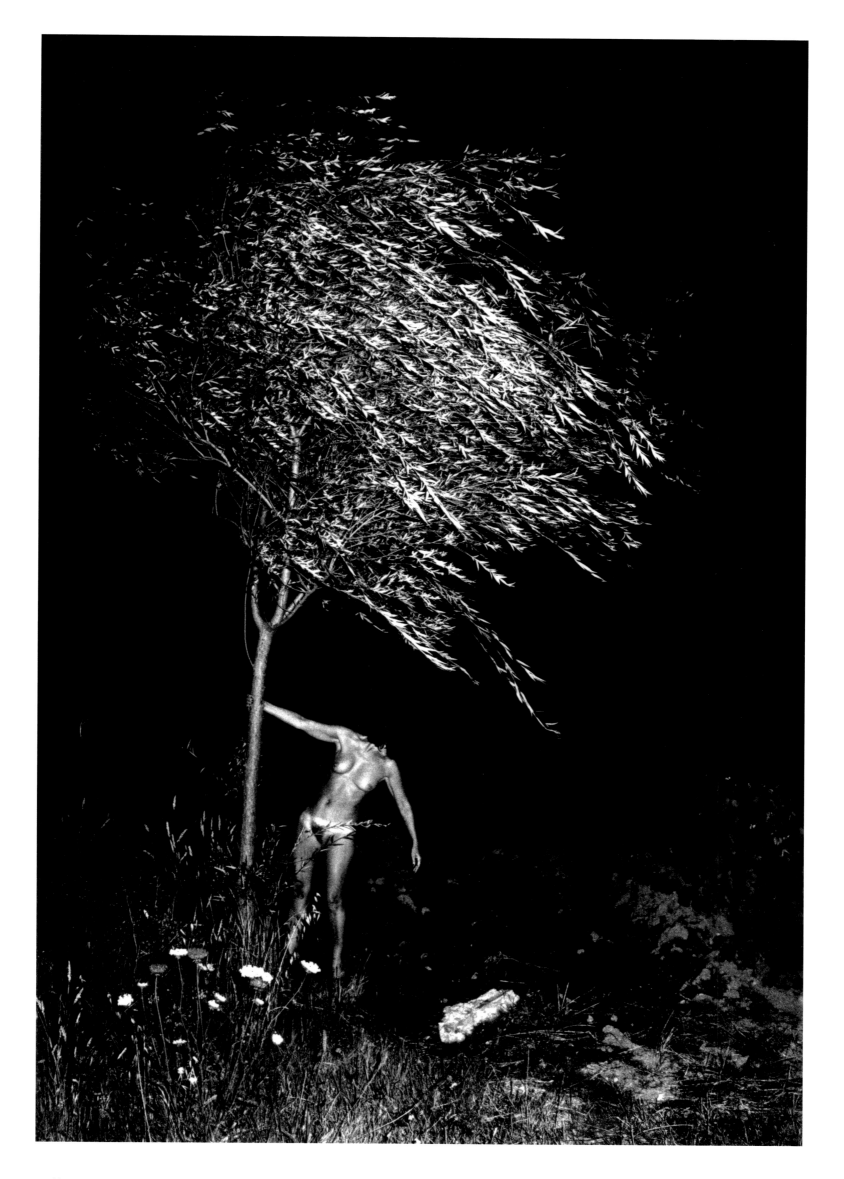

Newton pays homage here to the most voyeuristic of the elemental forces, shooting these pictures that tell the story of the landscape. A story that could begin like this: it was a dark and stormy night, the wind was rustling through the leaves in the trees, and the branches of the weeping willow were like a woman's hair immersed in a lake of pleasure. A moment later, a woman enters the scene. Is she June? Or is she simply the ideal of feminine beauty which defies the storm of good taste and offers her naked body to the photographer? Soon the sun will rise. Another day will begin at the house in Ramatuelle, near Saint-Tropez, where Helmut and June spent their vacations and where photography became one of the couple's most exciting games.

"I AM A VOYEUR! I THINK EVERY PHOTOGRAPHER, WHETHER HE DOES PICTURES THAT ARE EROTIC OR SEXY OR HE DOES SOMETHING ELSE, IS A VOYEUR. YOUR LIFE GOES BY LOOKING THROUGH A LITTLE HOLE. IF A PHOTOGRAPHER SAYS HE IS NOT A VOYEUR, HE IS AN IDIOT!"

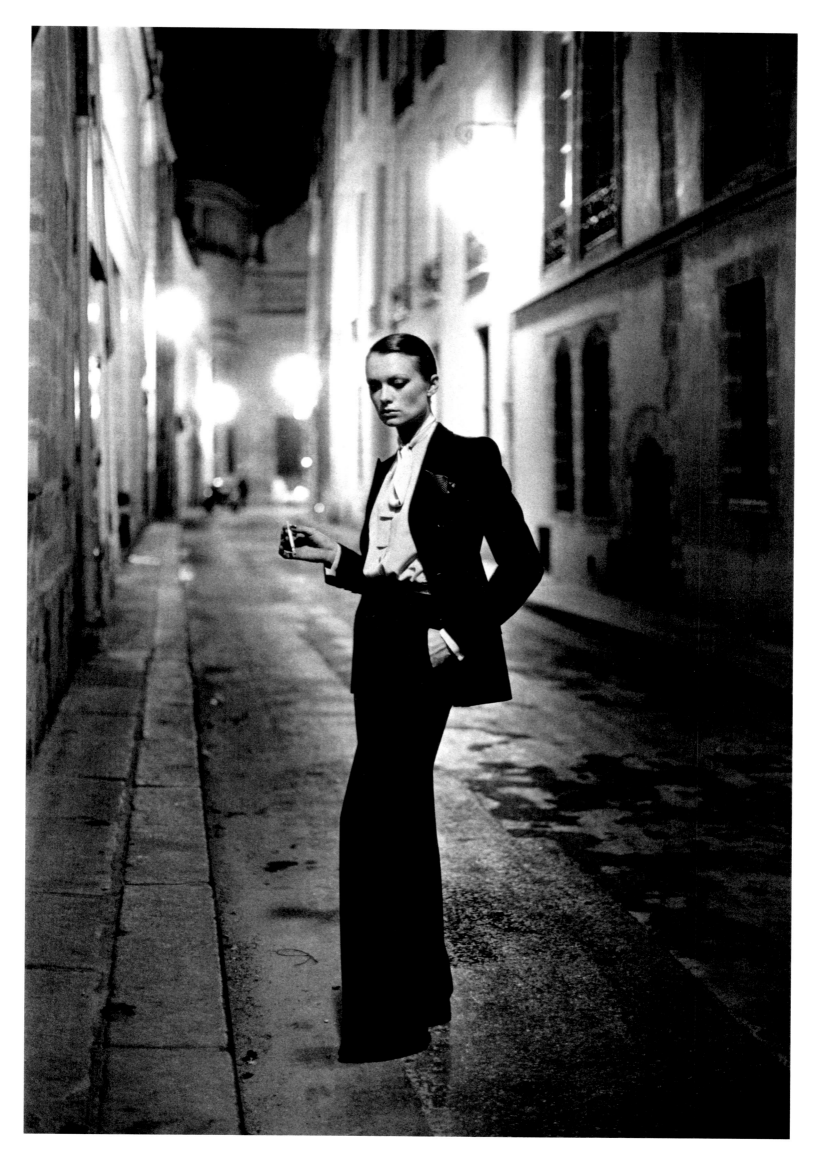

Vogue Paris, Paris, 1975
A Parisian street, an Yves Saint Laurent suit that blurs the line between masculine and feminine, and all around there is this sense of expectation and transgression that makes the scene so fascinating. Here is a glimpse of Newton's skill and an opportunity to discover the photographic and literary references that lie at the heart of his style. The first of these is Brassaï and his nocturnal Paris; then Erich Salomon and his frank gaze trained on the salons of high society. Finally, there is the allusive style found in the novels of Arthur Schnitzler and Stefan Zweig that Newton discovered in his father's library as a child. A key stolen for just a few minutes, a quick getaway, the warmth of the blankets, and young Helmut could savor that enchanting world he would never forget. Sensual, erotic, and laden with passion.

The Princesse de Polignac, Paris, 1979
"I think that the older a fashion photograph is, the more interesting it gets. And there is another thing that I think is important. You tend to go in close. Well, I pull back. Back, back, back. Because I found that what worried me when I took the picture, some car going by, some persons, something in the background that shouldn't be there, has become fascinating years later, because it's part of the time captured. So I started going back. I say to myself: 'I can always cut it out, if I want.' That's what I like about the 2 ¼ x 2 ¼. The person is in the middle, I leave it in the middle, I can cut the sides off later, it doesn't matter. The 35mm format drives me crazy, I miss so much on the sides."

Helmut Neustädter was born on October 31, 1920, in Berlin, to an haute bourgeoisie family. He acquired his first camera, an Agfa Box Tengor, at the age of twelve. Photography would become a true passion. When he was sixteen he became an assistant in the studio of Else Simon, known as Yva, an excellent portrait and fashion photographer. On November 9, 1938, after the Night of Broken Glass, Helmut, who was Jewish, was forced to go into hiding for two weeks. He was barely eighteen, the age required for a passport. After acquiring his passport, he left Berlin by train and, after obtaining a second-class ticket for the ocean liner *Conte Rosso*, sailed that December from Trieste direct to Tientsin, China. In his luggage he had two cameras. His parents would flee to South America. Yva would die in Auschwitz. By Christmas the *Conte Rosso* had docked in Singapore. The "social services committee" then came on board for the purpose of selecting passengers who wanted to disembark there. Helmut was accepted, and hired by the *Straits Times* newspaper as a photographer for the high society section. Then war broke out.

In 1940 Germany invaded Belgium. The British authorities put Helmut on the *Queen Mary*, headed for Australia. His final destination was the Tatura One internment camp, not far from Melbourne. Helmut spent two years there. Then he enlisted in the Australian army. He was discharged in 1946, took Australian citizenship, and changed his name. "Neustädter did not fit the new person I had in mind. I decided that this person would have preserved his links with his childhood, which is why I kept the name Helmut, and for a last name I chose Newton, which to me seemed a good translation of Neustädter." One year later he met June Browne, an actress who used the name June Brunell. They married in 1948. Helmut took photos for the Australian supplement of British *Vogue*. In 1957 came the turning point: a twelve-month contract to transfer to headquarters in London. But the atmosphere in England, especially its conservatism, did not stimulate his talent. After eleven months Newton broke the contract and moved to Paris, in order to work with *Jardin des modes,* which he saw as the most revolutionary fashion magazine in Europe, and where he claimed to have learned everything about fashion photography from those who really understood it.

Helmut and June returned to Australia in 1959, and left again two years later, once more for Paris. Their port of disembarkation: French *Vogue.* "That was my moment. I knew exactly which photos I wanted to take, and in the magazines they knew that if they chose me they would get something sexy." His clientele expanded to include Italian *Vogue,* British *Vogue,* and *Queen.* He spent two years at *Elle,* after a sharp quarrel with the management at *Vogue,* and then returned to Condé Nast in 1966.

In 1970, June began her own career as a photographer, filling in for Helmut, in bed with the flu, on a publicity campaign for cigarettes. In 1971, Alex Liberman invited Newton to New York in order to shoot forty-five pages for American *Vogue*. During the assignment, Newton suffered a heart attack, and the assignment was completed by June. Five years later, his first book, *White Women,* came out, followed in 1978 by *Sleepless Nights* and in 1981 by *Big Nudes.* That same year, Helmut and June left Paris for Monte Carlo, where they would spend their summers. Winters would be spent in Los Angeles, with his lens on the celebrities of Hollywood.

In 2003, the Helmut Newton Foundation opened in the heart of what used to be West Berlin, in a mansion dating to the early 1900s. Helmut Newton died in Los Angeles on January 23, 2004, struck by a heart attack while behind the wheel of his car, at the entrance to the hotel Chateau Marmont, on Sunset Boulevard. The following day he was to have started an important assignment. This time as well, June completed the task.

"I LOVE VULGARITY. I AM VERY ATTRACTED BY BAD TASTE—IT IS A LOT MORE EXCITING THAN THAT SUPPOSED GOOD TASTE WHICH IS NOTHING MORE THAN A STANDARDIZED WAY OF LOOKING AT THINGS."

HELMUT NEWTON

PARR

Page 360
Holland, 1997
Martin Parr uses an original method and point of view—the present day. This photo shows a person without a face, without a history, without apparent meaning. A tourist and a windmill turn together and are melded, amid the currents of global tourism.

Above
Disneyland, Tokyo, 1988
Nobody has pointed a lens at contemporary society—its myths and, in this case, its high-calorie emblems—quite like Parr.

MARTIN PARR

Maybe Mickey Mouse and his creators never imagined that the situation would become so dire. Nobody but the usual pessimists would ever have suspected that behind that semblance of a nice little mouse lurked a voracious beast, deformed by bulimia after binging on refined sugars and saturated fats. This bizarre creature is undeniably strong, and has its grip on the entire West as well as the parts of the East now looking westward. This terrible monster touches all socioeconomic classes and, unlike the Medusa, we must stare straight into its eyes in order to overcome the hypnosis of bad taste.

As an Englishman, Martin Parr comes from a culture that embraces both Queen Elizabeth and the Sex Pistols, prim cups of tea and miners' strikes, Lady Diana and Lady Thatcher. As a photographer, he has pointed his lens directly at the emblems of our consumer society and captured it, more often and better than anyone, at close range. While many of his colleagues at Magnum went off to faraway lands to denounce war or immerse themselves in the more photogenic corners of the Third World, Parr chose to go in the other direction: instead of taking beautiful photographs of tragedies and poverty, he captures obscene images of prosperity and wealth.

Parr has made supermarkets, country fairs, and working-class beaches his own personal trenches. In many ways this battlefield is as terrible and in decline as any other, and he is embedded in it like a one-man platoon with no bulletproof vest, under a constant barrage of cigarette butts, food scraps, paper money pressed between strangers' lips, flag-like bathing suits, bags of popcorn, lollipops, cakes frosted with smiley faces, and globe-shaped piggybanks whose rusted coin slot is as obscene as any other orifice reserved for money, sex, and junk food.

As a photojournalist-cum-storm-trooper in the global war of consumerism, armed only with a camera and a sense of irony, Parr leaves the more perplexing questions for us to answer. The woman who has no eyes—nothing to see out of, just a mouth demanding to be filled, permanently stuck in a Freudian stage of oral-fixation, gripping a sandwich between her bright blue fingernails—is she a victim or a perpetrator? Well, the photographer seems to say, she is simply one of us, both guilty and innocent. Her voracity is our voracity, and the kaleidoscope of acrylics, enamels, plastics, and additives are also ours. And because our reality is in color, and color is what makes any commodity both palatable and indigestible, Parr was quick to abandon black-and-white film. As an avid collector of photography books and souvenirs, he soon realized he was part of a noble tradition of European "colorists." He belongs to the generation of photographers who, as early as the 1970s, began giving the colors of the Old World, despite the louder American colors of the New World, their true voice.

In 1986, in the pastel shades of the sultry summer heat, Parr photographed the bathers of New Brighton beach, a bleak portrait of the United Kingdom's working class. Thereafter his colors grew more saturated, almost dripping pigment, as in the pages of *British Food* back in 1995, wherein the camera "digests" junk food, a symbol of national identity, before it even hits the stomach; the close-up technique Parr used is reminiscent of Araki's famous photographs for *The Banquet*. In 1999 he completed *Common Sense*, a series on kitsch and how it becomes an insatiable hunger, a disgust of food and bodies warming in the sun, and went on to capture blow-up dolls and mannequins, French fries and worms, as if civilization were happily rotting both from without and within, its expiration date long past.

Contamination knows no bounds in this society in perpetual motion, its denizens in constant search of a better island where they might lie down to rest for just a few dollars, just a few days. *Small World* reads the title of one of Parr's most beautiful works, and at this point he, too, is now traveling, the participant of an organized tour. The world gets smaller every day, exploring is as easy as hitting the copy and paste commands on a keyboard, from the Parthenon to the leaning tower of Pisa, from the pyramids of Giza to the sphinx in Las Vegas, from the Grand Canyon to Goa, from the Swiss Alps to a field of Dutch tulips. In these once-mythical, now tourist-trampled places Parr catches men and women off guard as they eat things, buy things, wrap themselves in plastic at the first drop of rain, try to navigate by reading guidebooks and maps even if printed on faux silk souvenir scarves, and above all as they take pictures and make films, even while riding on horseback, even while cradling a sleeping baby.

This unstoppable binge, this insatiable appetite prompts people to turn reality into a visual slagheap, and the millions of photos taken by millions of tourists every day weigh heavily on the stomach of the world. This is the plague of the digital age. On the first two pages of *Common Sense*, paired like twins, a woman snaps a photo and a girl snaps her chewing gum, blowing a bubble that is about to burst in her face. Is the bubble of consumerism about to pop, too? Are our stomachs so full they are about to rupture? In any case, one thing is for sure: Martin Parr, heir of Jonathan Swift and Monty Python, will be standing by to capture the horror of this revolting and colorful explosion.

New Brighton, Merseyside, England, 1983–85

This is us, we are all here. Maybe we have never vacationed on New Brighton's cold beaches, a few miles from Liverpool, but it matters little: this is a family photo, because Martin Parr spent his childhood summers here. It is also a group photo, a snapshot of a crowd that epitomizes—beyond the individuality of the patrons thirsting for a miserable cup of coffee or hastily garnishing their hot dogs—the whole of Western society.

This is not just Europe and America, it is everywhere Europeans and Americans have gone in the wake of the most recent colonization, the new empire of mass tourism. But when this photo was taken, back in 1985, during Margaret Thatcher's second term and with the highest unemployment rate ever recorded in England, the British working class could not afford to venture too far from home.

The holiday shown here is one of undigested consumerism, in one of the most popular seaside resorts in the UK. Never before had a British photographer dared to dip his finger, not to mention both hands and eyes, so deeply into the sauce of bad taste and the poverty of his countrymen. The island nation of Britain is personified here, and he babbles about this broken, vulgar world; his mouth is full and he clings to the ketchup bottle, hoping to add some flavor to his hot dog and his life. We are the woman clutching her purse in her armpit, her hands cradling a cup of hot coffee. We are the girl with sunburnt skin, wrapped in a rough towel, contemplating the horror of the counter strewn with scraps. Here we are, the bulimic buyers of anything and everything consumable, the ones who, after the binge, will struggle to digest the weight of our insatiable society.

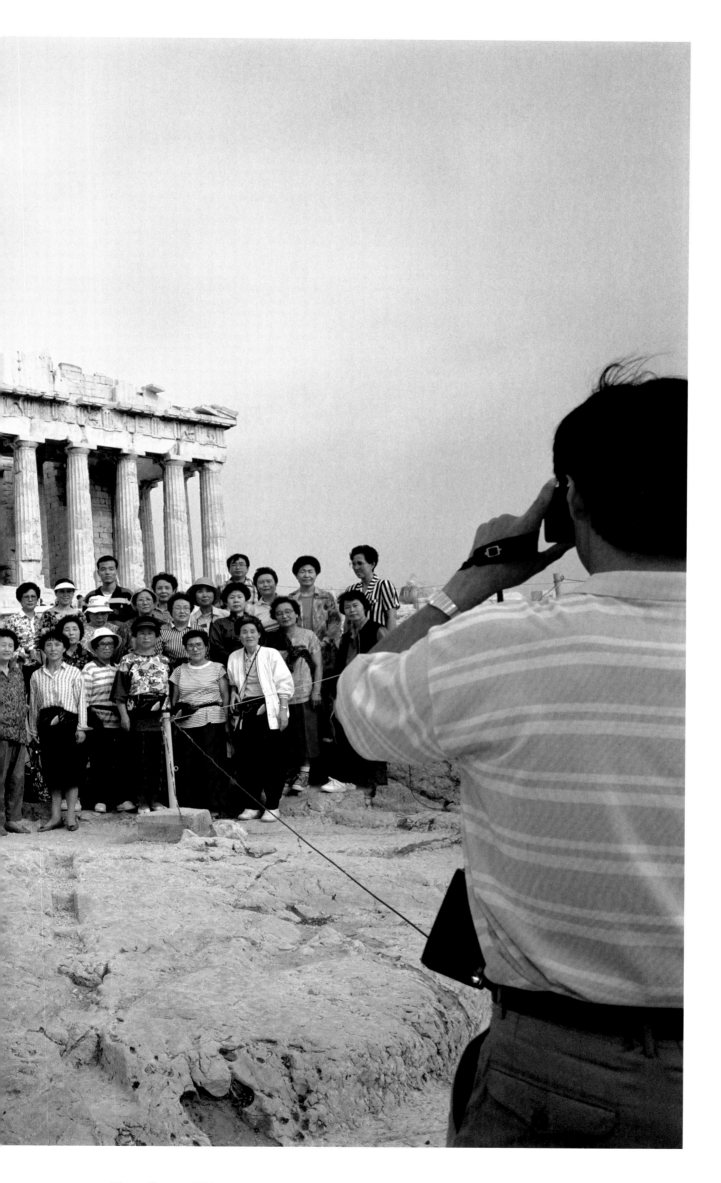

Athens, Greece, 1991
This, too, is a ritual. The group photo as an homage to the travel gods, the
deities of all-inclusive vacations, guided tours, prix fixe menus. The Parthenon
as backdrop, the Olympus of mass tourism in the foreground.
 Here, once again, color plays the leading role: the Greek summer sunlight is
tempered by the atmosphere of an ironic, leaden alienation.

England, 1991

Domestic interiors speak, telling the stories of their tenants and their tastes, models, ambitions, and color dreams, as in this picture from *Signs of the Times: A Portrait of the Nation's Tastes*.

"But then if you give sad and depressing stories to the world, I really have the feeling that no one is going to listen to you. That's why I like my pictures to be bright and colorful and, I hope, acceptable. Because I want to include my audience. I don't want to piss them off, I want to draw them in, and then there is more to be read when you are more inclined. But I would never expect my photography to change anything. That is so naive. People used to say that but they don't say it anymore."

"MAGNUM PHOTOGRAPHERS WERE MEANT TO GO OUT AS A CRUSADE TO PLACES [AFFLICTED BY] FAMINE AND WAR. I WENT OUT AND WENT AROUND THE CORNER TO THE LOCAL SUPERMARKET BECAUSE THIS TO ME IS THE FRONT LINE."

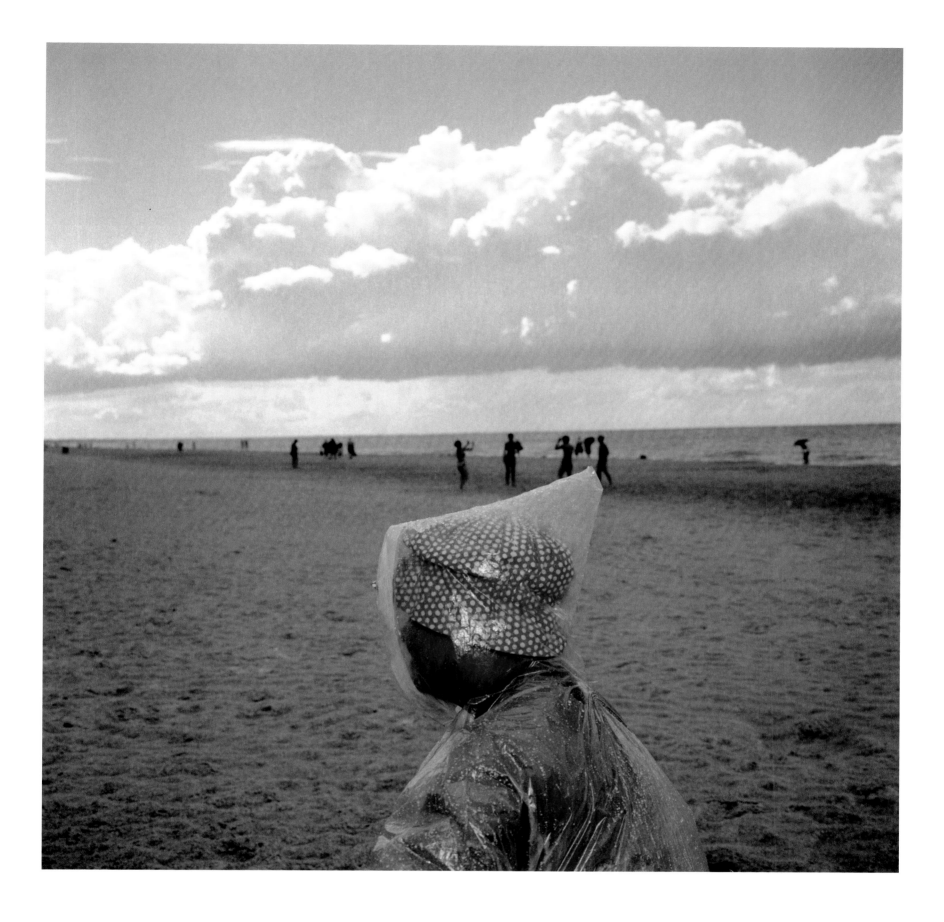

Jurmala, Latvia, 1999

Here is an average July day on the beach of Jurmala, near Riga. Communism collapsed a decade ago, but the air of Soviet poverty lingers, shrouded in uncertainty. And while the swimmers go on playing, the faceless figure in the foreground prepares for impending rain.

"I have a pretty good idea of how to make a good picture but of course I'm always going to be thrown because pictures will come up from nowhere about nothing, and that suddenly works and I won't understand why. So this is why I keep doing pictures—to try and understand it, to try and capture that spirit. If photography is the simplest medium, it is also the most difficult, and that's what makes it interesting."

Goa, India, 1993
What could be more sacred than vacations? Here the famous beaches of
Goa are transformed into a temple, in front of an ocean storm on the horizon,
with all the characteristic symbols of both ancient and modern religions—
Hinduism and tourism.

Kalkan, Turkey, 1994
"I always define myself as a documentary photographer. I always say, first a photographer, which is very important. And then you need to define this, to find a genre. And documentary is definitely the term I feel closest to. Part of my motivation is to record, understand, and interpret through photography what is going on in the world."

New Brighton, Merseyside, England, 1986
A threat looms large, and it is more than just the giant bulldozer that could crush the defenseless bodies of this woman and her daughter. It is something else, the unbearable weight of squalor and the absurd longing for sand where concrete reigns.

Regarding his photos, Martin Parr once said, "The reason why I like things like seaside resorts is not because they are kitsch but because they are very energetic, bright, and colored, and that's what I enjoy in them. Not just because it's a kitsch place. It is so condescending and reductive to say just that."

"I GO STRAIGHT IN VERY CLOSE TO PEOPLE AND I DO THAT BECAUSE IT'S THE ONLY WAY YOU CAN GET THE PICTURE. YOU GO RIGHT UP TO THEM. EVEN NOW, I DON'T FIND IT EASY. I DON'T ANNOUNCE IT. I PRETEND TO BE FOCUSING ELSEWHERE. IF YOU TAKE SOMEONE'S PHOTOGRAPH IT IS VERY DIFFICULT NOT TO LOOK AT THEM JUST AFTER. BUT IT'S THE ONE THING THAT GIVES THE GAME AWAY. I DON'T TRY AND HIDE WHAT I'M DOING—THAT WOULD BE FOLLY."

Sedlescombe, England, 2000

This figure, her head blocked out by a plastic flag, portrays the face of a nation—England—and calls to mind its idiosyncrasies and the unique pride capable of transforming a folding lawn chair into a throne and an anonymous elderly lady into the Queen.

Photography curator Quentin Bajac recently observed that, "Given the element of seduction inherent in a number of his images, it is sometimes forgotten that the essence of Martin Parr's approach is characterised by a certain reserve. It seems to me that the best term to describe this treatment, in which he displays neither empathy nor antipathy for his models, is deadpan. Although often used today in a pejorative sense to denote any documentary form of expression that strikes a neutral pose, deadpan refers historically to the American comic tradition immortalised by Buster Keaton and, to a lesser extent, Stan Laurel, of a certain neutrality in response to all circumstances, giving rise to humorous discrepancies."

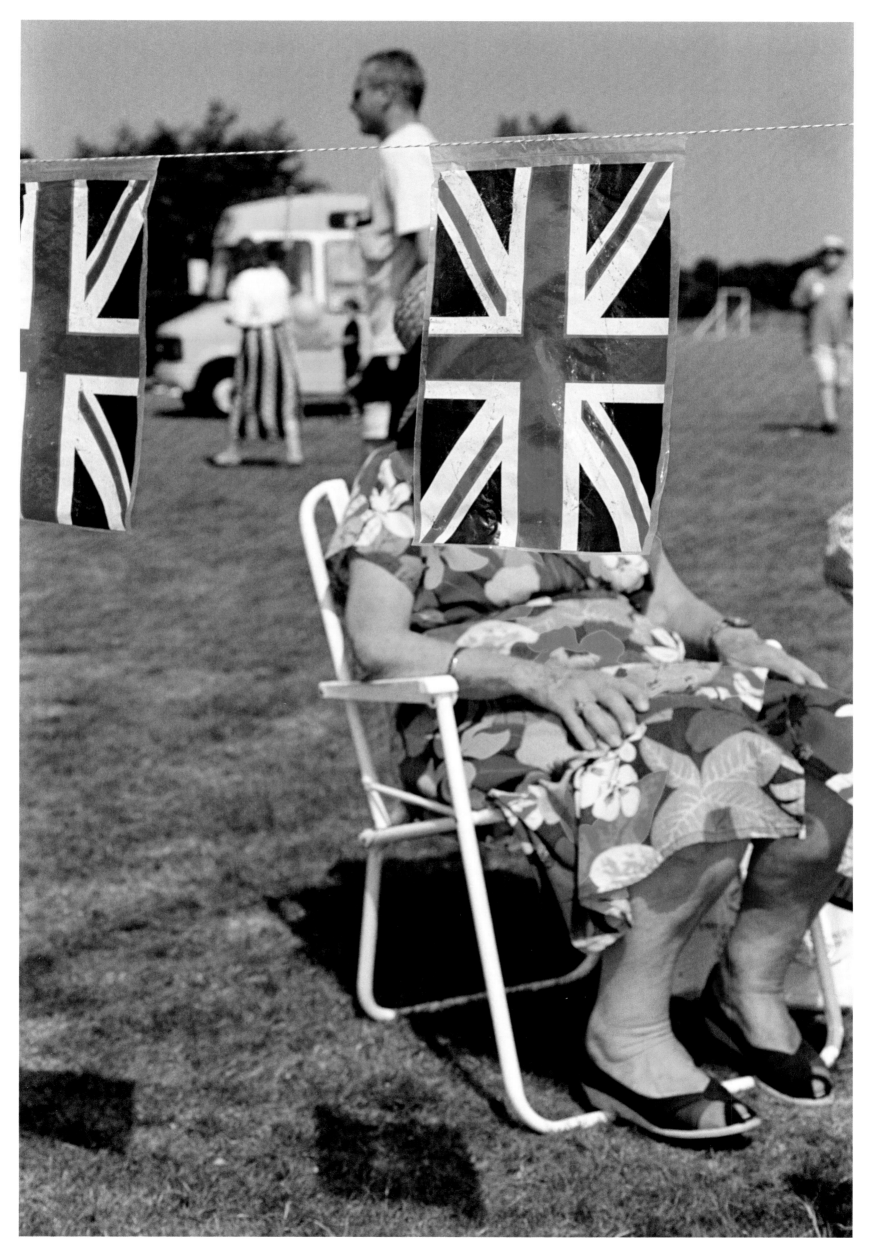

New Brighton, Merseyside, England, 1986
This man and woman have spent a lifetime together, but are united only by
an empty table whose lonesome flatware awaits the missing plates. The wall
of silence is still intact and their eyes avoid one another, looking for a horizon
to hold onto.

The color, predominantly soft tones fading into darkness at the edge of the
image, builds a space and atmosphere. It also hints at how reality often has
its own mysterious, unfathomable yet highly significant zones.

Benidorm, Spain, 1997
Age does not a wise woman make. Here Martin Parr's merciless gaze catches an unwitting, wealthy matron basking in her tan skin, her lipstick smudged across her wrinkles, her eyebrows drawn on and her gold bracelet glimmering in the rays of vulgarity.

Parr focuses on the particular, shows every detail, and gets so close as to expose the pores of her skin, reddened by the sun.

Self-Portrait

Martin Parr was born in Epsom, Surrey, on May 24, 1952. His passion for photography came from his paternal grandfather, George Parr, who was a fan of pictorialism and its elaborate techniques. From 1970 to 1973 Parr studied photography at Manchester Polytechnic. Throughout the early 1970s photography was in vogue in England, and the first major exhibitions of work by Lee Friedlander, Diane Arbus, Garry Winogrand, Bruce Davidson, Walker Evans, and other artists—all of whom greatly influenced Parr—were mounted. The Photographers' Gallery also opened in London, and introduced other important American photographers to the British public. In the early 1980s Parr photographed in black-and-white, and collected that work in three key books, *Calderdale Photographs*, *Bad Weather*, and *A Fair Day: Photographs from the West of Ireland*. 1986 was a turning point: he switched to color and published the book *The Last Resort: Photographs of New Brighton*, a seaside town close to Liverpool. His lens focused on the decline of an old resort town and the squalor of the new vacationers, who "appear fat, simple, styleless, tediously conformist and unable to assert any individual identity," to quote David Lee's review of it in *Arts Review*. "Only babies and children," he goes on, "survive ridicule and it is their inclusion in many pictures which gives Parr's acerbic vision of hopelessness its poetic touch."

No one had ever photographed the working class with such realism and cynicism, exposing its aspirations and its horizons, narrowed from bearing the brunt of Thatcher's recession. The book met with extreme reactions, but it was clear to everyone, both detractors and fans, that Parr had created a new type of social investigation. If the style was in tune with British humor and its corrosive acidity, the themes he tackled were much broader, and touched on the realities of globalization, consumerism, national identity, and cultural clichés. Each subsequent book added a tile to this merciless mosaic: *The Cost of Living*, from 1989, was dedicated to the social rituals of the British middle class; *Bored Couples*, from 1993, paid tribute to the ground zero of every love affair; *Signs of the Times*, from 1992, was an interior investigation of British domestic styles; and *Home and Abroad*, from 1994, was an early look at mass tourism.

In 1994, Martin Parr joined Magnum, scraping through by a single vote. Philip Jones Griffiths accused him of betraying the agency's humanist calling. In 1999 Parr published one of his most important books, *Common Sense*. It had no introduction and no captions, only pictures, confirming the visual strength of the material depicting a vulgar, bulimic world on overdose, as rotten as the leftovers it tosses away after each binge. According to Val Williams, "*Common Sense* is like a dictionary of sins, a malodorous concoction of the sugary, rotting and fascinating detritus of the Western world." It is a collection of horrors that Martin Parr, a tireless souvenir collector, sets on the shelf alongside the many other books that gave rise to yet another extraordinary book, *The Photobook: A History*. His publishing and curatorial pursuits continued with other important assignments. In 2004 Parr was director of the Rencontres d'Arles, and in 2007 he mounted the exhibition *Colour Before Color*, at the Hasted Hunt Gallery in New York, dedicated to European photographers like Luigi Ghirri who, from the 1970s onward, explored the expressive possibilities of color. In 2007 Parr won the Erich Salomon award. In addition to photography, he also directs radio shows as well as films and documentaries for television.

"PART OF THE ROLE OF PHOTOGRAPHY IS TO EXAGGERATE. MOST OF THE PHOTOGRAPHS IN YOUR PAPER, UNLESS THEY ARE HARD NEWS, ARE LIES. FASHION PICTURES SHOW PEOPLE LOOKING GLAMOROUS. TRAVEL PICTURES SHOW A PLACE LOOKING AT ITS BEST, NOTHING TO DO WITH THE REALITY. IN THE COOKERY PAGES, THE FOOD ALWAYS LOOKS AMAZING, RIGHT? MOST OF THE PICTURES WE CONSUME ARE PROPAGANDA."

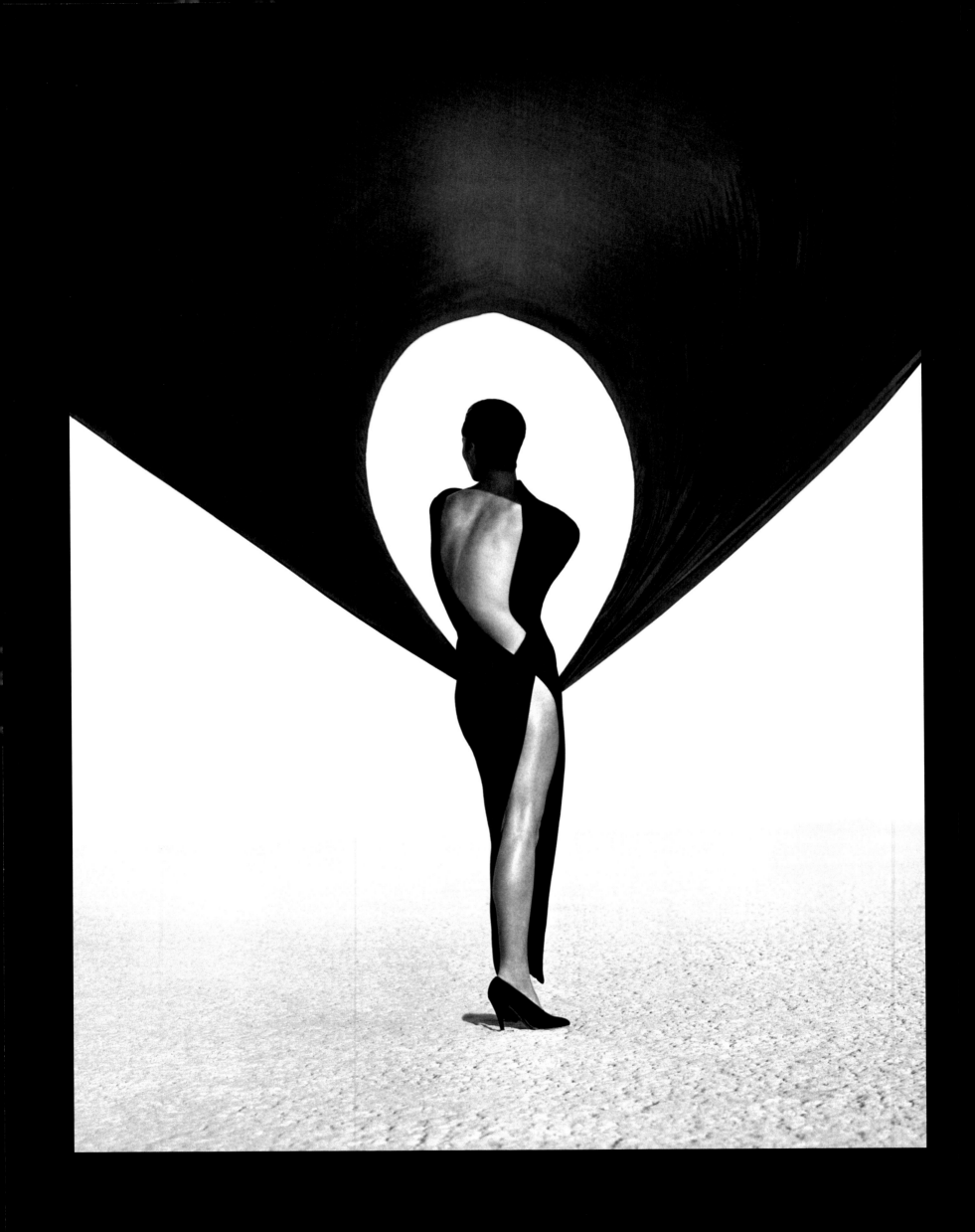

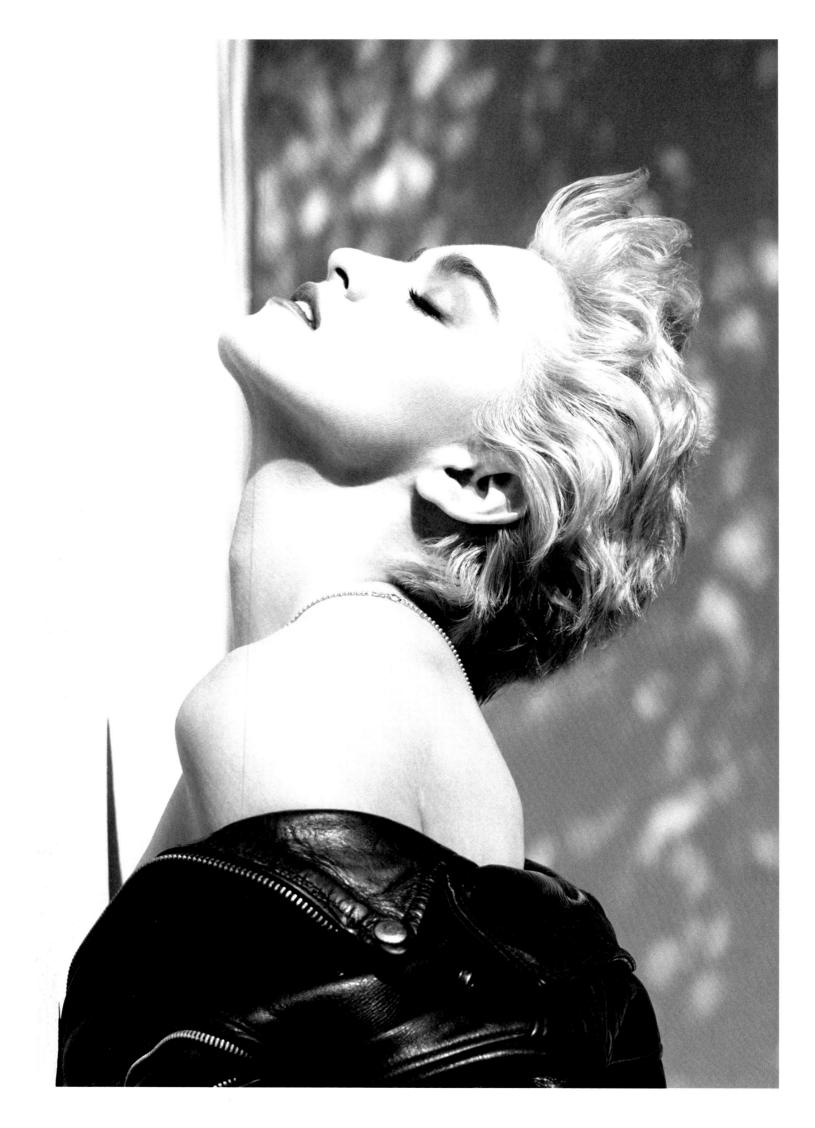

Page 382
Versace Dress, Back View, El Mirage, California, 1990
"A shadow, such as that produced by a mask or a veil, which has the double status of making us see that which reveals itself by veiling itself, and of seeing that which veils itself by revealing itself, shows the illusion of appearances and denounces that which is false or untrue. It is an aspect of creation that is truly photographic in nature, and which shows that Ritts's images, despite being just images, can be read on many levels, because there are always at least two pieces of information, with opposite meanings, that reinforce the impact."

Patrick Roegiers

Above
Madonna, Hollywood, 1986
"I think that with her, and with other people as well, the big word is trust. A person feels they can trust you because they know your reputation and what you're about. Or they can feel it because over the years a tight relationship develops, as it did with Madonna. You work together and it clicks; you evolve."

HERB RITTS

United States, 1978. A group of young men leave by car for the California desert. One of them is an aspiring actor, beautiful and brazen, his body sculpted with muscles. Another is an aspiring photographer, uncertain of his future.

They get a flat tire and stop at a gas station in San Bernardino. The photographer starts to take a series of photos of the actor. He puts him in different positions, "as if he were a hero in a Paul Strand movie," working out sensual poses, with jeans and an undershirt, and cars, gas pumps, and the desert for a background. The actor is Richard Gere, the photographer Herb Ritts, and some few months later those photos would consecrate the myth of Gere as young, sexy, and "angry," and of Ritts as a rising star of photography.

The son of a well-to-do furniture manufacturer, Ritts had a quiet childhood, sunny and peaceful, in Brentwood, an upper-middle-class neighborhood in Los Angeles. He studied economics in college but also took courses in art history. He had a great desire—a hunger, almost—to experience and to learn, to study and to fill in the gaps in a California that had much natural beauty but little by way of an artistic tradition. After finishing his studies, Ritts worked in the family business, taking photos in his spare time. He met Gere through a mutual friend, and that was the chance beginning of the photos that would soon appear on the covers of *Vogue, Esquire*, and *Mademoiselle*. Ritts became the photographer of Versace and Ferré, of portraits that appeared on the covers of the major women's magazines, of sculpted bodies, and of impalpable clothes that billowed in the desert wind.

He would become the photographer of very beautiful fashion models (as if no one else before him had known how to photograph them) who were goddesses in a pantheon where physical perfection had become something new, an icy-cold distance created by the giddy height of high heels, the length of a leg, the perfection of a body, a distant gaze.

But it would be a great mistake to think of Ritts as a photographer who worked only by instinct and charm in the sun and on the beaches of California, on the rolling waves of a glamour made glossy by the tabloids. Few artists are such refined chiselers of images, such exacting builders, restless in their own way, of new classic icons. Ritts chose photography as a vocation and out of curiosity, as a means of reflecting on the creations of the past and on the great visions of those artists who shared his sensibility, from Man Ray to Herbert List, and the great Horst P. Horst. He did not belong to any school of photography, and his true apprenticeship was a continuous exercise in observation and production. His reputation grew and became established quickly. He invented various formal solutions, understood beauty, admired genius, and observed the work of esteemed colleagues such as Bruce Weber, Peter Lindbergh, and Steven Meisel. Along with the important jobs that he received on commission, which came to him from all parts of the world, the publicity shots and the music videos that he produced as a director, he always tried to pursue his own personal research and inquiries, aware that the creation of a personal language is the only way for an artist to avoid burnout and being forgotten after just one season.

Even if Ritts would always admit that he knew little about technique, he would claim for himself a style that he pursued and cultivated with a telling constancy. "Within two hours of where I live, you have mountains and desert as location. I like the natural elements that abstract into light, texture, shape, and shadow. With everything depending on the subject in front of you, it's essential to have all these givens to create the image and the moment; and I feel that when I'm in that kind of environment. I feel trapped if it's a rainy, cold day inside a studio; that isn't me. I can still make a picture, but I know when I feel my best. Once you develop your own style, you know when you're able to give your best. Feeling at home is part of it, and I don't think that's an L.A. thing. It's a matter of the environment and of what affects you."

His compositions remain open to the magic of the moment, the possibility of something unexpected, a glance, or some amusing aspect that changes the way a photo is seen. Ritts's portraits are exemplary in this regard. "For me, a portrait is something from which you feel the person, their inner quality, what it is that makes them who they are." In front of his lens, the great names of theater and culture become timeless heroes, afflicted divinities, as in the portraits of Elizabeth Taylor undergoing a brain operation and Christopher Reeve immobilized in a wheelchair, or rather a sculptural stylization that reveals their personality and true nature.

Ritts loved beauty, in all its forms, and this love shines through in all the images he has left us. He loved the sun and the sky, the harmony of bodies and of forms. He loved to create compositions in which there was a balance of forces and volumes, silhouetted against empty skies and land that stretched out to the horizon, as if nature, for a brief moment, had decided to withdraw and offer a truce, a long breath in which to sing a hymn in praise of the beauty of a group of bodies, or to admire the fabulous, sinuous bliss of a silk that rustles in the wind.

Versace, Veiled Dress, El Mirage, California, 1990

The high heels don't sink into the desert sand but leave only a slight, single shadow on the ground, the sole proof we have that the figure in profile, wrapped in a great black dress made of layers of veils, is real, and not just the product of our imagination, an unexpected and overwhelming apparition, achieved by means of a strange process of developing and printing applied to the emulsion side of the photograph.

Everything is basic, obvious, yet also hinted at, imposing yet discreet in the play of a black and white that stylizes, designs, and evokes. In this image, among Ritts's most famous, the preferred elements of his creations are all here: continuous play amid an extreme of artifice, a Versace dress of which one can sense the silky softness and the sought-after workmanship, and the natural elements—the air that envelops everything, the sandy soil in the foreground, a mountain that loses itself far off in a cloudless sky, the wind that ruffles the dress. Ritts's strength, and the goal he set himself, was to have succeeded in photographing whatever was impalpable, mutable, and as fundamental as the atmosphere itself.

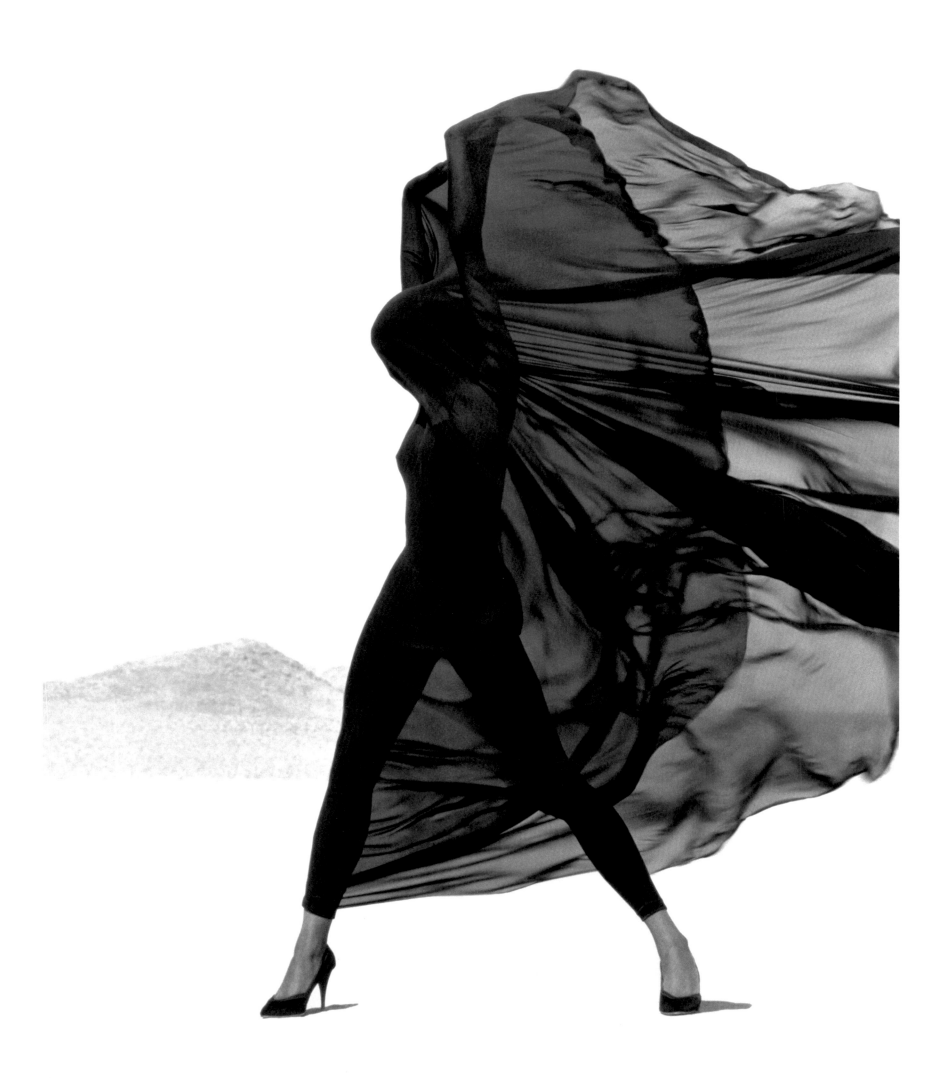

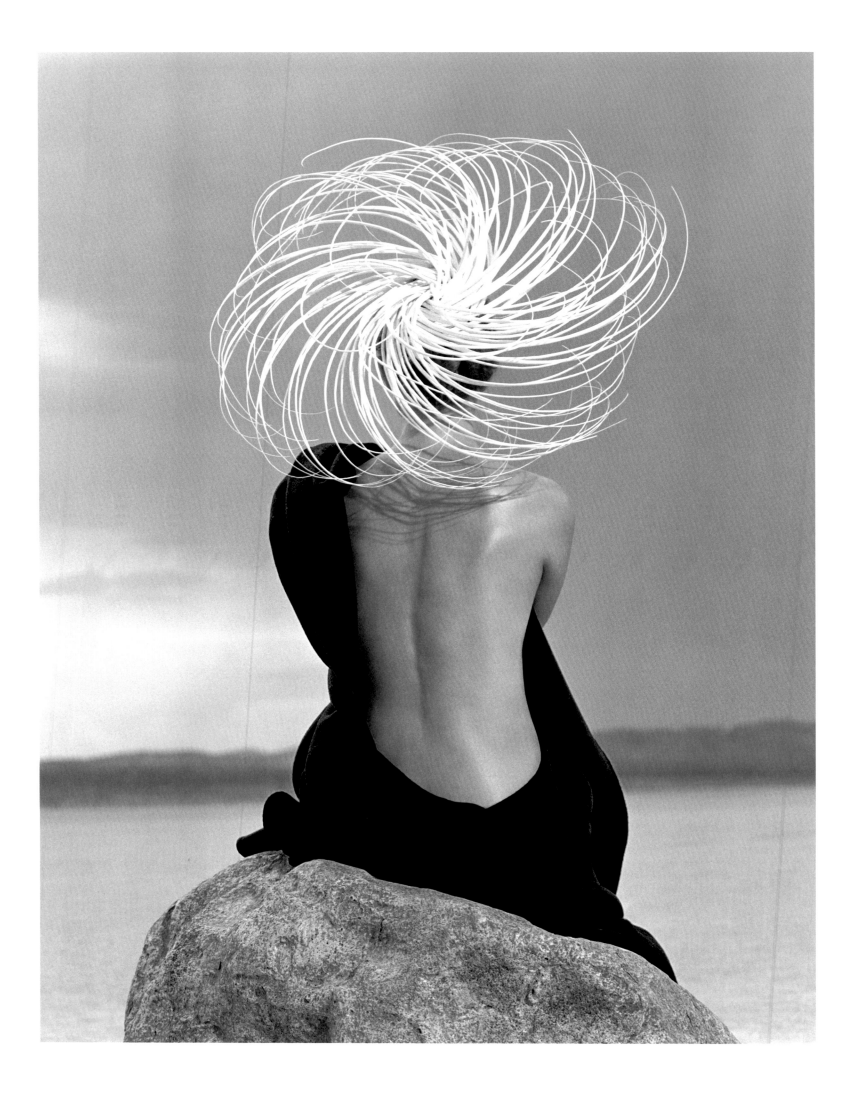

Zen Story, El Mirage, California, 1999

In the photos of Herb Ritts the body is observed, studied in its power and beauty, and exalted in its fragility and elasticity.

"The sculptural plasticity of the bodies is, in its stylization, subject to a will that is mannerist in nature, one that finds its perfect form in the profile. But it is also there in the nape of the neck and the back—not visible by the subject—the most fragile parts of the individual framed by Ritts, unlike those bodies of flesh and sweat, such as the marble models of Canova, who molded the very souls of his statues. He molded them with honey, beeswax, and well water, spread by him with earth, soot, sand, and grease from his workshop."

Patrick Roegiers

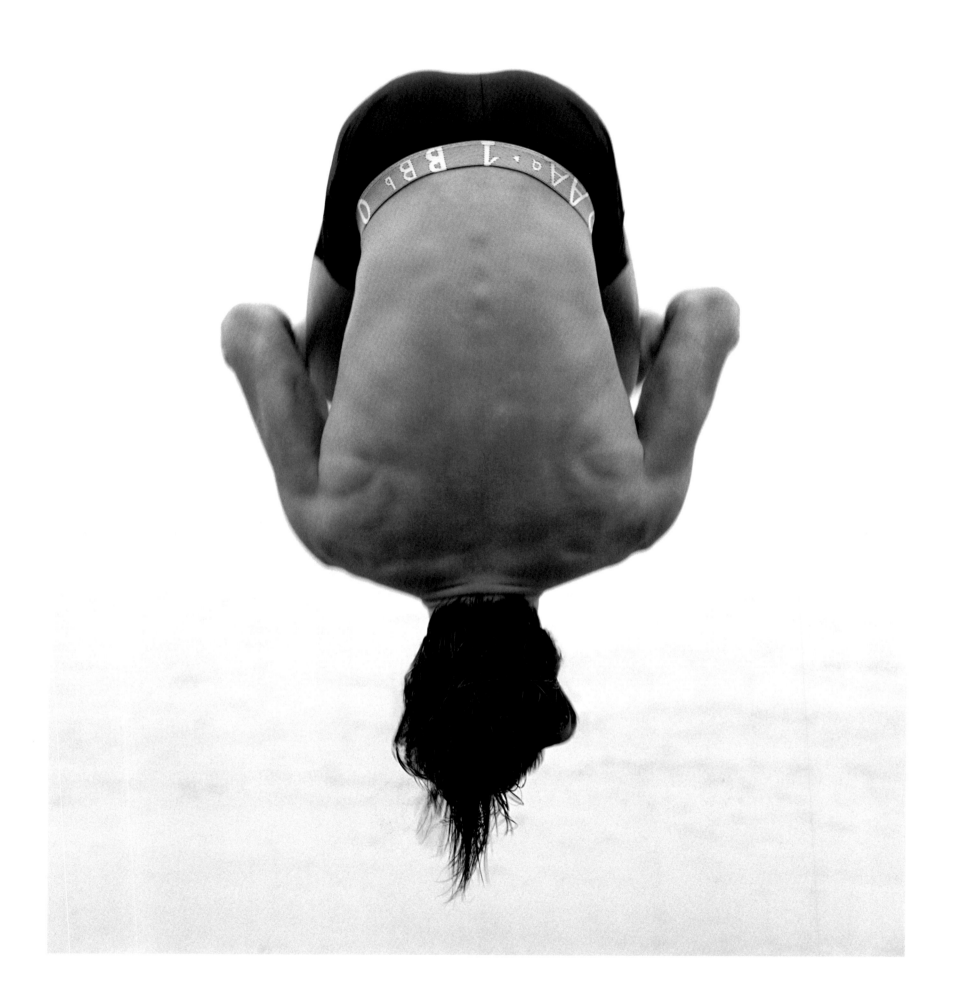

Backflip, Paradise Cove, California, 1987
The background practically doesn't exist in Herb Ritts's photos. Everything depends on the absolute blacks and whites and on the evocative power of a shadow that flickers on the surface of a dress or on the taut muscles of someone in the act of jumping.

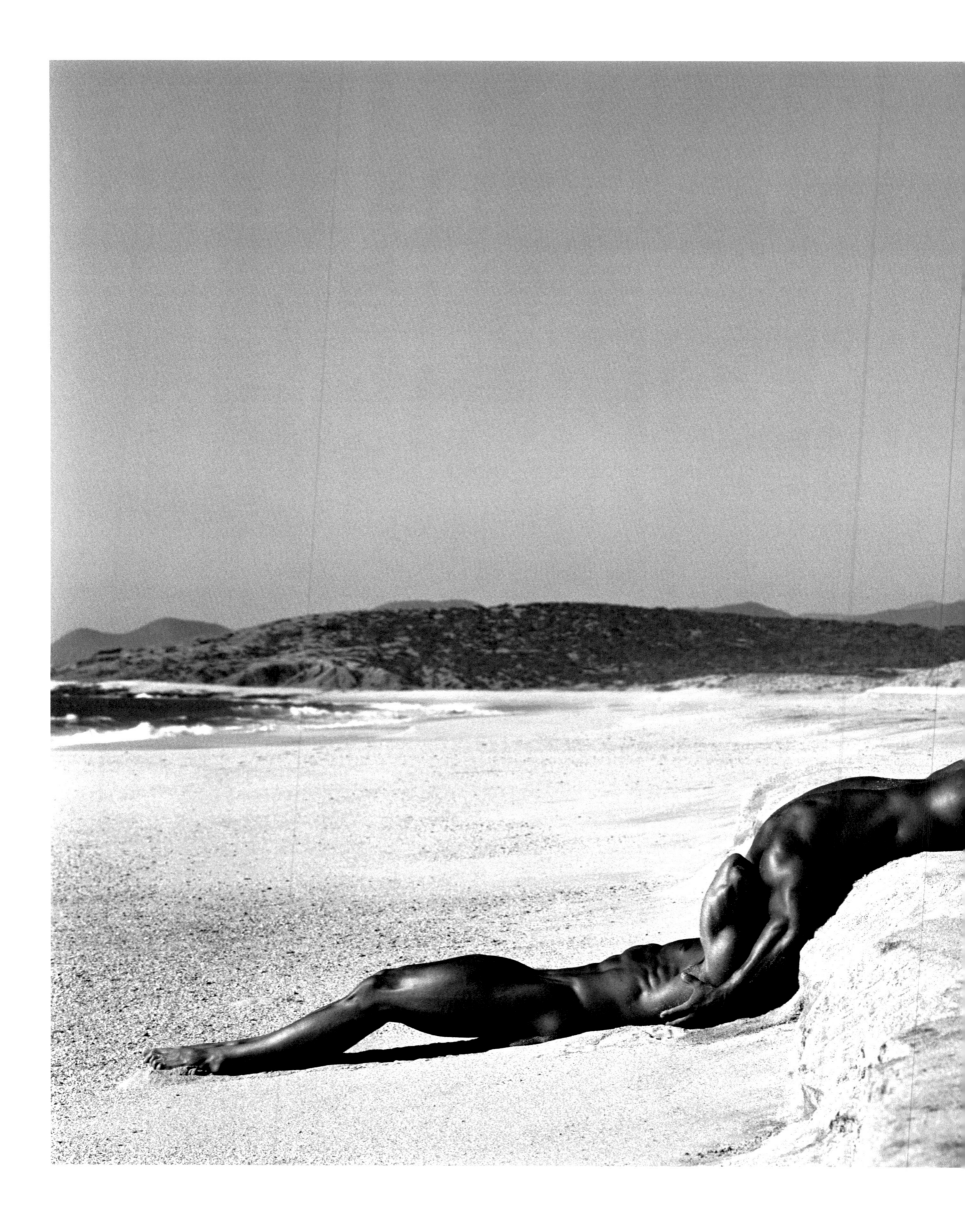

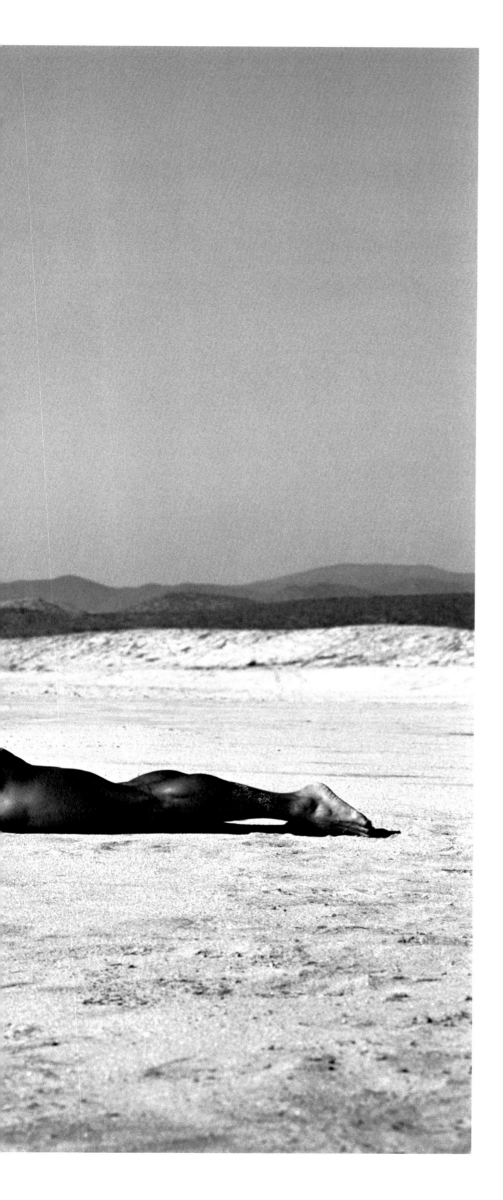

Duo I, Mexico, 1990
"Coming from California and growing up where I did, I've always had a fondness for and innate sensitivity to light, texture, and warmth. I abstract it in my photographs: I like large planes and spaces, areas of texture and light, like deserts or oceans or monumental places."

"I THINK A LOT OF THE TIME THESE DAYS PEOPLE ARE SO CONCERNED ABOUT HAVING THE RIGHT CAMERA AND THE RIGHT FILM AND THE RIGHT LENSES AND ALL THE SPECIAL EFFECTS THAT GO ALONG WITH IT, EVEN THE COMPUTER, THAT THEY'RE MISSING THE KEY ELEMENT. THAT ELEMENT IS DEVELOPING A STYLE THAT'S YOURS AND EXPERIMENTING WITH IT UNTIL YOU EVENTUALLY DISCOVER WHAT MAKES SENSE TO YOU ESPECIALLY."

Alek Wek, Los Angeles, 1998

An unknown being, newly arrived on earth from a far-off place, an unknown past, perhaps an uncertain future. The marvelous Alek Wek, a Sudanese model, one of the most fascinating of all, lends her black and perfect body to a thrilling metamorphosis and transforms herself into the queen of a parallel planet, as in a *Flash Gordon* adventure, portrayed in all her majesty.

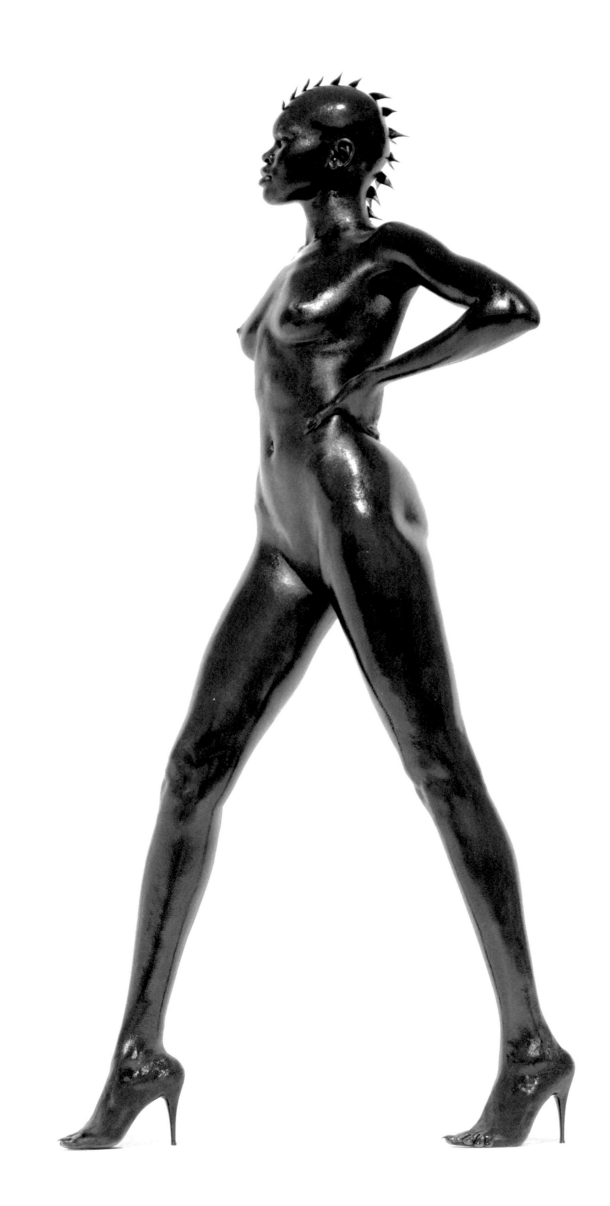

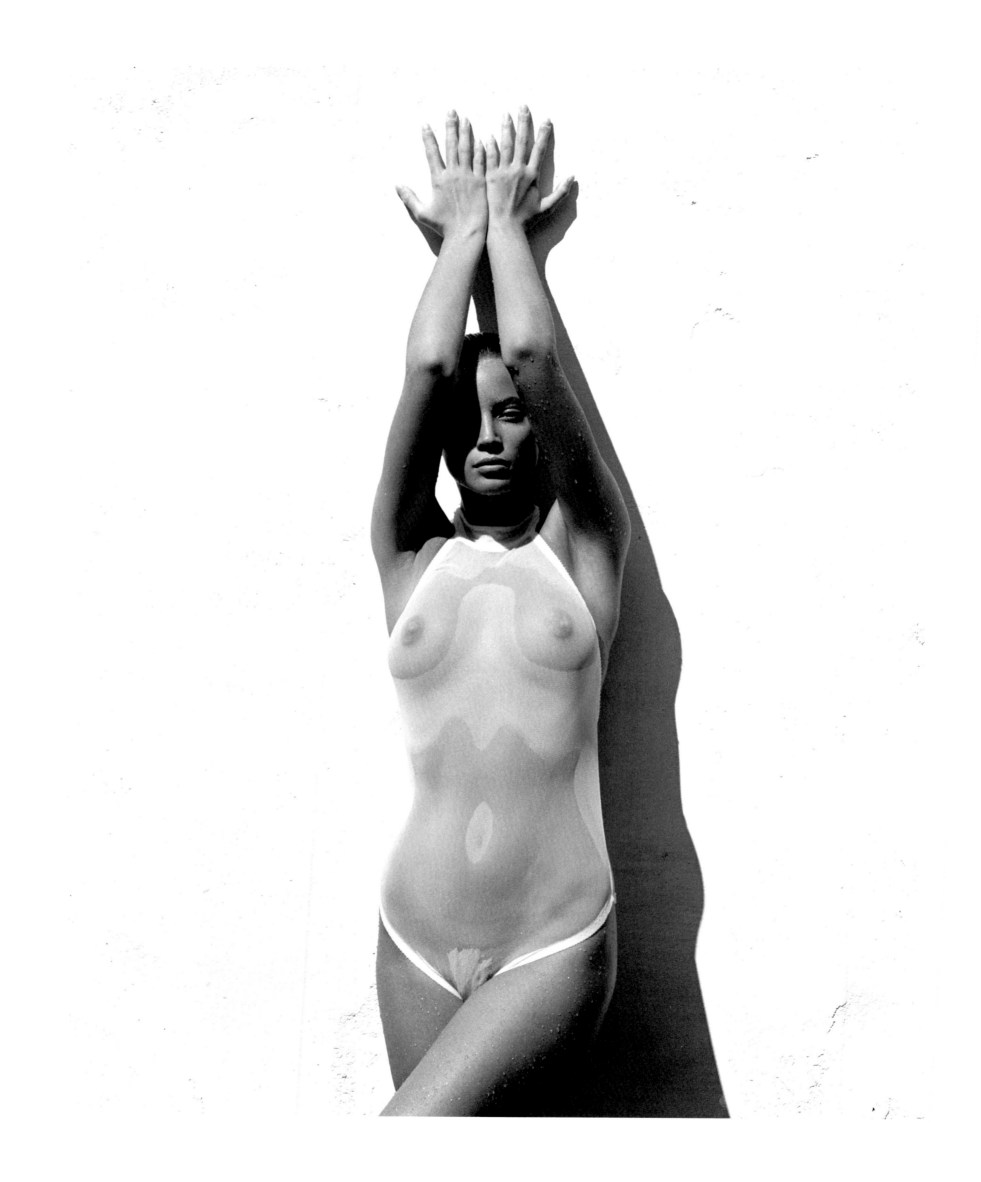

Christy Turlington in White, Hollywood, 1990
Herb Ritts always alternated work on commission with his own personal projects. One supported the other in daily life, and if the commission work set new challenges, the personal projects provided time for reflection and experimentation.

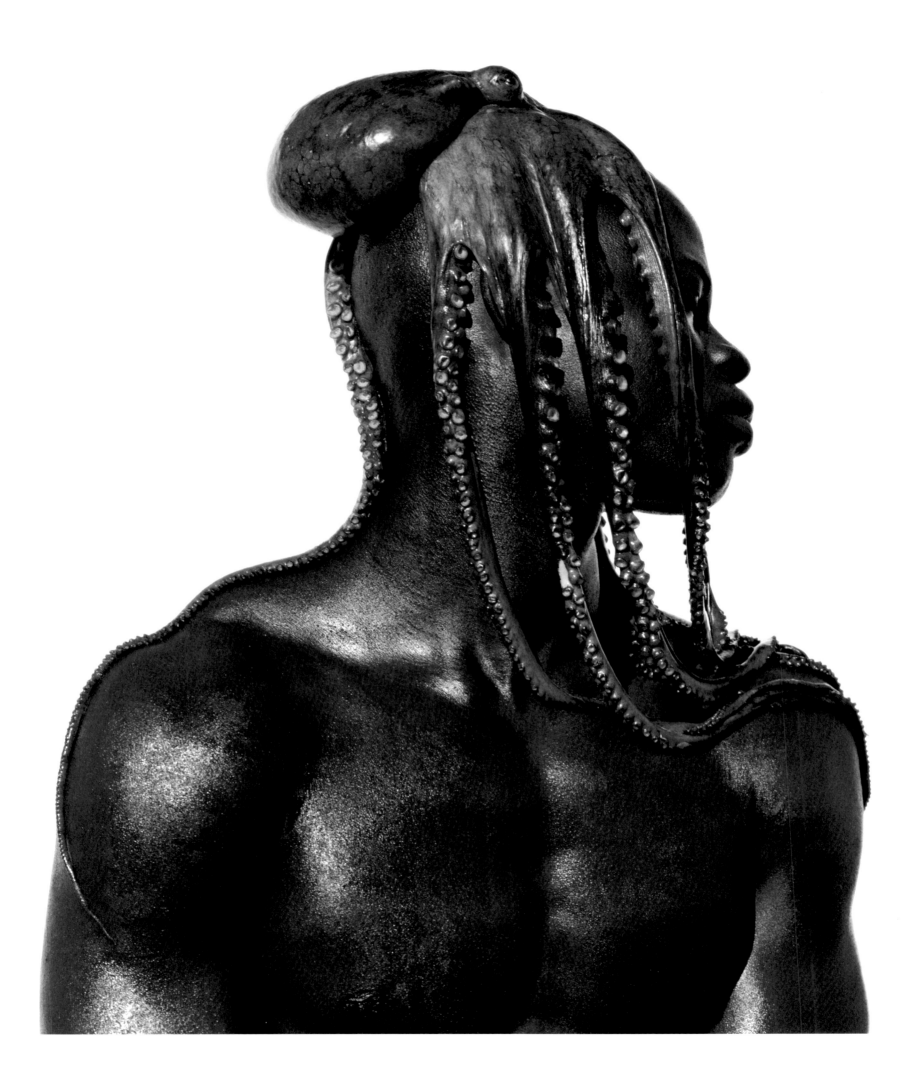

Djimon with Octopus, Hollywood, 1989
The strange and the fantastic were elements used by Ritts and ones with
which he played in a masterly way, at times giving form, as in this famous
photo, to a series of obsessions and little nightmares.

Jackie Joyner-Kersee, Point Dume, California, 1987
For more than a century and a half, photographers have asked themselves
how it might be possible, in a moment, in a fraction of a second, to freeze
motion. In his photos of jumps and leaps by athletes and ballet dancers, Ritts
reworks the lessons learned from the great masters of the past, beginning
with Martin Munkácsi.

Jump, Paradise Cove, California, 1987

"I started to do things for myself on certain days. That's when I started to develop my own style. I exposed myself to museums. I suddenly saw, for instance, the vision of a Man Ray, discovered more and more the history of photography. It put things in perspective. But it was at least four years or more before I started feeling a sense of my own style."

"AS I SEE IT, MY STYLE HAS SOMETHING ... SENSUAL. MY PHOTOGRAPHS ARE EROTIC IN A MORE APPROACHABLE WAY, RATHER THAN HARD-EDGED. IN SOME WAYS MY PICTURES ARE EROTIC, BUT I WOULD SAY, THERE'S MORE OF A SENSUALITY COEXISTING WITH EROTICISM."

Stephanie, Cindy, Christy, Tatjana, Naomi, Hollywood, 1989
"Still, I enjoy shooting women as feminine objects. There's a sensitivity to the photographs. Many times they're stripped down to the elements, as in the picture of the five models together. . . . I enjoy women being women in my way, and they're still feminine."

Pierre and Yuri, Los Angeles, 1999
A separate chapter in Ritts's work is his investigation of the male nude and the possible complementarity of forms and sculptural poses that two same-sex bodies can succeed in creating. The homosexuality proclaimed by Ritts is experienced, in these images, in a manner that is never forced, but is instead open, radiant, and rich.

Waterfall, Woman with Sphere, Hollywood, 1989
"I love to photograph certain people when I know there's going to be an energy between us, when I know they have something to give me. That's the importance of the subject. I remember Helmut Newton telling me whom you're shooting is ninety-five percent of the picture."

Tina Turner, Los Angeles, 1993
"I like photographing troupers, people who have been in the trenches, who have survived. Women like Elizabeth Taylor, Tina Turner—those types who've had careers in the business and are still going. . . . Tina's still onstage at sixty. I enjoy working with people like that the most, by far. . . . It's what's inside that you project outwardly."

Self-Portrait

Herb Ritts was born in Los Angeles on August 13, 1952 into a family that owned a furniture-manufacturing business. He studied art and tried to establish himself in the world of music.

In 1974 he graduated from Bard College in New York, where he took courses in economics and art history. He later returned to Los Angeles and worked in the family business. "I always enjoyed art history because, growing up in California, my exposure was limited, and it was a new experience. To learn the history of art opened up certain things to me, made me see. It intrigued me."

Ritts began his career as a photographer in the late 1970s. At first, he took informal portraits of friends, many of whom worked in the film industry, until he was able to gain a reputation as a skilled portraitist of artists, athletes, politicians, musicians, and fashion personalities. The photos that brought him to the attention of the general public were the first shots, taken almost by chance, of a relatively unknown Richard Gere, which in a short time were published all over the world. "One day soon thereafter, *Mademoiselle* tracked me down and asked me to do Brooke Shields, and I said sure. I didn't say I wasn't a photographer." One of his first assignments took him to the set of Franco Zeffirelli's film *The Champ.* Not long after, Andy Warhol asked him to be a photographer for his magazine *Interview.* The model Matt Collins, a friend, introduced him to the photographer Bruce Weber, who in those years was revolutionizing the male image in men's monthly magazines such as *GQ.* In the 1980s and 1990s Ritts worked for *Harper's Bazaar, Rolling Stone, Vanity Fair,* and *Vogue.* For each subject he would find a special way to immortalize a revealing gesture or unique glance that would emphasize the character and role of a public personality. This was how he produced, among others, portraits of Kofi Annan, Cindy Crawford, the Dalai Lama, Madonna, Jack Nicholson, and Elizabeth Taylor. The relationship with Madonna continued for a long time and would produce, with the complicity of the photographer, some of the most successful "transformations" in the career of the multiform diva. From the cover image of *True Blue* to the sneer on her face in her "cabaret" costume, or with the ears of an improbable Minnie Mouse: "She's the subject that I've been in front of maybe more than anybody else, and it's interesting that, over the course of perhaps fifteen years, I've seen her consistently grow as a person. And I'm changing as well.... But as we evolved, we were more open to experimenting in new ways. She's agreed to let me show a picture of her and her baby, taken several weeks after Lourdes's birth." Besides his work for newspapers, and his publicity work (the campaigns for Giorgio Armani, Chanel, Donna Karan, Gianni Versace, Calvin Klein, and Polo Ralph Lauren, among others, are especially memorable), Ritts repeatedly tried his hand at directing commercials and music videos. Among these were "Make a move on me" by Olivia Newton-John, "Cherish" by Madonna, "Love will never do with you" by Janet Jackson, and "Don't let me be the last to know" by Britney Spears.

Besides the portraits and his work on fashion campaigns, Ritts always carried out very precise and elaborate visual research. His stylistic hallmarks were a cleanness of line, the power of forms, graphic simplicity, imaginative invention, and a continuous recourse to the great visual and graphic tradition of art history and photography. Many important exhibitions have been dedicated to his work in cities such as Los Angeles, New York, London, Boston, Vienna, Hamburg, Rome, Tokyo, and Milan. Aware of social issues, Ritts was active in charity work and especially in the fight against AIDS. He died in 2002 in Los Angeles from complications linked to pneumonia.

"I'M RECORDING PEOPLE. OFTEN YOU FORGET THAT YOUR PHOTOGRAPHS ARE ACTUALLY RECORDS OF PEOPLE IN THIS PART OF THE CENTURY WHO HAVE HAD AN IMPACT POLITICALLY, AESTHETICALLY, OR SOCIALLY. THAT'S WHAT PHOTOGRAPHY DOES. WHEN YOU LOOK BACK AT PHOTOGRAPHS FROM THE TWENTIES OR THIRTIES, FOR INSTANCE, YOU'RE REMINDED THAT, EVEN AS YOU'RE CLICKING AWAY, DOING HUNDREDS OF ROLLS OF FILM A MONTH, WHAT YOU'RE REALLY DOING EACH TIME YOU SHOOT IS RECORDING SOMETHING. YOU'RE TRYING TO GET TO ONE MOMENT WITH ONE FRAME THAT EVENTUALLY MAY SPEAK FOR YOUR GENERATION."

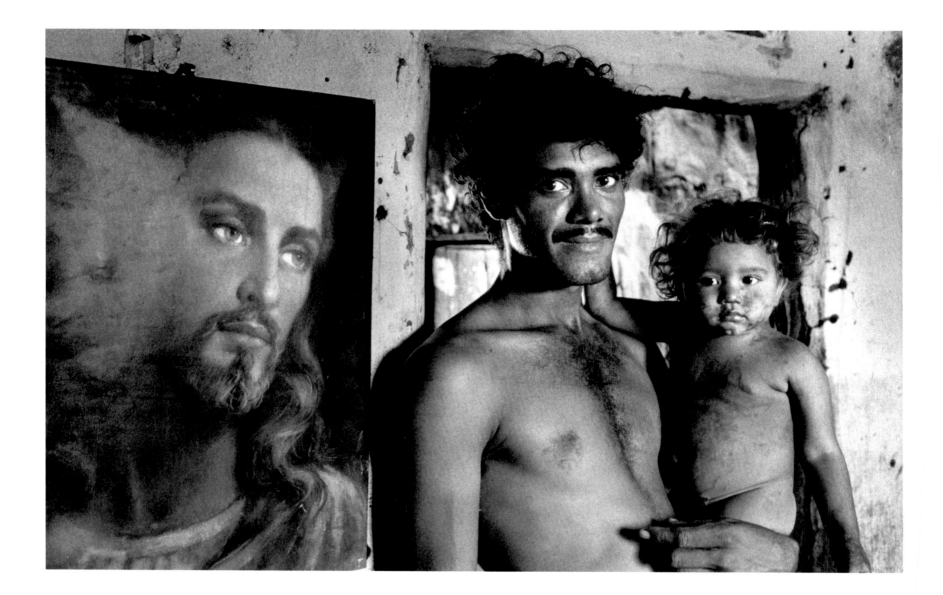

Page 404
Oaxaca, Mexico, 1980
A prayer of thanksgiving to the Mixe god Kioga for a successful harvest and
another year's survival.

Above
Sertão del Ceará, Brazil, 1983
One of Salgado's first works is about his America—or rather the "other
Americas" (the original title was *Otras Américas*), the ones that are not always
seen, and not as well known. In this image, taken inside a house in the
northeastern Brazilian town Ceará, Christ's gaze reveals an intimate kinship
between father and son.

SEBASTIÃO SALGADO

"I am often asked whether my training as an economist has influenced my work as a photographer. I think so, but it is more than that. In reality, I still bring all the baggage of past experiences to what I photograph. My university studies, my work experience, everything has been important.

But it is not just a question of education. Underlying my desires and my ability to work is a strong social motivation. I am from Brazil, a country of striking contrasts and struggles, especially social struggles. I have joined many organizations' battles, and been politically active in Brazil, all of which led me to help change, as much as I could, the reality in which I lived. I went to college, and after graduating I began work as an economist. At some point along the way I discovered photography, and from that moment on I realized you could communicate in other ways, more easily. Everything in my background—my upbringing, my education, my focus on sociology, anthropology, and geopolitics—has seeped into my photography.

From the very beginning, I have pursued different versions of the same story—the story, ultimately, of human evolution seen from our particular historical moment. That is what really interests me: to experience the present day and record it as an eyewitness.

I photograph the same way my country taught me to see. For example, a lot of my shots are backlit. Whatever the situation might be, if I think backlighting would make for greater impact, I do not hesitate to use it. That is a thoroughly Brazilian inheritance. At home, when I was young, eight months of every year brought terrible drought, and the sun beat down strong enough to split stones: that light deeply affected my outlook. As a little boy, when I watched my father come home, his image was almost always backlit; the shadows sheltered him from the blinding glare, as did his hat. "My aesthetic," if you can call it that—the way I see things—still reflects my childhood experiences.

But the rain, too, has had its influence. Every year in my hometown, after the hot and dry season, came the rains, and for three or four months we lived under a heavy, torrential rain. In those months everything was either black or white. I remember seeing skies with white clouds that gradually grew denser, passing through gray into the deepest black. I remember fearfully clinging to my mother during the storms. Those same heavy clouds often appear in my images, and the sky in my photos is the sky of my childhood.

If a young photographer were to ask my advice on becoming a photojournalist, I would say—as I do, in fact, reply—stop, take no pictures for a while, and instead study sociology, anthropology, economics.

When you are able to understand the present, in context, your photographs will relate to reality and history. Then and only then will your photos have no limit. Every photographic work must be seen as part of a process. If you understand all that, then you can travel within that system.

In my images there is always a strong connection between the people portrayed and their environment. People are a part of the environment they live in, part of the community. Sometimes I am asked why I always photograph poor people—but the subjects of my photos are simply people with access to fewer material resources. They are not "poor," they have real dignity, a deep nobility. They are part of a group and maybe they hope—with real determination—to make something of their lives, build a better environment, change things for the better for the social group to which they belong.

I seek out the human in my photos. Beneath it all, you have to understand that reality is made by human beings and that all human beings are the same, regardless of the color of their skin. We are all the same animal, organized into similar communities all around the world.

All conflicts, struggles, and revolutions are related. Good documentary photographs have to be representative, and in order to be representative, the photographer must take a comprehensive, global approach. For me, photography is an act of communication—it is also a political, social, and economic act.

That is what my work is about, my ongoing quest."

SEBASTIÃO SALGADO

First Communion in Juazeiro do Norte, Ceará, Brazil, 1981

As writer and critic Eduardo Galeano wrote of his good friend Salgado, "[He] photographs people. Casual photographers photograph phantoms."

Indeed, like no photographer before him, Salgado photographs people. He loves them, follows them, understands them, is riveted by their eyes, gets lost in their tales, wants to hear their histories, and celebrates them in his intense photographs.

The girls in this image are downtrodden angels, uncertain of their role, of their dress, and of their own growth—their shifting age makes them feel almost out of place. We can only guess at their nonexistent surroundings, and anything we might imagine is all in their eyes.

These girls are a transfiguration of Latin America, the two sides (and ethnic faces) of a continent in search of an economic and racial identity.

Setting all possible metaphorical games aside, they are also (and only) just two small individuals, two little girls Salgado met that day in a small town in northeastern Brazil; he followed and photographed them because he understood the fear, the fragility, the wonder, and the sense of the weight they bear, a weight so hard to sustain.

Galeano was right when he said that: "The picturesque, studiously avoided by Sebastião Salgado, would cushion the violence of his blows and foster the concept of the Third World, as, after all, just 'another' world: a dangerous, lurking world but at the same time *simpático*, a circus of odd little creatures."

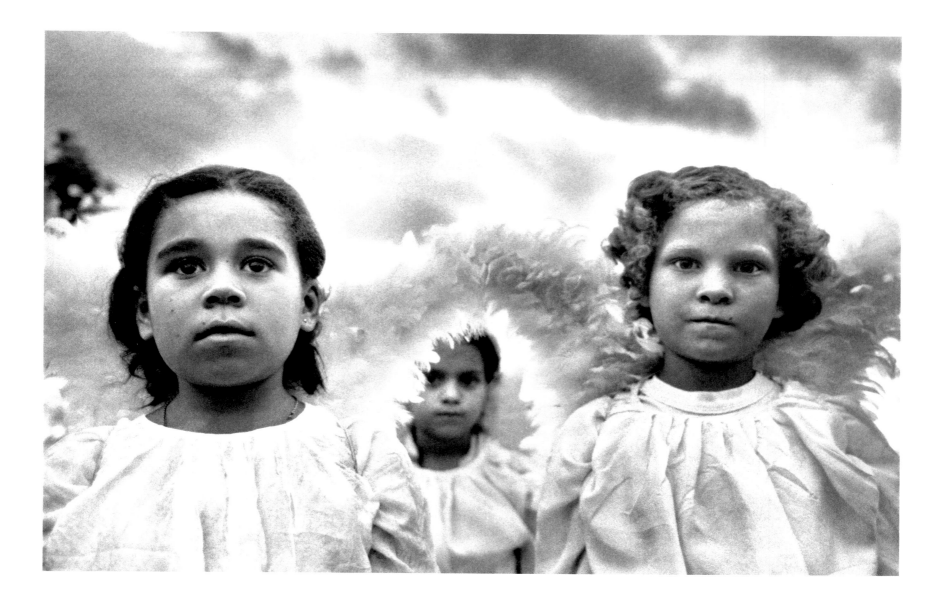

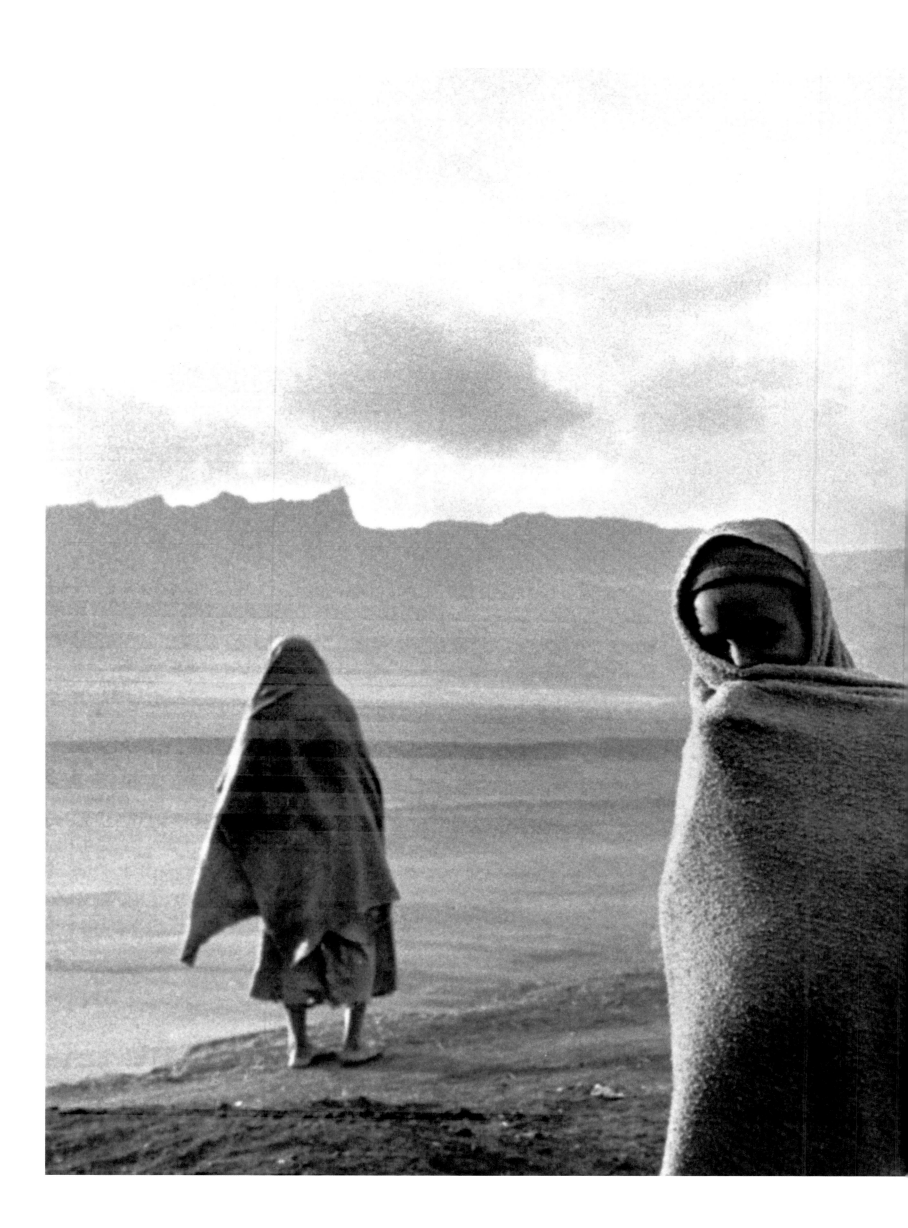

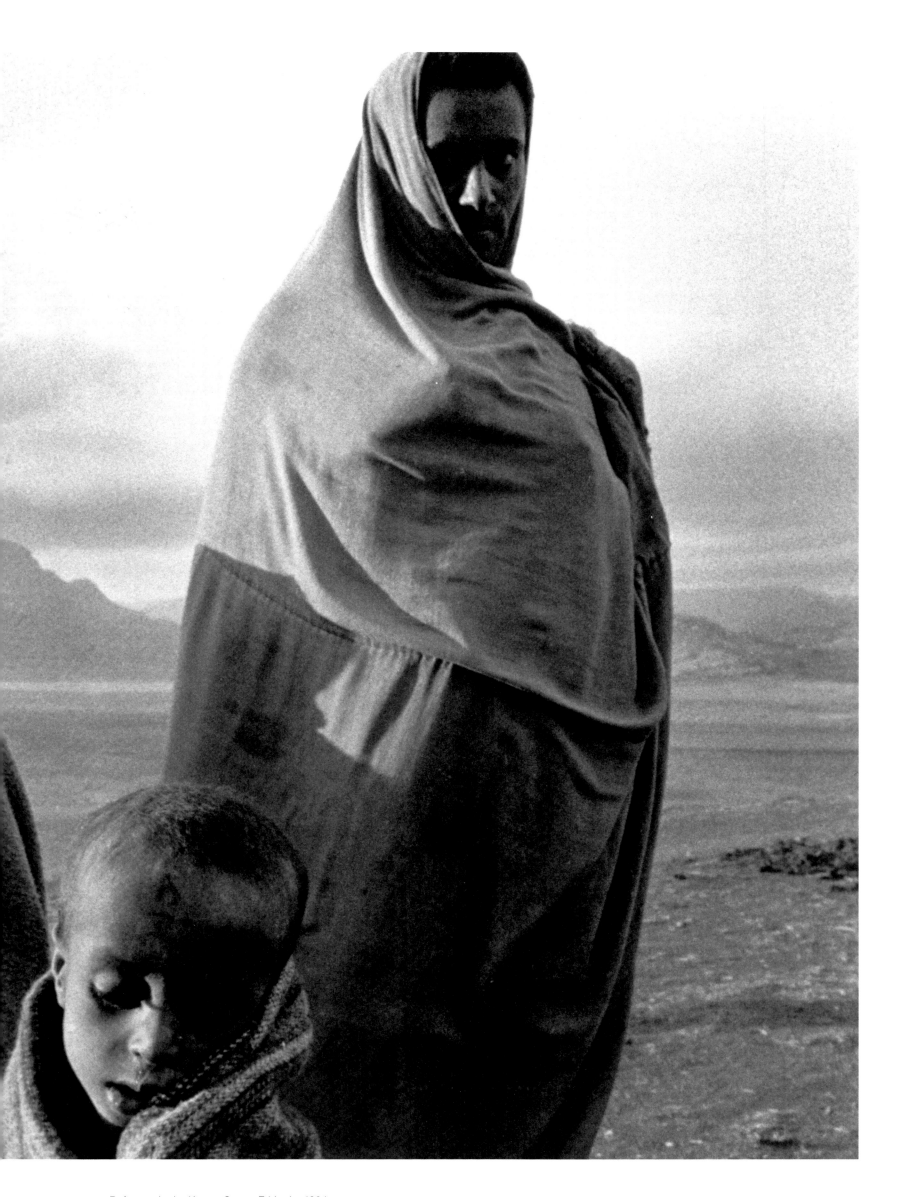

Refugees in the Korem Camp, Ethiopia, 1984
Working in collaboration with Médecins Sans Frontières (Doctors Without Borders), Salgado spent years covering the Sahel's tragic drought, and in 1986 published *Sahel: L'Homme en détresse*, which was published in English in 2004 as *Sahel: The End of the Road*. The sub-Saharan Sahel region encompasses Mali, Sudan, Ethiopia, Niger, Chad, and Burkina Faso (the former Republic of Upper Volta), all of which have low rainfall and few natural resources. The drought that hit the area in the 1980s was one of the harshest and longest, resulting in ten million refuges and an estimated 250,000 deaths.

In this image refugees cover themselves against the cold morning wind as they await aid in the Korem refugee camp.

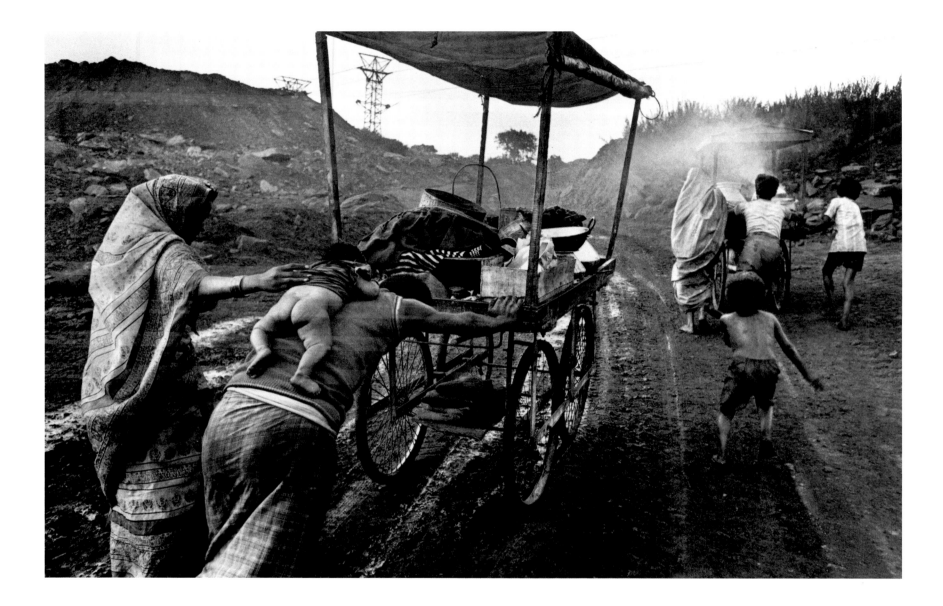

Dhanbad, Bihar, India, 1989

As the beginning of *Workers*, Salgado's photographic elegy to manual labor in an age of technological transformation, states, "These photographs tell the story of an era. The images offer a visual archaeology of a time that history knows as the Industrial Revolution, a time when men and women at work with their hands provided the central axis of the world." The project required vast sociological research before he even picked up a camera to capture the pockets of laborers who still have a close relationship to their own primary means of production. In this photo, taken at sunset near a coal mine in the Indian state of Bihar, an entire family leaves the open-pit mine, pushing the cart on which they bring food to the miners.

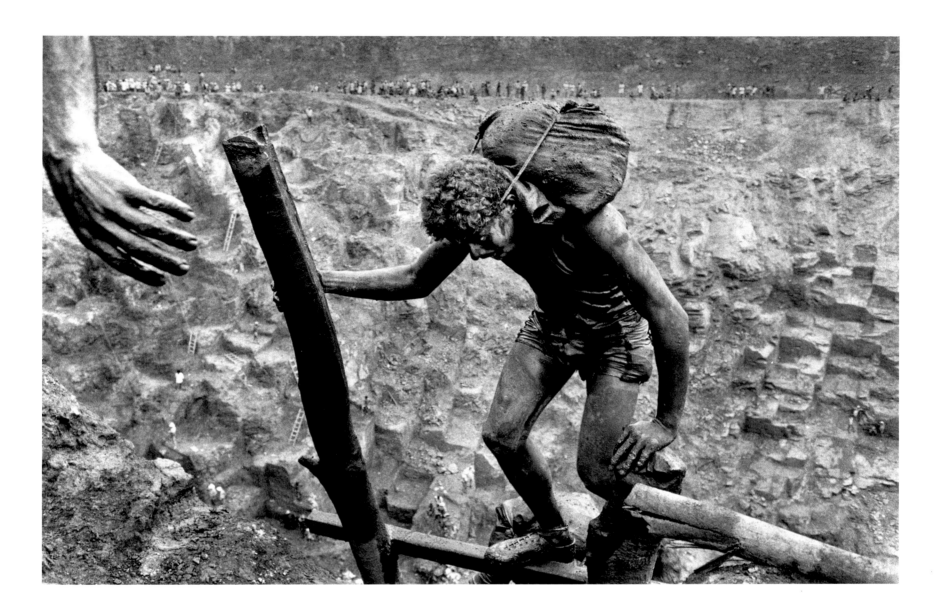

The Serra Pelada Gold Mine, Brazil, 1986
The open-pit mine of Serra Pelada, Brazil, became a major scandal in the 1980s because of the brutal ways in which the work was done. Salgado's photographs show the dramatic human side of the story, and helped bring worldwide attention to the infernal reality of this Dantesque place. "Every time a section finds gold, the men who carry up the loads of mud and earth have, by law, the right to pick one of the sacks they brought out. And inside they may find fortune and freedom. So their lives are a delirious sequence of climbs down into the vast hold and climbs out to the edge of the mine, bearing a sack of earth and the hope of gold."

"SALGADO'S CAMERA REACHES IN TO REVEAL THE LIGHT OF HUMAN LIFE WITH TRAGIC INTENSITY, WITH SAD TENDERNESS. A HAND, OPEN, REACHES OUT FROM NOWHERE TO THE MINER STRUGGLING UP THE SLOPE, FLATTENED BY HIS BURDEN. THE HAND, LIKE THE HAND IN MICHELANGELO'S FRESCO, TOUCHING THE FIRST MAN AND, IN TOUCHING, CREATING HIM. THE MINER ON HIS WAY TO THE TOP OF SERRA PELADA—OR GOLGOTHA— LEANS, RESTING, ON A CROSS."

EDUARDO GALEANO

The Serra Pelada Gold Mine, Brazil, 1986
A full view of the mine.

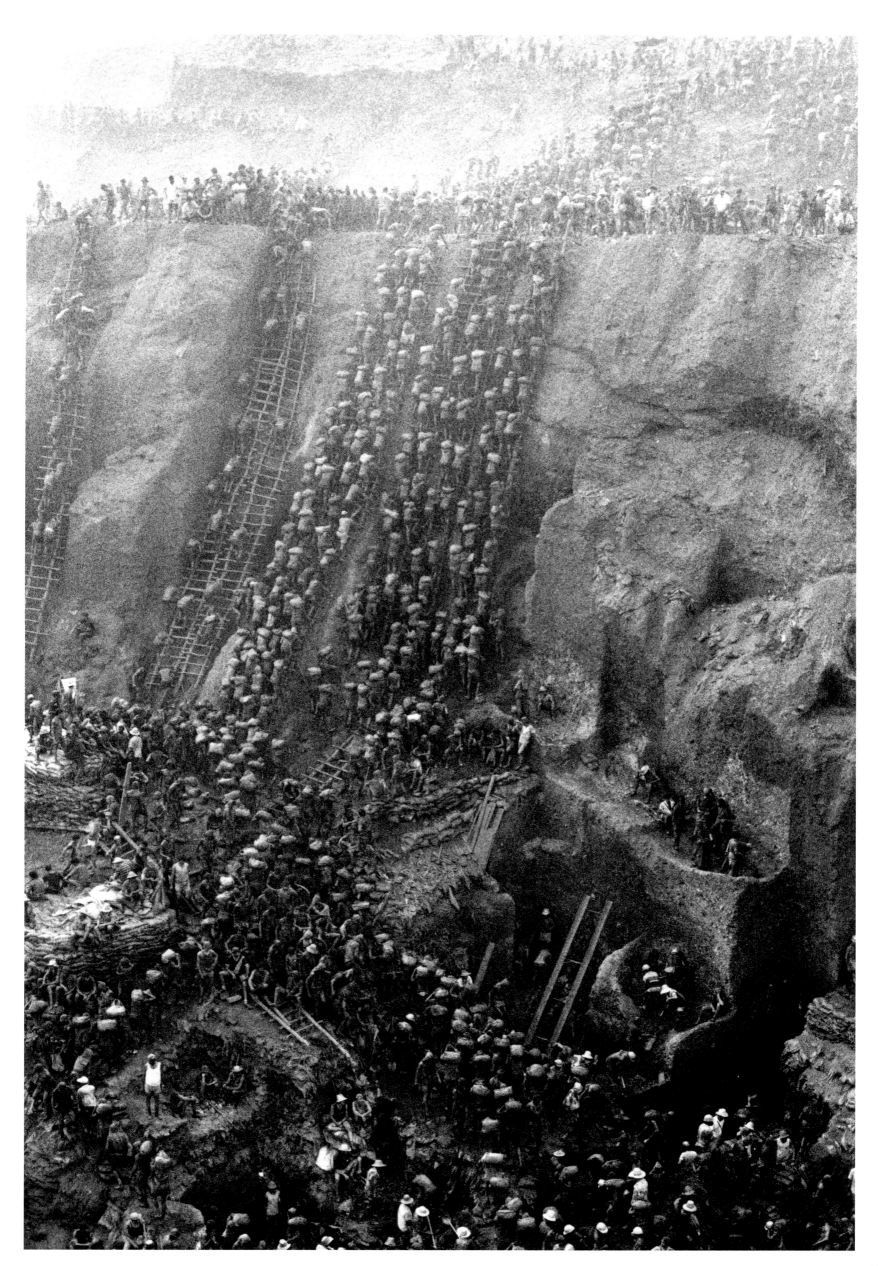

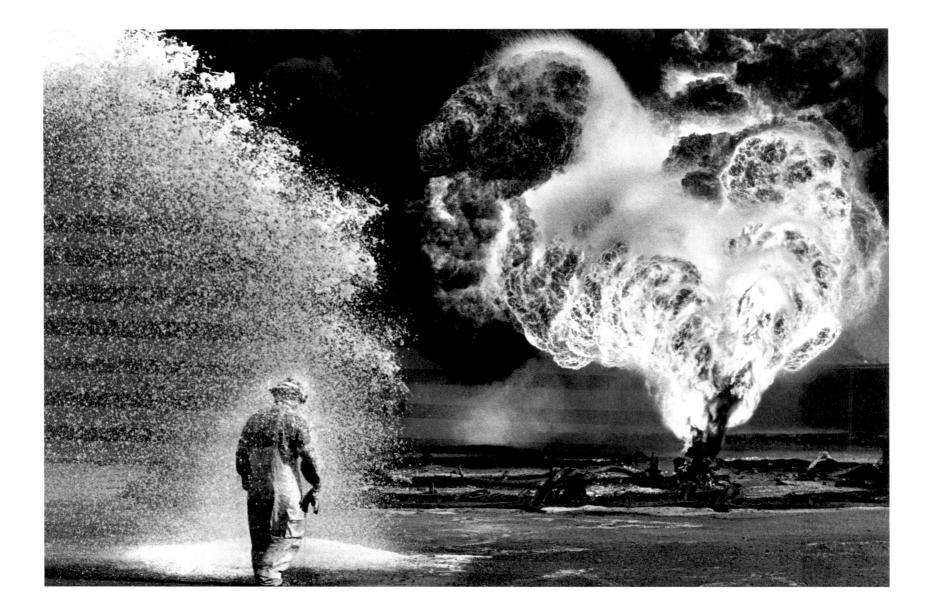

Oil Well, Burhan, Kuwait, 1991

"I went to Kuwait after the war against Iraq, when the oil wells were still burning and flowing out of control. There I lived the apocalypse and saw the black symbol of humanity. The war had ended just thirty days earlier, and the entire region was covered in oil: clouds of burned oil darkening the sky, lakes of oil polluting the land. For the first time, the people of Kuwait were seeing, touching their own oil. For weeks, teams of specialists from different parts of the world fought the flames and spills. It was like fighting against the end of the world, a world drenched in black and death."

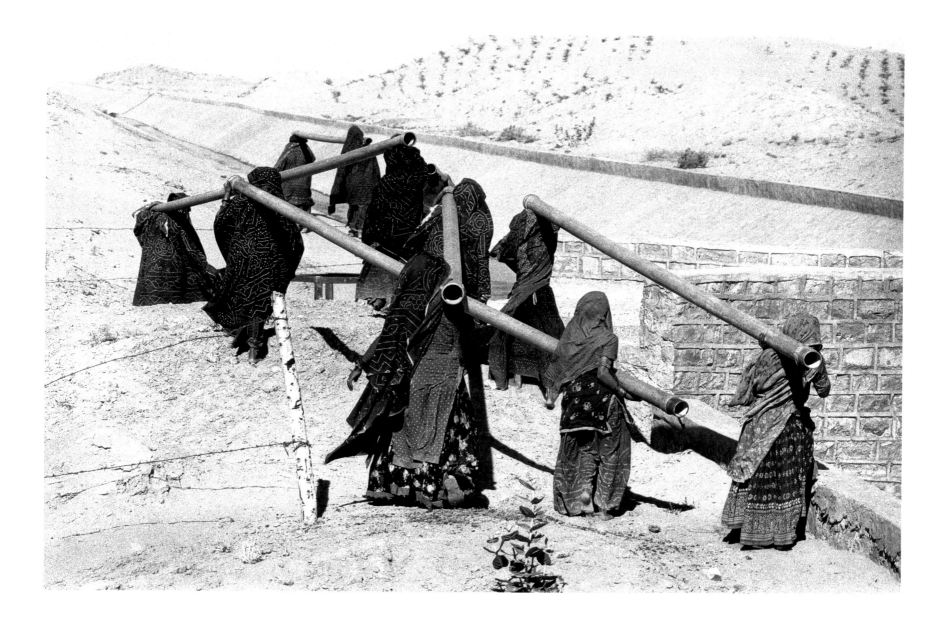

Rajasthan Canal Works, India, 1989

In Rajasthan, whole villages become itinerant for months on end to work on the construction of a canal. Women are also part of the workforce. For Salgado, these images focus on "women dressed in colorful dresses and adorned in sparkling bracelets, earrings, necklaces, women with jewelry attached to their bodies almost as if soldered to their skin, beautiful warriors of extraordinary dignity attacking the earth."

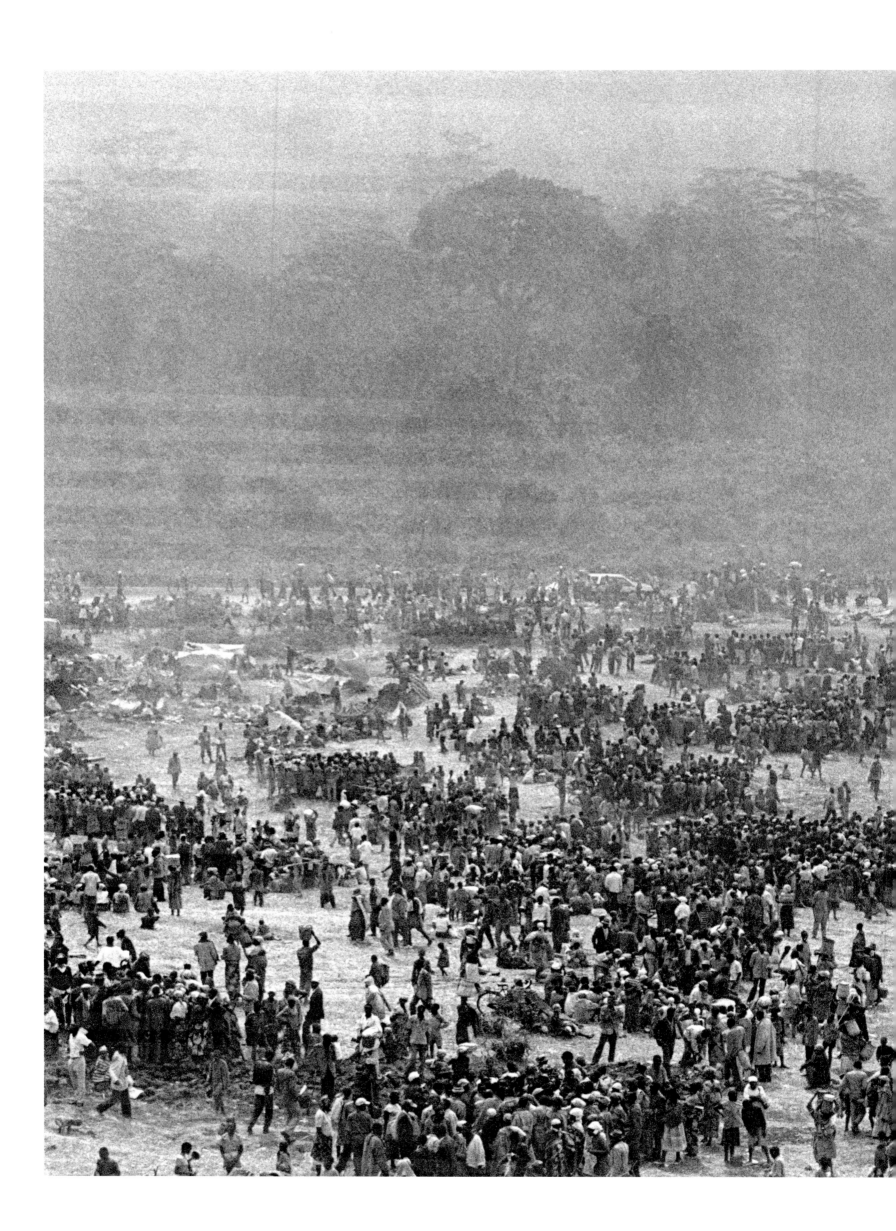

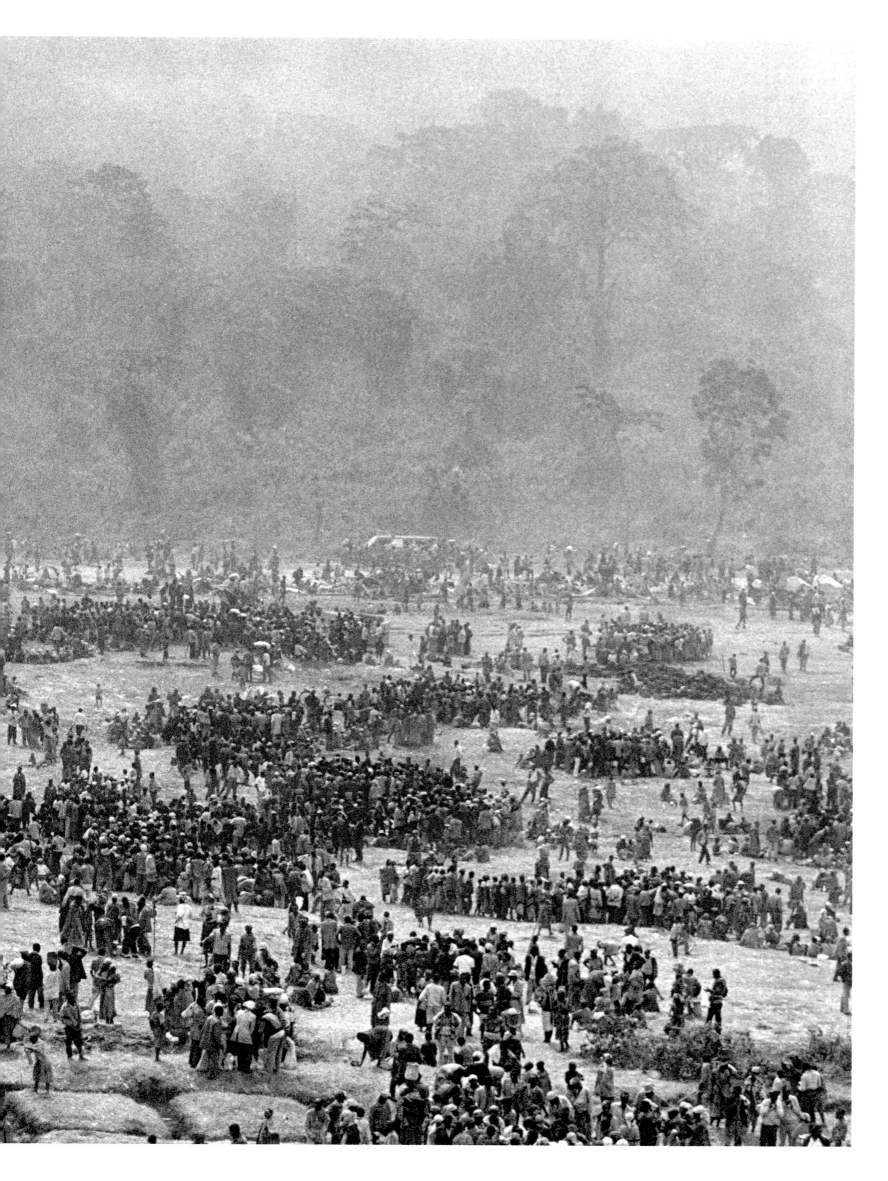

Goma, Zaire, 1994

Toward the end of the twentieth century, Salgado spent several years studying the causes and effects of migration around the world. The fruits of his labor became a project of incredible visual power: *Migrations*, a book (and traveling exhibit) featuring thirty-six photo essays from around the globe that explore the many facets of the issue. The work features refugees, immigrants, and other itinerant peoples—driven by fear, the horrors of genocide, or the desire for a better life—who continue to change the structure of so many nations. This extensive work also encompassed the tragic genocide in Rwanda that pitted the Tutsi and Hutu populations against one another, which struck the heart of Africa and the entire world. This photo shows the distribution of food to displaced Rwandans gathered in the Kibumba refugee camp, Zaire.

"WITH MY BACKGROUND AS AN ECONOMIST, SOCIOLOGIST, AND ANTHROPOLOGIST, MY PHOTOGRAPHY CAN BE NOTHING BUT SOCIAL. EVERYTHING IN MY BACKGROUND— MY UPBRINGING, MY EDUCATION, MY FOCUS ON SOCIOLOGY, ANTHROPOLOGY, AND GEOPOLITICS— HAS SEEPED INTO MY PHOTOGRAPHY. PHOTOGRAPHY, FOR ME, IS CONTINUITY."

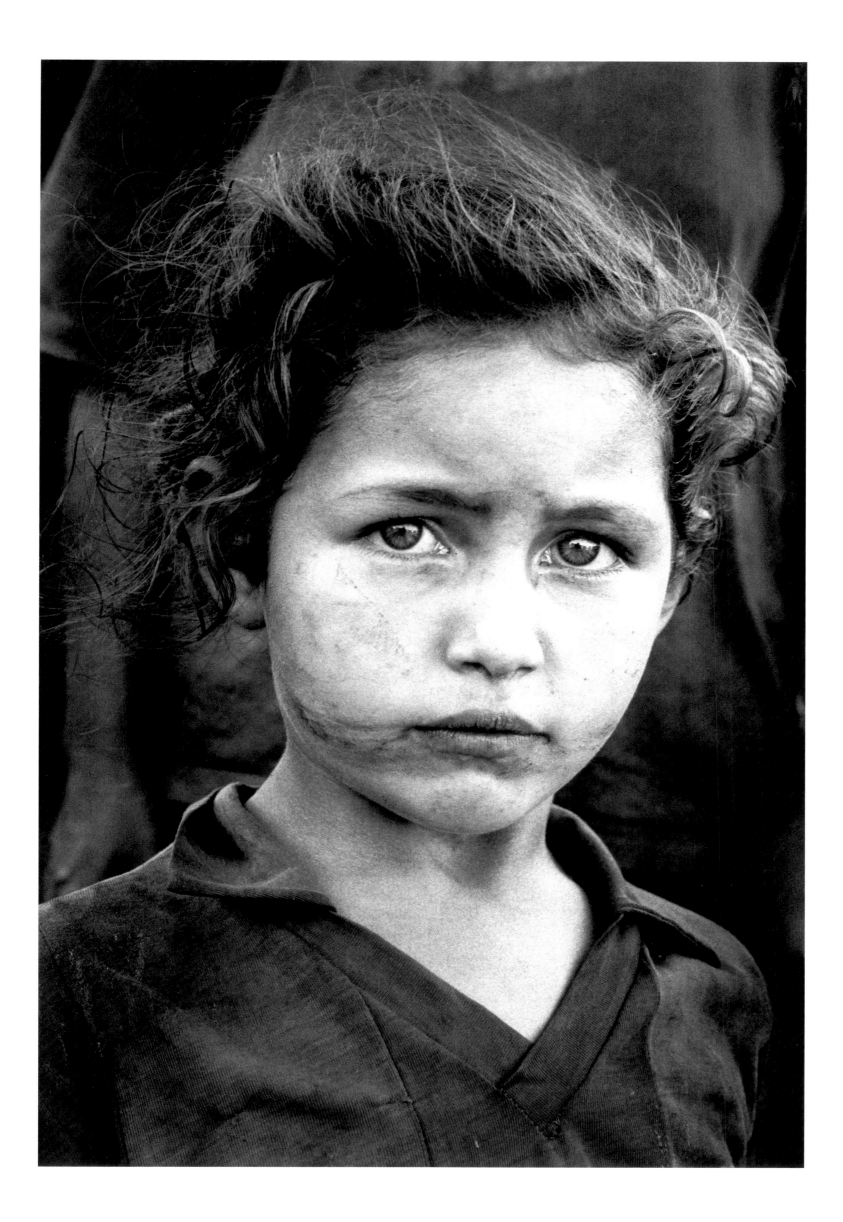

Paraná, Brazil, 1996
The face of this little girl has become the emblem of a project dedicated to the Landless Workers' Movement in Brazil, where peasants, whose land has been expropriated by large landowners, have long fought for the right to farm and live off their own produce. This image was taken in a makeshift camp beside a highway in the northeastern state of Paraná, where more than three thousand families awaited the right to inhabit their own land.

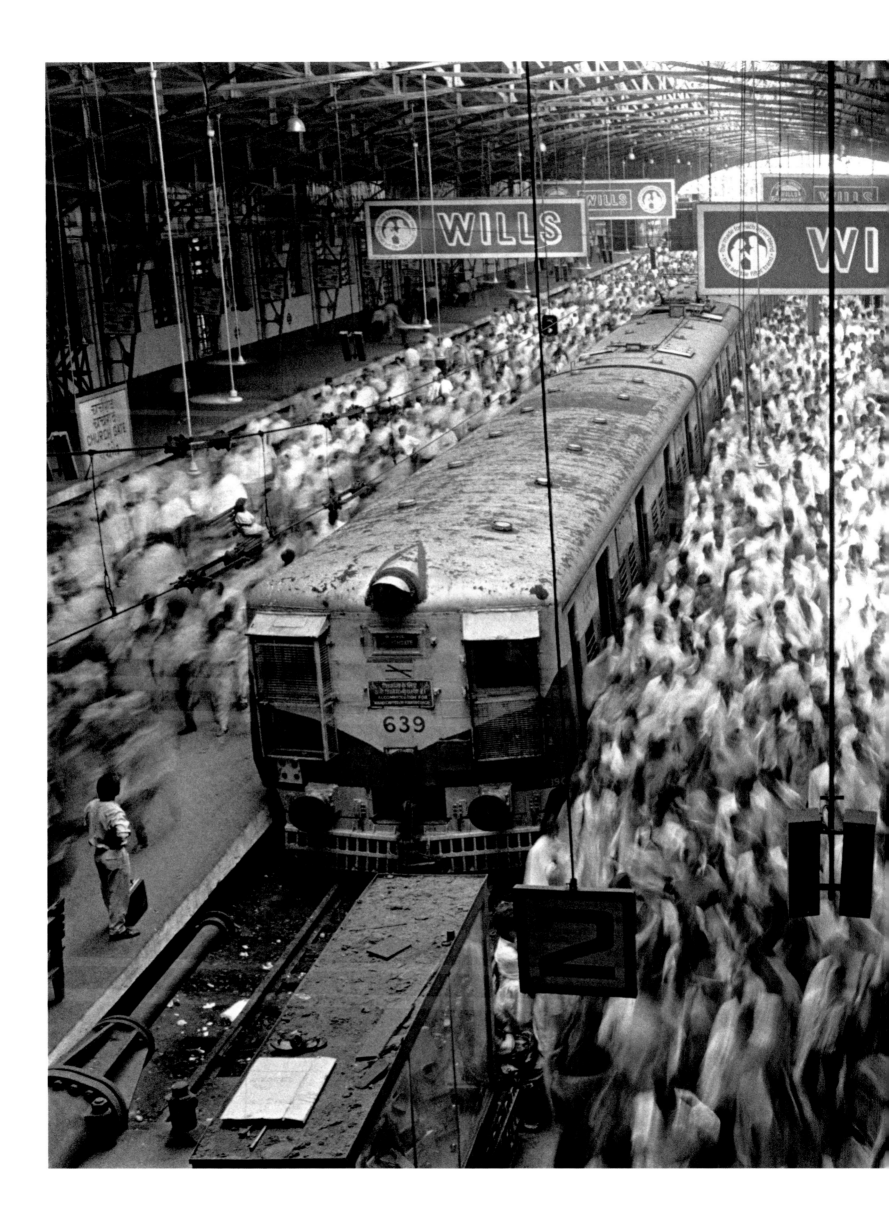

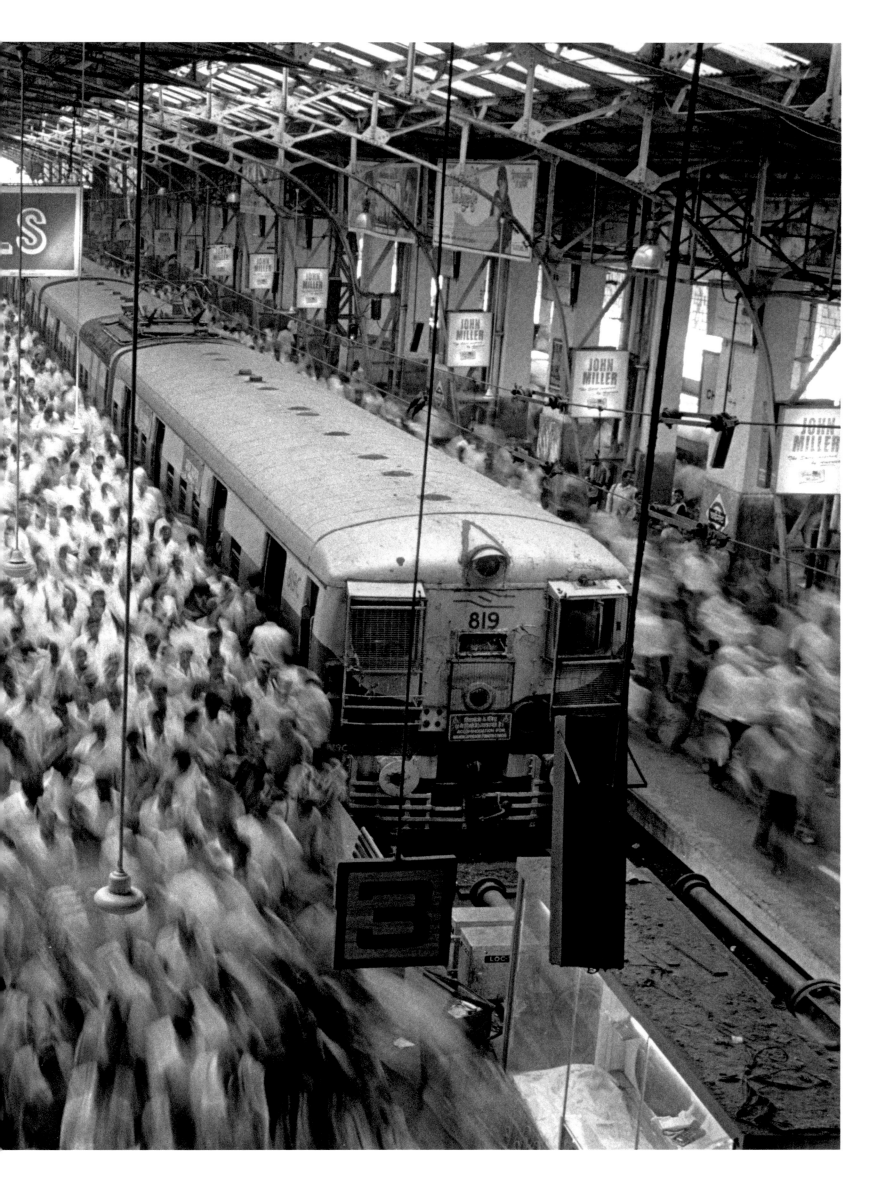

Church Gate, Mumbai (Bombay), India, 1995

The other face of migration can be seen in vast megalopolises like Cairo, Jakarta, and Mexico City, where overcrowding has enormous consequences. Church Gate is the terminus of the Western Railway, a line that carries over 2,700,000 commuters to central Mumbai each day. At rush hour, a train comes every twenty seconds.

As Salgado wrote in his introduction to *Migrations*, "Everywhere, the individual survival instinct rules. And yet, as a race, we seem bent on self-destruction. . . . The new millennium is only a date in the calendar of one of the great religions, but it can serve as the occasion for taking stock. We hold the key to humanity's future, but for that we must understand the present."

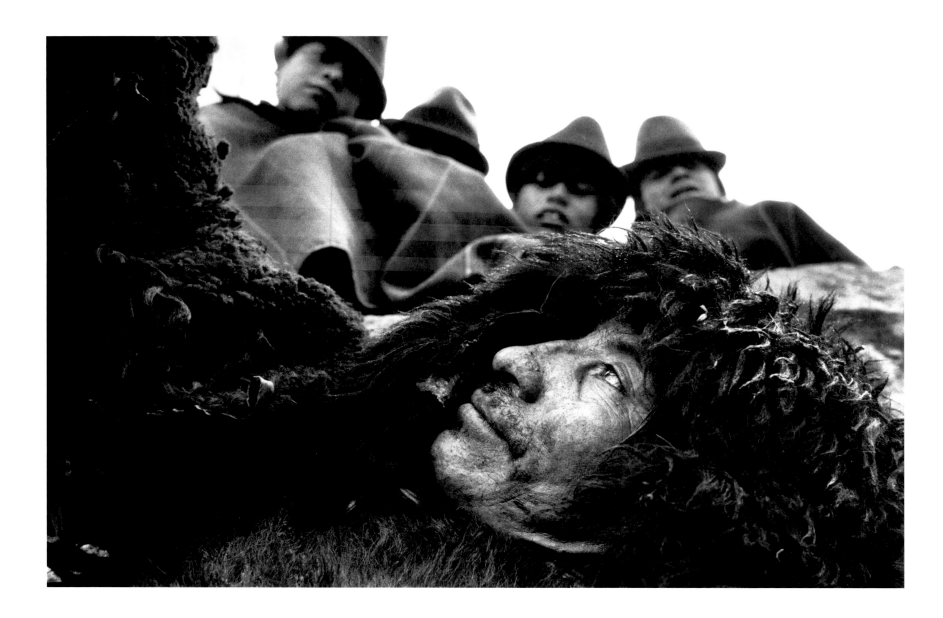

Atillo, Ecuador, 1982
Inhabitants of Ecuador's highlands wear thick sheepskins to protect themselves
from the cold and damp.

Sebastião Salgado was born on February 8, 1944, in Aimorés, in the state of Minas Gerais, Brazil. In 1964 he began studying economics at the University of Vitória, in the state of Espírito Santo. He graduated in 1967 and later that same year married Lélia Deluiz Wanick. They would go on to work together on all of his photography and communications-related projects.

From 1969 to 1971 he attended the National School of Statistics and Economic Administration (ENSAE) in Paris, completing his doctorate. In 1971 he moved to London to work for the International Coffee Organization, aiming to support the diversification of Africa's coffee trade. In the early 1970s he picked up his first camera, his wife Lélia's Leica: he quickly understood that photography was a flexible medium, and one that was perfect for getting to know the world and its social problems—and making them known.

In 1973 he completed his first photo essay on the drought in the Sahel and immigrants in Europe. The following year he worked with the Sygma agency and traveled to Portugal, Angola, and Mozambique. On February 15, 1974 the couple's first son, Juliano, was born. From 1975 to 1979 Salgado worked with Gamma in many countries throughout Europe, Africa, and Latin America. In 1979 he joined the legendary Magnum agency, and continued traveling the globe. The couple's second son, Rodrigo, was born on August 7, 1979.

Between 1979 and 1983 he made several trips to Latin America, working primarily on the inhabitants' living conditions: the project was published under the title *Otras Américas* (Other Americas), which won the Kodak/Ville de Paris prize for best photography book. In 1985 his vast, in-depth work on the drought in the Sahel region of Africa won the Oskar Barnack and World Press Photo awards, and was declared the most significant humanitarian work

of the year. In 1987 he began a long-running project on manual labor toward the dawn of the new millennium, which culminated in 1993 with an exhibition and was published in the book *Workers*. The traveling exhibition attracted millions of visitors worldwide. Salgado has won several major awards: in 1988 alone he won recognition from the King of Spain, the Erich Salomon prize (awarded in Germany), and was named Photographer of the Year by the International Center of Photography in New York. In 1989 he was granted the Erna and Victor Hasselblad prize in Sweden. The following year he left Magnum to co-found, alongside his wife Lélia, Amazonas Images, an agency devoted exclusively to his work. In 1997, in collaboration with the Brazilian Landless Workers' Movement, Salgado began work on the *Terra* (Earth) project, which also resulted in a book and traveling exhibition. During the same period, he started researching migratory workers' movements.

In 2000, after six years of field work and thirty-six individual photo essays, he published *Migrations*, a two-volume, in-depth examination of displaced populations, accompanied by a major exhibition that traveled to the world's most prestigious venues. In 2001, in collaboration with UNICEF and the World Health Organization, he produced a documentary on the prevention of polio in Africa and Asia. In 1998 he and Lélia co-founded the Instituto Terra, an organization dedicated to the reforestation of Brazil's Atlantic coast. Over the past few years the institute has grown, and its focus on environmental education has led to a total revaluation of the region (see www.institutoterra.com.br). Environmental protection is one of Salgado's key interests, and he is currently working on a vast project titled *Genesis*, focused on the planet and the delicate balance necessary for its survival.

"THESE PHOTOGRAPHS WILL LIVE ON AFTER THEIR SUBJECTS AND THEIR AUTHOR, BEARING TESTIMONY TO THE WORLD'S NAKED TRUTH AND HIDDEN SPLENDOR. SALGADO'S CAMERA ... SHOWS US THAT CONCEALED WITHIN THE PAIN OF LIVING AND THE TRAGEDY OF DYING THERE IS A POTENT MAGIC, A LUMINOUS MYSTERY THAT REDEEMS THE HUMAN ADVENTURE IN THE WORLD."

EDUARDO GALEANO

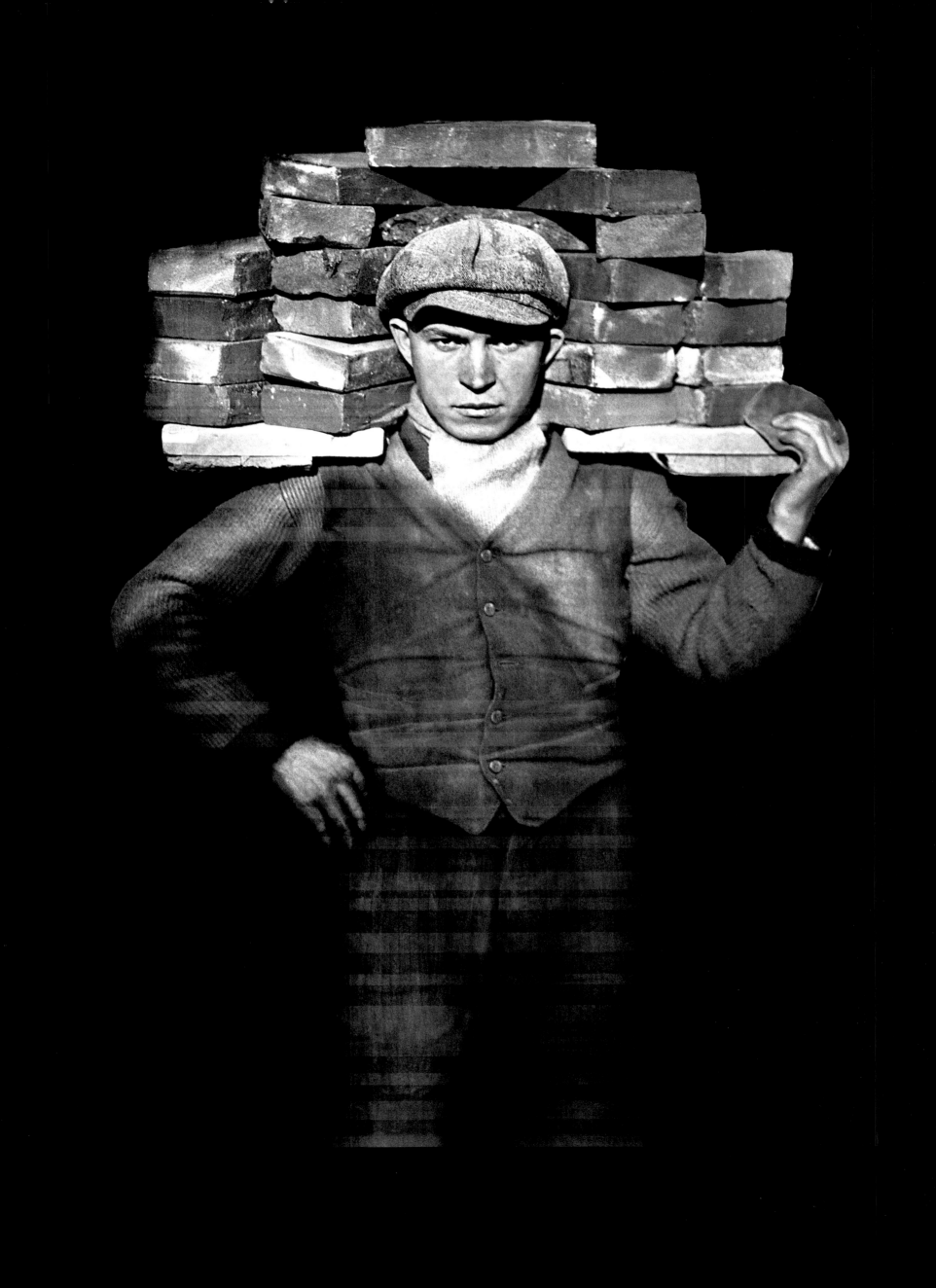

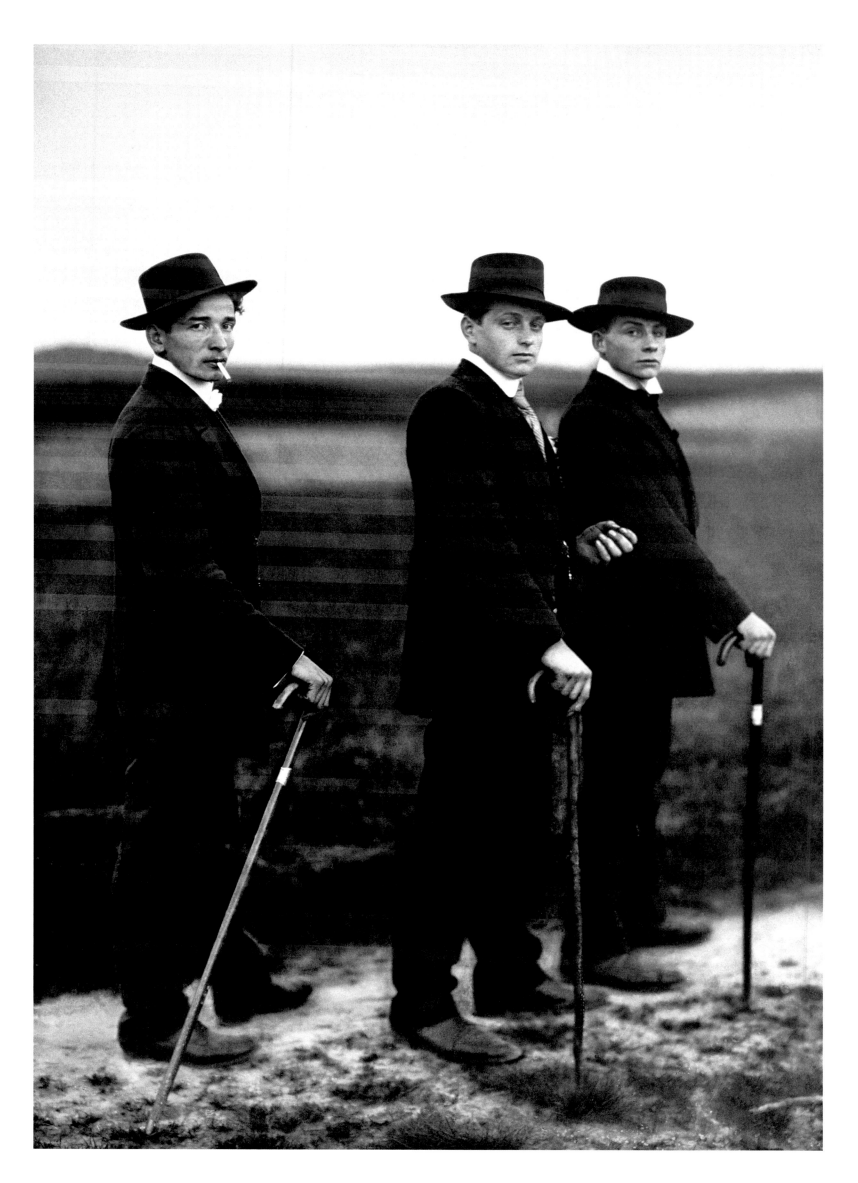

Page 426
Bricklayer, 1928

Above
Young Farmers, Westerwald, Germany, 1914
In the construction of his gigantic social fresco, Sander began with these young farmers—peasants, men tied to the land, representatives of a rural society that had long remained unchanged but was destined to disappear. The young men are wearing their best clothes, as if it were Sunday, and they turn to look at the photographer with a self-confident gaze that has not yet been hardened by the fatigue of work.

AUGUST SANDER

"Sander's work is more than a picture book. It is a training manual." Thus wrote Walter Benjamin in his *Kleine Geschichte der Photographie* (A Short History of Photography) published in 1931. But train oneself for what? For looking oneself in the face, for seeing in one's face an entire epoch, for discovering the faces of a nation whose history was about to be overwhelmed by disastrous political upheaval. *Antlitz der Zeit* (Face of Our Time), in other words, the title of Sander's first book, published in 1929.

Sander's origins extend deep into the mining heart of a Germany that was at the height of its industrial development. His roots are to be found there, not only his biographical roots but also the roots of his way of looking and of his work. Born in 1876 in Herdorf, a town surrounded by fields with mineral deposits, the young Sander went to work in the iron mines at the age of fourteen. The town was small, but lively: the presence of the miners and of the machine shops brought a large number of workers from all over Germany and Italy to Herdorf. And it was precisely in the large square in front of the San Fernando mine that Sander had his first encounter with photography, thanks to a photographer who had arrived with the assignment of producing a reportage on one of the mine shafts.

It was like a sudden flash of inspiration. He bought a camera and began to take portraits of whatever subjects were most available to him: his relatives and the miners. This was probably the birth of Sander's aspiration to "see things as they are and not as they should be or could be," that will to use photography in the service of truth and for the construction of an image of his own era.

"I first began working on my 'People of the Twentieth Century' in 1911, in Cologne, my adopted city," Sander wrote in his *Chronik der Stamm-mappe* (Chronicle of the Portfolio of Archetypes), "but it was in my little village of Westerwald that the personalities in my portfolio were born. It seemed to me that these people whose habits I knew from childhood existed specifically to embody my idea of an archetype, something which could also be seen in their connection to nature." One of the most fascinating aspects of Sander's work is the continuous tension between icon and document, between the particular and the universal. The people photographed are considered as prototypes of different social groups, but they are not reduced to stereotypes or stock characters. The monumental project "People of the Twentieth Century" is a portrait gallery with hundreds of portraits conceived as a fresco of contemporary society. Sander divided his research into seven main groups: farmers, workers, women, social positions, artists, the big city, and outcasts. Each group was then subdivided under various headings according to genealogical, social, or politico-ideological criteria. His intention was to capture the individual in his social, professional, and geographic aspects, to link him to the context of the here-and-now of those years.

Some examples of this work were shown for the first time in 1927 in an exhibit mounted by the Kunstverein in Cologne, and in 1929 his first book, *Antlitz der Zeit*, appeared (to be published much later in English as *Face of Our Time*). It had a text by Alfred Döblin, who wrote, "Standing opposite these portraits we meet the collective force of human society, of class, of the cultural level… it is about a widening of our field of vision."

Sander's vast body of portrait work is founded on and laden with political meaning because it shifts the viewer's attention from the aesthetic of the photograph to its social function. The camera is not impartial but, if handled by an eye that is capable of observation without bias, it cannot help but reveal the faces as social masks.

This idea of "pure photography," opposed to any artifice that might falsify the gaze, intent on searching for a vision capable of grasping reality in its most authentic essence, could not but be in conflict with the image of society propagandized by Nazism. It was not by chance that in 1936 the Gestapo seized all copies of *Antlitz der Zeit* and destroyed them. Nor that it confiscated a large part of Sander's material and blocked the publication of other books. Sander's work would be greatly obstructed. Despite this, and despite the upheaval that the war would bring to his private and family life, Sander continued, with indomitable optimism, his photographic search for that truth which, because of its pure documentary nature, was stretched to the point of becoming a symbol. After the war, Sander undertook a project on Cologne, photographing the damage caused by the bombing of the city. These images, which were combined in the book *Köln wie es war* (Cologne As It Was) with photos of the city taken before the war, was intended to be, in the words of the author, "a harsh and pitiless call to all his contemporaries, a warning of the need for good governance in every era." Sander's work remains a monumental sociological fresco of Germany during the first half of the twentieth century, a study in comparative photography that, as Alfred Döblin wrote, "goes beyond the detail to take its place in a scientific view."

Boxers, Cologne, Germany, 1929

Two young boxers pose in front of the photographer. The background is neutral. One of them smiles, the other assumes a pose that is a bit more stiff. These two, like all the subjects photographed by Sander, wear the clothes and carry the tools of their trade. The gaze of the photographer is always direct, frontal, clear, and precise. Everyone becomes in some way the archetype of his own "social type"—or, at least, that is what the author claimed. Even an advertisement for his studio in Cologne in 1912 carried the words: "I aim to create unusual photographs—not the everyday pictures made in the finer large studios of the big cities, but rather simpler, more natural images that show subjects in their characteristic environments; images that can be considered artistically and also hung like precious objects to adorn the wall."

What he wanted to capture in his very calibrated black and white was that "essential character" that was able to go beyond the particular individuality and say something about an entire society. To arrive, by way of photography, at the construction of a new way of understanding humanity.

August Sander started with the farmer and led the observer through all the social classes, through all the professions, from the highest culture to the portrait of a man accompanied by a caption that says "idiot," and then down, until the last, the outcasts of society. Photography was stripped of all pictorialist sentimentalism and called upon to portray the face of reality.

Sander's subjects, with their particular physiognomies, attitudes, and postures, look at us and, from the distance of their era, still surprise us with their rigid, statue-like expressions.

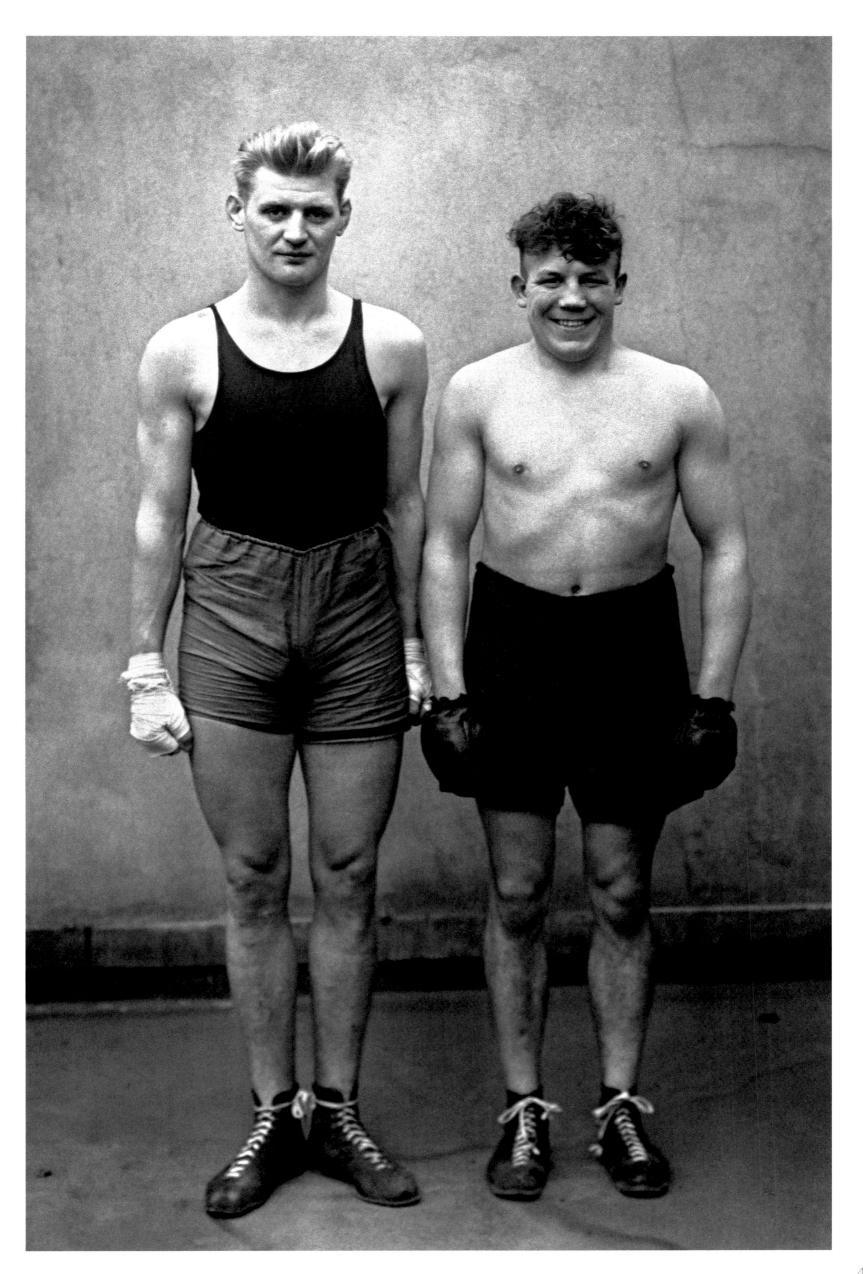

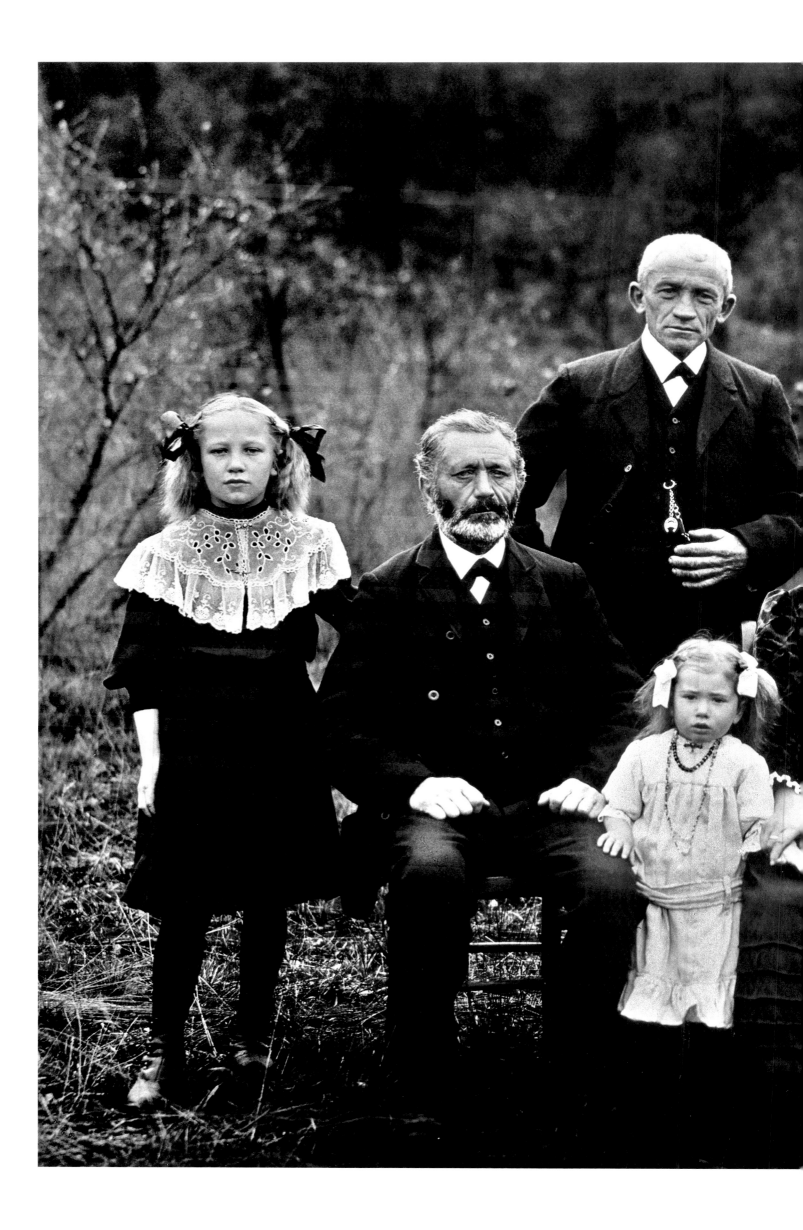

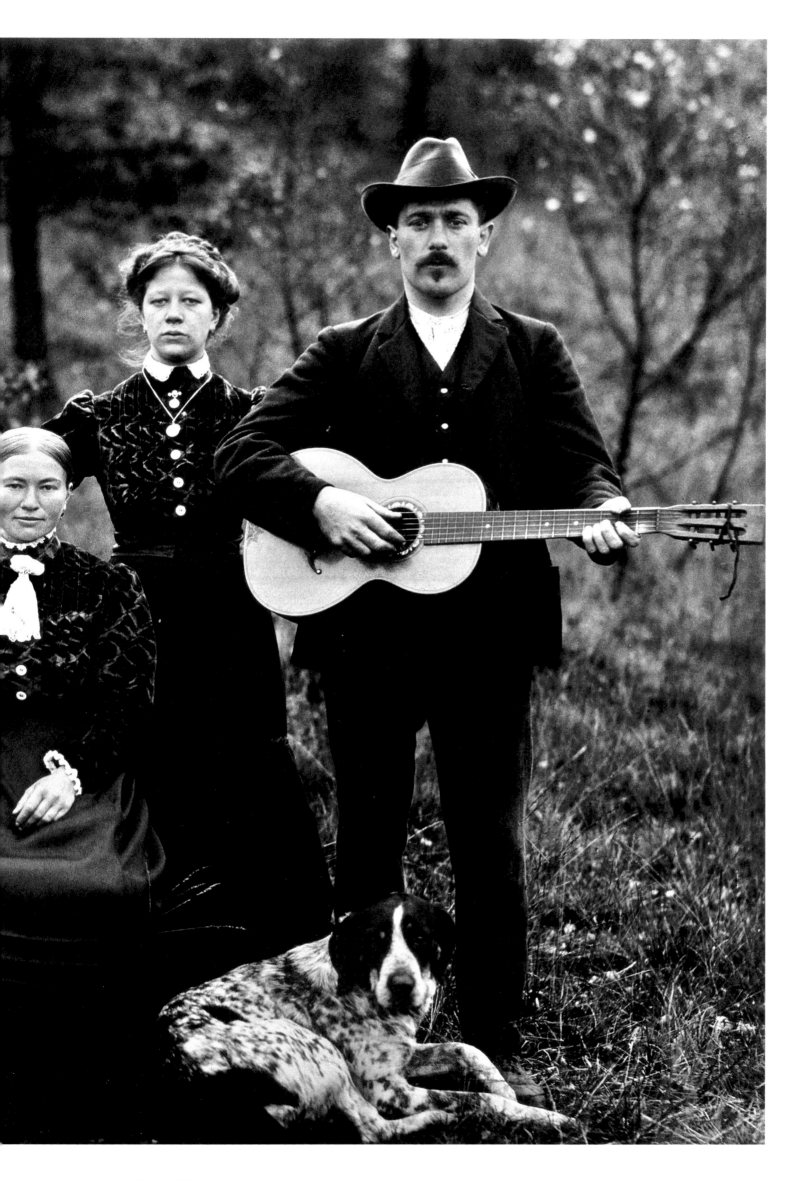

Farm Family, 1912
Döblin wrote in the introduction to *Face of Our Time*, "One can see the individual rustic types that likely remain the same, because the character of the small farm has, over time, a certain stability,... in them one sees the solitary families, even if the plow and the field are not in evidence; in these people one sees the heavy, rough, monotonous work that hardens and ruins their faces."

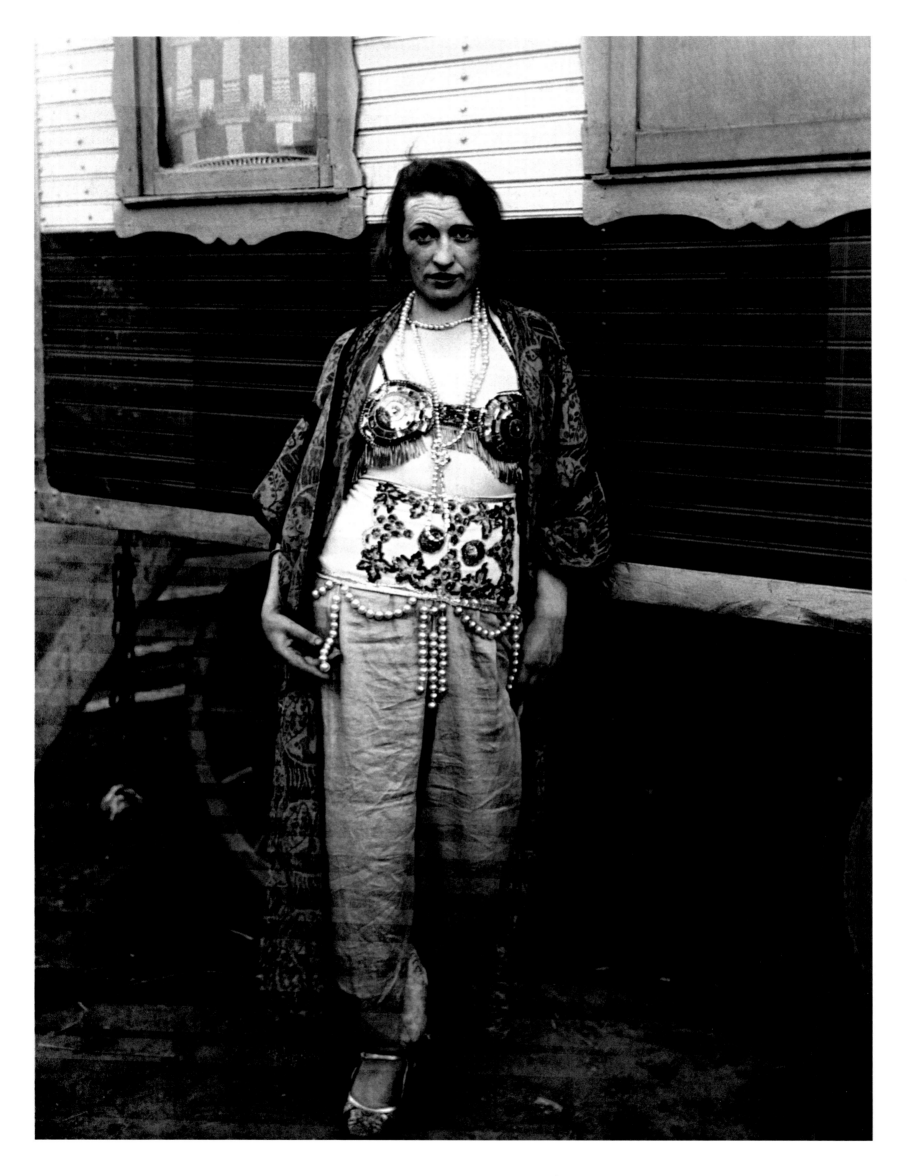

Circus Performer, 1926–32
In *People of the Twentieth Century*, Sander wrote, "We know that people are formed by the light and air, by their inherited traits, and their actions.... We can tell from their appearance the work that someone does or does not do; we can read in a man's face whether he is happy or troubled. It is not my intention either to criticize or to describe these people, but to create a piece of history with my pictures."

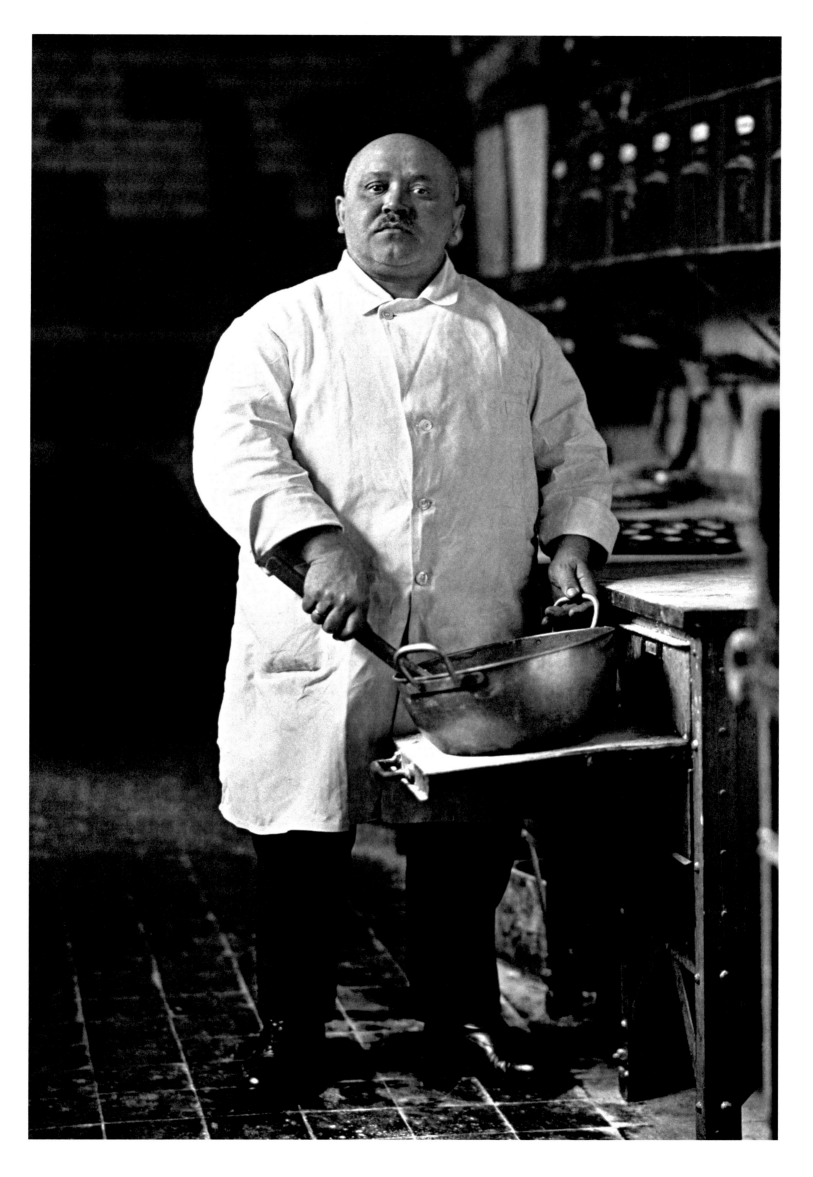

Master Confectioner, 1928
Stopped suddenly in an infinitely repeated motion, a confectioner stares fixedly at the camera. This time the background is not neutral, but lets us catch a glimpse of the utensils and objects belonging to his trade. The physiognomy and the body language make this single individual into an archetype of all master confectioners in Germany during the 1920s.

"PLEASE FORGIVE ME IF I, AS A MAN IN FULL HEALTH, AM SO IMMODEST AS TO SEE THINGS AS THEY ARE—NOT AS THEY SHOULD BE OR COULD BE. I CANNOT DO OTHERWISE. I HAVE BEEN A PHOTOGRAPHER FOR THIRTY YEARS NOW, AND HAVE DEALT WITH THE MEDIUM SERIOUSLY; I HAVE VENTURED DOWN GOOD AND BAD PATHS, AND HAVE RECOGNIZED MY ERRORS.... THERE IS NOTHING I HATE MORE THAN PHOTOGRAPHY THAT IS OVERSWEETENED BY GIMMICKS, POSES, AND EFFECTS. ALLOW ME THEREFORE, IN ALL HONESTY, TO TELL THE TRUTH ABOUT OUR TIME AND ITS PEOPLE."

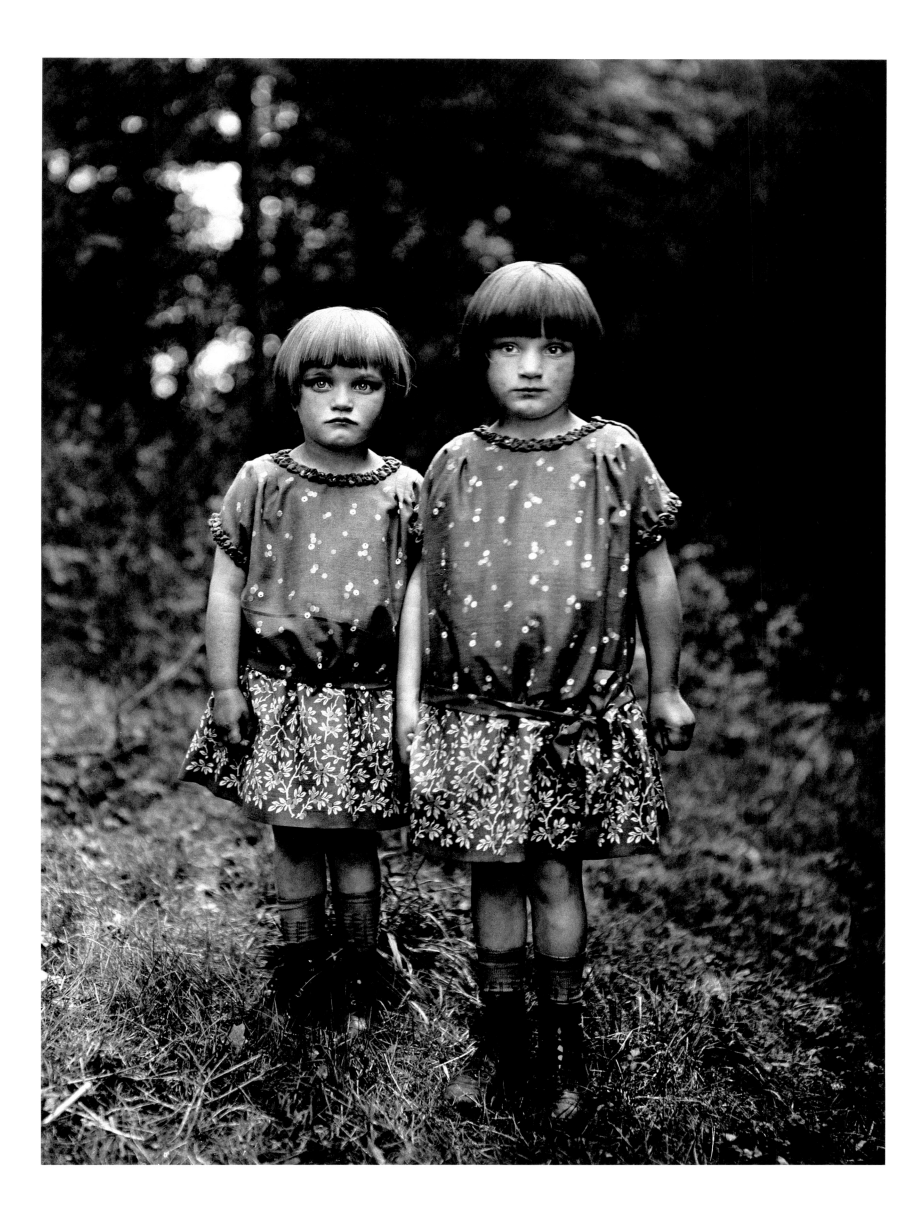

Children in the Countryside, 1925
Even children were part of Sander's great fresco. Children in the countryside, in the city, well-to-do, poor, or sick. Shot on their own or as part of a group portrait with their families. The way these children look at the camera, seen from the vantage point of the years that have passed, takes on a nuance that is almost sinister. We are at the beginning of the "short twentieth century" (to quote the historian Eric Hobsbawm), and World War II would soon turn that society and that childhood upside down.

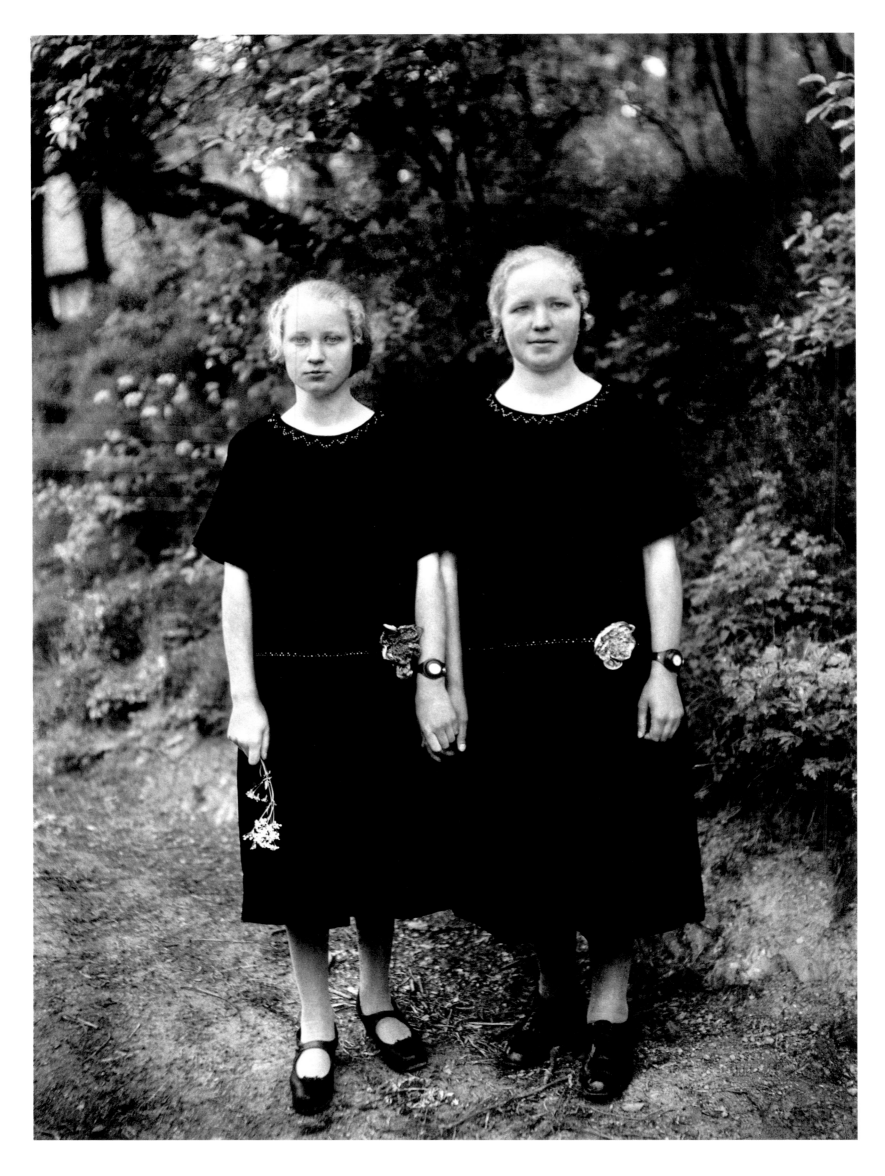

Young Women in the Countryside, 1925
Hand in hand, wearing the same dress and hairstyle, two young rural women agree to place themselves in front of the camera. There is no artifice, no particular pose—only the narrative potential of their existence, of their way of showing themselves, and of their gazes.

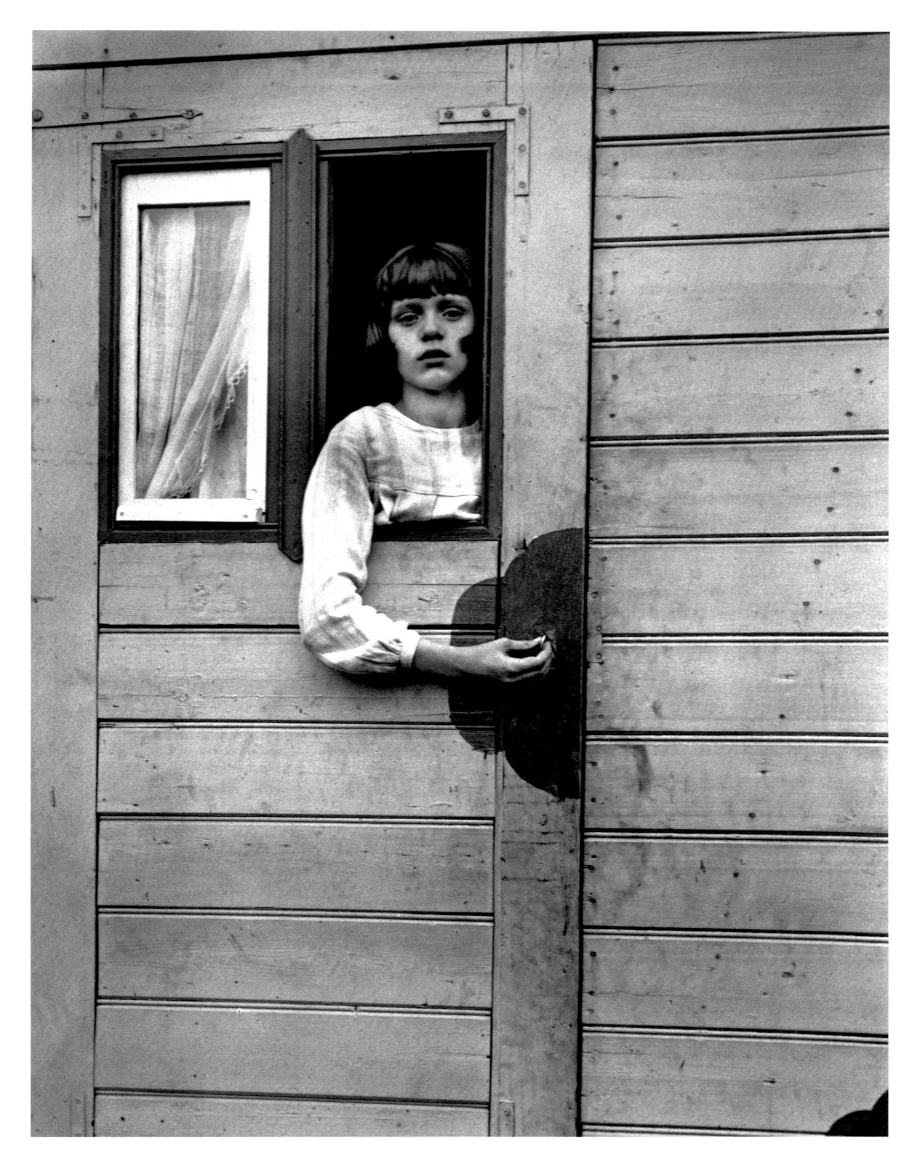

Young Girl in a Trailer at a Fair, 1926–32
This image seems almost like a stolen shot. A visually meaningful moment stopped by the perfection of the framing. A young girl looks out from the window of her trailer, sticks out an arm to open the door, or perhaps to close it. It seems to be a posed portrait, or at least we cannot tell, but what is certain is that for Sander, as he wrote in a letter to a friend in 1951, "a beautiful photograph is only the first step toward an intelligent use of photography.... I cannot show my work in a single image, nor in two or three; they would not be anything other than snapshots. Photography is like a mosaic that becomes a synthesis only when it is presented as a whole."

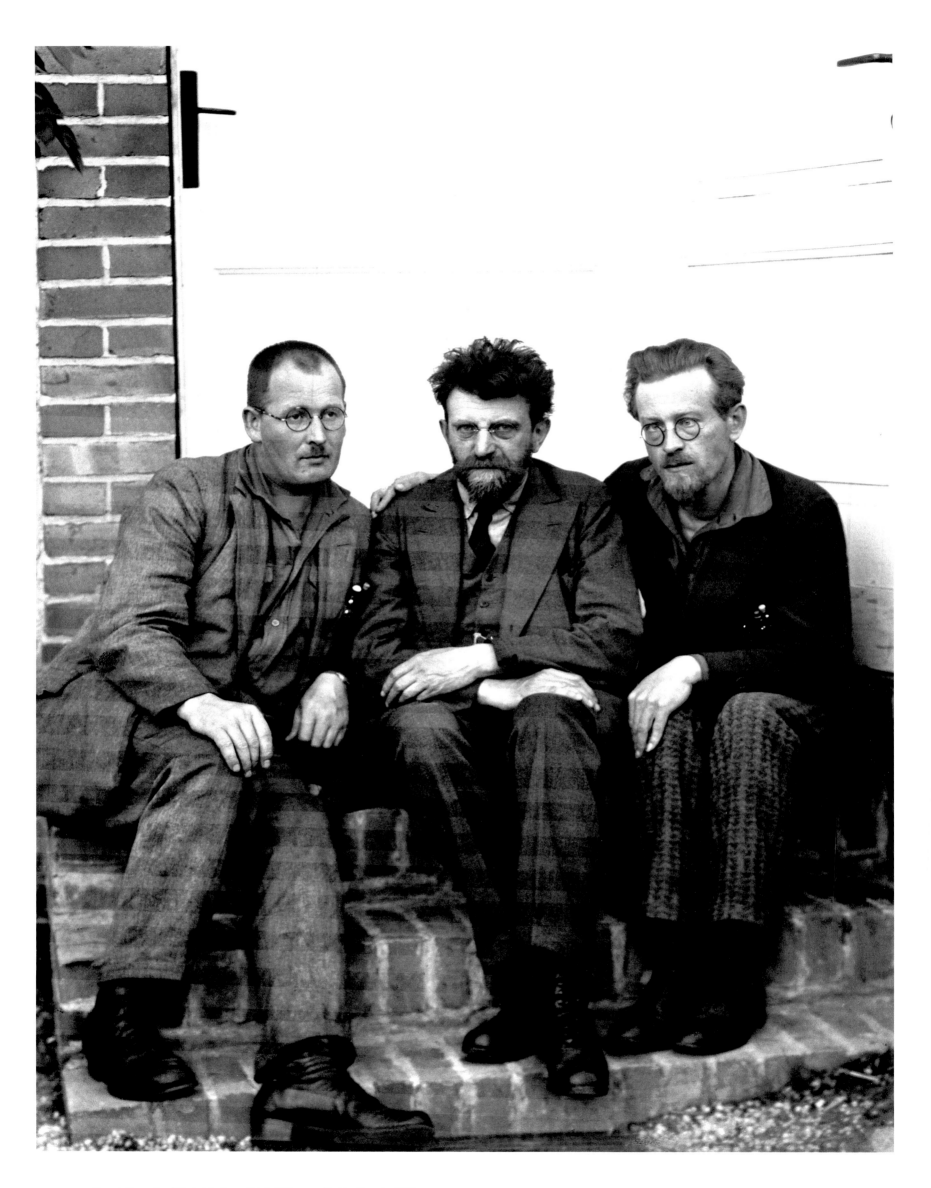

Revolutionaries (Alois Lindner, Erich Mühsam, Guido Kopp), 1929
In his *Short History of Photography*, Walter Benjamin wrote, "Work like Sander's could overnight assume unlooked-for topicality. Sudden shifts of power such as are now overdue in our society can make the ability to read facial types a matter of vital importance. Whether one is of the Left or the Right, one will have to get used to being looked at in terms of one's provenance.... Sander's work is more than a picture book. It is a training manual."

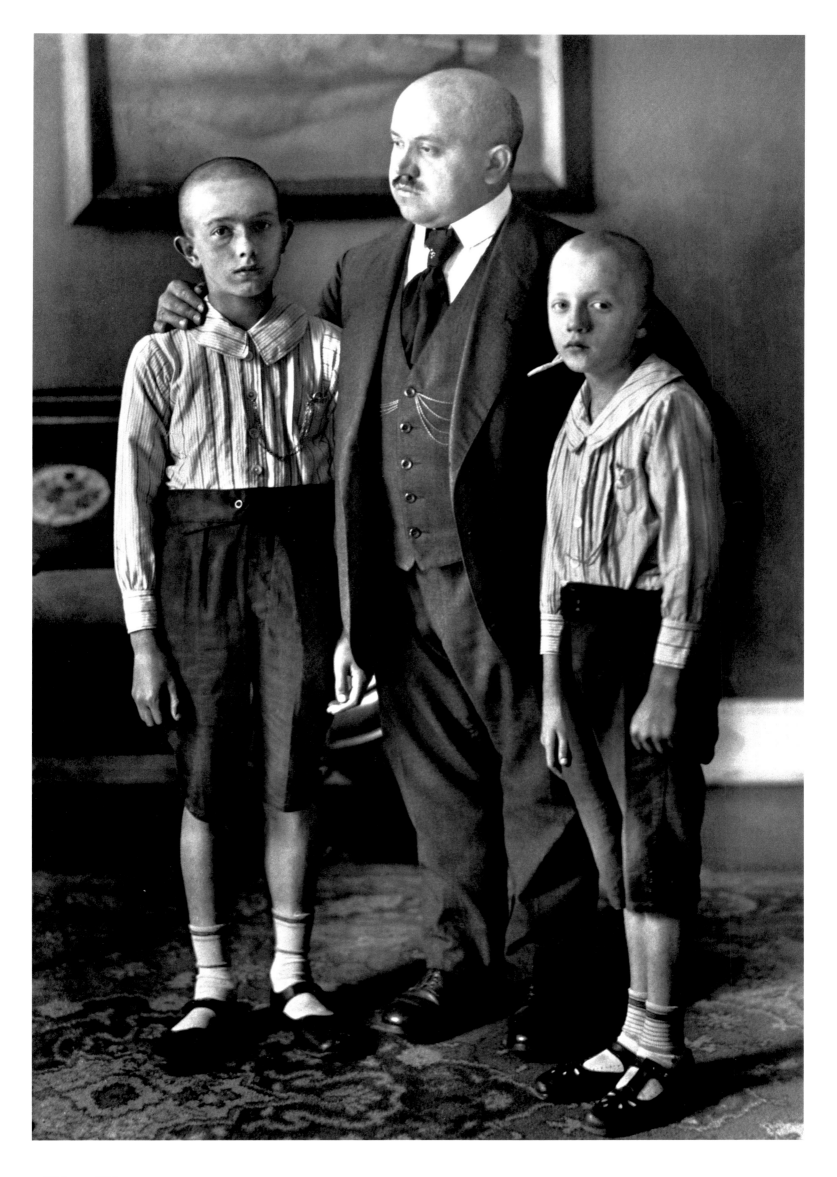

Widower, 1914
Just like work and social class, pain has the power to mold character. That is what Sander seems to be saying with this image of three human beings with their gazes full of a far-off sadness. The studied lighting from the side gives this image set inside a middle-class house an atmosphere that is intimately nostalgic.

"SINCE INDIVIDUALS NO LONGER MAKE CONTEMPORARY HISTORY, BUT NEVERTHELESS SHAPE THE EXPRESSION OF THEIR TIME AND ARTICULATE THEIR OUTLOOK, IT IS POSSIBLE TO CAPTURE A PHYSIOGNOMIC PICTURE OF AN ENTIRE GENERATION AND TO LET IT SPEAK FOR ITSELF IN A PHOTOGRAPH, THROUGH THE PHYSIOGNOMY DEPICTED. THIS PICTURE OF TIME BECOMES EVEN MORE UNDERSTANDABLE WHEN WE JUXTAPOSE PHOTOGRAPHS OF TYPES FROM THE MOST DIVERSE GROUPS OF HUMAN SOCIETY."

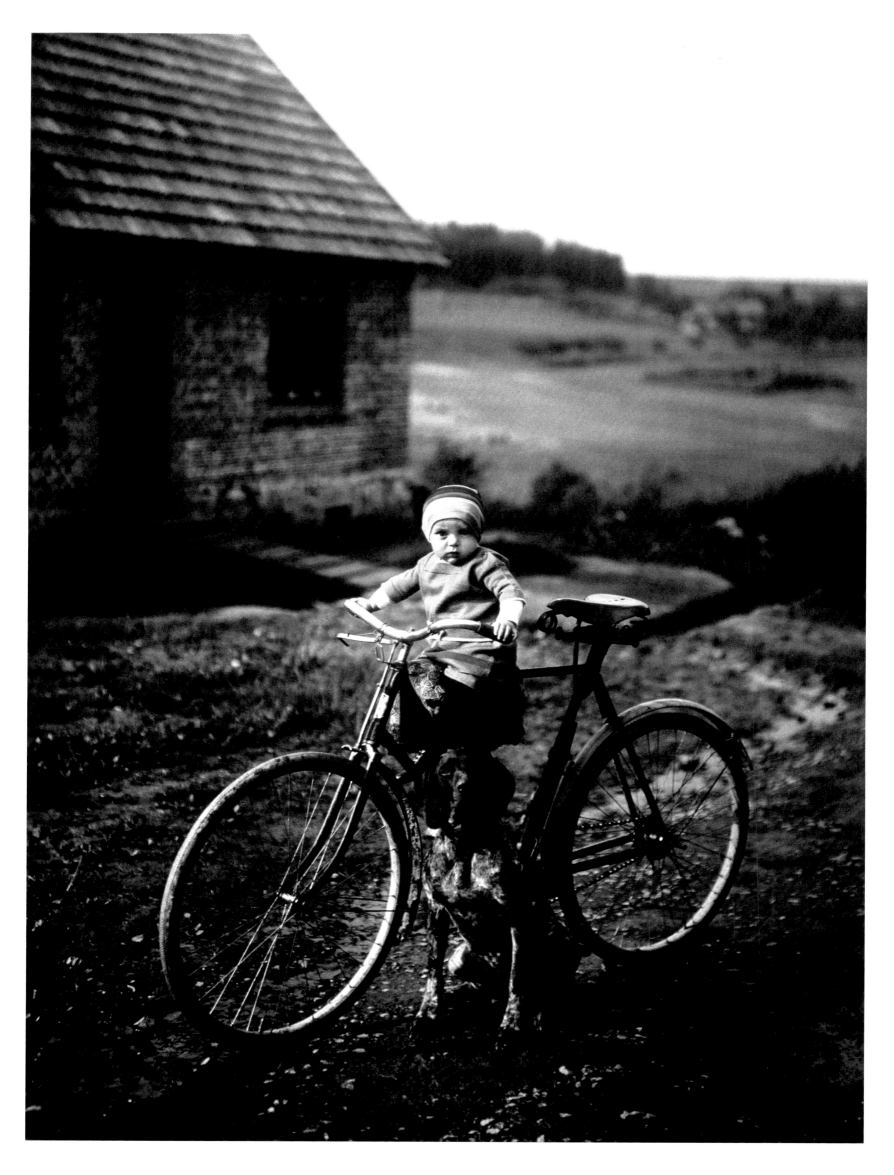

Child of Forest Rangers, 1931
As Sander wrote in *Mein Bekenntnis zur Photographie*, "I am often asked how I got the idea for this work: seeing, observing, and thinking. That is my answer."

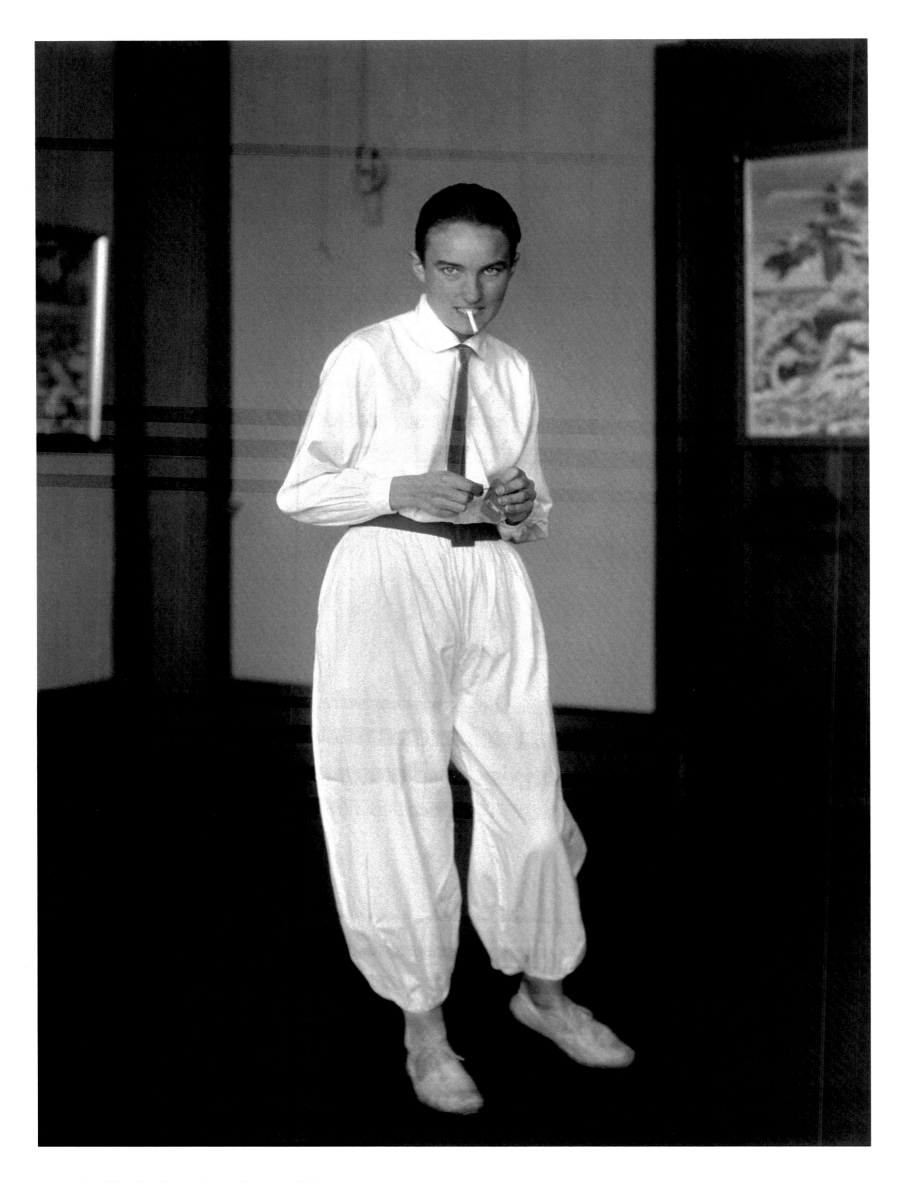

The Wife of the Painter (Helene Abelen), c. 1926

The painter Peter Abelen, who belonged to the Cologne Progressives group, asked Sander to make a portrait of his young wife, posed in their apartment and surrounded by his work. The result is a fascinating anomaly in the work of the photographer, stylistically suggestive in the manner of a fashion photo.

The woman in men's clothing, with short hair and a cigarette between her lips, shows her rejection of the traditional representation of sexual identity and lights up the imagination with all of her transgressive and emancipated personality.

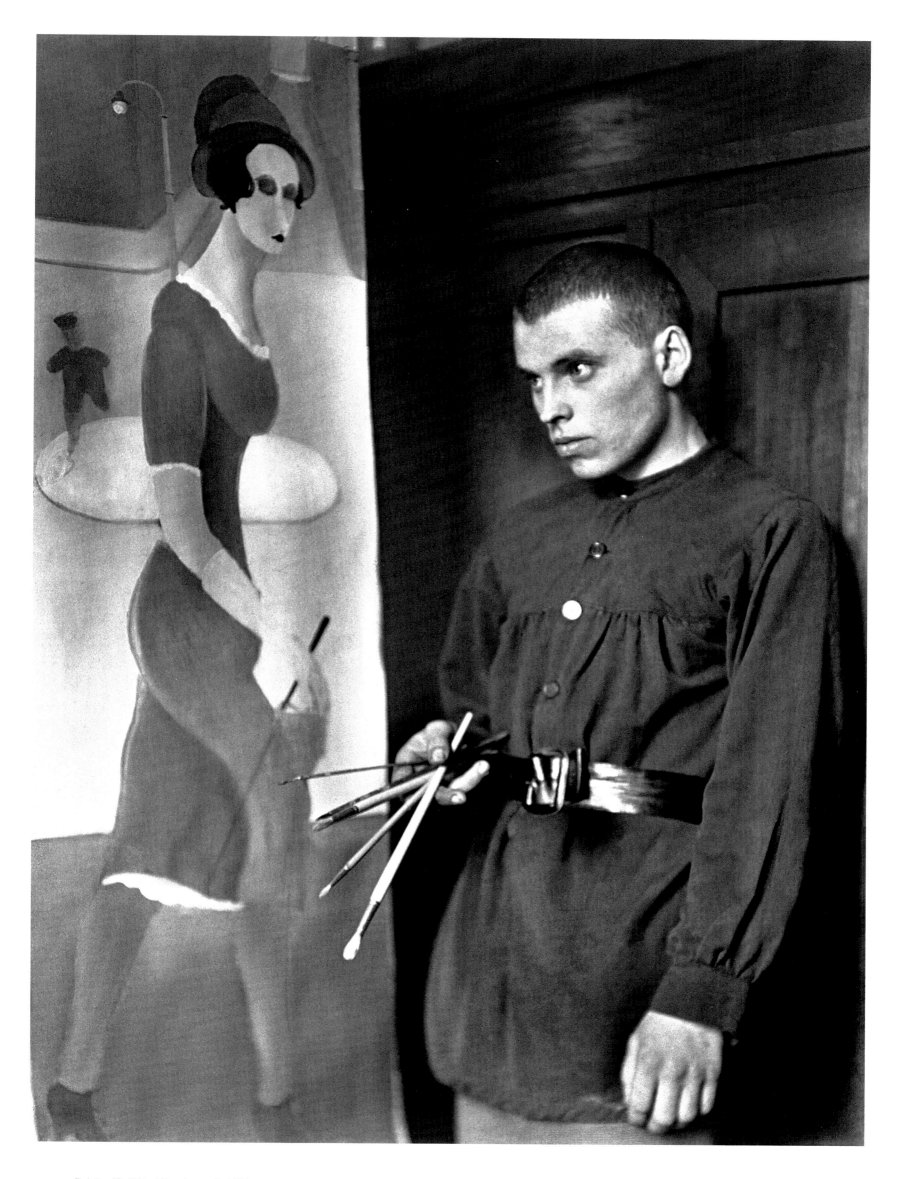

Painter (Gottfried Brockmann), 1924

The painter Gottfried Brockmann was a friend of Sander's. They were both part of the Cologne Progressives, an artists' group that was formed in the city during the 1920s. These politically radical artists were interested in the creation of a proletarian aesthetic, an innovative art that would combine constructivism and objectivism, thought up by—and made by—the working class. The photographic utopia of Sanders was perfectly aligned with the aesthetic intentions of the group, whose members considered him an important touchstone.

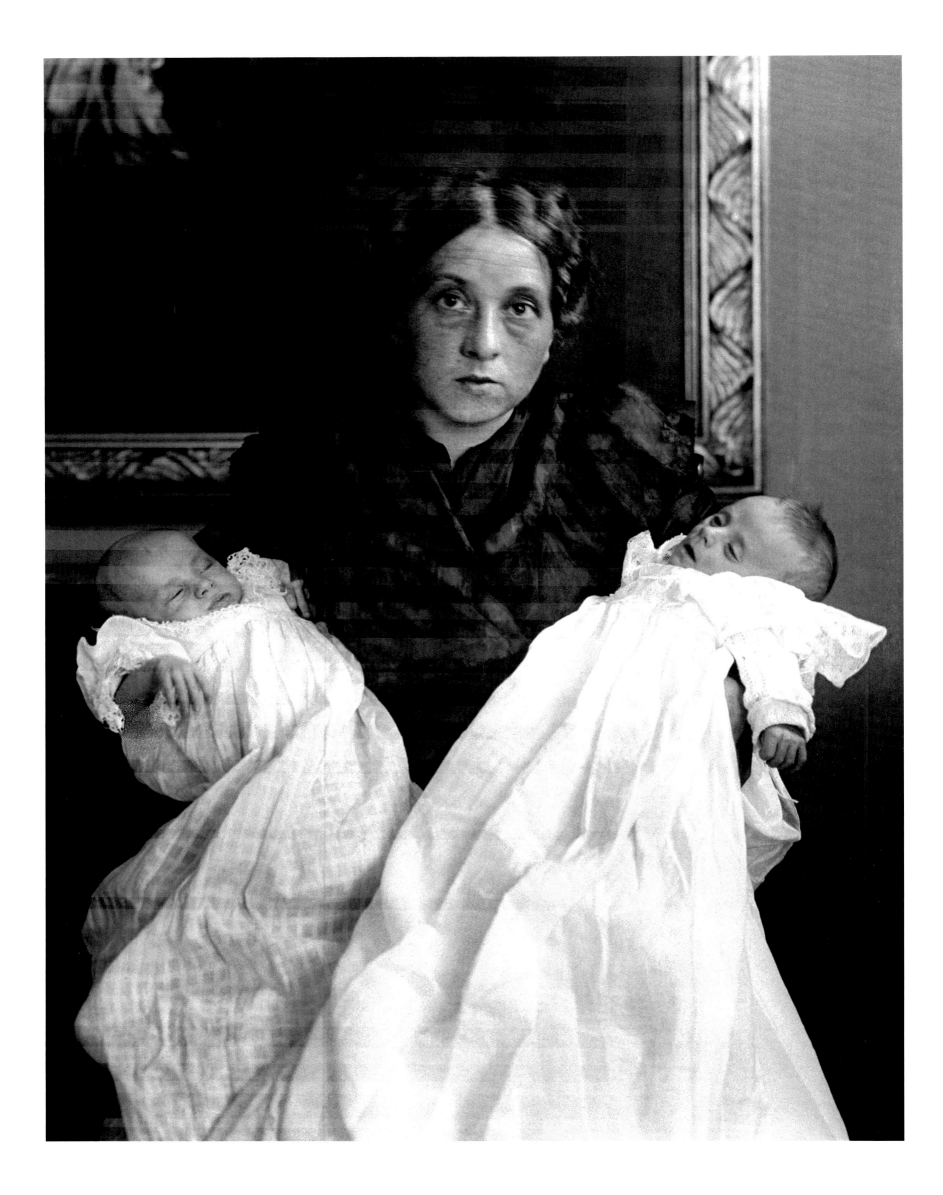

Mrs. Sander In Between Joy and Sadness, 1911
A portrait of Sander's wife with their newborn twins, Sigrid and Helmut, in her arms. Only Sigrid would survive.

Self-Portrait

August Sander was born in 1876 in Herdorf, Germany, an industrial town surrounded by fields with mineral deposits. At the age of fourteen he began working in the mines, as his father had. It was there that he discovered photography, thanks to a photographer assigned to shoot one of the mine shafts in Herdorf, to whom the young August was assigned as a helper to carry his equipment.

Thanks to the economic support of an uncle, Sander was able to set up his first studio close by his house and there began to photograph the mineworkers. He perfected and deepened his professional skills during his military service. While stationed in Trier he became an assistant to the military photographer Georg Jung. Starting in 1899, with his military service finished, Sander traveled to various German cities as a photographer's assistant until, in 1901, he found work in the Greif photography studio in Linz, Austria. He married Anna Seitenmacher and became a partner in the studio. From that moment his name began to be known beyond the limited circle of his clientele and he started to exhibit his work.

In 1910 Sander moved the photo studio to Cologne, acquiring a new and wider clientele. In that same year he took the first photos in his "Portfolio of Archetypes." At the outbreak of World War I, Sander was called to serve in the army and he would return home only in 1918. In his absence, his wife Anna would carry on the activity of the studio. The 1920s were marked on a social level by strong conflicts and constant tension between the classes. The enthusiastic patriotism of World War I was replaced by the horrors left by the wounds of the war. The artistic climate in Germany favored a new type of expression. In Cologne, some artists formed the Progressives group, of which Sander became a member. It was an artistic association that tried to combine constructivism and objectivism, the general and the particular, with avant-garde beliefs and political commitment aimed at a "new objectivity." It was during these years that Sander conceived his most famous work, *People of the Twentieth Century.*

In 1927 Sander presented his work at the Kunstverein in Cologne, and that same year he made a trip to Sardinia with the writer Ludwig Mathar. They worked on a book about the cultural traditions and landscape of the island, but it was never published. The year 1929 saw the publication of *Antlitz der Zeit*—an anticipation and "preview" of his monumental portrait work—which enjoyed great success. But politics was about to change things forever.

The Nazis were not fond of this book, and in 1936 the Gestapo destroyed the printing plates and prevented the publication of further volumes.

The upheavals caused by the war wounded Sander both in his work and in his family life. His son Erich died in 1944 after ten years in prison because of his membership in the Socialist Party. His studio in Cologne was destroyed by bombing, even though Sander miraculously managed to save part of his archive, transferring it to a new studio in Westerwald. But some thirty thousand negatives were destroyed by a fire bomb in the basement of his apartment in Cologne. In 1953 Sander published a book called *Köln wie es war* (Cologne As It Was).

The definitive consecration of Sander's work came with the exhibit *Family of Man*, organized in 1955 by Edward Steichen, the director of the Department of Photography at the Museum of Modern Art in New York.

Sander died in Cologne in 1964 at the age of eighty-seven.

"THE ESSENCE OF ALL PHOTOGRAPHY IS DOCUMENTARY IN NATURE."

AUGUST SANDER

SELECTED BIBLIOGRAPHY

Introduction
Eco, Umberto. *The Infinity of Lists*. New York: Rizzoli International Publications, 2009.

Nobuyoshi Araki
Araki, Nobuyoshi. Interview by Filippo Maggia. December 1999, Araki's studio, Tokyo. http://www.centropecci.it/htm/mostre/00/araki/inter00a.htm.
———. Interview by Michela Scotti. *Max*, 2010.
———. *Araki*. Cologne: Taschen, 2002.
Klose, Travis. *Arakimentari*. New York: Tartan Video, 2004.

Gabriele Basilico
Basilico, Gabriele. *Architetture, città, visioni: riflessioni sulla fotografia*. Edited by Andrea Lissoni. Turin: Bruno Mondadori, 2007.
———. *Basilico Beyrouth*. Paris: La Chambre Claire, 1994.
———. *Interrupted City*. Barcelona: Actar, 1999.
———. "La mia Milano del '44 ora è Luna Park." Interview by Francesco Cevasco. *Corriere della Serra*, July 2009.
———. "Lettera a un amico architetto." *Domus*, January 1999.
———. *Nelle altre città*. Udine: Art&, 1997.

Margaret Bourke-White
Bourke-White, Margaret. *Portrait of Myself*. New York: Simon & Schuster, 1963.
Heron, Liz, and Val Williams. *Illuminations: Women Writing on Photography from the 1850s to the Present*. Durham, NC: Duke University Press, 1996.

Robert Capa
Capa, Robert. *Slightly Out of Focus*. New York: Henry Holt & Co., 1947.
Kershaw, Alex. *Blood and Champagne: The Life and Times of Robert Capa*. New York: Da Capo Press, 2004.
Tolstoy, Leo. *What is Art?* Translated by Aylmer Maude. New York: Funk & Wagnalls, 1904.

Henri Cartier-Bresson
Cartier-Bresson, Henri. *The Decisive Moment*. New York: Simon & Schuster, 1952.
———. *Des Images et des Mots*. Paris: Delpire, 2004.
———. *Henri Cartier-Bresson*. Photo Poche. 12th ed. Arles: Actes Sud, 2004.
Clair, Jean. *Henri Cartier-Bresson: The Man, the Image and the World*. New York: Thames & Hudson, 2003.
Galassi, Peter. *Henri Cartier-Bresson: The Early Work*. New York: The Museum of Modern Art, 1987.

Robert Doisneau
Doisneau, Robert. *A l'imparfait de l'objectif : souvenirs et portraits*. Arles: Actes Sud, 2001.
———. *Robert Doisneau: From Craft to Art*. Paris: Fondation Henri Cartier-Bresson, 2010.
———. *Robert Doisneau Paris*. Paris: Flammarion, 2005.

Elliott Erwitt
Erwitt, Elliott. Interview by Jessica Bromer. March 2007. http://www.portlandart.net/archives/2007/03/an_interview_wi_1.html
———. Interview by Sue Steward. 2009. http://www.professionalphotographer.co.uk/Legends/Interviews/Elliott-Erwitt-interview
———. *Personal Exposures*. New York: W.W. Norton & Compton, 1988.
———. *To the Dogs*. New York: D.A.P./Scalo, 1992.

Walker Evans
Evans, Walker. Interview by Paul Cummings. *Art in America*, October–December 1971.
———. *American Photographs*. New York: The Museum of Modern Art, 1938. Reprint 1990.
———. *Documenting America, 1935–1943*. Edited by Carl Fleischhauer, Beverley W. Brannan, Lawrence W. Levine, and Alan Trachtenberg. Berkeley and Los Angeles: University of California Press, 1988.
———. *Many Are Called*. New Haven and London: Yale University Press in association with the Metropolitan Museum of Art, 2004.
———. *Photography*. 1969. http://www.masters-of-photography.com/E/evans/evans_articles2.html
Green, Jonathan. *American Photography*. New York: H.N. Abrams, 1984.
Mellow, James R. *Walker Evans*. New York: Basic Books, 1999.
Williams, William Carlos. "Sermon with a Camera." *The New Republic*, October 12, 1938.

Mario Giacomelli
Giacomelli, Mario. *La mia vita intera*. Turin: Bruno Mondadori, 2008.
———. *Le noir attend le blanc*. Edited by Alessandra Mauro. Arles: Actes Sud, 2010.
———. *Parlami di lui. Voci su Mario Giacomelli*. Ancona: Mediateca delle Marche, 2007.
Giacomelli, Mario, and Alistair Crawford. *Mario Giacomelli*. New York: Phaidon Press, 2001.
www.mariogiacomelli.it

William Klein
Klein, William. *Paris + Klein*. New York: D.A.P., 2003.
———. *William Klein*. Photo Poche. 4th ed. Arles: Actes Sud, 2008.
———, Quentin Bajac, Alain Sayag, Bruno Racine, and Alfred Pacquement. *William Klein: Rétrospective Exhibition*. Paris: Marval/Centre Pompidou, 2005.

Peter Lindbergh
Lindbergh, Peter, and Martin Harrison. *Peter Lindbergh: Images of Women*. Munich: Schirmer/Mosel, 2004.
Wenders, Wim. *Stories*. Berkeley, CA: Arena Editions, 2002.
www.peterlindbergh.com

Man Ray
Baldwin, Neil. *Man Ray: American Artist*. New York: Da Capo Press, 1988.
Leigh, Brandi. *The Pioneering Surrealist Photographer*. 2007. www.arthistoryarchive.com
Ray, Man. *Objects of my Affection*. New York: Zabriskie Gallery, 1982.
———. *Self Portrait*. London: Andre Deutsch, 1963.
Sers, Philippe. *Man Ray Photographe*. Paris: Centre Georges Pompidou, 1981.

Robert Mapplethorpe
Celant, Germano, and Betsy Evans. *Robert Mapplethorpe: Fotografie*. Milan: Idea Books, 1983.
Chatwin, Bruce, and Robert Mapplethorpe. *Lady: Lisa Lyon*. New York: Viking Press, 1983.
Joselit, David, and Janet Kardon. *Robert Mapplethorpe: The Perfect Moment*. Philadelphia: Institute of Contemporary Art, 1988.
Wolf, Sylvia. *Polaroids: Robert Mapplethorpe*. New York: Prestel, 2007.
www.mapplethorpe.org

Steve McCurry
Mauro, Alessandra, Rose Marie, and Chiara Tenze. *Les grands photographes de Magnum Photos: Steve McCurry*. Paris: Hachette, 2005.
McCurry, Steve. Interview with the BBC World Service. http://www.bbc.co.uk/blogs/photoblog/2010/07/steve_mccurry_retrospective.html
———. "Capturing the Face of Asia." Interview by C.B. Liddell. 1998. http://www.culturekiosque.com/art/interview/Steve_McCurry.html
———. "The Nine Lives of Steve McCurry." Interview with Utne Reader. December 1999. http://www.utne.com/archives/TheNineLivesofSteveMcCurry.aspx?page=2
www.stevemccurry.com

James Nachtwey
Nachtwey, James. *A conversation with....* Interview by Elizabeth Farnsworth. Online News Hour. 2000. http://www.pbs.org/newshour/gergen/jan-june00/nachtwey_5-16.html
———. *Inferno*. London: Phaidon Press, 1999.
———. "James Nachtwey: Interview with a photography giant." *BK Magazine*, 2007.
———. "James Nachtwey Fights TB, With Pictures." Interview by Niko Koppel. *New York Times*, 2010. http://lens.blogs.nytimes.com/2010/03/18/behind-37/

Helmut Newton
Newton, Helmut. Interview by Laura Leonelli. *Epoca*, September 1989.
———. *Autobiography*. London: Duckworth & Co., 2003.

Martin Parr
Bajac, Quentin. *Parr by Parr: Quentin Bajac meets Martin Parr: Discussions with a promiscuous photographer*. Amsterdam: Schilt Publishing, 2010.
Parr, Martin. Interview with the *British Journal of Photography*, 1989.
———. Interview by Robert Carroll. *The National*, 2009.
Secher, Benjamin. "The foibles of the world." *The Telegraph*, 2011. http://www.telegraph.co.uk/culture/art/art-features/8723045/The-foibles-of-the-world.html
Williams, Val. *Martin Parr*. London: Phaidon Press, 2002.

Herb Ritts
Ritts, Herb, and Patrick Roegiers. *Herb Ritts*. New York: Thames & Hudson, 2000.
www.herbritts.com

Sebastião Salgado
Salgado, Sebastião. Interview by Alessandra Mauro. *Photo* (Italian Edition), 1998.
———. *Sebastião Salgado: An Uncertain Grace*. Essays by Eduardo Galeano and Fred Ritchin. New York: Aperture, 1990.

August Sander
Benjamin, Walter. "Kleine Geschichte der Photographie." *Gesammelte Schriften*. Frankfurt am Main: Suhrkamp, 1931.
Sander, August. *Antlitz der Zeit*. Munich: Kurt Wolff/Transmare Verlag, 1929. Translated as *Face of Our Time*. Munich: Schirmer/Mosel Verlag, 1995.
———. "Confession of Faith in Photography." 1927.
———. *Menschen des 20. Jahrhunderts*. Gütersloh: Sigbert Mohn Verlag, 1962. Translated as *People of the Twentieth Century*. New York: Harry N. Abrams, Inc., 2002.

General
Pollack, Peter. *The Picture History of Photography*. New York: Abrams, 1977.
Szarkowski, John. *Looking at Photographs*. New York: The Museum of Modern Art, 1973.
www.magnumphotos.com